From Woodblocks to the Internet

Sinica Leidensia

Edited by

Barend J. ter Haar
Maghiel van Crevel

In co-operation with

P.K. Bol, D.R. Knechtges, E.S. Rawski,
W.L. Idema, H.T. Zurndorfer

VOLUME 97

From Woodblocks to the Internet

Chinese Publishing and Print Culture in Transition, circa 1800 to 2008

Edited by

Cynthia Brokaw and Christopher A. Reed

BRILL

LEIDEN • BOSTON
2010

Z
462.3
. F76
2010

Original Cover Art Designer: Leah L. Wong

This book is printed on acid-free paper.

Library of Congress Cataloging-in-Publication Data

From woodblocks to the Internet : Chinese publishing and print culture in transition, circa 1800 to 2008 / edited by Cynthia Brokaw and Christopher A. Reed.
 p. cm. — (Sinica Leidensia, ISSN 0169-9563 ; v. 97)
 "...originated in an international conference on modern Chinese print culture at the Ohio State University held from November 3 to 7, 2004"—Acknowledgements.
 Includes bibliographical references and index.
 ISBN 978-90-04-18527-2 (acid-free paper) 1. Publishers and publishing—China—History—19th century. 2. Publishers and publishing—China—History—20th century. 3. Printing—China—History—19th century. 4. Printing—China—History—20th century. 5. Books and reading—China—History. 6. Literature publishing—China—History. 7. Periodicals—Publishing—China—History. 8. Internet publishing—China. 9. Publishers and publishing—Social aspects—China—History. 10. Publishers and publishing—Political aspects—China—History. I. Brokaw, Cynthia Joanne. II. Reed, Christopher A. (Christopher Alexander), 1954-
 Z462.3.F76 2010
 070.50951—dc22

2010029377

ISSN 0169-9563
ISBN 978 90 04 18527 2

Copyright 2010 by Koninklijke Brill NV, Leiden, The Netherlands.
Koninklijke Brill NV incorporates the imprints Brill, Hotei Publishing, IDC Publishers, Martinus Nijhoff Publishers and VSP.

CONTENTS

ACKNOWLEDGEMENTS

From Woodblocks to the Internet: Chinese Publishing and Print Culture in Transition, circa 1800 to 2008 originated in an international conference on modern Chinese print culture at The Ohio State University held from November 3 to 7, 2004. The editors would like to thank the following sponsors of the conference for their generous support: the Freeman Foundation, and, at OSU, the Institute for Chinese Studies of the East Asian Studies Center, Office of International Affairs, and Department of History. We are particularly grateful to Professor Julia F. Andrews, then director of the Institute for Chinese Studies, for her encouragement and help. Professor Harvey Graff, in his keynote address to the conference participants ("Lessons from the History of Literacy in the West"), drew on his expertise in the study of literacy and book learning in the West to provide a larger global context for the study of modern Chinese print culture. Jeff Seiken provided efficient conference management; and Ying Bao, Vivian Li, and Patrick McAloon helped record and report on the conference proceedings. At later stages, Lara Di Luo helped create the bibliography, and Wenjuan Bi, Lara Di Luo, Yan Xu, Effie Yanfei Yin, and Yanfei Zhu proofread the Chinese characters. The thirteen essays in this volume have also benefited significantly from the expert copy-editing of Cynthia Werthamer, proofreading by William Russell Coil, and indexing by Cynthia Landeen. Finally, Leah L. Wong designed the conference poster and the image used on the cover of this book.

Cynthia Brokaw, Brown University
Christopher A. Reed, The Ohio State University

CONTRIBUTORS

Daria Berg is Associate Professor of Chinese Studies at the School of Contemporary Chinese Studies, University of Nottingham, United Kingdom. A specialist in late imperial and contemporary Chinese literature, she is the author of *Carnival in China: A Reading of* Xingshi yinyuan zhuan (Brill, 2002) and editor, with Chlöe Starr, of *The Quest for Gentility in China: Negotiations beyond Gender and Class* (Routledge, 2007).

Cynthia Brokaw is Professor of History at Brown University, U.S.A. She is the author of *The Ledgers of Merit and Demerit: Social Change and Moral Order in Late Imperial China* (Princeton University Press, 1991) and *Commerce in Culture: The Sibao Book Trade in the Qing and Republican Periods* (Harvard University Asia Center, 2007) and the editor, with Kai-wing Chow, of *Printing and Book Culture in Late Imperial China* (University of California Press, 2005).

Robert Culp is Associate Professor of History at Bard College, U.S.A. A historian of Republican China, he is the author of *Articulating Citizenship: Civic Education and Student Politics in Southeast China, 1912–1940* (Harvard University Asia Center, 2007) and the editor, with Tze-ki Hon, of *The Politics of Historical Production in Late Qing and Republican China* (Brill, 2007).

Andrea Janku is Senior Lecturer in the History of China at the School of Oriental and African Studies, University of London, United Kingdom. She works on the history of printing and environmental history in modern China and is the author of *Nur leere Reden: Politischer Diskurs und die Shanghaier Presse im China des späten neunzehnten Jahrhunderts* (Harrassowitz, 2003).

Paize Keulemans is Assistant Professor of East Asian Languages and Literatures at Yale University, U.S.A. He specializes in late imperial vernacular fiction and has published numerous articles on martial arts novels.

Jan Kiely is employed by the Center for East Asian Studies at the Chinese University of Hong Kong. He is working on two books on Republican history: one on Buddhist movements and civil society, the other on prison reform.

Joachim Kurtz is Professor of Intellectual History, Asia and Europe in a Global Context, at the University of Heidelberg, Germany. Specializing in European and Chinese intellectual exchange in late imperial and Republican China, he is the author of *The Discovery of Chinese Logic* (Brill, 2009) and the editor, with M. Lackner and I. Amelung, of *New Terms for New Ideas: Western Knowledge and Lexical Change in Late Imperial China* (Brill, 2001).

Christopher A. Reed is Associate Professor of Modern Chinese History at The Ohio State University, U.S.A. The former editor of *Twentieth-Century China* and a specialist in modern Chinese printing and publishing history, he is the author of *Gutenberg in Shanghai: Chinese Print Capitalism, 1876–1937* (UBC Press and University of Hawaii Press, 2004), which was awarded the 2005 ICAS Humanities Book prize. He is currently researching printed propaganda in twentieth-century China.

Ling Shiao is Assistant Professor of History at Southern Methodist University, U.S.A. She is writing a book on intellectual circles and their publications during the May Fourth period.

Ellen Widmer is Professor of East Asian Languages and Literatures at Wellesley College, U.S.A. A specialist in late imperial Chinese literature, she has published *The Margins of Utopia: Shui-hu hou-chuan and the Literature of Ming Loyalism* (Harvard University Press, 1987) and *The Beauty and the Book: Women and Fiction in Nineteenth-Century China* (Harvard University Asia Center, 2006). She has edited numerous works, including, with Kang-i Chang, *Writing Women in Late Imperial China* (Stanford University Press, 1997) and, with David Der-wei Wang, *From May Fourth to June Fourth: Fiction and Film in Twentieth-Century China* (Harvard University Press, 1993).

Gudrun Wacker is Researcher at Stiftung Wissenschaft und Politik, German Institute for International and Security Affairs. She is the editor, with Christopher R. Hughes, of *The Internet and Censorship in*

China (Routledge Curzon, 2003) and has written widely on relations between the European Union and China, China's sustainable development, and the Internet in China.

Guobin Yang is Associate Professor of Sociology at Barnard College, U.S.A. Specializing in contemporary social movements and internet politics, he is the author of *The Power of the Internet in China: Citizen Activism Online* (Columbia University Press, 2010) and the editor, with Ching Kwan Lee, of *Re-envisioning the Chinese Revolution: The Politics and Poetics of Collective Memories in Reform China* (Woodrow Wilson Press and Stanford University Press, 2007).

ABBREVIATIONS

AAS	Association for Asian Studies
AFCJ	Archives Françaises de la Compagnie de Jesus, Vanves
BDRC	Boorman, Howard L., ed. *Biographical Dictionary of Republican China*. 5 vols. New York: Columbia University Press, 1970.
BSOAS	*Bulletin of the School of Oriental and African Studies*
CCP	Chinese Communist Party
CNNIC	China Internet Network Information Center
CNPA	China National Publishing Administration (Zhongguo guojia chubanju 中国国家出版局)
GAPP	General Administration of Press and Publication (Xinwen chuban zongshu 新闻出版总署)
GMD	Nationalist Party (Guomindang 國民黨)
GWYGB	*State Council Bulletin of the People's Republic of China*
HJAS	*Harvard Journal of Asiatic Studies*
LMS	London Missionary Society
NIAS	Nordic Institute for Asian Studies
PRC	People's Republic of China
SCMP	*South China Morning Post*
SWB FE	Summary of World Broadcasts (BBC)—Far East http://www.umi.com/en-US/catalogs/collections/detail/BBC-Summary-of-the-World-Broadcasts-10.shtml
ZCSXB	Song Yuanfang 宋原放, ed. *Zhongguo chuban shilao: xiandai bufen* 中國出版史料：現代部分 [Source materials on Chinese publishing history: 1911–1949]. Vol. 5. Jinan: Shandong jiaoyu chubanshe, 2000.
ZXCS	Zhang Jinglu, ed. *Zhongguo xiandai chuban shiliao* 中國現代出版史料 [Contemporary Chinese publishing materials]. 6 vols. Beijing: Zhonghua shuju, 1954–57.

FROM WOODBLOCKS TO THE INTERNET: CHINESE PRINTING, PUBLISHING, AND LITERARY FIELDS IN TRANSITION, CIRCA 1800 TO 2008

Christopher A. Reed*

Introduction

Cinema, television, and other nontextual modes of communication notwithstanding, our world today still reverberates in astonishing ways with the influence of printed texts. Classic writings—the Bible, Machiavelli's *The Prince*, Shakespeare's collected works, Brontë's *Jane Eyre*, Marx and Engels' *Communist Manifesto*, Freud's *Interpretation of Dreams*, Rostow's *Stages of Economic Development*, among them—produced and disseminated through processes traceable to Europe's Gutenberg and post-Gutenberg revolutions, all influence our individual and collective senses of time, morality, politics, human motivation, and action, and create a context for our objective and subjective selves. Most modern or postmodern Westerners have been "imprinted" with their words in one way or another.

The observations in the previous paragraph draw in their particulars from Western history, but they apply to much of China's printing and publishing history as well. They also provide some of the rationale for the publication of the essays in this volume. The conference that produced these essays—"From Woodblocks to the Internet: Chinese Publishing and Print Culture in Transition," held at The Ohio State University in Columbus, Ohio, in fall 2004—was designed to encourage participants to develop new approaches to the study of modern Chinese printing and textual history.[1] By casting our net widely—indeed,

* Regarding the section of this essay called "Print, Media, and Genre," the author acknowledges for their suggestions early in the writing process: Kirk Denton, The Ohio State University; Michel Hockx, SOAS, London University; and Jon Eugen von Kowallis, University of New South Wales. Patricia Sieber of Ohio State and Michel Hockx also offered valuable comments on near-final versions of this chapter.

[1] In addition to the conference participants whose papers have been published in this volume, the editors would like to thank Professors James Flath of the University of Western Ontario, Martin Heijdra of Princeton University, and Hiromitsu Kobayashi of Sophia University, Tokyo, for delivering papers at the conference. Daria Berg was

by embracing the full context of text production from author to audi-
ence—the editors hope the essays indicate the roles that modern and
"postmodern" textual communications have played in reconfiguring
the publishing and print culture of China, one of the world's great
print- and text-producing and -consuming societies, over the past two
centuries.

For much longer than their peers in the West, of course, the Chi-
nese have been composing, printing, and publishing texts with at least
as wide a range of intentions as the more familiar beneficiaries of the
Gutenberg revolution noted above: restoration of a classical past, reli-
gious cultivation and/or proselytism, inculcation of morality, political
reform and/or revolution, education of the young, entertainment, and
so forth. As in Western textual history, some Chinese texts accomplish
all of these goals and others besides. And, because texts themselves are
unstable, often taking on different, perhaps even contradictory, mean-
ings in different contexts, works such as the Four Books (*Sishu* 四書),
the Thirteen Classics (*Shisanjing* 十三經), the Buddhist and Daoist
canons, philosophical commentaries by Zhu Xi 朱熹 (1130–1200), the
Classic of Filiality (*Xiaojing* 孝經), and *Quotations from Chairman Mao*
(*Mao Zhuxi yülu* 毛主席語錄),[2] among others, were/are capable both
of establishing orthodoxy and of provoking heterodoxy, depending on
the social context and the social position of the writer, publisher, or
reader. Indeed, ambiguity and instability seem to be permanent char-
acteristics of textual culture; therefore, the context of production and
consumption becomes critical in understanding the deployment of the
various forms of printed and virtual texts discussed in these pages.
Evaluating the benefits or liabilities of individual texts also depends
on factors that only scholars who combine the methods of political,
social, economic, technological, biographical, and intellectual history
can help to sort out, suggesting why the contributors to this volume
have adopted a wide range of approaches.

Broadly stated, the goal of this volume is to initiate a sweeping
examination of the modern Chinese literary field. "Literary field," of

invited to the conference and, although she could not join us then, contributed a
revised paper to this volume. Finally, appreciation is due the Institute for Chinese
Studies and the Office of International Affairs of The Ohio State University for their
financial support and all who attended our sessions and contributed their ideas.
 [2] Clearly, some of the Chinese texts listed, like the Western titles mentioned earlier,
have crossed cultural boundaries, and have been "imprinted" well beyond their initial
audiences.

course, is a concept first formulated by the French sociologist Pierre Bourdieu.[3] In 1999, Chinese literature scholar Michel Hockx restated the notion of a literary field as "an interest community of agents and institutions involved in the material and symbolic production of literature."[4] Denise Gimpel explains literary field in even more explicit terms:

> The idea of a literary field with its complex interaction of writers, publishers, critics, and readers, where autonomous (artistic) and heteronomous (nonliterary) principles together govern and guide the relationships between members of a community of writers and where institutions such as publishing houses, booksellers, critics, and academia play an important role in deciding the financial and literary success of any given work or body of works can also be helpful in the study of... literary production....[5]

Extending Hockx's and Gimpel's discussions, we have, in this volume, emphasized the role of publishing within the literary field in a collective effort to explore the interaction between literary production and printing/publishing over a period of two centuries. This is to say that each contributor began with an awareness of both material (heteronomous) forces, particularly the multiple printing technologies used by the Chinese for centuries prior to the period examined here, and autonomous forces such as content, genre, and style choices.

In this volume, we collectively examine the period that extends from the decline of xylography (woodblock printing) in the nineteenth century through China's expanding Gutenberg revolution (involving a vast complex of largely Western-originated more-or-less industrial technologies) of the late nineteenth and twentieth centuries, and on to the rise of post-Gutenberg, postmodern digital and Internet publishing in the late twentieth and early twenty-first centuries. A crucial concern, then, is the impact that the rapidly changing printing technologies of the nineteenth, twentieth, and twenty-first centuries has had on textual production and dissemination.

[3] Bourdieu discusses "literary field" in a number of places, among them, "The Field of Cultural Production, or: The Economic World Reversed" and "The Production of Belief: Contribution to an Economy of Symbolic Goods," both in Bourdieu, *The Field of Cultural Production*, 29–73 and 74–111, respectively. See also Bourdieu, *The Rules of Art*, 141–173; and Darnton, "What Is the History of the Book?" 69–84, on "communications circuits."

[4] "Introduction," in Hockx, *The Literary Field of Twentieth-Century China*, 9.

[5] Gimpel, *Lost Voices of Modernity*, 9, 176.

A second theme is the ways in which print, media, and genre have been reconceived not only as a result of shifts in communications technology but also as a result of dramatic political change, intellectual ferment, and social upheaval. In the period discussed here, the Chinese passed through the later years of the Qing imperial dynastic (1800–1911), Republican (1912–49), and People's Republic (1949-present) forms of government, with often drastic effects on the lives of ordinary and elite people. In these two centuries, even as China tried again and again to modernize, the country was also frequently at war with invaders from Europe and Japan. During this time, the print media provided education and escapism, stirred patriotic emotions, and contributed to a growing awareness of China as one distinctive country among many. Inevitably, broader social changes redounded upon the print media, necessitating adjustments in the ways that writing, reading, publishing, and distributing were done. And new forms of print communities were formed, whether organized around the imported media of newspapers, magazines, journals, or virtual texts, or the old but frequently renewed one of books.

Third, and finally, we are concerned here, too, with the impact that rapidly changing state-society relations have had on modern (and are having on contemporary) Chinese publishing and print culture. Expanding and retracting phases of state power and authority over the two centuries discussed here allow the scholars whose work is found in this volume to examine both vertical relationships (between state and society) and horizontal ones (regions, cities, towns, political parties, religious and educational communities). The era under investigation was (and is) one of growing state-mandated modern public education. Once new print communities were created, how did they react to statist controls and efforts at censorship? The following sections survey these three aspects of the literary field as they are treated in the essays in this volume.

Chinese Printing Technologies and Publishing in the Modern and Postmodern Periods

China is now generally acknowledged to have led the world in the development of paper and printing technology through the end of the early modern period. Prior to the nineteenth century, more books were likely written and published in Chinese than in any other single

published language. The Chinese invented woodblock printing for reproducing double pages of text as early as the eighth century; in the eleventh, they also developed a method of printing individual words using movable type made of hardened clay, to be followed by the use of wooden moveable type during the Yuan period (1279–1368). By the sixteenth century, they were printing texts in multiple colors and were highly accomplished in the printer's art of combining text and image.[6] The full complex of premodern technologies, including movable wooden and movable metal type, was deployed throughout the Qing (1644–1911).[7]

However, as most scholars agree, the nature of the Chinese language (with its thousands of individual logographs) and the economics of publishing combined to make xylography the dominant method of Chinese book production throughout these centuries and down through the end of the nineteenth century. In addition, the decreasing cost of printing during this extended period (thanks in part to lowered labor and paper costs), combined with the curricular demands of the civil service examination system and the requirements of a sophisticated bureaucracy, guaranteed an ever-expanding demand for the conventional texts required to study for the examinations and to administer the empire. In turn, the creation, production, and consumption of such texts, along with increasingly popular novels, ritual handbooks, medical guides, fortune-telling manuals, et cetera, influenced the social configuration and value systems of society. These processes also constituted what we might call a new geography of the Chinese text. According to Cynthia Brokaw, during the late Ming and Qing, most central places in the late empire gained expanded access to printing and publishing resources; the simplicity and easy transportability of woodblock printing technology even made it possible for more marginal locations to have access to texts.[8] With the availability of technology, authors and readers also multiplied at the regional and local levels.

[6] For a general introduction to premodern Chinese printing technology and publishing, see Tsien, *Paper and Printing*; the various essays in Edgren, *Chinese Rare Books in American Collections*; and McDermott, *A Social History of the Chinese Book*.

[7] See Andrea Janku's essay in this volume. Movable wooden type was practicable because of the repetitive nature of the language of official communications. It was also used by commercial printers for the semi-official *Peking Gazette* (*Jingbao*).

[8] See Brokaw's essay in this volume, and also her *Commerce in Culture*, 8–9.

Yet new technology—for example, the printing presses introduced during China's "Gutenberg revolution" of the late nineteenth and early twentieth century—when promoted through industrialization, also made the radical centralization of printing possible. The production, distribution, and social impact of the *Quotations from Chairman Mao* provide a dramatic illustration of this rather obvious point. Under the guidance of Minister of Defense Lin Biao 林彪 (1907–1971), "The Little Red Book" was edited in 1962 for use as motivational reading by soldiers in the People's Liberation Army. In May 1964 it was printed and published by the Political Department of the People's Liberation Army for mass consumption. Between 1964 and 1967, in the estimate of one writer, 720 million copies were printed for dissemination to the entire literate population of China.[9] In addition, during the Cultural Revolution (1966–76) and beyond, more inclusive collections of Mao's writings[10] and shorter extracts from the *Quotations* printed in newspapers were distributed by government-directed publishers, effectively saturating China's population of one billion with the Great Helmsman's words. Textual production and consumption on this scale would simply have been impossible for China's widely dispersed xylographic and preindustrial movable-type printers of the nineteenth century and earlier. Thus, the technologies of textual production are a vitally important consideration when scrutinizing the literary field of modern and postmodern Chinese printing and publishing. The rapid changes in printing technology—and the Chinese selection and adaptation of new, usually Western-derived, printing methods—undoubtedly played a formative role in the creation of modern and postmodern print culture.

To be sure, neither the Gutenberg revolution nor the more recent revolution in virtual print happened overnight (even though the latter happened more quickly than the former, in a matter of one decade as opposed to a century). Both involved continuities and discontinuities.

[9] Oliver Lei Han, "Sources and Early Printing History of Chairman Mao's *Quotations*."
[10] According to Meisner, *Mao's China and After*, 277, 120 million sets of Mao's *Selected Works* were printed. Barme, *Shades of Mao*, 7–9, quoting secret Xinhua Books's statistics from 1979, reports that, during the ten-year Cultural Revolution, more than forty billion volumes of Mao's various works were printed. By 1979, the unsold volumes represented 8 percent of all unsold books in China; by the end of that summer, all unsold copies of the *Quotations* were ordered pulped. In addition, 2.2 billion portraits of Mao were produced in the 1966–76 decade—enough for every Chinese citizen of that era to have three apiece.

Brokaw points out the continuing importance of woodblock printing, particularly in the hinterlands, through the early twentieth century. Ellen Widmer, in her essay on the late xylographic era, argues in favor of an alternately defined textual and social modernity that anticipates the need for analytical flexibility in pondering the defining influence of technology on modern and postmodern China. Providing further evidence of the need to think through the role of transitions and contingency in the creation of modernity, Andrea Janku then reminds us that the first "modern" Chinese-language periodicals appeared circa 1833, on a monthly rather than a daily basis. Although these were lithographed (a still relatively new Western technology dating from the 1790s), they looked more like Chinese books, with their thread binding and floppy bamboo paper, than like journals. Even the earliest newspapers, such as the *Shanghai Journal* (*Shenbao* 申報, founded in 1872), which Janku here examines, were long printed on Chinese bamboo paper, albeit using Western-style metal type. Similarly, Jan Kiely notes that the Nanjing Buddhist Jinling Scripture Carving House (Jinling kejingchu 金陵刻經處), one of numerous Buddhist woodblock publishers established or revived in the late Qing, began publishing with woodblock technology as late as 1866. Yet it and other similar houses survived well into the twentieth century; Jinling even carries on in the twenty-first.

All of these examples of publishing dependent on the marketplace contrast sharply with Christopher A. Reed's study of deprived and impoverished Communist Party printers in the Yan'an 延安 caves far from Shanghai, the urban printing center of the Republican era. There, a full complement of both "premodern" (Malan-grass paper, woodblocks) and "modern" (e.g., lithography and lead type) printing techniques were deployed in circumstances that owed little to the market conditions that underlie the accounts of Brokaw, Widmer, Janku, and Kiely. Even after the Yan'an (1937–47) era and the founding of the new state in 1949, when Communist China began to experience steady economic growth and modernization, xylography continued to be used alongside more recently adapted foreign printing processes.

Despite this patchwork of new and old technologies, it is reasonable to date the beginning of China's modern print culture to the 1870s. In that decade, industrialized Chinese- and foreign-owned print shops began producing "modern" texts in considerable quantities for a largely commercial market of textual consumption that predated, by centuries, the modern arrival of Western printing technology in

China.[11] Throughout the final quarter of the nineteenth century, coastal China embraced various Western print technologies, notably, but not exclusively, mechanized movable-type letterpress printing. In turn, as most of the essays included here either show or imply, this technological revolution irreversibly (but not all-encompassingly) transformed China's printing and publishing world along with its textual culture and literary field. It did so in part by centralizing the formerly far-flung craft-based business in treaty-port Shanghai, which was opened to Western trade in 1842. At the same time, such technology enabled the large text runs demanded by a rapidly growing population.[12]

By and large, Shanghai-based publishing companies were the organizational units that initially deployed the various forms of modern printing technology. Until recently, we thought we knew the general outline of this process of adaptation. However, the essays here offer a closer reading of the historical record. They examine connections and influences overlooked by previous scholarship and provide the basis for a revised synthesis that expands the range of significant actors.

For example, based on Joachim Kurtz's essay as well as other recent scholarship,[13] we can now say decisively that Jesuit printer-publishers appeared early in our period and were central to laying the groundwork that eventually yielded Shanghai-based Chinese print modernity. We have known for some time that secular newspaper publishers such as the *Shanghai Journal* Office (*Shenbao* guan 申報館) often printed books, at least initially as a sideline, and that Jesuit-trained, initially Xujiahui 徐家匯-based lithographers frequently went on to work for secular newspaper and book publishers. Similarly, building on the initiative of the newspapers and Protestant religious institutions, specialized secular book publishers are understood to have soon established themselves in the vanguard of China's print-technology revolution.[14] Now, however, thanks to Kurtz's essay on the Tushanwan 土山灣 Jesuit printers, it has become clear that at least four, not three, communities—Protestant printers, newspaper publishers, book pub-

[11] As the essays by Brokaw and Widmer suggest.
[12] In 1937, 86 percent of all Chinese book publishing and much of its periodical publishing occurred in Shanghai. Seventy percent of Shanghai's book publishing was accomplished by three large publishers: the Commercial Press, Zhonghua Books, and World Books. See Reed, *Gutenberg in Shanghai*, 207.
[13] Ibid., 79–80, 307 nn. 76, 78.
[14] Reed, *Gutenberg in Shanghai*, chapter 1, especially 28–30 (Tables 1.1 and 1.2).

lishers, and Catholic printers—were all fundamental to the creation of secular Chinese print capitalism.

Shanghai's newspaper and book publishers, along with the Catholic publishers studied by Kurtz, steadily reached ever-wider audiences. By the end of the first decade of the twentieth century, Shanghai utterly dominated modern Chinese print culture through the large corporatized firms such as the newspaper publishers *Shanghai Journal* Office and *Eastern Times* Office (*Shibao* guan 時報館), the book publishers Commercial Press (Shangwu yinshuguan 商務印書館) and Wenming Books (Wenming shuju 文明書局), and the Catholic printing facilities in the suburbs. At the time of the May Fourth/New Culture Movement (1915–21), Shanghai had become synonymous with modern Chinese print culture; a steady stream of works rolled off the newspaper, journal, and book presses, often to reappear in a complementary, crosstown medium, a phenomenon that began in the 1890s. In the 1920s and 1930s, the establishment anchors of Shanghai's Culture Streets (*Wenhuajie* 文化街, located on and around Simalu 四馬路 and Fuzhou 福州, Wangping 望平 [Shandong 山東], and Henan Middle 河南中 roads), the *Shanghai Journal, Eastern Times*, and the corporate "Big Three" (the Commercial Press, Zhonghua Books [Zhonghua shuju 中華書局], and World Books [Shijie shuju 世界書局]) found themselves surrounded by scores of smaller, more self-consciously progressive publishers and retailers, some of which are examined here by Ling Shiao. Few had their own printing plants, however, making them dependent on the book and newspaper publishers' print shops.

Beginning in the 1920s, modernity in print culture was associated with an audience defined commercially by the marketplace, culturally by schools and professions, and politically by party-subsidized publishers. Political parties as well as the successive governments of the Chinese Republic (until the late 1940s) and the People's Republic (from 1949 onward) also made vigorous efforts—through language standardization and orthographic reform, the promotion of innovative literary and educational standards, technological improvements, and even the publication of their own party- and state-subsidized materials—to expand (and to some extent to manipulate) the size and nature of the national reading public.

After 1937, war and the failure of the Nationalist Party (Guomindang 國民黨, or GMD) state combined to bankrupt the Shanghai publishers, clearing the way for Beijing's rise as the new center of modern Chinese publishing and print communism. New monopolistic state-

run organizations appeared, controlling printing, publishing, and distribution networks under the general rubric of New China Books (Xinhua shudian 新華書店) and several other firms. By then, of the hundreds of pre-1949 printer-publishers, only the Commercial Press, Zhonghua Books, the Tushanwan printer-publishers, and a handful of others survived (the Tushanwan Catholic printing works were dissolved in 1962, but the Commercial Press and Zhonghua Books remain among China's most influential publishers today).

Both market-driven and noncommercial industrialized and nonindustrialized printing and publishing remained in place until the 1949 revolution. At that time, print communism—defined in Reed's essay as the hegemonic, state-directed industrial production and dissemination of texts—was implemented on a national scale, largely (but not exclusively) favoring the mechanized processes inherited from the previous era. Access to technology was now regulated by the state, which also put constraints on who could be a published writer or author. Decades later, in the 1980s and 1990s, China's theretofore government-dominated industrial printing and publishing establishment was reconfigured again, first by computerization and then by the Internet, producing ever-newer postmodern forms of texts along with redefined author-audience relationships (in particular, see the essays here by Guobin Yang and Daria Berg), even as earlier technological production processes continued to thrive.[15] Maggie Holtzberg-Call notes somewhat melodramatically in her study of the "hot-metal" printer that the Gutenberg era "ended" in America in the 1980s, when it was superseded by computerization.[16] Although in theory China's Gutenberg era came to an end at about the same time, in practice, as in the West, older technological processes remained in operation; even as technology changed, modes of analysis that were developed to study texts and print culture in the modern Gutenberg era can validly be extended to this postmodern, post-Gutenberg period, as Yang and Berg argue here.

In the 1990s, just a few years after its takeoff in the West, the development of digital texts first on computers and then their dissemina-

[15] On the postmodern transition but lacking an interest in the role of technological change in shaping it, see Yuezhi Zhao, *Media, Market, and Democracy in China,* and Kong, *Consuming Literature.*

[16] Holtzberg-Call, *The Lost World of the Craft Printer.*

tion on the Internet—another imported revolution in the technology of textual production adapted to the Chinese language and then manipulated by Chinese print and textual culture—served further to rework the culture of Chinese information transmission. As Yang explains, China established limited e-mail links to the Internet in 1987, and the Internet itself officially arrived in 1994. It then proliferated far faster than had the printing press during China's Gutenberg era. Like the Gutenberg revolution, the digital one initially affected only a fraction of China's huge population, but by 2008, 23 percent of China's citizenry—300 million people—were netizens (*wangmin* 网民). Similarly, most of those are still concentrated in urban areas. However, the Internet, like xylography and modern Western printing before it, seems likely to spread far beyond its initial urban nodes and to promote innovations in both authorship and readership.

This most recent and highly dramatic transformation in communications history coincides with China's reappearance as a world power, and its consequences are particularly important, as they seem likely to challenge our current understanding of textual in/stability, the force and reach of governmental textual control, and the nature of political participation in China. They are also helping to reshape the country's identity in this era of globalization by returning China to a central place in the world's economy, politics, and culture.

Print, Media, and Genre

As important as technologies may be for helping to create context, in and of themselves they do not create change; they, too, are conditioned by history and context, and, as suggested above, not necessarily in a linear fashion. Borrowing a term from Yang's essay, we can say that the printing press and the computer are "platforms" for communication. And from these platforms, publishers and writers, whether working in print and/or virtual print, have created or are creating their own audiences or reading communities, as well as new genres of writing.

In terms of media, in the early nineteenth century when our coverage opens, books, studied here by Brokaw, Widmer, and Paize Keulemans, clearly reigned supreme. By the end of our period, they had been joined by newspapers of the sort discussed by Janku, magazines and journals of the sort studied by Kiely, Kurtz, and Robert Culp, and, then, mostly recently, by the endless variety of virtual texts found on

the Internet (all of the above, plus the Web sites, electronic chat rooms [*wangluo liaotian shi* 网络聊天室], blogs [*boke* 博客], and so on) studied by Gudrun Wacker, Yang, and Berg. All of these media became quite mutable in our period, with successful texts often transcending their initial medium to reappear in new ones. Although numerous other genres have clearly played a role—poetry and drama come to mind—the easily identified cases of this phenomenon involve journalism and fiction, the genres that have most engaged modern scholars; they are at the heart of the discussion in this section. And because recent scholarship has tended to focus on Shanghai and Beijing, where sources produced by and for a literate elite have been most plentiful, observations here have a more obviously urban/elite-oriented perspective than the previous or the following sections.

To help us to make sense of this complex new realm, Alexander Des Forges offers a model for understanding the new relations between authors, readers, media, and genres that unfolded from the 1890s to the 1930s in Shanghai; his model also has implications for subsequent modern and postmodern Chinese print culture. Des Forges draws on Benedict Anderson's notion of the "imagined communities"[17] of national identity created in Europe in the eighteenth century by the then-new medium of the newspaper and the then-new genre of the novel to suggest that an innovative form of shared understanding was brought forth by Shanghai's late nineteenth-century print media and its readers.[18] In Des Forges's view, these changes are apparent initially through lithographed pictorials and novels, and then via letterpress-printed ones.

The late-Qing, early-Republican Shanghai mediasphere that fascinates Des Forges is a mode of cultural production made up of three elements: an expanding visual and textual realm, a widening range of media-related commodities that influence and borrow from one another ("fiction and nonfiction books, newspapers, magazines...and

[17] Anderson, *Imagined Communities*, 6–7, 46.

[18] Like most scholars of the period, Des Forges has difficulty ascertaining the size of the late-Qing reading public. However, in *Mediasphere Shanghai* he does note, 10, that, in late nineteenth-century Shanghai, 60 percent of adult males and from 10 to 30 percent of adult women could read simple texts and, further, that in the first decade of the twentieth century, more than twenty thousand copies of the novel *Haishanghua* were in print, 189 n. 20.

eventually film and radio"),[19] and frequent links and references across texts, genres, and media.[20] For Des Forges, a clearly identifiable genre of long vernacular fiction—Shanghai novels (*haishang xiaoshuo* 海上小說)—came into existence in the 1890s and flourished through the 1930s. Interestingly, similar to the online novels discussed by Berg that are united by the phenomenon of "body writing" (*shenti xiezuo* 身體寫作),[21] these novels are "characterized by obsessive attention to the contemporary, precision and accuracy in details of place and time...."[22] Indeed, Des Forges finds in the serialized novels that began with Han Bangqing's (韓邦慶 1856–94) *Lives of Shanghai Flowers* (*Haishang hua liezhuan* 海上花列傳), which appeared in newspaper installments in 1892 and then in book format in 1894, a social force that actually prompted "Shanghai's rapid rise to prominence as a national media center"[23] from the late Qing into the Republican period.

As is now widely known, journalism introduced several new genres to Chinese print culture, in particular the fiction supplements to newspapers and the idea of "the news" itself, along with what can be called the epistemological mode of factuality. Barbara Mittler has recently examined one of late imperial Shanghai's newspapers—the *Shanghai Journal*—and, in addition to showing how the "alien" newspaper medium became a Chinese one, also suggests how it introduced the culture of specificity, verifiability, and factuality upon which Des Forges's mediasphere thrived. In her study of the early *Shanghai Journal*, Mittler finds, unsurprisingly, that in its early decades the Sino-British newspaper lacked a modern journalistic voice and language. Still influenced by Chinese literary and fictional prose conventions, it mixed fact with fiction, subjectivity with objectivity. However, after 1905, partly as a result of new foreign journalism textbooks that stressed the recent Western ideal of "truthful and objective reporting," the categories of

[19] Ibid., 16. This environment is clearly similar to the world described by Yang and Berg, one in which fiction and nonfiction, different media, and different genres become mixed up and intermingled.

[20] Ibid.

[21] In her essay in this volume, Berg defines body writing "as a narrative genre signifying the sensuality, sensitivity, and focus on private experience in the works of the new wave women writers."

[22] Des Forges, *Mediasphere Shanghai*, 3. Des Forges's comment about "precision and accuracy" can be related to Mittler's argument about the deliberate effort to separate fact from fiction that is discussed below.

[23] Ibid., 3, 5. Des Forges's argument is supported by the findings of Reed, "Re/Collecting the Sources," 44–72.

"important news" (*yaowen* 要聞) and "local news" (*benbu xinwen* 本埠新聞) arrived in print; six years later, fact and fiction were no longer freely mixed together in the pages of the *Shanghai Journal*. Even traditional "strange and amusing" (*zhiguai* 志怪) tales were now viewed with a clinical eye. In the long run, Mittler concludes, "the 'invention' of the keywords *factuality* and *objectivity* [*gongzheng ke-guan, zhunque wuwu* 公正客觀, 準確無誤]...and the ensuing separation of the factual from the fictional, and objective narration from the subjective, an invention that was accompanied by a re-evaluation of literature, or *wenxue*, as a collection of timeless works of universal value...created a new view of newspaper prose...."[24]

Together, Des Forges and Mittler illuminate the situation that Leo Ou-fan Lee has described as the creation of a "modern imaginary."[25] Key to this imaginary was an innovative, updated sense of time. Like modern print technology, modern Chinese authorship and readership, and aspects of modern Chinese media and genre, this new sense of time was adapted from Western models, sometimes via Japan, and reworked to create a new context and form of expression.[26] Thus, whether one finds the late-Qing source of change in fiction (Des Forges), in journalism (Mittler), or in a new imaginary and sense of temporality (Lee), it is clear that the epistemological distinctions between fiction and fact, and the conventions tied to each, are considered by scholars to have become part of the literary field assumed by twentieth-century Chinese authors and readers.

Literacy and the relative size of potential readerships can shed light on the scale and thus the significance of these changes, and also provide an additional impetus for the publication of the essays in this volume. Literacy rates of the Qing era are hotly debated, partly because historians cannot agree on the size of Qing China's population. However, assuming a population of four hundred fifty million, and converting the prevailing low and high estimates of literacy advanced by scholars into approximate numbers, suggests that China had a functionally literate population of at least one hundred million between 1700 and the mid-1800s.[27]

[24] Mittler, *A Newspaper for China?* 113, 97.

[25] Leo Ou-fan Lee, *Shanghai Modern*, 63.

[26] Ibid., 43–44.

[27] Rawski, *Education and Popular Literacy in Ch'ing China*, 23 argues that the overall rate of literacy in the eighteenth and nineteenth centuries ranged between 30 and

At the same time, as Brokaw makes clear elsewhere, the role of vary-
ing competencies, or what has been called "literacy registers," must not
be overlooked.[28] Similarly, Widmer reminds us that well-established
elite and evolving non-elite female audiences must be included in such
registers. Based on anecdotal accounts published in the late 1800s,
overall literacy rates probably declined with the post-Taiping Heav-
enly Kingdom (1851–64) collapse of the educational and civil service
system but then started to grow again toward the end of the century.
Kurtz's study of Li Wenyu clearly shows the late-Qing Chinese Jesuit
writer-publisher mastered a range of registers, from the "flat and shal-
low" language of the uneducated on up to a "rarefied classical prose"
aimed at sophisticated readers. Within the period discussed by Des
Forges and Mittler, as well as by Janku, Keulemans, and Kiely in this
volume, the five-century-old civil service examination system ended
(in 1905). Chinese students, including both well-known figures and
anonymous millions of others, were being educated using the old cur-
riculum of primers, classics, and poetry as well as the textbooks only
just then being generated, each of which represents a separate literacy
register, thereby indicating the need for small-scale, local studies of
reading and readerships such as those contained in most of the essays
found herein.

At the same time—that is, at turn of the twentieth century—Shang-
hai publishers began paying their authors, establishing a trend that
continued into the Republican and People's Republic periods. Gimpel
finds that, in 1907, when the short story journal *Grove of Literature*
(*Xiaoshuo lin* 小說林) appeared, and again in 1910, with the publi-
cation of *The Short Story Magazine* (*Xiaoshuo yuebao* 小說月報),
journals conspicuously printed their pay rates for easy consultation
by potential contributors.[29] However, Perry Link observes that royal-
ties were usually too paltry to allow authors to live off them alone.
This circumstance explains why many writers doubled as journalists.
In the 1910s, in fact, there were only about fifty well-known authors
(almost none were women but a good number were men writing as

45 percent for males and may have been as high as 10 percent for females. Idema, in
his review of Rawski's book in *T'oung Pao*, 314–324, argues that the actual literacy
rate was between 20 and 25 percent overall, which suggests the one hundred million
estimate.

[28] Brokaw, *Commerce in Culture*, chapter 14.

[29] Gimpel, *Lost Voices*, 218. Pay scales ranged from three to five yuan per one thou-
sand characters.

women), and many of those had to combine teaching with writing to earn a living.[30] In his view, only in the 1920s, when literacy and readership rates rose thanks to the attendance of perhaps five million students in modern schools, did pay rates climb high enough to allow fiction writing to become a career.[31] Even as fiction writing may have become a remunerative career for some, other social groups often organized around both publishing organs and schools, as in the case of the writer-publishers described by Culp and Ling Shiao. Shiao, discussing freelancing and the mission-driven "colleague" (*tongren* 同人) publications of the 1920s, even finds that post-May Fourth authors banded together twice, in 1927 and 1928, to form, unsuccessfully, professional authors' unions that sought in part to protect the products of authors' intellectual labor, suggesting that the system was less remunerative than formerly believed and complicating our sense of steady improvement in authorial remuneration.

Even as some popular authors of the 1930s reached unprecedented heights of recognition, income, and respect, other writers, troubled by China's precarious international position, rejected the commercialized professional writing environment of Shanghai's Culture Streets to shoulder what they perceived to be the moral and political burdens of modern Chinese writing. Aware of the need for an "objective" approach to social and political problems, these Marxist and May Fourth-inspired writers "produced the notion of a true 'path' [*daolu* 道路] for the nation to follow."[32] A decade later, in Yan'an, Mao Zedong clarified the distinction between art and politics, and "removed the determination of correctness from writers [and market-oriented readers] and handed it to political authorities."[33] Another decade passed and what Reed here calls "print communism" was enshrined as national policy in the PRC. Individualistic self-referentiality largely went out the window along with entertainment fiction—that is, popular stories

[30] Link, *Mandarin Ducks and Butterflies*, 156.

[31] Without identifying his sources on the topic, Link, *Mandarin Ducks and Butterflies*, 12–13, reports that rates of two yuan per thousand in the 1910s rose to four and six yuan in the 1920s, which he says then allowed writers to support themselves solely through authorship; yet Gimpel (see above) identifies rates of five yuan in 1900–10, suggesting that such rates had remained level for some twenty years.

[32] Link, *The Uses of Literature*, 107. Without using the term "*daolu*," Denton, *The Problematic of Self in Modern Chinese Literature*, 15, and Wong, "A Literary Organization with a Clear Political Agenda," 316–320, make a similar point.

[33] Link, *Mandarin Ducks and Butterflies*, 15.

of romantic love, martial arts, and so on.[34] Reflecting the idealistic, cir-
cumscribed view of literary composition in that era, in which writing
for the market was unknown, Beijing literary historian Hong Zicheng
洪子誠 comments:

> From 1949 until the 1970s, the relationship between literature and com-
> modities was a continuation of the "tradition" of the "base areas" and
> "Yan'an literature."...Literature was "a state of consciousness," a "spiri-
> tual product" unrelated to money or commodities....During the Cul-
> tural Revolution, this "pure" quality of literature achieved a state never
> previously seen.[35]

Only in the late 1980s and the 1990s did changes in public policy
(allowing for the recommoditization of literature) and the rise of the
Internet, respectively, make possible the return of purely recreational
literature on a large scale, simultaneously promoting the forms of pop-
ular literature that Yang and Berg discuss here.

Although the Chinese Communist Party sustained some of the
changes that had occurred in the market-driven literary fields of
the late Qing and Republican periods, it also radically altered other
aspects, partly in its pursuit of a new, sometimes hypothetical, read-
ership through multiple media and genres. As Shiao's and Culp's
essays make clear, in the first half of the twentieth century, especially
in the post-May Fourth years, a wide variety of publishing and lit-
erary groups came into being, some of which included both writers
and publishers as well as writers who evolved into publishers. Those
discussed by Culp had noncommercial motives and used their print
communities to professionalize teaching and advance their careers in
education. Others, such as those discussed by Shiao, began with non-
commercial motives but eventually embraced the market. Members of
a third group, the CCP, discussed by Reed, tried but failed to extri-
cate themselves from market conditions in the 1920s. In the 1930s
and 1940s, however, antimarket CCP-directed restrictions successfully
displaced the assortment of options depicted by Shiao and Culp, only
some of which were directly related to the commoditization of print.

By the 1950s, with the establishment of the All-China Writers'
Association (Zhongguo zuojia xiehui 中國作家協會) and its pro-
vincial affiliates along with related infrastructural systems, ideological

[34] Ibid., 104–05; Link, *The Uses of Literature*, 220.
[35] Hong, *Zhongguo dangdai wenxueshi*, 271–272.

uniformity came to characterize most Chinese writing. Freelance writers of the type seen in the late-Qing and Republican eras no longer existed; print runs now did not influence a writer's income; and authors' fees were now paid at a standard rate per one thousand characters,[36] superficially similar to the late-Qing system discussed by Gimpel. However, the state now absorbed any financial risk rather than the private publishing companies and the individual authors of the pre-1949 era. In effect, a new form of literary field was created. Moreover, unlike writers in the Soviet Union, which provided the general model for the post-1949 system of print communism, most Chinese authors now reverted to a part-time status that recalls the literati "system" in place before the appearance of Des Forges's Shanghai mediasphere. Only a tiny minority wrote fiction full time; the majority worked for various "work units" (danwei 單位) at the local, provincial, and national levels. Merle Goldman reports that the Great Leap Forward (1958–61), with its blurring of the line between "red" and "expert," boosted membership in the Writers' Association "from fewer than a thousand in 1957 to nearly 200,000 in 1958,"[37] as part-time and amateur writers came to predominate. By the mid-1960s, some creative writing was even being done by "anonymous groups, attached primarily to the Propaganda Department of the [People's Liberation Army]," particularly in the genre of the "semi-fictional diary."[38]

However, regulations on royalties were adjusted to a socialist standard only gradually; amidst large-scale nationalization of industry and agriculture, the 1950s were in fact a near-golden decade for established authors, Mao Zedong among them.[39] No royalties were paid during the Cultural Revolution,[40] however, and a reworked royalty system did not resume until after it ended in 1976. Between 1949 and 1966, when

[36] Hong, Zhongguo dangdai wenxueshi, 39–40.
[37] Goldman, "The Party and the Intellectuals," 351.
[38] Ibid., 387.
[39] Financially, Mao was by far China's most successful writer between 1949 and his death in 1976—despite the fact that some of his works were authored by committee; see note 93 below. Current estimates of his estate, which was mostly drawn from his writings (which accrued to the Chinese Communist Party upon his death), run as high as US$17.6 million. In 1967, he was worth only $700,000. See Bristow, "Who Owns Mao's Millions?" However, Mao was not the only Chinese writer who did well after 1949, especially in the 1950s. See Link, Uses of Literature, 129–130, which reports that Ba Jin, Mao Dun, and Yang Mo each made sizable fortunes from their writing in that decade.
[40] Hong, Zhongguo dangdai wenxueshi, 272.

China's population was at least twice what it had been in the 1920s, only twenty to thirty authors in all of China could live off their writing; from 1966 to 1990, none could.[41] And yet, during the Cultural Revolution, when all provincial literary magazines and all branches of the writers' associations closed, would-be authors continued to write. Although stories were occasionally scripted by worker-peasant-soldier committees, theoretically undermining the notion of the single author that had evolved during the mediasphere decades and remained throughout the 1950s and early 1960s,[42] most Cultural Revolution fiction continued to be single-authored.[43] "Spare-time writing" also flourished, to a degree; Lan Yang mentions two such occasional authors, both from "bad" class backgrounds, who independently submitted their work to Shanghai's People's Press (Renmin chubanshe 人民出版社) and saw it published in the mid-1970s.[44] Some twenty years later, as Berg explains, the author herself became the marketing hook; now, bans on distribution actually promoted sales, at least of popular literature, whether in print or on the Internet.

In the 1950s, print runs grew even as the numbers of new titles declined. Before 1949, only a few thousand copies of major novels had typically been printed. By the 1950s, however, new printings frequently ran to tens or even hundreds of thousands of copies—still a relatively small number given China's population of five hundred million at the time, but one that reflected the low literacy rate and continuing urban bias in education and distribution.[45] The number of new literary titles had averaged between 135 and 270 per year from 1912 to 1949;[46] from 1949 to 1966, an average of only ten new titles appeared annually.[47] Luo

[41] Link, *The Uses of Literature*, 134–135.

[42] Ibid., 115.

[43] The impact of anonymous "collective writing" has been overstated. Lan Yang, *Chinese Fiction of the Cultural Revolution*, 9–10, analyzes 126 Cultural Revolution-era novels and finds that 85 percent were by a single author, 6 percent were jointly authored, and only about 8.5 percent were authored by collectives of some kind.

[44] Ibid., 11.

[45] Ibid., 13, reports that the print run for a novel started at one hundred thousand copies during the Cultural Revolution; with reprintings, some reached five hundred thousand—a huge number compared to the ten thousand or so that made up a typical print run in the 1980s.

[46] Link, *Mandarin Ducks and Butterflies*, 15–16.

[47] Lan Yang, *Chinese Fiction of the Cultural Revolution*, 4. Hong *Zhongguo dangdai wenxueshi*, 21–26, observes that large numbers of translations, not included in the yearly average and coming from both the socialist and nonsocialist worlds, were also published. This activity resumed after 1980 (ibid., 262–267).

Guangbin 羅廣斌 (1924–67) and Yang Yiyan's 楊益言 (b. 1925) *Red Crag* (*Hongyan* 紅嚴, 1961), the leading socialist-era best seller, was printed 126 times, for a total of 6.8 million copies—more than twice the number of its nearest competitor[48] but still not an overwhelming figure, all things considered.

Surprisingly, from 1966 to 1976 the yearly average of new titles rose slightly, to nearly thirteen.[49] Overall, slightly fewer than a thousand humanities titles were available during this period.[50] Just as in the 1949–66 era, readers were, in Hong's view, "in most circumstances...a construct, a concept not to be concretely analyzed...authoritative criticism often used 'the masses' and 'readers' (especially 'worker, [peasant], and soldier readers') to embrace a group of readers who had identical ideological outlooks and artistic tastes, and that in fact did not exist."[51] Frustrated, individual readers responded by hand-copying (*shouchao* 手抄) popular stories; this method, which recalls readers' tactics of the Qing and earlier periods, broadened circulation throughout the 1960s and 1970s.[52] Reflecting an ancient practice while also anticipating the erotic exhibitionism of Wei Hui's 卫慧 (b. 1973) *Shanghai Baby* (*Shanghai baobei* 上海寶貝), discussed here by Berg, even pornography circulated as hand-copied editions (*shouchaoben* 手抄本) in the 1970s.[53] Individual self-examination (in contrast to stories of group life) reappeared in the post-Mao period as early as 1980, with Yu Luojin's 遇羅錦 (b. 1946) outrageously frank autobiographical novel about the love life and intimate feelings of an educated young woman.[54] Yu herself anticipated the wave of women writers who burst onto the scene in the 1980s, in such large numbers that Hong considers them to have been "the second 'high tide' of women writers after

[48] Link, *The Uses of Literature*, 175. Hong, *Zhongguo dangdai wenxueshi*, 127, notes that the novel continued to be issued in the 1980s, by which time it had sold eight million copies.

[49] Link, *The Uses of Literature*, 116; Lan Yang, *Chinese Fiction of the Cultural Revolution*, 4, observes that Hao Ran's 1,336-page *The Golden Road* (*Jinguang dadao*, 1972), an "agricultural" novel, was the most favored politically.

[50] Volland, "The Control of the Media in the People's Republic of China," 455, citing Li Honglin, "Dushu wu jinqu" ["No taboos for reading"], *Dushu* [Reading] 1 (1979): 2–7.

[51] Hong, *Zhongguo dangdai wenxueshi*, 32.

[52] Hong, *Zhongguo dangdai wenxueshi*, 249–253.

[53] Link, *The Uses of Literature*, 243.

[54] See Minford, "Introduction," vii–xix.

that which emerged during the 'May Fourth' period."[55] A little later, exposé and anticorruption literature returned to the marketplace.[56]

Despite the obstacles to the circulation of fiction, and perhaps thanks to its "truth-telling" function, literature had become an essential part of Communist Chinese life for many.[57] In 1979, when Chinese publishers issued some eleven thousand book titles overall, one sixth (more than 1800) of them concerned literature or art. There were then 1,100 periodicals, reaching 165 million readers. The two highest-circulation literary magazines, however, reached a mere two million readers.[58] Part of the blockage lay not in publishing per se but in circulation. As Nicolai Volland explains, already in the late 1970s critics pointed publicly to the excesses of the "internal circulation-only" (*neibu faxing* 內部發行) system that allowed collectives to requisition and essentially "bury" publications.[59]

In response, the "second channel"—that is, the unofficial, market-driven publishing sector discussed in detail in the next section—opened up. As in the Republican and early PRC years, fiction in the 1970s continued to shift between media. By 1979, handmade copies of some types of popular literature had become so widespread, and printed, standardized versions so rare, that the authorities actually called in the illicit copies and used them as exemplars to issue new, printed, and therefore more easily monitored copies.[60]

Disappointment with the Maoist "utopia" was now often manifested in literature. Sometimes converted into cynicism, that disillusionment was passed on to the generation of writers described here by Yang and Berg even as the sociopolitical situation and technological conditions for authorship changed. China's recent history, including the events of 1989, which turned many away from politics, also came to influence the context in which literature was created. In the 1990s, the ultrasolemn political stance that had characterized the *daolu* of Chinese writing from the 1930s to the 1980s was weakened as the market for that literature dwindled. At the same time, youth- and

[55] Hong, *Zhongguo dangdai wenxueshi*, 270.
[56] See Kinkley, *Corruption and Realism in Late Socialist China*.
[57] Link, *The Uses of Literature*, 216.
[58] Ibid., 167.
[59] Volland, "The Control of the Media," 460.
[60] Hong, *Zhongguo dangdai wenxueshi*, 249–253. The best-known example, also discussed by Link, is Zhang Yang's *The Second Handshake* [*Di'er ci woshou*], which went through at least seven versions from 1963 to 1979.

entertainment-oriented pulp fiction in print (and virtual print) of a
sort that recalled the boom years of the 1920s and 1930s returned,
now sometimes from Taiwan and Hong Kong. Unlike the 1950–80
period, when the main influences on literature were political, but simi-
lar to the 1900–49 period, a variety of media and the market now
shaped communities of authors and the various forms in which their
work appeared. Yang in particular argues that Internet publication
"is changing the meaning of authorship and the boundaries between
authors and readers" in a way that recalls the downward extension of
the written word during the Qing that is described by Brokaw in her
essay.

Nonetheless, as in the market-oriented realms of the pre-1949
period, the emphasis in the 1980–2008 context was again focused on
"selling words" to make money, both for clearly identified publish-
ers and recognizable, legally defined authors seeking real rather than
conceptualized readers. In the 1990s, the close relationship between
literature and electronic media that had been established in Shanghai
in the 1930s and reestablished in the 1950s again opened up all sorts
of opportunities for writers and readers willing to pursue them, even
as the ever-larger consuming public was, and remains, largely urban.
The reasons for that are related to issues of state and society, to which
I now turn.

State and Society in Printing and Publishing

In China, the relationship between writing, publishing, and the print
media system has been distinctively shaped by both state-society and
public-private interactions. In periods of declining state intervention,
whether in the nineteenth century (as Widmer, Kurtz, Keulemans, and
Janku demonstrate) or the twentieth (as Kiely, Culp, Shiao, and Reed
show), private-sector, market-driven publishing often created (some-
times unintentionally) new social groups as well as social and politi-
cal change. In periods of renewed statist vigor—for example, under
the Nanjing-based Republican government, during the Communists'
Yan'an Decade (1937–47), or in the PRC after 1949—government or
party-state organizations repositioned themselves to undertake major
changes in print and publishing culture and practices. In the PRC,
textual communication became essentially synonymous with party-
state activities from 1949 to the mid-1980s, with profound implica-

tions for the Chinese literary field.[61] At the end of the 1980s, the two models—private sector and governmental—diverged significantly as the Chinese state tried to reinvigorate itself via broad marketization. Printing and publishing operations followed, with related modifications in authorship and audience.

More than twenty years ago, Leo Ou-fan Lee and Andrew J. Nathan coauthored an essay on China's modern media that continues to influence research agendas in the study of modern China's print and publishing culture.[62] Focusing on the implications of the modern periodical press, particularly the political press, for state and society issues, Lee and Nathan argue that the effects of the changes that occurred between 1895 and 1911 laid the foundations for modern Chinese mass culture. They find that over the course of the twentieth century, largely but not solely via the press, "popular culture was overlaid with and to some extent displaced by mass culture—that is, culture that is nationwide, universal to all classes, and consciously engineered and controlled from above."[63]

Lee and Nathan's 1985 essay reflects both the concerns of the era it addresses and those of foreign scholars observing China in what was still, it is now clear, the wake of the Cultural Revolution. The media to which they chiefly refer, the modern periodical press from 1895 to 1911, took shape in the same nongovernmental, independently organized, market-oriented, treaty-port environment that has since been discussed in more nuanced ways by Hockx, Gimpel, Des Forges, and Mittler, among others. Ruthless commercial and industrial competition, largely unregulated by the government, characterized that first stage of "Chinese print capitalism." This system prevailed in treaty-port China until the ascent of the Guomindang state in the late 1920s. The 1931 murder of the *Shanghai Journal*'s Chinese owner-editor, Shi Liangcai 史量才 (1879–1934), by GMD assassins was simply a belated public signal that early-phase, or "savage," print capitalism was being increasingly reined in by the Nanjing Regime after 1927. In light of their growing dependence on government policies, particularly in

[61] Lynch, *After the Propaganda State*, 22ff., argues convincingly that Beijing's central propaganda and media control never equaled the ultracentralized hegemony of the Soviets' media system due to a major transfer of control shifting outward to territorial units and provinces after 1953.

[62] Lee and Nathan, "The Beginnings of Mass Culture," 360–398.

[63] Ibid., 360.

education, and government publishing contracts from April 1927 onward, Shanghai's Big Three (the Commercial Press, Zhonghua Books, and World Books) in particular had little choice but to succumb to the growing media control of the GMD party-state. However, they did not do so before other printer-publishers, including the New Culture publishers and Communist propagandists examined here by Shiao and Reed, respectively, began to question the principles behind what we might call the "crony print capitalism" of 1930s China.

Central to this phenomenon was the accordion-like expansion and contraction of China's public sphere, a concept that was the cause of considerable controversy in the early 1990s[64] but now seems to have been adopted as a working hypothesis by many scholars—even when they do not agree with all aspects of the original notion. In her 1996 study of the Shanghai newspaper *Eastern Times* (*Shibao* 時報) in late-Qing China, Joan Judge echoes Lee and Nathan even as she invokes Anderson's *Imagined Communities* and Jurgen Habermas's writings on civil society and the public sphere. Rather than a public sphere per se, Judge identifies what she calls "the late Qing middle realm."[65] Mittler, too, in *A Newspaper for China?* argues that invoking the notion of a rational public sphere is not quite appropriate to late-Qing China, as the late nineteenth-century "public sphere" that did develop was shaped heavily by the state: "It was state recognition alone that made public opinion in the treaty ports a force... [and] the forces of this public sphere remained largely restricted to the treaty ports themselves."[66]

Similar concerns animate Janku's study here of shifts in journalistic genre regarding famine. In particular, Janku examines the evolution of editorials on famine in three Shanghai and one Tianjin newspapers. Among the most distinctive new features of late-Qing print culture, these newspapers and their editorials locate the transition from a medium run by literati-journalists assuming the role of quasi-officials advising the throne to one operated by professional journalists positioning themselves as representatives of the society at large. Reminding us that modernity did not happen overnight, Janku identifies the late Qing as a period when "early journalistic writings aspired to belong

[64] Whether nineteenth- and twentieth-century China actually had a public sphere was the subject of a spirited debate in *Modern China* 19: 2 (1993).

[65] Judge, *Print and Politics*, Shibao *and the Culture of Reform in Late Qing China*, 1ff.

[66] Mittler, *A Newspaper for China?* 4.

to a quasi-official sphere...[and at] the same time...were beginning to break up this sphere."

But what was happening in China beyond Shanghai, Tianjin, and other metropolitan areas? How was China at large evolving in ways that were contemporaneous but not necessarily aligned with Shanghai's mediasphere? And what happened to the public sphere under the impact of the millions of potential new readers being introduced into it by an expansion of the educational system after the fall of the Qing? Kiely and Culp both give us a sense of this important new realm beyond Shanghai, but still within the Jiangnan region. Kiely describes the revitalization of Buddhist publishing in Jiangnan partly through its adaptation of modern business methods that originated in the treaty ports; and Culp, through his discussion of educational circles in Wuxi, Shaoxing, Ningbo, and Changshu, shows how a public sphere in which readers were also writers and even publishers developed in smaller towns in the same metropolitan region. Reed's essay takes the story far beyond Jiangnan to the north and northwest, Shaanxi in particular, suggesting how the commercially defined public sphere of the coastal cities was undermined by print communism, wartime conditions, and impoverishment. Together, these forces extinguished Republican China's already unstable commercial public sphere, creating conditions that expedited the development of a model for national print communism bereft even of a modified, anemic public sphere.

Concurrent with scholarly investigations of the public sphere have appeared ever-more-thorough studies of modern Chinese education. These studies contain implications for literacy and, by extension, the size of potential audiences and thus the extent of informed public opinion. In 1905, as noted above, the Qing government terminated the civil service examination system that had previously been the main career target for China's vast male-dominated reading public. Throughout the rest of the century, whether in the Republican or People's Republic era, Chinese families, schools, and governments continued to favor male education over female. After 1911, the late-imperial emphasis on rural schooling was superseded by urban-biased education, transient Yan'an-style reforms of the 1940s such as rural "people-run" (*minban* 民辦) schools notwithstanding.

Thus, partly because it heightens our awareness of differences along the rural/urban (dis)continuum, state-run education must be an important element in an attempt to understand the impact of print culture on China. As Paul J. Bailey has observed, "The appearance of

public schools for girls during the last decade of the Qing dynasty represent[ed] one of the most dramatic social and cultural changes of the period."[67] As the new century advanced, girls, who had formerly been educated at home if at all, did in fact begin to join boys in modern (and recycled traditional) public and private schools, adding a significant but difficult-to-pinpoint gender component to education and literacy.

Of course, school enrollment statistics prior to the 1930s are open to considerable criticism and should be used only as a general guide. Similar to literacy rates, however, over the long term they do suggest general trends of amelioration and expansion.[68] Just as absolute numbers of students attending public primary schools had increased between the 1900s and the 1920s, so, too, did the number of students attending public secondary schools and even tertiary institutions (colleges and universities). In 1923, for instance, female students, although concentrated in pre-teacher-training normal schools rather than academically oriented middle schools, amounted to 14 percent of all public secondary school enrollments.[69]

In absolute terms, China's modern functionally literate population can be said to have grown significantly both in number and across the gender and even rural/urban spectrums, albeit not evenly, during the late Qing and Republican periods. The cumulative effect of three decades of public schooling, from 1905 to 1937, suggests an escalating number of print communities with cross-cutting and conflicting concerns. They included journals such as *Jiangsu Student* (*Jiangsu xuesheng* 江蘇學生) and *Zhejiang Youth* (*Zhejiang qingnian* 浙江青年), both studied by Culp, and Yan'an's Marxist-Leninist texts and newspapers, whose production is examined by Reed. Culp demonstrates the existence of sizable audiences that were only semi-urban, and even non-urban; Reed hints at "disciplined" communities of party, military, and mobilized readers. Culp also notes that female students read and even published journals as often as their male counterparts in the 1930s. Similarly, the Catholic publications that are the focus of Kurtz's essay

[67] Bailey, *Gender and Education in China*, 34.

[68] Ibid., 35 (Table 2.1); Pepper, *Radicalism and Education Reform in 20th Century China*, 65, 76, 78 (Table 4.2).

[69] Bailey, *Gender and Education in China*, 86 (Table 4.4). In 1919, the first Chinese-founded university for women—Beijing Women's Higher Normal School (Beijing nüzi shifan daxue)—opened. The first female students enrolled at Beijing University in 1920 (ibid., 108).

and the Buddhist religious materials studied by Kiely reached out to new or revived audiences made up of both elite *and* low-brow readers within and beyond Shanghai.

However, growing school attendance rates and government-sponsored improvements in educational or market conditions do not by themselves translate into a high demand for reading materials, nor does basic literacy necessarily translate into the reading habit. School attendance alone cannot tell us the actual size of the reading audience; that must be estimated by comparing school attendance rates, print runs, and anecdotal information. In this regard, for example, the size of Republican China's actual reading public, expanding school and university attendance rates notwithstanding, was probably quite low relative to developed nations of that era. In 1936, in national rankings of *total* numbers of titles issued, China, the world's most populous nation, placed sixteenth, well behind Britain, Japan, and the United States, and even lower than Switzerland, which, in the 1930s, had a population of slightly over four million (0.8 percent of China's population).[70]

In the 1930s, Wang Yunwu, director of the Commercial Press, China's leading publishing house, lamented that the Chinese were simply *not a nation of readers.* Wang, who edited numerous modern collections (*congshu* 叢書) intended for sale to public libraries and schools in the 1930s, blamed the Shanghai publishers for what he regarded as their passive approach to marketing.[71] The large number of Chinese characters—in the 1920s, research determined that from four to seven thousand characters were needed for easy access to the modern Chinese language found in media such as newspapers, magazines, and novels[72]—and the need for leisure to master enough of them to acquire literacy also limited the growth of a reading public.

Further—even with the innovative efforts of the May Fourth publishers studied here by Shiao, the professional educational circles studied by Culp, and the Communists examined by Reed—in the 1930s, few beyond the Jiangnan region and China's other urban centers had mastered the modern Westernized language (*baihua* 白話) in which

[70] On China's ranking in publishing statistics, see Peterson, *The Power of Words*, 347 n. 75. For Switzerland's population in the 1930s, see Tschopp et al., "Accessibility, Spatial Organization, and Demography in Switzerland," 1 (Figure 1).
[71] Peterson, *The Power of Words*, 347 n. 71.
[72] Ibid., 10.

modern journals and other works were published. Culp's and Reed's discussions of reading primers are important for revealing efforts by non-Shanghai-based educators and publishers to appeal to these underserved potential readers, but the results of such efforts were quite limited through 1949. When the PRC was established that year, the national literacy rate was a mere 32 percent. Among members of the new elite—that is, the Communist Party's membership—only 31 percent were literate, and even "literate" cadres often relapsed into illiteracy, again partly because of a lack of encouragement for, interest in, or practice reading.[73] And yet, the new nation's citizens looked to the Communist Party to correct the abuses of the past, particularly with regard to access to and achievement in education. Contrasting radically with the definition of literacy in the 1920s cited above, the CCP in 1950 set the standard for literacy at mastery of a mere one thousand characters; in 1952, that quota was doubled.[74] Despite numerous government efforts to expand literacy throughout the 1950s, early 1960s, and 1970s, overall percentages did not rise significantly in these decades, even as absolute numbers did. Seeberg estimates that the national literacy rate ranged from 30 to 40 percent in the 1970s; she pegs the reading public then at approximately three hundred million.[75]

Only in the post-1978 era under Deng Xiaoping did the PRC finally begin to break out of its low-literacy/high-relapse cycle; literacy now became a public priority. In 1978, five years of universal primary education were mandated (with 94 percent compliance) and adult literacy again promoted.[76] The national female illiteracy rate was then approximately 45 percent,[77] but it diminished steadily by age cohort. Perhaps most striking for what it says about interest in reading in general, given the long history of bias against females in the educational system, is the early-1980s claim by editors of literary magazines that their main readers were young and female.[78]

Thus, by the 1990s, thanks to the cumulative effects of literacy campaigns, educational reforms, and, one must add, the broadening and deepening of China's by-then irreversible Gutenberg revolution, the

[73] Ibid., 48.
[74] Ibid., 50.
[75] Seeberg, *Literacy in China*, 268 (Table 6–9). Seeberg, *The Rhetoric and Reality of Mass Education in Mao's China*, 428, cites a 1982 literacy rate of 68 percent.
[76] Seeberg, *Literacy in China*, 150.
[77] Peterson, *The Power of Words*, 178.
[78] Link, *The Uses of Literature*, 215–216 n. 26, 249.

country's literacy rate was widely reported by the government (and, in turn, by the United Nations) to be approximately 91 percent.[79] Not surprisingly, scholars have steadily questioned these and other similarly high government figures, partly because of the issue of "relapsing illiteracy" resulting from either a lack of reading opportunities or an interest in reading, partly because of dubious standards of measurement, but also because of persistent gender and geographic bias in educational opportunity. Contrary to the hopes of the nation in 1949, the history of literacy education in the PRC appears to have been a checkered one. Nonetheless, that history has yielded a higher rate of literacy—along with higher absolute numbers—than those found in other developing countries.[80]

A shortage of texts interesting enough to read might have exacerbated the difficulties of maintaining literacy during the first several decades of the People's Republic. Severely limited print runs and inadequate distribution networks also restricted the supply of texts available to readers.[81] Significantly, the government's administrative and technological policy changes in the late 1980s and 1990s addressed both of these problems—first, through the recommoditization of publishing, and second, through the development of the Internet. Since the state-run print distribution system, dominated by the New China Books (Xinhua shudian 新華書店) after 1949, could no longer keep up with the demands of a rapidly modernizing economy,[82] policy decisions in the 1980s gave provincial publishers parity with national ones, allowing a "second channel" of private entrepreneurs, for whom monetary profit trumped all other concerns, to elbow into the book, journal, and newspaper business. The development of this provincial publishing system, led to the creation of "cooperative publishing arrangements" with private book dealers by 1984. Soon, private book dealers gained access to state-owned printing presses and, more important, to the book license numbers (similar to ISBNs) that made published books

[79] United Nations Development Programme, *Human Development Report 2007/ 2008*, 226.

[80] Peterson, *The Power of Words*, 5, 178, notes that, in 1982, when China's *illiteracy* rate was claimed to be at least 34.5 percent, rates of illiteracy in countries with similar levels of economic development were: Pakistan, 74 percent; India, 60 percent; Indonesia, 32.7 percent; and Mexico, 17 percent. In all countries, the rural and female illiteracy rates were even higher.

[81] Link, *The Uses of Literature*, 213 n. 14.

[82] Kong, *Consuming Literature*, 65, 71.

look legitimate. The result was a drastic expansion in the variety of publications available. Popular literature and light entertainment of the sort that Yang and Berg discuss here, and that had been largely eradicated in the 1950s, now started to make money for its authors and publishers; at the same time, the "serious literature" promoted by official publishers and journals lost readers. As a result of these government policies, reading became a market-oriented, even technology-driven pastime to the extent that it required access to a computer and the Internet, which now produced its own lexicon in Chinese.

The unprecedented second channel made possible the meteoric emergence in 1987 of the supposed Hong Kong female writer Xue Mili 雪米莉, a publishing phenomenon in the People's Republic of China.[83] Profit on the nearly one million copies of her books anticipated the best-seller phenomenon of the 1990s, when former "cultural workers" transformed themselves into "cultural entrepreneurs." No one was more spectacularly successful than Wang Shuo 王朔 (b. 1958). In this present volume, Berg takes the story of the second channel into the computer age via the "recreational" writers Wei Hui and Mian Mian 棉棉 (b. 1970), whose success recalls the easy translation among various media found in Des Forges's mediasphere a century earlier. Both Wei and Mian appeared first in print and then made their transition to the Internet. Conversely, Muzi Mei 木子美 (b. 1978), a third author discussed by Berg, started on the Internet and made her way into print from there. Yang, too, talks about the influence of the print-based literary sphere on its Internet analogue, particularly with respect to literary prizes.

As noted earlier, computers arrived in China in the late 1980s, just as they did in much of the West and in Japan. China joined the Internet in 1994. By 2005, China reportedly had greater absolute numbers of Internet users than the United States; Chinese had also become the most-often used language online.[84] However, just as in the Gutenberg era, only a relatively small, albeit ever-growing portion of China's total population had access to the sort of texts that matter in the postmodern era. Nonetheless, that readership is larger than the reading public of any single Western nation, and to the extent that politics and public

[83] Xue Mili was later exposed as the creation of several male Chinese writers working in an assembly-line format.
[84] Reuters, "China Overtakes US as Top Internet Market," 9.

opinion (rather than inarticulate or illiterate mass movements) matter in Chinese affairs, this is a group of utmost importance to students of China.

This group is a vital component of what political scientist Daniel Lynch has termed the PRC's post-Mao "praetorian guard" public sphere. Drawing again on the Habermasian notion of a public sphere,[85] Lynch argues that the 1980s were a critical watershed in Chinese party-state relations with respect to the media. In his view, what has been undermining Beijing's control since then is technological advance combined with administrative fragmentation, a view that finds some support in the essays by Wacker, Yang, and Berg.[86] At the same time, Wacker disputes the view, held by the general Western public as well as by numerous governments and IT corporations (if not Lynch himself), that the Internet will "democratize" China any more than the Gutenberg revolution did.

How have the changes in print technology and the issues of authorship discussed above affected the Chinese state's understanding of censorship and the notion of intellectual property? "Authorship," in a discrete, autonomous, legal sense, did not begin to become established until the late Qing. By implication, then, the concept of authors' control over their work, an issue that was aired sporadically in the imperial period, was renewed at this time. In fact, China's first copyright law was issued in 1906, at about the same time that Shanghai's earliest publishing corporations were founded,[87] The new law was at least partly a response by the Qing government to the ineffectiveness of guild-based efforts at self-regulation.[88]

With expensive new fast-paced technology and the strengthened copyright law came heightened efforts by the government to control or censor how that technology was used in printing. As Brokaw has argued elsewhere, during the Ming and Qing periods, the government did not succeed in implementing a comprehensive and effective pre-publication censorship of the sort that operated under ancien régime

[85] In addition to the Habermasian notion of public sphere, Lynch draws on the idea of a propaganda state as first articulated by Peter Kenez in *The Birth of the Propaganda State: Soviet Methods of Mass Mobilization, 1917–1929* (1985) and praetorianism as developed by Samuel Huntington, in *Political Order in Changing Societies* (1968).

[86] Lynch, *After the Propaganda State*, 2, 3–5.

[87] Reed, *Gutenberg in Shanghai*, 337 n. 48, and Ting, *Government Control of the Press in Modern China*, chapter 1.

[88] Reed, *Gutenberg in Shanghai*, 176–178.

France, the book inquisitions of the Yongzheng (r. 1723–35) and Qianlong (r. 1736–96) emperors notwithstanding.[89] In this collection, Widmer makes clear that existing imperial interference in publishing was considerably mitigated from the time of the latter's successor, the Jiaqing (r. 1796–1821) emperor, onward. At the end of the Qing, the most famous censorship case involved not a book but a newspaper— the *Jiangsu Journal* (*Subao* 蘇報)—which, strikingly, was part of the new constellation of industrially produced publications of the era.

By 1928, when the Guomindang issued its first press laws, including a ban on antigovernment publications,[90] the situation had changed. Whereas the *Jiangsu Journal* journalists were found guilty for already-published articles, the GMD now attempted to preempt such situations from occurring at all. Thanks to its expanding rapprochement with Shanghai printers and publishers after the White Terror of 1927, the GMD was able to compel publishers to register with the government, to join a government-sponsored "trade association," and to apply for prepublication approval. In this way, the need for outright censorship was reduced, if not eliminated. At the same time, the courts, increasingly controlled by the party, enforced copyrights and the payment of royalties, stabilizing working conditions for both publishers and authors. Simultaneously, numerous local organizations such as schools, universities, and political parties began to force their own press regulations on authors and contributors, beyond the formal regulations of the courts (as the 1930s writer-publishers depicted in Culp's chapter and the post-1937 Yan'an-based print communists found in Reed's quickly learned). The exigencies of the Second Sino-Japanese War (1937–45) also imposed a ruthless form of censorship on GMD-dominated China.

By the time the PRC was founded, of course, modern notions of authorship, copyright, royalties, and censorship (whether by government or self-imposed) were all thoroughly internalized by the new Chinese elite. Little wonder, then, that all continued to operate, even as their meanings were reworked after 1949; one spectacular example involves the discovery that much of Mao Zedong's presumed corpus of single-authored writings was in fact penned by various other individu-

[89] For more on this topic, see Brokaw, "Introduction," in Brokaw and Chow, *Printing and Book Culture in Late Imperial China*. See also Brokaw, "Book History in Premodern China; and Brook, "Censorship in Eighteenth-Century China," 177–196.

[90] Reed, *Gutenberg in Shanghai*, 206, 223.

als and even committees.[91] Similarly, it was apparently not necessary to reeducate readers as to the general meaning of authorship, copyright, et cetera, after Mao's death in 1976.[92] Geremie Barmé explains, "The Chinese Copyright Law of 1990 dealt with possible claims by former official ghostwriters by clearly stipulating that the copyright of any work...written by state employees for the leadership belonged to the person in whose name that work was produced or published."[93] As for censorship per se, Nicolai Volland argues that the PRC has developed a unique form of it. Instead of placing responsibility on an army of government censors, "the CCP has shifted this responsibility one level downwards, to the editors....In practice, the 'responsible editor system' (*zeren bianji* 責任編輯) means that the editor of a particular magazine or book is responsible for its content."[94]

When China connected to the Internet a few years later, both authorship and censorship had become fixed parts of China's print cultural terrain. One challenge for outside observers is to understand how writers deal with the context in which they work. Some Chinese writers have accused their colleagues of self-censorship: in order to preserve their careers and incomes, the argument goes, writers adapt their work to what they understand to be the requirements of the government. Yang further emphasizes in his essay that, rather than struggle against censorship, "the symbolic struggles of Chinese Internet writers are less a matter of dealing with Internet control and censorship...and are much more oriented to making claims about one's own writings, building reputations, and negotiating identities vis-à-vis print writers." Where Yang and others find accommodation, however, Wacker finds resistance to government interference, particularly via the Internet. Reminding us that four elements in cyberspace—"laws, social norms, the market and...the architecture of the Internet itself, i.e.,...its code"—can be shaped and regulated by *all* governments, she argues that "Chinese Internet users...have found means...to outsmart government-prescribed blockades and restrictions." For Wacker, the biggest change on the Internet, and the one that has led to enhanced

[91] Barmé, *Shades of Mao*, 27–28, notes that the list of ghost-written works includes the so-called "Three Standard Articles": "In Memory of Norman Bethune," "The Foolish Old Man Who Removed the Mountains," and "Serve the People."

[92] In one academic article I saw in Shanghai in the early 1990s, it was necessary to explain to readers that pre-1949 newspapers were supported by their advertising.

[93] Barmé, *Shades of Mao*, 28.

[94] Volland, "The Control of the Media," 234.

control, is commercialization, not government per se. To her, com-
merce and "government online" efforts mean that communications
technology and the Chinese government have grown more tightly
together than ever before in history.

In this evolving situation, China's Internet publishers themselves
remind us that, even as the technology of textual production has
changed over the past two centuries, printers, publishers, authors, and
audiences have frequently been confronted by similar concatenations
of issues. Internet users today must deal with issues of authority and
dissent just as surely as Qing and Republican publishers and authors
did and as their descendants continue to do so today in the People's
Republic. The four elements of cyberspace mentioned by Wacker have
in fact been parts of the history and changing contexts of Chinese
print and publishing culture since at least the Qing dynasty. The recent
context of Internet "print" culture thus exhibits both ruptures and
continuities with the past; this volume is dedicated to deepening our
awareness of them.

Organization of This Book

The essays in this volume are arranged chronologically in four clus-
ters, each marking a different period in the development of modern
Chinese print culture. The first of these, "Modern Print Culture in
Historical Perspective," traces connections between the largely xylo-
graphic print technology and book culture of the late Ming and Qing,
and the modern technologies and print genres introduced in the late
nineteenth century. The second, "New Technologies and the Transi-
tion to Modern Print Culture," describes and analyzes the new kinds
of writing—newspapers, popular fiction in dialect, Roman Catholic
and Buddhist periodicals and tracts—and the corresponding innova-
tive practices of reading and new textual communities that developed
along with them. Next, "The Golden Age of Print Capitalism" treats
the impact of new technologies and business forms on the creation of
the major reform-oriented literary societies and on debates over edu-
cational reform in the Republican era, while also describing the ways
in which the subversive Communist Party made use of a wide range
of printing technologies to propagate its beliefs. Finally, "Print in the
Internet Era" examines the ways in which the technology of the Inter-

net has more recently affected literary production, both electronic and print, and the ability of the government to control the print media.

In their entirety, these essays remind us that context was/is everything, regardless of the technology employed, whether xylography, lithography, letterpress with movable type, or computers. None of the textual technologies discussed in this volume have turned out to have inherent characteristics automatically conducive to autocracy, democracy, or party-state rule. At the same time, technology has facilitated both public and private discussion—the anonymous and the personal—as well as audience formation and skill acquisition, strengthening trends that originated with China's earliest print technologies. The essays in this collection do not offer last-word assessments of these issues. Still, the end of the Gutenberg, or modern, era and the beginning of the post-Gutenberg—virtual or postmodern—one seems an ideal moment to ponder these continuities and discontinuities. We hope that these essays will encourage others to take these themes farther.

MODERN PRINT CULTURE IN HISTORICAL PERSPECTIVE

COMMERCIAL WOODBLOCK PUBLISHING IN THE QING (1644–1911) AND THE TRANSITION TO MODERN PRINT TECHNOLOGY

Cynthia Brokaw

It is generally assumed that the introduction of Western mechanized printing to China in the nineteenth century (along with a host of other factors) changed both the nature and reach of Chinese book culture. The new technology made possible the rapid reproduction of a great many copies of texts, increasing significantly the sheer number of texts that could be produced at any one time. Improvements in transportation networks made the dissemination of these texts much easier and quicker. New ideas and new genres of writing, supported by the new printing methods, created new forms of print—here the modern newspaper is perhaps the most obvious example. Scholars have argued that, as a result of the greater accessibility of print, a true mass reading public developed for the first time in the early twentieth century. The technological and capital demands of the new methods encouraged the development of new commercial business forms and a new kind of "print capitalism." And Shanghai, as the major conduit for modern technology, commercial capital, and new ideas, rapidly became the dominant center of the new publishing industry.[1] In sum, in the late nineteenth and early twentieth centuries, a complex interaction of technological, economic, social, and cultural factors transformed Chinese book and print culture.

My purpose here is not to question the validity of this picture—indeed, I believe that a real sea change in Chinese print culture did take place in the late Qing and Republican periods. It would be very hard to argue against the idea that the technology of modern printing had a profound impact on textual production and transmission and the Chinese reading audience, not only in the littoral areas, but also (though more slowly) in the hinterland. So too, the development of a

[1] Reed, *Gutenberg in Shanghai*, 8–9.

new school system and a "new culture" in the early twentieth century transformed the content of Chinese book culture.

But it is useful to put the dramatic technological, educational, and cultural changes of the late nineteenth and early twentieth centuries into a broader context, to look at the continuities as well as the ruptures between the predominantly woodblock publishing industry and book culture of the nineteenth century and the "modern" publishing industry and book culture of the twentieth. Ellen Widmer, in the next essay, suggests ways in which some of the changes generally associated with "modern," twentieth-century publishing, particularly in the field of fiction, can be traced back to the early nineteenth century. Here I focus on three other areas of continuity and connection. First, I consider briefly the degree to which "traditional" commercial woodblock publishers were already serving a fairly broad and deep reading public, particularly in south China, during the Qing. Second, I discuss the dual transition to new printing technologies and a new text culture in the late Qing and Republican eras, pointing out the persistence of woodblock printing and the texts of woodblock print culture, especially in the hinterland but even, at times, in major cities. Finally, I examine the ways in which the commercial publishing houses of Shanghai established their dominance of the book trade by forging links to the old woodblock publishing centers. During the period of transition from traditional to modern print culture, commercial woodblock publishers and commercial lithographic and letterpress publishers enjoyed a symbiotic relationship.

The Expansion of Commercial Woodblock Publishing and Print Culture in the Qing

As I have argued more fully elsewhere, the Qing, even before the introduction of modern print technologies, marked a distinct shift in the history of Chinese commercial publishing and book culture.[2] The boom in commercial publishing, starting in the sixteenth century, accelerated (after a brief decline during the Ming-Qing transition) through the late seventeenth, eighteenth, and early nineteenth centuries. Tsuen hsuin Tsien, though highly critical of the quality of Qing publishing,

[2] Brokaw, "On the History of the Book in China," 27–32.

nonetheless acknowledged that this dynasty saw a significant increase in the sheer number of texts produced: "Of the quarter of a million titles of Chinese publications known to have accumulated throughout the dynasties, no less than one half were produced during this period, the greatest amount in all history."[3] Supporting evidence for the widespread availability of texts is supplied by Western observers impressed by the contrast with Europe. As early as the late sixteenth century, Mateo Ricci remarked on "the exceedingly large numbers of books in circulation here and the ridiculously low prices at which they are sold."[4] Over two centuries later, in the 1830s, W. H. Medhurst echoed this observation: "[B]ooks are multiplied, at a cheap rate, to an almost indefinite extent; and every peasant and pedlar [sic] has the common depositories of knowledge within his reach. It would not be hazarding too much to say that, in China, there are more books, and more people to read them, than in any other country in the world."[5]

As both Ricci and Medhurst suggest, books were widely available not just to the highly educated scholar-official and gentry elite—the class that had dominated the book market until the late Ming[6]—but also to "peasants and pedlars," people low on the socioeconomic scale. Although estimates of literacy rates vary considerably,[7] most scholars agree that literacy increased significantly in the late Ming and Qing, in part as a consequence of the spread of and increase in the number of schools.[8] Distribution networks established by book merchants suggest, too, that the peasant population—and even its poorer sectors—formed an increasingly important market for books. In nineteenth-century Sichuan, for example, a small publishing industry grew up in the county seat of Yuechi 岳池 and the neighboring town of Qiaojia 喬家 to meet the demand for cheap primers and local songbooks from the surrounding peasant villages.[9] By the nineteenth century at the latest,

[3] Given the likely higher survival rates of more recent imprints, this is clearly a very crude measure, but it nonetheless gives a rough idea of the magnitude of publishing activity in the Qing. Tsien, *Paper and Printing*, 190.

[4] Gallagher, *China in the Sixteenth Century*, 20–21.

[5] Medhurst, *China: Its State and Prospects*, 106.

[6] Inoue, *Chūgoku shuppan bunkashi*, 322–324.

[7] See Brokaw, *Commerce in Culture*, chapter 14, for references and a fuller discussion of this debate.

[8] Leung, "Elementary Education in the Lower Yangtze Region," 381–388, 403–404; and Rawski, *Education and Popular Literacy in Ch'ing China*, 81–108.

[9] Interviews, Zhenlongxiang, July 24, 1997; Qiaojia, July 18, 1997; and Yuechi, July 17, 1997.

itinerant booksellers working for commercial publishers in Sibao 四堡 township, western Fujian, carried cheap primers, editions of the Four Books, correspondence and ritual manuals, songbooks, and popular novels to village and lineage schools in the impoverished hinterland regions of Jiangxi, Guangdong, and Guangxi provinces.[10]

The simplicity and portability of woodblock printing technology facilitated the diffusion of imprints, particularly in south China. Block cutting, the part of the production process that required the highest skill, did not require extensive training or technical knowledge, or even literacy. The *Shunde County Gazetteer* (*Shunde xianzhi* 順德縣志) of 1853 notes dismissively that the skill required was so minimal that "women and children could all do it."[11] Certainly the "machinery" required for cutting was negligible—just a set of easily portable cutting and scooping tools. Medhurst, writing in the early decades of the nineteenth century, commented:

> The whole apparatus of a printer, in that country, consists of his gravers, blocks, and brushes; these he may shoulder and travel with, from place to place, purchasing paper and lamp-black, as he needs them; and borrowing a table anywhere, he may throw off his editions by the hundred or the score, as he is able to dispose of them. Their paper is thin, but cheap; ten sheets of demy-size, costing only one half-penny. This, connected with the low price of labour, enables the Chinese to furnish books to each other, for next to nothing.[12]

This simplicity helps to explain the rapid diffusion of publishing concerns throughout the empire over the course of the late Ming and Qing.

It also helps to explain the decentralized nature of commercial publishing in the Qing before the rise of Shanghai.[13] Although Beijing dominated Qing book production until the late nineteenth century,[14] commercial publishing concerns developed throughout China Proper at all levels. A number of provincial capitals (always important sites of government printing) and regional cities emerged as centers of commercial publishing. In Sichuan, for example, Chengdu, after recover-

[10] Brokaw, *Commerce in Culture*, chapters 6 and 7.

[11] *Shunde xianzhi* (1853), 3.50a, cited in Rawski, "Economic and Social Foundations of Late Imperial Culture," 18.

[12] Medhurst, *China: Its State and Prospects*, 105–106.

[13] Rawski, "Economic and Social Foundations," 21–22.

[14] Zhang Xiumin, *Zhongguo yinshua shi*, 550–551.

ing from the destruction of the Zhang Xianzhong 張獻忠 (1605–47) rebellion in the late Ming and the Manchu invasion, became in the late Kangxi (1662–1722) and early Qianlong (1736–95) eras the site of at least ten large commercial publishing houses.[15] Guangzhou became a noted commercial publishing center in the mid-Qing and then flourished in the late Qing as a site for the production of Guangdong "statecraft" writings.[16] During the peak of Guangzhou commercial publishing from the Daoguang era (1821–51) through the first decade of the twentieth century, the city had at least 120 commercial woodblock print shops.[17]

With the spread of commercial publishing to the major provincial and regional centers came the rise of new intermediate-level publishing centers. The best examples here are provided by Baoqing 寶慶 (now Shaoyang 邵陽, Hunan); and Xuwan 滸灣, Jiangxi. Baoqing, relying on paper produced in Longhui 龍回 county, developed publishing houses that supplied not only Hunan but also Guangxi, Guizhou, and Sichuan with texts in the high and late Qing. The book trade in Guizhou seems to have been initiated and dominated by Baoqing publisher-booksellers, and as late as the 1920s migrants from Baoqing were establishing shops in Anshun 安順, a trading center in the western part of the province.[18] Xuwan, a market town on the upper reaches of the Xu river 肝江, about forty *li* (about thirteen miles) from Fuzhou 撫州, developed a publishing industry in the eighteenth century. By the late nineteenth century, according to the estimate of one scholar, Xuwan's roughly sixty print shops produced more texts than all but one other contemporary woodblock production site.[19] Influential publishing industries could be found at even lower levels of the central place hierarchy in the Qing, in places quite distant from major transport routes. Sibao township, a cluster of peasant villages deep in

[15] Wang Gang, "Qingdai Sichuan de yinshuye," 62–70; and Wang Xiaoyuan, "Qingdai Sichuan muke shufang shulüe," 44–45.

[16] Rawski, "Economic and Social Foundations," 24–25. On the book trade in Guangzhou, see Xu Xinfu, "Guangzhou banpian jilüe," 13–19.

[17] *Guangdong shengzhi: Chuban zhi*, 69–70; see also Zhang Xiumin, *Zhongguo yinshua shi*, 556.

[18] Interview, Anshun, August 31, 2004. I am grateful to Professor Hou Zhenping of Xiamen University for sharing some of his research material on the Baoqing publishers.

[19] Magang, a center of block cutting in Guangdong, was the more prolific site mentioned in Jin Wuxiang, *Suxiang sanbi*, j. 4.10b; cited in Nagasawa, *Wa Kan sho no insatsu to sono rekishi*, 85.

the mountains of western Fujian, became the home of at least fifty different print shops that sold texts throughout the south during the late eighteenth and nineteenth centuries.[20]

The Transition to Modern Print Culture

New Print Technologies and the Persistence of Woodblock Publishing

In sum, the boom in commercial woodblock publishing, begun in the late Ming and continuing through the nineteenth century, created a decentralized empirewide pattern of commercial publishing concerns and extensive networks for the distribution of texts. Probably for the first time in Chinese history, it gave peasants, petty merchants and traders, craftsmen, poor aspiring students, and others in the population previously excluded from book culture some access to texts. The introduction and spread of new technologies, particularly lithography (*shiyin* 石印, literally "stone printing") and letterpress (*qianyin* 鉛印, literally "lead printing"), in the nineteenth century propelled an even greater expansion. By making possible the rapid reproduction of far greater numbers of copies of texts—a good woodblock might at best produce twenty-five thousand copies, whereas a lithographic stone could produce one hundred thousand[21]—the new printing technologies very significantly expanded the potential reach of commercial publishing and fulfilled at least the technological requirements for the development of a true mass audience of readers. But this mass audience was built on a foundation established by commercial woodblock publishing over the course of the previous two centuries.

Moreover, woodblock printing did not by any means disappear. Despite the obvious advantages of lithography and letterpress, woodblock publishing culture survived the introduction of the new technologies well into the 1940s and even the 1950s. To some degree intellectual conservatives in the government indirectly supported continued reliance on woodblock technology. In Chengdu, for example,

[20] Brokaw, "Commercial Publishing in Late Imperial China," 49–59. Although this spread of publishing industries was most notable in south China (perhaps because of the greater availability of paper), examples can be found in north China as well: Jinan and Liaocheng (Shandong) according to unpublished reports on field research by Lucille Chia, in "Mapping the Book Trade," 1–4.

[21] Tsien, *Paper and Printing*, 201; and Reed, *Gutenberg in Shanghai*, 110.

provincial authorities responded to court officials' fears that, in the shift to a modern educational system, students might lose touch with traditional Chinese scholarship by establishing in 1910 the Cungu xuetang 存古學堂, a school devoted to the study of traditional culture. Through the early years of the Republic, this school published woodblock texts, both reprints of works that had been published by Sichuan's elite academies, the Zunjing shuyuan 尊經書院 and the Jinjiang shuyuan 錦江書院, in the late nineteenth century, and new works by scholars still working within the tradition of late-Qing classical studies.[22]

In other cases this survival can be identified as expressive of an elite nostalgia for the book culture of the past; wealthy merchant book collectors throughout China continued to publish texts with the woodblock method through the Republican period. For example, the Jiaye tang 嘉業堂 (the book collection and publishing house of Liu Chenggan 劉承幹 [1882–1963] in Nanxunzhen 南潯鎮, Huzhou 湖州, Zhejiang), specialized in the woodblock publication of works of local literati and facsimile reproductions of Song editions from the collection. Beginning in the early years of the Republic, the Jiaye tang produced over three thousand chapters (*juan* 卷) of such texts.[23] Smaller-scale literati publishers also continued to rely on woodblock printing. Families wishing to honor the work of a distinguished ancestor (and support their claims to local or national distinction) might hire block cutters or commission a block-cutting shop to cut and print a woodblock edition. Thus, the Xue family of Wujin 武進, Jiangsu, had a facsimile edition of *Simple Words of Master Xue* (*Xuezi yongyu* 薛子庸語), by their famous ancestor the Ming official and historian Xue Yingqi 薛應旂 (1500–ca.1573), together with the *Jottings of Master Xue Xiemeng* (*Xue Xiemeng xiansheng biji* 薛諧孟先生筆記), by the less-famous Ming loyalist Xue Cai 薛寀 (*jinshi* 1630), cut and printed in 1939.[24]

[22] Brokaw, "Regional Publishing and Late Imperial Scholarship." Sichuan was here following an empirewide trend; Cungu xuetang were established in several other provinces at the encouragement of the court.

[23] Miao Quansun, Wu, Changyuan and Dong Kang, eds., *Jiaye tang cangshu zhi*, 1–6. This was not simply a phenomenon of Jiangnan. In Chengdu, Yan Yanfeng and then his son Yan Gusun published fine editions of phonological studies, medical texts, and classical scholarly through the late 1930s. Brokaw, "Regional Publishing and Late Imperial Scholarship," 64–65.

[24] Struve, "Ancestor *Édite* in Republican China," 33–65.

This kind of publishing—including both the publishing efforts of wealthy collectors and the single-title "vanity" publications of families of more modest means—produced, very much in the tradition of private or literati publishing, texts that were for the most part either facsimiles of rare editions, elite literary collections, or works of scholarship. Though they were significant contributions to the world of scholarship and the study of rare books, they played only a small role in Chinese book culture as a whole. More significant is the fact that, in many parts of the country, woodblock publishing remained the dominant commercial form decades after the introduction of the new technologies. In Chengdu, for example, woodblock publishers outnumbered publishers of lithographic and lead-type texts through the Revolution of 1911, despite the fact that the machinery of the new technology had been introduced to the city in the 1890s.[25] In Shandong province, most commercial woodblock publishers began to decline after the establishment of the Republic, but of nineteen major shops, two continued in operation until 1920, and another nine lasted until the late 1930s or early 1940s.[26] In western Fujian, though the Sibao publishing industry was in decline from the 1920s, two households were still producing woodblock texts in the mid-1940s.[27]

In the 1940s, the Chinese Communist Party also recognized and exploited the usefulness of woodblock printing technology, as Christopher A. Reed explains in "Advancing the (Gutenberg) Revolution: The Origins and Development of Chinese Print Communism, 1921–1947," in this volume. In Yanan, where the Communists had only limited access to modern printing methods, woodblocks provided one cheap and simple means for printing at least a part of the *Liberation Weekly* (*Jiefang zhoukan* 解放週刊) in 1938.[28] The party was not quite so enthusiastic about this method, however, after the founding of the People's Republic in 1949. As late as the mid-1950s, the central Bureau of News and Publishing (Xinwen chubanchu 新聞出版處), concerned over the continued production of woodblock editions of "reactionary" works—"superstitious" almanacs and "pornographic" songbooks—

[25] *Sichuan shengzhi: Chuban zhi*, 1: 5, 229–230.
[26] *Shandong shengzhi: Chuban zhi*, 23–31.
[27] Interviews, Wuge, November 14, 1995; and Mawu, November 23, 1995.
[28] See Reed, "Advancing the (Gutenberg) Revolution" in this volume.

launched a campaign in Sichuan to eradicate the publication of such texts and to retrain block cutters in new crafts.[29]

Nor was this phenomenon limited just to hinterland areas and interior provinces; in Guangzhou, with early and easy access to new print technologies, commercial shops like the Wugui tang 五桂堂 and the Fuwen zhai 富文齋 printed woodblock texts through the Qing; the Wugui tang converted to the production of texts with a "Japanese hand-powered printing machine" (Riben shouyao yinshuaji 日本手搖印刷機) only in the early Republic. As late as 1934, as many as thirty female cutters were still active in Magang 馬崗, a major source of block cutters for the shops of Suzhou, Guangzhou, and Sibao.[30] Genealogies continued to be printed by woodblock and wooden movable type (the most popular method for such publications in the Qing) through the Republican period. Of 184 extant Republican-era genealogies from the provinces of Jiangsu and Zhejiang, 124 were produced either by woodblock (twenty-four) or wooden movable type (one hundred); forty-four were printed by letterpress, fourteen by lithography, and two by mimeography.[31]

The persistence of the older woodblock and wooden movable-type technologies can perhaps best be explained by the continued profitability of woodblock publishing outside Shanghai and the Jiangnan area—that is, in regions where access to the new technologies was limited. Commercial publishers could still produce relatively short popular works cheaply with the woodblock method through the nineteenth century. Evelyn Rawski concludes, after surveying woodblock production costs, that "it was possible to produce cheap books selling for a few cash" in the Qing.[32] The cost of block cutting, the single heaviest expense in woodblock publishing, could be very significantly reduced by the hire of female cutters, who were paid a mere twenty to thirty cash (wen 文) per one hundred characters (compared to eighty to ninety cash [wen] per hundred for male cutters in the late nineteenth century).[33] And those publishers with a store of cut blocks ready

<hr />

[29] "Yuechixian mukeye qingkuang diaocha baogao," 42b–43a. The authors of the report estimated that there were still four hundred to five hundred block cutters active in Yuechi county in eastern Sichuan.

[30] *Guangdong shengzhi: Chuban zhi*, 72–73.

[31] Xu Xiaoman, "'Preserving the Bonds of Kin,'" 350.

[32] Rawski, *Education and Popular Literacy*, 123.

[33] Ye Dehui, *Shulin qinghua*, 186.

for printing had little incentive to change to a technology requiring sophisticated machinery and training.

In short, through the nineteenth century at least, block cutting remained an attractive investment to publishers without access to the machinery and technical knowledge required by lithography or letterpress printing. As Reed has explained, lithography caught on quickly in Shanghai for three reasons: it required a relatively low initial investment; lithographic texts replicated even more closely than woodblock texts the aesthetic qualities of Chinese calligraphy; and the technique required only "limited changes in publishing outlook."[34] But it still demanded new machinery more complex (and more expensive) than the blocks and a cutter's simple set of tools sufficient for xylography; it demanded, too, new technical knowledge, on the part of both publishers and workers, quite different from the simple technology of woodblock printing. Easy to access in Shanghai, both the machinery and the knowledge (as well as the skilled workers) were difficult to transport long distances or deep into the countryside. It is no accident that, although other cities in the Jiangnan area developed lithographic printing operations, none were able to rival Shanghai for quality, despite their relatively short distances from Shanghai. Neither were the lithographic publishers of the more distant metropolitan centers of Wuchang 武昌 and Guangzhou.[35]

The new technologies—particularly the attractive technology of lithographic printing—did of course eventually spread throughout China. Many commercial shops combined technologies, continuing to print from woodblocks at the same time that they hired "lithography masters" (*shiyin shi* 石印師) to print texts and forms. By the end of the nineteenth century, first lithography and then letterpress printing (a more complex technology requiring a larger capital investment) had been introduced in most provincial capitals and major metropolitan areas. In Shaanxi province, lithography was in use in the late Qing for the production of stationery and official forms as well as books. In 1896 the provincial government printing office (Shaanxi guanshuju 陝西官書局) in Xi'an purchased a letterpress machine, and commercial publishers gradually began to turn to the new technology as

[34] Reed, *Gutenberg in Shanghai*, 89.
[35] Ibid., 323, n.74.

well.[36] In Sichuan, the commercial publisher Yang Chaozong 楊朝宗, owner of the Jinghong shuju 精宏書局 in Chongqing, began printing lithographic texts (though he continued to produce woodblock texts as well) in 1897; shortly thereafter, he added letterpress printing, the first publisher in Sichuan to do so. By 1910 there were five commercial operations using letterpress technology in the province. Through most of the Republican era, the Shancheng tang 善成堂 of Chongqing produced and sold not only woodblock and lithographic texts, but eventually also letterpress editions; when the shop closed in 1945, it was producing only the latter.[37]

Naturally the new technologies spread more slowly in rural areas. But certainly by the 1920s and '30s lithography and letterpress printing were available even in the countryside. According to one informant, sent at the age of ten to work as a woodblock printer in the Ma (馬) family bookstore in Shanghang 上杭 county seat, Fujian, in the mid-1930s, the store also employed a lithography printer. In out-of-the-way Bose 百色, in far western Guangxi, by the late 1940s the Enlightenment Printing Bookstore (Qizhi yinwu shudian 啟智印務書店) employed two workers in letterpress as well as two lithographic printers and one woodblock cutter.[38]

Technology and the Book Cultures of the Transitional Period

In terms of technology, then, throughout the Republican period parallel publishing operations (that is, operations using exclusively either xylography or modern technologies)—as well as some mixed-technology shops—persisted in sites ranging from hinterland settlements and interior provincial cities to advanced coastal cities. To a limited extent the parallel technologies produced parallel book cultures—that is, a "traditional" book culture associated with woodblock production, and a "modern" (or "foreign") book culture associated with lithography and letterpress. Traditional book culture included the primers and educational texts tied to examination study; a wide range of practical guides to family ritual, correspondence, rhymed-couplet (*duilian* 對聯) composition, medical diagnoses and treatment, medicines, divination, geomancy (*fengshui* 風水), fate calculation, selection of auspicious

[36] *Shaanxi shengzhi: Chuban zhi*, 177.
[37] *Sichuan shengzhi: Chuban zhi*, 1: 5, 260.
[38] Interview, Lingyun, May 12, 1996.

days, etc.; and popular novels, short-story collections, and songbooks. Modern book culture included the textbooks of the new educational system, newspapers and journals, and the fiction and polemical writings of the New Culture Movement.

In wartime Changting 長汀, the temporary home of Xiamen University, texts of the different book cultures were sold in different shops. Certain booksellers were known as purveyors of traditional texts: woodblock editions of primers and the classics, divination guides, popular adventure or martial arts (*wuxia* 武俠) novels, and in one case, Buddhist scriptures. Other booksellers offered contemporary schoolbooks and newspapers.[39] Yet in other cases, a bookseller might carry both kinds of texts. The Suwei shanfang 素位山房, a Sibao branch bookstore in Zhangzhou (漳州), Fujian, active in the 1920s and 1930s, sold traditional titles (divination handbooks, medical manuals, and popular fiction) in woodblock editions, with modern texts—the works of the New Culture Movement—in lithographic or letterpress versions.[40] The continued economic feasibility of woodblock bookselling can be explained in part by the continuing demand and in part by the greater longevity of woodblocks; booksellers were printing texts from still-usable blocks (even ones that might have been cut decades earlier), to profit from the still-considerable demand for such texts.

What is perhaps most surprising here is the continued popularity of traditional educational texts, particularly the "Three-Hundred-Thousand" ("San-Bai-Qian")—*Three Character Classic* (*Sanzi jing* 三字經), *Hundred Family Names* (*Baijia xing* 百家姓), and *Thousand Character Essay* (*Qianzi wen* 千字文), primers that were studied in succession—and editions of the Four Books, the core texts of the late imperial educational curriculum. As late as 1938, thirty-three years after the abolition of the examination system and twenty-six years after the establishment of the modern Republican school system, the leftist writer Lao Xiang 老向 (1901–1968) noted the ubiquity of these texts in the hinterland:

> When I was working in the countryside in Hebei's Ding county, I noticed two old bookstores on the northern street. The entrances were so neglected and deserted you could almost "set up a bird trap" there, and I thought they must have closed long ago. But this was not the case;

[39] Interviews, Changting, December 14, 1995 and December 15, 1995.
[40] Interview, Zhangzhou, April 1, 1996.

they just kept on day after day. I only found out after close questioning that they completely relied on the wholesale trade of those outdated old books that still (somehow) survive: the *Hundred Family Names*, the *Thousand Character Classic*, and the *Three Character Classic*.[41]

The fact that these texts were still much in demand suggests something of the difficulties the Republican government had in implementing a modern school system. Distribution of modern school texts was a problem, particularly since the contents of the texts were changed frequently, requiring the regular replacement of texts. The modern textbooks were often too expensive for rural students; and many hinterland residents found the texts mystifying because of their use of a vocabulary adopted from Western languages not familiar to hinterland dwellers, or offensive because of their subversion of custom.[42] Given the instability of the times, a better bet might have been to continue using the well-tried and familiar woodblock "Three-Hundred-Thousand" than to embrace texts imposed by a distant and ineffective government, with contents largely irrelevant to daily life. Lao Xiang noted that most peasants, for whatever reasons, preferred the older textbooks: "Many uneducated peasants, in town to trade in their spare time, often buy a copy of the *Three Character Classic* to take home with them. I hardly ever saw them buy a modern, vernacular book put out by the Commercial Press in Shanghai."[43]

In many areas, in part because of these problems, parallel educational systems also developed. In rural areas the old family or private schools still flourished—and still taught the "Three-Hundred-Thousand" and the Four Books—alongside the new primary schools. Many of the older men of Sibao, for instance, recall that they in essence went to two different schools in their youth—to a modern primary school mandated by the county government and a family or private school preferred by their parents.[44] And even in the cities private schools persisted through the Republican period. In Guangzhou, for example, there were 636 private schools with about thirty thousand students in 1924—around the same number of students as attended the modern schools. The number of schools had dropped to seventy-four by

[41] Lao Xiang, "Guanyu kangri *Sanzi jing*," cited in Borthwick, *Education and Social Change in China*, 123.
[42] Borthwick, *Education and Social Change in China*, 122.
[43] Lao Xiang, "Guanyu kangri *Sanzi jing*," 292–293.
[44] Interviews, Wuge, November 9, 1995; and Mawu, April 23, 1996.

1937, but began to increase again during the Sino-Japanese War, as the city government lacked funds to support the new school system. Not until after 1949 did the old schools finally disappear.[45] A similar pattern emerged in Hanchuan 漢川 county, around the metropolis of Wuhan. Hanchuan had 168 private schools in 1935, only twenty-three of which were "reformed" (that is, which used modern school texts). By 1942, the number had increased to 310, only seventy of which were reformed; a great many new private schools were founded during the Sino-Japanese War. Not until 1945 did they begin to decline.[46]

Even when local governments were fairly successful in establishing modern schools, some overlap still existed between the old and the new educational approaches. According to Lao Xiang, the market for the old primers included not only peasants ignorant of, or resistant to, modern education, but also teachers in the modern schools themselves: "Not only do private family schools use them, but foreign-style, modern schools also use them as supplementary reading material."[47] Thus, a popular market was still very much in evidence for the old texts, and woodblock publishers who could not afford machinery for the new technology could still rely on their old blocks to meet at least some of this demand.

But more than just the old-style textbooks continued to be published by woodblock. The songbooks published widely in Chaozhou 潮州, Guangdong, in the early twentieth century, for example, were woodblock productions, despite the fact that this region had long since been introduced to modern print technologies. So, too, in Republican-era Chengdu and Chongqing, "Confucianized" songbooks produced as part of a movement to reform popular literary and oral culture came out of several houses specializing in cheap woodblock publishing. For example, *(Newly edited and reformed) A Girl Laments Her Marriage* ([*Xinbian gailiang*] *Nü'er ku jia* [新編改良] 女兒哭嫁), a crudely cut songbook-pamphlet published by the Xiangjia gou 向家溝 in 1931, "reforms" a traditional marriage lament into a song celebrating the joys and benefits of marriage.[48] This phenomenon can perhaps be explained by the fact that such texts were often written in the local

[45] Cao, Lin, and Zhang, *Guangzhou jinbainian jiaoyu shiliao*, 263–264.
[46] *Hanchuan xianzhi*, 523.
[47] Lao Xiang, "Guanyu kangri *Sanzi jing*," 191–193.
[48] On the marriage laments, see McLaren, *Performing Grief*.

dialect and, as works enjoying a limited regional circulation, might simply not have been economically attractive to the Shanghai lithographic or letterpress publishers.

But to assume a simple association between print technology and content would certainly be a mistake. Many of the texts of late Qing reform thinking and the "new learning" (*xinxue* 新學)—translations of Western works on science and technology—were produced originally in woodblock editions by publishers in Beijing and on the southeast coast. But hinterland woodblock publishers as well might take the initiative to publish such works, works that arguably could be seen as challenges to traditional learning and textual culture. The success of the Zhigu tang 志古堂 in late nineteenth- and early twentieth-century Chengdu, for example, rested originally on the bibliographic expertise of its manager, Zhou Dasan 周達三 (1856–1922), who oversaw the careful editing and production of classical and literary texts for the provincial capital's scholarly elite. But he also produced texts supportive of political reform such as *Warnings to a Prosperous Age* (*Shengshi weiyan* 盛世危言, 1893) by Zheng Guanying 鄭觀應 (1842–1922), *Discourse on New Government* (*Xinzheng lunyi* 新政論議, 1895) by He Qi 何啟 (1859–1914), and the works of Kang Youwei 康有為 (1858–1927) and Liang Qichao 梁啟超 (1873–1929).[49] In his reminiscences, the Communist revolutionary Wu Yuzhang 吳玉章 (1878–1948) in fact recalls books purchased from the Zhigu tang—particularly the writings of Liang Qichao—as the sources of his early revolutionary thinking.[50]

The Rise of Shanghai and Woodblock Book Culture: Texts and Distribution Networks

As Lao Xiang's comment above suggests, the two book cultures were not by any means strictly parallel or mutually exclusive; they overlapped at certain points, as in the modern schools that used the "Three-Hundred-Thousand" as supplementary texts. Or, as in the case of the Shancheng tang or the Suwei shanfang, shops that originated as woodblock publishing houses might diversify their technology and

[49] Cui, "Zhou Dasan," 500–501.
[50] Wu Yuzhang, *Wu Yuzhang huiyi lu*, 7.

sales, producing and/or selling "foreign-style" texts (*yangban* 洋版) as well as woodblock productions. And, most significant, the Shanghai publishers were interested in absorbing the texts of what we could call woodblock book culture. Indeed, in part through their success in absorbing this culture—that is, in using new technologies to reprint traditional texts—Shanghai publishers rose to dominate the book market of the late Qing and Republican periods.

Beginning in the 1870s, these publishers sought out woodblock editions of old texts, particularly the textbooks of the civil service examination system and popular novels, for conversion into lithographic or letterpress editions. The lithographic publishers played a particularly important role in this process, perhaps because of the earlier spread of this technology and its aesthetic affinity with woodblock printing. Lithographic publishing in Shanghai was in large part a reprint industry, responsive to the ever-growing demand for examination texts and to official calls for reprints of important scholarly and literary collections.[51] But interest in reproducing works of popular entertainment and humbler textbooks persisted as well. The Jinzhang shuju 錦章書局 of Shanghai, for example, specialized in the production of lithographic editions of both classic novels and popular military romances, cheaply printed on coarse paper.[52] The Lüye shanzhuang 綠野山莊 of Chengdu and the Suwei shanfang of Zhangzhou both sold woodblock works like the popular textbook *Treasury of Knowledge for Young Students* (*Youxue gushi qionglin* 幼學故事瓊林) to Shanghai publishers for conversion into *yangban*; these two publishers in turn sold the modern Shanghai texts in their shops.[53] Though the demand for examination textbooks obviously declined precipitously with the abolition of the examination system in 1905, a market for traditional novels and primers remained. To the extent that Shanghai publishers were interested in meeting the continuing demand for such texts, they affirmed the continuing vitality of the old book culture.

The Shanghai publishers sought to absorb not only the contents of woodblock book culture, however. In many areas they relied on long-established bookshops and routes of sale—those established by woodblock publishers—for the distribution of their texts. As early

[51] Reed, *Gutenberg in Shanghai*, 90.
[52] *Guangxi shengzhi: Chuban zhi*, 64.
[53] *Sichuan shengzhi: Chuban zhi*, 1: 255.

as the 1880s Shanghai lithographic publishers saw the advantages of using long-established networks to market their books; these networks covered the empire, "ranging from Qingdao and Beijing's Liulichang in the north to Chongqing in the west and south to Canton."[54] In the early twentieth century, many hinterland booksellers handled both woodblock texts and *yangban* printed in Shanghai, a reflection of the persistence of woodblock book culture and also how thoroughly the Shanghai publishers could penetrate the woodblock-text markets. In the 1930s, even a lowly Sibao book peddler was selling both wood-block texts (produced in Sibao, his native place) and lithographic texts (produced in Shanghai and shipped to Fuzhou).[55] Many print shops (*shufang* 書坊) established in the late Qing to publish and sell woodblock texts became, in the course of the Republican period, retail bookstores (*shudian* 書店), which distributed *yangban* from Shanghai and other modern publishing sites.[56] The great publishing concerns of Shanghai—the Commercial Press (Shangwu yinshuguan 商務印書館), China Books (Zhonghua shuju 中華書局), and World Books (Shijie shuju 世界書局)—all seem to have pursued this strategy: they would first distribute their texts through an established local shop and then, if business was brisk enough, they would move in and establish their own branch outlets. This act usually presaged the dominance of the modern technology in the area; in Sichuan, for example, only after the Commercial Press established branches in Chengdu and Chong-qing, in 1903 and 1906, respectively, did letterpress texts became more and more common in the province.[57]

Not surprisingly, these branch shops were first established in what had been major provincial publishing centers like Chengdu and Chongqing, and then gradually in lower-level cities and towns. Thus, the Commercial Press established a branch in Guilin, Guangxi's pre-mier publishing center, in 1912, but did not move into Nanning, an urban center of secondary importance, until the 1930s.[58] Interested in extending their markets as widely as possible, the Shanghai publishers had a shrewd sense of where to develop distribution networks and were willing to employ somewhat unconventional business arrangements to

[54] Reed, *Gutenberg in Shanghai*, 111.
[55] Interviews, Wuge, October 27, 1993; November 14, 1995; and April 25, 1995.
[56] *Guangxi shengzhi: Chuban zhi*, 42.
[57] *Sichuan shengzhi: Chuban zhi*, vol. 1: 255.
[58] *Guangxi shengzhi: Chuban zhi*, 64; *Nanning shizhi: Wenhua juan*, 238–239.

do so. In Anshun, an outpost in the western Guizhou frontier and a key link in the opium trade network, a triangular exchange eased the entry of modern texts into bookstores originally established to sell woodblock texts from Baoqing, Hunan. Bookstore managers paid for their Shanghai texts by sending wolf and jackal pelts to Shanghai furriers; these merchants then transmitted payment for the furs to publishers in the city, who shipped the books thus purchased back to Anshun by post. By the mid-1920s, Anshun booksellers carried publications of the Shanghai Commercial Press, China Books, World Books, and New Asia Books (Xinya shuju 新亞書局), as well as woodblock texts.[59] The modern publishers here were building on the channels and patterns of distribution long established by woodblock commercial printers.

Conclusion

As the Shanghai publishers gradually absorbed the texts of woodblock book culture into their own stock, as they extended the distribution routes for their texts throughout Republican China, and as they established branch bookstores even in distant outposts like Guiyang (where the Commercial Press had established a branch by 1925), they succeeded in centralizing—or recentralizing—the Chinese book trade and book culture. In the late Ming, commercial publishers in the great cities of Jiangnan and in northern Fujian dominated the trade; a handful of sites produced the bulk of commercially sold texts. In the Qing, though Jiangnan (particularly Suzhou and Nanjing, as Widmer points out in her essay in this volume) remained important, and Beijing rose to a new eminence, commercial publishing was much more widely diffused throughout the empire, with significant industries in provincial capitals, prefectural seats, market towns, and even peasant villages. The portability and relative simplicity of woodblock printing made this decentralization of production a natural response to the population boom, increased literacy, and heightened demand for texts noticeable since the late sixteenth century.

With the introduction of faster and more efficient technologies (but ones requiring higher initial capital investment in machinery and greater technological knowledge) came the rise of Shanghai to

[59] Interview, Anshun, August 31, 2004.

a position of unprecedented dominance in the publishing world. At the center of the Chinese business world, in the clearinghouse for the introduction of new technologies from the West and Japan, Shanghai entrepreneurs had access to the knowledge (of both new technologies and new business forms) and the funds to achieve this dominance. Their ability to corner the enormous market for modern textbooks in the Republican period ensured their unquestioned centrality in the modern Chinese book world.[60]

In so doing, the Shanghai publishers relied on contacts forged with "old style" publisher-booksellers to absorb the most popular titles of woodblock book culture, to take advantage of existing distribution routes and bookstore sites, and, finally, to establish branch stores of their own. These publishers' rapid rise should not obscure the fact that they built their success on a book culture that had a geographically broad and socially deep reach before the advent of modern printing, and that much of the book culture of the late nineteenth and early twentieth centuries remained mixed, both in terms of technology and content. Nor was the development of a new "modern" book culture necessarily a linear one. The late 1930s and early 1940s saw a spurt in the production of old-fashioned primers, often in woodblock editions, after decades of decline, in response to the failures of modern educational institutions during the Sino-Japanese War.

Much work remains to be done before we can assess the impact on Chinese book culture of Shanghai's rise and the modern centralization of publishing. Most of the work on twentieth-century publishing focuses quite naturally on the production of modern texts—the new textbooks, new literature, newspapers, and so forth. But an understanding of the relationship between the old-style and new texts in the creation of modern Chinese book culture is useful. How large was the market for modern reprints of old texts? To what degree was that market eclipsed—if it was—by the demand for new works?

Did the absorption of certain woodblock texts into the stock of Shanghai booksellers lead to a broadening of Chinese book culture—that is, were texts that had once enjoyed only a regional circulation suddenly available to a nationwide readership through the complex distribution networks radiating out from Shanghai? Or did the

[60] Reed, *Gutenberg in Shanghai*, chapter 5.

Shanghai publishers deliberately choose texts already known to be universally popular, thus reinforcing the dominance of a core set of primers, novels, and how-to manuals, and diminishing the impact of regionally popular texts or texts in local dialects? In short, did the rise of Shanghai mean a tighter integration of Chinese textual culture (and the development, perhaps, of a unified national book culture) or did that rise support a more varied, regionally diverse set of book cultures?

MODERNIZATION WITHOUT MECHANIZATION: THE CHANGING SHAPE OF FICTION ON THE EVE OF THE OPIUM WAR

Ellen Widmer

This study explores patterns in Chinese publishing before the technological revolution of the late nineteenth century. It centers on the late Qianlong, Jiaqing, and Daoguang reign periods (1796–1850). The focus is largely on fiction, but I occasionally look beyond that genre by way of supplementing the discussion. Well before the mechanization that took place after "Gutenberg" arrived in 1870s Shanghai (to use Christopher A. Reed's formulation),[1] changes were under way in four areas—the amount of fiction published, the way it was distributed, the degree of international awareness of this work, and the composition of the readership for which it was designed—that point in the direction of what are generally identified as later markers of literary modernity. The existence of these trends prior to the late nineteenth-century revolution in printing technology and, even more, early twentieth-century changes in education and literary life suggest that, in our efforts to define literary modernity, we should be attentive to continuities as well as to the causal force of sudden outside influences or internal revolutions.

Increased Production of Fiction

One of the striking features of Shanghai publishing after 1876 is the immense rise in the publication of fiction. Leaders in this area were such major firms as the *Shanghai Journal* Office (*Shenbao* guan 申報館) and Shanghai Books (Shanghai shuju 上海書局). Their emphasis on fiction was part of the modernization and commercialization of the publishing era as a whole during the Guangxu era (1875–1908), but fiction began appearing in increasing quantities well before this time.

[1] See Reed, *Gutenberg in Shanghai,* Introduction, 3–24.

Evidence comes from several quarters. The first is the *Record of Book-sellers of Novels* (*Xiaoshuo shufang lu* 小說書坊錄), edited by Wang Qingyuan 王清原, Mou Renlong 牟仁隆, and Han Xiduo 韓錫鐸.[2] This catalogue is organized by bookshop. If a store began in one reign period and continued on through others, it is assigned to the period in which its first title appeared. The table below indicates the number of bookshops and the reign period to which each is assigned:

Reign	Period	Bookshops	Average Number of Bookshops/Year
Shunzhi	1644–61	11	.6
Kangxi	1662–1722	31	.5
Yongzheng	1723–35	9	.7
Qianlong	1736–95	93	1.6
Jiaqing	1796–1821	98	3.8
Daoguang	1822–50	121	4.2
Xianfeng	1851–61	36	3.3
Tongzhi	1862–74	43	3.3
Guangxu	1875–1908	379	11.1
Xuantong	1909–11	85	28.3

Granting that our knowledge of books and bookshops is greater for later periods than for earlier ones, these rough figures suggest that the number of new fiction publishers was rather low until the end of the Qianlong era, ascended to a somewhat higher level during the Jiaqing and Daoguang eras, declined slightly during the Xianfeng and Tongzhi eras, and then grew exponentially during the Guangxu and Xuantong eras.

The question of fiction production in and after the late eighteenth century can be approached in a second way. Shang Wei has discovered a list, dated 1837, of 116 titles deemed heretical or obscene by one Yu Zhi 余治 (1809–1874). A gentleman from Wuxi, Yu drew up the list in support of a campaign launched by the Suzhou administration to prohibit such works.[3] Texts included on the list vary widely.

[2] Wang, Mou, and Han, *Xiaoshuo shufang lu* (2002).
[3] Shang, "The Reception of the *Story of the Stone*," 31. The list is found in Yu Zhi, *Deyi lu*, 11: 10a–11a. It includes a few works that are no longer extant, including one *Dream of the Red Chamber* sequel, *Honglou bumeng*, about which nothing is known.

Some are famous erotic works from the late Ming (1368–1644) and early Qing (1644–1911) dynasties, such as *National Beauties, Heavenly Charmers* (*Guose tianxiang* 國色天香), and *The Prayer Mat of Flesh* (*Rou pu tuan* 肉蒲團). Others are much more innocent, among them, *Dream of the Red Chamber* (*Honglou meng* 紅樓夢) and its sequels. The list was endorsed by sixty-five commercial publishers of Jiangnan, who promised to see that these 116 works would not be reprinted. However, the names of only eight of these booksellers, presumably the most prominent, appear as signatories on the document.

What is particularly interesting from our point of view is to consider this list in light of the fate of Jiangnan publishers during the Taiping Rebellion (1851–64). The shop of one of the best-known booksellers on the list, Suzhou's Saoye shanfang 掃葉山房, suffered rampant destruction, and its proprietor was jailed and probably killed by the Taipings in 1862.[4] Only because of the vast wealth of the family behind the firm was the Saoye shanfang able to regroup, eventually adding outlets in Shanghai and elsewhere. Doing so allowed it to compete with the likes of the Shanghai Journal Company and Shanghai Books during the late Qing.

Wang, Mou, and Han list no fiction titles for Saoye shanfang before the Guangxu era, but we know that at least one of its fiction imprints, *Flowers in the Mirror* (*Jinghua yuan* 鏡花緣), came out in 1832.[5] This small lacuna in Wang, Mou, and Han, coupled with common sense, encourages us to believe that the list of 116 censorable titles represents a selection from a much longer list of fictional works in circulation in 1837. Might some of the titles on this extended list, censorable or not, have been put out by Saoye shanfang but destroyed by the Taipings? And what of the other seven firms? Wang, Mou, and Han have no record of two of them, Youshan tang 酉山堂 and Sanwei tang 三味堂. The output of the other five is as follows:

[4] Yang Liying, "Saoye shanfang yanjiu," 58. See also Widmer, "The Saoye Shanfang of Suzhou and Shanghai."

[5] It is listed in the electronic catalogue of the National Library of China.

Publisher-Booksellers	Fiction Titles from the Qianlong, Jiaqing, and Daoguang Eras	Fiction Titles from the Tongzhi Era (1862–74)	Undated Fiction Titles	Total
Shuye tang 書業堂 (Suzhou store)	16	2	5	23
Xingxian tang 興賢堂			1	1
Wenyuan tang 文淵堂	4			4
Tongshi shanfang 桐石山房	4		1	5
Wenlin tang 文林堂	1 (Daoguang era)		1	2
Total	25	2	8	35

This overview gives us 25 titles identifiably from the Qianlong, Jiaqing, and Daoguang eras. As it happens, four of Shuye tang's titles (three of them dated) are on Yu Zhi's list of censorable titles. These are *Strange Stories Old and New* (*Jingu qiguan* 今古奇觀), *The Romance of Opposing the Tang* (*Fan Tang yanyi* 反唐演義), *Slap the Table in Amazement* (*Pai'an jingqi* 拍案驚奇), and *National Beauties, Heavenly Charmers*.[6] All in all, then, these eight firms published at least 25 titles, plus one *Flowers in the Mirror*, during the Qianlong, Jiaqing, and Daoguang eras, and agreed to avoid 113 other titles (the total of 116, minus the three dated, censorable titles among those published by Shuye tang) by around 1837. These figures translate into 138 works of fiction known or in circulation at this time. If we count the undated ones, the total rises to 146, and we can imagine that, if all noncensorable works issued by these firms were included, the true total would be considerably higher.

Taking these data together, we can make the following projection: these eight (and presumably other) Jiangnan publishing houses of the late Qianlong, Jiaqing, and Daoguang eras turned out a significant number of fiction titles, or they at least knew about such titles, even though they might have felt constrained not to publish them. The Taipings succeeded in destroying many titles, blocks, and, presum-

[6] Three of these came out well before 1837, and the other is undated.

ably, firms.[7] More clearly than the data in Wang, Mou, and Han indicate, this evidence gives us reason to believe that a significant surge in the publication of fiction took place in the late Qianlong era, whether gradually or suddenly, or whether because of diminished censorship, the stimulus of *Dream of the Red Chamber*, a new vogue for pornography, or some other unknown reason. This surge has been difficult to detect because of the devastation that followed just a few decades later in Jiangnan. More work will be necessary to test this hypothesis, but it seems a reasonable inference from the data at hand.

Censorship is an element in the picture of fictional output for this period. We know that it was especially acute during the Qianlong reign.[8] *Water Margin* (*Shuihu zhuan* 水滸傳) was one of the most heavily censored novels of the Ming and Qing. It appears on the list compiled by Yu Zhi, and Wang, Mou, and Han's data suggest that no *Water Margin* was published until the final four years of Qianlong's sixty-year reign. By comparison, the chaste "scholar-beauty" (*caizi jiaren* 才子佳人) novel *The Two Cousins* (*Yu jiao li* 玉嬌梨), of the early Qing, where one can assume little or no censorship (it does not appear on Yu Zhi's list), continued to be published at fairly regular intervals throughout the Qing.[9] However, the data are too skimpy to make a strong case in this regard. As we saw with Yu Zhi, the censorship of fiction was often approached at the local, not national, level.[10] Even so, the fear of being censored must have had a dampening effect on all publishers of certain kinds of fiction during most of the Qianlong regime.

Works outside of vernacular fiction encourage speculation that censorship may have relaxed somewhat following the the end of the Qianlong era. For example, the *Compendium of Works of Our Time* (*Zhaodai congshu* 昭代叢書), a collection of classical tales and sketches edited by Zhang Chao 張潮 (fl. 1676–1700), was published by Saoye shanfang in 1697 and not republished until 1833.[11] Another example

[7] See the Saoye shanfang catalogue of 1882, *Saoye shanfang shuji fadui*, reprinted in Xu and Song, *Zhongguo jindai guji chuban faxing shiliao congkan*, vol. 23 (see the editor's preface in particular).

[8] This is the thesis of Okamoto Sae, in *Shindai kinsho no kenkyū*.

[9] McMahon, in *Misers, Shrews, and Polygamists*, 99–125, uses the term "chaste beauty-scholar novel."

[10] Okamoto, *Shindai kinsho no kenkyū*, 531.

[11] The edition held in the Harvard-Yenching Library was published in 1697 by Saoye shanfang. I am still trying to find out whether the 1833 edition used the same

is *Newly Recorded Letters* (*Chidu xinchao* 尺牘新鈔), a collection of letters compiled by Zhou Lianggong 周亮工 (1612–1672) that was first published in the early Kangxi era; reissued, then censored, under Qianlong; and republished in the Daoguang era.[12]

Diminished censorship is not the only reason that fiction publishing might have expanded toward the end of the Qianlong reign: demand may also have played a part. For example, the publication of *Dream of the Red Chamber* in 1791 inspired a number of reprintings during the Jiaqing and Daoguang eras, as well as a proliferation of sequels.[13] The first, *Later Dream of the Red Chamber* (*Hou Honglou meng* 後紅樓夢), was produced between 1791 and 1796. It was closely followed by four more: two named *Continuation of Dream of the Red Chamber* (*Xu Honglou meng* 續紅樓夢), one in thirty and one in forty chapters; *Revisiting the Silken Chambers* (*Qilou chongmeng* 綺樓重夢); and *Return to Dream of the Red Chamber* (*Honglou fumeng* 紅樓復夢), all of which were in print no later than 1805. This group of five early sequels helped set the tone for what would come later, either by inspiring specific features in the later works or by manifesting a generally high level of concern for women characters and readers (on this latter point, see below).

The next twenty years saw the publication of four additional sequels: *Complete Dream of the Red Chamber* (*Honglou yuanmeng* 紅樓圓夢), *Dream of the Red Chamber Supplemented* (*Honglou meng bu* 紅樓夢補), *Supplement to Dream of the Red Chamber* (*Bu Honglou meng* 補紅樓夢), and *Supplement to Supplement to Dream of the Red Chamber* (*Zengbu Honglou meng* 增補紅樓夢), all of which were in print by 1824. After that date, *Dream of the Red Chamber* sequels appeared much more sporadically. No other extant sequel appeared before the Opium War, although one other, *Illusory Dream of the Red Chamber* (*Honglou huanmeng* 紅樓幻夢), came out in 1843. Many of these sequels were themselves reprinted, some as many as a dozen times.[14]

blocks and who its publisher was. My information on the reprint edition comes from the Shanghai tushuguan catalogue *Zhongguo congshu zonglu*.

[12] On censorship, see Okamoto, *Shindai kinsho no kenkyū*, 87 and 626; see the catalogue of the Shanghai Library for the 1847 edition.

[13] Yisu, *Honglou meng shulu*, 89.

[14] On reprints, see Sun, *Zhongguo tongsu xiaoshuo shumu*, 121–123; and Ōtsuka, *Zōho Chōgoku shōsetsu shomoku*, 60–63.

A key reason for the large number of sequels was reader dissatisfaction with the way the original novel ends. In the book's central love triangle, Baoyu 寶玉, the hero (or antihero), is duped into marrying Baochai 寶釵, a woman he loves, but far less than he loves Daiyu 黛玉, the heroine. To make matters worse, Baoyu loses Daiyu through a cruel subterfuge: because the bride's face is covered during the wedding, the groom thinks he is actually marrying Daiyu. These events lead in due course to Daiyu's death and Baoyu's withdrawal from the world. All of the book's sequels try in one way or another to compensate for these outrages and tragedies, either by bringing the dead woman back to life, reconciling the hero to his new life, or some other means. Another source of disappointment is the gradual decline of the Jia family, around which the novel revolves. Most sequels find some way to repair the fortunes of the Jias, even as they chide them for the self-indulgence that led to their demise.

Distribution Patterns

There is also evidence that distribution patterns for fiction were expanding around the time of the Opium War, well before the introduction of new printing technology and modern transport networks in the late Qing and early Republic period. I focus here on two works, the Chinese novel *Flowers in the Mirror* and the missionary novel *The Two Friends*, each of which seems to have enjoyed extensive distribution.

Flowers in the Mirror

Flowers in the Mirror by Li Ruzhen 李汝珍 (1763–1830) is unusual for the amount of interest the author took in the publication and distribution process. More precisely, Li's demonstrable entrepreneurship is unusual in a novel of this caliber and level of scholarly display. Surely there were novels whose only raison d'être was to make money, but "scholarly novels" like Li's were usually written as if in full innocence of commercial concerns.[15] The history of the publication of *Flowers in the Mirror* can be divided into roughly two stages: a series of editions published between 1817 and 1832, which represents the formative

[15] On "scholar-novelists," see Roddy, *Literati Identity and Its Fictional Representation in Late Imperial China*.

period in the production of the novel; and a period of very active reprinting or new printings of one or more of these editions.

Data on the timing of the six editions published in the first stage present some points of confusion but can be summarized as follows:

1) *Initial publication.* First and second drafts were completed in Li's hometown of Banpu 板浦, near the salt fields of Haizhou 海州 in northern Jiangsu province. From there Li traveled to Suzhou, a distance of several hundred miles, when it came time to publish.[16] A somewhat revised edition came out in Suzhou in 1818, but it may not have been the first edition; or it may have come out around the same time as an edition published in Nanjing and dated 1817, evidently pirated from an earlier draft of the manuscript (Li was understandably outraged at this development). The 1818 edition carries prefaces by Li's brother-in-law Xu Qiaolin 許喬林 (b. 1775) of Haizhou (under the name Meixiu Jushi Shihua 梅修局士石華) and Hong Diyuan 洪棣元 of Hangzhou. It also features six endorsements (one by a woman, Zhu Mei 朱玫).[17] The 1817 edition, in contrast, has no paratextual materials.[18]

2) *1821 edition.* Another edition came out in Suzhou in 1821, under Li's supervision. It carries the same prefaces as before but, among other changes, adds eight more endorsements, for a total of fourteen: four women—Zhu Mei, Xu Yuru 徐玉如, Qian Shoupu 錢守璞, and Jin Ruolan 金若蘭—and ten men. However, the edition is sloppy and some of the endorsements did not come through clearly. The end-of-chapter commentaries by Xu Xiangling 許祥齡 first appear in this edition.

3) *1828 edition.* In 1828, Jiezi yuan 芥子園, a well-known publisher, put out another edition, very likely in Guangzhou. I have not seen a copy of this edition, about which there is some uncertainty.[19]

[16] Unlike either Banpu or Haizhou, Suzhou was a major publishing hub in premodern times. See Brokaw, "On the History of the Book in China," 25.

[17] Except where otherwise indicated, all information on *Flowers in the Mirror*'s publishing history comes from Sun, *Jinghua yuan gong'an bianyi*, especially 27–31.

[18] A copy of the 1817 edition is held at the University of Tokyo Library. Another, in the National Library of China, has prefaces but no other additions. A volume believed to be the 1818 edition is held in the Beijing University Library. For the locations of the other editions discussed in this section, see Ōtsuka, *Zōho Chūgoku shōsetsu shomoku*, 152–155.

[19] Ōtsuka, *Zōho Chūgoku shōsetsu shomoku*, 152.

However, among the prefaces to the 1830 and 1832 editions is one written in 1829 by Mai Dapeng 麥大鵬 of Guangzhou. Mai talks of encountering the novel in a school (or bookshop?), Zhangzi's Xieting shushu 張子燮亭書塾,[20] and of hearing that an edition had just been put out in 1828 by Jiezi yuan. As the 1830 and 1832 editions were issued in Guangzhou, it is likely that the 1828 edition first appeared there as well. Like the 1821 edition, the 1828 edition underwent corrections by the author himself. It also includes all fourteen endorsements, now presented legibly, plus prefaces by Xu and Hong, with Xu identified by his real name.

4) *1830 edition.* In 1830, Jiezi yuan of Guangzhou published another edition, this time with 108 fine illustrations by Xie Yemei 謝葉梅. Like Mai, Xie was from the Guangzhou area. A preface by the illustrator dated 1830, as well as the one by Mai dated 1829, were added at this time. (It was Mai who introduced Xie to this novel.) In all other respects, this edition follows the 1828 edition.

5) *1832 edition.* Finally, in 1832, yet another Jiezi yuan edition came out, now with a full complement of 108 illustrations (according to bibliographer Ōtsuka Hidetaka, the 1830 edition had inadvertently omitted the twenty-second illustration). All but three of these illustrations are of female characters, including Wu Zetian 武則天 (625–705), Shangguan Wan'er 上官婉兒 (664?–710), and one hundred imperial examination candidates.[21]

Since Li died in 1830, he may never have seen either set of Xie's fine illustrations. Another point of uncertainty is how Li (presumably still based in Haizhou) was able to work on the 1828 edition, which most likely came out in Guangzhou. Obviously, some kind of mail or travel was involved. What these data allow us to hypothesize is that Li thought in terms of finding the best possible way of marketing his masterpiece nationwide. Perhaps worried by the limited reach of the market at home, he turned to a more prominent publishing center, Suzhou, before settling on Guangzhou for a final round.

Li Ruzhen was quite poor. We learn as much from the novel's various poems of endorsement, including one by Sun Jichang 孫吉昌, which

[20] For a comment about the close relationship of schools and bookshops in China, see Chartier, "Gutenberg Revisited from the East," 1–9, especially 2.

[21] Until I have seen the Saoye shanfang edition of 1832 (in the National Library of China) I cannot comment on how it fits into this picture.

observes "now old, you are still driven by hunger" but concludes with the cliché that the book, already in the hands of the printer, is selling well and will cause the price of paper to rise.[22] It further observes that the author's intense dedication to his project has paid off in the form of recognition by his generation. These comments point to Li's interest in making money, not just gaining fame, from his work, and suggest that, in order to maximize profit, wide-ranging publication was important. This interest is the likely reason he fed his work into the large publishing networks centered in Suzhou and Guangzhou.

As a result, *Flowers in the Mirror* became quite widely distributed even before the Opium War, and much better distributed after 1840. To a large extent, the increase was the result of the second stage in *Flowers in the Mirror*'s publishing history, when reprint editions and new imprints of the now complete text, with paratexts and illustrations, proliferated. Ōtsuka's bibliography of extant Chinese works of fiction lists about twenty such works (excluding the 1828 edition), whereas Han, Mou, and Wang list around thirty-five, including the 1828 edition. Later places of publication include Shanghai, and the editions include lithographs as well as xylographs, although the type of print is not always specified. At least thirteen of the later editions came out in Shanghai; some were published at such famous firms as Saoye shanfang and Dianshizhai 點石齋 (in a lithograph edition with new illustrations and a preface by Wang Tao 王韜 [1828–1897]). Marketing alone may have been responsible for *Flowers in the Mirror*'s rather wide sales and frequent reprints, but the novel would not have sold well if readers had not enjoyed or benefited from the story and illustrations, and called for further printings.

Dialogue between Two Friends Zhang and Yuan (Zhang Yuan liangyou xianglun 張遠兩友相論)

Missionary perceptions of Chinese reading habits provide a second angle of observation on the strength of consumer demand for fiction during the period under review. At first, it would seem that missionary tactics derived as much from experiences in India as in China, and hence were not necessarily tailored to the Chinese scene.[23] But a local-

[22] Sun wrote two poems of endorsement; the line quoted is from the first. I have used the 1832 Jiezi yuan edition held in the Qinghua University Library.

[23] See, for example, Hanan, "The Missionary Novels of Nineteenth-Century China," 418 and 431.

ized sense of how greatly China cared for fiction developed fairly early. Charles Gutzlaff (1803–1851) was one of the first missionaries to set foot in China, arriving illegally in the early 1830s, some years before the Opium War. In 1834, he noted with approval China's interest in reading, comparing the Chinese favorably with "Mohammedans and even Hindoos," in the following terms: "Here we meet with a reading people, comparatively free from prejudice, willing to listen to the truth."[24] But Gutzlaff was not as happy about the Chinese love of fiction. In 1838, he wrote: "[T]he government prohibits these licentious books [fiction]; but as the contents so very much incite the depraved appetite of men, people read them only with the greater avidity."[25] In fact, Gutzlaff was one of the first foreigners to read widely in Chinese fictional literature and to introduce it to other missionaries. He was also one of the first to use a writing style based on Chinese novels as a way of expounding Christian principles.[26]

These are but a few of many indications that missionaries sought, somewhat subversively, to reach beyond elite circles in order to spread their message.[27] Despite Gutzlaff's words about "depraved appetites," missionaries aimed to take advantage of fiction's strong appeal and hence its usefulness as a vehicle for propagating their ideas. Their many efforts to appropriate familiar Chinese works like *Three Character Classic* (*Sanzi jing* 三字經) and adapt them to their own ends is evidence of the same strategy.[28]

Patrick Hanan proposes that we consider some of the fiction-like work by missionaries as a branch of Chinese fiction, despite such works' Christian content.[29] As Hanan, Daniel Bays, and others have noted, probably the most popular of these was William Milne's (1785–1822) *The Two Friends*.[30] This work is said to have been particularly favored by Chinese readers because of the dialogue format, in which one friend explains the virtues of Christianity to the other in a gentle,

[24] Quoted in Hanan, "Chinese Christian Literature," 263. See also Gutzlaff, "Remarks Concerning the Conversion of the Chinese," 565.

[25] Gutzlaff, *China Opened*, 468.

[26] Hanan, "Missionary Novels," 419–431.

[27] See Wylie, *Notes on Chinese Literature*, 202.

[28] "Catalogue of Publications by Protestant Missionaries in China," 4; no. 88 is a *Three Character Classic*.

[29] Such works appear in two indices of Chinese fiction in Hanan, "Missionary Novels," 416.

[30] Hanan, "Missionary Novels," 418; and Bays, "Christian Tracts," 19–34.

nondogmatic manner. The second friend's interior monologue as he grapples with the new ideas provides much of the work's drama and appeal. The use of traditional printing materials and methods, along with traditional Chinese dating, may have further contributed to the book's wide reception among Chinese.

According to Hanan, *The Two Friends* went through at least thirty editions between 1819, when the book was first written in Malacca, and 1886. These editions were published and republished in Hong Kong and several southern treaty ports: Fuzhou, Amoy (Xiamen), Shanghai, and Ningbo. They appeared in both woodblock and letterpress forms, although the letterpress format seems to have been the rule from the mid-1860s on.[31] The text was not standardized—the title was not always the same,[32] and even the ending could vary[33]—and authorship was sometimes ascribed to the reviser rather than to Milne. But linguistically, most of these editions were roughly identical in that they were written in a "light *wenli*" 文理: simple, classical Chinese with no irregularities and allusions, a language far simpler than that of *Flowers in the Mirror*. (For the sake of this study, I am grouping all books based on Milne's original under the rubric *The Two Friends*.)

As with *Flowers in the Mirror*, the early history of *The Two Friends* merges with a later history that originates from the treaty ports and in which mechanized printing processes are the rule. In these two specific examples lies evidence of how the ground may have been paved for mechanized publication, as well as national distribution, in the decades after the Opium War. There are obviously a number of sharp contrasts between the two texts. Yet together they show an important

[31] This work was published in the following sites: Malacca (1819 xylograph and 1831 reprint); Singapore (1836 reprint); London, with Hong Kong distribution (1844 stereotype); Fuzhou (1849 xylograph reprint, 1871 and 1875 letterpress reprints in Fuzhou dialect); Amoy (1854 xylograph reprint); Hong Kong (1851 and 1867 letterpress); Shanghai (1852 letterpress; 1853 xylograph; 1857 xylograph in Beijing dialect; 1861, 1863, and 1865 letterpress; 1868 letterpress in Beijing dialect; 1869 stereotype; 1906 letterpress in Shanghai dialect); and Ningbo (1857 letterpress reprint, 1864 xylograph). (In addition, there is an 1844 reprint that does not list a publishing site.) This list is drawn from Wylie's *Memorials of Protestant Missionaries to the Chinese*; "Catalogue of Publications by Protestant Missionaries"; and the Harvard University Library catalogue.

[32] The titles include *Zhang Yuan liangyou xianglun, Eryou xianglun,* and *Jia Yi eryou lunshu.*

[33] Later editions resolve the second friend's (Yuan's) uncertainty and have him convert to Christianity.

commonality in their trajectory from premodern to modern publication and distribution patterns.

Like the reduced censorship of and heightened demand for fiction that began in the late Qianlong era, these more extensive distribution patterns cannot be attributed to changes in printing technology. It is possible that these patterns were affected by two significant developments: the silting over of the Grand Canal and the resulting move toward river and ocean transport in the mid-nineteenth century, and the burgeoning opium trade. One important factor in Shanghai's rise as a commercial hub is thought to be Yangzhou's decline once the Grand Canal became less usable. This would have meant that the old merchant routes, which centered on the canal and on such hubs as Hangzhou and Suzhou, would also have declined.[34] And although the opium trade developed more rapidly after the war ended in 1842, it existed before then. During the days when Westerners were confined to Guangzhou, both boat traffic in and out of the city and the mails increased in frequency, which probably affected the distribution of a work like *The Two Friends*.[35] Our look at *Flowers in the Mirror*'s publishing history gives us some reason to believe that this novel, too, may have been affected by these changes, since at least five of its early editions were published in Guangzhou. This would not have to mean that Cantonese readers were particularly avid consumers of Li's novel (although some may have been enticed by its setting in that city). It could also mean that, given new transportation patterns, it was cheapest to publish in Guangzhou and send the book by boat to other locales.

Internationalism

Fiction of the early nineteenth century also reflected a new interest in action set in multiple sites within China (or the Qing empire) or in a conception of China as one country among many. In this regard, the sequels to *Dream of the Red Chamber* are particularly noteworthy. Though the place of publication is usually unknown, we can some-

[34] For more on China's trade routes, see Brook, *The Confusions of Pleasure*, 179–182. On Yangzhou's decline, see Finnane, *Speaking of Yangzhou*, 297–315.

[35] On the relationship of the mails to the opium trade, see Liu, *Zhongguo gudai youyi shi*, 385–392.

times learn where they were written or where their authors came from. Most of the early ones appear to have originated in the Yangzi delta area, but *Return to Dream of the Red Chamber* (1805) was written by a man from Guangzhou (with editorial help from his sister) and the *Complete Dream of the Red Chamber* of 1814 was written by an author with Manchu ties.[36] Furthermore, among the numerous books of criticism to spring up around the parent novel are those by writers from Anhui and Guilin.[37]

As for the site of the action, most sequels range broadly around China, including its border areas, and several venture onto foreign soil. Thus, the forty-chapter *Continuation of Dream of the Red Chamber* takes the action to Siam, some of *Another Supplement to Dream of the Red Chamber* takes place in Hami and Turfan, *Return to Dream of the Red Chamber* features pirates from the Ryūkyū Islands of Japan, *Complete Dream of the Red Chamber* contains a few European characters, *Illusory Dream of the Red Chamber* features female warriors of the Miao tribe, and episodes involving Vietnamese and other "barbarian" evildoers appear in *Revisiting the Silken Chambers*. When foreign action is involved, it tends to be part of an effort to show the Jias in a good light by sending them to the defense of the dynasty, as if to compensate for their self-absorption in *Dream of the Red Chamber*. Of course the action in *Flowers in the Mirror* takes place largely outside of China, although the foreign settings of this novel are all imaginary lands. All these works contrast with the *Dream of the Red Chamber*, which rarely abandons its focus on the Jia family compound in Beijing and never thinks in international terms.

As for what prompted these signs of internationalism, we know too little about the books' authors to do more than speculate, but the changing shape of trade routes and the British presence in Guangzhou most likely played a role.

Engaging the Female Reader

Writers and publishers' increasing efforts to include women among their intended audience did not affect all works of fiction, of course, but evidence of the trend can be found in Li Ruzhen's *Flowers in the*

[36] See Liuru, preface to *Honglou yuanmeng* by Mengmeng Xiansheng, 1.
[37] Yisu, *Honglou meng shulu*, 163 and 174.

Mirror, "plucking rhymes" (*tanci* 彈詞) edited by Hou Zhi 侯芝 (1764–1829), and certain sequels to *Dream of the Red Chamber,* among other examples. Not only can one imagine women reading these works, as was the case in the seventeenth century with the "scholar-beauty" novels, but women are referenced in texts and paratexts in ways that suggest deliberate outreach.

The four endorsements written by women for *Flowers in the Mirror* are less remarkable for their substance than for the fact that Li sought them in the first place. Of the four women who wrote them, one was quite well known as a poet and one can be traced in existing records; the two others are known to me only as names attached to their endorsement poems. As far as I know, the inclusion of such endorsements is a first in the history of Chinese vernacular fiction. Given Li's intense preoccupation with marketing, his solicitation of these endorsements would seem to mean that he anticipated that women readers would be a part of the broad audience he hoped to attract. His publishers clearly shared his views. Additionally, Li's plot revolves around women: *Flowers in the Mirror* is a fantasy about Tang Empress Wu Zetian in which women are allowed to take and pass the imperial examinations.

The strong presence of women in this novel does not, in and of itself, indicate that Li meant his fictional characters to stand for real women. Scholars have debated whether they might be intended as metaphors for disempowered men,[38] and at least one scholar has raised the possibility that the remarkable skill at mathematics of one or two of the "girls" might be an ironic comment on the absence of mathematics on the imperial examinations.[39] Without discounting either possibility, it still seems likely that the endorsements imply some sort of "feminist" comment, if only in the sense that Li thought of these and other women as capable of reading his book. Additionally, he must have understood that women would neither read nor enjoy his text if it offered no characters with whom they could identify. As it happens, two of his four endorsers explicitly mention that *Flowers in the Mirror* returned them to pleasures they had experienced in reading

[38] Roddy, *Literati Identity and Its Fictional Representation,* 175–179.
[39] Elman, *On Their Own Terms,* 275–278.

Dream of the Red Chamber, where capable women characters can also be found.[40]

Another example is found in five "plucking rhymes" edited by Hou Zhi.[41] Hou was an almost exact contemporary of Li Ruzhen, although she lived in Nanjing and would not have known Li directly. "Plucking rhymes" come in more than one type, but the type with which Hou was associated are prosimetric narratives aimed primarily at women readers. That they are so aimed is discernible from the heavy emphasis on female characters, the direct address to women readers by the female-seeming narrator, and in one instance (*Flowers on Brocade* [*Jinshang hua* 錦上花]), the endorsements by seven women poets. In Hou's case, more readily than Li's, the publisher was involved in the marketing process. One of the works Hou published, *Destiny Reborn* (*Zaisheng yuan* 再生緣) by Chen Duansheng 陳端生 (1751–ca.1796), advocated a stance of which Hou turned out to disapprove—namely, that it was all right (in fantasy) for a woman to succeed in the examinations and assume political powers. A well-known poet, Hou claimed to have acquiesced to a request by publishers to add a preface, and only later learned of the plucking rhyme's contents: "I had not finished revising it when the bookseller wanted a preface for the original edition. I do not like to refuse people's requests, and so I cobbled together a few words as a preface, never expecting that it would be printed."[42] She then proceeded to write two new rhymes of her own in an attempt to salvage her reputation.

Hou's case differs from Li's in two ways—the author was a woman, and women were the work's primary intended audience—but both works demonstrate that women were perceived as suitable readers. We also learn from Hou's poems that her turn to plucking rhymes after a long career as a poet was motivated by a yearning for renown:

> *Steadfast in probing depths and sources, I knew I learned a lot,*
> *But for people to pass on my fame as a poet—I fear that day will never come.*
> *Better to switch to "plucking rhymes,"*
> *So that I might be praised as a good writer.*[43]

[40] These endorsements are detailed in Widmer, *The Beauty and the Book.*

[41] Most are listed in Hu Wenkai, *Lidai funü zhuzuo kao,* 411. For the term "plucking rhyme," see Idema and Grant, *The Red Brush,* 717–763.

[42] Preface to Hou, *Jin guijie,* n.p.

[43] Hu Siao-chen, "Literary *Tanci,*" 106. The translation is Siao-chen's, with slight modifications.

Like Li Ruzhen's female endorsers, Hou's outreach to a feminine read-
ing public and her publishers' enthusiasm for her projects are telling
indicators of women's growing inclusion in the reading market of the
day. Indeed, the entire genre of "women's plucking rhymes" and its
surge in the early nineteenth century are signs of how important the
woman reader had become. It is of further interest that some of these
rhymes take up international concerns.[44]

Dream of the Red Chamber and its sequels can also be counted as
evidence of outreach to women. The parent novel must have been
expected to attract women readers, since it has such vivid women
characters that are (for the most part) treated with much sympathy—
even though the author and the fictional center of consciousness are
male. We know that the novel had a profound impact on women
poets almost immediately after its publication in 1791.[45] As for the
sequels, many of their prefaces report that Dream of the Red Chamber
was widely known among women and children. One sequel, Return
to Dream of the Red Chamber, is particularly apt to have anticipated
women readers, a hypothesis I derive from the preface written by the
author's sister. This preface decries the fact that men and women read
Dream of the Red Chamber in such radically different ways:

> The talented men of the world read [Dream of the Red Chamber] philo-
> sophically, while the gifted woman calls out in anguish "What can be
> done?" Love comes from the heart. Why must [the characters in the
> novel] be so ill fated? Since [the novel] is the product of feelings, what
> is the harm in prolonging the dream?[46]

This observation suggests that all or some of this particular sequel was
written with women readers in mind. Eventually, readers could turn
into writers, but the first sequel demonstrably by a woman was com-
posed years after the earliest sequels were published. The first of these,
Awakening from the Dream of the Red Chamber (Honglou juemeng
紅樓覺夢), dating from before 1844, does not survive.[47] In 1877, the

[44] For example, Hou's Zai zaotian (1828), which places some of the action in
Korea.

[45] Deng Hongmei, Nüxing cishi, 339.

[46] Chen Shiwen, preface to Honglou fumeng by Chen Shaohai, 1. I have used
the translation in Wang Ying's "Imitation as Dialogue," 18, with only minor
modifications.

[47] Zhao Jianzhong, Honglou meng xushu yanjiu, 31–36. The dating is based on the
life dates of the author who mentioned this work.

woman poet Gu Taiqing's 顧太清 (1799–1877) *Shadows of Dream of the Red Chamber* (*Honglou meng ying* 紅樓夢影) appeared.

Missionaries made much of their efforts to teach Chinese girls and women to read, claiming that their publishing activities and schools played a significant role in legitimizing and increasing female literacy from the 1880s on. Certainly, missionary education, usually aimed at the illiterate and near-illiterate poor, did have an impact on literacy rates. But the evidence cited above suggests that Chinese fiction writers and publishers had already begun to make room for women readers in the years before the Opium War—although the audience they targeted was clearly of higher social status and could be assumed to already enjoy a considerable level of literacy.[48] The reasons for this new outreach to women readers were various, but the popularity of *Dream of the Red Chamber* among women doubtless alerted both writers and publishers to a large potential audience. Perhaps the efforts of Yuan Mei 袁枚 (1716–1798) and other literati to educate women and encourage them to write also suggested the existence of a new and lucrative group of consumers of fiction. Whatever the cause, the new outreach to women readers of the immediate post-Qianlong era meant that, well before the missionary effort to expand female literacy, there was most likely a considerable increase in the numbers of women readers.

Conclusion: On Fertile Ground

In all four of the ways discussed in this paper, the late Qianlong, Jiaqing, and Daoguang eras witnessed a move toward late-Qing patterns of publishing that would later be described as modern. First, fiction was developing as a growth area of publication, not because of Western predilections for this art or the leadership of Western-influenced Chinese but because of such factors as a reduction in censorship and a new surge of interest in the form. Second, distribution patterns appear to have been changing then, and an empirc-wide publishing process, centered in a place such as Suzhou or Guangzhou, was a possibility long before Shanghai took on its modern prominence. This "national"

[48] The high educational levels of elite Chinese women were noted by missionary S. Wells Williams in 1863; see Idema, "Proud Girls," 232. On the low social status of the women whom missionaries educated, see Hyatt, *Our Ordered Lives Confess*, 77.

vision can be inferred both from Li Ruzhen's approach to publishing *Flowers in the Mirror* and from missionary writings. Third, China's sense of itself as described in fiction seems to have grown more relativistic as the fictional canvas grew more international. Li Ruzhen mirrors missionary writings in his depiction of China as one area among many, although his "international" world is quite fanciful and, of course, he does not promulgate Christianity. The set of sequels to *Dream of the Red Chamber* discussed here yields better examples of this broadening of horizons, especially in comparison with the original novel, which is not international minded. Fourth, fiction between the end of the Qianlong era and the Opium War clearly sought to engage female readers in ways not seen before. To be sure, urbanization and population growth also stimulated the expansion of a female readership. But, more important, at this time women began to be included prominently in the intended audience for some works of fiction, and even, eventually, to turn out some fiction of their own. Here, again, the causes were domestic rather than external. All four of these effects were felt no later than the beginning of the Jiaqing reign.

These changes are remarkable in the way they prefigure patterns that would develop in the late Qing. But the prominence of similarly directed Western efforts has made it easy to lose sight of indigenous developments and to sweep them under the rug of Western (particularly missionary)-inspired change. This view does not dispute that the mechanization of the publishing industry in China brought tremendous transformations of the kind that Reed and others have described. But the changes delineated in this essay mean that certain of the currents understood in Shanghai as "modern" had begun to show themselves well before the Opium War. Any study of these supposedly modern Shanghai-centered currents must be understood in the context of the early nineteenth-century changes outlined here.

NEW TECHNOLOGIES AND THE TRANSITION TO
MODERN PRINT CULTURE

MESSENGER OF THE SACRED HEART:
LI WENYU (1840–1911) AND THE JESUIT PERIODICAL PRESS IN LATE QING SHANGHAI[1]

Joachim Kurtz

My life has been long and flawed, full of failings, negligence and coward-ice, and I have scandalized you—I beg you to forgive me. I am happy to die in the Society [of Jesus] for...he who dies in the Society is assured of his salvation. I am happy, very happy indeed, to die in the Society; and I am happy to die in Zikawei as I have been happy to live in Zikawei because there are fewer dangers in Zikawei than outside and, by living here, I have been able to render some services through my writings. I beg you to pray for me, now and even more so after my death. My purgatory will be long and terrible; that is dreadful! Forgive me—and pray for me.[2]

Thus a mild-mannered Chinese priest addressed the Jesuit brothers and disciples who had gathered around his sickbed, shortly before he descended into a delirium that would end with his death on June 8, 1911. Although forgotten today, the life that preceded these anguished last words was far from insignificant. Their speaker, Li Wenyu 李問漁 (1840–1911), was the most prolific Chinese-Christian author of the late Qing period and the first Chinese editor of a Chinese-language news-paper in modern China's emerging publishing capital, Shanghai.[3]

The neglect of Li Wenyu's life and achievements is representative of the pervasive disregard for the role of Roman Catholic agents in the development of late Qing print culture. China's long nineteenth century is generally seen as the domain of Protestant missionary

[1] I am indebted to Zhou Zhenhe and Zhang Qing in Shanghai, Iwo Amelung and Wang Yangzong in Beijing, as well as Viviane Alleton and Fathers Robert Bonfils and Michel Masson in Paris for their hospitality, assistance in locating and reproducing materials, and incisive comments on earlier versions of this essay. In addition, I have benefited from criticisms and suggestions by Nicolas Standaert, Elisabeth Kaske, and Marianne Bastid. All remaining errors and omissions are my own.
[2] "Le Père Laurent Li, S.J.," 256–259.
[3] For a full bibliography of Li's writings, see Kurtz, "Works of Li Wenyu."

endeavors, especially but not exclusively in Anglophone scholarship, and this one-sided image has also affected views of Catholic publishing. Certainly, Catholic contributions cannot match the sum of Protestant activities,[4] let alone compare with purely commercial enterprises such as the *Shanghai Journal* (*Shenbao* 申報) empire of Ernest Major (Meicha 美查, 1841–1908).[5] Yet this hardly justifies the near-complete neglect of Catholic undertakings. Several Catholic organizations succeeded in establishing productive print shops in various parts of China. In Beijing, French Lazarists, who had moved into the former Jesuit premises after the dissolution of the Society of Jesus in 1773,[6] operated a press adjacent to the Beitang 北堂 Library that published more than five hundred titles between 1864 and 1930, most of them devoted to religious subjects.[7] In 1874 Jesuit fathers active in Zhili, the province surrounding the capital, opened a slightly smaller press in Sien-hsien (Xianxian 獻縣) to publish devotional materials and their own sinological works, among them, Séraphim Couvreur's influential French translations of the Four Books and other Confucian classics, and Léon Wieger's pioneering, if misguided, explorations of the Chinese script. Hong Kong's Nazareth Press, founded in 1884 by the Parisian Société des Missions Étrangères for all their Asian publications, was another sizable enterprise that specialized in pious works and dictionaries.[8]

The Catholic press with the highest output and the most lasting impact on China's print and publishing culture was the Imprimerie de T'ou-sè-wè, or Tushanwan Press (Tushanwan yinshuguan 土山灣印書館), run at the Jesuit headquarters in Zikawei (Xujiahui 徐家匯), near Shanghai. From 1864 onward the Imprimerie produced hundreds of religious treatises, many adorned with complex illustrations, and an almost equally high number of nonreligious books of undisputed scholarly value in Chinese, French, and Latin.[9] As many authors acknowledge in footnotes or asides, the press also pioneered several technological innovations—for example, collotype printing and

[4] Charbonnier, *Histoire des Chrétiens de Chine*, 230–233.
[5] Janku, *Nur leere Reden*; and Mittler, *A Newspaper for China?*
[6] Charbonnier, *Histoire des Chrétiens*, 204–205.
[7] See van den Brandt, *Catalogue des principaux ouvrages sortis des presses des Lazaristes à Pékin de 1864 à 1930.*
[8] Dehergne, "La presse catholique en Chine," 75–76.
[9] See, for example, Meng, "Xiaoshi de Tushanwan," 41; Gu Yulu, "Shanghai tianzhujiao chuban gaikuang," 30–34; and Zhuang, "Tushanwan yinshuguan suoji," 35–36.

photo-engraving—in late Qing Shanghai,[10] and trained generations of printers that went on to staff commercial and Protestant workshops across the Jiangnan region and beyond.[11] And, last but not least, it made possible the remarkable career of Li Wenyu, which this essay aims to reconstruct.

Before telling Li's story let us reflect on the reasons for the scholarly neglect of Catholic publishing in late Qing China. Given historians' insatiable appetite for chronological precedence, the pioneering role of the Imprimerie de T'ou-sè-wè, if nothing else, should have sufficed to inspire multiple studies, in China and abroad. Why, then, the sustained indifference? One set of reasons seems to be ideological. Catholic activities do not fit narratives portraying foreigners and their native collaborators in late imperial China unambiguously as either imperialist villains or incubators of reluctantly embraced change and "progress." As such, they have been dropped from the roster of studies devoted to tracing the genealogy of Chinese modernity as defined by the May Fourth orthodoxy.[12] The charge that Catholics remained on the sidelines, or rather the wrong side, of history was voiced early on by their Protestant competitors, who, as an example, insinuated that even in their educational undertakings the Jesuits and other Catholic denominations made no effort "to diffuse information, enlighten the mind, arouse general impulses, and turn out well-informed, truth-seeking men and women."[13] Although such claims rested to a large extent on European-bred contempt, the Catholic clergy in China, foreign or native, did indeed act much more cautiously in politically sensitive matters than such outspoken Protestant champions of reform as Young John Allen (Lin Yuezhi 林樂知, 1836–1907) and Timothy Richard (Li Timotai 李提摩太, 1845–1919). Consequently, they attracted far less interest among the emerging Chinese intelligentsia and later historians tracing the course of cultural change in China. Moreover, in contrast to the "top-down" strategy of the early Jesuits, Catholic missionary efforts in nineteenth-century China were mainly

[10] See Reed, *Gutenberg in Shanghai*, 44, 59–64, 79–80; and He Shengnai, "Sanshiwu nian lai Zhongguo zhi yinshuashu," 267, 269, 272–273.

[11] Cf. Hu Daojing, *Shanghai xinwen zhi*, 669; Ge Gongzhen, *Zhongguo baoxue shi*, 82; and Chen Yushen, Wan-Qing baoye shi, 13.

[12] See Wagner, "The Canonization of May Fourth," 66–122.

[13] Williamson, *Journeys in North China, Manchuria, and Eastern Mongolia, with Some Account of Corea* 1: 25–26. See also Wolferstan, *The Catholic Church in China*, 286–287.

directed at converting large numbers of souls among the rural and
urban poor, and thus relied to a far lesser extent on the written and
printed word.

The Jesuit mission at Zikawei was an exception among its peers in
its insistence on continuing the "apostolate by the press"—that is, the
attempt to impress the educated Chinese elite through the display of
scholarly excellence, as demonstrated with much-lauded results by
Matteo Ricci (Li Madou 利瑪竇, 1552–1610) and his successors dur-
ing the initial phase of the Jesuit China mission in the seventeenth and
eighteenth centuries.[14] Although Catholics and even a good number of
Protestants admired the printed products of the Imprimerie, the seem-
ingly anachronistic approach of the press has done little to further its
appeal among increasingly social-minded historians. Even research-
ers with a Jesuit background, who have done much valuable work in
chronicling their order's missions in the late Ming and early Qing,
habitually shy away from the disconcerting complexities of the foreign
presence in nineteenth-century China, to which the new Jesuit mission
contributed through its entanglement with France and that country's
imperialist aspirations.

In addition to all these factors, the most serious disincentive to more
in-depth studies of the Catholic missions and their contribution to the
transition of Chinese print and publishing culture remains the scarcity
of source materials (and, to a lesser extent, the fact that many of the
accessible materials are written in French and Latin). Although most
of the publications printed at Zikawei have survived, albeit in many
cases only in libraries and archives outside of China, key documents
on which any attempt to write a history of the Imprimerie de T'ou-
sè-wè would have to rely are either lost or, if they escaped destruction
in the various waves of antireligious wrath directed at the remnants of
Catholic activity after 1949, have not yet been made accessible. For the
time being, reconstructions of Catholic publishing in late Qing Shang-
hai must therefore focus on individual pieces of the whole picture, in
the hopes that these may eventually serve as building blocks for more
complete accounts.

The present essay is an attempt to move one step in this direction.
By documenting the career of the most prolific writer working for the
most productive Catholic press of the period, I hope to highlight some

[14] See Standaert, *Handbook of Christianity in China* I: 600–631.

of the themes that more comprehensive, but as yet elusive, histories will have to address. Following brief outlines of the new Jesuit mission, the Imprimerie de T'ou-sè-wè, and Li Wenyu's early formation, my analysis will focus on Li's work as a journalist, an editor, and the founder of the Jesuit periodical press in Shanghai, the area of activity in which he left his most visible mark on late Qing print and publishing culture.

The New Jesuit Mission at Zikawei

The Jesuits needed almost three decades to convince the Holy See to reconstitute their China mission after the rehabilitation of the order in 1814.[15] When their first emissaries arrived in China in 1841, they quickly adapted their strategy to the new opportunities emerging with the Treaty of Nanjing.[16] Instead of returning to Beijing, the center of their previous mission that was now served by the Lazarists, the Jesuits decided to establish their headquarters near Shanghai and limit their activities to the Jiangnan region. Backed by the French Consul, they negotiated the restitution of most of the Church's former properties in Shanghai.[17] In addition, the Jesuits bought land around the village of Zikawei, located about eight kilometers southwest of the city center, former residence of Xu Guangqi 徐光啟 (1562–1633), one of the "three pillars of Christianity" in Ming China.[18] Due to its protected location, Zikawei soon became a harbor for old and new Chinese Christians uprooted by famine, drought, and rebellion. The fathers accommodated the steady and, to them, highly welcome influx of souls by continuously expanding the facilities in the vicinity of their central residence. By 1900, Jesuit Zikawei had thus developed into a veritable town of its own, "a kind of Vatican of the Far East," extending over 600 hectares.[19]

While the new Jesuits did not adopt all the strategies of their predecessors, some of their practices clearly distinguished them from other

[15] See Mungello, "The Return of the Jesuits to China in 1841 and the Chinese Christian Backlash," 9–46.

[16] Wiest, "Bringing Christ to the Nations," 661–662.

[17] La Servière, S.J., *La nouvelle mission du Kiang-nan*, 2–5.

[18] Kelsall, *Zi-ka-wei and the Modern Jesuit Mission to the Chinese*, 113–114. On Xu Guangqi, see Dudink, "Xu Guangqi's Career," 399–410.

[19] Brossollet, *Les Français de Shanghai*, 160.

Catholic denominations and most of their Protestant competitors. Most obvious was their consistent adoption of Chinese customs in attire, food, and etiquette, a practice that puzzled many foreign visitors.[20] Keenly aware that penetrating the Chinese interior required blending in with the local populace, the Jesuits placed great emphasis on teaching their members the Chinese language. In addition, they immediately sought ways to recruit local helpers to further their cause. In this latter regard they moved much more swiftly and with greater efficiency than their competitors. As early as 1848 the mission established a college aimed at educating the children of often impoverished Chinese Christians, the brightest of whom, it was hoped, would join the order as novices and, in the most promising cases, continue their training to be ordained as native clergy.[21]

The building of educational institutions consequently became one of the central concerns of the new mission. In the winter of 1849–50 the Collège St. Ignace (Xuhui gongxue 徐匯公學) opened its doors to the first classes of students at Zikawei.[22] The school's curriculum concentrated on traditional Chinese subjects, supplemented with religious instruction, mathematics, and physical education.[23] In 1852 a Minor Seminary (Xiao xiuyuan 小修院) was added that taught Christian philosophy, theology, French, and, from 1859 onward, Latin.[24] In 1878 the Major Seminary (Da xiuyuan 大修院), which had admitted its first novices in 1862, also moved to Zikawei, from the outer Shanghai suburb Dongjiadu 董家渡.[25] Finally, in 1903, the Jesuits supported Ma Xiangbo 馬相伯 (1840–1939)[26] in establishing the Université l'Aurore (Zhendan shuyuan 震旦書院), which enrolled both Christian and non-Christian students in its French-style programs.[27] Although a dispute between Ma and the Jesuits led to the school's temporary closing and the founding of Fudan University (復旦, the "revived Aurora")

[20] Beckmann, *Die katholische Missionsmethode in neuester Zeit*, 283–284.
[21] La Servière, *Histoire de la mission du Kiang-nan* 1: 220.
[22] "Le Collège Saint Ignace."
[23] Hermand, *Les Étapes de la Mission du Kiang-nan*, 32; Gu Weimin, Zhongguo tianzhujiao biannianshi, 369.
[24] La Servière, *Histoire de la mission du Kiang-nan* 1: 210.
[25] "Zi-ka-wei, Séminaires." See also Ruan and Gao, *Shanghai zongjiao shi*, 667–671.
[26] Kropp, "Ma Xiangbo," 399–406; Charbonnier, *Histoire des Chrétiens*, 237–239; and Hayhoe and Lu, *Ma Xiangbo and the Mind of Modern China*, 4, 37–38.
[27] Hayhoe, "Towards the Forging of a Chinese University Ethos," 326–333; Kropp, "Ma Xiangbo," 415–423.

in 1905,[28] all institutions mentioned in this paragraph continued their operations under Jesuit direction until 1949.[29]

Due to a lack of resources and qualified researchers,[30] reviving the scientific activities that had contributed so much to the success of the first Jesuit mission in the seventeenth and eighteenth centuries proved to be more difficult. Decisive action was not taken until 1872, when the newly established Comité scientifique du Kiang-nan drafted a plan to turn Zikawei into a center of scientific research, not least due to "the need not to let the unbelievers have the monopoly of natural sciences, which they often easily and daringly misuse to cheat ignorant people."[31] In order to counter the apparent scientific advantage of the Protestants, the committee directed the mission to take action in four areas.[32] The first and initially most successful was the construction of a meteorological observatory "worthy of the Society."[33] From 1873 onward the Observatoire météorologique published daily weather reports and forecasts that instantly raised the mission's visibility in the region and provided data for comparative studies in Europe. The observatory's activities were soon expanded to include seismological and astronomical studies, and in the 1890s researchers at the Observatoire developed a maritime warning system that was adopted by the Inspectorate General of Customs all along China's coast.[34] A second project strengthening Zikawei's position in the public realm was the foundation of a museum of natural history. Under the direction of the renowned scientist Pierre Heude (Han Bolu 韓伯祿, 1836–1902), who had begun to collect and study potential exhibits immediately after his arrival in China in 1868,[35] the Musée attracted considerable curiosity. After the opening of its new building at Lujiazui 陸家嘴 in 1883,[36] its Chinese and foreign visitors soon outnumbered those drawn to John

[28] Willaeys, *L'Aurore*, 30–35.
[29] Brossollet, *Les Français de Shanghai*, 173–186.
[30] Latourette, *A History of Christian Missions in China*, 340–341.
[31] La Servière, *Histoire de la mission du Kiang-nan* 2: 196; trans. from the French adapted from Lazzarotto, "Xujiahui," 48.
[32] La Servière, *Histoire de la mission du Kiang-nan* 2: 192–198; Gu Weimin, *Zhongguo tianzhujiao biannianshi*, 397–399.
[33] Lazzarotto, "Xujiahui," 43.
[34] Lazzarotto, "Xujiahui," 42–45; Ruan and Gao, *Shanghai zongjiao shi*, 701–705; and Bruhnes, "Les travaux des Jésuites à l'observatoire de Zi-ka-wei," 26–38.
[35] Gu, *Zhongguo tianzhujiao biannianshi*, 381, 387–388.
[36] Brossollet, *Les Français de Shanghai*, 187–188.

Fryer's (Fu Lanya 傅蘭雅, 1839–1928) famed Shanghai Polytechnic Institution and Reading Room (Gezhi shuyuan 格致書院), founded in 1876.[37]

The remaining two areas of activity identified by the Comité scientifique are most important in our context. On the one hand, the committee suggested editing several series of publications in European languages on the history and geography of China. The best known of these are the *Variétés sinologiques*, which were begun in 1892, continued until 1938, and were revived by the Ricci Institute in Taipei and Paris in 1982.[38] On the other hand, the superiors promoted a significant increase in Chinese-language publications, with special emphasis on science and apologetics. This last project was initially to be directed by Ma Xiangbo and his younger brother Ma Jianzhong 馬建忠 (1844–1900).[39] After both left the order in 1876, the work was divided among the next most brilliant native Jesuits in the eyes of the committee, among them, quite naturally, Li Wenyu, who lacked the charisma of the Ma brothers but had distinguished himself throughout his studies.

The Imprimerie de T'ou-sè-wè

Publications in all four areas were to be produced at the printing press attached to the Tushanwan orphanage. Orphanages were a key component in the Jesuit effort to increase the numbers of Chinese-Christian souls through charitable work. From the beginning the new mission's orphanages were equipped with schools for boys and girls, as well as workshops instructing the children in manual trades. Although some workshops had a commercial orientation (teaching trades such as carpentry, shoe making, and embroidery), most focused on the production of liturgical objects and devotional articles (goblets, paintings, sculptures, stained glass, and so on).[40] Printing could contribute to both areas. The first Jesuit print shop was established at the orphanage of Caijiawan 蔡家灣, about eighteen kilometers west of Shanghai,

[37] Piel, "Le 70ème anniversaire du Musée Heude," 8–46.

[38] See Cadafaz de Matos, *História da imprensa e da circulação das ideias religiosas na China*.

[39] La Servière, *Histoire de la mission du Kiang-nan*, 2: 194.

[40] Lazzarotto, "Xujiahui," 57–61; and *Shanghai zongjiao zhi*, 373–375. See also, Fink, *Si-Ka-Wei und seine Umgebung*, 14–27.

in the early 1850s. Following an attack by marauding Taiping forces, both the orphanage and the print shop were transferred to the vicinity of the Catholic church in Dongjiadu in 1860 and, in the winter of 1864–65, to new premises in Tushanwan at the southern tip of Zikawei.[41] With two further buildings added in 1867 and 1869, the press remained in these facilities for almost a century until its formal dissolution in 1962.[42]

Before moving to Tushanwan, the print shop operated on a very small scale. Relying on woodblocks carved by their young apprentices under the supervision of the Spanish Jesuit Juan Ferrer (Fan Yanzuo 範延佐, 1817–56) and his Chinese assistant Lu Bodu 陸伯都,[43] the shops at Caijiawan and Dongjiadu initially produced small numbers of liturgical texts, prayer books, and images of saints and biblical figures that were to be distributed in churches across Jiangnan.[44] Once the first generation of printers was sufficiently familiar with the technology, they also began to work on new editions of writings by earlier Jesuits such as Ricci and Giulio Aleni (Ai Rulüe 艾儒略, 1582–1649). Yet most of the new editions were only published after the establishment of the Imprimerie de l'Orphelinat de T'ou-sè-wè in 1865 at Tushanwan, where many more laborers were at hand to complete the various tasks.[45] By 1869, the Jesuits claimed to have produced woodblock editions of no fewer than seventy titles and were able to employ more than one hundred apprentices in their expanded print shop at Tushanwan.[46]

The strategic initiative of the Comité scientifique paved the way for the next stage in the press's development. Equipped with sizable funds to realize the committee's ambitions, new production manager Yan Siyun 嚴思愻 introduced metal type for the printing of works in both Chinese and Western languages in 1874.[47] Instruction in the

[41] Gu Yulu, "Shanghai tianzhujiao chuban gaikuang," 30–31; Reed, *Gutenberg in Shanghai*, 44.

[42] Ibid., 34.

[43] Meng, "Xiaoshi de Tushanwan," 40. On Ferrer, cf. *Shanghai zongjiao zhi*, 697; and Kavanagh, *The Zi-Ka-Wei Orphanage*, 13.

[44] Colombel, *Histoire de la mission du Kiang-nan*, 460–461; and Zhuang, "Tushanwan yinshuguan suoji ," 35.

[45] *Shanghai zongjiao shi*, 720–723.

[46] Dehergne, "La presse catholique en Chine," 75. See also, an undated promotional brochure in "L'Imprimerie de T'ou-sè-wè."

[47] According to La Servière, Yan bought the fonts from a "European Press in Shanghai"; see La Servière, *L'orphelinat de T'ou-sè-wè*, 37. See also, Reed, *Gutenberg in Shanghai*, 44.

new technology was supervised until 1896 by the French Jesuit Casimir Hersant (Weng Shouqi 翁壽祺), who simultaneously worked in Zikawei's art shop.[48] The first Chinese text printed with the new lead type was a slim liturgical manual, the *Preces tempore Missae recitandae* (*Misa guicheng* 彌撒規程).[49] The inaugural issue of the *Bulletin mensuel de l'Observatoire Magnétique et Météorologique de Zi-ka-wei* of September 1874 was the first text in French.[50] In 1876 Yan and Hersant enlisted the help of the non-Christian printer Qiu Zi'ang 邱子昂 to bring lithography to Zikawei.[51] Lithography, which had been used to print Chinese texts from 1828 onward by Protestant missionaries but was still not widely used in China itself,[52] and the related process of collotype printing, with which Hersant and Qiu started to experiment shortly thereafter,[53] enabled the print shop to create much more sophisticated illustrations than traditional techniques allowed. Thus, both techniques helped the press not only to increase the appeal of their religious materials among illiterate and semiliterate converts[54] but also to print more accurate scientific texts and, more important, produce better maps, which were among its commercially most successful products. Although Tushanwan played a pioneering role in the application of modern printing technology, commentators seem to agree that lithographic printing only made its final breakthrough in Chinese publishing culture through its use in purely commercial undertakings. Principal among these was the Dianshizhai 點石齋 Lithographic Bookstore with its popular *Dianshizhai Pictorial* (*Dianshizhai huabao* 點石齋畫報), whose publisher, Ernest Major, hired Qiu Zi'ang from Tushanwan in 1877.[55] Still, the investments in advanced technology paid off at the Imprimerie as well. Not only did they enable the press to raise its output to a new level and thus meet the challenges emerging

[48] Colombel, *Histoire de la mission du Kiang-nan*, 461; Meng, "Xiaoshi de Tushanwan," 40–41. On Hersant, see La Servière, *L'orphelinat de T'ou-sè-wè*, 29.

[49] *Shanghai zongjiao shi*, 721.

[50] Hu Daojing, *Shanghai xinwen shiye shiliao jiyao* 1: 879.

[51] He Shengnai, Sanshiwu nian lai *Zhongguo zhi yinshuashu*, 269–270; and Reed, *Gutenberg in Shanghai*, 79–80.

[52] Drège, "Les aventures de la typographie et les missionnaires protestants en Chine au xix^e siècle," 294–295. See also, Jing Su, "The Printing Presses of the London Missionary Society among the Chinese."

[53] He Shengnai, Sanshiwu nian lai *Zhongguo zhi yinshuashu*, 273–274, 285.

[54] Reed, *Gutenberg in Shanghai*, 79.

[55] See, for example, Reed, *Gutenberg in Shanghai*, 80–83; Vittinghoff, *Die Anfänge des Journalismus in China*, 44; and Ye Xiaoqing, *The Dianshizhai Pictorial*, 4.

from the ambitious plans of the Jesuit superiors; they also facilitated the acquisition of lucrative external commissions—for example, the printing of official documents for the French consulate.[56] In the ensuing decades the Imprimerie strove to remain at the forefront of technological developments. In 1898, when its workforce had increased to over 140, the Imprimerie bought automatic equipment to increase the degree of mechanization in its print shop,[57] and in 1900 it began to experiment with photo-engraving, yet another new technique the press helped to introduce in Shanghai's expanding modern publishing sector.[58]

Although it is beyond the scope of the present article to discuss the whole range of the press's products, some numbers may serve to illustrate its rapid development from 1874 onward. The first catalogue issued by the Imprimerie, in 1875, already listed 180 titles in Chinese and Western languages.[59] In 1876 the number of Chinese publications alone rose to 127.[60] In 1889, 221 works were in print, and in 1900 the list contained 293 Chinese books, 12 bilingual items, and 90 titles consisting mainly of illustrations.[61] Throughout this period and beyond, the ratio between religious and nonreligious Chinese materials, at least according to the press's classification, remained almost unchanged at roughly 2.5 to 1. Of the 911 Chinese titles advertised in the *Catalogus* of 1917, for instance, 650 are listed as "religious works" in ten categories, including bibles, music, and calendars, while the remaining 261 titles, including scientific writings as well as books on calligraphy and the arts, are classified as "secular."[62] This very same ratio, accidentally or not, also applies roughly to the seventy publications in which Li Wenyu, the Imprimerie's most productive author, played a part: fifty of these titles appear as "religious" books in the various editions of the *Catalogus*; the other twenty as "secular."[63] It thus seems all the

[56] Ye Zaisheng, *Zhongguo jindai xiandai chuban tongshi* 1: 114–115.

[57] Ibid.

[58] Reed, *Gutenberg in Shanghai*, 59–60.

[59] Zhuang, "Tushanwan yinshuguan suoji," 35–36.

[60] *Catalogus librorum venalium in Orphanotrophio Tou-sai-vai prope Chang-hai ex typographia missionis Catholicae.*

[61] Zhuang, "Tushanwan yinshuguan suoji," 36.

[62] *Catalogus librorum lingua sinica scriptorum* (1917). See also, the catalogues of 1904, 1909, 1927, and 1934.

[63] Ibid. See also Streit and Dindinger, *Bibliotheca Missionum*, 556–564. For a more complete bibliography, see Kurtz, "Works of Li Wenyu."

more justified to treat Li's work as representative of the Imprimerie's program in the final decades of the Qing dynasty.

The Making of a Chinese-Jesuit Journalist

Biographical information on Li Wenyu is as scarce as accounts of the Imprimerie itself. Li was born into a Christian family, the second of six children (four girls and two boys), on August 12, 1840, in the village of Xi Lijia 西李家 in Jiangsu's Nanhui 南匯 district, an area located in today's Pudong 浦東 district, east of Shanghai.[64] His original name was the stout Confucian *ming* Haoran 浩然. In his publications he tended to use his *hao* Di 杕 and, less often, his second style Damuzhai zhu 大木齋主 (Resident of the Big Tree Studio).[65] The early education of the precocious child in the local school consisted of standard Confucian lore.[66] Sometime after the school was closed, most likely as a result of the famine that struck the region in the winter of 1849–50,[67] Li was sent to Zikawei to continue his education. Some authors claim that he entered the Collège St. Ignace as early as 1852, but we have solid evidence that he became a member of the Congregation of Our Lady of the Immaculate Conception (Shengmu shitai hui 聖母始胎會), a pious association attached to the Collège, only in 1856.[68] His baptismal name, there on record for the first time, was Laurentius or, in French, Laurent.[69] In 1859 he enrolled in a Collège preparatory course that included instruction in Christian philosophy and Latin, in which Li particularly excelled,[70] in addition to classes in Chinese, French, and mathematics. At the same time, he began to work as a precept, tutor-

[64] Fang Hao, *Zhongguo tianzhujiao shi renwu zhuan* 3: 284–288; Chen Baixi, *Tamen yingxiang le shijie*, 66–69; and "Le Père Laurent Li," *Relations de Chine*, 191–192. The most reliable sketches are two anonymous articles published soon after Li Wenyu's death: "*Huibao* faqiren jian zhubizheng sanshi'ernian zhi xiaozhuan," *Huibao* 33, no. 38 (16 June 1911): 1–3; and "Le Père Laurent Li (1840–1911)," 135–141.

[65] Jia, *Shanghai xinwen zhi*, 669.

[66] "*Huibao* faqiren jian zhubizheng sanshi'ernian zhi xiaozhuan," 1.

[67] La Servière, *La nouvelle mission du Kiang-nan*, 7–8; La Servière, *Histoire de la mission du Kiang-nan* 1: 172, 176; Brossollet, *Les Français de Shanghai*, 162–163.

[68] Fang Hao, *Zhongguo tianzhujiao shi renwu zhuan* 3: 284; Brossollet, *Les Français de Shanghai*, 240.

[69] Variants of Li's name in Western publications include Laurentius Li, Laurent Ly, and Lawrence Lee.

[70] *Vita functi in Provincia* 5, no. 221. See also, "Le Père Laurent Li (1840–1911)," 136.

ing younger boys in Chinese. In May 1862 Li and ten others, among them the now much more famous Ma Xiangbo, who was the same age as Li, were received as the first novices in the Major Seminary.[71] Even before finishing the two years of his novitiate, Li was allowed to begin further studies, probably in October 1863. He emitted his first vows in June 1864.[72]

According to the revised curriculum of the Nanjing mission, which had been approved in 1852, the training of Chinese priests required six years of instruction. The first two were devoted to the study of philosophy—logic, metaphysics, and ethics—supplemented "every third day" with lectures in mathematics in year one and physics in year two. All courses were taught using Latin textbooks. In addition, students continued their studies of the Chinese classics so that they would be prepared to take the civil examination in case they failed the novitiate or decided to leave the Jesuit order. Years three through six of the curriculum focused on dogmatic theology, supplemented in years three and four with lessons in moral theology and either Latin or French; in year five with classes in church history, liturgy, and canonical law; and in year six with biblical exegesis.[73] Li's mentor throughout these six years was the Italian Father Angelo Zottoli (Chao Deli 晁德蒞, 1826–1902),[74] whose command of the Chinese language rivaled that of any Westerner in late imperial China and who apparently also excelled as a teacher. Under the direction of Zottoli and his successor Henri Havret (Xia Wulei 夏鳴雷, 1848–1902),[75] Li and Ma Xiangbo used what little spare time they had to assist in building the collection of the Zikawei Library (Xujiahui cangshulou 藏書樓), which had been expanded consistently since its foundation in 1847.[76] In 1872, after finishing his studies and an ensuing period of probation in various

[71] Couturier, *Histoire de la Mission de Kiangnan*, 58.

[72] I am indebted to Father Robert Bonfils, S.J., for providing this information and correcting chronological errors in an earlier version of this biographical sketch.

[73] "Ratio studiorum pro utroque Seminario Missionis Sinensis in Provincia Nankinensi" (Manuscript, 4 , n.d.), AFCJ (FCh 303). See also La Servière, *Histoire de la mission*, 1: 220–221.

[74] Fang Hao, *Zhongguo tianzhujiao shi renwu zhuan*, vol. 3: 260–262; and Gu Weimin, Zhongguo tianzhujiao *biannianshi*, 368–369.

[75] On Havret, see Couturier, *Histoire de la Mission de Kiangnan*, 156–157.

[76] See King, "The Xujiahui (Zikawei) Library of Shanghai," 460–461; and Huang, "Xujiahui cangshulou—The Xujiahui Library," 24–25.

parishes to complete his novitiate, Li was ordained, together with his classmate Ma, as a priest in the Shanghai mission.[77]

Li spent his first years in the clergy preaching in rural areas of southern Jiangsu and Anhui.[78] In 1875 he returned to Zikawei to teach Chinese at the Minor Seminary. In addition to his lecturing duties he temporarily served as a priest at several churches in the vicinity of the city. In 1878 he was appointed Superior of the Major Seminary, where he also taught Chinese and Latin. Up until this point, then, nothing seemed to indicate that Li Wenyu was about to embark on a career as a uniquely productive author. To be sure, he was well versed in Chinese, French, and Latin, and had enjoyed a broad, bicultural education. If anything, however, he seemed on his way to becoming a respected Chinese-Christian schoolmaster. His first and only published work to date had been a *Short Treatise on Purgatory* (*Lianyu lüeshuo* 煉獄略說), initially printed in 1871 and reedited in 1877. The book enumerated, with abject horror, the multiple tortures sinners had to endure in the afterlife according to the Bible, various hagiographies, and the teachings of "theology" (*chaoxingxue* 超性學), as Li explained in his preface.[79]

The plan that came to determine the further course of his life and work, developed by his Jesuit superiors sometime in 1878, was to use the new capacities of the Imprimerie to publish a Chinese-language newspaper that could challenge Shanghai's two existing papers: Young J. Allen's Protestant *Church News* (*Jiaohui xinbao* 教會新報), founded in 1868 and continued from 1874 onward as *The Globe Magazine* (*Wanguo gongbao* 萬國公報; from 1889 subtitled *Review of the Times*); and Ernest Major's commercial *Shanghai Journal*, launched in 1872.[80] Li joined the preparations in late 1878 and came to serve as the venture's editor-in-chief and main contributor for the remaining thirty-two years of his life, from 1879 to the day of his death in June 1911.[81]

[77] *Vita functi in Provincia, 1897–1926* 5, no. 221.
[78] Jia, *Shanghai xinwen zhi*, 669. See also, "Le Père Laurent Li," *Relations de Chine*, 191.
[79] Li Wenyu, *Lianyu lüeshuo*, 1b.
[80] On Allen, see Bennett, *Missionary Journalist in China*; and Ma Guangren, *Shanghai xinwen shi*, 42–47. On the *Shanghai Journal*, see Janku, *Nur leere Reden*; and Mittler, *A Newspaper for China?*.
[81] See "Le Père Laurent Li, S.J."

Li thus emerged quite unexpectedly as the first Chinese editor of a Chinese newspaper in Shanghai. While earlier Chinese had played prominent roles as authors and translators, their work had always remained subject to a foreign editor's approval.[82] That the notoriously ideological Jesuits would be the first to break with this practice can be explained in either of two ways. On the one hand, as mentioned earlier, the Jesuits may indeed have been more inclined to admit their dependency on native collaborators than other foreigners working in late Qing China. On the other hand, one may argue that the ideological constraints set by the Society were so strict that the nationality of the person overseeing their enforcement hardly mattered. Even if there is some truth to this latter view, it does not justify the reluctance of most commentators to credit Li Wenyu with any contribution to the development of Chinese journalism at all.[83] Notwithstanding his unwavering faith in Catholicism or the "foreign" identity of the papers he edited—which is commonly assumed, as if newspapers necessarily have a national identity beyond the language in which they are written[84]—Li demonstrated remarkable versatility in exploiting the possibilities offered by the new medium and adapting them to the changing predilections of his audience, achievements that should suffice to earn him a secure position in any genealogy of the Chinese journalistic trade.

Useful News for All

Although Li Wenyu and his superiors cherished high hopes for their advance onto Shanghai's growing news market, they initially moved with great caution in introducing their product. Before committing to publish a full-fledged newspaper, they decided to distribute small test runs of so-called "bound leaflets" (cebao 冊報) to gauge their prospects. The first sample issue of their projected I-wen-lou (Yiwen lu 益聞錄, literally "Record of Useful News") appeared on December 16, 1878; five more followed in fortnightly intervals. Obviously, the cebao

[82] Ma Guangren, Shanghai xinwen shi, 55–56.

[83] See, for example, Britton, The Chinese Periodical Press; Ge Gongzhen, Zhongguo baoxue shi; or, more recently, Vittinghoff, Die Anfänge des Journalismus.

[84] On the question of newspapers' "national identities," see Goodman, "Networks of News," 1–10.

were sufficiently well received. The inaugural edition of the *I-wen-lou*, under the official editorship of Li Wenyu, appeared on March 16, 1879; further issues were published on a weekly basis. From August 16, 1882, onward, the frequency was increased to two issues per week. By August 18, 1898, eighteen hundred consecutive issues had appeared, with annual intermissions around Christmas and the Lunar New Year. Each issue consisted of twelve broadsheet pages, printed with the Imprimerie's state-of-the-art lead type.[85]

The preface (*bianyan* 弁言) to the inaugural edition presented the *I-wen-lou*'s self-definition, siting, with no false modesty, the paper's mission of providing accurate information to the benefit of its readers in the tradition of the Grand Historian Sima Qian 司馬遷 (ca. 145–85 BCE). Drawing on Sima Qian's renown as an incorruptible chronicler, the editors declared their responsibility for keeping their readership abreast of events on all five continents, and claimed that Christian authors were widely known for their sincerity and impartiality, in contrast to Buddhists and Daoists, whose writings offered nothing to readers wishing to extend their knowledge. The *I-wen-lou* was to open each issue with the latest "imperial instructions," thus "demonstrating its respect for the monarchy," and close with pieces on "geography, astronomy, mathematics, and the like" intended to "promote substantial learning." In between these two regular features, readers would find articles on "moral philosophy" (*daoxue* 道學) and current affairs, as well as "all kinds of texts, including news reports, biographies, prose, and poetry."[86]

By downplaying the centrality of the Christian message in its self-definition and organization, the *I-wen-lou* underlined its primary aim of reaching out to non-Christian readers. The paper's mix of rubrics, which was apparently well suited to the taste of its targeted readership of educated city dwellers,[87] may well have been inspired by the con-

[85] I have not been able to locate a complete run of these eighteen hundred issues. The most complete set I could consult, missing only nos. 679–727 and 828–832, is held at the Bibliothèque Nationale in Paris.

[86] *Yiwenlu* 1 (March 16, 1879): 2a.

[87] See Couturier, *Histoire de la Mission de Kiangnan*, 63–64. Couturier cites a letter by Father Simon Kiong, one of Li Wenyu's editorial assistants, dated June 21, 1883, in which the latter describes the actual readership of the paper consisting largely of "literate pagans, even degree-holders and officials": "La plupart des lecteurs de l'*I-wen-lou*, pour ne pas dire tous, sont des lettrés païens, voire docteurs ou mandarins. Que cinq á six milles lettrés païens aient le courage de lire un écrit qui contient des traités de philosophie chrétienne, où l'on réfute toutes les erreurs, toutes les superstitions

clusions drawn earlier by the Protestant publicist Young J. Allen, who had integrated more and more nonreligious contents in his *Church News* before eventually recasting it, with great success, as the *Globe Magazine*, a paper with an entirely secular structure.[88] Li Wenyu apparently exploited Allen's insight with little hesitation for his purposes. In practice, Christian motifs permeated most of the *I-wen-lou*'s pages, the only consistent exception being the space reserved for official announcements. The section on moral philosophy, for instance, was from the outset mainly devoted to Christian apologetics. In the paper's first thirty issues this section carried a series of essays by Li Wenyu discussing the Jesuit theory of the human soul and its differences from Confucian conceptions of moral principle (*li* 理) or psychophysical "stuff" (*qi* 氣), Daoist notions of the spiritual and divine, and Buddhist views on transmigration. In many of his contributions to this section Li adopted a style of argumentation that had already been exploited by his seventeenth-century predecessors as part of their strategy of "accommodation."[89] Whenever possible, he couched Christian notions in established Confucian terms in order to affirm the essential identity of both traditions' moral views and thus alleviate concerns about the alterity of the Jesuits' teachings. For example, in an essay on key Christian virtues, which he used simultaneously to underline the church's loyalty to the dynasty, Li explained the Christian emphasis on "respect for one's elders" (*jingzhang* 敬長) in a language that was perfectly acceptable to any Confucian gentleman or government official:

> The difference between top and bottom has always been most pronounced and is of utmost importance. Father and mother gave me life; rulers and officials govern me; teachers and lecturers instruct me—they are all my elders. When those on top established the laws, they took loyalty [*zhong* 忠] and filial piety [*xiao* 孝] as the root. Being disloyal to one's ruler, unfilial to one's kin, or disrespectful to one's teachers is seen as criminal behavior by our Church.[90]

reçues par eux aussi bien que par le peuple ignorant, que deux fois par semaine ils assistant ainsi à notre prédications écrits sans faire trop de critiques, soit pour le fond, soit pour la forme, voilà je pense un succès dont nous ne pouvons nous dispenser de remercier Dieu."

[88] Janku, *Nur leere Reden*, 53–60; Bennett, *Missionary Journalist in China*, 1337.

[89] Mungello, *Curious Land*, 44–73.

[90] *Yiwen lu* 438 (March 4, 1884): 3b; see also, Ruan and Gao, *Shanghai zongjiao shi*, 705.

Whether such conceptual appropriations had the desired effect is difficult to assess. After more than two and a half centuries of Chinese Christian writings, their purpose was probably transparent enough to educated readers—who still may have appreciated the effort, if only because of Li's smooth prose. Many of Li Wenyu's apologetic articles for the "moral philosophy" column were collected in two separate monographs that were to become his most widely read works: the *Well of Reason* (理窟 *Li ku*) and the posthumously published *Sequel to the Well of Reason* (續理窟 *Xu li ku*). Both texts went through numerous reprints into the 1930s and were distributed across the country as concise introductions to Jesuit doctrine.

The current affairs column of the *I-wen-lou* was filled with church-related reports, stories of local interest, and, most important, international and political news translated from foreign papers. The inclusion of global news in this section was another feature that Li Wenyu borrowed from his Protestant and commercial competitors. In contrast to his models, however, he included articles from the French press in his translations. In its presentation of local news, the *I-wen-lou* concentrated on stories with a moral twist. Here, too, many pieces included tacit hints of the Christian message of redemption, as, for instance, a moving tale about a pickpocket who was led to sincere remorse and consequently the truth of the Christian God by the unforeseen harm his misdemeanors caused an innocent maiden.[91] Church-related news ranged from reports on expansions or repairs of local churches to stories about miracles witnessed by missionaries in the far corners of the globe to biographies of Matteo Ricci and Giulio Aleni, each published in over a dozen installments. Over the years, Li and his staff—among them, Huang Xiexun 黃協塤 (1852–1924), who later became editor-in-chief of the secular *Shenbao*,[92]—mastered the art of writing pieces that combined religious themes with secular information, thus countering the impulse of spiritually nonreceptive readers to skip straight through the paper to the science column and the occasional literary text or poem. As in other missionary publications, the *I-wen-lou*'s science section proved to be of greatest interest to the paper's target audience. The tone for this section was set in the first twelve numbers, which carried

[91] *Yiwen lu* 1 (March 16, 1879): 7a.
[92] Ma Guangren, *Shanghai xinwen shi*, 56–57. On Huang, see Janku, *Nur leere Reden*, 33–42.

a full description of world geography, including high-quality maps. Starting with a general explanation of the earth's roundness, the serialized piece successively narrowed its focus from physical descriptions of the five continents to introductions of individual Chinese provinces. In the ensuing years many articles were devoted to similarly broad topics in astronomy, mechanics, hydraulics, and mathematics. If at all, religious beliefs came into play only in accounts of natural history that carefully avoided references to evolutionary theories while advertising the research conducted at the Musée Heude. The science section also helped Li Wenyu build direct connections between editor and readers. Beginning in the summer of 1879, the *I-wen-lou* regularly presented "crafty riddles" (*qiaomi* 巧謎) and encouraged its readers to mail in their solutions.[93] In the early 1890s this feature was expanded into a question-and-answer (*dawen* 答問) section that addressed scientific trivia ("How long would a train ride take from Shanghai to the South Pole?" Answer: "Eleven and a half days") as well as religious queries that in many cases may have been planted or solicited by the editor himself ("How does the Lord of Heaven punish criminals?").[94] Perhaps because the attempt to use this column for the purpose of proselytizing was so thinly veiled, the section initially failed to attract contributions by more than a handful of readers in any single issue.

Balanced Discussions

During the first two decades of its existence, the *I-wen-lou* and its editor Li Wenyu carefully avoided taking sides in the political controversies of the day. Yet, even neutral reports about the political systems of other countries or the state of reforms abroad could, of course, be interpreted as implicit pleas for change by readers who were so inclined. In general, however, Li used every noncontroversial opportunity to

[93] One example of such a not-so-crafty riddle reads as follows: "Once a man asked a boy: 'How many brothers and sisters do you have?' The boy replied: 'The number of my brothers equals the number of my sisters.' The man found this strange. He then asked the eldest sister: 'And how many brothers and sisters do you have?' The girl replied: 'The number of my brothers is twice the number of my sisters.' The man found this even stranger. Could you, distinguished reader, figure out how many brothers and sisters there are in this family?" (*Yiwen lu* 15 [September 14, 1879]: 8). The answer, published in the following week's issue, is four boys and three girls (*Yiwen lu* 16 [September 21, 1879]: 11–12).

[94] Examples are taken from *Yiwen lu* 1743 (January 15, 1898).

declare his and the church's support for the Qing.[95] The only excep-
tions to this choreographed stance of political abstinence were deci-
sions endangering or restricting missionary activity. Li's strategy here
was to discount anti-Christian statements as willful "slander" (*wu* 誣)
and counter them with detailed and emphatic refutations.[96] Even in
such cases, however, he avoided antagonizing the throne and instead
directed his indignation toward unspecified "scholars" (*ruzhe* 儒者)
whose malignant advice had lured the administration into issuing
erroneous decisions.

 In a period of increasingly fierce political debates, the *I-wen-lou*'s
studied neutrality did not help to broaden its appeal, especially among
the growing numbers of impatient advocates of reform. The limits of
the paper's approach are perhaps best exemplified by its coverage of the
Sino-French War of 1884–85, a conflict that presented a uniquely
delicate dilemma of loyalty for the *I-wen-lou* and its French-educated
Chinese editor. In its articles on the unfolding crisis, the paper strug-
gled to maintain a strictly nonpartisan position; that is, a stance that
was offensive to neither side. Relying on translations from, amongst
others, the English-owned *North China Daily News* and the French
newspaper *L'univers*, as well as letters, telegrams, and phone calls from
Chinese and foreign contributors close to the actual events, the paper
reported only the barest verifiable facts about the intermittent hostili-
ties, without offering any analysis of their underlying causes or pos-
sible consequences. Also absent from its pages was any reflection of
the passionate debates about the appropriate Chinese course of action,
debates in which Li Hongzhang 李鴻章 (1823–1901), arguing against
a premature Chinese confrontation with a better-equipped enemy,
clashed with a faction of hotheaded young scholars from the capital
and an increasingly aroused public, who called for all-out war.[97] While
moving with extreme caution as long as the outcome of the conflict
seemed uncertain, the paper provided extensive information on the
draft agreement negotiated between Li Hongzhang and the French
naval Captain E. F. Fournier in May 1884.[98] As soon as the agree-

[95] Ma Guangren, *Shanghai xinwen shi*, 56.
[96] See, for example, *Yiwen lu* 471 (June 27, 1885), 472 (July 1, 1885), 475 (July 11, 1885), and 479 (July 25, 1885).
[97] Janku, *Nur leere Reden*, 81–88.
[98] See Eastman, *Throne and Mandarins*, 108–125.

ment became available,[99] the *I-wen-lou* prepared a new, "more accurate" Chinese translation[100] and offered a lengthy commentary that not only welcomed the potential settlement but also insisted, inaccurately, that France had never harbored hostile intentions toward China but had been forced into action by Annamese provocations.[101] The paper defended the terms of the agreement even after its eventual rejection by both sides,[102] and especially after the renewed, and for China severely bruising, clashes in the summer of 1885. When the final peace settlement, which largely followed the terms of the Li-Fournier agreement, was signed in November 1885, Li Wenyu claimed with some satisfaction that the paper's "impartial" (*gonglun* 公論) assessment was eventually confirmed.[103]

Despite—or perhaps because of—Li's obvious satisfaction with the outcome of the war and his claims of impartiality, the *I-wen-lou*'s coverage damaged the paper's reputation and sales. As Andrea Janku has shown in her detailed analysis of the *Shanghai Journal*'s response to the events,[104] self-declared "neutrality" was simply not an option in the heated political climate of the day. Even contemporary observers were surprised at the public outcry against France's attempt to enlarge its sphere of influence in Indochina, and interpreted the passionate popular reaction as the first awakening of Chinese nationalism. "Neutrality," even if enacted as cautiously as in the *I-wen-lou*, was inevitably seen as treason, and the paper was consequently reviled as a mouthpiece of French interests.[105] As the Grand Historian on whom he had based the *I-wen-lou*'s self-definition could have taught Li Wenyu, "impartiality" was in no way equivalent to political abstinence. As if to prove this point, the *Shanghai Journal* and its main commercial rival, the Chinese version of *North China Daily News* (*Zilin hubao* 字林滬報, 1882–1900), edited by the North China Herald Company,[106] had skillfully used the conflict to solidify their emerging roles as mediators

[99] *Yiwen lu* 358 (May 17, 1884): 2a.

[100] *Yiwen lu* 360 (May 24, 1884): 2a–b.

[101] *Yiwen lu* 361 (May 28, 1884): 2a–b.

[102] See, for example, *Yiwen lu* 407 (November 5, 1884): 2b; and *Yiwen lu* 444 (March 25, 1885): 2a.

[103] *Yiwen lu* 511 (November 11, 1885): 2a.

[104] Janku, *Nur leere Reden*, 83–141. See also, Janku, "The Uses of Genre in the Chinese Press," in the present volume.

[105] Ma Guangren, *Shanghai xinwen shi*, 56.

[106] Ibid., 85–90. See also, Janku, *Nur leere Reden*, 132–41.

and agents of Chinese political discourse, while significantly increasing their circulation. In contrast, Li Wenyu's reluctance to embrace the causes favored by his potential readers proved to be a severe burden for the *I-wen-lou*, not only in this instance but also, and even more emphatically during the 1890s, when calls for fundamental reform of China's political system intensified. Despite the paper's confident claims to provide "mandarins" with "the actual truth on political matters, which they are not able to gather from periodicals of the stamp of a *Hupao* [*North China Daily News*] or *Shenpao* [*Shanghai Journal*],"[107] the number of subscribers declined from 1,500–2,000 in the 1880s[108] to about 700 in 1898.[109]

Science to the Rescue

In the turbulent summer of 1898, Li Wenyu reacted to the paper's ever-more-sluggish sales and initiated a major shift in its orientation. Starting with the August 17 issue, the *I-wen-lou* merged with the scientific journal *Revue scientifique* (*Gezhi xinbao* 格致新報) to form the *I-wen-lou et Revue scientifique* (*Gezhi yiwen huibao* 格致益聞匯報), which was to appear twice weekly—that is, in one hundred issues per year.[110] As he wrote in the last issue of the *I-wen-lou*, Li saw the merger as the only way to satisfy his readers' increasingly secular interests.[111] The *Revue scientifique* itself had been established in March 1898 by the Chinese Catholic Zhu Kaijia 朱開甲 (1863–1955), a nephew of Ma Xiangbo who had studied at Zikawei and Dongjiadu and gone on to become a successful entrepreneur in early twentieth-century Shanghai.[112] Despite Zhu's Christian background, the *Revue scientifique*, which published sixteen issues per year, contained few references to religion and, like the *I-wen-lou*, rarely touched upon politically charged issues. In the tradition of John Fryer's *The Chinese Scientific and Industrial Magazine* (*Gezhi huibian* 格致彙編), whose last edition was published in 1892,[113] the *Revue* instead offered the latest in "Western knowledge"

[107] Cited in Navarra, "The Institution of the Jesuit Fathers at Sikawei," 13.
[108] Couturier, *Histoire de la Mission de Kiangnan*, 63.
[109] Ruan and Gao, *Shanghai zongjiao shi*, 709.
[110] *Gezhi yiwen huibao* 1 (August 17, 1898): 2.
[111] *Yiwen lu* 1800 (August 13, 1898): 2a.
[112] See *Shanghai zongjiao zhi*, 705.
[113] See Xiong Yuezhi, *Xixue dongjian yu wan-Qing shehui*, 418–55.

(*xixue* 西學) through translations from leading Euro-American journals. In addition to scholarly articles focusing on physical and applied sciences, the journal carried columns devoted to scientific and world news as well as a very lively Q & A section that engaged readers from towns and villages across Jiangnan and beyond.[114] The latter was in all likelihood the most valuable asset Fryer's magazine contributed to the merger with the ailing *I-wen-lou*, and Li Wenyu consequently went to great lengths to preserve and exploit its vigor and appeal.

The sixteen broadsheet pages of the combined paper were divided equally between scientific articles and general news. The Q & A column and the inevitable riddles were included in the science section; official announcements and imperial edicts were integrated in the news pages. The apologetic articles and local news that had been regular features of the *I-wen-lou* were eliminated. From its second issue onward, the *I-wen-lou et Revue scientifique* reproduced on its last page the weather reports and forecasts issued by the Zikawei observatory.[115] In the ensuing months, the paper tried to adapt to the demands of reformist discourse. The first unambiguously political essay, "On the Advantages and Disadvantages of Parliaments" ("Yiyuan libi shuo" 議院利弊說), appeared in September 1898, shortly before the collapse of the Hundred Days' Reform that may have prompted its publication.[116] In October, in line with the once-again more conservative climate, the paper analyzed the comparative military strength of the various European powers;[117] and in November it provided detailed instructions on the construction of torpedoes.[118] The drastic secular reorientation soon began to bear fruit: within less than one year the number of the paper's subscribers rebounded, to more than thirty-two hundred.[119]

After one hundred issues, Zhu Kaijia resigned from his coeditorship because his industrial projects required his full attention. Reinstated as the sole editor, Li Wenyu abridged the paper's name to the less unwieldy *Revue pour tous* (*Huibao* 匯報). In his introductory remarks to the first issue under the new name, Li vowed to continue the successful format of the *I-wen-lou et Revue scientifique* and promised that

[114] Ibid., 455–74.
[115] *Gezhi yiwen huibao* 2 (20 August 1898): 16.
[116] *Gezhi yiwen huibao* 6 (3 September 1898): 8–10.
[117] *Gezhi yiwen huibao* 17 (12 October 1898): 9–11.
[118] *Gezhi yiwen huibao* 31 (30 November 1898): 2–5.
[119] See Ruan and Gao, *Shanghai zongjiao shi*, 709.

his staff would do everything they could to answer readers' questions on all possible topics, excluding only those related to medicine, politics, or indecent practices of any kind.[120] Readers were quick to take him at his word, so that the Q & A section came to occupy more and more space. On an average day in the spring of 1904, for instance, the *Revue* editors needed two full pages to answer ten questions, covering issues such as a new edition of a certain world map; the best way to prevent rust from corroding iron tools; the reason why humans breathe more quickly when riding horses; the qualities of a certain chemical element; the reason why rickshaw boys prefer Western over Japanese cigarettes; the best Chinese text on international law; differences between German and British philosophy; the way in which the Holy Ghost affects the human soul; where to buy a good Latin grammar; and, finally, how to explain the strange atmospheric phenomenon of ball lightning, popularly known in Chinese as "fire dragon" (*huolong* 火龍).[121]

Despite the continued success of the Q & A, the *Revue pour tous* soon lost much of the momentum it had gained in 1899. With increasing numbers of Chinese studying abroad, new channels of information opening up, and the rapid development of Shanghai's publishing sector, the missionaries' monopoly as mediators of new and useful knowledge began to crumble. In September 1908 the *Revue* tried to stem the tide of the times by separating its science and news sections. Li Wenyu remained editor of the general news edition, published twice weekly as *Huibao News Digest* (*Huibao shishi huibian* 匯報時事彙編). The science portion was turned into a biweekly magazine called *Revue scientifique* (*Huibao kexue huibian* 匯報科學彙編) under the direction of the Belgian Jesuit Aloys van Hee (He Shishen 赫師慎).[122] Both papers adopted a smaller magazine format, and this new size was retained when the two parts were reunited under the old name in late 1909 after van Hee returned to Europe. Li Wenyu's persistence kept the paper alive for two more years without significant modifications. The final edition of the *Huibao* appeared on August 20, 1911, a little more than two months after his death.

[120] *Huibao* 100 (August 9, 1899): 9.
[121] See *Huibao* 570 (April 12, 1904): 7–8.
[122] First editions of both papers appeared on September 24, 1908. See Hu Daojing, *Shanghai xinwen shiye shiliao jiyao*, 203, 539.

Messenger of the Sacred Heart

Although less visible in Shanghai's public sphere, Li Wenyu's second journalistic endeavor, the *Messager du Sacré-Coeur* (*Shengxin bao* 聖心報), enjoyed even greater longevity. Founded as a monthly paper in June 1887, it ran without interruption through May 1949. The *Messager du Sacré-Coeur* differed starkly from the *I-wen-lou* and its successors, both in its objectives and in its content and style. While the *I-wen-lou* was explicitly devoted to the conversion of China's "higher classes," the *Messager* was directed toward "believers who had finished elementary school."[123] In its dedication the paper's sole purpose was defined as providing little-educated Chinese Christians with information on "facts and principles of Catholicism" (*Tianzhujiao shili* 天主教事理). In the first issues this mission was translated into a colorful mixture of devotional stories—depicting mostly miracles, but also memorable events in the lives of saints, experiences leading to conversion, and so on—basic church news, such as proclamations by the Pope and international reactions to them, and instructions facilitating the day-to-day operations of the parishes, such as lists of current prayer items. This basic structure proved so successful that it was maintained until the end of the Qing. The *Messager* was available for purchase at churches throughout Jiangnan and beyond at the very cheap subscription price of ten copper cash (*wen* 文) per year.[124] The quality of the paper and print were correspondingly low. Each issue consisted of twelve folio pages. The subscriber base quickly rose to about three thousand, a level that remained more or less stable throughout the final decades of the imperial era.[125]

Li Wenyu served as editor-in-chief and main contributor of the *Messager* from 1887 to 1911. In this capacity he displayed talents very like those that marked his earlier journalistic endeavors. To reach his target audience, he chose a written style for the *Messager* that was extremely simple (or "flat and shallow" [*pingqian* 平淺], as Li himself once characterized it[126]) and close to the spoken vernacular—so close, in fact, that many articles can be read as anticipating the style

[123] Couturier, *Histoire de la Mission de Kiangnan*, 64.
[124] Britton, *The Chinese Periodical Press*, 59.
[125] Arens, *Das katholische Zeitungswesen in Ostasien und Ozeanien*, 7; for later statistics, cf. Rudolf Löwenthal, *The Religious Periodical Press in China*, chart I, sheet 2.
[126] Li Wenyu, "Lun qidaohui zongzhi," *Shengxin bao* 1, no. 2 (July 1, 1887): 12b.

advocated by the champions of literary revolution in the May Fourth era. An excerpt from an early issue may serve as a fairly typical example of the paper's colloquial tone:

> In the first issue of this paper, I've already talked a little bit about the proper behavior at prayer meetings. In this second issue, I will say a thing or two about the general meaning of those meetings. First of all, we have to know that our first ancestor Adam committed a crime and lost God's favor so that the door to paradise was locked, and he could no longer hope to rise up to Heaven....
>
> 本報第一號，略講過祈禱會規矩。這第二號上，我要說幾句祈禱會本義。先該知道原祖亞當犯了罪，失了聖寵，把天堂門閉了，再不能助望升天....[127]

Li's readiness to adapt his style, in disregard of all literary conventions, to the capacities of his audience bespeaks not only a decided lack of personal vanity but also considerable marketing genius. The latter is also obvious in his effort to build bonds with his readers. Rather than initiate dialogues on scientific and other learned topics as in the *I-wen-lou*, Li invited his very different target audience to contribute to communal projects. In 1889 he thus enlisted the names of nine thousand heads of household from Jiangnan for the consecration of the Basilica of the Sacré-Coeur in Paris; in 1892 he launched a call of assistance for the benefit of children educated in local Christian schools; and in 1898 he secured subscriptions to finance exquisitely embroidered banners for a new chapel.[128] The close links forged between the paper and its readers secured the lasting success of this decidedly lowbrow enterprise. At the same time, the longevity of the *Messager du Sacré-Coeur* confirmed the shrewdness and persistence that also characterized Li's work as editor-in-chief of the *I-wen-lou* and its various offspring.

Conclusion

The range of Li Wenyu's publishing activities and the devotion with which he pursued them throughout his otherwise uneventful life distinguish him, as I hope I have shown in the preceding pages, as one of the most prolific and versatile publicists in late Qing China. As a

[127] Ibid., 13b.
[128] Couturier, *Histoire de la Mission de Kiangnan*, 65.

journalist and translator, Li demonstrated unique virtuosity in adapting his style and vocabulary to the requirements of different genres and audiences. His mastery of diverse registers enabled him to explain basic tenets of Christian doctrine in the "flat and shallow" vernacular of the poor and uneducated masses, while also allowing him to compose essays on the subtleties of moral philosophy in rarefied classical prose. Readers could not help but be moved by his descriptions of the lives of saints or his impersonations of the breathless voice of the war correspondent, which he simulated with perfect ease for the news section of the *I-wen-lou*, if current events required him to do so.

Although little in his formation prepared him for the task, Li Wenyu proved quite savvy in the management of the periodicals he edited during the last three decades of his life. The *I-wen-lou* and its offspring were invariably well produced and embraced all the formal features that have been singled out as decisive factors for success in late Qing China's emerging news market. With the exception of the apologetic tracts inserted in the moral philosophy column, Li went to great lengths to ensure that the paper lived up to its promise of providing "useful news for all"—that is, for Christian and non-Christian readers alike. The mix of rubrics he adapted from existing secular and Protestant periodicals aroused fair interest among his target audience of "mandarins" and well-educated city dwellers. Hostility only erupted in times of political controversy, when the *I-wen-lou*'s claims of maintaining a stance of strict "neutrality" became a severe burden on its credibility. Li Wenyu may not have possessed the commercial drive of his most seasoned competitors, but he was capable of moving swiftly and creatively once he had decided on a certain course of action. One example was the secular reorientation of the *I-wen-lou* and its continuation as *Revue Scientifique* in the summer of 1898. Although the belated attempt to join the reformist bandwagon inevitably smacked of political opportunism, the redesign led to a rapid increase in subscriptions and reinvigorated, for some time at least, the bond with the paper's readership. Yet, in the waning years of the imperial era, neither this drastic facelift nor Li Wenyu's later attempts to save his *Revue* by splitting it into two could prevent its eventual decline into irrelevance.

What are the implications of Li Wenyu's career for our initial question about the role of Catholic agents in the transformation of late Qing Shanghai's print and publishing culture and for the more general

concerns of this volume? The Imprimerie de Tou-sè-wè undoubtedly proved to be a powerful tool in the Jesuit endeavor to compensate for their belated start in Christianity's nineteenth-century race for Chinese souls. Drawing on a nearly unlimited reservoir of cheap labor from the Tushanwan orphanage, and investing aggressively in new technologies almost as soon as they became available, the Jesuit fathers systematically expanded the operations of their print shops. Although their press never had the single best-equipped facility in the city, it was capable of responding at any given time to even the most ambitious demands put forward by the Comité scientifique or other clients, inside and outside the Christian community.

Technological handicaps can thus hardly be made responsible for the relatively weak position of the Jesuit press in the "big picture" of late Qing Shanghai's print and publishing culture. Nor would it be fair to place the blame on authors and editors incapable of recognizing or exploiting the opportunities opening up with the emerging new media and technologies. Li Wenyu's ventures, which exploited the most advanced technology, highly "progressive" forms of language use, and the most "modern" media of his day in order to spread a thoroughly "conservative" faith, underline that at least some Jesuit journalists were lacking neither in talent and ability nor in shrewdness. Put very crudely, then, the single most important factor limiting the reach and appeal of the Jesuit publishing efforts, and especially their periodicals, was the message rather than the medium. As long as the publications remained associated with the foreign faith they were intended to spread, the non-Christian majority of Chinese readers treated even the most "useful news" the Jesuits offered with more or less explicit reservations, regardless of how lavishly illustrated or well translated the texts in which the news was presented. Parallel to contemporary Protestant texts, Jesuit publications were mined for useful knowledge by increasingly savvy readers who had no difficulty separating what they found palatable from indigestible remnants of religious propaganda. In late Qing Shanghai's competitive market of ideas, neither the latest media nor the most ingenious authors and editors could salvage, let alone sell, a message that did not satisfy the demands of a more and more radicalized audience.

Of course, this assessment does in no way justify the continued disregard for the Jesuit publishing endeavor as a whole. On the contrary: without more comprehensive studies of the Imprimerie de T'ou-sè-wè

and its diverse agents and products, our picture of late Qing Shanghai's publishing landscape will remain incomplete. The Jesuits of Zikawei were an integral part of that landscape and maintained multiple connections to more commonly cited individuals and institutions. Detailed reconstructions of these connections and the multilayered contexts in which they were established are indispensable to a fuller understanding of the contentious transnational environment from which Shanghai's, and thus China's, modern print and publishing culture emerged.

THE USES OF GENRES IN THE CHINESE PRESS FROM THE LATE QING TO THE EARLY REPUBLICAN PERIOD[1]

Andrea Janku

> *Genres bring to light the constitutive features of the society to which they belong.*
> —Tzvetan Todorov[2]

Introduction

To organize the universe of texts into a system of genres is no more and no less than an exercise in taxonomy. It is an aid for understanding, an attempt to define borders that might have become blurred or were even nonexistent or irrelevant before. Genre distinctions are by no means very clear and may be subject to change. But once a system is established, it proves to be very powerful. Genre attributions not only help us to understand the significance of texts but also create significance. Modern genre theory teaches us that such attributions tend to guide readers' expectations and thus determine the potential impact of a text.[3] The need to label texts, then, is an indication of changing practices, of increasing complexity in need of new ordering principles. As genres respond to the needs of the society of which they are a part, they are defined not only by formal features but also by the uses to which they are put. One of the most pertinent examples in the context of Chinese print culture in a time of decisive technological innovation and sociopolitical transition (or, to be more precise, of the early periodical press of the late nineteenth and early twentieth centuries) is the transformation of the *lun* 論 (essay of judgment), a literati genre, into the *shelun* 社論 (editorial), a journalistic one. This essay

[1] I wish to thank the "From Woodblocks to the Internet" conference participants for their very helpful comments on a first draft of this paper. I am also extremely grateful for Elisabeth Kaske's highly valuable comments on a later version.
[2] Todorov, "The Origin of Genres," in Duff, *Modern Genre Theory*, 200.
[3] See Genette, *Palimpseste*, 14, and *Paratexte*, 94ff. See also Miller, "Genre as Social Action," 151–167, and Duff, *Modern Genre Theory*, for an introduction to genre theory.

is an attempt to deal with some aspects of the universe of texts captured in the pages of Chinese newspapers, focusing on genres used for the articulation of opinion.[4] We will pursue the following questions: Which genres did early Chinese journalists favor, and why? When did new genres evolve, and what were the changing sociopolitical realities they reflected? And finally, how did the successive introduction of ever more advanced print technologies affect their evolution?

In order to find answers to these questions, we will trace the genres of political comment through their uses in the daily press and relate changes in their use to changes in the sociopolitical environment, which are conterminous with technological innovations in the printing industry. The analysis is based on a sample of issues of the leading Shanghai dailies—*Shanghai Journal* (*Shenbao* 申報, 1872–1949), *Shanghai Daily* (*Xinwenbao* 新聞報, 1893–1960), and the *Eastern Times* (*Shibao* 時報, 1904–1939)—and the *L'impartiale* (*Dagongbao* 大公報, 1902–49), published in Tianjin.[5] There are two main threads leading through the discussion. The first is the transformation of the newspaper from a medium dominated by literati-journalists assuming the guise of quasi-officials loyal to the throne, to a medium dominated by professional journalists pretending to represent society at large. The second is the topic of famine, which, as one of the core concerns of the Chinese state, proved to be a good means of tracing the changes and continuities in the uses of genres and their social and political significance. The geographical focus of the story is Shanghai, although it receives vital impulses from the central Chinese province of Hunan, from "the West," and from Japan.

We first look at an eighteenth-century Chinese theory of genre and its role in the development of journalistic writing. Then we proceed with the comparison of a newspaper editorial and an earlier political essay, both in the authoritative genre of the *lun*, showing how the policy-advisor stance of the quasi-official was adopted by the literati-journalist. This is followed by the reconstruction of the technological innovations in the printing industry and the material conditions for the formation of mass-market journalism. And finally, we examine

[4] I am not referring to the newspaper as a distinct genre but rather as a new medium within which new uses and adaptations of both old and new genres of writing are worked out.

[5] Apart from the early *Shenbao*, sample issues of *Shibao*, *Shenbao*, *Xinwenbao*, and *Dagongbao* from the years 1907, 1910, 1911, 1920, and 1929 have been used.

how these processes are related to new ways of writing and new read-ing habits, leading to the emergence of new journalistic genres and a new awareness of genre in the years after the turn of the century.

A Pragmatic Theory of Genre and Its Journalistic Transformations

The idea that genre is closely related to the function of a text and to assumptions about its underlying communicative structures is not a modern Western invention but rather central to the most influential Chinese literary theory of the late imperial period. In the preface to his *Classified Anthology of Writings in the Ancient Style* (*Guwenci lei-zuan* 古文辭類纂), the standard textbook for classical prose (*guwen* 古文) in the late nineteenth century, Yao Nai 姚鼐 (1731–1815) gives a sketch of what has been called a pragmatic theory of genre.[6] He defines thirteen categories or genres (*tilei* 體類) of texts according to their uses and relates them to specific communicative situations. This list includes judgments and argumentative essays (*lunbian* 論辨), comments on texts (*xuba* 序跋; literally, "prefaces and colophons"), memorials and policy proposals (*zouyi* 奏議), letters and speeches of persuasion (*shushui* 書說), words of advice or encouragement given to a friend at parting (*zengxu* 贈序), imperial edicts and instructions (*zhaoling* 詔令), biographical accounts (*zhuanzhuang* 傳狀), eulo-gistic inscriptions (*beizhi* 碑誌), miscellaneous accounts (*zaji* 雜記), admonishing epigraphs (*zhenming* 箴銘), eulogies (*songzan* 頌讚), songs and prose poems (*cifu* 辭賦), and elegies (*aiji* 哀祭).[7] What is common to all—discursive, narrative, and poetic genres alike—is a strong moral character, an emphasis on blame and praise, instruction and admonition. Serious writing had to serve the political orthodoxy. This became the most distinctive characteristic of this style of prose, named Tongcheng 桐城 after its most famous proponents' place of origin in Anhui province.

[6] For a thorough discussion of Yao Nai's ideas, see Kern, "Yao Nais pragmatischer Umbau der literarischen Genretheorie." See also, Hightower, "The Wen Hsüan and Genre Theory," 512–534, and Edwards, "A Classified Guide to the Thirteen Classes of Chinese Prose," 770–788, for earlier attempts to sort the multitude of text catego-ries based on the famous sixth-century *Anthology* (*Wenxuan* 文選), giving priority to poetic genres and a prose anthology of the 1930s organized according to Yao Nai's generic categories. For an overview of Chinese theories of genre, see Wu Xiaozhou, "Genre Theories from the Chinese-Western Perspective," 39–74.

[7] Yao Nai, "Guwenci leizuan xumu," in Yao Nai, *Guwenci leizuan*, 1–19.

The first four of these categories are most pertinent for the evolving journalistic genres of opinion, because they belong to the discursive mode (i.e., writings engaging in some kind of argument). The labels appearing in the titles of the texts assigned to these genres also frequently appear in the titles of newspaper articles.

First is the essay of judgment, the most authoritative genre, the function of which is to differentiate between right and wrong, to distinguish what is true and what is false. In Yao Nai's view the origins of this genre can be traced to the writings of the ancient philosophers Confucius and Mencius, who used their learning to instruct later generations. The preeminence of this genre is symptomatic of the high cultural prestige given the discursive as opposed to the poetic mode of writing from the time of the Song dynasty (960–1279) onward.[8] The writings by the leading political essayists of the Former Han dynasty (206 BCE–220 CE) and the *guwen* stylists of the Tang (618–907) and Song that fall under this genre heading include "judgments" (*lun*), although some essays are identified as "on the origin of…" (*yuan* 原); "argumentations" (*bian* 辨); "explanations" (*jie* 解); "proposals" (*yi* 議); "persuasions" (*shui* 説); and even "panegyrics" (*song* 頌). Authority for their judgments is drawn exclusively from the Classics and the ancient philosophers.[9]

The second genre, comments on texts, can be traced back to the explanatory chapters of the *Classic of Changes* (*Yijing* 易經) and the preface to the *Classic of Songs* (*Shijing* 詩經). Their basic function is to "explain the origins" and "expound the correct meaning" of texts. While most of the texts in this category are called "prefaces" (*xu* 序), some are termed "comments on reading…" (*ji…hou* 紀…後, *du…* 讀…, or *shu…hou* 書…後) or "judgments on…" (*lun* or *bian* 辨); these forms are also frequently found in newspapers, in lead articles commenting on news reports, and the court gazette or other documents.[10]

[8] The distinction between "modes" and "genres" follows Genette, "The Architext," 210–218. In his opinion, genres, as proper literary categories, involve a thematic element that eludes purely formal or linguistic description, whereas modes are mainly linguistic categories.

[9] The labels appearing in the titles of the texts are not necessarily indicative of the genre to which they belong. Kern also observes this in "Yao Nais pragmatischer Umbau der literarischen Genretheorie," 159, as does Edwards, who remarks: "Many essays belonging to this class [of *lun*] omit the word 論 from the title, and many compositions with 論 in the title belong to other classes" ("A Classified Guide," 771).

[10] Yao Nai, "Guwenci leizuan xumu," 3–4.

The most important distinction between memorials and letters of persuasion, which constitute the third genre, is the communicative situation. For Yao Nai, memorials are derived from the plans and admonitions that the sages of antiquity, loyal and full of praise, offered to their rulers. The first examples are recorded in the *Classic of Documents* (*Shangshu* 尚書). In contrast, letters of persuasion offer an argument on state affairs in an unofficial communication, written or oral. They originated in the Spring and Autumn Period (770–476 BCE) as "responses to the letter by..." (*da...shu* 答...書) or "discussions...with..." (*yu...lun...*與...論...) exchanged between members of the nobility or high officials. The persuasive speech a wandering scholar made before a ruler during the Warring States period (475–221 BCE) would also belong to this category. But, if this scholar had been employed as a minister, the same text would belong to the category of "memorials." If he, however, had left his sovereign and offered his advice to another ruler, then the text would have to be included in the category of "persuasions."[11] The difference between these two generic categories thus depends, not primarily on stylistic features, but on the status of the people involved and the character of their communication (official, quasi-official, private). Genres could be put to new uses; they could change with social practices—but these transformations may or may not be reflected in their names.

What has all this to do with newspapers? The essay of judgment (*lun*), a genre with high cultural prestige and an air of authority, a carrier of moral and political orthodoxy, was the form adopted as the lead article in the nineteenth-century press. Thus, there is at least potentially a strong continuity in the characteristics of the genre (the kind of discourse it carries, the prestige, and so on), even though it might be put to entirely different uses (e.g., as a newspaper editorial within the public sphere, or as a memorial or a letter to a fellow official or friend in an official, a quasi-official, or a private sphere). A generic link may be established—a link that includes aspects of form as well as of contents—between the leading articles of the early newspapers and the political writings of scholars trained in the orthodox style of classical prose.[12] This implies that early journalistic writings aspired to

[11] Ibid., 4.
[12] See Janku, "Preparing the Ground for Revolutionary Discourse," 69–125.

belong to a quasi-official sphere, in much the same way that writings circulating among the scholar-official elite did.

At the same time, these journalistic writings were beginning to expand the boundaries of this sphere. The evolving use of the genre and its changing audience set the stage for its transformation into a new genre. The use of new labels for distinct kinds of texts in newspapers from the early twentieth century onward, besides being part of a newly designed newspaper layout, reveals a consciousness of the newspaper voice as a distinctive force in the field of political discourse. According to Donald Francis McKenzie, "New readers make new texts, and their new meanings are a function of their new forms."[13] In a way, the labels marked a break with former practice. The best example is the term *shelun* 社論, or editorial, which identifies a piece as the expression of a newspaper's (*baoshe* 報社) judgment based on its own authority, as opposed to an orthodox voice assuming the air of a sage. Nevertheless, the break is not as sharp as it might appear, as there is still is a generic continuum from the unlabeled editorials or lead articles in the early dailies to those explicitly called "editorials" in the post-1900 press. The new editorials still carry the authority and the prestige of the former *lun*; only the source of this authority and prestige has changed.

The proliferation of shorter and wittier genres of comment, combined with the new prominence of the novel as a genre of critique and a variety of other innovations, was closely linked to the newspaper's resurgence in Shanghai after the coup d'état of 1898 and the ensuing ban on the political reform press.[14] This resurgence of critical voices was consolidated by the founding of the *Eastern Times* in 1904.[15] The tremendous success of this paper was closely linked to contemporary educational reforms and the input of students and young intellectuals returning from Japan, where most of the reformers had found refuge. The new genres, in their stylistic brevity and emotional distance, reflected a novel urban lifestyle, characterized by a faster pace of living and a greater diversity of choices. They were a part of the nascent field of feuilletonistic writing, the appearance of which was conterminous with the growing capacity of the printing press and the beginnings of

[13] Quoted in Chartier, "Gutenberg Revisited from the East," 1–9.
[14] See Janku, "Ironie, Spott und Kritik," 207–223.
[15] On which see Judge, *Print and Politics*.

mass journalism (only slightly behind similar developments in western Europe and North America).

The new professional journalists, who had by and large taken the place of the earlier generation of literati-journalists, had a very different understanding of their responsibility toward their country. They were city dwellers following their own ways of life, free of the constraints their predecessors had endured. They did not labor under self-imposed strictures to behave as would-be officials. Although they did not entirely abandon former attitudes—they still felt responsible, but for society, not for the state—they also played with alternative forms of writing. Whereas lead articles or editorials continued to be devoted to serious political discourse, the new genres of opinion, with their playful cynicism expressing a distinctly urban sentiment, show the city dweller's growing sense of difference and his increasing alienation from his rural compatriots—and state authorities.

These dramatic changes are reflected in articles on the uses of genres in the press, which appeared in journals and newspapers around the turn of the twentieth century. The first part of the story is told, in strikingly different ways, by two men: Tan Sitong 譚嗣同 (1865–1898) from Liuyang 瀏陽 in Hunan, one of the heroes of the reforms of 1898 and a champion of the new possibilities of the newspaper, and Huang Xiexun 黃協塤 (1852–1924), a literati-journalist of the first generation, the *Shanghai Journal*'s editor-in-chief since 1894, and a desperate defender of the stylistic orthodoxy of classical prose as the only proper form for journalistic writing. The second part of the story is captured in a Japanese article on newspaper editorials that was translated and published in the *Eastern Times* in 1907. We will come back to that later.

In a remarkable article on newspaper genres published in 1897, [16] Tan Sitong praises the newspaper (which should be understood as the periodical press more generally) as the one and only form of publication, in which the writings of all times and places are brought together. He attributes a very high cultural significance to the new medium: heirs to the historians of high antiquity and the anthologists of historical times, newspaper writers are devoted to the transmission of the

[16] This essay was first published as "Baozhang wenti shuo" in the Shanghai reform journal *Shiwubao*, nos. 29 and 30 (June 10 and June 21, 1897). It was reprinted as "On the Newspaper, Which Brings All the Writings of the Universe Together" ("Baozhang zong yuzhou zhi wen shuo") in Tan Sitong, *Tan Sitong quanji*, 375–377.

true way of learning, the most fundamental cultural knowledge. But in Tan's eyes the newspaper is superior even to the ancient histories and anthologies; the historians could not possibly cover all places, and the anthologists considered only the works of the Chinese past. In the pages of the newspaper, a parochial worldview is superseded by a universal worldview, the old replaced by the new.

Obviously some voices criticized the newspapers and journals as a disorderly jumble of texts running counter to the established rules of writing. In response to these unnamed critics, Tan Sitong devised his own system of "the world's genres of writing" (*tianxia wenzhang tili* 天下文章體例). His system distinguishes ten journalistic genres (*ti* 體), in three categories (*lei* 類): "names" (*ming* 名), "forms" (*xing* 形), and "laws" (*fa* 法).[17] Names" encompasses the different genres of factual (news) writings, such as the record (*ji* 紀) and detailed reports (*zhi* 志); opinion pieces, such as essays of judgment (*lunshuo* 論說), which should elucidate the information given in the news reports and show why they are relevant; and the commentary (*zizhu* 子注), a more occasional form of judgment. "Forms" encompasses visualized representations of information in the form of maps (*tu* 圖), tables (*biao* 表), and charts (*pu* 譜). "Laws" includes cases or precedents (*xuli* 敍例), regulations (*zhangcheng* 章程), and "calculations," or financial reports (*ji* 計). For Tan, too, it is important to trace the origins of all these genres back to the Classics, where he finds multiple examples for each. But only the newspaper brings them all together in one compilation.

Tan's view of what are relevant genres owes very much to the late imperial literati sense of responsibility for the affairs of the world. Like Yao Nai, he presents a pragmatic catalogue of genres, excluding songs and prose poems as "not pertinent to the needs of the people" (*bu qie min yong* 不切民用). Nevertheless, poems, songs, plays, and popular sayings, even advertisements and announcements, may also find a place in his newspaper universe, albeit only at its margins on the leisure pages. They are not part of his ten proper genres of journalistic writing. But, in contrast to Yao Nai's scheme, here the essay of

[17] Tan's notion of *lei*—category—is remotely akin to Genette's "modes." In Tan's system *ti*—here translated as "genre"—is on a lower ordering level. It differs from the system of Yao Nai, who uses both terms as equivalent denominations for "generic categories" (*tilei*). There was no unified Chinese terminology at that time. *Ti* could also be translated as "style" or "form," but here it includes content or substance as well. It seems that Tan based his system on the kinds of texts that could be found in *Shiwubao*.

belong to a quasi-official sphere, in much the same way that writings circulating among the scholar-official elite did.

At the same time, these journalistic writings were beginning to expand the boundaries of this sphere. The evolving use of the genre and its changing audience set the stage for its transformation into a new genre. The use of new labels for distinct kinds of texts in newspapers from the early twentieth century onward, besides being part of a newly designed newspaper layout, reveals a consciousness of the newspaper voice as a distinctive force in the field of political discourse. According to Donald Francis McKenzie, "New readers make new texts, and their new meanings are a function of their new forms."[13] In a way, the labels marked a break with former practice. The best example is the term *shelun* 社論, or editorial, which identifies a piece as the expression of a newspaper's (*baoshe* 報社) judgment based on its own authority, as opposed to an orthodox voice assuming the air of a sage. Nevertheless, the break is not as sharp as it might appear, as there is still is a generic continuum from the unlabeled editorials or lead articles in the early dailies to those explicitly called "editorials" in the post-1900 press. The new editorials still carry the authority and the prestige of the former *lun*; only the source of this authority and prestige has changed.

The proliferation of shorter and wittier genres of comment, combined with the new prominence of the novel as a genre of critique and a variety of other innovations, was closely linked to the newspaper's resurgence in Shanghai after the coup d'état of 1898 and the ensuing ban on the political reform press.[14] This resurgence of critical voices was consolidated by the founding of the *Eastern Times* in 1904.[15] The tremendous success of this paper was closely linked to contemporary educational reforms and the input of students and young intellectuals returning from Japan, where most of the reformers had found refuge. The new genres, in their stylistic brevity and emotional distance, reflected a novel urban lifestyle, characterized by a faster pace of living and a greater diversity of choices. They were a part of the nascent field of feuilletonistic writing, the appearance of which was conterminous with the growing capacity of the printing press and the beginnings of

[13] Quoted in Chartier, "Gutenberg Revisited from the East," 1–9.
[14] See Janku, "Ironie, Spott und Kritik," 207–223.
[15] On which see Judge, *Print and Politics*.

The most important distinction between memorials and letters of persuasion, which constitute the third genre, is the communicative situation. For Yao Nai, memorials are derived from the plans and admonitions that the sages of antiquity, loyal and full of praise, offered to their rulers. The first examples are recorded in the *Classic of Documents* (*Shangshu* 尚書). In contrast, letters of persuasion offer an argument on state affairs in an unofficial communication, written or oral. They originated in the Spring and Autumn Period (770–476 BCE) as "responses to the letter by…" (*da…shu* 答…書) or "discussions…with…" (*yu…lun…* 與…論…) exchanged between members of the nobility or high officials. The persuasive speech a wandering scholar made before a ruler during the Warring States period (475–221 BCE) would also belong to this category. But, if this scholar had been employed as a minister, the same text would belong to the category of "memorials." If he, however, had left his sovereign and offered his advice to another ruler, then the text would have to be included in the category of "persuasions."[11] The difference between these two generic categories thus depends, not primarily on stylistic features, but on the status of the people involved and the character of their communication (official, quasi-official, private). Genres could be put to new uses; they could change with social practices—but these transformations may or may not be reflected in their names.

What has all this to do with newspapers? The essay of judgment (*lun*), a genre with high cultural prestige and an air of authority, a carrier of moral and political orthodoxy, was the form adopted as the lead article in the nineteenth-century press. Thus, there is at least potentially a strong continuity in the characteristics of the genre (the kind of discourse it carries, the prestige, and so on), even though it might be put to entirely different uses (e.g., as a newspaper editorial within the public sphere, or as a memorial or a letter to a fellow official or friend in an official, a quasi-official, or a private sphere). A generic link may be established—a link that includes aspects of form as well as of contents—between the leading articles of the early newspapers and the political writings of scholars trained in the orthodox style of classical prose.[12] This implies that early journalistic writings aspired to

[11] Ibid., 4.
[12] See Janku, "Preparing the Ground for Revolutionary Discourse," 69–125.

put the ideas into practice. But in formal terms—and following Yao Nai's classification—these texts can be divided into writings of advice and comment written either by authors without official rank or by officials not in charge of famine relief (twenty-seven texts, eleven of which are by nonofficials), memorials and other administrative texts (nineteen), and letters among members of the official class (six). As to be expected, the letters are called *shu* 書 and the administrative texts "memorials" (*shu* 疏), "official notes" (*die* 牒), "proclamations" (*xi* 檄), or "letters submitted to…" (*shang…shu* 上…書). The titles of the first group of texts, by people who were not in charge of the administration of famine, have labels such as "persuasion" (*shui* and *quan* 勸), "proposal" (*yi*) or "private proposal" (*siyi* 私議), "essay of judgment" (*lun* and *bian*), and "comment on" (*shu…hou*). *Shang-hai Journal* editorials on the same topic from the early 1870s are also called "essays of judgment" (*lun*), "persuasions" (*shui* and *quan… shui* 勸…說), "proposals" (*yi*), "comments on" (*shu…hou*), and even "reverently remarking" (*du…gong ji* 讀…恭紀) and "drafting a letter on…to submit to those in charge" (*ni shang dangshi…shu* 擬上當事 …書). Formulations such as this last one in particular suggest that the journalist loved to see himself in the role of a policy advisor providing interpretations of the world and offering instruction to those in positions of power. He did this from an unofficial position and in a voice claiming authority based on his familiarity with the Classics and the histories, as well as his knowledge of "current affairs" (*shiwu* 時務).[24] This generic continuum between the statecraft essays and early newspaper editorials, which is manifest in the communicative practices associated with these forms, will be examined in the following comparison of two texts on rain rituals, one a *Shanghai Journal* editorial, the other a *lun* by Wang Gai 王概, an eighteenth-century private scholar from Zhejiang whose work is included in Wei Yuan's anthology.

Wang Gai's essay "On the Yu Sacrifice" ("Yu shuo" 雩說) deals with the problem of what should be done about drought in the growing season.[25] The text starts conventionally with the formulation of a question, a literary ploy with which newspaper readers also would have been familiar:

[24] Only a small percentage of the newspaper articles were signed. These were submitted by readers who styled themselves private scholars, recluses, or "commoners."

[25] Wang Gai, "Yu shuo," in He Changling, *Huangchao jingshi wenbian*, j.45, 33a–35b.

world. The very success of Internet literature has helped to reproduce the symbolic power of print culture. In a comparable way, the cultural success of the periodical press also helped to replicate the structures of quasi-official discourse within the pages of the newspaper, manifest in their adherence to the old genre hierarchies. At the same time, this success transformed the character of the newspaper "by complicating its social organization and challenging its cultural hegemony,"[22] resulting in the transformation of writing genres and their uses.

The Authority of the Lun

What did a typical lead article by the literati-journalist assuming a quasi-official guise look like? From where did he draw authoritative power—how did he articulate his advice? What are the similarities and differences in comparison with earlier essays of judgment? In order to find an answer to these questions, we turn to exemplary writings on famine before and after the advent of the modern newspaper press.

The *Collected Writings on Statecraft from our Great Dynasty* (*Huangchao jingshi wenbian* 皇朝經世文編), compiled in the early nineteenth century by Wei Yuan 魏源 (1794–1856) under the aegis of He Changling 賀昌齡 (1785–1848), both from Hunan, may be considered one of the most representative anthologies of political writings from the Qing dynasty (1644–1911), by authors both inside and outside the bureaucracy. Five of its chapters (*juan* 41–45) are devoted to the "administration of famine" (*huangzheng* 荒政), indicating that this was one of the core concerns of the state. The first of these chapters includes excerpts from well-known administrative handbooks. It also includes policy suggestions, from people outside the establishment, that had attained the status of works of reference—for example, the writings of Wei Xi 魏禧 (1624–1681), a "private" scholar who refused to serve the new dynasty and lived as a recluse,[23] and Lu Shiji 魯仕驥 (a *jinshi* of 1771), who served as a county magistrate for some time but later also styled himself as a mountain recluse.

The texts assembled in the remaining four chapters also offer suggestions on how to relieve and prevent famine, addressed to either the imperial government or to an official who would be in a position to

[22] Guobin Yang, "Virtual Transgressions into Print Culture."
[23] Will, *Bureaucracy and Famine in Eighteenth-Century China*, 84.

As for the style of the *lunshuo*, Huang intended to (re)establish the model of classical prose as the journalistic standard: one should use a free prose style, with only occasional parallelisms. The wording should be to the point yet elegant, avoiding vulgar and presumptuous talk, a requirement he underlined with quotes from the *Analects* (*Lunyu* 論語) and Han Yu 韓愈 (768–824), the great master of Tang-dynasty classical prose. Most of the labels Huang suggested for possible titles were familiar from Yao Nai's examples for the discursive genres (*lun, shui, yi, ji* 紀, *zhu* 注, *shuhou* 書後, *dawen* 答問, *ce* 策, *kao* 考, *bian*). As for the factual reports the newspaper received from its correspondents, considered to be of inferior literary quality, they should be slightly polished by the editor, so that their grammatical style, at least, would be correct. Only the advertisements had to be accepted as they were, reflecting the low status Huang ascribed to them.[21]

What remains invisible behind this rigid scheme of literary orthodoxy is that Huang Xiexun was one of the most eager contributors to the poetry columns of the pre-1890 *Shanghai Journal* and a great connoisseur of opera. He thus seems to have had broader literary tastes than Tan Sitong, although these more catholic tastes were not apparent in his later editorial writings. What he had in common with Tan was the seriousness with which he treated the newspaper as a medium of political discussion in a quasi-official sphere—that is, the sphere of all those concerned about the welfare of the country and "the people." In a way, both writers excluded the views of the majority of the latter from this sphere. What distinguished the two was that while Tan took an affirmative attitude toward the possibilities of the newspaper form—epitomized in the lack of clear hierarchies in his system of genres—Huang, although he also cherished the newspaper as an effective medium for discussion and relaying information, took a defensive stance, focusing on preserving the familiar hierarchical structures of political discourse.

In a way, the literati-journalists, exemplified here by Huang Xiexun, behaved like the Internet authors described by Guobin Yang elsewhere in this volume. They appropriated the new medium very quickly, yet still desired to gain recognition in the old and more familiar off-line

concerned about the establishment of high professional standards for journalists. See Janku, *Nur leere Reden*, 326–332.

[21] Huang Xiexun, "Zhengdun baowu yuyan."

judgment does not occupy the first place; indeed, the most important difference probably is that Tan's system does not reveal a clear hierarchy at all. If there is one, it is the news (*ji* and *zhi*), which provides the basis for all judgment and opinion. However, the first item on his agenda is "the great project of ordering the country" (*jingguo zhi daye* 經國之大業), and all the genres have to serve this task. This seriousness of purpose links him to his predecessors, the literati-journalists. He is genuinely enthusiastic about the possibilities the new medium offers: "There is nothing as perfect and splendid as a newspaper!"[18] But Tan never thinks of the newspaper's potential to popularize knowledge via the means of mass production. He simply sees it as a superior medium of information and opinion, in terms of the scope of coverage it allows for, both in terms of time and space (up-to-date reporting on important affairs everywhere in the world).

One year later, in 1898, the *Shanghai Journal's* Huang Xiexun wrote an article on what he perceived as a much-needed readjustment of journalistic writing.[19] As a literary purist of sorts, Huang hoped to purge the reform press of what he saw as increasingly unorthodox, unrestrained, and wanton tendencies. In contrast to Tan Sitong's cautious attempt to root the "new" of the newspaper deeply in the Chinese cultural tradition, Huang clearly stated that journalistic writing was something different and new, with as yet undefined genre rules. But the rules he then suggested closely followed the model of Tongcheng classical prose. In his view the lead article or editorial, written in the authoritative form of the essay of judgment (*lunshuo*), was the most important genre of journalistic writing. His view was thus decidedly different from Tan's. Huang listed news reports second, and, at the bottom of the hierarchy, advertisements. This ranking followed the layout of the *Shanghai Journal*, which featured the editorial prominently on the title page, followed by the news sections, with advertisements on the last pages.[20]

[18] Tan Sitong, "Baozhang wenti shuo," in *Tan Sitong quanji*, vol. 2, 377.

[19] Huang was editor-in-chief of the so-called "old *Shenbao*." He had gained a reputation of supporting the conservative opposition to the 1898 reforms because of his disapproval of Kang Youwei. When in 1905 a new generation of Japanese-educated journalists launched a reform of the paper he was forced to leave. Cf. Janku, *Nur leere Reden*, 33–42.

[20] Huang Xiexun, "Zhengdun baowu yuyan," *Shenbao*, August 24, 1898. This article is a response to the reformers' suggestion to draft a press law and is genuinely

There was a guest asking me the following question: Today the drought demon is behaving terribly cruelly; from spring to summer the rains have failed for sixty days. Not even half of the grain seedlings have been planted. And for the few that have been planted people draw on water from dams for their irrigation. When the water is exhausted, how should they continue to irrigate the fields? It is true, the governor and the county officials are concerned about the people: they prohibited butchering and the sale of alcohol, they put an end to litigation, they built up altars for sacrifices, they called for alchemists, they prayed with one mind, but after another ten days, the hot and dry weather was even fiercer and the crops withered. How can this be dealt with?[26]

The author's reply begins with a reference to a poem from the *Classic of Songs* that in his view is the best expression of grief about drought and the best prescription for disaster relief. The poem presents the Yu sacrifice, an imperial rainmaking ritual, as the solution to drought. The sacrifices and prayers of the officials, described by Wang's "guest," have clearly not been effective. In late nineteenth-century reprints of this text, the following two lines explaining why are stressed through emphatic punctuation: "The eight stanzas of this poem [from the *Classic of Songs*] are like an urgent cry, there is nothing else to say: there is only the prayer. But today's prayers are not comparable to those in ancient times."[27]

The Yu sacrifice originated as an annual ritual performed by the emperor. Abandoned after the Qin (221–206 BCE) and Han dynasties (206 BCE–220 CE), it was resurrected occasionally during times of severe drought. Then, the Son of Heaven, following the example of the sage Emperor Tang 湯 of the Shang (ca. 1600–1045), would go to the southern suburbs of the capital, blame himself for committing "the seven offences" (including indulgence in wasteful extravagance and women, corruption and general moral decline, and most importantly failure to care for the people), and make a sacrifice to the gods. Wang provides a detailed description of the ancient ritual, based on the poem. The problem, he concludes, is that people in eighteenth-century China did not know how to perform the Yu sacrifice. They only listened to one or two Daoist priests, who muttered spells to expel demons and spirits: "What spiritual skills do these Daoists have, that they would be able to move Heaven to summon wind and rain?" In Wang's opinion,

[26] Ibid., 33a.
[27] Ibid., 33a.

worthy people were needed who, by performing the ancient ritual with the utmost sincerity, would move Heaven to produce rain.[28]

The guest then asks: "But the Yu sacrifice has been abandoned for a long time, and all kinds of different sacrifices have been performed through the ages, how can we today find a compromise?" The author gives his answer, explaining in detail how rain rituals should be performed, in accordance with the Yu sacrifice of antiquity. He ends with references to the *Rites of Zhou* (*Zhouli* 周禮) and recounts the story of Emperor Tang's self-accusations and his readiness to sacrifice himself in return for rain. Then he gives a list of the different kinds of failure for which later rulers blamed themselves, followed by proofs from ancient times of the effectiveness of each. The phrases presenting these proofs are again stressed through emphatic punctuation. Wang's conclusion is, of course, that the officials of the day should follow the example of the ancients and examine themselves, in order to make their rain rituals effective. The guest then has the last word: "Examining all that you have said, I find that everything can be proven with the Classics and the Histories. So please make a record of these words in order to present them to the officials in the counties and prefectures to support them in their performance of rain rituals."[29]

Adaptations of the rhetorical figure at the end of this passage—that is, the exhortation to record and disseminate the author's conclusion to officials or, more generally, those in positions of power—are frequently found in newspaper articles of the period. Interesting also is the use of emphatic punctuation, which was popular with Tongcheng scholars (see Illustration 1), who used it to point out the crucial passages of texts to students. However, it was not universally embraced. Although Yao Nai used this device in the first edition of his *Anthology*, he later abandoned it as a study aid, considering it "too vulgar."[30] (Since Song times, cheap, commercial prints had also used this kind of punctuation.)[31] The early *Shanghai Journal* perpetuated this elitist stance. Indeed, with few exceptions, only after 1900 did newspapers use different kinds of punctuation to draw attention to crucial passages or to indicate the end of phrases.

[28] Ibid., 33b.

[29] Ibid., 35b.

[30] See Guan Xihua, *Zhongguo gudai biaodian fuhao fazhanshi*, 260–292. My thanks to Martin J. Heijdra, who pointed me to this study.

[31] Chia, "The Development of the Jianyang Book Trade, Song-Yuan," 10–48.

夫以蛟之不難制若此而數千百年以來罕有言之者蓋田夫野老知而不能言文人學士鄙其事而以為不

足言司牧之官又絓掌於簿書而不暇致詳也一旦橫流猝發藏晉及溺然後開倉廩以賑恤之則已晚矣天

下狃於故常而忽於遠慮貽事可勝道哉予故亟錄其說廣為刊布且縣示賞格有捕得者官給銀十兩使僻

遠鄉村之地轉相傳說人人屬耳目注精神先時而偵候臨事而周防庶幾大害可除此郊永絕其禍而他省

之有蛟患者皆可踵而行之幸無以為不急之迂談也。

雲說

王楙

客有問於王子曰方今旱魃為虐自春徂夏不雨六十日矣曰禾蔚者未及其牟大率取諸陂塘瀦瀆而已矣

濼將竭何以繼之即制府暨郡邑大夫輪念斯民禁屠沽息訟獄建醮壇召方士齋心祈請亦復何日而亢陽

愈驕愬來交來將何法以處此乎王子曰古之憂旱怵災莫如雲漢一詩其詩八章呼號迫切別無他語惟有

祈禱顧今之祈禱非古之所禱也左傳曰龍見而雩龍者東方角宿孟夏初旬晉中始見即有雩祭是雩不待

旱而歲有常祭矣故雩以後雩漢之後始廢大旱乃一舉行然猶天子降服親詣南郊以七事自責七日乃祈岳瀆及

諸山川之神能興雲雨者又七日祈社稷及古百辟卿士有益於人者又七日祈宗廟及古帝王有神祠者又

七日祀五天帝及五人帝各依其方祈禱祠宮上下奠瘞靡神不宗郊即天地宮即宗廟自天

而上百地而下無不畢其瘞之禮也又七日不雨乃徧祈社稷山林川澤之神聚於一處命舞童六十四人

皆衣元衣為八列各執羽翿而舞每歌雲漢一章七日復如其初郡縣有司雩祭亦然但舞用六而不用八耳

今人不知雩禮率聽一二黃冠妄挾符呪驅使鬼神彼黃冠者有何神術而能格昊天召風雨乎必賢有司齋

Illustration 1: Examples of emphatic punctuation in the early nineteenth-century *Collected Writings on Statecraft*, an 1873 Jiangxi woodblock print, from the 1992 Zhonghua shuju reprint.

Let us compare Wang Gai's essay to "On how to find relief from drought" ("Jiu han shuo" 救旱說), a *Shanghai Journal* editorial written in July 1873 in response to repeated reports of rain rituals performed by officials in Suzhou, Hangzhou, and Shanghai (see Illustration 2).[32] The text begins with a rhetorical question: "Alas, flood and drought disasters, although one says they are decreed by Heaven, do they not actually belong to the affairs of man?" Accounts of the nine-year flood brought under control by the Great Yu 禹 and the seven-year drought during the reign of Tang, who sought the aid of Heaven with his offer of self-sacrifice, are used in illustration. The reader then learns how Duke Xi of Lu 魯僖公 also successfully overcame a drought by following Tang's example:

> Tang was a sage ruler and therefore he could influence Heaven. Duke Xi was only an ordinary ruler, but his sincerity moved Heaven and Heaven responded. Therefore one can see that if a ruler is able to love his people and beseeches Heaven, then Heaven will reflect his sincerity and answer his plea. When rulers in later times faced years of drought and were able to do what Emperor Tang and Duke Xi did, why then did Heaven likewise send rain? This was due to the principle of action and response. It is the same with today's officials. Whether their prayer is effective or not depends entirely on their sincerity.[33]

This opening passage, linking the times of the sage rulers to the present, emphasizes the importance of people's moral behavior and, especially, the sincerity of the officials in their performance of the rituals. (A further reference to a passage from the *Mencius* [*Mengzi* 孟子] adds yet more authority to this point.)

More than half of the text is concerned with these fundamental preliminaries, establishing a common ground before the main point is finally introduced—by quoting a very different source of authority, the *Record of Things Heard and Seen from the East and the West* (*Zhongxi wenjian lu* 中西聞見錄), a monthly missionary magazine published in Beijing and devoted to the introduction of modern scientific knowledge.[34] The editorialist cites a report on drought control in America

[32] "Jiu han shuo," *Shenbao*, July 29, 1873. There were reports about droughts and rain prayers on July 18, 22, and 25, and again on the day when the editorial appeared.

[33] "Jiu han shuo."

[34] The *Zhongxi wenjianlu* was published between August 1872 and August 1875 by W. A. P. Martin and Joseph Edkins for the Society for the Distribution of Useful Knowledge in China.

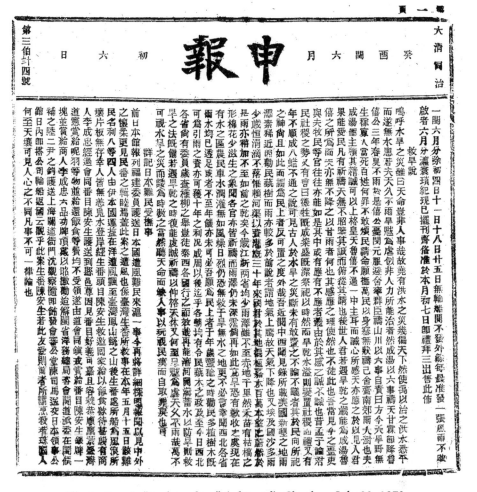

Illustration 2: "Jiu han shuo" (editorial), *Shenbao*, July 29, 1873.

that demonstrates that the planting of trees encourages rainfall. This claim is supported by a reference to an equally successful case, where a similar method brought rain to the dry lands of British-ruled Egypt.[35] Only at this point does the author address what really concerns him: the current drought in Jiangsu and Zhejiang, which the *Shanghai Journal* had been following closely. Although there was not yet imminent

[35] This report appeared in *Zhongxi wenjian lu* 6 (January 1873), under the column "Meiguo jinshi" (reprinted. Nanjing: Nanjing guji shudian, [1992], 377–378).

danger of serious harvest failures, the rituals performed by the offi-
cials were not successful, which meant that the situation could easily
worsen. The editorialist's crucial point is that more meaningful action
should be taken. Directly addressing "those governing the people" (*wei
min shang zhe* 為民上者), he writes:

> I hope that in years of rich harvests officials encourage the people to
> plant many trees; this helps to attract more rain, and it can also be a
> long-term source of profit. This should be even more so, as from the
> times of the Duke of Zhou all the dynasties had a policy of ordering the
> people to plant trees,... How could it be that only the Western countries
> would carry through this policy successfully! And further if we are able
> to dredge the rivers and develop irrigation canals, to collect water in
> order to provide protection from drought, then the methods of relieving
> drought will be perfected.[36]

Only then—and the following brief conclusion carries the author's
strongest point—can one revert to time-honored rituals in all sincerity:

> Then, if there is drought, one can offer devotional prayers that reach
> the heavens, and, no matter how cruel the drought, could Heaven hold
> back the rains for long? One must not blame the drought on the natural
> course of fate and surrender to Heaven's command, neglecting the role
> of human agency. One might just as well commit the crime of ignoring
> the sufferings of the people.[37]

While this last passage may mean that the editorialist approves of the
rain prayers as rituals, it is first and foremost a pointed criticism of
hypocritical officials who failed to fulfill their duty to prevent drought
(while assuming the air of the great rulers of antiquity who blamed
themselves for something that was really caused by "nature"). This cri-
tique, written in classical prose, appears to draw heavily on the Clas-
sics for support. But its true source of authority is the report from
abroad that was published in the *Record of Things Heard and Seen
from the East and the West*. The overall tone of the editorial is that of
a would-be official submitting a policy proposal to those in charge of
government.

Essays such as that by Wang Gai usually circulated among friends
and colleagues for some time before they were published, in many
cases posthumously. The inclusion of Wang's essay in Wei Yuan's col-

[36] "Jiu han shuo."
[37] Ibid.

lection helped tremendously to broaden the circle of potential read-
ers. In the case of the *Shanghai Journal* article, the potential number
of readers was much higher from the beginning, although it is hard
to say how high it actually was. It is very likely that a majority of the
Jiangnan scholarly elite took note of it in one way or another. Both
Wang and the unknown editorialist articulated the hope that acting
officials would heed their advice, and for both the fact that their argu-
ments could be supported by strong evidence from the Classics was
important—although much more so for the newspaper editorial than
for the statecraft essay. Both authors shared the goal of improving
local government, to which they had no direct access. But the editori-
alist was in a much more vulnerable position—which is perhaps why
he introduces a thick layer of classical authorization to make his judg-
ment palatable to more conservative readers (including the officials he
criticizes).[38] With this strategy, the newspaper seems to have followed
an agenda comparable to that of the reform-minded scholar-officials
from Hunan: enabling their mostly classically educated readers to
participate in discussions of state affairs. Even though the *Shanghai
Journal* editorialist draws on sources of authority outside the classi-
cal canon, he was still employing the rhetoric and style of so-called
statecraft writings.

Writings on famine abound in the pre-1900 press. After the turn of
the century, famine continued to be a pressing problem, but, increas-
ingly, it was rarely the subject of lengthy and authoritative editorials.
Instead, new discursive genres were used to cover the topic in differ-
ent ways. Generally speaking, we could say that the editorial offering
constructive criticism to the government was marginalized or trans-
formed by new types of opinion pieces that showed less reverence for
the established authorities. This change may be indicative of changes
in the constitution of society and of how it perceived its government;[39]
it is certainly indicative of changes in the views of the people produc-
ing and consuming the newspapers. These social and political changes

[38] It should be noted that, although many of them do, not all editorials fit into this
pattern so nicely. Different authors had different styles; some were more orthodox
than others.

[39] It is hard to tell why famine became a marginal theme in editorial writing in
this period. The shift from the centrality of *huangzheng* to a new discourse on politi-
cal economy, together with an increasing disillusionment with the Qing government,
might have played a role here. See Janku, "'New Methods to Nourish the People'"
(forthcoming).

went hand in hand with new technological developments, which made the process of printing much faster, allowed for much higher circulation numbers of more and more voluminous periodicals, and promoted a new culture of reading and writing.

The Speed of the Printing Press

The ideas associated with the newspaper's advent included modernity and progress. This perception is closely linked to the fact that Chinese-language periodicals were mostly produced with imported technology—that is, letterpress or lead-type printing (*qianyin* 鉛印). The aim of both commercial publishers and the missionaries who pioneered the use of the medium in China was to reach and create large audiences. Therefore, the capacity to produce large print runs was seen as a basic requirement, and for that, the most advanced technology was needed.[40]

Apart from these commercial and ideological considerations, the very character of the newspaper seemed to ask for a printing technology based on movable type. Even the *Peking Gazette* (*Jingbao* 京報) had been printed with movable wooden type since the Ming dynasty (1368–1644).[41] As opposed to woodblocks, matrices set with movable type could be dismantled after use and the type used again. Publishers had no need to keep printing blocks for later reprints, as the periodical newspaper, even the court gazette, was perceived to be ephemeral. Therefore, one of the great advantages of woodblock printing—the

[40] Martin J. Heijdra suggests that missionaries and Sinologists were convinced that "Western technology was always superior," but adds that the lack of access to skilled woodblock cutters and printers may have been another reason for their preference for the Western technology. Similarly, the first Japanese publishers, "for a long time were attracted to printing with type because of its association with modernity rather than for any demonstrated advantage." See his "The Development of Modern Typography in East Asia, 1850–2000," *East Asian Library Journal* 11.2 (Fall 2004), 100–168, 102. However, according to a calculation of the cost for the printing and binding of more than five million pages by Walter Medhurst, woodblock printing would have been the most expensive and least efficient technology; see McDermott, *A Social History of the Chinese Book*, 24, 42.

[41] Copies of the court gazettes were also produced with wax molds, or, perhaps more efficiently, in handwriting. The bad quality of these prints was generally deplored. See Britton, *The Chinese Periodical Press 1800–1912*; Fan Muhan, *Zhongguo yinshua jindai shi*, 54. See also Vittinghoff, *Die Anfänge des Journalismus in China*, 56–61; Mittler, *A Newspaper for China?* 173–242.

possibility of easy reprinting—was of no use in periodical publishing. Or, to put it in a positive way, newspaper publishing was characterized by a process of "daily renovation"—a formulation that appealed to the reformers of the late 1890s.[42]

But actually, none of this was true for the first Chinese-language periodicals, which were published by missionaries. The imported technology was new and expensive (as long as print runs were small), but not necessarily efficient. Moreover, these early missionary publications reached only a comparatively small audience. Most of them appeared monthly; they were thread-bound and printed from woodblocks on soft Chinese bamboo paper, and they looked more like traditional Chinese books than modern newspapers. Most were published in rather modest numbers, though some of them were actually reprinted, either in their original form or as digests. The first periodical to appear on the Chinese mainland, in 1833, was the *Chinese Magazine* (*Dongxiyang kao meiyue tongjizhuan* 東西洋考每月統記傳), a monthly published in Guangzhou by the Prussian Protestant missionary Karl Gützlaff (1793–1851). Apparently produced by lithographic printing on high-quality bamboo paper (so-called *lianshi* 連史 paper),[43] it included hand-colored maps and was printed in six hundred copies.[44] But the boom in lithographic technology that finally marginalized woodblock printing only came with the introduction of photolithography in the late 1870s.[45]

[42] The term "daily renovation" has been taken from the canonical literature by the late-nineteenth century reformers and developed into a veritable obsession with the notion of "newness" in the first years of the twentieth century. The original source is the *Daxue* (The Great Learning), in James Legge's translation: "If you can one day renovate yourself, do so from day to day. Yea, let there be daily innovation"; see *The Chinese Classics*, vol. 1 (Oxford: Oxford University Press, 1960), 361. The reference to the "new people" in the same paragraph became of course famous with Liang Qichao (1873–1929).

[43] *Lianshi* paper was praised for its strength, whiteness, smooth surface, and resistance to insects. See Brokaw, "Commercial Publishing in Late Imperial China," 49–92, especially 53.

[44] Fan Muhan, *Zhongguo yinshua jindai shi*, 112–113. Invented in 1796 in Bavaria, lithography must have been well established there by the 1830s, as Medhurst's calculations of 1838 were based on the prices there (see n. 31); McDermott, *A Social History of the Chinese Book*, 41. The London Missionary Society (LMS) introduced the technology to Canton in 1832; see Reed, *Gutenberg in Shanghai*, 28.

[45] While the Jesuits had brought lithographic technology to Shanghai in 1876 (see Reed, *Gutenberg in Shanghai*, 79, and Joachim Kurtz, "Messenger of the Sacred Heart," in this volume), the Shenbao Company (Shenbao guan) first introduced photolithography in 1878. See Wagner, "Joining the Global Imaginaire," 105–173; 163, n. 55.

The first Chinese-language paper to use lead type was the monthly
Chinese Serial (*Xia'er guanzhen* 遐邇貫珍), published between 1853
and 1856 by the London Missionary Society Press under editor James
Legge.[46] It appeared as a twelve- to twenty-four-page thread-bound
booklet in very high runs of three thousand copies, and cost fifteen
copper cash (*wen* 文).[47] It did not survive for long, as its editor soon
embarked on the more prestigious project of translating the Chinese
Classics, but the *Serial*'s equipment was crucial for the launching in
1874 of the *Universal Circulating Herald* (*Xunhuan ribao* 循環日報),
the first Chinese-run daily in Hong Kong.[48] But the older technolo-
gies were not abandoned. When the American Baptist Mission pub-
lished a Chinese-language newspaper in Ningbo between 1854 and
1861, the *Chinese and Foreign Gazette* (*Zhongwai xinbao* 中外新報),
it used lithography. The *Record of Things Heard and Seen from the
East and the West*, published in 1872 by American missionaries in
Beijing, appeared as a thread-bound monthly magazine printed from
woodblocks in rather high runs of about one thousand copies. Lead
type was, to be sure, more enduring than wooden type and could be
used for much larger print runs than either woodblocks or wooden
type, but the casting of Chinese lead type was time-consuming, cum-
bersome, and so expensive that letterpress printing was unaffordable
for most printers before the application of the electrotype process to
Chinese printing by William Gamble (1830–1886) in 1859.[49]

With Gamble's innovation came the great breakthrough of letter-
press printing, and China was well on its way to developing a modern
publishing industry. But other crucial developments were also nec-
essary: modern mechanized printing presses, paper that would not
crumple when sent at high speed through the cylinders of the modern
rotary presses, and last but not least, the social need for tens of thou-
sands of newspapers daily. It took another six decades to arrive at this

[46] On the "Hong Kong type" used by the LMS press, see Heijdra, "The Develop-
ment of Modern Typography in East Asia," 115. On the beginnings of the Chinese
periodical press in Southeast-Asia and Hong Kong see Toh Lam-seng (Zhuo Nan-
sheng), *Chûgoku kindai shimbun seiritsushi 1815–1874*; Fang Hanqi, *Zhongguo xinwen
shiye tongshi*; and Vittinghoff, *Die Anfänge des Journalismus in China*, 36–56, and
especially 157–161.

[47] Fan Muhan, *Zhongguo yinshua jindai shi*, 135–137.

[48] Vittinghoff, *Die Anfänge des Journalismus in China*, 157–161.

[49] See Heijdra, "The Development of Modern Typography in East Asia," 101–2,
112, 115. See also Reed, *Gutenberg in Shanghai*, 45ff; Fan Muhan, *Zhongguo yinshua
jindai shi*, 105.

stage. Nevertheless, from the 1860s onward, most newspapers (like the *Shanghai Journal*, founded in 1872) were printed from lead type, most on traditional Chinese bamboo paper. Only the *Shanghai News* (*Shanghai xinbao* 上海新報, 1861–1872) used Western paper, which could be printed on both sides. It was the first Shanghai newspaper to appear in modern broadsheet format,[50] but it was pushed off the market by the *Shanghai Journal*, which pursued an aggressive marketing strategy on both the economic and the cultural level, and thus quickly gained popularity.[51] The smaller, folded format and conservative layout of the *Journal* would become the model for the Chinese newspaper for the next three decades. Only the reformers' journals that proliferated after 1895 preferred lithographic printing (e.g. *Chinese Progress* [*Shiwubao* 時務報], which appeared every ten days). And some journals (a few published in Hunan and Sichuan, for example), that apparently lacked access to the new technologies were set in wooden movable type or even printed from woodblocks.

The circulation numbers of Chinese dailies generally remained low before 1900.[52] The famous Hong Kong *Universal Circulating Herald* did not surpass one thousand copies until after 1900.[53] The *Shanghai Journal* began with 600 printed copies per issue. But the surviving data are scarce and contradictory. According to an account in the volume celebrating the paper's fifty-year jubilee, the *Journal*, in its first years of publication, relied on a hand press that printed several hundred sheets (*zhang* 張) per hour on lower-quality bamboo paper. Two years

[50] One page measured 18 by 11 inches. The so-called "Daotai paper" (*Xinbao*, 1876–82) also used this format, and the *Zhongwai ribao* (1898–1909) was another later follower. The first paper in Shanghai to use this format successfully was *Shibao*, in 1904. In Hong Kong, however, newspapers—for example, *Huazi ribao* (1864), *Zhongwai xinwen* (1858) and *Xunhuan ribao* (1874)—all had a broadsheet format.

[51] *Shenbao* was published daily (*Shanghai xinbao* appeared only every second day) and was sold at a price two copper cash below that of its rival. In addition, the paper appealed to Chinese taste with a more "traditional" format (on which, see Mittler, *A Newspaper for China?*, 47), and it catered to the political ambitions of the cultural elite by featuring a daily editorial article.

[52] In Europe and America newspaper circulation numbers were equally low, ranging from several hundreds to hardly more than one thousand copies, before the invention of the first steam-powered mechanical printing press by Friedrich König (1774–1833) in 1814.

[53] Vittinghoff, *Die Anfänge des Journalismus*, 71. This figure does not say much about the number of readers. One single paper could have had as many as ten or even more readers. For an attempt to assess the size of the late Qing reading public, see Nathan, "The Late Ch'ing Press," 2: 1281–1308.

later, in 1874, higher quality *lianshi* paper was used.[54] In an editorial announcement, the *Shanghai Journal* claimed to have printed forty-five hundred copies in June 1872, but this seems rather unlikely.[55]

The print runs could have been this high once the journal switched to a mechanized press within several years of its founding, but sales most certainly did not rise to that level until another few years later. The number is more likely the product of a marketing campaign, as it appears at the end of an announcement to sale agents and advertisers listing retail prices and the costs of placing an advertisement in the newspapers. In 1877 an editorial stated that in the beginning daily circulation was below one thousand, but that by 1877 it had reached nearly ten thousand, making the *Shanghai Journal* the most widely circulated newspaper in China.[56] Four months later, another editorial announcement, again catering to advertisers, reported the paper's circulation as eight thousand to nine thousand copies.[57] But still in 1876 *Journal* founder Ernest Major (1841–1908) is reported in consular papers to have given a circulation figure of "only 5,000."[58] The account in the jubilee volume is even more modest; it states that the circulation in 1876 was two thousand copies, and that it had risen to five thousand only in 1877.

However difficult it may be to find accurate statistics, clearly a significant increase in circulation had taken place by 1877.[59] To some extent, the increase could be explained by improved technology. The use of more durable *lianshi* paper after 1874 would suggest that around

[54] One issue consisted of one sheet that was divided into eight pages; each page was 25.7 by 24 cm. In 1874, when finer paper was used, the size changed to 30 by 26 cm. During several months in 1898 glazed paper (*youguang zhi*) was used, which seems to have been detrimental, at least for long-term conservation. See Li Songsheng, "Benbao zhi yange," 2: 29–34.

[55] *Shenbao*, June 27, 1872. This announcement appeared daily beginning on June 21. By that time, *Shenbao* was sold in the treaty ports Ningbo, Hankou, Zhenjiang, and Tianjin, as well as in Suzhou and Hangzhou; the price was ten cash. In Huzhou, Jiaxing, Yangzhou, Hong Kong, Guangzhou, Wuchang, and Nanjing the price was twelve cash. The price for Beijing was "not yet determined"—which meant that no retail agent had yet been found.

[56] "Lun ben guan xiaoshu," *Shenbao*, February 10, 1877.

[57] "Ben guan zishu jiazeng," *Shenbao*, June 20, 1877.

[58] Cf. Vittinghoff, Die Anfänge des Journalismus, 72.

[59] According to Wolfgang Mohr's graph showing the development of *Shenbao*'s circulation from its foundation to 1949, circulation numbers had reached twelve hundred in 1875, two thousand in 1876, and then suddenly five thousand in 1877. Mohr, *Die chinesische Tagespresse* 2: 47.

this time a new mechanized cylinder press, which could print one thousand sheets per hour, was in use. But higher production capacity alone did not create a bigger market. The figures also suggest that the crucial factor for the sudden rise in circulation was the Sino-foreign famine relief campaigns of 1876–77 and 1877–78, both of which relied heavily on the daily press. Famine relief was a topic that appealed to two distinct groups of readers: the scholar-official class engaging in arguments about how to best deal with the famine, and gentry-philan-thropists who aspired to broaden their sphere of influence and used the press to publicize their activities. Although these groups were quite numerous in late-Qing Shanghai and Jiangnan, they represented only the social elite—a far cry from the mass audiences newspapers would achieve in the early twentieth century.[60]

Wolfgang Mohr, in his study of the Chinese press, provides no sta-tistics on the *Journal*'s circulation for the period from 1877 to 1912, although he indicates the number may have been as low as seven thou-sand in 1912. But Roswell Britton, relying on a missionary source, reports a circulation of fifteen thousand in 1895,[61] which would be very high but not improbable. According to the *North China Herald*, new kerosene-powered engines reduced the time needed to print one edition from eighteen hours to five to six hours, with fewer workers.[62] Liang Qichao's 梁啟超 (1873–1929) lithographed journal *The Chinese Progress* appeared in a like number of copies. Moreover, war coverage always enhanced circulation. This could have been the case in 1884–85 (the Sino-French War) and again in 1894–95 (the Sino-Japanese War). Mohr's low circulation figure for 1912 could be explained by a decline in the popularity of the paper after the 1898 coup d'état. As mentioned above, under its editor Huang Xiexun the *Journal* had joined the con-servative voices condemning Kang Youwei 康有爲 (1858–1927) and the exiled reformers; it then solidified its conservative stance by refus-ing, at least initially, to embrace the new stylistic trends introduced by the young revolutionaries from Japan.[63]

[60] Cf. Vittinghoff, *Die Anfänge des Journalismus in China*, 121–122. On vernacular journalism see Kaske, *The Politics of Language in Chinese Education*, chapter 3.

[61] Britton, *The Chinese Periodical Press 1800–1912*, 68.

[62] Cf. Reed, "Gutenberg in Shanghai," 223, referring to the *North China Herald* issues of October 21, 1890, and January 16, 1891.

[63] This is how Zhang Mo, one of a new generation of *Shenbao* journalists in the early twentieth century, explains the history of the paper in the early 1930s. See his "Liushi nian lai zhi Shenbao," 265–283.

After the post-1898 depression, staff and ownership changes took place, as well as two major editorial reforms (1905 and 1911), and the import of a Wharfedale cylinder press from Great Britain in 1909,[64] before the *Journal* reached pre-1898 circulation numbers again. The new press also made necessary the import of Western paper, which was printable on both sides. But rising circulation numbers must also be seen in the context of the rights-recovery and constitutional movements, as well as other events that led to the revolution of 1911, all of which were extensively covered in the press and created a greater demand for newspapers. These developments also contributed to the shift away from a state-centered attitude of the earlier period. In 1912 a "R. Hoe Co. two-cylinder rotary press," able to print two thousand sheets per hour, was purchased. Speed became more and more important, and a factor in the competition between the big dailies. In 1914 the *Shanghai Daily*, the *Journal*'s rival on the Shanghai newspaper market since 1893, purchased a "Potter's two deck rotary printing press," able to print seven thousand newspapers per hour, and added three even faster machines in 1916. In the same year the *Journal* imported a Japanese-manufactured French web press, which produced eight thousand printed sheets per hour.[65] With its new machinery, the *Shenbao* Office produced twenty thousand copies of the newspaper in 1917. In 1920 a new press, including a folding and cutting machine, was imported from America. Now, forty-eight sheets could be printed simultaneously, for a total production of forty-eight thousand copies per hour—the speed required to ensure that the paper could be delivered in time for the morning train. Circulation rose to thirty thousand in 1920, forty thousand the following year, and fifty thousand in 1922, when new machinery was added.[66]

In Western cities, the production of newspapers on an industrial scale had become a part of everyday life and a characteristic of a new urban culture by the turn of the century. Many newspapers had a morning

[64] Reed, *Gutenberg in Shanghai*, 74.

[65] The falling price of imported paper during World War I seems to have contributed to these companies' ability to purchase new machinery. See L. Sophia Wang, "The Independent Press and Authoritarian Regimes," 216–241, 221.

[66] Li Songsheng, "Benbao zhi yange," 2: 29–34. The *Huashang lianhebao* records a *Shenbao* circulation of fourteen thousand as early as 1909; see Judge, *Print and Politics*, 40. The figures for the *Xinwenbao* and *Shibao* are fifteen thousand and seventeen thousand, respectively. According to Judge, these figures are confirmed by Japanese consular reports.

and an evening edition; the speed of the news was all that counted. By the 1920s, the situation in Shanghai was nearly the same. The *Shanghai Journal* had reached a circulation of 141,440 by 1926, although it did not rise above one hundred fifty thousand until it was handed over to the *Liberation Daily* (*Jiefang ribao* 解放日報) in 1949.

We have seen that it took several decades before a lasting qualitative change in terms of circulation numbers was achieved. This change was intrinsically linked to the rising demand for newspapers and the import, largely from the West, of increasingly powerful printing machines crucial to faster production and higher volume. It was preceded by the transformation of the overall appearance of newspapers and a demand for new ways of writing, which in turn led to the transformation of old text genres and the adoption of new ones.[67] Most significant in this process was another import, this time from Japan: the short critique or editorial comment.

New Genres and the Constitution of Society

The story of changing genres that began with Tan Sitong and Huang Xiexun was continued in an anonymous article on the editorial form that was originally published in the *Waseda University Journal* (*Waseda gakuhō* 早稻田學報) and translated into Chinese in the *Eastern Times* in January 1907. This article celebrates the newspaper as the carrier of public opinion and assigns the task of both reflecting and guiding public opinion to those writing the daily editorial or lead article. But the problem was, how many among the tens of thousands of newspaper readers actually read the editorial articles? The author suggests that the answer was only a very few. But everybody, he claims, loved to read the miscellaneous and more playful writings. The solution he proposes is to move from the classical to the vernacular style and to abandon lengthy articles in favor of short comments. In light of the newspaper's function,

[67] Chen Shengshi has compiled a list of the terms used by different papers for their different forms of commentary. He describes the "evolution of editorials" in somewhat idealized terms as progressing from signed to unsigned, from the classical written language to the vernacular, from long to short, from a position on the first page to a position on the second or third page, from subjective to objective, from individual to collective authorship, and from independent specialized treatises to news commentary. Chen Shengshi, "Jindai Zhongguo baozhi shelun zhi yanbian," 8–15. More recently, Li Liangrong has also treated the topic of journalistic genres—without, however, mentioning the Japanese impact; see his *Zhongguo baozhi wenti fazhan gaiyao*.

however, the author allows for one exception that will be important for our further discussion: important state issues.[68]

The feature for which the *Eastern Times* became most famous was the *shiping* 時評, or "short critique of current affairs," an entirely new form in the universe of Chinese genres. The model for this new genre was the short "editorial comment" (*jihyō* 時評) pioneered in Japan by people like the Christian pacifist Uchimura Kanzo 内村鑑三 (1861–1930) and the anarchist Kôtoku Shûsui 幸徳秋水 (1871–1911). Both wrote "short comments" (*tanron*, or in Chinese, *duanlun* 短論) for the Tokyo *General Morning News* (*Yorozu chôhô* 萬朝報, 1892–1916); their pieces were identified in the *Waseda University Journal* article as exemplars of the desired new form. Both were in contact with Chinese exiles, who introduced the short-comment form on their return home.[69] It soon gained ground in Chinese newspapers. One of the best-known and most prolific writers in this new genre was Chen Leng 陳冷 (Jinghan 景韓, 1877–1965), a young journalist who had spent some time in Japan before returning to Shanghai to work for the *Eastern Times*. Chen distinguished himself from his literati predecessors not only in his choice of Western dress and conspicuous use of a bicycle[70] but also in the new tone he introduced into editorial writing. His success in writing "short critiques of current affairs" (*shishi piping* 時事批評, or *shiping*) made him one of the most famous representatives of his generation of professional journalists. In the following pages we will briefly analyze the features of the new genre before looking at how the other major dailies responded to the new trend.

The famine in Huaibei 淮北 and Xuzhou 徐州 in northern Jiangsu and Anhui provinces during the winter of 1906–1907 demanded a high degree of attention from both the imperial government and members of the Jiangnan elite, perhaps because of the refugees flooding into the wealthier cities of southern Jiangsu. The wide-ranging relief activities were covered copiously in the press; memorials, petitions, telegrams, and letters reporting on famine conditions and relief work appeared in the newspapers. Interestingly, despite a flurry of nonofficial relief activities, communications on relief measures sent by the governor

[68] "Lun ribao shang zhi lunshuo," *Shibao*, January 6, 1907.
[69] I am grateful to Matthias Zachmann, who provided me with this information. He characterizes these short critiques as exceedingly short, witty, and often cynical.
[70] Ge Gongzhen's *Zhongguo baoxue shi*, 188, has a picture showing Chen Leng in Western-style clothing with his bike.

to local officials and the central government were often published "in place of the lead article" (*dailun* 代論).[71] Otherwise—and in clear contrast to the situation in the 1870s—the famine was hardly ever treated in the *Eastern Times'* editorials, which were largely concerned with the politically more important educational reforms and constitutional movement. Instead, comments on the famine frequently appeared in the new form of "short critiques of current affairs," which were much less reverent than editorials in that they expressed some skepticism about the abilities of the existing government to deal with the crisis. And in these critiques the message was usually heavily underlined by the excessive use of repetition and emphatic punctuation. Crucial points were often repeated in staccato phrases, and three different kinds of emphatic punctuation were used: black dots, unfilled dots, and bold unfilled dots. (Phrases marked with black dots in the original are reproduced in normal type; unfilled dots, in italics; and bold unfilled dots, in small capitals.) For example:

> The Americans plan to use two warships to transport grain *in order to relieve our people in Xuzhou and Huaibei.* Chinese and Western missionaries hold meetings and collect funds *in order to relieve our people in Xuzhou and Huaibei.* ____The two palaces [the empress-dowager and the emperor] have already issued 100,000 [silver dollars?] and then again 100,000 from the imperial treasury *in order to relieve our people in Xuzhou and Huaibei.* Opera singers have performed and performed again *in order to relieve our people in Xuzhou and Huaibei.* Women and students hold meetings and again hold meetings, collect money and again collect money, *in order to relieve our people in Xuzhou and Huaibei.* Gentry-merchants and philanthropists urge contributions and distribute relief *in order to relieve our people in Xuzhou and Huaibei.* How COMES IT THAT, WHEN THE PEOPLE OF XUZHOU AND HUAIBEI ARE SUFFERING FROM HUNGER, AND THERE IS NOT ONE, AMONG THE PEOPLE ABOVE AND BELOW, IN CHINA AND ABROAD, WHO IS NOT CONCERNED ABOUT THE PEOPLE OF XUZHOU AND HUAIBEI, ALONE THOSE FROM THE LIJIN-TAX OFFICES IN XUZHOU AND HUAIBEI ARE NOT CONCERNED—AND, ON THE CONTRARY, MAKE CONDITIONS EVEN WORSE? HOW COULD IT BE THAT THESE [PEOPLE] WOULD NOT BELONG TO HUMANKIND? COULD IT BE THAT THOSE WHO GOVERN WOULD SIT QUIETLY IN IGNORANCE OF [SUCH SUFFERING]? ([Signed Chen] Leng.)[72]

[71] "Xu Huai zaizhen gongdian," *Shibao*, December 31, 1906.
[72] Chen Leng, "Shishi piping," *Shibao*, December 29, 1906, 1.

In this example, the respect for the dynasty is formally preserved (the words "two palaces" are preceded by a blank to express reverence), but the reproaches to the local and provincial officials, expressed through pointed rhetoric, are very strong. Although the critique remains within moderate limits—only members of the local government are criticized, which was also rather common for editorial articles in the pre-reform press—the form is much more offensive than the cautious old "essays of judgment" (*lunshuo*). The most important characteristic of the new genre, as in the Japanese model, is its brevity, its biting criticism, and its distanced, cynical attitude.

Another critique, appearing in early January 1907, goes further, articulating outright distrust for the government (see Illustration 3).

> *Who says our government is short of money?*
>
> Losses in sterling exchange! Losses in sterling exchange! *But today there are gains of more than 10 million.*
>
> In Guangxi, subscriptions are made because of the calamities and unrest there. *But the excess funds from the contributions amount to more than one million.*
>
> In Fengtian, relief is distributed to those displaced by the unrest there. *But the excess relief funds amount to more than two million.*
>
> This shows that if something happens, which is harmful to the country and the people, then THE GOVERNMENT WILL CERTAINLY GET A LOT OF MONEY.[73]

The second part of this piece, which criticizes the government for speculating at the expense of the people's livelihood, ends with a phrase, emphasized with bold unfilled dots, paralleling the last phrase of the first part in its open contempt for the government: "How is it that they govern the country like merchants only striving for their private profit?"[74]

When flood and famine racked large parts of the country in the late summer of 1911, the *Eastern Times* responded with numerous, and increasingly cynical, editorial comments. Chen Leng commented on the unending floods throughout the country: "Alas, how does it come about that Heaven has so much water!"[75] Bao Tianxiao 包天笑 (1876–1973)[76] remarks on the high cost of rice and the government's

[73] Chen Leng, "Shiping," *Shibao*, January 5, 1907, 1.
[74] Ibid., 1.
[75] Chen Leng, "Shiping yi," *Shibao*, August 28, 1911.
[76] Bao was a famous journalist and educator, and a prolific writer of satirical novels.

Illustration 3: "Shiping," *Shibao*, January 5, 1907.

inability to transport wheat from Gansu to the south due to the lack of transport infrastructure, observed: "Today's China still is stuck in the time of remote antiquity!"[77] One journalist commented on a meeting of the Women's Public Speech Association (Funü xuanjianghui 婦女

[77] Bao Tianxiao, "Shiping er," *Shibao*, September 1, 1911.

142 ANDREA JANKU

宣講會), where a certain Mr. Gu Tieseng 顧鐵僧 ("Iron Monk") had
been invited to give a speech.[78] The journalist first reports that this
speaker claimed to have lived for ten years on only two vegetarian
meals a day, while his body became stronger than it had ever been
before; six months previously, he had again reduced his diet, to only
one meal every evening. He then observes:

> If in these times of horrific high rice prices everybody could do this,
> then not only would the citizens (*guomin* 國民) grow stronger every
> day, but there would also be no lack of food for the people (*minshi*
> 民食). Would this not be a wonderful method to solve China's most
> urgent problem?
> The horse, without eating any grass, could still work hard. I do indeed
> hope that this gentleman teaches [us all] this spiritual method.[79]

It is possible that one important reason for the apparent lack of serious
and constructive editorial articles on important state issues toward the
end of 1911 was the imminent breakdown of the Qing government.
But by this time, the short form had become increasingly popular
among the urban population. Readers could find numbered "current
critiques" scattered across the pages of the newspaper. They could
quickly read these short pieces as they browsed the news sections. This
kind of rapid perusal encouraged a reading habit very different from
that required to read a long editorial article, let alone the eye-crossing
"essays of judgment" in the old *Shanghai Journal*, which were printed
in lines forty-six characters in length, without any punctuation or
structuring aids, and densely covered a large part of the title page.

Interestingly, however, the new form lost its distinctive tone as it
was adapted to different purposes, sounding in the end rather like the
editorializing lead articles of an earlier era. Some short critiques urged
people to contribute to relief funds, some criticized local authorities
for behaving like marionettes, and at least one concerned a proposal
addressed to a higher authority (in this case, the International Famine
Relief Commission); all were written in the serious tone of the old

[78] Jie [pseudonym, full name unknown], "Shiping san," *Shibao*, September 4, 1911.
Gu Tieseng was Gu Shi (1876–?), from Jiangsu. He had studied law in Japan and later
became a professor at different universities. He also campaigned for the romanization
of Chinese writing and participated in the Conference for the Unification of Reading
Pronunciations (Duyin tongyihui) in 1913. My thanks to Elisabeth Kaske for provid-
ing this information.
[79] Jie, "Shiping san."

essays of judgment.[80] The attempt to strictly define the border between the two forms and to reserve discussion of "important state affairs" for solemn and lengthy editorials written in classical Chinese seems to have worked in theory only.

When the other big dailies were trying to catch up with the *Eastern Times* and copy the "short critique" form, a variety of terms were used for the new genre. The *Shanghai Journal* of 1907 contained no short comments, but by 1910 a new genre called "pure talk" (*qingtan* 清談) and a column called "leisurely talk in Shanghai" (*Haishang xiantan* 海上閒談) had appeared. "Pure talk" was a term that had been used traditionally to suggest fearless moral critique;[81] and some of these "pure talk" pieces were, following the style of the old lead articles, earnestly addressed to those who were "concerned about the hardship of the people."[82] Others were as brief as Chen Leng's short critiques and written in a similar tone (although Chen's pieces had quickly lost their sharpness).[83] During the 1920s the *Journal*'s short editorial comments appeared as "miscellaneous critiques" (*zaping* 雜評), a term the *Shanghai Daily* was already using in 1911 (see Illustration 4). The blurred boundaries of the new forms show that the liveliness of the genre was as much dependent on the imagination and spirit of individual authors as on the challenges of the environment. The short editorial comments in the Tianjin daily *L'impartiale*, called "idle critiques" (*xianping* 閒評), illustrate this nicely. The biting cynicism that characterizes these pieces tells perhaps more about the character of *L'impartiale*'s publisher, Zhang Jiluan 張季鸞 (1888–1941), than about the newspaper clientele in treaty-port Tianjin.[84] One of these critiques, written in 1911 (see Illustration 5), reads:

> Before the floods in Jiangsu and Anhui are over [*weiyi* 未已], Hunan and Hubei are also immersed in floods. Before the floods in Hunan and

[80] "Shiping san" in *Shibao*, September 10, 1911. This piece ends with the phrase: "If we would propose this to the gentlemen of the International Famine Relief Commission, what would they think about it?"

[81] Eastman, "Ch'ing-i and Chinese Policy Formation during the Nineteenth Century," 595–611; Rankin, "'Public Opinion' and Political Power," 453–484.

[82] See *Shenbao*, September 6, 1911, on the question of how to deal with the high rice prices; the article ends with the familiar phrase "I hope that those who are concerned about the suffering of the people will do their utmost to pursue this [method]."

[83] *Shenbao*, December 23, 1910.

[84] Even though we may assume that all the major dailies catered to a national audience, it would be interesting to explore to what extent Tianjin newspaper readers, who were much closer to the political center, were different from those in Shanghai.

Hubei are over, Jiangsu and Zhejiang also are immersed in floods. Before the floods in Jiangsu and Zhejiang are over, the metropolitan area also is immersed in floods. Why are there so many floods today?!

Before the epidemic in Manchuria is over, Zhili is also struck with an epidemic. Before the epidemic in Zhili is over, Shandong is also struck with an epidemic. Before the epidemic in Shandong is over, Shanghai is also struck with an epidemic. Why are there so many epidemics today?!

If our people do not die in floods, then they die in epidemics. Could it be that Heaven wishes to extinguish our people, so that they do not survive as a race [*lei* 類]?

I say: This is actually a case of Heaven helping the government. One man more dying a violent death means one man less to oppose the government. Floods, oh floods! Epidemics, alas! Epidemics! They are so much superior to the army when it comes to the task of suppression.[85]

Concern about the possible extinction of the Chinese people and fury at a government that seemed to be working toward that aim are the themes of this piece. The radical attitude here is akin to the spirit that motivated the journalists of the *Eastern Times* in its first years of publication: to challenge political authority. According to Joan Judge, the ultimate aim of the *Eastern Times'* founders was "to fragment and disperse centralized imperial authority through constitutional reform."[86] As this initial impetus faded, the playful short comments either gradually migrated to the entertainment sections of the newspapers[87] or lost their playfulness, assuming a more conformist, serious tone.

The immediate success of the short critique also had consequences for the editorial article. On the one hand, the need to differentiate between the old genre and the new brought about a clearer definition of the function of the former (for example, the assignment of the discussion of important state issues to the editorial); on the other hand, the desire to make these articles more appealing to the new, urbanized readers led to stylistic changes in this genre. With the foundation of

[85] Menghuan, "Xianping yi," *Dagongbao*, September 10, 1911.

[86] Judge, Print and Politics, 14.

[87] The beginnings of the entertainment press go back to the late 1890s, when people like Bao Tianxiao were pioneering the feuilleton press, without abandoning political commentary. See Catherine Vance Yeh, "Shanghai Leisure, Print Entertainment, and the Tabloids, *xiaobao* 小報." By 1911 the big dailies all had literary supplements, in response to the increasing popularity of the genre. *Xinwenbao* had its *Forest of Joy* (*Kuaihuolin*), *Shenbao* its *Free Talk* (*Ziyoutan*), best known for the *zawen* (miscellaneous essays) appearing on its pages in the 1930s. The new supplement of the *Eastern Times* was called *Comic* [or *Grotesque*] *Times* (*Huaji shibao*).

Illustration 4: "Zaping," *Xinwenbao*, August 29, 1911.

Illustration 5: "Xianping," *Dagongbao*, September 10, 1911. Note the lack of punctuation and the simple layout, suggesting that the paper lacked the modern machinery that could have produced a more complex design.

the *Eastern Times* in 1904, a new format and layout were introduced that, in contrast to earlier attempts, proved extremely successful.[88] An increasingly specific system of labeled columns was introduced to organize the paper's varied content, and graphics were used to make it easier to read. One year later, in 1905, the *Shanghai Journal* and the *Shanghai Daily* followed the lead of the *Eastern Times* and came out with an entirely new layout (see Illustration 6).

With the labeling of specific columns came a greater awareness of genres and their different uses. This was most conspicuously expressed in a new term for the lead article, an innovation again inspired by Japanese practices. While the leading article in the *Eastern Times'* last issue of 1906 was still labeled "the opinion of our publishing house" (*benguan lunshuo* 本館論説)—a rather clumsy literal translation—the first issue in 1907 had an "editorial article" (*shelun*). The new term drew on the Japanese term *shasetsu* 社説 (editorial), which was also used in China by the short-lived revolutionary papers published in Shanghai. Of course, consciousness of the new genre's development predated the use of this new term (as we saw, there was already discussion of the genre before 1900, and probably even at the very beginning of the periodical press). But the application of the new term testifies to the increasing need to differentiate the new genres from earlier genres, to make it a distinct voice in the public sphere. The *Eastern Times'* first page (which actually was the second page, as the title page was now covered with advertisements) was devoted exclusively to opinion (*yilun*). This included columns titled "editorial" (*shelun*), "short critique" (*shiping*), "readers' contributions" (*laigao* 來稿), "translations" (*yicong* 譯叢), "communications" (*tongxin* 通信), and (the serialized) "novel" (*xiaoshuo* 小説). The editorial page of January 5, 1907, features four of these columns (see Illustration 7).[89]

By 1907, despite the modernized layout, many of the *Eastern Times'* leading articles still appeared without an explicit label and in the familiar form of a serious policy proposal (*yi*). The suggestions for reconstruction measures after the famine in Huaibei, for example, repeat basic knowledge from the standard famine-relief manuals: prohibition of poppy cultivation, reduction of taxes, provision of grain and seed,

[88] See n. 50 above.
[89] "Benguan tebie gaobai" *Shibao*, February 21, 1907. The inclusion of the novel on the *Eastern Times'* opinion page is an interesting feature deserving further separate discussion.

Illustration 6: "Lunshuo," *Xinwenbao*, December 13, 1906.

Illustration 7: *Shibao* opinion page with *shelun, shiping, laigao,* and *xiaoshuo,* May 1, 1907.

and so on. They are addressed to "those in charge of these affairs," in the hope that they will benefit the people.[90] But at the same time, the authors of these proposals also criticize what they see as a sign of increasing indifference, on the part of both the government and urban newspaper readers, toward the fate of the people stricken by famine. The author of one of the rare editorials on famine states that in "civilized countries" people dying a violent death were regularly reported by name in the newspapers, whereas in China human life was worth nothing. And in the case of flood, the government returns to routine work only after repairs and relief measures have been completed. Looking at his own country, he wishes that "my compatriots would die, never to be reborn in this world, so that they would feel the pain [of famine sufferers]."[91] Such a sentiment would not have been expressed in the old-style editorials.

Another author, pessimistic about leadership at the top, shifts the focus—and his hopes for change—to the lower strata of society (*xiadeng shehui* 下等社會). In ancient times, he writes, when social customs were in decay, knights-errant came to the rescue; now, it was members of the lower classes, actors and prostitutes, who were coming to the rescue of social morale. The appearance of journals in the vernacular and illustrated magazines is presented as evidence of this rescue effort.[92] In terms of genre, both of these articles belong to the "serious comment" category, but, unlike earlier examples, they do not offer constructive advice to the government. If anything, they issue a serious warning to society at large. Although there is no suggestion that the current government be overturned, the need for broader participation in political affairs is clearly on the agenda.

The *Shanghai Journal*'s style changed significantly in 1911, when the paper was sold to Shi Liangcai 史量才 (1879–1934), who was determined to transform the *Journal* into China's biggest newspaper empire. Another reform of the paper was immediately announced. This reform, so the announcement said, was a response to the progress of the times and the growing diversity of human affairs; the new *Shanghai Journal*

[90] Gong [pseudonym], "Huaibei zhenwu shanhou shiyi yi," *Shenbao*, January 29, 1907.

[91] Lu [pseudonym], "Yangzhou jimin canzhuang ji," *Shenbao*, January 4, 1907; this was the lead article.

[92] "Lun jinri yanju zhuzhen shi," *Shenbao*, January 19, 1907. But the big dailies were still oriented toward the educated elite; by 1911, only the *Dagongbao* and the *Xinwenbao* had columns written in *baihua*.

was to accord with the demands of the modern reader. First, the rich detail and the thoroughness (*xiangjin* 詳盡) for which the paper had always been known would now be joined by the simplicity and convenience (*jianbian* 簡便) favored by the modern reader. The needs of those cherishing the details were to be served through the use of small type; those preferring to browse quickly through the paper could just follow the text set in large type. The text would make perfect sense even if one read only the part printed in bigger type (see Illustration 8). This principle was used for the news sections. It was never used for the lead article, which had to be read in its entirety and with undivided attention, or not at all.

Second, the "solemn seriousness" (*yanzhong zhengdang* 嚴重正當) for which the paper had been praised in the past was now seen as inimicable to the modern preference for liveliness (*huopo* 活潑).[93] In order to make the paper more interesting, *pinglun* 評論 ("comments"), editorial articles much shorter than their *lunshuo* predecessors (and rather like the *Eastern Times'* "short critiques"), were introduced. Pages were now divided into four columns, making the lines much shorter and thus easier to read. To cater to the modern reader's need for intelligent entertainment, a new literary supplement, *Free Talk* (*Ziyoutan* 自由談), was added (see Illustration 8).

Here, the changes in the lead article indicate a major shift in the conception of a newspaper's function: The newspaper no longer speaks "in the guise of the loyal official" to offer his censorial critique of the government but in its own right, to create and articulate public opinion, and thus to represent society at large. In both cases the newspaper has a responsibility to speak up, to voice criticism, for the sake of the common good. As late as 1932 the editor of an anthology of the *Eastern Times'* editorials describes the genre's new function as a guide to society—that it should recognize and support the needs of society by speaking out (*yanze* 言責).[94] This transformation of the editorial genre also marks the transformation of the newspaper, from a comparatively elitist medium of political discourse to a modern daily providing information, entertainment, and opinion to a socially wide-ranging readership. Concomitantly, the changing complexion of information, entertainment, and opinion—and the change in importance accorded

[93] "Benbao gaige yaoyan," *Shenbao*, August 25, 1911.
[94] *Shenbao* guan "Zixu," Shenbao *pinglun xuan* (Shanghai: *Shenbao* guan, 1932).

Illustration 8: "Pinglun," *Shenbao*, July 7, 1911. Note the four columns and the use of both large and small type.

each over time—reflects shifts in historical context and social attitudes from the late nineteenth through the early twentieth century.

Conclusion

The emergence of new genres is indicative of new social practices. In the case examined here, this emergence involved the introduction of new media and the creation of new reading audiences. In China the appearance of the modern press during the late Qing period served as a challenge to the established forms of political debate and participation, although not in a straightforward way. Modern technology was crucial to this process—it made it all possible. But modern technology was no more and no less than a tool. It neither initiated nor determined this process. Changes in newspaper functions and genres must be seen, rather, as the consequences of combined social, political, and technological pressures. In the late nineteenth century, the first newspapers in the treaty ports functioned as a strong integrating force, adapting to the existing sociopolitical fabric in their appeal to largely elite readers. But, beginning in the first decade of the twentieth century, newspaper genres arose from an increasingly diverse media landscape that reflected greater political diversity, a new and distinctly urban sensitivity, and the growing alienation of the residents of the urban publishing centers from their rural compatriots. Technological innovation supported and spurred these changes, insofar as it made the mass production of newspapers possible.

But the changes outlined above came gradually. At first, newspapers, written in the classical style, inherited the authority of traditional orthodox texts. Newspapers were seen as providing the truth. They confirmed or corrected rumors, which carried news to the provinces faster than the press; as such, they were to be read thoroughly from beginning to end. This view helps explain why the earliest Chinese newspapers did not adopt the format and layout of Western models; instead (following the lead of the *Peking Gazette*), they were designed in such a way as to require careful and consecutive reading.[95]

[95] Henrietta Harrison makes these points in her analysis of a Shanxi daily in the 1920s. See her "Newspapers and Nationalism in Rural China, 1890–1929," 83–102, especially 90–95.

This authority ascribed to the newspaper was maintained to some
extent even through the turbulent early decades of the twentieth cen-
tury, when an attempt was made to confine the discussion of important
political issues to the editorial. However, the crisis of authority in the
political sphere eventually eroded the supremacy of the old editorial
genre. Shorter genres of opinion proliferated. A common ground was
hard to define; even fiction was included under the "opinion" umbrella.
This multiplication of minor forms reflected, it seems, the newspaper's
dwindling authority. A Beijing journalist writing in 1927 confirms this
assessment. In the first period (pre-1900), newspapers were regarded
as printing the truth and, as a result, the press had tremendous power.
But the breakdown of political unity and the rise of factionalism led
to the abuse of this power, and the public became aware of how the
press could manipulate opinion. This awareness resulted in the decline
of opinion journalism.[96]
But political weakness alone was not responsible for the changes
in opinion genres. By the early twentieth century, the modern urban
environment demanded new reading habits. Writing in 1927, Ge
Gongzhen observed that "some people say that when Chinese people
read a newspaper they usually read it from the beginning to the end
without omitting a single word";[97] this was the kind of reading associ-
ated with the earliest papers. He then criticized this custom as inap-
propriate for people who are truly concerned about public affairs, since
they should not have enough time for such a thorough reading. A new
sense of time, arising from the modern urban environment, validated
the development of "short comments" and other, formal changes in
the newspaper's layout that would reduce reading time.
As a result of both political disintegration and the demands of mod-
ern life, a new system of opinion genres had evolved by the 1920s.
Shanghai Journal's main editorial was now the *shiping*. Further, each
of the two main news sections carried a very brief *zaping*. The *Shang-
hai Daily*'s short comments were called "new critiques" (*xinping* 新評),
and there were usually three of them in each issue. The *Eastern Times'*
main editorial was now called *pinglun*, and was complemented by
three *shiping* in the various news sections. While a multitude of genres
need not necessarily reflect a failure of authority, the lack of a strong,

[96] "Baohua," *Beijing ribao*, December 11, 1927.
[97] See Ge Gongzhen, *History of the Chinese Press*, 221.

focused editorial voice seems to indicate a certain weakness of public opinion, which in this particular historical context can be linked to the unstable political situation.

At the risk of stretching the evidence too far, one might say that the situation changed again after the establishment of the new National Government in Nanjing in 1928. *L'impartiale*'s editorials, now called *sheping* 社評, forcefully reminded the new government of its responsibility to its starving people (see Illustration 9). From then on, a consolidation of the genre can be observed. The *Shanghai Daily* started to use the broader *shelun* in the late 1930s; the *Shanghai Journal*, in the late 1940s.[98]

The fluctuations in newspaper authority described here had more to do with social and political changes rather than technological ones. But technology enhanced the efficiency of the press, making the quick and broad dissemination of newspapers possible (although more so in the urban modern centers of modernity than in the peripheries). Both sociopolitical and technological changes reinforced one another, each advancing the other in a kind of dialectical interaction. But it is impossible to see the changes in genre here as the simple result of the introduction of new technologies. Indeed, evidence exists that, when social conditions are not right, technological change has little or no impact. In 1876 the *Shanghai Journal*, in an effort to reach a mass readership, tried to launch a *People's Daily* (*Minbao* 民報), written in the vernacular and printed with punctuation (spaces indicating phrase and sentence breaks within a text) designed for easier reading.[99] This experiment failed—not because the technology was lacking but because there was no social grounding for it. The time for popular newspapers written in the vernacular had not yet arrived.

Similar ventures in the early twentieth century had a very different outcome—indeed, worked toward the creation of a new national language.[100] In this process, the leading newspapers, with their advanced technology, had next-to-no input. They continued to use classical language, albeit in an adapted form, in their editorial comments. It was

[98] Very quickly, however, with the founding of the People's Republic of China by the Communist Party, the genre went through yet another transformation. The editorial of the party paper marks the preliminary endpoint of this process, and the newspaper's emergence as a powerful, integrative tool of authority.

[99] "Quan kan *Minbao*," *Shenbao*, June 3, 1876.

[100] Kaske, *The Politics of Language in Chinese Education*, esp. chapter 3.

Illustration 9: "Sheping," *Dagongbao*, September 21, 1929.

in alternative, and technologically much less powerful, spheres that innovation took place: the woodblock-printed reform journals of the 1890s, the noncommercial print products of the revolutionary groups in the first decade of the twentieth century, and, finally, the Communist guerrilla press discussed by Christopher A. Reed in his essay elsewhere in this volume.

PRINTING THE SOUND OF COSMOPOLITAN BEIJING: DIALECT ACCENTS IN NINETEENTH-CENTURY MARTIAL ARTS FICTION[1]

Paize Keulemans

Toward the end of *The Three Knights and the Five Gallants* (*San xia wu yi* 三俠五義), one of the more popular martial arts novels published in the nineteenth century, two young heroes put on an elaborate act of cross-dressing.[2] Hoping to infiltrate the stronghold of a rebellious outlaw, the two, Black Demon Fox Zhi Hua (Heiyaohu Zhi Hua 黑妖狐智化) and the knight Ding Zhaohui 丁兆蕙, disguise themselves as lowly Hubei fishermen. When the two heroes reach the gate of the stronghold, the guards at the gate become suspicious and threaten to shoot, at which point Zhi Hua answers not in his own voice, but instead affects a strong Hubei fisherman's accent, saying,

> Hold your fire! Waddaya (*what are you*) shootin' for? Uz (*us*)'re comin' on invite. Us two brothers 'ave bo'ath (*both*) come with fish for the lord. Officials don't beat those carrying gifts, do they? So waddaya shootin' for?

> *Zhu dala ba, ni fang ma(ma) jian xia, nan(an)men chen qiwang de, an dangjia de dixiong dou(dou) lai le, tete gei ni jia dawang song yu lai le. Guanr hai bu da songli de ne, ni you fang jian zuo ma ne?*

> 住搭拉罷, 你放麻(嗎)箭吓, 難(俺)們陳起望的, 俺當家的弟兄斗(都)來了, 特特給你家大王送魚來了. 官兒還不打送禮的呢, 你又放箭做嘛呢?[3]

[1] I would like to thank Haun Saussy as well as the anonymous reader for Brill for their thoughtful comments.

[2] Between 1879 and 1900, the novel was republished at least thirteen times, under three different titles. Originally published as *The Tale of Loyalty and Righteousness* (*Zhonglie xiayi zhuan*) in 1879, it was renamed *The Three Knights and the Five Gallants* in 1883, only to be renamed yet again, after a careful headcount of the actual knights, as *The Seven Knights and the Five Gallants* (*Qi xia wu yi*) in 1889. For the sake of consistency, I refer to the novel solely by the 1883 title, *The Three Knights*, the most widely accepted title in the Chinese mainland. For a general preface to this novel, see Susan Blader's introduction in Shi, *Tales of Magistrate Bao*, i–xlvi.

[3] The translation of a particular Chinese dialect into English is difficult and is made even more so by the novel's inconsistent use of paratextual techniques. Susan Blader's translation avoids these problems by eliding the novel's use of dialect. See Shi, *Tales*

Fooled by Zhi Hua's stellar performance of their native dialect, the two
guards take the heroes to be two of their own and grant them access
to the stronghold.

In the scene from *The Three Knights* quoted above, two aspects
draw our attention. The first is the great lengths to which the printed
text goes to impress upon the reader the sounds of dialect speech.
As Illustration 1, from the first printed edition of *The Three Knights*,
shows, the novel registers the sound of dialect speech by printing cer-
tain words twice, one character to register the sound of the character's
accent and once to offer the reader the appropriate meaning as well as
sound. For instance, before the character 俺 (pronounced *an*), a per-
sonal pronoun meaning "we" (itself a word already "vulgar" in tone),
the text prints 難 (pronounced *nan*). "Both" is printed first as 斗 (*dou*,
third tone), only then as 都 (*dou*, first tone). The final particle *ma* is
similarly printed twice, first with the second tone 麻, and next with
the toneless 嗎. The result of the paratextual device of double printing
is a remarkable sonic feat: even though faced with the silent pages of a
text, the reader can imagine the sounds of Hubei dialect.

The second striking aspect of this scene is the highly self-conscious
way in which it captures the sound of dialect speech. After all, the
scene quoted above does not simply depict a Hubei fisherman speak-
ing his own dialect, but rather a clever martial arts hero *pretending*
to speak in a Hubei accent. The great attention to the acoustic details
of dialect speech thus does not strictly follow the logic of mimesis,
that is, the literal transcription of dialect speech onto the page in an
attempt to represent reality. Indeed, upon closer scrutiny the dialect

of Magistrate Bao, 113–48. Since this essay is a work of scholarly inquiry, rather than
a work of literary translation, I have created a set of conventions that may not always
capture the spirit of dialect for an English speaker, but do give the reader a better
sense of how accent is used in the original language. First, I follow the original text's
inconsistent practice in terms of the word order of dialect accent and standard charac-
ter. Second, even though the original text does not always offset the second character,
I have consistently placed the translation of that character in parentheses and italics.
Third, I mark dialect accent by "miswriting" words in the translation. Fourth, words
that are very colloquial, but not marked in the text as having a distinct accent, I have
translated in a conspicuously "vulgar" manner, but I have not misspelled such words.
Even though there exist slight differences between the original 1879 Juzhen tang edi-
tion and the later (1996) Zhonghua shuju edition, I will usually refer to the more
easily accessible Zhonghua shuju edition, unless the differences are significant. In this
case, the modern reprint (using modern punctuation to set off the dialect accent more
clearly) mistakenly adds an accent in the first phrase. See, Shi Yukun, *Zhonglie xia'yi
zhuan*, chapter 111, 6a; Shi Yukun, *San xia wu yi*, 2: 644.

Illustration 1: Dialect Mimicry in the 1879 edition of *The Three Knights* (Source: Shi Yukun, *Zhonglie xia'yi zhuan*, Chapter 111, 6a. Courtesy of the Yale University Library.) As a comparison between illustrations 1 and 2 shows, the paratextual techniques used to print dialect accents were not consistent even within a single novel. Whereas in illustration 1 (Chapter 111) the dialect accent is printed first and without any typographical distinction from the regular text, in illustration 2 (Chapter 24) the dialect accent follows the standard character, is printed in a slightly smaller type and slightly to the right. Translating these dialect passages, I follow the original text's choice in order of dialect and standard character, but have consistently used parentheses to make the use of dialect clearly visible.

accent performed by Zhi Hua turns out to be a rather far cry from an actual Hubei accent.[4] Instead, the scene follows the logic of performance, emphasizing the artistry (and artifice) of a person mimicking accents. The text's acoustic delight, in short, is found in the very act of representing, not in the scrutiny of, the object represented.

How do we understand the remarkable interest in recording the sounds of dialect speech and, in particular, its theatrical, imitative nature? To answer these questions, this essay first examines the imitation of dialect accents in Beijing novels in the broader context of nineteenth-century cultural and social use of regional dialects. Whereas an increasing number of novels produced in the provinces during this time staked regional claims by employing their own dialects, Beijing-produced novels such as Wen Kang's 文康 *The Tale of Romance and Heroism* (*Ernü yingxiong zhuan* 兒女英雄傳) (1878), *The Three Knights*, and *The Tale of Everlasting Blessings and Peace, Part I* (*Yongqing shengping quanzhuan* 永慶昇平全傳; first published in 1892) reaffirm Beijing's central position in the empire by self-consciously imitating other regional dialects. Just as the capital, functioning as the political center of the Qing state, gathered all the different regional dialects within its walls, so too did the Beijing-produced novels aim to reproduce the city's central linguistic position for its reader by gathering a host of different dialects within its pages. The way these novels mimicked different dialects allowed them to stage a verbal and acoustic form of masquerade that functioned to produce not one, but two, distinct regional identities: on the one hand, a fictional character whose inferior, provincial nature is told through his linguistic incompetence and regional accent; on the other, a cosmopolitan performer/reader whose superior Beijing identity is established precisely through his distinction from and skillful imitation of the various forms of provincial speech.

To underscore my point that the printing of dialect accents does not follow the logic of mimesis but instead the aesthetics of performance, I employ the term "mimicry" to describe this practice. However, to

[4] Though rendered with a great ear for acoustic detail, Zhi Hua's Hubei accent is not all that accurate. The pronoun *an*, for instance, is used quite widely in regional speech, but pronounced as *nan*, it is used in only three dialects: Hebei dialect, Hunan rural accent, and Chaozhou dialect, none of which correspond with the supposed local scene of action, Xiangyang in Hubei. See Xu and Miyata, *Hanyu fangyan da cidian*, 4: 4917–4919.

emphasize the oral and aural connotations of the method these novels use to reproduce various dialects as the source of Beijing identity, I also introduce the term "cross talking." Today, "cross talking" (*xiangsheng* 相声) is used solely to describe a comic dialogue between two performers. However, during the nineteenth century the term (also *xue xiangtan* 學鄉談 or *daokou* 倒口) referred primarily to the way storytellers in marketplaces and temple fairs acted out different personae through the imitation of variegated regional accents. In this context, cross talking first of all serves to remind us of the early nineteenth-century storyteller performances by Shi Yukun 石玉昆 on which *The Three Knights* was based, or the performances by Jiang Zhenming 姜振名 and Hafuyuan 哈輔源, who first performed *The Tale of Everlasting Blessings and Peace, Part I.* Yet this storyteller background also helps to explain the self-consciously performative aspects of cross talking in print; even when reproduced in printed form, the imitation of different dialects had strong oral performative connotations which allowed the discerning reader to appreciate the text not because it accurately offered actual accents, but because it offered the kind of superior craftsmanship and deliberate artifice that only a connoisseur of Beijing storytelling would appreciate.

Finally, this essay argues that, despite the strong oral connotations of the use of dialect in martial arts novels, the printing of regional accents should be understood as a practice of the written language—and as a phenomenon linked, as Song Lihua has noted,[5] to the major intellectual movement of the eighteenth and nineteenth centuries. In the novels analyzed here, the nineteenth-century storyteller's performance of cross talking was given textual form by drawing on a rather unlikely counterpart: the Qing-dynasty scholar's philological (*kaozheng* 考證) interests in recording dialect. The best example of such intentional juxtaposition of vulgar storyteller performance and elite philological scholarship is found in the first published vernacular novel to employ dialect mimicry, Wen Kang's *The Tale of Romance and Heroism.* In this martial arts novel, dialect mimicry represents a self-conscious exploration and crossing of the boundary between orality and text, playing with the medium of sound in voice as well as print. This play allows the author to create a unique Beijing identity that takes pride in the mastery of the universal realm of text as embodied by philological

[5] Song Lihua, "Fangyan yu Ming Qing xiaoshuo ji qi chuanbo," 41.

acumen—and yet remains truly "Beijing" in its appreciation of local storytelling practice.

Printing Dialect in the Nineteenth-Century Novel

In order to understand the function of dialect mimicry in the late-imperial Beijing novel, I first focus on the broader nineteenth-century historical trend of regionalism and the literary trend of dialect literature. As evidenced by a steady stream of scholarly publications, the nineteenth century saw a remarkable rise in the importance of regionalism and local identity.[6] As Tobie Meyer-Fong and others have argued, the increase in regionalism was explored through a variety of scholarly and literary endeavors such as the penning of local gazetteers, the lyrical exploration of local sites, and the celebration of local customs in bamboo branch poetry.[7]

This historical and literary shift toward regionalism in the nineteenth century found linguistic and literary expression in vernacular novels that explicitly used dialect, as opposed to the more standard vernacular (*baihua* 白話) used in most popular fiction, to construct notions of regional identity.[8] The most famous of these texts is undoubtedly *Flowers of Shanghai* (*Haishang hua liezhuan* 海上花列傳, 1894) by Han Bangqing 韓邦慶 (1856–94), a work which, as Alexander Des Forges points out, juxtaposes the Wu dialect of Suzhou with the northern vernacular so as to put Shanghai on the map as a distinct cul-

[6] Whereas earlier scholarship was primarily interested in tracing such regionalism as a negative symbol of the Qing dynasty's political decline, more recent scholarship, wary of the often nationalistic agenda hidden behind earlier studies, has taken a more neutral approach to "China's" nineteenth-century regionalism. The study of regional dialect literature contains a similar shift from condemning the experiment with dialect language to an actual embrace of such regional expressions. Compare, for instance, the early work by Hu Shi on the use of Shanghai dialects with the more recent evaluation in Zhang Zhen's *An Amorous History of the Silver Screen* and Alexander Des Forges's *Mediasphere Shanghai*. For Hu Shi's opinion, see his "*Haishang hua liezhuan* xu," 365–88.

[7] Meyer-Fong, *Building Culture in Early Qing Yangzhou*. While Meyer-Fong investigates the shift from the seventeenth century to the nineteenth century from the perspective of the city of Yangzhou, her study has clear implications for greater China.

[8] As Patrick Hanan points out, most premodern vernacular fiction, despite making claims to orality, was written in language that was "a semi-standardized version of Northern [dialect]." See Patrick Hanan, *The Chinese Vernacular Story*, 2.

tural center.[9] Yet *Flowers of Shanghai* is merely the end point of a long nineteenth-century novelistic tradition that was characterized by an ever more sophisticated use of dialect in novels.[10] Fifteen years before the *Flowers of Shanghai* went to press, the *Shanghai Journal* Office (*Shenbao* guan 申報館), one of Shanghai's leading late-nineteenth-century publishing companies, had already published the Wu dialect comedy *What Classic?* (*He dian* 何典?).[11] Before *What Classic?* novels were printed in Yangzhou dialect, most notably the novels *The Sluices of Qingfeng* (*Qingfeng zha* 清風閘) and *The Tale of the Flying Cripple* (*Feituo quanzhuan* 飛跎全傳), both of which employed the Yangzhou vernacular to reflect the splendor of eighteenth-century Yangzhou.[12] As Liu Ts'un-yan and Cynthia Brokaw have demonstrated, moreover, a host of vernacular works were printed in Guangzhou and Fujian that employed Cantonese to give color to local history and characters.[13] A similar trend toward the use of local dialect as a sign of regional identity is found in works that circulated in Fujian. Most famously, *An Unofficial Record of the Capital of Fujian* (*Mindu bieji* 閩都別記) employs Minnan 閩南 dialect to turn "wild history" into "local history."[14]

To a degree the Beijing novels produced in the late nineteenth century partake in this broader trend of late-Qing regionalism. As eminently local products, these novels produced a variety of signs (both linguistic and cultural) that established Beijing as a unique locale. For instance, the novels are filled with references to local Beijing food items such as corn muffins, layer cake, or mutton, sometimes even describing

[9] Des Forges, *Mediasphere Shanghai*, 32–37. For a more complete survey of Wu dialect novels, see Zhang Huaijiu and Liu, *Wu di fangyan xiaoshuo.*

[10] Song Lihua, "Fangyan yu Ming Qing xiaoshuo ji qi chuanbo."

[11] For a comprehensive edition, see Zhang Nanzhuang, *He Dian?* Apart from a fully annotated text, this edition also offers the *Shenbao* advertisements for the novel and prefaces by both the author and later scholars such as Lu Xun (1881–1936). For a good discussion of the aesthetics and politics of the novel itself, as well as of the twentieth-century discussions surrounding its republication, see Rea, *A History of Laughter.*

[12] *The Tale of the Flying Cripple* is ascribed to the eighteenth-century Yangzhou storyteller Zou Bixian and was first printed in 1817. *The Sluices of Qingfeng* was published two years later and was based on the performances by the famous Yangzhou storyteller Pu Lin.

[13] Liu Ts'un-yan, *Chinese Popular Fiction in Two London Libraries.* See also Cynthia Brokaw, *Commerce in Culture.*

[14] *An Unofficial Record of the Capital of Minnan* circulated as hand-copied manuscript beginning from the late Jiaqing reign (1796–1820) and was apparently a perennial crowd-pleaser in shops renting out novels. The novel is a sprawling tale in 401 chapters that recounts the history of Fujian from its mythical origins to the present. Fu Yiling, "Qianyan," in *Mindu bieji.*

the appearance of characters in terms only a local gourmand would truly appreciate. *The Tale of Everlasting Blessings and Peace, Part I*, for instance, describes one of its villains as having "a face as pudgy as sweet porridge, a nose dotted like sugared pretzels, and his two eyebrows and large eyes matched his two big sugar-cookie ears."[15] Similarly, protagonists in these novels often are claimed for Beijing even if the historical figures upon which they were based originally hailed from other provinces. For instance, *The Cases of Judge Peng* (*Peng gong'an* 彭公案, first printed in 1892) is based on a historical figure, Peng Peng 彭鵬 (1637–1704), a commoner from Fujian province who finally made it to the rank of governor of Guangdong.[16] The novel changes this Fujian native into a Manchu bannerman belonging to the fifth regiment of the Bordered Red Banner (Xianghongqi Manzhou Wujiala 鑲紅旗滿洲五甲喇), and opens its tale with the man living in a *hutong* 胡同 located close to the first ceremonial arch of Dongdan 東單, just inside Beijing's Chongwen 崇文 Gate.[17] Indeed, on the level of language as well, the various martial arts novels produced in late-nineteenth-century Beijing are often recognized as exemplary in their use of Beijing dialect, as attested not only by the praise lavished on them by twentieth-century literary scholars such as Hu Shi 胡適 (1891–1962), who famously called *The Tale of Romance and Heroism* a "textbook of Beijing vernacular," but also by the fact that contemporary Beijing slang dictionaries invariably draw upon these novels to illustrate their dialect terms.[18]

However, the local martial arts novels first produced in Beijing are in some ways also different from the dialect novels produced in the other regions of the late-Qing empire. Most notably these Beijing novels do not only use their own dialect, but gather a host of different dialects. This distinction had clear sociopolitical ramifications: whereas during the nineteenth century an increasing number of novels produced in the provinces staked their regional claim by employing their own dialect, the Beijing-produced martial arts tales reaffirmed

[15] Guo Guangrui, *Yongqing shengping qianzhuan*, 3.

[16] For the historical Peng Peng, see Hummel, *Eminent Chinese of the Ch'ing Period*, 2: 613–14.

[17] Tanmeng daoren, *Peng gong'an quanzhuan*, 1:1. For more on the life of the historical Judge Peng, see Li Yonghu, "Jiaodian houji," in Tanmeng daoren, *Zhengxu Peng gong'an*, 4: 330–334. I would like to thank Mark Elliott for help in translating the Manchu term "*jalan*," i.e. "regiment."

[18] Hu Shi, "*Ernü yingxiong zhuan xu*," 345–362.

their central position in the empire by self-consciously collecting and imitating other regional dialects. *The Tale of Everlasting Blessings and Peace, Part I,* for instance, has rightfully been lauded for its lively use of Beijing language, but in the nineteenth century the story was actually most famous for its use of Shandong dialect, spoken by the central character, the uncouth and unorthodox "Shandong Ma" 山東馬. Similarly, *The Tale of Romance and Heroism* self-consciously mirrors the sociopolitical regionalization of the nineteenth century by including in its pages colorful characters who are said to speak in local Shandong language, rural Hebei dialect, or impossible-to-comprehend Jiangnan dialects. *The Three Knights* does not simply offer us snippets of typical Beijing dialect, but also includes phrases of Jiangsu dialect, a Zhejiang accent, a Hubei fisherman's accent, a rural Hejian 河間 prefecture accent, or a striking Shanxi dialect.

By bringing so many different regional languages together, martial arts romances such as *The Three Knights* offer the reader a printed reflection of the way the capital was imagined as the center of a vast empire, a place where all languages came together. An early-twentieth-century source, *Scattered Notes on the Old Capital (Jiujing suoji* 舊京 瑣記) by Xia Renhu 夏仁虎 (1874–1963), for instance, emphasizes how Beijing gathers not only all the different people found throughout the empire, if not the world, but indeed all the languages these people speak:

> The capital is a sea of people; it is a hybrid place that mingles people from all corners, and as a result, the languages they speak are multifarious. Still, between these various languages clear borders exist. After a while you become used to the language of the bannermen, local patois, official language, so that you can differentiate them as soon as you hear them. Amongst these are also mingled Manchu and Mongolian,... also the language called Hui 回, and secret guild language, which is often used by actors to prevent others from understanding them. After the Boxer Rebellion one or two European languages were added to the mix, as well as Japanese, but these were used just for laughs, and the grand men of the capital regarded them as beneath their notice.[19]

[19] Xia, *Jiujing suoji,* 44. It is not entirely clear when *Scattered Notes* was written. Based on the events it describes, it must have been written in the early years of the Republic. In the preface, the author himself notes that he came to the capital in 1898 and that he explicitly limits his discussion to events of the late-Qing period.

Yet, even though Xia Renhui celebrates here the way various languages mingle in the capital, he establishes a strict hierarchy within this linguistic melting pot, beginning, at the top, with the language of bannermen and ending, at the bottom, with truly foreign languages, which, of course, are only to be laughed at by the grand gentlemen of Beijing. Moreover, Xia also suggests that while these languages coexist, they do not mix: "clear borders exist." Indeed, an authentic cosmopolitan identity is based on the ability to distinguish between these various languages; a true Beijing denizen is the person who "can differentiate them as soon as he hears them." To explain how this notion of appreciating the different sounds of a variety of languages actually plays out in printed texts, we need to move to the next section, which explains the act of dialect mimicry.

The Double Printing of Regional Characters in the Beijing Novel

Printing the sound of dialect accents played a crucial role in reaffirming Beijing's central and superior linguistic position amidst the sea of different dialects spoken in the empire. To illustrate this point, I turn to a particularly telling episode of *The Three Knights and the Five Gallants* which revolves around a single, simple conceit: a Shanxi merchant by the name of Qu Shen 屈申 is murdered, but comes back to life in the body of a woman. In turn, the soul of the woman, Bai Yulian 白玉蓮, the wife of the primus of the imperial examinations (*zhuangyuan* 壯元) who had hanged herself to defend her chastity, is reincarnated in the body of the Shanxi merchant. The result is a typical comedy of errors, where mistaken identities, physical slapstick, bad puns, and several unexpected reversals of fortune create a pleasurably loud and vociferous chaos that is untangled only when Judge Bao finally takes the matter in hand. Recognizing that Bai Yulian speaks Shanxi dialect while Qu Shen uses a typical feminine upper-class form of speech, Judge Bao unravels the dense plot of double murders and puzzling substitutions and finally succeeds in returning the souls of the Shanxi merchant Qu Shen and the *zhuangyuan*'s wife Bai Yulian to their original bodies, so that once again speech matches identity.

To establish the displacement of identities, *The Three Knights and the Five Gallants* employs a host of different physical and sartorial

signs, most notably the use of bound feet. As a linguistic medium, however, the novel most heavily relies on the language of the various characters as markers of their different identities. Gender, class, and, most significant, regional identities are distinguished on the basis of a character's speech. When Qu Liang 屈良, Qu Shen's brother, finds his brother's body now inhabited by Bai's spirit, he immediately recognizes something is wrong, because his brother does not speak with the appropriate Shanxi accent. Similarly, when the magistrate's helper Zhao Hu 趙虎 finds Qu Shen (who now is in the body of the elegant Bai), the male voice coming out of the "woman's" mouth does not correspond to her female appearance. Simply put, Qu Shen, despite his female body, talks like a man from the province of Shanxi and, correspondingly, Bai Yulian, despite her male appearance, speaks like an upper-class lady married to a *zhuangyuan*.

Some of the techniques *The Three Knights* uses to register vulgar dialect speech, most notably lexicon and syntax, are familiar devices of the late-imperial vernacular novel.[20] The novel is set apart, however, by the way it performs the dislocation of identity acoustically, making the Shanxi merchant's regional background unmistakable by the printing of dialect accents. When Qu Shen, for instance, finds himself away from home late at night on a business trip, this is the way he introduces himself as he requests a shelter for the night:

> I am traveling and it's become dark (*dairk*), so excuse (*'scuse*) me, could you help me find a place to put up? 'Morrow I'll reward you handsomely.

> *Wo shi xinglu de, yin tian hei(he) le, jie guang(guan)r, xun ge xiur, mingr zhong li xiang xie.*

> 我是行路的, 因天黑(賀)了, 借光(官)兒, 尋個休兒. 明兒重禮相謝.[21]

By printing certain words twice, once to mark the meaning of the word and once to mark the Qu's dialect pronunciation, the novel gives the sound of dialect speech a printed form (see Illustration 2).

[20] For a general overview of the use of dialect in the vernacular novel, see Yan Jingchang, *Gudai xiaoshuo yu fangyan.*

[21] Shi Yukun, *Zhonglie xia'yi zhuan*, chapter 24, 6b. I here quote the first edition because the Zhonghua shuju reprint has reversed the order between standard and dialect characters.

忠烈俠義傳 第二十四回

道我誰的屈申道我是行路的因天黑貺了借光官兒尋
個休兒明呪重禮相謝婦人道你等等又遲了半天方見
有個男子出來打着一個燈籠問道做甚嗎的屈申作個
揖道我是個走路兒的因天晚萬唎拉難以行走故此驚
動借個休兒明呪重禮相謝男子道原來如此這有甚麼
呪請到家裡坐屈申道我還有一頭驢男子道只管拉進
來將驢子拴在東邊樹上便持燈引進來讓至屋內屈申
提了錢敕子陸在後回進來一看卻是兩明一暗三間草
房屈申將敕子放在炕上從新與那男子兒禮那男子還
禮道茅屋草舍盆掌櫃的不要見笑屈申道好說好說男子

Illustration 2: Mimicking Shanxi Dialect in *The Three Knights*.
(Source: Shi Yukun, *Zhonglie xia'yi zhuan*, Chapter 24, 6b. Courtesy of the Yale University Library.)

"Dark (*dairk*)" in Qu Shen's speech is printed first as *hei* to mark the meaning ("dark"), and then slightly below and to the side as *he* to mark his Shanxi accent. Similarly, "Excuse (*'scuse*) me" is double printed as *guang* and *guan*. Paying unprecedented attention to the sound of the dialect accent, the novel offers the reader an image of a dialect speaker that seems to jump from the page thanks to its lively acoustic color.

It is tempting to mistake the registering of the sound of dialect speech in the novel as merely an objective reflection of the fact that the most notable aspect of dialect speech is its sound.[22] At stake in the episode, however, is not a mimetic accuracy that objectively depicts a character in lifelike fashion, but rather a comic theatricality that establishes Qu Shen as a lively, but also unmistakably inferior, character. Simply put, Qu Shen does not just speak with a Shanxi dialect (an accent established in the small characters that mark his pronunciation), he also mispronounces the standard language (something of which the reader is constantly reminded because the correct character is consistently offered first). And, by showing the reader how the merchant from Shanxi misspeaks, the novel at the same time inscribes a power relationship: the distinction between the cosmopolitan elite and provincial outsiders.

The need for the reinscription of a hierarchical relationship between cosmopolitan and provincial follows from an potential loss of distinction, the threat that telling provincial outsider and cosmopolitan elite apart would become impossible. Indeed, the plot of the entire episode involving Qu Shen and Bai Yulian is a comic mise-en-scène of the horrific idea that a low-class provincial outsider might actually take the place of those who belong at the center of the imperial order: the wives of *zhuangyuan*.[23] To state the case slightly differently, the mimicry of a Shanxi accent in "The Shanxi Merchant" is in fact a response to an earlier act of mimicking dialect, namely the moment where the Shanxi outsider threatens to imitate his social betters. Whereas the first act of

[22] As Patrick Hanan noted long ago, Chinese characters normally obscure the crucial phonetic level of language that allows the reader to tell dialects apart. Hanan, *The Chinese Vernacular Story*, 2.

[23] Even though the *zhuangyuan*'s wife does not hail from the capital, she does not speak in a regional accent. In *The Three Knights*, then, regional identity has to be combined with nonelite class background for dialect to be noted. In contrast, *The Tale of Romance and Heroism* notes the dialect accent of a well-educated southerner, Teacher Cheng. See below.

mimicry by the outsider aims to dissolve social distinctions, the second act is used to reinscribe them.

In *The Three Knights* the boundary that defines the Shanxi merchant as culturally inferior is most strongly defined when he threatens to bring upper-class expressions and lower-class accent together by aping the manners of his social betters. Such moments come to the forefront most clearly when Qu Shen attempts to access a higher level of civil discourse by speaking in a more formal manner. When Qu Shen and the male head of a household introduce themselves, for instance, a series of formal bows and ritualistic salutations take place:

> Qu Shen placed his bag on the earthen bed and once again greeted the man. The man returned the greeting and said, "My humble hut is a mere thatched hut, please do not ridicule me for it."
>
> Qu Shen said, "Well put."
>
> The man said, "What is your honorable surname? And where does your business flourish?"
>
> Qu Shen said, "My surname is Qu, I am called Qu Shen (*Sheng*). I run the Prosperous (*Pros'prous*) Woodshop on the avenue (*av'nue*) next to the drum (*droim*) tower in town (*t'own*). However, I have (*'ave*) not yet requested (*requoisted*) you for your honorable surname (*surnaim*)."[24]

Here official phrasing and ritual exchanges are mixed in with dialect sounds to produce a grotesque disjunction. In response to the host's polite phrases—his humble reference to his dwelling as a "thatched hut," for example—Qu Shen describes his own home in heavily accented language that undermines his efforts at elegant civility. And while Qu Shen politely bows back to his host when asking the man's name, he butchers the formal phrase accompanying this ritual. Much as the Shanxi merchant would like to partake in polite, cosmopolitan discourse, his accent keeps him from ever rising above the level of a vulgar provincial.

The mimicry of speech dramatized in "The Case of the Shanxi Merchant and the *Zhuangyuan*'s Wife" reflects a broader social anxiety regarding the imitation of Beijing speech by provincials. An early-twentieth-century bamboo-branch song, for instance, directly addresses the aping of cosmopolitan speech and notes how Beijing people reinscribe the

[24] Shi Yukun, *San xia wu yi*, 1: 147.

crucial difference between metropolitan Beijinger and provincial hick
with a vengeance:

> The language of each province each has its own mark;
> The clear and melodious tones of Beijing are most worthy of extolling.
> There are those who have the bad habit of putting on official airs;
> "Impure Beijing tones" (*yuebai jingqiang* 月白京腔) really make your
> flesh crawl.[25]

The author, Master Youhuan 優患, remarks on the different languages
spoken in the various provinces of the empire, noting how the "clear
and melodious tones" of the capital are of course the best and as such
"most worthy of extolling." Outsiders seek to imitate such metropoli-
tan speech, but Beijing residents, not easily foiled, quickly reestablish
the difference between themselves and their provincial cousins by
coining a specific phrase—"impure Beijing tones"—to ridicule those
who think they can fake a Beijing accent.[26]

If the notion of "impure Beijing tones" seeks to expose the provin-
cial who takes on the airs of a cosmopolitan Beijing native by speaking
in a fake Beijing accent, the notion also crucially serves to hide some
distinctions. Most notably, the poem derives its power by proposing
that the universal language of communication is the language spoken
in Beijing. A note to the poem explains:

> Those who live in the outer provinces cannot communicate through spo-
> ken language and have to force themselves to learn the language of the
> capital so that they can talk. But recently, people from neighboring prov
> inces whose language always has been comprehensible, each time they
> are in Beijing, they take joy in making noise; with the tongue stiff and
> their mouths blunt, their diction is completely off. Their sounds are not
> clear and melodious, and they have the bad habit of putting on official
> airs, which makes it really unbearable to listen to them. People make fun
> of them, calling [their speech], "impure Beijing tones."[27]

The note seeks to paper over some differences easily overlooked. To
begin with, the official, universally spoken language was Mandarin
(*guanhua* 官話), which was close to—but not really the same as—the

[25] Youhuan sheng, "Jinghua baier zhuzhici," 273-297. The poem is on page 291.
Master Youhuan's collection was first published in 1909.

[26] *The Tale of Romance and Heroism* employs the term "impure Beijing tones" to
describe the phenomenon of a provincial outsider attempting to speak with a Beijing
accent. See below.

[27] Youhuan sheng, "Jinghua baier zhuzhici," 291.

speech used in Beijing. Even more important, the actual linguistic medium of the late-imperial period was the written, not the spoken, language. Accusing the provincial of mispronouncing the tones of Beijing, then, serves not only to create a distance between the Beijing accent and the improper accent of the provincial outsider, but also to establish the mirage of a homogeneous Beijing accent that elides the difference between local and imperial Beijing and between voice and text.

This supposed elision between voice and text made the late-nineteenth-century martial arts novel attractive to the New Culture critics and champions of the vernacular. Seeking to establish a language that would help unite China as a modern nation, scholars such as Hu Shi could not but be attracted to novels such as *The Three Knights and the Five Gallants* and *The Tale of Romance and Heroism*, whose language seemed such a direct reflection of the ideal vernacular—that is, a direct transcription of the spoken voice of the Chinese people into text.[28] As the notion of "impure Beijing tones" and the example of double printing shows, however, the process of translating voice into text is hardly a process of easy equivalence. Rather, the creation of a standard Beijing pronunciation depended on a complicated process of elision of internal differences, an elision established through the distinction from the provincial other.

Moreover, even though scholars such as Hu Shi would have liked to have seen novels such as *The Three Knights* as examples of a pro-tonational vernacular form, the way these martial arts romances transcribed spoken voice into text did not necessarily point toward a single nation speaking in a univocal fashion. To be sure, giving printed form to the sound of the spoken language allowed, to paraphrase Marshall McLuhan's famous dictum on the relationship between print culture and political identity, readers "to *see* their vernaculars for the first time, and to visualize unity and power in terms of the vernacular bounds."[29] However, as the double printing of the late-Qing martial arts novels makes clear, the identity produced through visualization of the spoken voice was not one of homogeneous national unity, but rather one that

[28] See in particular Hu Shi, "*San xia wu yi* xu," 293–323.

[29] Marshall McLuhan's original quotation includes the term "national," reading, "For the hot medium of print enabled men to *see* their vernaculars for the first time, and to visualize national unity and power in terms of the vernacular bounds...." In McLuhan, *The Gutenberg Galaxy*, 138.

placed different and clearly hierarchalized localities within a frame-work of imperial power.

Between Oral Storytelling and Textual Erudition: Cross Talking in
Wen Kang's Tale of Romance and Heroism

Earlier in this essay I referred to a description by the author Xia Renhu, who suggested that a true cosmopolitan identity was not based on native ability in a single language, but instead on the superb mastery of all languages. The appreciation of dialect mimicry in print, I argue, follows a similar logic. It speaks not of a straightforward transcription of the oral language, but rather of a cultured connoisseurship of multiple languages, the oral and the textual. To explore the process through which this cosmopolitan appreciation of printed orality is established, I first focus on the notion of cross talking, that is, the oral performance of dialect accents by storytellers. I then juxtapose the art of cross talking with the scholarly appreciation of dialect accents in the philological tradition of *kaozheng* scholarship. Finally, I focus on the Beijing martial arts novel that first brought the two together, Wen Kang's *Tale of Romance and Heroism*. As analysis of the novel shows, the acoustic pleasure of this text is found in a unique play with the boundaries between voice and text, allowing the author to create an identity that draws its prestige from both, and creating a reader who congratulates himself on being a connoisseur of storytelling *and* philology.

To begin understanding the appearance of printed dialect mimicry in these popular romances, we first need to trace its roots to actual oral storytelling performances, in particular the performance of "cross talking" (referring here, as noted above, to a storyteller's mimicry of regional accents to act out different characters). A late nineteenth-century Beijing bannerman's tale (*zidishu* 子弟書), "A Cosmopolitan Teller of Tales" (*Fengliu cike* 風流詞客), describes such an oral performance by the "Pockmarked Cross Talker" (*xiangsheng mazi* 相聲麻子), a storyteller from Shuntian 順天 prefecture (Beijing), who plies his trade on the streets of the capital:

> Best of all to listen to was the way he imitated different sounds.
> Sharp tones and round tones, thick tones and thin ones, each had its phrasing.
> When he imitated toothless old women with stiff lips, he would half swallow and half spit [the words].

> When he imitated the petulant tones and coy words of young women, he would sound neither hard nor soft.
> When he imitated the shouting and cursing of drunkards, he would strike one pose after another.
> When he imitated scholars, their mouths full of quotations, he would be really pedantic.
> When he imitated rural slang, every word would really sound like the eight prefectures.
> If he imitated southern speech, every word would be like those of the Three Rivers Country.[30]
> The country speech of the Western District, he could really hit it off.
> Only his Shandong dialect was better still.[31]

As this segment suggests, the cross talker excels not simply in the mimicry of a single voice. Rather, what is stunning about the man's act is the way it brings a whole profusion of characters, a riot of voices together within a single performance. Like the capital, the storyteller here is presented as a center that gathers together the speech from all other cardinal directions, the north, the south, the west, and the east. The linguistic superiority of the cosmopolitan teller of tales, in short, is not based on fluency in a single native language, but rather on his ability to mimic all languages.

Given that so many of the late-nineteenth-century martial arts novels claimed to be based on popular storytelling performances, the appearance of different dialect accents on the pages of Beijing martial arts novels thus would at first seem to be an attempt to translate this typical cosmopolitan linguistic acumen into print.[32] For instance, both storytellers associated with the novel *The Tale of Everlasting Blessings and Peace, Part I,* Jiang Zhenming and Hafuyuan, were famous for their uncanny ability to cross talk by putting on a Shandong dialect. In the case of Jiang, this reputation is not surprising; the man actually hailed from Shandong province. Jiang, however, seems to have faithfully transmitted his accent to his disciple Hafuyuan, a bannerman

[30] The term "Three Rivers Country" probably refers to the southern region of Guangdong, where there are three famous rivers, the Xijiang, Beijiang, and Dongjiang.
[31] "Fengliu cike."
[32] As I have shown elsewhere, the late-nineteenth-century martial arts novels are remarkable in alerting their readers to their storyteller lineage in a variety of paratextual features, such as prefaces and title pages, often explicitly mentioning the particular storyteller associated with telling the novel. See Keulemans, "Recreating the Storyteller Image."

turned Peking opera actor, turned storyteller, who was equally famous for his ability to mimic Shandong dialect.[33] In the first printed edition of *The Tale of Everlasting Blessings and Peace, Part I*, traces of this popular oral act can indeed still be found in the occasional snippet of double-printed dialogues spoken by its protagonist "Shandong Ma."

If in the case of *The Tale of Everlasting Blessings and Peace, Part I*, the link between storytelling practice and printed text seems obvious, in the case of *The Three Knights* the relationship is much more tenuous. Not only do we not have references to Shi Yukun ever practicing cross talking, but the earliest handwritten manuscripts on which *The Three Knights* is based, a series of storyteller librettos closely associated with the Shi school of storytelling, do not include such imitation of dialect either. Take, for instance, the way in which the earliest textual version of the story of the Shanxi merchant and the *zhuangyuan*'s wife, the libretto *The Cases of Judge Bao* (*Bao gong'an* 包公案) depicts the language spoken by Qu Shen:

> Isn't this the black donkey that I rode?
>
> *Zhei bu shi wo qi de hei lü me?*
>
> 這不是我騎的黑驢麼?[34]

Though presumably the closest to an actual oral storytelling performance, this line does not employ any dialect markers to signal the accent of Qu Shen's regional speech. In contrast, a slightly later version of the tale and a more immediate predecessor to the printed novel, *The Aural Record of the Cases of the Dragon Diadem Scholar* (*Longtu erlu* 龍圖耳錄), is filled with dialect speech and accent markers:

> Hey! Dat (*that*) blaeck (*black*) donkey is moin (*mine*).
>
> *Wu! Zhei huai(ge) he(hei) lü hai shi e(wo) de lie.*
>
> 唔! 這懷(個)喝(黑)驢還是餓(我)的咧.[35]

Compared to the original storyteller libretto, the later text, with its bevy of exclamations and, in particular, dialect markers, is remarkably loud. Or, to state it differently, the text closest to the actual storyteller

[33] For more on the storyteller Hafuyuan, see Zhang Cixi, *Renmin shoudu de Tianqiao*, 123.

[34] Shi Yukun, *Bao gong'an*.

[35] Shi Yukun, *Longtu er lu*, 276.

performance ironically appears to be the most reticent in representing dialect.

The "silence" of the earliest storyteller libretto, *The Cases of Judge Bao*, however, should not necessarily mean that the storyteller Shi Yukun did not employ dialect mimicry. Arguably, the absence of dialect markers shows instead that readers did not yet feel the need for paratextual markers of dialect to imagine the text acoustically. Locally produced by a small shop that specialized in the transcription of popular storyteller tales and opera scripts, the libretto of *The Cases of Judge Bao* was presumably read by readers who were so familiar with storytelling practices, either by Shi Yukun or others, that they would appreciate the dialect accent of the Shanxi merchant even without paratextual prompts. Focusing on similar markers of storyteller performance in other popular martial arts texts, Margaret Wan has made the point eloquently that, if dialogue markers such as "he said:...." (*yue* 曰), "serv[ed] a function analogous to punctuation, then one would expect to find them less often in texts closely related to performance, and more often in texts that are primarily for reading."[36]

The absence of dialect speech markers in the earliest versions and their appearance in later versions also leads to a second point, namely, that these markers were not simply a direct transcription of voice into text, but rather a textual sign that needed to be invented so as to elide the absence of speech. Indeed, as a textual device geared toward writing the sound of a dialect accent, the double printing of characters seems indebted not as much to storytelling performance as to the philological interests of Qing-dynasty literati. As various scholars have pointed out, one of the major intellectual endeavors of the Qing dynasty revolved around the formulation of a set of methodologies that would allow literati to reconstruct the true meaning and true form of classical texts and thereby restore the ideal political order of the ancient sages.[37] Interestingly enough, the two fields through which the meaning of classical texts could best be established had close ties

[36] See Wan, *"Green Peony" and the Rise of the Martial Arts Novel*, 137.

[37] Take, for instance, the following preface to one of his studies by Gu Yanwu (1613–82), one of the first major scholars of phonology in the Qing dynasty: "...To summarize the ten divisions of ancient pronunciation, I prepared the *Table of Ancient Pronunciation* in two chapters. As a result, the Six Classics are now readable....Heaven, by preserving these writings, has demonstrated that the sages will one day return and restore the pronunciation of today to the clarity and purity of ancient times...." Elman, *From Philosophy to Philology*, 61.

to the spoken language: dialect studies and phonology. In pursuit of textual knowledge, a host of ever-more-sophisticated studies provided increasingly detailed differentiations of sound by recording the pronunciation of various rhyme categories as well as dialect accents, thus creating a written metalanguage that allowed the mapping of the spoken word.[38]

At first glance, nothing might seem further removed from the popular world of dialect performance in the marketplace or the printing of vulgar novels than the elite world of literati scholarship. The rise of dialect literature in the nineteenth century is most likely related, however, to *kaozheng* scholarship.[39] Indeed, it bears remembering that many of the most famous eighteenth-century novels were not popular tales intended for barely literate readers, but rather works of remarkable sophistication that brought literati interest in textual scholarship to the vernacular page. For instance, Li Ruzhen's 李汝珍 (1763–ca. 1830) early nineteenth-century novel *Flowers in the Mirror* (*Jinghua yuan* 鏡花緣, 1828), an exemplary literati novel, includes extensive discussions about rhyme categories and scholarly lectures about interlinguistic differences.[40] This penchant for scholarly discussions of phonology is not surprising because, long before he published his novel, Li Ruzhen had already penned a work he himself would have found much more important, *Master Li's Mirror of Rhymes* (*Lishi yinjian* 李氏音鑒; first published in 1810), a comprehensive study of phonology.[41] Yet even though a work such as Li Ruzhen's *Flowers in the Mirror* incorporates the phonological discussions of the *kaozheng* scholars into the text, this scholarly interest in linguistic detail does not necessarily translate into literary praxis. Discussions about dialect in the novel are written in a standard, indeed quite scholarly, *baihua*.

In contrast, the later Beijing novel, *The Tale of Romance and Heroism*, not only discusses matters of dialect and rhyme categories in a scholarly manner, it does so in a language that gives this erudite

[38] For a brief overview of the study of rhyme categories during the Qing, see Hu Anshun, *Yinyunxue tonglun*, 243–275; see also Elman, *From Philosophy to Philology*, 212–221. For a good overview of Qing dynasty dialect studies, see He Gengyong, *Hanyu fangyan yanjiu xiaoshi*, especially chapter 6, 59–83.

[39] See Song Lihua, "Fangyan yu Ming Qing xiaoshuo ji qi chuanbo," 41.

[40] For good examples of such discussions of phonology see Li Ruzhen, *Jinghua yuan*, chapters 17, 31.

[41] For one of the first discussions of Li Ruzhen's accomplishments in phonology, see Hu Shi, "*Jinghua yuan de yinlun*," 391–423.

knowledge of the spoken word a matching literary form. The result
is a text that is curiously heteroglossic, playfully acting out scenes of
linguistic confusion amongst speakers of different dialects and socio-
lects, all the while self-consciously juxtaposing the spoken and written
language to comic effect. As David Rolston has pointed out, one way
in which the author Wen Kang constructs this tension between oral-
ity and textuality is through the construction of different narrators
and authors. Not only does Wen Kang construct the liveliest story-
teller voice in the history of vernacular fiction, he also juxtaposes this
storyteller with a fictional author, a pedantic scholar who supposedly
wrote the novel in the isolation of his studio by the light of a candle.[42]
The novel, in short, does not elide the artificiality of either oral or
textual provenance, but instead consistently contrasts the two, taking
pleasure not in the mimetic affect of either register of language, but
rather in lampooning any reader who would forget the artificiality of
such mimetic affects.

Nowhere does this contrast between scholarly textual and lively oral
tone come to the fore more strongly than in the scene where Wen
Kang provides the first example of cross talking in print. The scene
tells of a southern scholar, Master Cheng (Cheng shiye 程師爺), who
has come to the Beijing household of his student to congratulate the
latter on passing the examinations with the highest honors. When
Master Cheng turns to the mother of the successful candidate, he con-
gratulates her as follows:

> After these two phrases, he tried to speak in a Beijing accent, "Dis (*this*)
> is cawled (*called*) 'The son ov (*of*) a good bowmaker, will be able to lea'n
> (*learn*) how to make a sieve; the son ov (*of*) a good foun'er (*founder*)
> will be able to lea'n (*learn*) how to make a fir ga'ment (*garment*).'[43] Dis
> (*this*) iz (*is*) all da (*the*) rezult (*result*) of your fam'ly (*family*) teach-
> ing. Wat (*what*) merit do Ai (*I*) have? I'm not worty (*worthy*), I'm not
> worty (*worthy*). Pleaze (*please*), let me congrittalate (*congratulate*) my
> shissa-ter-in-law [the two syllables 'shissa' and 'ter' should be read aloud
> together according to the *qie yin*, forming the word 'sister']."

> *Ta shuo le zhei liang ju, bian piezhe jingqiang shuodao, "gu(zhei) jiao
> zuo(zuo) 'lianggong zi(zhi) zi, bi ya(xue) wei ji; liang ya(ye) zi(zhi) zi,
> bi ya(xue) wei qiu.' Gu(zhei) dou si(shi) lao xiansang(sheng) ge(de) ding*

[42] Rolston, *Traditional Chinese Fiction and Fiction Commentary*, especially 304–311.
[43] This is a famous passage from the *Classic of Ritual* (*Liji*), creating a juxtaposition
of classical text and inappropriate pronunciation that accentuates the comedy.

(ting)xun, yong(xiong)di e(he) gong zi(zhi) you? San(can) kuai(huai), san(can) kuai(huai)! Saofu nayin (er zi qieyin hedu, gai 'ren' zi ye) mian-qian, ya (ye) qin(qing) huhu(hehe)!

他說了這兩句, 便撇着京腔說道, "顧(這)叫胙(作) '良弓滋(之)子, 必鴨(學)為箕; 良雅(冶)滋(之)子, 必雅(學)為裘.' 顧(這)都四(是)老先桑(生)格(的)頂(庭)訓, 雍(兄)弟哦(何)功滋(之)有? 傘(慚)快(愧), 傘(慚)快(愧)! 嫂夫納銀(二字切音合讀, 蓋 '人'字也)面前, 雅(也)窺(請)互互(賀賀)![44]

Unlike examples of vernacular writing that seek to elide the difference between voice and text, Wen Kang employs double printing to produce both textuality and orality, juxtaposing elite scholarly concerns and vulgar oral performance to create a self-consciously theatrical effect that showcases the author's linguistic expertise by foregrounding the text's artifice. On one level, Wen Kang's use of double printing borrows from the more popular storyteller use of cross talking, making fun of a southerner who puts on pedantic airs and who, despite his quotation of classical texts, cannot help but come across as an utter fool. Yet on another level, Wen Kang clearly also employs scholarly textual devices to produce this popular oral effect. Most notably, Wen Kang employs the *qieyin* (切音) system (used by scholars to describe the pronunciation of characters by breaking the pronunciation in two), writing the characters *na* and *yin* and explaining that when "read aloud together" it will produce the word for "sister" pronounced in a typically southern way as *nin*. Playing with textuality and orality, Wen Kang here puts on display his linguistic skill in both philological and storyteller's practice. At the same time, Wen Kang calls upon his reader to read like a "cosmopolitan" man, to read the silent text of philological orthodoxy with an ear for the sound of locally produced cross talking.

Conclusion: Modern Echoes

The late-nineteenth-century experiment with printing dialect mimicry did not last. The system of double printing, devised to record the sound of dialect speech, proved too cumbersome. As the narrator of the first sequel to *The Three Knights*, the 1891 novel *The Latter Five Gallants* (*Xiao wu yi* 小五義), put it, "If we were to add the Shanxi accent to

[44] Wen Kang, *Ernü yingxiong zhuan*, 2: 876.

each character, you would not be able to understand it anymore when reading, and when listening you would simply feel confused."[45] In the twentieth century, the printed mimicry of dialect was used only by a now almost-forgotten Beijing bannerman author, Cai Youmei 蔡友梅 (also known as Song Youmei 宋友梅; pen name Sungong 損公), and even this writer admitted that "this mimicry is not only annoying, it is a pain (xue budan taoyan, erqie mafan 學不但討厭, 而且麻煩)."[46]

The use of double-printing characters to register the sound of dialect speech, however, did not disappear merely because it was "a pain." More important were the profound structural shifts that took place in the writing of vernacular novels. The northern vernacular was elevated to the status of national language and displaced the classical language in the process. The novel took over the role of poetry as the single most important genre of elite writing, heralded as the genre most suited to reawaken the Chinese nation. Mimetic models of realism began to displace the self-consciously performative aspects of fictional writing. Authors who had previously anonymously dallied with the vernacular novel as acts of literati connoisseurship were either outmaneuvered by intellectuals too seriously interested in saving the nation to engage in literary play or displaced by professional writers who were too invested in reaching a popular audience to indulge in obtuse linguistic games. And, as these shifts took place and a more modern notion of the individual author appeared (see the introduction to this volume), the central rhetorical figure of the storyteller disappeared from the pages of Chinese fiction, taking with him the lively voice that had animated dialect mimicry.

As argued by a variety of scholars, the shifts that took place in the twentieth-century literary scene were very real, but can still be overstated. As these scholars begin to explore genres, languages, and modes of writing that fall outside of the May Fourth narrative of modern Chinese literature, it is becoming increasingly clear that a variety of repressed modernities inherited from the late Qing have remained irrepressibly relevant.[47] The writings of the above-mentioned Cai Youmei, arguably the most influential of the early Beijing-style

[45] Shi Yukun, Xiao wu yi, 293.

[46] Cai Youmei, "Cao Erjing [Ergeng]," 629. For a general discussion of the author and his works, see Lei, "Jindai Beijing de Manzu xiaoshuojia Cai Youmei," 108–16.

[47] See, among others, Ellen Widmer's essay in this volume and David Wang, Fin-de-Siècle Splendor.

novelists, present a perfect example of the continued interest in modes of writing seemingly outdated by the onset of a singular twentieth-century modernity.[48]

Most notably, Cai continued the storyteller/novelist tradition that had supposedly come to an end with the arrival of the twentieth century. Writing in a lively Beijing vernacular, Cai peppered his writings with storyteller clichés and colloquial asides to his "listening audience," referring to his own writing as "storytelling" and ending his tales with the usual storyteller promise to tell a new tale the next day. Cai Youmei explicitly acknowledged his affinity with historical storytelling practices, comparing his own novels to the tales of a nineteenth-century storyteller, Wu Futing 吳輔亭, not coincidentally the "student-brother" of Hafuyuan, and likewise famous for his dialect mimicry in the tale *Everlasting Blessings and Peace*.[49] Cai Youmei's reference to Wu Futing is thus not coincidental, since Cai is one of the few, if not the only, twentieth-century authors who still employed double printing to produce the effect of dialect mimicry.

Yet even though the writings of Cai Youmei recall the sounds of earlier vernacular fiction, they also represent a marked shift. When Cai promised to continue "telling his tale" the next day, he did so in a daily newspaper, *The Progress* (*Jinhua bao* 進化報), a modern vernacular-style newspaper of which Cai was both cofounder and main editor. Though comparing himself to storytellers of yore, Cai was writing what he called a "social novel" (*shehui xiaoshuo* 社會小說), a concept that would have been meaningless to his storyteller predecessors. Though writing in a style that was unmistakably "Beijing," Cai was clearly influenced by the techniques of Shanghai novelists such as the newspaperman Bao Tianxiao 包天笑 (1875–1973). While using a variety of Beijing expressions, Cai was also aware that he was writing for a national audience, and although writing tongue-in-cheek, he still acknowledged that both overly vulgar and overly obscure Beijing phrases had to be avoided, or at least annotated.[50] Indeed, while describing the old bannerman customs with great gusto, Cai admitted

[48] For a more extensive discussion of the life and work of Cai Youmei, see Hatano Tarō, "Hyōron tanpen shakai shōsetsu *Shōgaku*," in *Chūgoku shōsetsushi kenkyū*. For a more general discussion of early-twentieth-century Beijing authors, see Yu Runqi, "Wo guo Qingmo Minchu de duanpian xiaoshuo," in *Qingmo Minchu xiaoshuo shuxi*, 1–17.

[49] See Cai Youmei, "Xiao E," 2: 323.

[50] Cai Youmei, "Kuduanyan," 510–546.

that these would have to be relinquished in order to create a new modern China. As to the storyteller figure central to vernacular fiction, Cai did employ the various phrases and mannerisms typical of the storyteller, but added to these phrases a new, explicitly autobiographical sensibility completely foreign to the vernacular authors of the earlier era.

Cai's hybrid mode of writing, part storytelling and part journalism, part self-conscious theatrics and part observation-based realism, is also revealed in the way Cai recorded the sounds of dialect accents. In his most famous work, the 1907 short story "Xiao E" (小額), for instance, Cai Youmei includes heavily theatrical moments of southern dialect mimicry reminiscent of Wen Kang's earlier inclusion of southern dialect speech. Yet Cai also appended a rich bevy of pronunciations to his description of everyday Beijing phrases. Thus the reader learns that in old Beijing, people pronounced the term "pan-fried cakes dipped in oil" (*shaobing youzha guo* 燒餅油炸果) not with a final *guo* but a *gui* (*yin gui* 音鬼), that "everybody" (*dajiahuo* 大家伙) was pronounced as "everybro" (*dajiahui* 大家會), and that the word *xun* in the phrase *nao xun le* 鬧薰了 was pronounced with a fourth tone (*qusheng* 去聲). Indeed, as if wanting to reflect the disappearance of a society in which crucial distinctions of status were marked by different ways of addressing others, Cai tells the reader that the honorific variant of the third person pronoun *ta* 他 was pronounced as *tan* 貪.[51] As in the late nineteenth century, Cai here employs the double printing of characters as a way of registering the sound of a dialect accent, but as is clear from the few examples listed here, no longer was such sound employed solely to mimic the mispronunciations of regional "others." Instead, as an acoustic reflection of the ever-more-marginal status of the capital, characters were now double printed to record the dying language of Beijing bannermen. Perhaps even more important, whereas the sounds performed by the nineteenth-century storyteller persona had sought to attract attention to the artful artifice of the speaker himself, in Cai Youmei's recording of the speech of old Beijing, the sounds recorded did not necessarily perform such a theatrical function. Instead, these sounds sought to recall a disappearing world with as much mimetic detail as possible, ushering in new modes of direct, realist representation while borrowing a theatrical voice that now had come to represent the past.

[51] Cai Youmei, "Xiao E," 275, 286, 288, and throughout.

SPREADING THE DHARMA WITH THE MECHANIZED PRESS: NEW BUDDHIST PRINT CULTURES IN THE MODERN CHINESE PRINT REVOLUTION, 1866–1949

Jan Kiely

The Buddhist contribution to the history of imperial Chinese print culture is well known. Much of it was animated by what has been termed the Buddhist "cult of the book," a historically evolved culture in which the copying, printing, distribution, and use of sacred scriptures were deemed religious practices of metaphysical consequence. Buddhist sutras, like morality books, were not to be distributed solely to propagate the faith or to assist worship; they often explicitly promised karmic merit to those who reproduced and circulated them.[1]

What happened to this once potent tradition in modern times? For the most part, the dominant narratives of twentieth-century Chinese history ignored the modern Buddhist experience. Did Chinese Buddhists have no part in the print media revolution of the late nineteenth and early twentieth centuries? This essay contends that Chinese Buddhists actively engaged in the new print culture of the late Qing and Republican eras, a distinctive culture that arose with the importation of mechanized print technologies and the concentration of publishing in a few urban industrial-commercial centers. These technologies made long-standing Buddhist dreams of sacred-text reproduction possible on an unprecedented scale. Moreover, Buddhists involved with the urban publishing industry established new types of texts that were used and conceptualized in innovative ways. The physical and cultural geographies of Buddhist publishing shifted, and previously unknown organizations and patterns of production emerged. Buddhist monks and laity formed new textual communities of writers, producers, distributors, buyers, and readers. A mass audience for Buddhist texts was conceived and constituted by Shanghai publishers churning out popular titles. The result was a series of new Buddhist "cultures of the

[1] Xiao Dongfa, *Zhongguo tushu chuban yinshua shilun*, 42–47, 61, 117, 123; Teiser, *The Scripture of the Ten Kings*, 10; Kieschnick, *The Impact of Buddhism on Chinese Material Culture*, 160–181; Dai Fanyu, *Zhongguo fodian kanke yuanliu*, 148–149.

book" that gained a significant, if now largely forgotten, prominence and contributed to the formation of China's modern print culture.

Yang Wenhui and "Buddhist Revival" Woodblock Sutra Carving

The term "Buddhist revival" has been used to refer not to a unified movement but to an array of monastic reform and reconstruction projects, a proliferation of new Buddhist organizations, philanthropic and educational enterprises, and a general rise in popular and elite interest in Buddhism from the 1860s through the 1940s. Scholars attempting to give some narrative order to this "revival" have often traced its origin to Yang Wenhui 楊文會 (1837–1911) and his Nanjing publishing house.[2] Even if such claims are overstated, they surely suggest the importance of publishing to modern Chinese Buddhist activism. And certainly the case of Yang and his sutra printing house provides insight into an obscure yet notable aspect of Chinese Buddhist print culture in transformation.

Like many Buddhist conversion tales, Yang Wenhui's story begins with a personal trauma and a book. A native of Shidai 石埭 county, Anhui, and a veteran of the Qing war with the Taiping rebels, Yang was convalescing from a serious illness in Anqing in 1864 when he read the *Mahayana Awakening of Faith* (*Dacheng qixin lun* 大乘起信論). Transfixed by this ancient text and, later, by the *Surangama Sutra* (*Lengyan jing* 楞嚴經), Yang credited them with his conversion to Pure Land (Jingtu 淨土) Buddhism. A passionate interest in sacred texts formed the core of his Buddhist identity. In 1866, a year after arriving in Nanjing as a supervising manager of urban reconstruction in Zeng Guofan's post-Taiping administration, Yang established the Jinling Scripture Carving House (Jinling kejingchu 金陵刻經處) with the intent of recovering and reproducing Chinese Buddhist texts and disseminating them for the karmic salvation of all. Jinling became the leading Buddhist publisher of the last decades of the Qing, and continued to produce high-quality woodblock print sutras into the 1950s.[3]

[2] Welch, *The Buddhist Revival in China*, 1–2; Wing-tsit Chan, *Religious Trends in Modern China*, 60–61; Kenneth Chen, *Buddhism in China*, 448; Deng Zimei, *Chuantong fojiao yu Zhongguo jindaihua*, 23–30, 40, 84–85.
[3] Chang Kangping, "Jinling kejingchu de bianqian," 361; Xiao Ping, *Jindai Zhongguo fojiao de fuxing yu riben fojiaojie de jiaowang lu*, 132; Chen and Deng, *Ershi shiji Zhongguo fojiao*, 80. Soothill and Hodous, *A Dictionary of Chinese Buddhist Terms*,

Yang Wenhui's enterprise arose in the context of the cataclysmic destruction caused by the Taiping Rebellion in southern China. Yang had witnessed horrific devastation in his home district and, in Nanjing, he lived amidst the ruins of the sackings of 1853 and 1864, first by the Taipings and then by government troops. The Taipings ravaged monasteries and their printing establishments and burned Jiangnan libraries that had preserved sacred texts. For Yang, the suffering and destruction represented a karmic catastrophe; the immolation of scriptures was no small part of this tragedy, and a loss that needed to be reversed.[4] "In areas that soldiers had burned," he wrote, "one saw only small volumes of the *Amitabha Sutra* [*Amituo jing* 阿彌陀經] and even now one cannot find large volumes of the *Larger Sukhavativyuha Sutra* [*Wuliangshou jing* 無量壽經] or the *Sixteen Guanyins Sutra* [*Shiliu guanyin jing* 十六觀音經]."[5] To rectify matters, he embarked on a quest to find, preserve, reproduce, and distribute Buddhist texts as an act of cultural and metaphysical recovery. The scriptural heritage had to be reconstituted in order to spread the Dharma and ensure karmic merit for all.

In 1878 Yang joined the staff of the Qing legation in London, living there and then in Paris for several years. In London he discovered a treasure trove of "lost" Chinese Buddhist scriptures in the British Museum and other collections. He also met a Japanese scholar, Nanjō Bunryū 南條文雄 (1849–1927), then at the University of Oxford, who shared his enthusiasm, became a lifelong friend, and joined him in seeking out hundreds of sacred texts in European, Japanese, and Korean collections.[6] Traveling the globe by steamship and train, and interacting with foreigners, Yang Wenhui was thoroughly engaged with the changing world.

Due in large part to his instruction of a generation of reformers and the popular educational projects he embraced in his last years,

84, 402; Wu Yankang, "The Revered Master Deep Willows," 14, 19–20. See also Wu Yankang, "Yang Renshan and the Jinling Buddhist Press." *Dacheng qixin lun* is the *Mahayana sraddhotpadasastra* attributed to Asvaghosa and first translated by Paramartha in 553. *Lengyan jing* is a Tantric treatise translated by Paramiti in 705.

[4] Chen and Deng, *Ershi shiji Zhongguo fojiao*, 80. Wu Yankang, "The Revered Master Deep Willows,"16–18.

[5] Yang Wenhui, *Jingtu sijing ba*, cited in Chen and Deng, *Ershi shiji Zhongguo fojiao*, 79.

[6] Chang, "Jinling kejingchu de bianqian," 361; Wu Yankang, "The Revered Master Deep Willows," 20–21, 25. See also Pittman, *Toward A Modern Chinese Buddhism*, 34–42.

Yang has been remembered as a founding figure of modern reformist
Buddhism. Nonetheless, throughout his long career as a publisher he
consistently pursued an intrinsically conservative agenda to recover
and lovingly reproduce a lost textual legacy. Jinling became renowned
for its exquisite woodblock carving, maintaining this traditionalist
style long after most other publishers had turned to imported modern
technologies. Indeed, it perfected a quality of carving considered far
superior even to the best xylography of the early nineteenth century.[7]
Although Jinling mostly published quite basic Pure Land texts, Yang
eschewed the opportunity to mass-produce cheap tracts with mecha-
nized presses in favor of hand-printing limited editions of exquisite
volumes that materially represented sacred value. The attention to aes-
thetic quality had much to do with the fact that the subscription to a
print run was taken as a Buddhist ritual act. When, for instance, the
writer Zhou Shuren 周樹人 (aka Lu Xun 魯迅) subscribed to a run
of the *Hundred Parables Sutra* (*Baiyu jing* 百喻經) from the Jinling
Scripture Carving House in 1914, he was performing a filial ritual act
on behalf of his ailing mother.[8]

As with religious images or statues, the artistry of such ritual repro-
ductions mattered. The sense of value preserved in these volumes was
generated by their "graceful ancient style" (*guse guxiang* 古色古香)—
the look, feel, and smell of a fine book, qualities that became even
more important as the market gradually filled with cheap, industrially
produced books.[9] In rejecting technological advances and pursuing a
preservationist agenda of publication—one that produced sacred texts
in a self-consciously traditionalist, aestheticized style—Yang Wenhui
created a new kind of Buddhist text whose cultural meaning was con-
veyed through its material form and its reference to the past.

Yang was not alone in this endeavor. Jinling was only the most
prominent in a series of Buddhist woodblock-carving houses estab-
lished or revived in the last decades of the Qing in Yangzhou, Suzhou,
Changzhou, Hangzhou, Changsha, and Beijing. The most celebrated
were those at the Xiannü 仙女 Temple and the Fazang 法藏 Monas-
tery in and around Yangzhou; the Fengxiang Tripitaka Carving House
in Yangzhou; and the Piling Sutra Carving House (Piling kejingchu

[7] Chen and Deng, *Ershi shiji Zhongguo fojiao*, 80.
[8] Chang, "Jinling kejingchu de bianqian," 362; Soothill and Hodous, *A Dictionary of Chinese Buddhist Terms*, 217.
[9] On *guse guxiang*, see Zhu Ziqing, "Wenwu, jiushu, maobi," 471.

毗陵刻經處), founded by Chan master Yekai 冶開 (1852–1922) at Changzhou's Tianning 天寧 Monastery in 1901. Well into the 1940s, these establishments followed traditional methods and seasonal customs in carving stylistically refined woodblocks used in printing Buddhist texts intended for veneration and ritual use.[10]

Buddhist Revival Publishers and Modern Urban Print Culture

Early in the twentieth century, an increasing number of Buddhist lay and clerical elites were inspired to progressive social and political activism. Liang Qichao 梁啟超 (1873–1929), Zhang Binglin 章炳麟 (1868–1936), and Cai Yuanpei 蔡元培 (1868–1940) promoted Buddhism as a potential new source of public morality. Some were roused by the examples and the perceived cultural threats of Euro-American Christian and Japanese Buddhist missionaries and their charitable-educational enterprises. Others responded to the opportunities presented by the loosening of imperial controls on religion, or organized politically in defense of Buddhist properties threatened with expropriation by state-building officials or militarists.[11] New Buddhist associations, educational organizations, and philanthropic societies arose, along with publishing ventures that represented these organizations or sought to spread the Dharma on a mass scale.

Many Buddhist reformers were caught up in the print-media revolution. The importation of mechanized printing primarily into the treaty-port bases of imperialism and global capitalism by Christian missionaries in the second half of the nineteenth century began a process of technology transfer to China that led to a shift from woodblock carving to the use of stone-based lithography, lead type, and, finally, photomechanical printing. The combination of these new technologies with intensifying capital and commercial development saw the

[10] Xiao Dongfa, *Zhongguo tushu chuban yinshua shilun*, 123, 152–153; Chen and Deng, *Ershi shiji Zhongguo fojiao*, 81, appendix 477; Chen Jilong, "Ye Kai qingrong chanshi shilue," 340–341. Piling kejingchu printed over 960 different Buddhist texts in the Republican era.

[11] Sin-wai Chan, *Buddhism in Late Ch'ing Political Thought*, 9, 13, 18, 30, 42, 146–147; Ge Zhuang, *Zongjiao he jindai Shanghai shehui de bianqian*, 87–88. Ge Zhaoguang, "Xihu que zi dong liulai," 144; Chang, "Jinling kejingchu de bianqian," 362; Welch, *The Practice of Chinese Buddhism*, 11–12; Deng Zimei, *Chuantong fojiao yu Zhongguo jindaihua*, 19, 28, 49, 54, 97–98; Tsu, "Present Tendencies in Chinese Buddhism," 87–92.

rise of three major urban book centers at the end of the Qing: Beijing, Tianjin, and Shanghai. As Christopher A. Reed has shown, Shanghai soon became by far the most important of these.[12] In his memoir, Master Tanxu 倓虛 (1875–1963) recalled, "[S]ince the beginning of the Republic already some thirty-years ago, printing enterprises, movable type, and the kinds of paper [needed for printing] are so exponentially more convenient than before...."[13]

Of course, the existing late-imperial institutions of Buddhist publishing did not vanish overnight in response: the Dafo 大佛 Monastery in Beijing and monastic publishing operations in Yangzhou retained their significance into the 1920s. And, when poet and essayist Zhu Ziqing 朱自清 (1898–1948) sought Buddhist tracts in early 1920s Beijing, he still went to the Jiufeng 鷲峰 Temple on Wofosi 臥佛寺 Street. Yet, increasingly, new organizational patterns and geographies of Buddhist publishing arose. Most Buddhist text printing shifted to lay-managed presses independent from monasteries, and were concentrated in and influenced by the commercial practices of the urban publishing centers—above all, Shanghai.[14] The advantages of the new technologies and distribution structures were quickly apparent to those interested in producing mass quantities of salvationist texts at low cost. By 1909, even many publishers intent on reproducing rare Tripitaka volumes were experimenting with the new technologies.[15]

In the 1910s and 1920s, the interests of elite lay devotees and some clergy in expanding propagation of the faith fueled the emergence of new Buddhist promotional societies, publishing establishments, and bookstores. The Bodhi Society (Jueshe 覺社), organized in Shanghai in 1918 by the reformist monk Taixu 太虛 (1890–1947) with the assistance of such scholarly and business luminaries as Zhang Binglin, Jiang Zuobin 蔣作賓 (1884–1942), and Wang Yiting 王一亭 (1867–1938), and the populist Buddhist Propagation Society in Beijing supported

[12] Yang and Zhang, "Tianjin chuban shi gailue," 102–103, 115–116; Reed, *Gutenberg in Shanghai*, 10, 26, 28, 62.

[13] Tanxu, *Yingchen huiyi lu*, 355.

[14] Pratt, *The Pilgrimage of Buddhism*, 381; Zhu Ziqing, "Mai shu," 419.

[15] Chen and Deng, *Ershi shiji Zhongguo fojiao*, 105, appendix 481; Xiao Dongfa, *Zhongguo tushu chuban yinshua shilun*, 137, 151; Zhang Hua, *Shanghai zongjiao tonglan*, 6. The first lithographic printing of the Tripitaka, a lead-plate printing of 8,416 *juan* of the *Pinjia da zangjing* by the monk Zongyang, appeared in 1909.

public preaching and publication and dissemination of scriptures.[16] The fervent Beijing/Tianjin-based devotee and publisher Xu Weiru 徐蔚如 (1878–1937) paid homage to Yang Wenhui's traditionalist style when he founded the Beijing Scripture Carving House (Beijing kejingchu 北京刻經處) in 1918 and the Tianjin Scripture Carving House (Tianjin kejingchu 天津刻經處) in 1919, but he was far more interested in reaching a mass audience and far more engaged with the modern business of bookmaking than Yang had been.[17] Xu's efforts notwithstanding, by the late 1910s Buddhist publishing was increasingly centered in Shanghai. In a 1923 letter the highly astute monk Hongyi 弘一, or Li Shutong 李叔同 (1880–1942), sketched the state of Buddhist publishing: popular texts, he observed, could be found at Nanjing's Jinling Scripture Carving House, the Manao (Agate) Scripture House (Manao jingfang 瑪瑙經房) in Suzhou, and the Beijing Scripture Carving House, but they were mainly available in large runs from such publishing firms as Youzheng Books (Youzheng shuju 有正書局), Yixue Books (Yixue shuju 醫學書局), and the Commercial Press (Shangwu yinshuguan 商務印書館)—all based in Shanghai.[18]

Ding Fubao and the Yixue Books Publishing Company

Yixue Books exemplified the sort of new, hybrid organization that produced large numbers of Buddhist texts along with other books, and was attuned to commercial success in the Shanghai publishing market. Yixue was the highly personal enterprise of the extraordinary, eclectic polymath Ding Fubao 丁福保 (1874–1952). Born into an upper-class but impoverished Wuxi 無錫 family, Ding experienced early success in his Confucian studies, passing the county level examinations in 1896. After failing to attain the provincial, or *juren*, degree, he turned first to the study of mathematics, and then to chemistry in several new schools. Because of financial difficulties, he also took up annotating and editing manuscripts. During a stint studying Japanese

[16] Chen and Deng, *Ershi shiji Zhongguo fojiao*, 42; Pittman, *Toward A Modern Chinese Buddhism*, 90–91; Pratt, *The Pilgrimage of Buddhism*, 381.

[17] Chen and Deng, *Ershi shiji Zhongguo fojiao*, appendix 488; Xiao Feng, *Hongyi dashi wenji shuxin juan* 1: 132; Shen Quji, *Yinguang fashi nianpu*, 81. Xu was first a disciple of the Tiantai master Dixian and later a follower of Yinguang. He was assisted in founding his publishing houses by the wealthy and influential devotees Jiang Weiqiao, Mei Guangxi, and Jiang Weinong.

[18] Xiao Feng, *Hongyi dashi wenji shuxin juan* 1: 239–240.

at Sheng Xuanhuai's 盛宣懷 (1844–1916) Dongwen 東文 Academy in 1902, Ding compiled a popular book of Japanese language usages. The success of the volume led him to join with Yu Fu 俞復 (1866–1930) and Lian Quan 廉泉 (1868–1931) to found Wenming Books (Wenming shuju 文明書局), an enterprise that Reed has described as "the largest and most important Chinese-owned general publishing firm of the early 1900s."[19] After teaching mathematics and physiology at the Imperial University in Beijing, Ding returned to Wuxi in 1906 to establish another press, which soon failed. Then, in 1908, he moved to Shanghai, where he launched Yixue Books and practiced medicine.[20]

As the primary compiler and editor of his press, Ding Fubao initially concentrated on spreading and exchanging information about traditional Chinese and Western medicine. He set up the Sino-Western Medical Studies Research Society (Zhongxi yixue yanjiuhui 中西醫學研究會) and an accompanying journal, and the great majority of books produced by his press concerned medicine (seventy-five volumes) or health and longevity (twenty-six volumes). Still, he would eventually compile, edit, and publish many books related to his other varied interests, including mathematics, the study of Chinese characters, philology, early poetry, numismatics, and moral education. And, second in numbers only to works on health and medicine, Ding published religious books, primarily thirty-four Buddhist texts. Aside from his adaptation of Oda Tokuno's 織田得能 (1860–1911) *Dictionary of Buddhism* (*Bukkyō daijiten* 佛教大辭典) as his own *Dictionary of Buddhism* (*Foxue dacidian* 佛學大辭典) in 1920, Ding's Buddhist books, mostly issued between 1917 and 1925, were chiefly introductory readers aimed at a mass readership. For a time Yixue Books would be the leading publisher for the Shanghai Buddhist Lay Devotee Association (Shanghai jushilin 上海居士林) and of all Buddhist materials in Shanghai. To be sure, health/medicine and religion were widely considered to be proximate fields, but Ding's commitment to Buddhism was at once deeply personal and consistent with a trend of the day.[21]

[19] Reed, *Gutenberg in Shanghai*, 60.

[20] Boorman, *Biographical Dictionary of Republican China [BDRC]* 3: 269–270; Shen Quji, *Yinguang fashi nianpu*, 82–83.

[21] *BDRC* 3: 270; Shen Quji, *Yinguang fashi nianpu*, 82–83; Ding, *Foxue Dacidian*; Zhang Hua, *Shanghai zongjiao tonglan*, 199.

Although impressed by Yang Wenhui and interested in sutras since about 1900, Ding directed his attention toward Buddhist text publishing only in 1916, when, following a conversion experience, he became a lay devotee (with the Buddhist name Chouyin 疇隱). In one telling, he turned to Buddhism while suffering from a serious illness. In another, a dramatic miracle story, Ding and his fellow passengers aboard a Yangzi River steamer on the verge of capsizing in a storm called out to Guanyin 觀音, and were saved when a vision of the Bodhisattva appeared; thereafter, Ding dedicated himself to Buddhism. Whatever one makes of these intriguing accounts (both of which echo common Pure Land conversion narratives), Ding clearly entered into an intense period of personal religious devotion that happened to be consistent with a trend among certain Shanghai elites at the time.[22]

Some of the Shanghai commercial/industrial elites interested in Buddhism appear to have wanted to fill a spiritual-ideological and elite-relational void in the postimperial era that would not involve a Christian, "foreign" religion but that would preserve, in the face of New Culture critiques and the most aggressive forms of modern nationalism, many of the "traditional values" of a "Chinese" faith. At the same time, the turn to Buddhism for Ding and like-minded Shanghai laity corresponded with both a period of major economic expansion in the city and the immense growth of their personal fortunes. Ding, who had once taken on editing work just to pay his school fees, had become a prosperous philanthropist,[23] His gravitation toward Buddhism appears to have been partly the result of a cultural anxiety, common in his circle, about the problem of wealth. Raised within the "three-in-one" tradition (a syncretism of Confucianism, Buddhism, and Daoism), many were sincerely concerned about the interrelated issues of profit, public morality, and the karmic consequences of their actions and accumulated wealth. Indeed, the proliferation of morality books in the late-imperial period was in part a response to this tension. So, too, the eagerness of the Buddhist elite to support new publishing organs and to increase propagation appears to have derived from this moral anxiety. As so many of the Pure Land texts made clear, textual propagation could reform and save the masses even as

[22] *BDRC* 3: 270; Wu Bao, "Preface," in Ding Fubao, *Foxue dacidian*; Ding Fubao, *Foxue zhinan* and *Foxue chujie*; Welch, *The Practice of Chinese Buddhism*, 517. Welch relates Karl Reichlet's account from *The Transformed Abbot* (1954), 47.

[23] *BDRC* 3: 270; Shen Quji, *Yinguang fashi nianpu*, 83.

it earned individual karmic merit. Thus, the publication of Buddhist
texts provided an opportunity, supported by cosmic moral authority,
to promote social discipline—a compelling notion for wealthy and
precariously situated Shanghai capitalists.

*The Commercial Approach of the Shanghai Buddhist Books Publishing
Firm*

Lay-devotee circles would come to include not only some of the
wealthiest Shanghai capitalists—Jian Yujie 簡玉階 (1875–1957), Jian
Zhaonan 簡照南 (1870–1923), Wang Yiting, and Nie Qijie 聶其傑
(1880–1953)—but also figures with close ties to the commercial pub-
lishing world.[24] Ding Fubao of Wenming Books had worked with Lufei
Kui 陸費逵 (1886–1941), later of the Zhonghua Books publishing
company. Di Baoxian (Chuqing) 狄葆賢 (1873–1921), who founded
the *Eastern Times* (*Shibao* 時報) newspaper in Shanghai in 1904 and
People's News (*Minbao* 民報) in 1905, would in 1912 establish the
Buddhist Youzheng Books publishing firm in the same building as his
news organization, in the heart of the Fourth Street publishing district.
Yang Wenhui's disciple Wang Kangnian 汪康年 (1860–1911) started
Current Affairs News (*Shiwubao* 時務報) in Shanghai. And Chen
Wuwo 陳無我 (1884–1967), who would become editor of the influ-
ential Buddhist journal *Bodhisattva* (*Jueyouqing* 覺有情) in Shanghai,
had earlier served on the staff of *Pacific Ocean News* (*Taipingyang bao*
太平洋報) and headed the World News Agency (Shijie xinwenshe
世界新聞社). Ye Shengtao 葉聖陶 (1894–1988) was also sympathetic
to certain lay and clerical leaders when he served as an editor at the
Commercial Press in the 1920s and Kaiming Press (Kaiming shudian
開明書店) in the 1930s.[25]

[24] Xu Youchun, *Minguo renwu dacidian*, 43, 54, 74–77, 81, 98, 31, 545; Goodman,
Native Place, City, and Nation, 188, 208, 213; Shen Quji, *Yinguang fashi nianpu*, 102,
310; Chang, "Jinling kejingchu de bianqian," 362. The Jian brothers were the tycoons
behind the Nanyang Brothers Tobacco Co. Wang Yiting rose from clerk to comprador
for a Japanese steamship company, and eventually owned interests in banking, ship-
ping, flour milling, and electrical appliance manufacturing. He held regional govern-
ment positions in the early Republic, headed the Pudong Native-Place Association
(Pudong tongxianghui), and became a famed painter in the Shanghai Ren Bainian
painting school. Nie Qijie (Yuntai) (C. C. Nieh), a grandson of Zeng Guofan, ran his
family's Shanghai-based textile and land-holding empire.

[25] Shen Quji, *Yinguang fashi nianpu*, 78; Xiao Feng, *Hongyi dashi wenji shuxin juan*
1: 152, 2: 298; Ye Shengtao, "Liang fashi," 109–111; Reed, *Gutenberg in Shanghai*, 64,

With such connections and with the rise in the number of Buddhist presses in Shanghai, Buddhists were also soon publishing in collaboration with major commercial publishers, who evidently recognized the potential of this religious market. In 1918 Jiang Weinong published, through the Commercial Press, Buddhist scriptures he had "discovered" in the Beijing Library. The next year, the Commercial Press issued a collection of sermons by the Ningbo Tiantai 天臺 master Dixian 諦閑 (1858–1932), and in 1920, the writings of Yinguang 印光 (1861–1940)—one of the great Buddhist best sellers of its time. By the Nanjing Decade, many other well-known Buddhist monks and laymen were publishing with secular presses like Zhonghua Books (Zhonghua shuju 中華書局) and Great East Books (Dadong shudian 大東書店). In addition, World Books (Shijie shuju 世界書局), Kaiming Press, and the Commercial Press continued to print significant numbers of Buddhist titles in the 1930s and 1940s.[26]

Meanwhile, wealthy Buddhist businessmen established a series of Buddhist publishing companies in Shanghai. The most prominent of these in the 1930s and 1940s were Shanghai Buddhist Books (Foxue shuju 佛學書局), Great Magnificence Books (Daxiong shuju 大雄書局), and Great Wheel of the Dharma Books (Dafalun shuju 大法輪書局). This last press, founded early in the war by the Quanzhou native and Southeast Asia—based businessman Su Huichun 蘇慧純, was especially popular with Buddhist intellectuals.[27] With the exception of purely charitable organizations like the Buddhist Treasures Hall (Fabao guan 法寶舘), established by Ye Gongchuo 葉恭綽 (1881–1968) in the Shanghai Pure Karma Society (Shanghai jingye she 上海净業社) compound in 1937, the major Buddhist presses were colored by Shanghai-style commercialism and operated with the latest technologies.[28] In this respect, one Buddhist publishing firm stood out.

227, 283; Ge Gongzhen, *Zhongguo baoxue shi*, 178; Xu Youchun, *Minguo renwu dacidian*, 408. On Kaiming, see Ling Shiao's essay in the present volume.

[26] Tanxu, *Yingchen huiyi lu*, 98, 389–390; Chen and Deng, *Ershi shiji Zhongguo fojiao*, appendix 489, 503. Taixu published his collected works with Great East Books and Hongyi published his major opus with Zhonghua Books.

[27] Cai and Yu, "Jueyuan yu Zhongguo fojiao"; Tanxu, *Yingchen huiyi lu*, 293; Xiao Feng, *Hongyi dashi wenji shuxin juan* 1: 125, 185–186.

[28] Xiao Feng, *Hongyi dashi wenji shuxin juan* 1: 139, 144, 2: 126; Zhang Hua, *Shanghai zongjiao tonglan*, 199–200; Chen and Deng, *Ershi shiji Zhongguo fojiao*, 105, 321. In Shanghai, there was also Neishan Books (Neishan shuju), the Fayun Sutra Printing Association (Fayun yinjing hui) at Master Xingci's Fazang Monastery, Shanghai Banruo Books, and Daode Books.

As Yinguang noted in a letter, "[Shanghai] Buddhist Books, with its expansive communications and commercial character, will be able to sustain itself for a long time...."[29]

Shanghai Buddhist Books (Shanghai foxue shuju 上海佛學書局) was founded in August 1929 by leading Pure Land devotees Wang Yiting, Li Jingwei 李經緯, and Fan Gunong 範古農 (1881–1952). These men were serious about their Buddhism. Fan Gunong underwent a conversion experience when he came upon the *Great Commentary on the Perfect Enlightenment Sutra* (*Yuanjue jing dashu* 圓覺經大疏) in a bookstore and came to see Buddhism as a means to "save the nation." Influenced as a young man by Zhang Binglin, Fan studied with Yang Wenhui, who directed him to the *Amitabha Sutra*, *Mahayana Awakening of Faith*, and other Pure Land texts. In 1918 he became a disciple of the Tiantai master Dixian and began to travel throughout Jiangnan preaching. He later became a follower of Master Yinguang.[30]

As sincere in their faith as Fan and his partners were, they were also businessmen committed to "spreading the Dharma" on a grand scale. By 1937, Shanghai Buddhist Books had edited, printed, and distributed 3,319 different texts, including two extended series, dictionaries and encyclopedias, Tripitaka reproductions, and, at various points, the journals *Sound of the Waves* (*Haichaoyin* 海潮音), *Buddhist Half-Monthly* (*Foxue banyuekan* 佛學半月刊), *World Buddhist Lay Devotees Journal* (*Shijie fojiao jushilin linkan* 世界佛教居士林林刊), and *Buddhist Publishing Circles* (*Foxue chubanjie* 佛學出版界). As this last title implies, Fan's press considered itself to be at the center of a Chinese Buddhist publishing world, and its considerable commercial success appears to have allowed it to expand to realize that ambition. From a one-office operation on Baoshan 寶山 Road, amidst the many printing shops gathered near the Zhabei 閘北 Commercial Press compound, Shanghai Buddhist Books quickly expanded, moving to a new headquarters building at 7 Jiaozhou 膠州 Road and then to 154 Yuyuan 愚園 Road within four years. In 1933 it became a limited-liability joint stock company. By 1936 it was maintaining six facilities in Shanghai; major branch offices in Beijing, Hangzhou, Fuzhou, Changsha, and Kunming; and contracted sales offices in Harbin, Changchun, Yingkou, Jinan, Qingdao, Lanzhou, Xi'an, Kaifeng, Suzhou, Anqing, Hankou, Wuchang, Chengdu, Chongqing, Nanchang,

[29] Shen Quji, *Yinguang fashi nianpu*, 250.
[30] Xu, *Minguo renwu dacidian*, 588; Shen Quji, *Yinguang fashi nianpu*, 137–138.

Shantou, Guangzhou, Hong Kong, Taipei, Singapore, and Rangoon. It would also invest in early experiments with Buddhist radio broadcasting in Shanghai, sponsoring the broadcasts of the Yongsheng 永生 Radio Station in 1933 and the establishment of the Huaguang 華光 Radio Broadcasting Station in 1936.[31]

At first, Shanghai Buddhist Books produced octavo-format volumes with fine quality *jiaxuanzhi* 夾宣紙 rice paper (from Xuancheng 宣城, Anhui), cloth covers, and "fold" bindings that, in the Yang Wen-hui manner, were intended to impress buyers with their aestheticized, traditional look. Yet despite the high production costs, lithographic printing and industrial binding methods, in Master Hongyi's view, only mimicked genuine book-making artistry. "As the printing and binding [were] not refined," he wrote, "they did not look beautiful." Hongyi approved of the press's subsequent shift to producing cheaper, less pretentious "Chinese-paper cover and thread-binding" books.[32]

Shanghai Buddhist Books' strength was not production quality but rather the size, reach, and, above all, commercial character that it began to develop under editor Shen Binhan 沈彬翰 in the mid-1930s. Encouraging a follower to publish with this press, Hongyi wrote: "Buddhist Books has many branches, a very wide circulation, and is more suitable than Kaiming. The printing costs can also be handled by Buddhist Books and all requests can be discussed with devotee Shen."[33] Clearly, Shanghai Buddhist Books was distinguished from major commercial presses by its market advantages in service, financing, and distribution, guaranteed by personal relationships with coreligionist Shen.

Introductory Readers and a Buddhist Mass Readership

A notable consequence of Buddhist publishing's shift toward urban commercial publishing centers was the appearance of two new types of Buddhist texts: the introductory reader and the modern periodical. The idea of converting a vast popular audience via simple texts was, of course, neither new nor original. It had inspired the dissemination of the earliest Chinese Mahayana Buddhist missionary tracts as

[31] Gao, "Shanghai fojiao gaikuang," 6–7; Chen and Deng, *Ershi shiji Zhongguo fojiao*, appendix 502; Zhang Hua, *Shanghai zongjiao tonglan*, 201, 207; Shen Quji, *Yinguang fashi nianpu*, 137–138.

[32] Xiao Feng, *Hongyi dashi wenji shuxin juan* 2: 139.

[33] Ibid., 1: 91.

well as the proliferation of Pure Land texts and morality books in the late imperial era. But mechanized publishing and new, rapid forms of transportation made ancient dreams of universally spreading the Dharma through the printed word seem possible. But something more than the fact that these readers could now be produced in vast quantities distinguished them from the earlier tracts and morality books; the readers were new in both form and style, and, to an extent, in content as well. Educated Buddhist compilers, like secular publishers producing modern primers, made these books cheap, lightweight, portable, and easy to read. In this respect they were in line with trends in urban Chinese publishing that were shaped by a confluence of market and technological influences, shifting domestic and foreign tastes, and the emergence of a new ideal of mass literacy. Such texts were created, moreover, by those who envisioned a mass collectivity that, although an abstraction, differed significantly from the vague and misty vision of humanity implied in earlier generations of Pure Land texts. The compilers of the new readers envisioned a "community" of thousands of believers, each of whom would have his or her own copy of the same text. These texts were not just talismans for numinous possession. They were also designed *to be read*, and as such they would guide and transform the community of believers. If such texts were often still reminiscent of late-imperial morality books, they were increasingly coming to resemble such mass-produced handbooks of conduct as the contemporary pocket summaries of Sun Yat-sen's Three Principles of the People and, later, Mao Zedong's "Little Red Book."

One of the first of these readers, the *Buddhist Introductory Textbook* (*Foxue chuxue keben* 佛學初學課本), was compiled by Yang Wenhui in 1906. Although Yang made certain the book was issued in a fine woodblock printing with an accordion binding, the textbook was of a far more elementary sort than the *Mahayana Awakening of Faith*. It was written with a vocabulary and a clarity that Yang imagined would make it comprehensible to children and common folk of minimal education. Although he identified his reader with a long tradition of popular Buddhist educational texts that originated with the *Buddhist Three Character Classic* (*Fojiao sanzijing* 佛教三字經), he also acknowledged the influence of recent Japanese textbooks that effectively condensed information for elementary instruction.[34]

[34] Yang Wenhui, *Fojiao chuxue keben*, "Preface," 4.

The Buddhist introductory reader grew into a genre of its own in the 1910s with the publication of *Outline of Buddhism* (*Foxue dagang* 佛學大綱, 1916) by Xie Wuliang 謝無量 (1884–1964) and the many volumes compiled by Ding Fubao and his collaborators Mei Guangxi 梅光羲 (1880–1947) and Xu Weiru at Yixue Books. Much like late-imperial morality books, Ding's *Buddhist Inspiration of Faith* (*Foxue qixin bian* 佛學起信編), *Elementary Buddhism* (*Foxue chuji* 佛學初級), *A Buddhist Guide* (*Foxue zhinan* 佛學指南), *On the Six Paths and the Cycle of Rebirth* (*Liudao lunhui lu* 六道輪回錄), *Discussing Buddhist Experiments* (*Foxue shiyan tan* 佛學試驗談), and *Buddhist Summary* (*Foxue cuoyao* 佛學撮要) featured anecdotal "real life" evidence (with recorded names, dates and places) of Pure Land "cause and effect" (*yinguo* 因果) ethics, or karma. Yet the simplicity of vocabulary, style, and formatting, the brevity, and the practical portability of these books indicate that they were written for large-scale production and distribution to a mass audience of busy urban remedial readers of basic classical Chinese.[35] In subsequent decades figures like Mei Guangxi and Huang Hanzhi 黃涵之 (1861–1941?) would take the development of these popularized, mass readership texts to their fullest extent. But the real beginning of mass Buddhist publishing must be traced to Master Yinguang and the publication of his best-selling book in the 1920s. *The Collected Writings of Dharma Master Yinguang* (*Yinguang fashi wenchao* 印光法師文鈔; hereafter, *Collected Writings*) was undoubtedly a Buddhist publishing phenomenon that launched what was probably the most popular religious movement in China in the first half of the twentieth century.[36]

A Shaanxi native, Master Yinguang had spent over twenty years on Putuoshan 普陀山 Island off the central Zhejiang coast before his

[35] Xiao Feng, *Hongyi dashi wenji shuxin juan* 1: 296; Chen and Deng, *Ershi shiji Zhongguo fojiao*, 106; prefaces to Ding Fubao, *Foxue chujie, Foxue zhinan*, and *Foxue qixin bian*; Welch, *The Buddhist Revival in China*, 118, 295 (cites Otto Franke, *T'oung Pao*, Ser. 2, 1909, 567); Deng Zimei, *Chuantong fojiao yu Zhongguo jindaihua*, 187–188; Xu Youchun, *Minguo renwu dacidian*, 797. An 1897 *juren* from Nanchang, Mei Guangxi studied in Japan and held a series of impressive academic and government posts in the late Qing and early Republic eras that culminated in his appointment as chief procurator of Shandong. He also led several Buddhist associations.

[36] Yinguang did not author the only Buddhist best seller of the time. In 1915 *The Mysteries of Guanyin* (*Guanyin lingyi ji*), a collection of miracle tales by Wan Jun 萬鈞, was first published in Beijing. By 1931, thirty-two editions had been published by several presses based mainly in Shanghai, yielding a production total of 5.3 million volumes. See the prefaces, 1–2, in Wan Jun, *Guanyin lingyi ji*.

writings were published and his reputation as a Pure Land master writer and teacher was made. Following several early efforts by lay devotees Gao Henian 高鶴年 (1872–1962), Di Baoxian, and Xu Weiru to publish Yinguang's essays in Shanghai, Xu compiled and published the *Collected Writings* in 1918. This compilation not only remained in print for years; it was also issued in new, usually expanded, editions by various presses for the next two decades. In the second, 1919 edition, the volume had grown from twenty-two to thirty-eight sections. In 1920 Xu arranged both a woodblock edition by the Yangzhou Scripture Hall (Yangzhou zangjing yuan 揚州藏經院) and, responding to great demand, a four-*juan* lead-type edition by China's largest commercial publishing house, the Commercial Press in Shanghai. Other editions appeared each year between 1921 and 1926, including a second Commercial Press edition in 1922 and Zhonghua Books editions in 1925 and 1926. In fact, in 1922, when the Commercial Press printed the largest run of the volume to date, several smaller presses combined to produce an additional 20,000 copies. Each new "expanded" edition included not only the master's latest writings (e.g., letters, prefaces, even anti-opium medicine recipes) but also, like morality books, assorted texts that were loosely related. With a hundred more pages than any previous version, the 1925 Zhonghua Books edition had become so massive that it was inordinately expensive to print. Still, new editions continued to be published by various presses—above all, by Yinguang's Honghua Society (Honghua she 弘化社)—throughout the 1930s and 1940s.[37]

The influence of Yinguang and the success of his writings owed much to the strong support he received from the wealthy lay Buddhist elite of Shanghai, Jiangnan (and environs), and northern Zhejiang, and to his own energetic cultivation of these relationships and the pursuit of funds and support to publish his and other Pure Land works. Yet it is striking how his fame, which was dependent on and inseparable from the renown of his *Collected Writings*, grew with a rapidity and on a scale possible only at this moment in the newly mechanized, mass-media age. The Yinguang phenomenon developed around the com-

[37] Zhenda, "Preface," 6–7, in Yinguang, *Yinguang fashi wenchao*; Shen Quji, *Yinguang fashi nianpu*, 97, 100, 144, 194; Xiao Feng, *Hongyi dashi wenji shuxin juan* 1: 21, 221. See also the prefaces in Yinguang, *Yinguang fashi wenchao* (2000 [1918]). The 1935 Honghuashe edition of the *Collected Writings* was the seventh edition issued by this organization since 1927.

pelling and inspiring message that a simple practice could uncover the "Buddha nature" within all. It celebrated a familiar combination of "cause and effect" metaphysics, popular familial Confucian ethics, and hagiographic tales of this modest ascetic of unwavering habits and impeccable morals.[38]

The process, scale, and site of the manufacture of this message were all very new. With a hint of resentment, Master Tanxu later remarked that when Yinguang first began preaching, few came to hear him; but when his published writings appeared (complemented by his prolific correspondence with his readers), much excitement arose around his special preaching events, and he became vastly popular.[39] The creation of modern China's first spiritual leader with mass appeal churned through the presses, the bookstores, and the capitalist elite-domi-nated commercial-industrial and transportation networks centered in Shanghai. Hundreds of thousands of people, mainly but not exclusively in central-eastern China, are thought to have considered themselves Yinguang's followers, emulating him in "reciting the Buddha's name" and in reading and distributing his *Collected Writings*. Yinguang was contacted by people from around the country who wanted to become lay followers. Hundreds, sometimes thousands, flocked to his revival events and took lay devotee vows. And even though his best-known associates were rich, older, urban men, he attracted a wide range of followers, including many women of modest means. When Yinguang died, at Lingyanshan 靈岩山 Monastery outside Suzhou in 1940, many monks and lay people pledged to devote themselves to preserv-ing his ideas and memory. Most strikingly, the monk Zhenhua 真華 (b. 1922) recalled that "many people who had never seen him cried like orphaned children on hearing the news of his death."[40] Yinguang

[38] Shen Quji,*Yinguang fashi nianpu*, 3, 27, 100–111, 132–133, 149.

[39] Tanxu, *Yingchen huiyi lu*, 163.

[40] Shen Quji, *Yinguang fashi nianpu*, 3, 83, 142, 245, 279; Gao, "Shanghai fojiao gaikuang," 3–6; Zhenda, "Preface," 7–9, 14, in Yinguang, *Yinguang fashi wenchao*; Daoyuan, "Wo suo jianwen de Yin gong dashi," in Yinguang, *Xinyuan nianfo*, 19; Yin-guang, *Yinguang dashi kaishi lu*; Chen-Hua, *In Search of the Dharma*, 109, 112. More than two hundred people took devotee vows during a three-day preaching event led by Yinguang in Wuxi in 1924, and many more did so following his preaching at the 1936 Protect the Nation and Stop Calamity Meeting (Huguo xizai fahui). The Shanghai lay devotees of the Bodhi Garden led by Dou Cunwu established a society to commemo-rate Yinguang in 1941. The Lingyanshan Monastery preserved the Yinguang tradition into the early 1950s and is doing so again; other monasteries have done the same in Taiwan, Hong Kong, Southeast Asia, and Australia.

had become a kind of Buddhist-mediated popular sensation primarily through the distribution of his *Collected Writings* to a mass readership eager for the products of the Shanghai publishing world.

The influence of Yinguang and his book in the subsequent expansion and development of a modern, mass-market Buddhist print culture persisted through the 1940s. One of Yinguang's leading Shanghai followers, Huang Hanzhi, emulated him, becoming the preeminent popularizer of Pure Land texts for a modern readership. Huang pioneered the annotated, modern-vernacular versions of Buddhist sutras and introductory texts with his *Vernacular Explanation of the Amitabha Sutra* (*Amituo jing baihua jieshi* 阿彌陀經白話解釋), *Vernacular Explanation of the Guanyin Sutra* (*Guan wuliangshou fojing baihua jieshi* 觀無量壽佛經白話解釋), and *Introductory Guide to Pure Karma* (*Chuji jingye zhinan* 初級淨業指南). Mass-produced by the Shanghai publishing industry, these books sold in the hundreds of thousands of copies.[41] Following in Yinguang's path, Huang produced texts for a Buddhist mass *readership*, not just for large-scale possession for numinous purposes. This sort of projection to a mass audience was consistent with Buddhists' pioneering efforts in radio broadcasting as well. The 1930s saw the rise of Buddhist broadcasting in Shanghai prisons, by Taixu and the Shanghai Buddhist Books group on the Shanghai Yongsheng Radio Station, and the founding of the Buddhist radio station XMHB Shanghai.[42]

Religious devotion, not the market, was the impetus for mass-media Buddhism. The accompanying rise of fervent Pure Land activism in the 1920s—which saw followers of Yinguang distributing pamphlets to convicts in Zhejiang and Jiangsu prisons, soldiers in Beijing, and passengers on the Shanghai-Nanjing railway—surely played its part.[43] But the fact that there were exponentially larger numbers of cheap, simple Buddhists texts materially present in China in this period than

[41] Shen Quji, *Yinguang fashi nianpu*, 231; Gao, "Shanghai fojiao gaikuang," 3. Shanghai-born Huang Hanzhi attained the *gongsheng* degree, became a Qing county magistrate and studied in Japan. In the early Republic, he served as a Shanghai Higher Level Court judge and an Intendant of the Circuit in Zhejiang.

[42] Chen and Deng, *Ershi shiji Zhongguo fojiao*, appendix 508, 511; Gao, "Shanghai fojiao gaikuang," 7; Welch, *The Buddhist Revival*, 43. Taixu first broadcast his "Great Meaning of Buddhism" sermon at Yongsheng Radio in March 1933 and broadcast on the Central Radio Station in 1935.

[43] Pratt, *The Pilgrimage of Buddhism*, 371, 380–381.

ever before was foremost due to the technologies and practices of the new urban publishing industry.

Buddhist Periodicals, Publishers, and New Elite Textual Communities

Even as some Buddhist revivalists appealed to a mass—and not necessarily well-educated—readership, others devoted their attention to developing texts for a new kind of educated reader. From the early 1910s, Buddhist associations and presses participated in the general proliferation of modern-style journals, a project of social relational construction that involved articulating the positions of various Buddhist groups and linking communities of well-educated writers and readers. Buddhist reformist organizations, lay associations, and presses established journals that corresponded to the stylistic conventions of the new periodical press of the day. Chen Bing and Deng Zimei have estimated that about three hundred Buddhist periodicals and newspapers appeared in China between 1912 and 1936.[44] Various references to circulation and duration suggest that around sixty Buddhist periodicals of significance were published between 1912 and 1949. Many of these periodicals lived very brief publishing lives, as the solidarity and financial stability of groups waxed and waned. One of the earliest, the Chinese Buddhist Association's (Zhonghua fojiao zonghui 中華佛教總會) *Buddhist Monthly* (*Fojiao yuebao* 佛教月報), launched in May 1913, ran only four issues before folding due to financial difficulties. In contrast, Taixu's *Sound of the Waves*, founded in 1920, remained influential into the 1930s; and the Chengdu *Buddhist News* (*Fojiao xinwen* 佛教新聞) continued to be published for twenty years after its first appearance in 1926.

The Buddhist periodical press flourished in the wake of the May Fourth Movement, when it was championed by self-consciously modernist-reformist activists associated with the Zhejiang monk Taixu. But a diverse array of other Buddhists also founded "modern" periodicals. Although some monks took leading roles in developing these publications—notably, Daxing 大醒 (1899–1952) and Zhumo 竺摩 (1913–2002)—most were managed and supported by the laity.

[44] Chen and Deng, *Ershi shiji Zhongguo fojiao*, 106.

The range in the editorial positions and supporters of these periodicals was extraordinary. There were those issued by the Shanghai lay devotee associations led by prominent metropolitan capitalists; those produced by the socially and politically radical Buddhist youth activist Zhang Zongzai 張宗載; and those published by the monk Daxing and his conservative wing of the reform movement. There were highly intellectual journals like Ouyang Jingwu's (1871–1943) *The Inner Learning* (*Neixue* 內學), as well as one founded by the venerable Tiantai master Dixian.[45] Biographer Don A. Pittman has called Taixu's *Sound of the Waves* "the most important and widely read Buddhist periodical of the Republican period."[46] Although this view is understandable in light of the journal's importance to the reformist camp, it also echoes the Taixu group's overestimation of its own importance.

What is so striking about this world of Buddhist journals is how eclectic it was and how many groups were convinced of their own significance—and busily went about publishing accordingly. There was a palpable sense that to be a new-style Buddhist association of any consequence meant having a periodical or newspaper. As a result, many new Buddhist textual communities of writers, editors, publishers, and readers were formed. Unlike Buddhist societies of former eras, which coalesced around a unified set of texts that served as the source of ritual practices or canonical teachings, these groups were drawn together in public dialogues about religion, society, and culture. These communities, often of quite impressive geographic reach, were formed by discrete networks of intellectuals writing for and responding to one another and representing themselves as a community through comparatively regular and frequent communication with the textual forums that these periodicals provided. Leading periodicals of this sort were found in many cities—Beijing, Wuhan, Hangzhou, Xiamen, Guangzhou, and Hong Kong each had several—and regional communities also formed around them. It is equally significant, however, that about a third of the most significant periodicals were based in Shanghai.[47] New Culture styles and Shanghai publishing methods set the tone for most Buddhist periodicals, and the majority of Buddhist

[45] Ibid., appendix 492–496, 500; Shen Quji, *Yinguang fashi nianpu*, 59, 146–147.
[46] Pittman, *Toward a Modern Chinese Buddhism*, 93.
[47] See footnote 27.

textual communities with a national scope grew up around those produced in Shanghai.

Master Hongyi and His Circle

Surely, many different kinds of Buddhist textual communities, occupying various regions of China's physical and cultural geography, existed in this period, including a number that were little changed since late imperial times. The interaction between groups of Buddhists and the emerging modern publishing industry did not follow any single path. In the 1910s, for instance, a traditional pharmacist and medical practitioner named Wang—the future Master Tanxu—was, with his four years of semiformal schooling, the most educated member of a lively "morality lecture hall" in Yingkou 營口, Liaoning. This group regularly discussed a hodgepodge of mostly popular Daoist, Confucian, Buddhist, and "foreign" religious/philosophical ideas. Taking a greater interest in Buddhism in 1917, the group dispatched Wang to Beijing to purchase Buddhist texts for study. The sutras he brought back became the textual sources around which this casual assembly of some forty men and four hundred women restructured their beliefs and practices, ultimately becoming a Buddhist association (even though Wang, the most skilled reader among them, had difficulty understanding many of the terms in the sutras).[48]

Regionally peripheral non-elites could clearly, in various ways, form communities around texts produced in the major urban publishing centers. As one might expect, however, evidence is far more plentiful for elite intellectual textual communities forged through vital links with Buddhist periodicals and publishers in the major urban publishing centers. One example of such a community was the loose alliance of highly educated Buddhist laity that interacted publicly through mostly Shanghai-based Buddhist publishers and periodicals, and took the brilliant and culturally gifted monk Hongyi as their intellectual and spiritual guide. In this case, shared engagement not only with particular texts but also in the practical matters of the publishing process served as a filament that knit this community together.

Master Hongyi, scion of a prominent Zhejiang family long engaged in the official salt monopoly in Tianjin, gained renown as a promising

[48] Tanxu, *Yingchen huiyi lu*, 55–57.

young poet and man about town in Shanghai literary circles after mov-
ing to the city in 1898. Studying later in Japan, where he learned about
Western art, he became a pioneer artist in a variety of media: he com-
posed music, painted, and acted. Returning to Shanghai, he did much
to spread interest in Western art and music, and edited the arts page
of the *Pacific Ocean News*. He went on to be a charismatic progressive
art teacher at the First Zhejiang Normal School in Hangzhou, where
he inspired many notable figures at this institution, the heart of May
Fourth radicalism in the city. Hence, it shocked many when he left the
school to become a monk in 1918.[49] As Master Hongyi, he lived an
ascetic existence mainly in monasteries in Wenzhou and Quanzhou,
and, for the longest period, at the South Putuo (Nanputuo 南普陀)
Monastery in Xiamen. He was also known for reviving the Disciplin-
ary Sect (Lüzong 律宗) and editing a major volume on the *vinaya*
(monastic rules).[50]

Throughout these years Hongyi's scholarly credentials, diverse tal-
ents, and influential friendships earned him great respect from a range
of intellectuals, writers, and artists. Like Yinguang, Hongyi cultivated
relationships with lay supporters through frequent correspondence
and visits. He also stayed well informed about the Shanghai publish-
ing world and had close ties to editors and publishers. The essayist,
cartoonist, and Kaiming Press editor Feng Zikai 豐子愷 (1898–1975)
was a former student at First Zhejiang Normal and became Hongyi's
lay disciple in October 1927. And a Kaiming general editor (as well as
noted writer and translator), Xia Mianzun 夏丏尊 (1886–1946), had
been a close colleague and friend at First Zhejiang Normal. Hongyi
had known Fan Gunong of Shanghai Buddhist Books since 1917 and
corresponded with Ding Fubao, Xu Weiru, Huang Hanzhi, and Cai
Gaiyin 蔡丐因 (d. 1990s), the editor of World Books. (In 1936 an edi-
tor at the Commercial Press abandoned his Shanghai life and moved

[49] "Preface" (1944), 7–8, in Lin Ziqing, *Hongyi fashi nianpu*; Tanxu, *Yingchen huiyi lu*, 385–386, 390; Xiao Feng, *Hongyi dashi wenji shuxin juan* 1: 1–3; Barmé, *An Artistic Exile*, 33, 161–165; Wen-hsin Yeh, *Provincial Passages*, 84; Hongyi, *Hongyi dashi gequ quanji*; Birnbaum, "Master Hongyi Looks Back," 75–77, 86, 88. In Tokyo, Li Shutong studied oil painting and Western folk music; he also composed patriotic and popular songs that are still sung in China and Taiwan today. Li was a founding member of the Spring Willow Drama Society (Chunliu jushe), an early experimental Western-style theater group.

[50] Tan Guilin, *Puti xinyu*, 87; Tanxu, *Yingchen huiyi lu*, 390; Birnbaum, "Master Hongyi Looks Back," 75; Soothill and Hodous, *A Dictionary of Chinese Buddhist Terms*, 301.

to Xiamen to become a monk under the guidance of Hongyi.) In his last years Hongyi was in frequent contact with the founder of the Great Wheel of the Dharma Books, Su Huichun, and its editors, Chen Wuwo and Chen Hailiang 陳海量 (1909–82). Hongyi also corresponded with such wealthy Shanghai devotees as Wang Yiting, Shi Xingzhi 施省之 (1865–1945), and Nie Qijie, and he maintained a close friendship with the cotton mill tycoon Mu Ouchu 穆藕初 (1876–1943) that dated to their youthful days as members of a Shanghai literary society.[51]

Although being in correspondence with Hongyi meant receiving beautifully written classical Chinese missives that visually represented his erudition and scholarly pedigree, the content of such letters was often less concerned with lofty or spiritual matters than with the down-to-earth issues of producing, circulating, and reading books. Hongyi and his circle, though surely linked by shared ideas and beliefs, primarily spun the web of their living relationships through discussions of the practical and material aspects of books and periodicals. Not only did they read, write, edit, and critique mainly Buddhist texts, but they were also continually recommending books, sending them to one another, writing to and visiting with editors and publishers in Shanghai, and discussing book production and distribution. By the late 1930s Hongyi often counseled his correspondents to read the Shanghai-based Buddhist periodicals *Buddhist Half-Monthly* and *Bodhisattva*. In his regular communications with Shanghai publishers and other Buddhists it is clear that Hongyi and his circle knew well the process of publishing, the location of bookstores and presses, the titles that were coming out, and their exact prices. Hongyi held strong opinions about paper size, types of covers and bindings, and the types of print technology used in the Buddhist presses and by Kaiming, Zhonghua, and the Commercial Press. He discussed the differences between *jiaxuanzhi*, a layered rice paper from Anhui; *lianshi* 連史 paper from Jiangxi and Fujian; and the less expensive Jiangnan papers. He expressed opinions about xylography, lithography, and lead-plate printing, even making technical comments as specific as "it is not possible to do a lithography reprint from a collotype."[52]

[51] Feng, *Feng Zikai sanwen manhua jingxuan*, 475; Xia Mianzun, "Hongyi fashi zhi chujia," 101; Xiao Feng, *Hongyi dashi wenji shuxin juan* 1: 12, 17–18, 22, 88, 112, 125, 201, 216, 285, 288, 2: 164, 194, 236.

[52] Xiao Feng, *Hongyi dashi wenji shuxin juan* 1: 20, 29, 53, 55–57, 65, 88, 197, 239–240, 282–283, 285, 2: 139, 333.

Hongyi understood the book business as well as he knew the technical aspects of publishing. Although he personally rejected royalties on his book sales, he was not naive about the commercial side of publishing. His letters show that he fully appreciated how profits from book sales secured the good will of publishers and that he had a sophisticated knowledge of Shanghai publishing practices. In a 1931 letter, for instance, he offered ample advice on securing a publishing deal, describing the initial investment that would be required and the specific demands to make to the editors about paper and printing.[53] This familiarity derived in part from his regular trips to Shanghai, where he invariably visited publishers and editors, discussed publishing projects, and purchased books. Hongyi knew the bookstores and presses of Shanghai so well that he could provide not only exact addresses but also precise directions specifying the proper electric-tram lines to take.[54]

For Hongyi's circle books and their production served as both means and topics of communication, as links that connected (and supplied topics of discussion to) a community of religiously minded readers, writers, and editors. When Hongyi sought artists for a book he was working on in 1940, he urged his partners to advertise the positions in the pages of the *Buddhist Half-Monthly* and *Bodhisattva*. More poignantly, as he lay dying at South Putuo Monastery in October 1941, Hongyi informed his old friend Xia Mianzun that all future attempts to contact him should go through Chen Wuwo and Chen Hailiang, the editors of *Bodhisattva* and Great Wheel of the Dharma Books.[55] Master Hongyi and his cohort, who by the late 1930s identified closely with Shanghai's Great Wheel of the Dharma Books, engaged not in a tightly closed culture of texts for the spiritually initiated elite but in ongoing public discussions about the content, production, and business of Buddhist texts that forged a self-selected group of Buddhist intellectuals into a new kind of Buddhist textual community. To be sure, they were acting on their religious beliefs. But practically, the subjects of their communications—and thus the basis of their community—were their writings and publications. And, as important as Hongyi was to these mostly lay Buddhists, it was the continual exchanges among

[53] Ibid., 1: 60, 129, 181.
[54] Xia Mianzu, "Hongyi fashi zhi chujia," 105; Tan Guilin, *Puti xinyu*, 87; Xiao Feng, *Hongyi dashi wenji shuxin juan* 2: 140.
[55] Xiao Feng, *Hongyi dashi wenji shuxin juan* 1: 181, 185–186.

those within and outside the Shanghai hub of text production that connected this national network of Buddhist intellectual elites.

Conclusion

There is much to be learned from exploring this little-researched period in Chinese Buddhist print culture. It obviously contributes to an appreciation of the diversity of actors, institutions, and motivations within the rise of modern Chinese print culture. But it also, more interestingly, further exposes the complexity of China's mediated cultural politics during the first half of the twentieth century. Greater attention to these Buddhist publications would likely reveal them as providing both space for the articulation of alternative perspectives on the cultural politics of the time and surprising echoes of broad discursive shifts in rhetoric and social-political values. It is striking, for instance, to see that self-styled opponents of "modernity" like Master Yinguang published writings for mass consumption that disseminated concepts and rationales, characteristic of the modern era, about the nation, society, and the individual. The Yinguang texts could also well support the contention that, as much as modern Shanghai print culture took a leading role in constructing Chinese modernity, it also produced its opposite: widely disseminated concepts of the Chinese "tradition."[56]

The emphasis of this essay, however, has been on the formation of the modern Buddhist cultures of textual production. To be sure, these arose from the changing social and political conditions surrounding the fall of the imperial state, the rise of the modern authoritarian nation-state, and intensifying stages of China's integration with global commerce and second-stage industrialization. For the educated elite among Buddhist activists there were long-standing as well as newly important motives for pursuing religious-text production. Many Buddhists seized upon the new methods and led the way for a shift in Buddhist text production toward the major urban industrial-commercial publishing centers, particularly Shanghai. New types of Buddhist presses and bookstores, influenced by this new print culture, developed. At the same time, the major commercial publishers recognized the significance of the Buddhist publishing market. Unprecedentedly

[56] Lee, *Shanghai Modern*, 43–44.

vast quantities of Buddhist books were produced and circulated in the mechanized printing age, and new types of Buddhist texts, with new forms, uses, and meanings, were introduced. Popular introductory readers aimed at the conversion of a mass audience and the modern Buddhist periodical, both consistent with secular publishing trends, were among these influential new texts. At a time dominated by neither the censors of a modern authoritarian state nor the homogenizing effect of full-blown capitalist mass-media markets, Buddhist writers, editors, and publishers constructed their own versions of modern textual communities and the abstract mass publics of religious readers. In doing so they shared much with their secular counterparts. Like the regional Zhejiang journals treated elsewhere in this volume by Robert Culp, Buddhist periodicals represented communities of writers and readers discussing agendas that, in Culp's apt phrase, were "trading in social and cultural value."[57] And such community formation, as with Ling Shiao's "May Fourth intellectuals" and Reed's early Communist publishers, involved not only essential personal connections but also the creation of a public collective identity that was centered in and colored by the industrial-commercial publishing culture of Shanghai.[58] As with so much in the dramatically changing media revolution of this era, this new Buddhist print culture derived the better parts of its design, content, and distinctiveness from the particular individuals, communities, and religious traditions involved. And yet, in a fundamental sense, it was largely industrially manufactured—principally, in China's new print capital, Shanghai.

[57] See Robert Culp's essay elsewhere in this volume.
[58] See the essays by Ling Shiao and Christopher A. Reed in the present volume.

THE GOLDEN AGE OF PRINT CAPITALISM

CULTURE, COMMERCE, AND CONNECTIONS: THE INNER DYNAMICS OF NEW CULTURE PUBLISHING IN THE POST–MAY FOURTH PERIOD

Ling Shiao

Standing on Fourth Street (Simalu 四馬路, today's Fuzhou lu 福州路) in Shanghai in 1928, even the most avid consumers of May Fourth–inspired publications would likely have felt a little overwhelmed by the vast choices at their disposal. For there, vying for their attention, were as many as twenty-six avant-garde press bookstores, as well as the retail stores of the Commercial Press (Shangwu yinshuguan 商務印書館, hereafter Shangwu), Zhonghua Books (Zhonghua shuju 中華書局), and Shijie Books (Shijie shuju 世界書局), the biggest Chinese publishing companies of the day.[1] Eighteen of these small presses managed to find a foothold on bustling Fourth Street. The rest had to be content with a spot on the narrow cross streets. Thirteen more such small press bookstores awaited shoppers on North Sichuan Street (Sichuan beilu 四川北路), a good thirty-minute trolley ride to the north, where cheaper rents were available for the more budget-minded publishers. To exhaust the list, book lovers would need to visit another sixteen stores scattered over the rest of the city.[2]

Referring to themselves as "new press bookstores" (*xin shudian* 新書店), or "new publishers" (*xin shuye* 新書業) of "new publications" (*xin shu* 新書)—that is, of May Fourth–inspired works of modern literature, sciences, and social sciences—these small publishing companies emerged slowly in the aftermath of the May Fourth/New Culture Movement (1915–21) and then mushroomed during the second half of the 1920s.[3] New publishing reached its apex in 1928, with a total of eighteen independent presses founded in Shanghai in that year alone.

[1] In the Republican era, all publishers ran their own retail outlets. The retail outlet of a small press was usually housed in the same building as the press itself.

[2] Bao, "1928 nianjian Shanghai de shudian," 1: 2, 444–447.

[3] In this paper, "May Fourth Movement" is used interchangeably with the New Culture Movement (1915–21) that sought to reconstruct Chinese culture and society by repudiating Confucian orthodoxy and introducing ideas and attitudes of the modern West. "May Fourth demonstrations" refer to the protest movement of May 1919 that

In a broad sense, the new presses of the day were those that departed from the old practice of reprinting or printing without paying their authors royalties.[4] However, the specific term "new press" was coined by publishers who emerged in the 1920s as a way to indicate their partnership with May Fourth authors and to set themselves apart from the existing publishing industry. In this narrow sense, it was often used to distinguish the new presses from the mainstream publishing companies such as Shangwu, Zhonghua, and Shijie. As Zhang Jinglu 張靜廬 (1898–1968), a leading new publisher and scholar of publishing history, wrote in 1938, "[Unlike Shangwu,] the new presses' primary focus was [May Fourth] New Culture and New Literature" (*xin wenyi* 新文藝).[5] In other words, the new presses were small publishers whose self-identity was intrinsically tied to May Fourth intellectual communities still active during the 1920s.

Throughout their history, the new presses stood in the shadows of the colossal retail buildings of the "Big Three" publishers listed above. But they were far from being overshadowed. Their presence solidified the Fourth Street neighborhood's proud title of "Culture Streets" (*wenhuajie* 文化街).[6] More significantly, with a strong propensity for treading the path of cultural avant-gardism and political radicalism that was not shared by the more commercial big publishers, these presses were the undisputed champions of New Culture and harbingers of the subsequent cultural experimentation of the 1920s and 1930s. Indeed, they provided the forums for political and literary debates that pushed the intellectual world from the liberal-leaning May Fourth values of the early twenties to the more radical post–May Fourth values of the late 1920s and 1930s. Finally, these small presses initiated the process

sparked the May Fourth/New Culture Movement. "May Fourth intellectuals" include those who, after playing a leading role in the New Culture Movement, continued to be active through the period treated here, the 1920s ("the post–May Fourth Era"). I occasionally refer to the creation of a "new culture" as the goal of intellectuals in the 1920s and early 1930s, but this should not be confused with the specific New Culture Movement of 1915–21. This "new culture" was as pluralistic and sometimes ill-defined as it had been during the May Fourth Era itself.

[4] See Bao Ziyan's definition in his "1928 nianjian Shanghai de shudian," 444.

[5] Zhang Jinglu, *Zai chubanjie ershinian*, 110.

[6] As early as the late nineteenth century, the Fourth Street neighborhood had become home to many dozens of newspaper agencies and old-style publisher-bookstores producing and selling woodblock and lithographically printed materials. However, not until the late 1920s and 1930s did the neighborhood reached the apex of its fame. See Hu Yuanjie, *Fuzhou lu wenhua jie*, i–iii, 1, 93–104.

whereby May Fourth intellectuals came to envision themselves as a modern intelligentsia independent of, and frequently in opposition to, the state.

Contrary to the widely accepted but unexamined assumption that they were endowed with cultural and political potency and thus destined for prominence, May Fourth intellectuals actually faced an increased vulnerability relative to their late Qing predecessors. Even after the debacle of the 1898 Hundred Days' Reform, Kang Youwei 康有為 (1858–1927), Liang Qichao 梁啟超 (1873–1929), and their reformist colleagues were able to maintain their influence through their published writings. No one would dispute the indispensable role their traditional fame as imperial degree-holders and the architects of the Guangxu emperor's short-lived reforms played in creating their new fame as independent authors and publishers. Indeed, publishers during the last years of the Qing hotly sought the service of high degree-holders and ex-officials to enhance the prestige of their companies.[7] In contrast, the May Fourth intellectuals entered a brand-new post-examination world. To a large measure, Western-style education had, in the 1910s and 1920s, replaced the examinations in certifying the social cultural elite. Yet it did not provide May Fourth intellectuals with the same clarity and authority as had the former system for their late-Qing counterparts. When they followed the footsteps of the reformists to embrace writing and publishing as an alternative avenue to social influence, few established publishers were willing to take them on. The avant-garde new presses were the publishers that brought them to the public spotlight and eventually national prominence.

Indeed, new presses worked hand in hand with May Fourth and post–May Fourth intellectuals to turn their mutual marginality into a powerful weapon in their challenge to the publishing and cultural establishment. During their heyday, in the late 1920s and early 1930s, the importance of the new presses lay not only in furthering the New Culture cause in the post–May Fourth era, but also in ushering in a distinctive era in the history of modern publishing in China. It was a new era in which avant-garde, highbrow, May Fourth–inspired publications became both popular and profitable. In bringing about this transformation, the new presses also established the organizational support that gave rise to the professionalization of May Fourth

[7] See Ji Shaofu et al., *Zhongguo chuban jianshi*, 320–321.

and post–May Fourth intellectuals as writers, editors, and publishers. These small new presses, the intellectuals who allied with them, and the inner dynamics of the interlocking developments of new publishing and new cultural experiments are the focus of this essay.

The Cradle, the Nursery, and the Infant: A Story of Symbiosis

The close identity of independent publishing with the May Fourth/ New Culture cause derived from a symbiotic relationship between the rise of new presses and the emergence of the May Fourth intelligentsia as a cultural and political force. By "the May Fourth intelligentsia," I refer not only to the dozen leaders of the liberal New Culture Movement at *New Youth* (*Xin qingnian* 新青年) magazine from 1915 to 1920[8] who enjoyed prestige and employment as professors at Beijing University but, more important, to the younger, subsequent generation of men and women who responded to their call for a fundamental change of Chinese culture and politics.[9] During the May Fourth Era itself, many of these young persons embraced the modern press as their effective agent. The result was an unprecedented growth in the periodical press at the height of the New Culture Movement and the arrival of the new presses later in the 1920s. Independent publishing, in turn, transformed these young people from "the new youth," that is, the audience that *New Youth* magazine aimed to arouse, to the second generation of the May Fourth intellectual elite.

This symbiosis was perfectly illustrated by the unfolding relationships between the Creation Society (Chuangzao she 創造社, 1921–29) and its three publishers. As early as 1918, watching with excitement the rising influence of the *New Youth* magazine and its editors, four close friends, Guo Moruo 郭沫若 (1892–1929), Yu Dafu 郁達夫 (1896–1945), Cheng Fangwu 成仿吾 (1897–1984), and Zhang Ziping 張資平 (1893–1959), all students in Japan at the time, developed a plan: they would follow the example of *New Youth* to help reshape the course of Chinese culture by publishing a *tongren* magazine (*tongren zazhi* 同人

[8] As made clear in Christopher A. Reed's chapter in this volume, *New Youth* moved in a communist, not a liberal direction, from 1920 onward.

[9] The coeditors of *New Youth* included Chen Duxiu, Li Dazhao, Hu Shi, Qian Xuantong, Gao Yihan, and Shen Yimo. The magazine's more than a dozen frequent contributors included Liu Bannong, Zhou Zuoren, and Lu Xun.

雜誌)—a magazine that would carry only writings of the members of a close-knit society with a well-defined agenda.[10] The central task for the group was to find a way to launch its magazine. Two years went by, however, and the young men had no luck at all. This was because a *tongren* magazine, usually mission-driven and targeting a highly educated audience, was often a money-losing venture that few publishers were willing to undertake. One friend who worked at Zhonghua Books reported back to them: "I've been running in and out of a number of publishing houses [to present your proposal]. Zhonghua has declined. The Yadong Press (Yadong tushuguan 亞東圖書館) has also said 'No.' I am afraid Shangwu will not have a positive answer either."[11] At this time, Shangwu and Zhonghua constituted nearly half of the country's modern publishing industry.[12] Yadong was a small publisher closely connected to the *New Youth* group and can be said to have been the first exclusive New Culture agent.[13]

These aspiring writers were running in circles, their project unable to take off. At this critical juncture came the news that the Taidong Press (Taidong shuju 泰東書局) was undertaking reforms that might create new job openings. The prospect excited Cheng Fangwu, who apparently believed he had a good shot at being hired thanks to having a friend at Taidong. He was so confident that this contact would ensure success, Chen gave up his studies and traveled back to Shanghai. Guo Moruo, who entertained the same hope, went along with him.[14] It

[10] In his reminiscences, Guo recalled his conversation with Zhang Ziping in the summer of 1918 during which both young men considered *New Youth* the only readable magazine in China. Even so, they considered it rather rudimentary and believed it did not deserve high regard from intellectual circles. See Guo Moruo, "Chuangzao shinian" in *Xuesheng shidai*, 38.

[11] Ibid., 92.

[12] Lufei, "Liushinian lai Zhongguo zhi chubanye yu yinshuaye," 1: 2, 421.

[13] For more information on Yadong, see Wang Yuanfang, *Huiyi Yadong tushuguan*; and Wang Yuanfang, "Yadong tushuguan jianshi," 1: 1, 287–296.

[14] Guo claimed that Taidong offered Cheng Fangwu a job as the editor in charge of literature, only to find upon his arrival at the press that it was an empty promise. Guo's story has been repeated in memoirs and scholarly work so often that a consensus has built up among scholars about Taidong's treachery. However, the recently discovered diary of Taidong's manager, Zhao Nangong, who meticulously recorded work matters, betrays no information about such a promise of employment. The few entries that mention Cheng Fangwu after the young men's arrival indicate a very cordial relationship between Zhao and Chen that would have been less likely had Chen been cheated by Zhao. See Guang, "Yijiu eryi nian de Taidong tushuju," 96. In his otherwise wonderfully detailed study of the relationship between the Creation Society and Taidong, Liu Na (*Chuangzao she yu Taidong tushuju*, 79) follows the previous

turned out, however, that Taidong's small budget would not allow it
to accommodate new editors. Chen moved on while Guo stayed at the
press to work on his poetry collection and other projects, but without
an employment contract.[15] Eventually, his perseverance paid off when
Taidong agreed to sponsor the magazine. Guo immediately struck
out for Japan to bring the good news to his friends. Their society, the
Creation Society, named with provocative confidence, was formally
established in the summer of 1921.[16] Immediately, it launched an all-
out war against the new authorities of the May Fourth circles such as
Hu Shi 胡適 (1891–1962) and the members of the Literary Research
Association (Wenxue yanjiuhui 文學研究會), thereby making them-
selves the newest May Fourth celebrities. Later in this essay, I discuss
their battles to highlight the importance of May Fourth societies and
their *tongren* magazines in gaining recognition for their members. It is
important to note here that, ultimately, sponsorship by a press made
the very formation of the society possible and meaningful.

Why would Taidong take the financial risks of underwriting a *ton-
gren* magazine by a group of obscure young writers shunned by other
publishers? A look into the background of the press and the profile of
its manager resolves this puzzle. Founded in 1914 by anti-Yuan Shikai
intellectual politicians of the so-called Zhengxue Clique (Zhengxue xi
政學系), Taidong was designed to be a political vehicle of this group
rather than a commercial enterprise.[17] After 1916, Zhao Nangong
趙南公 (1882?–1938), a shareholder of the press, took charge. Zhao
was no average book merchant. He was politically active and enjoyed
strong ties to intellectual communities. During the May Fourth dem-
onstrations of 1919, he was elected a representative of the Shanghai
General Alliance. Seven years later, during the Shanghai workers'
uprisings of 1926, he was nominated by Chen Duxiu 陳獨秀 (1878–
1942) to serve as a representative to the short-lived Shanghai People's

assumptions based solely on the writings of the society members, and on the whole
portrays Zhao in a negative light.

[15] Publishers of the time customarily provided food and board to their unmarried
employees.

[16] These young men accused the members of the *New Youth* Society and the Liter-
ary Research Association of being capable only of *talking* about a literary revolution
and translating Western literary works into Chinese without any real ability to engage
in actual creative literary writing. By naming their society "Creation," they intended to
lay their claim to the true leadership of the literary revolution. For the story of choos-
ing a name for their society, see Tao Jingsun, "Ji Chuangzao she," 775–776.

[17] Zhang Jinglu, *Zai chubanjie*, 67–70.

Government.[18] In the fast-changing cultural milieu of the late May Fourth Movement, Taidong found itself besieged by financial difficulties and a lack of direction. Zhao therefore decided to rebuild Taidong as a cultural avant-garde press. The fact that this move could only be accomplished by sacrificing his established distribution network—which typically handled mainstream publications—and by investing a handsome sum to set up a new one testified to his determination.[19]

Zhao's first attempt to rebuild Taidong was less than successful, however. The three-person editorial team formed at the beginning of 1920 to develop a new orientation for the press consisted of three obscure young men, including Zhang Jinglu, a self-taught writer who later became a famous publisher and scholar of Chinese publishing history.[20] The team showcased their "newness" by issuing the *New Fiction* (*Xin xiaoshuo* 新小說, 1920–22) and *New People* (*Xinren* 新人, 1920–22) monthlies. They also proved themselves to be prodigiously energetic writers and translators. But the absence of a clearly defined agenda, coordinated voice, and mutual commitment remained a problem, as Taidong failed to achieve a distinct brand, which was important both for taking an intellectual position and for marketing. Also, Taidong's lack of affiliation to any May Fourth societies or networks of writers meant that the press struggled constantly to find contributions for the two monthlies. In his memoir, Zhang Jinglu recalled that the lack of contributors to *New People* once forced its editor, Wang Wuwei 王無為, "to labor around the clock for ten days to write all

[18] Zhao's ties to intellectual circles and radical movements were also evidenced by his arrest in 1919 for selling the works of Kropotkin and his subsequent defense in court by Zhang Shizhao, a leading intellectual of the time. For Zhao's role during the May Fourth demonstrations, see Zhang Jinglu, *Zai chubanjie*, 64. For Zhao's connection to the Shanghai People's Government, see Wang Yuanfang, *Huiyi Yadong tushuguan*, 108.

[19] Zhang Jinglu, *Zai chubanjie*, 66–68, who wrote that a publisher at the time typically had to allow his book retailers to retain a portion of the money from book sales as an added incentive or a debt that obligated them to carry his publications in the future. These conditions made the establishment of new networks of distribution more expensive and therefore more difficult.

[20] An activist during the May Fourth demonstration in 1919, Zhang Jinglu met Zhao Nangong in Shanghai. The other two editors were Wang Wuwei, a young, talented writer-poet and soon-to-be editor in chief of the GMD *Minguo ribao*, and Wang Jing, an early translator of modern European literature who adopted the vernacular as the literary language for Chinese.

the articles in all the sections" in a special issue on the abolition of prostitution.[21]

The arrival of the Creation Society, now a dozen members strong and better connected to the May Fourth communities, changed all this. The release of *Creation Quarterly* (*Chuangzao jikan* 創造季刊, May 1922–February 1924) was soon followed by that of *Creation Weekly* (*Chuangzao zhoukan* 創造周刊, May 1923–May 1924). Both were coedited by Guo Moruo, Yu Dafu, and Cheng Fangwu, the society's three leaders. The quarterly enjoyed a circulation of over four thousand; the weekly over six thousand.[22] While these are not extraordinary figures, they were essential in establishing a public voice for the Creation Society.

However, their book series (*congshu* 叢書) marked the true financial success of the collaboration between the press and the society.[23] Between 1921 and 1924, Taidong released four book series, all of which were produced by society members.[24] In addition, five books issued in 1921, including Guo Moruo's *The Goddess* (*Nüshen* 女神), Zhu Qianzhi's 朱謙之 *Revolutionary Philosophy* (*Geming zhexue* 革命哲學), Yu Dafu's *Sinking* (*Chenlun* 沉淪), and Zhang Ziping's *Fossils of the Alluvial Period* (*Chongji qi de huashi* 衝擊期的化石), each enjoyed three print runs within a year, creating a market sensation.[25] Guo's translation of Johann Wolfgang von Goethe's sentimental novel, *The Sorrows*

[21] See Zhang Jinglu, *Zai chubanjie*, 68–69.

[22] Rao et al., *Chuangzao she ziliao*, 391.

[23] Issuing a book series was a promotional strategy popular among publishers even before the advent of modern printing technologies. Book series encouraged readers to make multiple purchases by impressing upon them a sense of the continuity, completeness, collectability, and even authority of its titles. Republican publishers, assisted by modern printing technologies, were particularly enthusiastic about, as well as successful in, issuing book series. For a brief discussion of book series as a publishing format in history, see Liu Chen, "Congshu, lieshu, baike quanshu jiqi bijiao." See also Christopher A. Reed's discussion of book series publishing by Shangwu, Zhonghua, and Shijie in his *Gutenberg in Shanghai*, chapter 5. The book series as a publishing format disappeared during the Mao years but has made a rigorous comeback since the 1980s. Guobin Yang in this volume touches on the relationship between print publishers and Internet publishing in issuing book series.

[24] These included the Creation Society Book Series (*Chuangzao she congshu*), the World Masterpieces Series (*Shijie mingjia xiaoshuo*), World Children's Literature (*Shijie shaonian wenxue xuanji*), and the Xinyi Mini-Book Series (*Xinyi xiao congshu*). The Creation Society Book Series, which continued to be released by the Guanghua Press and the Creation Society Publishing Office until 1929, would eventually amount to over seventy titles.

[25] *The Goddess* and *Sinking* enjoyed nine print runs in nine years and twelve print runs in ten years, respectively. During the Republican Era, a typical print run was

of Young Werther, released in 1922, sold more than ten thousand copies in just a couple of years.[26] In retrospect, Taidong's sponsorship of the society turned out to be a wise investment, with hefty symbolic and financial returns.

The collaboration between Taidong and the Creation Society lasted for three years. Perhaps growing weary of the contentiousness of the society's *tongren* magazine contributors, Taidong found various reasons to fail to release the magazine on schedule. Unhappiness over this and the issue of financial compensation eventually soured the relationship between the society and the press.[27] Despite the breakup in the summer of 1924, even Guo Moruo, who became the most bitter and partial of the group, recognized the critical role the press had played in the birth and growth of the society.[28] He wrote, "It was said to be impossible in Shanghai for a group of authors such as the Creation Society to release its [*tongren*] magazine before it officially became a literary society. In the midst of such impossibility, Taidong agreed to be our publisher."[29] Taidong was later credited with being "the cradle of the Creation Society" (*Chuangzao she de yaolan* 創造社的搖籃).[30]

The Creation Society rather quickly found a new publishing outlet, the Guanghua Press (Guanghua shuju 光華書局). When it first opened its shop in 1925, Guanghua had a total investment of twenty-five yuan of silver, used to purchase some stationary and a shop sign inscribed with the company's name.[31] One wonders how a company could start on such an impossibly small sum of money. Indeed, the greatest assets of the company were not the meager funds used to establish the press, but rather their networks (*guanxi* 關係)—their connections to

2,000 to 3,000 copies. For the circulations of the books, see Lu Yingyong, *Rentong yu hudong*, 38; and Ji et al., *Zhongguo chuban jianshi*, 394.

[26] Liu Na, *Chuangzao she yu Taidong tushuju*, 103–104.

[27] The leading members of the society eventually took to ridiculing Zhao Nangong bitterly in their published recollections of this period. The heavy reliance of earlier scholarship on the writings of these members frequently obscures the true nature of these relationships.

[28] Guo Moruo, "Chuangzao shinian," 167.

[29] Ibid., 92.

[30] The term was first used by Zhang Jinglu in his *Zai chubanjie*, 71. It was later adopted by many other writers and historians, further tying together the press and the society in historical memory.

[31] My account of Guanghua's founding and its relationship with the Creation Society is primarily based upon three sources: Zhang Jinglu, *Zai chubanjie*; Shen Songquan, "Guangyu Guanghua shuju de huiyi," 31–47; and Shen Songquan, "Huainian Zhang Jinglu xiansheng," *Chuban shiliao* 3 (1990): 26–32, 66.

the world of cultural production, in particular their close ties to the Creation Society. The founders included Zhang Jinglu; Shen Songquan 沈松泉, previously brought to Taidong by Zhang as an assistant; and Lu Fang 盧方, a childhood friend of Shen.[32] The three young men worked out a division of labor, as Zhang Jinglu recalled: "I worked on getting the needed paper and the printing of the first books done entirely on credit. Lu Fang managed the distribution. And Shen Songquan was responsible for soliciting manuscripts that did not need to be paid for right away."[33] It is fair to say that these young men's friendship networks were responsible for Guanghua's miraculous birth.

Zhang Jinglu readily acknowledged Guanghua's critical underpinning: its tie to the Creation Society.[34] Thanks to what Guo Moruo called "a friendship built on the experience of eating from a common pot" (*chi daguofan de jiaoqing* 吃大鍋飯的交情), for more than half a year in the Taidong Press's boarding quarters, Shen Songquan secured a dozen manuscripts from society members who were willing to accept future payments in lieu of immediate cash, including one play and one collection of essays by Guo Moruo.[35] The society also offered free help in copyediting and cover design. In addition, the society gave Guanghua the right to release its new magazine, the biweekly *Flood* (*Hongshui* 洪水), for "the lowest possible editing fee of fifty yuan per issue" and no financial compensation for its contributions.[36] Both the magazine and books were an instant success. Before the year's end, Guanghua proceeded to open a retail store on Fourth Street.[37]

Like the Taidong/Creation Society collaboration before it, the Guanghua/Creation Society relationship by no means benefited only the publisher. The new relationship in fact revived the society. In the closing issue of *Creation Weekly* published in May 1924, the editors announced to their readers, "Dear friends, please wait for us. You will hear the roaring sounds of our comeback!"[38] Yet, their readers had to wait for more than a year before the society was able to find a pub-

[32] Shen Songquan, "Huainian Zhang Jinglu xiansheng," 28.

[33] Zhang Jinglu, *Zai chubanjie*, 84.

[34] Ibid.

[35] Guo's words are cited in Shen Songquan, "Huanian Zhang Jinglu xiansheng," 28.

[36] As a point of reference, the Beixin Press offered Lu Xun and his friends at the Yusi Society (*Yusishe*) two hundred yuan for their writings and fifty yuan for editing each issue in 1925. See Li Xiaofeng, "Lu Xun xiansheng yu Beixin shuju," 339.

[37] Zhang Jinglu, *Zai chubanjie*, 84–85.

[38] Cited in Liu Na, *Chuangzao she yu Taidong tushuju*, 215.

lishing outlet. Despite their growing reputation, the Creation Society authors still had a hard time finding a publisher. Originally, the editors of *Creation Weekly* claimed that the Pacific Society (Taipingshe 太平社) would join them to issue a new periodical. But, as that project never materialized, the society, a year later, made an attempt to revive its weekly by raising money on it own. That plan also failed.[39] Now, without its own magazine, the society lost its sense of cohesion. Without the inspiration and pressure of the often relentless regularity and demanding pace of publishing a periodical, the creative energy of its writing members also suffered. During the long months between the spring of 1924 when they left Taidong and the fall of 1925 when their collaboration with Guanghua began, the publishing fortunes of the young writers ebbed; their writings appeared only infrequently.

Under these circumstances, Guanghua's proposition, though financially unrewarding and full of uncertainties, was attractive. It provided the society with a platform on which to stage their comeback. And the comeback was indeed as loud and earthshaking as promised. In 1922, the society's battle cry was unrestrained individualism and romanticism, against what they saw as the hegemony of the Literary Research Association and the realism that it espoused. Three years later, on the eve of their collaboration with Guanghua, they were ready to bombard the cultural field with literary Marxism—or to cleanse it with their unstoppable "flood," a bombastic term, as in the name of their new biweekly. To highlight Guanghua's indispensable role in the society's revival, Guo Moruo called the press "the nursery for the Creation Society" (*Chuangzao she de tuo'ersuo* 創造社的托兒所).[40]

The Creation Society, finding that Guanghua was able to achieve success with a mere twenty-five yuan initial investment, soon left these comfortable conditions to run its own publishing business, thereby allowing its members to reap the full financial rewards of their creative labor. Within months, preparation for launching the Creation Society Publishing Office (Chuangzao she chubanbu 創造社出版部) was under way. As writers and cultural warriors, Guo Moruo, Yu Dafu, and a later member, Zhou Quanping 周全平 (1902–1983), showed impressive business acumen. They decided to tap resources from the readership they had built over the years for their new company's initial

[39] Cited in Gong and Fang, *Guo Moruo nianpu*, 165–166.
[40] Guo Moruo, "Chuangzao shinian," 215.

operating capital. They made announcements in *Flood* and other peri-
odicals that the Publishing Office would sell its stock for five yuan per
share, making it easy for their readers to subscribe. To create a further
incentive, they offered their stockholders a 20 percent discount on their
future publications.[41] All the society members, now over thirty strong,
participated in the fund-raising campaign. The Publishing Office set
up its headquarters in Shanghai and another six branch offices in
China and Japan to handle the selling of its stock and future magazine
subscriptions and book orders. The campaign was a resounding suc-
cess, yielding some one hundred thirty shareholders and around five
thousand yuan of capital. Several paid positions were created to run
the new company, which held its grand opening in March 1926.[42]

This examination of the interaction between the Creation Society,
Taidong, and Guanghua illustrates the symbiotic relationship between
the new presses and May Fourth intellectual communities in the 1921
to 1926 period. Many more examples could be provided. To name just
two: Yadong Press, the oldest of all the new presses, was closely inter-
twined with the early career of Chen Duxiu and later with those writ-
ers Chen brought into the *New Youth* circle.[43] And of course Beixin
Press (Beixin shuju 北新書局) earned notice as a publisher of works
by Lu Xun and his young protégés.[44] The writer-publisher symbiosis
found its perfect expression in the new presses established by May

[41] Zhang Jinglu, *Zai chubanjie*, 85–86. For more information on the founding of the
Creation Society Publishing Office, see also Zhang Ziping, "Shuxinqi de Chuangzao
she"; and Rao et al., "Chuangzao she dashiji," 707–716, 1128–1129.

[42] Rao et al., "Chuangzao she dashiji," 1129. The branch offices were set up in Bei-
jing, Wuchang, Suiding, Yangzhou, Changsha, Tokyo, and Kyoto.

[43] Chen Duxiu started his first magazine, *Anhui Vernacular Biweekly* (*Anhui suhua-
bao*) in Anqing in 1904 with the help of his friend Wang Mengzou, who owned a
small-publisher bookstore. After the 1911 Revolution, Chen pushed Wang to come
to Shanghai and start Yadong. Four years later, Wang persuaded Qunyi Publishing
House to publish *New Youth* monthly for Chen Duxiu. After becoming the dean of the
College of Arts and Letters at Beijing University in 1917, Chen commissioned Yadong
to distribute all of the university press publications and brought his new friends at
New Youth into the Yadong orbit, which, according to Wang, "turned Yadong into a
successful business." Wang Yuanfang, "Yadong tushuguan jianshi," 289–291.

[44] Beixin evolved from the New Tide Society of student followers of the *New Youth*
group. The society's publication activities came under the ad hoc directorship of Lu
Xun in the early 1920s. Though soon to be a towering presence, Lu Xun was still
relatively obscure before his publication through the society of his first collection of
short stories, *A Call to Arms* (*Nahan*), in 1923. Previously, he had published only one
work, on mining, in 1906. As for Beixin, it found its independent identity only in 1925
when Lu Xun commissioned it to release *Yusi*, a *tongren* weekly founded by Lu Xun
and his intellectual friends, to engage in an acrimonious debate with those who ran

Fourth writers themselves. In addition to the Creation Society Publishing Office, as many as two dozen examples of this type of new press sprang up during the last years of the 1920s (see the appendix). Topping the long list was the Kaiming Press (Kaiming shudian 開明書店), which eventually rose to become Republican China's fifth-largest national publishing company.[45]

The Search for Identity and Power

These examples of the links between May Fourth societies and their avant-garde publishers reveal the essential mechanism that gave rise to the May Fourth intelligentsia as well as to the new publishing. The New Culture Movement came at a time when political revolution had failed to save China and, as the *New Youth* intellectuals insisted, a cultural revolution was in order. The call for a fundamental transformation of the Chinese consciousness brought forth an era in which the primary focus of educated Chinese patriots was the creation of a new people and a new national community through the press and education. For these patriots, it was also an era of publish or perish. Because they did not identify with the reformist intellectuals or the professional revolutionaries of the preceding decades, the members of the May Fourth generation found themselves in need of a new identity. It was through the press rather than bureaucratic offices or political parties that they found their public voice; it was through publishing that they turned themselves into modern intellectuals. At the same time, the new publishing strived to distinguish itself from commercial publishing and based its identity and influence on its service to New Culture.

That publishing shaped the identity and careers of the May Fourth generation was clearly evidenced by the lives of the Creation Society writers. During their long years in Japan in the 1910s, they all trained for modern professions other than literary studies. Guo Moruo pursued a degree in medicine, Yu Dafu in economics, Cheng Fangwu in military engineering, and Zhang Ziping in geology.[46] During the months

Modern Critique (*Xiandai pinglun*). See Li Xiaofeng, "Xinchao she de shimo," 128; and Li Xiaofeng, "Lu Xun xiansheng yu Beixin shuju," 336–337.

[45] For information on Kaiming, see Shiao, "Printing, Reading, and Revolution: Kaiming Press and the Cultural Transformation of Republican China."

[46] For their professional training, see Gong and Fang, *Guo Moruo nianpu*, 36, 60; and Yang Yi, *Zhongguo xiandai xiaoshuo shi*, 546, 594.

of searching for a publisher for their *tongren* magazine, Guo recalled, "[At the time,] I was suffering from depression and vacillation. Cheng Fangwu was going through the same [emotional swings]."[47] The "vacillation" was, of course, between their chosen careers and literary pursuits. In this, Guo was essentially speaking about the dilemma faced by all the future Creation Society members at this critical point. The angst from which Guo and Chen suffered eventually landed them on a boat to Shanghai to try their luck with Taidong.

The importance of the *tongren* magazine as a genre cannot be overstated. With a well-defined agenda, coordinated voices, and autonomy from the book market, this formidable fighting vehicle spearheaded the May Fourth/New Culture Movement. It can be argued that cultural battles (*dazhang* 打仗) against opponents outside of the May Fourth camp and cultural "brawls" (*dajia* 打架) against fellow new writers within the camp provided the essential driving force behind the New Culture enterprise throughout the May Fourth Era and the 1920s.[48]

New Youth, the very first May Fourth *tongren* magazine, had set the precedent. In 1918–19, the magazine's orchestrated attacks against the reformist positions of Shangwu-owned *Eastern Miscellany* (*Dongfang zazhi* 東方雜誌) and the classicist and translator of Western literature Lin Shu 林紓 (1852–1924) paved the way for the *New Youth* group to assume leadership in the cultural field. Leo Ou-fan Lee has highlighted Chen Duxiu's "brilliant polemical stroke of co-optation" as his winning card against Du Yaquan 杜亞泉 (1873–1933), the eminent editor of *Eastern Miscellany*, over the issue of China's proper position toward Western culture and its own tradition.[49] More important for Chen was his complete freedom to engage his *tongren* magazine in polemical debates while his opponent's hands were tied by the Shangwu management.[50] No studies on the actual contemporary reception of the debate are available, and the historical jury is still out with regard to the relative merits of their arguments. But Chen was unquestionably the one left standing. As for the debate with Lin Shu over classical

[47] Cited in Liu Na, *Chuangzao she yu Taidong tushuju*, 55.

[48] "Brawl" was the term used by both sides during the fight between the Creation Society and the Literary Research Association. See Rao et al., *Chuangzao she shiliao*, 1045.

[49] For Leo Ou-fan Lee's detailed analysis of the controversy, see his "Incomplete Modernity," 39–45.

[50] Shangwu subsequently pressured Du to resign so as to avoid further controversy.

versus vernacular literature, *New Youth* was able to use its group soli-
darity and strength to overwhelm its opponent.[51]

The young writers in the Creation Society also sought collective
strength through forming their group and issuing a *tongren* magazine.
By 1921, a year before the society's founding, Guo Moruo had already
become a published poet and Yu Dafu also started to see his work in
print. They recognized, however, that being a group with their own
magazine would put them on the fast track to fame. Indeed, once
they secured the publication of their *Creation Quarterly*, they staged
their quest for an authoritative literary voice by attacking the Liter-
ary Research Association for its alleged "hegemonic domination of
the literary scene" (*longduan wentan* 壟斷文壇) and countering the
notion of "art for life" espoused by the association with their "art for
art."[52] Styling themselves as "the bomb-throwing braves" (*tou zhadan
de jian'er* 投炸彈的健兒), in Guo Moruo's phraseology, they "forced
open a bloody path" (*shachu yitiao xuelu* 殺出一條血路) onto the
new literary scene.[53] Indeed, their noisy aggressiveness did more than
their literary work to catapult them to the coleadership of the literary
revolution.

Looking behind the pages of each influential *tongren* publication,
one finds that its sponsoring publisher was almost always a small
avant-garde press. As shown in the appendix, the new presses were fre-
quently born or reborn out of a single periodical publication. To start
such a project, a few like-minded friends only needed to put together a
couple of hundred yuan for buying and editing a collection of writings

[51] The radical proposal for a literary revolution in *New Youth* at the beginning of
1917 went unheeded at first. In the following year, in order to spur heated debate
and arouse public interest, *New Youth* editors Qian Xuantong and Liu Bannong came
up with a scheme: Qian faked a reader's response, written in archaic classic prose,
defending Confucian notions of literature and making unsubstantiated attacks on the
New Youth editors. Liu then wrote a much longer rebuttal ridiculing the established
reformist writers. Enraged, Lin Shu famously walked into the trap by siding *with New
Youth*'s fictive opponent. Chen Duxiu, Li Dazhao, Lu Xun, and many others joined
the ensuing debate.
[52] Without naming names, Yu Dafu belittled the leading cultural celebrities as
"maggots in the night soil—fat-bodied and empty-headed." Cheng Fangwu referred
to the poetry collections by Hu Shi, Kang Baiqing, Yu Pingbo, and Zhou Zuoren as
"weeds" in the "palace of verses." For a more detailed discussion, see Chen Fukang,
Zheng Zhenduo zhuan, 112–121; and Liu Na, *Chuangzao she yu Taidong tushuju*,
124–125, 157–160. Mao Dun also offered an insightful recollection of the event in his
Mao Dun zizhuan, 119–129.
[53] Liu Na, *Chuangzao she yu Taidong tushuju*, 136, 157, 177.

and for covering printing costs. If they were writers themselves, which was often the case, or they had close contact with writers who would accept deferred payment, they could further reduce the needed initial capital. During the Republican Era, a magazine needed to sell only a couple of thousand copies to break even. If it proved to be marketable by selling more than that figure, the venture would move to the second stage of development by releasing books, usually by the same authors who had contributed to the magazine. In this way, the media form of the magazine was an ideal sounding board and advertisement for the new presses and new writers. From the perspective of readers, because of its affordability, a magazine was often an impulse purchase rather than a major buying decision. This made a print run of two thousand a reachable goal.[54] Once the project started to show some promise, additional capital could be made available for its expansion. Guanghua, after using twenty-five yuan to fund its opening, was soon able to raise close to two thousand yuan, with which the press was able to move out of the small office it shared with a news agency to rent its own space on Fourth Street.[55]

This small-capital magazine initiative set the new presses apart from their typical big commercial counterparts, whose origins were rooted in large-capital investments and the textbook industry. In contrast to the humble beginnings of the new presses, big presses usually started big and grew bigger on enormous profits from textbook production. A look at the top four publishing enterprises of the first two decades of the twentieth century makes this point clear. Shangwu started in 1897 with 3,750 yuan, or an equivalent of roughly eight thousand yuan in the 1920s. Four years later, in 1901, it managed to raise fifty thousand yuan in its first round of financing. In 1902, Wenming Books (Wenming shudian 文明書店), soon to be Shangwu's fierce competitor, opened shop with fifty thousand yuan in initial investment. Zhonghua started in 1911 and Shijie Books in 1917, with twenty-five thousand yuan each.[56] It was no secret that, among all publications, the capital-

[54] Some contemporaries noted the particular advantage enjoyed by magazines. See Hu Daojing, "1933 nian de Shanghai zazhijie," 355. Also Yang Shouqing, *Zhongguo chuban jianshi*, 65.

[55] Shen Songquan, "Guanyu Guanghua shuju de huiyi," 33.

[56] For the operating capital of the four big publishers in their early days, see Zhu Lianbao, *Jin xian dai Shanghai chubanye yinxiang ji*, 85, 120, 139, 333–334.

intensive textbooks were also the most lucrative business.[57] In 1904, Shangwu established its supremacy by issuing its first set of textbooks; one hundred thousand copies were sold.[58] Textbooks could also be an effective weapon—Zhonghua used them in its coup d'état against Shangwu and turned itself into China's second publishing giant in just a few years.[59] The heavy reliance of these major publishers on textbooks profits prompted Christopher A. Reed to observe that "textbooks [underwrote] Shanghai's modern publishing."[60]

Given the fact that *tongren* periodicals were mission-driven and blind to market demand, they were invariably shunned by mainstream Shanghai publishers. Even Shangwu, which belonged to the category of what Pierre Bourdieu calls a "great publisher" for masterfully combining both cultural prestige and commercial success, was never interested in publishing a *tongren* periodical.[61] At the height of the May Fourth Movement, Shangwu was quick to update its intellectual profile by cultivating close ties to New Culture celebrities and incorporating new intellectual agendas into their own. In so doing, it also confirmed the legitimacy of the May Fourth cultural agendas. However, its commitment to satisfying the maximum readership, maintaining political neutrality, and supporting intellectual centralism—that is, its unwillingness to alienate any cultural factions—remained unaltered. To meet Shangwu's standards for sponsorship, a periodical had to demonstrate the prestige of its editors and frequent contributors as well as its marketability.[62] Despite Shangwu's general policy of respecting the

[57] Textbook publishing required a large amount of capital that small publishers could not afford. A print run for a title in the general book category was usually short, three thousand copies or less, requiring modest use of capital. Subsequent printings were funded from the revenues provided by selling the previous one. While less profitable and often harder to market, this strategy minimized the strain on cash flow and greatly reduced risk. As for textbooks, they usually came in a series consisting of a dozen or more books. Frequently tens of thousands of copies of each textbook in the series had to be ready for purchase, since schools would need them in large quantities at roughly the same time before a semester started.

[58] Reed, *Gutenberg in Shanghai*, 304.

[59] For the early history of textbook publishing, see Ji, *Zhongguo chuban jianshi*, 297–302.

[60] Reed, *Gutenberg in Shanghai*, 379n.

[61] Bourdieu, *The Field of Cultural Production*, 103.

[62] In 1920, for example, Shangwu declined a request from the radical Citizen Society (Guomin she 國民社), a Beijing University student patriot organization, to take over the printing and distributing of its monthly, precisely on these grounds. See Zhang Yuanji, *Zhang Yuanji riji*, 2: 716–717.

editorial autonomy of its existing magazines, it consistently repri-
manded or fired editors who got involved in controversies and made
themselves a liability to the press.[63] Like all mainstream publishers,
Shangwu would not underwrite the cultural avant-garde that underlay
the May Fourth project.

The prestige and marketability of the author were also the criteria
applied to the selection of book manuscripts at Shangwu. Therefore,
topping its author list during the first two decades of the twentieth
century were leading reformist intellectuals and writers such as Cai
Yuanpei 蔡元培 (1868–1940), Liang Qichao, Yan Fu 嚴復 (1854–
1921), and Lin Shu. Leading May Fourth writers were added from the
beginning of the 1920s only *after* their names became widely known.
When it came to unknown writers, Shangwu played only a limited role
in spotting talent. Unpublished authors rarely had a chance with the
press.[64] Even Lu Xun did not fare well. His manuscripts were rejected
twice by Shangwu, once in 1906 and again in 1922.[65] Disillusioned
with established publishers, he began to assist the publishing activities
of the New Tide Society, which in turn released his first collection of
short stories, *A Call to Arms*, in 1923.[66]

[63] The fate of Du Yaquan, mentioned earlier, was a case in point. In 1922, Shangwu
also fired Mao Dun from *Short Story Monthly* (*Xiaoshuo yuebao*) when he involved
his magazine in polemics against the so-called "Mandarin Duck and Butterfly School"
(*yuanyang hudie pai*). The rest of the polemics between the association and other
cultural factions appeared in its own *tongren* magazine, *Literature Quarterly* (*Wenxue
jikan*). In 1925, Shangwu struck again against Zhang Xicheng, the editor of its *Ladies'
Magazine* (*Funü zazhi*) for proposing moral relativism and sexual radicalism (*xingjiao
ziyou*), which outraged conservatives and liberals alike. In defiance, Zhang and his
intellectual friends founded *New Women* (*Xin nüxing*) in 1926, which would soon
evolve into the Kaiming Press.

[64] A youthful Guo Moruo could testify bitterly to this reality. His translations of the
poetry of Indian Nobel Prize–winner Rabindranath Tagore and his very first modern
short story in vernacular, which he submitted to *Eastern Miscellany*, were rejected
in 1917 and 1918 respectively. Shangwu did not start to publish Guo's work until
1925, by which time he too had acquired fame. One exception to Shangwu's practice
was its sponsorship of the Literary Research Association, first through its *Short Story
Monthly* after its reform in 1921 and then through the Literary Research Association
Book Series.

[65] Lu Xun submitted to Shangwu his translation of science fiction in 1906 and his
translation of *A Collection of Fairy Tales* by blind Russian poet V. Erosenko in 1922.
Chen Jiang, "Lu Xun yu Shangwu Yinshuguan," 544–545; and Li Xiaofeng, "Xinchao
she de shimo," 121.

[66] The first modern vernacular short story in Chinese literary history, "A Madman's
Diary" (*Kuangren riji*) by Lu Xun did not appear until 1918. "Madman" and most of
his other early short stories first appeared in *New Youth*, a *tongren* magazine. After
Lu Xun acquired his status as the most eminent writer of his time, Lu Xun had the

In contrast, new presses by definition sought undiscovered avant-garde writers. Invariably, they were the ones who performed the first acts in the creation and development of New Culture and modern Chinese literature. From 1920 to 1922, Yadong, which had close personal ties to Chen Duxiu and Hu Shi, became the pioneering publisher for the *New Youth* intellectuals and first sponsor for vernacular "new poetry."[67] In 1922, Taidong took on the task of sponsoring the Creation Society and its literary romanticism. In 1925, Guanghua facilitated the literary Marxism introduced by the Creation Society. Yadong helped to unleash the wave of "revolutionary literature" that dominated the literary scene in the late 1920s by publishing a series of novels by the previously little-known writer Jiang Guangci 蔣光慈 (1901–1936) between 1926 and 1928.[68] The list of new writers who rose to stardom through new presses is a very long one. In 1923, New Tide Society, the predecessor of Beixin, became the first and sole publisher for Lu Xun, who already by that time constituted a salient force in modern Chinese literary history. Kaiming, which set the promotion of New Literature as its primary mission at the time of its founding in 1926, was responsible for launching the literary careers of, among others, Ding Ling 丁玲 (1904–1986), Ba Jin 巴金 (1904–2005), Feng Zikai 丰子愷 (1898–1975), and Fei Ming 廢名 (1901–1967), all of whom became prominent figures in modern Chinese literature.[69]

The symbiotic relationship between new presses and May Fourth writers also guaranteed intellectual autonomy. Again taking Taidong as an example, Guo Moruo's bitterness over Taidong's alleged exploitation of him and his colleagues did not prevent him from appreciating the freedom the press allowed, a freedom essential for the rise of the Creation Society. He wrote:

pleasure of ignoring Shangwu's powerful presence and published his work exclusively through Beixin, which grew out of the New Tide Society.

[67] Yadong released the very first works of May Fourth intellectuals in book form. They included a volume of Hu Shi's translation of Western short stories in 1919; Hu's collection of new vernacular poetry *Experiments in New Poetry* (*Changshi ji*); a collection of letters between Tian Han, Guo Moruo, and Zong Baihua in 1920; collected writings of Hu Shi and Wu Yu in 1921; collected writings of Chen Duxiu; and three new vernacular poetry collections by Kang Baiqing, Wang Jinzhi, and Yu Pingbo between 1922 and 1924.

[68] All influential works of Jiang Guangci were published through Yadong within the three-year 1926–28 span. See Wang Yuanfang, *Huiyi Yadong tushuguan*, 219–221.

[69] See Shiao, "Printing, Reading, and Revolution," 130–131. The writers listed above published their first and most of their works through Kaiming.

> To be fair, we worked for Taidong only because we could take advantage of it at the same time. Those who formed the Lone Soldier Society (Gujun she 孤軍社) were all editors at Shangwu. Yet they sought sponsorship at Taidong rather than at Shangwu. This was because they wanted to write without constraints (*duo shuo ji ju yinghua* 多說幾句硬話). Those who ran periodicals for Shangwu dared not utter a single word that was contradictory to the management...In our Creation [Society] periodicals, we wrote without constraints (*shuole bushao yinghua* 說了不少硬話). You simply could not contemplate getting Shangwu's support for such periodicals![70]

"To write without constraints" meant to go against the grain of the time. Only the small new presses such as Taidong offered room for such endeavors.

Indeed, Taidong seemed to be all about freedom. Zhao Nangong's policy toward the operation of the editorial department can be best described as laissez-faire par excellence. Nothing was clearly defined. This included the workloads of the editors, daily work schedules, the ownership of the writings done in the editorial office, salaries, and sometimes even employment status![71] In 1921, when Zhao failed to offer jobs to Cheng Fangwu and Guo Moruo, he allowed Guo to stay to edit his own writings and help Zhao with editorial decisions.[72] Conversely, when it came to compensation, all the hired and ad hoc editors would get a few silver yuan now and then from the cashier or a large sum directly from Zhao to cover major expenses.[73] For this, Guo and his colleagues later accused Zhao of "excessive economic exploitation." Their fellow editor Zhang Jinglu, however, offered no such complaints, despite Zhao's favoring the newcomers. He attributed such haphazard management to Zhao's style.[74] Zhao preferred to regard his editors as friends rather than employees. As such, they enjoyed total freedom in their work and even retained their say with regard to their employment at Taidong. Zhao had once planned to fire the existing editors and replace them with Creation Society leaders. He later confided in his diary his inability to remove these editors due to their protests. One of the editors he intended to remove claimed that he would stay on at the press even if he were not paid. As for Zhang Jinglu, not only

[70] Cited in Liu Na, *Chuangzao she yu Taidong tushuju*, 220.
[71] Zhang Jinglu, *Zai chubanjie*, 69–70.
[72] Liu Na, *Chuangzao she yu Taidong tushuju*, 79–81, 97–100.
[73] Guo Moruo, "Chuangzao shinian," 92–93.
[74] Zhang Jinglu, *Zai chubanjie*, 69–70.

did he refuse to leave, but he insisted that his family be allowed to stay in the press's living quarters.[75] In sum, Taidong resembled more of a writers' colony than a business establishment.

This loose managerial style that allowed the essential freedom for May Fourth writers was characteristic of the new presses. Before its adoption of modern management techniques in order to better meet the challenge of the marketplace in the late 1920s, Kaiming operated in a similar fashion. Its editors jokingly called it "a family artisan workshop" (*jiating shougong zuofang* 家庭手工作坊).[76] Song Yunbin 宋雲彬 (1897–1979), a longtime Kaiming editor, recalled those good old days: "There were only a few people working there, all friends who shared common interests. There were no real rules and regulations, no clear division of labor. [The company operated] completely in the style of an artisan workshop [and thus] was full of [collegial] warmth."[77]

This workshop atmosphere and laissez-faire managerial style posed a stark contrast to the big publisher model aimed at maximizing productivity and profit. Shangwu, for example, which already had in place a recruitment system by examination, at the beginning of the 1920s accelerated its introduction of "scientific management," which included a requirement that all its editors punch time cards when they arrived at work.[78] The new presses' lack of such managerial practices contributed to their general risk-taking propensity and thus their role as critical sponsors of the May Fourth generation.

An important explanation for the old style of the new presses is the attitude of the new publishers toward their work and self-identity. As Reed points out, printers and publishers had always occupied an ambiguous status between culture and commerce, and often painstakingly stressed their ties to scholarship rather than business.[79] Not surprisingly, Li Xiaofeng 李小峰 wrote, "The goal of associational publishers was not profit. Rather, they were committed to the spread

[75] Guang, "Yijiu eryi nian de Taidong tushuju," 99.

[76] Song Yunbin, "Kaiming jiushi," 31: 7.

[77] Ibid.

[78] Its system of recruitment through examination operated side by side with the traditional method of recruitment through connections. For Shangwu's changing attitude toward its editors and its new chief editor Wang Yunwu's introduction of "scientific management," see Tao Xisheng, "Shangwu yinshuguan bianyisuo jianwen ji," 489–495. Reed offers a detailed discussion of the business structure and management of the three publishing giants; see *Gutenberg in Shanghai*, chapter 5.

[79] Reed, *Gutenberg in Shanghai*, 30–35.

of scholarship, and the dissemination of culture" (*xuanyang xueshu, chuanbo wenhua* 宣揚學術, 傳播文化).[80] Li was a member of the New Tide Society, which later expanded the society's publishing project to the Beixin Press.[81] Compared to mainstream publishers, new presses placed more emphasis on the cultural aspect of their work and thus regarded themselves as producers of culture rather than as book merchants. This commitment to culture often prompted them to issue manifestos or mission statements at the founding of their enterprise in much the same manner as a May Fourth society.[82] Though profitability of their ventures was important, the new presses strived to be agents for cultural change rather than cater to mass readership.[83]

In this "interest in disinterestedness,"[84] to borrow Pierre Bourdieu's phraseology, new presses found perfect partnerships with May Fourth intellectuals, who readily exhibited an exaggerated disdain toward alleged mainstream commercial writers. Indeed, this partnership, implicitly and explicitly cultivated, set the new presses apart from mainstream publishing companies. Many May Fourth intellectuals later lauded the presses that promoted their careers. Chen Duxiu, for instance, wrote of his old publisher Wang Mengzou 王孟鄒 (1879–1953): "Twenty years ago [in 1907], Mengzou, a bookish man without any business experience, came to Wuhu to start a new press. Such rashness! It was all his passion for reform that led him to [publishing]." Hu Shi wrote, "For twenty years, [the Wuhu Science Press] has functioned as the midwife of culture." The Wuhu Science Press was the predecessor of the Taidong Press, both owned by Wang Mengzou.[85] "Midwife of culture" was an identity with which all new presses felt comfortable and in which they took pride. Indeed, the partnership with May Fourth communities confirmed the new presses' self-identity and privileged position in cultural history.

[80] Li Xiaofeng, "Xinchao she de shimo," 116.

[81] The two characters "Beixin" were short for the Beijing University and New Tide Society (Xinchao). Beixin was formed in Beijing in 1925. See Li Zongfeng, "Li Xiaofeng yu xin wenxue yundong," 61.

[82] For the manifestos of Yadong and Kaiming, see Wang Yuanfang, *Huiyi Yadong tushuguan*, 23–24; and Zhonggong Shanghai, 156.

[83] For Zhang Jinglu's musing on the difference between publishers and book merchants, see Zhang Jinglu, *Zai chubanjie*, 147.

[84] Bourdieu, *Field of Cultural Production*, 40.

[85] Cited in Wang Yuanfang, *Huiyi Yadong tushuguan*, 200.

Politics, Profits, and Professions

Although the new presses never intended their products to appeal to a mass audience, their audience did become massive in the context of political turmoil and popular activism during the second half of the 1920s. Two major events came to define these years: the May Thirtieth Movement of 1925 and the Great Revolution of 1926–27.[86] These political maelstroms galvanized millions of young men and women who sought exposure to new worldviews, which they then incorporated into their redefinitions of the Chinese social and political order. Consequently, they became the catalyst for the rapidly enlarging audience for May Fourth–inspired publications and created a golden age for new publishing. The flourishing of new publishing in turn set the stage for a transformation of the intellectual life of the May Fourth generation.

In the second half of the 1920s, avant-garde presses mushroomed in Shanghai. Four notable ones—Beixin, Guanghua, the Creation Society Publishing Office, and Kaiming—all appeared in 1925 and 1926.[87] In the next two years, over a dozen more opened shop on the Culture Streets. By 1928, the total number of small presses in Shanghai had reached sixty-one, creating the Culture Streets phenomenon described at the beginning of this essay.

The boom in new publishing was also reflected in the rapid expansion of individual presses. In the three years following its founding, Guanghua opened four branch stores.[88] Between 1926 and 1929, Beixin had to move three times to larger spaces so as to accommodate

[86] Sparked by the killing of a union leader by Japanese guards and the indiscriminate firing by British police on a mass rally protesting the Japanese killing, May Thirtieth anti-imperialist demonstrations raged throughout the country. These demonstrations involved twenty-nine cities and gave impetus to an unprecedented sixteen-month-long large-scale general strike in Guangzhou (Canton) and British-ruled Hong Kong in 1925 and 1926. Like the May Fourth Movement before it, the May Thirtieth Movement became a symbol and a rallying cry. The Nationalist Party (GMD) and the CCP, now both headquartered in Guangzhou and allied on the common ground of anti-imperialism and anti-warlordism, worked to channel the rage and energy of the Chinese people into what was called the Great Revolution. Spearheaded by the 1926–27 Northern Expedition under the leadership of the GMD-CCP alliance to unify China, the Great Revolution was the first true mass mobilization in the country's history.

[87] To flee the political prosecution of the warlord government, Beixin moved its headquarters from Beijing to Shanghai in 1927.

[88] Shen Songquan, "Guanyu Guanghua shuju de huiyi," 33–34.

Revenues and Expenditures of the Yadong Press, 1919–1928 (in yuan)

Year	1919	1920	1921	1922	1923	1924	1925	1926	1927	1928
Revenues	12,943	36,070	40,902	67,524	48,046	65,011	64,597	70,677	76,280	79,690
Expenditures	4,426	6,883	10,423	13,045	18,163	22,167	27,239	25,686	28,701	33,547

Source: Wang Yuanfang, *Huiyi Yadong tushuguan*, 230–31.

its expanded operations.[89] As for Yadong, it grew from a very modest operation in the late 1910s to a sizable enterprise that had 390 retail outlets across the country as well as in Japan, Southeast Asia, and even the United States in the early 1930s. Its revenue grew more than six-fold in ten years (see table above).

New publications were all the rage during the late 1920s. Shen Songquan conveyed the exuberance he felt when he wrote about the opening of Guanghua's first branch in Nanchang, Jiangxi, in 1926 right after the city was captured by the National Revolutionary Army of the GMD-CCP Alliance:

> [As we were setting up a branch in Nanchang,] we requested Lu Fang in Shanghai to waste no time in delivering to us large shipments of new books published by Guanghua and other new presses. Upon the arrival of the first shipment, we had our grand opening. As expected, an enthusiastic crowd descended on the store on the first day. [Zhang] Jinglu and I busied ourselves in taking care of our customers. The first shipment was sold out in no time. With the second and third shipments, we still could not meet the demands [of our readers].[90]

In the second half of the 1920s, years after the launching of the Literary Revolution, May Fourth writers finally arrived at a position to compete with writers of old-style popular fiction for readership.[91] Jiang Guangci is a case in point. Returning to China after three years of studies in Soviet Russia, he was determined to combat once again what he saw as the harmful influence of the decadent old-style literature. In his self-appointed role as the "singer for the East Asian revolution" (Dongya geming de gezhe 東亞革命的歌者), he quickly produced five novels or novellas and one collection of short stories before he died of

[89] Cai Shuliu, "Beixin shuju jianshi," 2: 91.
[90] Shen Songquan, "Guanyu Guanghua shuju de huiyi," 34.
[91] Many critics have pointed out that old-style popular fiction continued to dominate the book market throughout the 1920s and beyond, despite fierce and concerted attacks from the May Fourth camp in the early 1920s. See, for example, Li Zongfeng, "Beixin shuju de shengshuai," 72.

tuberculosis in 1931. All of his works, which were released by Yadong, became runaway successes. His first novella, *Young Loafer* (*Shaonian piaobo zhe* 少年漂泊者), first issued in 1926, enjoyed five print runs in two years. This record was to be surpassed only by his later novel *The Moon Shining through the Clouds* (*Chongchu yunwei de yueliang* 衝出云圍的月亮, 1927), which went through six print runs in the year it was first released.[92] Jiang's work started a literary vogue of using "revolution + love" as a formula for successful fiction writing. Works of many other May Fourth writers also became popular. As Li Zongfeng, who has written extensively on Beixin, notes, "Lu Xun's *A Call to Arms*, Bin Xin's *Letters to Young Readers* (*Ji xiao duzhe* 寄小讀者), and Yu Dafu's *Diaries* (*Riji jiuzhong* 日記九種) were so popular that all lovers of literature could claim ownership of a copy each."[93] In particular, Lu Xun's *A Call to Arms*, issued in 1923, was reprinted thirteen times in eight years with print runs reaching 48,500.[94] In the early 1930s, Kaiming's release of Mao Dun's *Midnight* (*Ziye* 子夜) and Ba Jin's *Family* (*Jia* 家), became hits. The former enjoyed a circulation of 23,000 in the first three months after it went to press in 1933. The latter went through as many as thirty-three print runs in the two decades after it first appeared in 1933.[95] Both pushed the popularity of modern vernacular literature, indeed publications in any genre, to new heights.[96]

Works of nonfiction, especially those in the social sciences, also scored impressive successes. Thanks to the new presses, social sciences were another category that generated interest among the reading public. In 1929, for example, 155 new titles in social sciences appeared.[97] The new presses issued the lion's share. The high circulation figures of some of the titles in this category indicated its popularity. For example, *China under the Economic Exploitation of the Powers* (*Jingji qinlüe xia*

[92] For the circulation of his work, see Wang Yuanfang, *Huiyi Yadong tushuguan*, 139; and Kuang, *1928: Geming wenxue*, 97.

[93] Li Zongfeng, "Beixin shuju de shengshuai," 72. These were all Beixin publications.

[94] See Wang Xirong, "*Nahan* geban guoyan lu," 49–54.

[95] See Kuang, *1928: Geming wenxue*, 39.

[96] To appreciate the scale of these successes, one can look at sales figures for the most popular novel of the teens and twenties, the sentimental love story by Xu Zhengya, *Jade Pear Spirit* (*Yuli hun*, first released in 1912). It took the book market by storm and eventually enjoyed thirty-two print runs over the next few decades, with total numbers reaching several hundred thousand. For the popularity of Xu's novel, see Yang Yi, *Zhongguo xin wenxue tuzhi*, 59.

[97] Ji, *Zhongguo chuban*, 439.

zhi Zhongguo 經濟侵略下之中國), written by a young Marxist and released by Guanghua in 1925, enjoyed three print runs in a short span of four months before it succumbed to the warlord government's censorship.[98] The same thing can be said about *The Women's Emancipation Movement* (*Funü yundong gailun* 婦女運動概論) by Yang Zhihua 楊之華 (1901–1973).[99] Its first three thousand copies were sold in no time in 1927. Its publisher, Yadong, proceeded to make an unprecedented order of ten thousand copies for its second print run. What was amazing about the sale was that it was done without any promotional efforts. Every indication was that this book would have been one of the most widely read of its time had it not been suppressed by the new Nationalist government in the same year.[100]

In the heated atmosphere of the mid-to-late 1920s, readers' appetites for radical literature were enormous. The increased market demand for the works of May Fourth writers went unabated even after the GMD White Terror of 1927 and subsequent censorship. New publishing did much both to create and to meet this new market demand. Radicalism can be seen as a trademark of many new presses. Guanghua and the Creation Society Publishing Office became the most notable publishers entering dangerous political territory and, in fact, thriving. They and many others issued books that would end up on the warlord and Nanjing governments' lists of censored publications. These publishing ventures were chiefly responsible for the production and distribution of radical literature. They also helped to move the New Culture production of the 1920s toward the left.[101]

Indeed, with their new and vastly expanded audience, the new presses seemed to enjoy a better chance than their conventional counterparts of issuing titles in the general interest category that would become hot items on the book market. This is evidenced by the fact that their titles became the primary targets of the book piracy that

[98] Shen Songquan, "Guanyu Guanghua shuju de huiyi," 33. The author of the book, Qi Shufeng, was murdered by the warlord police two years later.

[99] Yang, a Communist and labor organizer, was married to Qu Qiubai, a well-respected writer who was to become the secretary-general of the CCP in 1929.

[100] Wang Yuanfang, "Yadong tushuguan jianshi," 138.

[101] Oftentimes, because they all carried what was deemed "radical" literature, the authorities had difficulty distinguishing between a Communist press of the sort discussed by Christopher A. Reed in his essay and the avant-garde presses such as Guanghua and Creation Society Publishing Office. Ironically, the avante-garde firms often proved more effective in promoting an intellectual environment sympathetic to the spread of Marxism.

ran rampant in the late 1920s and 1930s.[102] According to one report filed by the Publishing Trade Association's Piracy Investigation Office (Chuban tongye diaocha fanban 出版同業調查翻版), which covered copyright violation cases in Beijng and vicinity between 1930 and 1935, far more book pirates stole from the new presses than from the major publishers. Out of the forty violations in the report, ten book pirates printed Beixin's copyrighted titles, four Yadong's, four Kaiming's, and three Xiandai's (現代), while the Big Three only suffered from theft by one book pirate each.[103] Ultimately, this rampant book piracy and the GMD's tightened censorship were among the primary causes for the terrible hardship the new presses started to experience in the late 1920s.[104]

Clearly, works of May Fourth writers had become profitable commodities. Their profitability had a profound impact on the publishing world. Irrespective of their disclaimers of interest in profit, new presses now turned themselves into successful businesses. This development was paralleled by mainstream publishers' sponsorship of May Fourth writers once the writers had initial success with an avant-garde publisher. With more options, new writers expanded their publishing networks. Likewise, new presses reached out to build broader circles of authors. Consequently, the May Fourth cultural avant-garde and political radicalism increasingly became the mainstream.[105] May Fourth publications came to enjoy a mass audience. In other words, the May Fourth Movement was no longer synonymous with the anticommercial exclusivity and elitism that had characterized it during the late teens and early twenties.

The publishing boom in the second half of the twenties was accompanied by a great migration of May Fourth writers to Shanghai. Lu Xun, after fleeing Beijing and spending an unhappy year teaching in the southern cities of Guangzhou and Xiamen, finally settled in Shanghai to start a new freelancing career in 1927. So did his old friend and new foe Lin Yutang, who moved from Xiamen to Shanghai after

[102] Chinese copyright laws were first issued by the Qing Court in 1910, then by the Yuan Shikai and the GMD governments in 1915 and 1928, respectively. For the development of copyrights in China, see Li Mingshan, *Zhongguo jindai banquan shi* and Wang Lanping, *Jindai Zhongguo zhuzuo quan fa de chengzhang*.

[103] Chuban tongye, File 313:156.

[104] By the early 1930s, many were driven out of business.

[105] The CCP publishers discussed by Reed in this volume now emerged as the producers of radical writings.

a stint in Wuhan as foreign secretary of the National Revolutionary Government under the GMD-CCP alliance. In the same year, Mao Dun and many members of the Creation Society and radical Sun Society (*Taiyang she* 太陽社), including Guo Moruo, Qian Xingcun 錢杏村 (1900–1977), and Jiang Guangci, who had joined the Northern Expedition, fled to Shanghai to escape the GMD purge. Also in 1927, Chen Duxiu parted company with the CCP he had helped found and lead. He took refuge in Shanghai's French Concession, to which Hu Shi also returned after a lengthy around-the-world tour. Others who joined this historical migration to the city included Wen Yiduo 聞一多 (1899–1946), Shen Congwen 沈從文 (1902–1988), Hu Yepin 胡也頻 (1903–1931), Ding Ling, Feng Xuefeng 馮雪峰 (1903–1976), all from Beijing; Xia Yan 夏衍 (1900–1995), Feng Naichao 馮乃超 (1901–1983), and Li Chuli 李初梨 (1900–1994), all from Japan; Ba Jin from France; Liu Na'ou 劉吶鷗 (1905–1940) from Taiwan; and Liang Shiqiu 梁實秋 (1903–1987) and Yu Shangyuan 余上沅 (1897–1970) from Nanjing. By the end of the 1920s, the majority of known May Fourth writers had settled in Shanghai.[106] The attraction of the city was obvious, as it boasted an immense publishing and distribution capacity that far surpassed any other city in China.

The prosperity of May Fourth publications played a significant role in moving the May Fourth generation toward professionalization. As they settled into this capital of modern Chinese publishing, the May Fourth writers now rubbed shoulders with the professional old-style writers or the "treaty-port littérateurs," whom they had dismissed as profit seekers. Now they had also come to write for a living. Disillusioned and marginalized by the political violence of the mid-1920s and pressured by economic imperatives, members of the May Fourth generation were steadily moving away from their idealistic self-identity as social prophets and coming more into line with a new breed of modern professionals. Editorial offices now provided some of the best employment to these intellectuals. Freelancing writers, lacking salaried positions in corporate organizations, were very much supported (as well as constrained) in their work by the corporate process in publishing. By the end of the 1920s, those avant-garde new presses that had managed to survive started to adhere to the standard business practices of their commercial counterparts, such as content selection,

[106] Kuang, *1928: Geming wenxue*, 19–20.

production timetables, and standardized royalties. May Fourth writers changed along with their publishers.

By the late 1920s, it had become common for the May Fourth communities to "sell one's writings for a living," or in the unsentimental phraseology of Xia Mianzun 夏丏尊 (1886–1946), the editor-in-chief of Kaiming, "to sell small characters" (*mai xiaozi* 賣小字).[107] For example, Shen Congwen's early writing career had a lot to do with selling small characters both high in quality and large in quantity. Once settled in Shanghai, Shen turned out manuscripts with amazing speed. His output in 1927 and 1928 included half a dozen novellas in book form and many essays and short stories released in magazines. These quickly secured Shen's literary stardom. In financial terms, his work fetched him roughly one hundred yuan per book manuscript, putting him into the new socioeconomic group of middle-class professionals. His publishers included Xiandai, Xinyue 新月, Guanghua, Beixin, Renjian 人間, Chunchao 春潮, Huaguang 華光, and Shenzhou guoguang she 神州國光社—all new avant-garde presses.[108] A successful career of selling small characters in the twenties could be as socially influential and financially rewarding as traditional office holding or land holding. Indeed, a merchant cousin of Lou Shiyi 樓適夷 (1905–?) enviously commented on Lou's royalties from Kaiming Press, "It's as if you've bought a few *mu* of land and have the land rent to collect every year!"[109] Lou, previously a member of the Sun Society and later an active member of the League of Left-Wing Writers 左翼作家聯盟, was at the time serving his sentence in a GMD prison. And yet he was able to continue to support his family by writing and translating. Indeed, by the late 1920s, writing and publishing had become as much a job as a New Culture cause.

Conscious of their new position in the rapidly changed socioeconomic landscape, writers formed various organizations for professional support. In the spring of 1927, May Fourth writers in Shanghai, mostly leading members of the Literary Research Association, initiated the Shanghai Authors Association (Shanghai zhuzuoren xiehui 上海

[107] "Selling small characters" was a play on the expression "to sell big characters" (calligraphy), used in late imperial times to describe the literati practice of selling their writings or calligraphy when down on their luck. Lou, *Wo yu Kaiming*, 51–55.

[108] Kuang, *1928: Geming wenxue*, 32–33.

[109] Lou, "Nanwang de guli he bangzhu," 53.

著作人協會).[110] A year later, Zheng Zhenduo 鄭振鐸 (1898–1958)
worked with Zhang Shenfu 張申府 (1893–1986) and the members of
the Creation Society to form the Chinese Authors Association (Zhong-
guo zhuzuozhe xiehui 中國著作者協會).[111] The announcement of
the founding of the Shanghai Authors Association reads: "With the
emergence and growth of capitalism…the spiritual products of the
author have become commercialized; the author has been turned into
a (cultural) retailer or employee; he/she now shares the same fate as
manual laborers due to his exploitation by capitalists."[112] In addition
to conveying similar messages about intellectuals becoming "retailers"
and "employees," the manifesto issued by the Chinese Authors Asso-
ciation also clarified the writers' dual role: "We make a living by selling
our labor. In the interest of our own livelihood, we need to improve
our economic condition and legal protection. At the same time, we
are also workers of culture and thus shoulder the responsibilities of
constructing and promoting Chinese culture."[113]

Both passages reflect the determined professionalism of the authors,
as well as the degree to which class discourse influenced the way they
thought about their work. In 1927, the GMD purge put a quick end to
the Shanghai Authors Association and an internal dispute over cultural
issues paralyzed the Chinese Authors Association.[114] But clearly, May
Fourth intellectuals had made conscious attempts to combine their new
vocation as modern professionals, as sellers of their labor, with their
traditional mission of providing spiritual guidance to the nation.

Conclusion

"In the last year, the Shanghai publishing world has experienced a sud-
den show of vitality," an observant commentator proclaimed in 1928.

[110] See Chen Fukang, *Zheng Zhenduo zhuan*, 168–169.

[111] The Association elected a nine-person acting committee, which included Zheng
Zhenduo, Zheng Boqi, Shen Duanxian (aka Xia Yan), Li Culi, Peng Kang, Zhou
Yutong, Pan Zhongyun, Pan Zinian, and Zhang Xicheng, who was the founder of
Kaiming. See Chen Fukang, *Zheng Zhenduo zhuan*, 209–212.

[112] "Shanghai zhuzuoren gonghui yuanqi," cited in Chen Fukang, *Zheng Zhenduo
zhuan*, 168–169.

[113] Cited in Chen Fukang, *Zheng Zhenduo zhuan*, 211.

[114] Chinese journalists of the Republican Era were more successful than creative
writers in turning their work into a professional pursuit. See Xu Xiaoqun, *Chinese
Professionals and the Republic State*, chapter 6.

He continued, "The reasons that led to this phenomenon are many. But the most direct one is the arrival of the small presses [on Fourth Street]."[115] Indeed, the rise of the new presses did breathe new life into the existing publishing world. In locating and creating audiences for May Fourth–inspired publications, the new presses also found their own niche in the book market. They helped to create a boom in general interest publications, particularly in magazines, while the three publishing giants put most of their resources into textbook production.[116] More important, by making May Fourth–inspired publications popular and profitable, they changed the dynamics of the entire book market as mainstream publishers quickly followed their lead and rushed to buy manuscripts from or offer book contracts to May Fourth writers.

The new presses played a significant role not only in the boom in Shanghai publishing but also in the formation and direction of new literary and cultural experiments in the post–May Fourth period. The new presses' willingness to publish *tongren* periodicals—a willingness that distinguished them from the larger commercial presses of the day—gave May Fourth intellectuals much-needed vehicles for the expression and dissemination of their ideas. The often unconventional writing and publishing relationships that developed between intellectuals and the new presses allowed intellectuals considerable freedom to write what they chose, as well as considerable control over the publication process. And their experiences working with (and often at) the new presses helped professionalize these writers, preparing the way for their entry into the larger print marketplace by the end of the 1920s.

Indeed, the progress of the May Fourth intellectuals—from elitists writing for their peers to truly professional authors seeking to reach a large mass audience—can be traced through their relationship with both the new presses and the larger commercial publishers like Shangwu, Shijie, and Zhonghua. During the May Fourth Movement and even, in some cases, until the mid-1920s, despite their populist conviction in promoting a national awakening, these intellectuals paradoxically focused on writing for a small, college-educated

[115] Wang Yintong, "Xiao shudian de fazhan," n.p.
[116] The boom of the periodical press culminated in 1933, the "magazine year," when as many as 247 different magazine titles were available. Hu Daojing, "1933 nian de Shanghai zazhijie," 351.

audience and earned recognition from their peers by fighting liter-
ary and cultural battles in their *tongren* magazines. For this reason,
recent revisionist historians dispute the classic notion of the May
Fourth Movement and the cultural changes it spawned as "the Chinese
enlightenment," claiming instead that it started a hegemonic cultural
tradition that prepared fertile ground for eventual Communist ideo-
logical dominance.[117] But a look at the inner dynamics of publishing
in the mid- to late 1920s reveals a more complicated picture. While
continuing to disclaim economic interests and oppose capitalism,
May Fourth intellectuals, as their increasing fame made them attrac-
tive to the large commercial publishers, became increasingly wedded
to the capitalist marketplace. And, no longer content to write for a
tiny, elite readership, they also started to pursue a larger reading pub-
lic.[118] At the same time, many of the new presses also began to expand
and seek larger profits and thus larger audiences. Both these trends
stimulated the spread of ideas and values that had originated with the
May Fourth Movement far beyond college campuses and circles of
avant-garde youth. Only in the late 1920s, then, did the May Fourth
enlightenment—in the sense of a new cultural movement that aspired
to redefine Chinese culture for all—truly begin.

Ironically, the success of the new presses in many cases presaged
their downfall. When the larger commercial publishers, armed with
significantly larger capital resources, more sophisticated production
organizations, and more expansive distribution networks, began to
court the newly famous May Fourth writers, the new presses were at
a serious disadvantage. In addition, the presses' propensity for politi-
cal radicalism and cultural avant-gardism often invited government
censorship and shutdown. By the early 1930s, most of the new presses
had lost out in the fiercely competitive world of publishing. Only
a few, such as Kaiming and Beixin, emerged triumphant, and these
only because they turned to less politically risky publications and
incorporated some of the business strategies of their competitors into
their own operations. But the ultimate failure of the new presses

[117] The revisionist view first emerged in China during the late 1980s. See Gu Xin's
discussion of the historiography of the May Fourth Movement and its revisionism
in his *Zhongguo qimeng de lishi tujing*. The most recent research representing the
revisionist view is Doleželová-Velingerová, Král, and Sanders, *The Appropriation of
Cultural Capital*.
[118] Shiao, "Printing, Reading, and Revolution," chapters 3, 4.

should not lead us to ignore the significant contributions they made to modern Chinese intellectual life during the crucial third decade of the twentieth century. In large part as a consequence of their support of the new intellectuals, the direction of Chinese publishing was permanently altered in favor of the May Fourth generation, allowing its members to consolidate their claim to leadership of the Chinese cultural realm.

Appendix:
Leading New Presses of the 1920s

Time Span	Name	Founders	Network of Authors	Initial Magazine Publication	Reason for Closure
1913–53	Yadong Press	Wang Mengzou	Chen Duxiu, Hu Shi, and other *New Youth* editors		financial
1915–late 1930s	Taidong Press	Zhao Nangong	Creation Society	*Creation Quarterly* (1922–24)	censorship & financial
1925–46	Beixin Press	brothers Li Zhiyun (李志雲), Li Xiaofeng	Lu Xun, his friends and disciples	*Yusi* (語絲, 1924–30)	merged
1925–35	Guanghua Press	Zhang Jinglu, Shen Songquan, Lu Fang	Creation Society, League of Left-Wing Writers from 1930	*Flood* (1925–27)	GMD censorship & financial
1925–46	Liangyou Press (良友圖書印刷公司)	Wu Liande (伍聯德)	Lu Xun, Mao Dun, Ba Jin, Lao She, Shi Zhecun	*Young Companion* (*Liangyou*, 良友, 1926–46)	war, censorship, discord among the board members
1926–33	Creation Society Publishing Office, later Jiangnan Press (江南書局)	Creation Society	writers-publishers	*Flood* (taking over from Guanghua in 1926), *Creation Monthly* (1926–29)	GMD shut down
1926–53	Kaiming Press	Zhang Xichen, Zheng Zhenduo	writers-publishers	*New Women* (*Xin nüxing* 新女性, 1926–29)	merged
1927–35	Xiandai Press	Hong Xuefan (洪雪帆), Zhang Jinglu, Shen Songquan	previous members of Creation Society, Lu Xun	*Modern* (*Xiandai* 現代, 1928–2)	financial

(cont.)

Time Span	Name	Founders	Network of Authors	Initial Magazine Publication	Reason for Closure
1927–33	Xinyue Press (新月書店)	Xu Zhimo (徐志摩), Hu Shi, Liang Shiqiu (梁實秋), Yu Shangyuan	writers-publishers	Crescent Moon (Xinyue 新月, 1927–33)	Death of Xu Zhimo in 1931 and subsequent absence of a full-time editor
1927–55	Guangming Press (光明書局)	Wang Zicheng (王子澄)	Xue Zhengbi (薛正壁), Xie Bingxin (謝冰心)		merged
1928–32	Kunlun Press (昆侖書店)	Li Da (李達)	writers-publishers		GMD shut down
1928–33	Dajiang Press (大江書鋪)	Chen Wangdao (陳望道), Shi Cuntong (施存統)	writers-publishers	Yangzi River (Dajiang 大江, 1928)	financial & GMD censorship
1928–32	Diyixian Press (第一綫書店)	Dai Wangshu (戴望舒), Shi Zhecun (施蟄存), Liu Na'ou	writers-publishers	Trackless Trains (Wugui dianche 無軌電車, 1928)	financial
1928–37	Xinshengming Press (新生命書局)	Zhou Fohai (周佛海), Tao Xisheng (陶希聖), Fan Zhongyun (樊仲雲)	writers-publishers	New Life (Xin sheng-ming 新生命, 1928–30)	war

Sources: Zhu Lianbao, Jin xian dai Shanghai chubanye yinxiangji; Wang Guilin, Zhu Hanguo et al., eds., Zhongguo baokan cidian, 1815–1949.

READING AND WRITING *ZHEJIANG YOUTH*: LOCAL TEXTUAL ECONOMIES AND CULTURAL PRODUCTION IN REPUBLICAN JIANGNAN[1]

Robert Culp

In Republican-period, lower–Yangzi region education circles (*jiaoyujie* 教育界), readers were also writers. Students, teachers, administrators, and government officials at various levels read, edited, and wrote for a wide array of educational journals that were provincial or local in self-conception and circulation. The proliferation of these educational journals created a regionally bounded textual economy that depended on modern industrialization and market networks to make relatively inexpensive mechanized printing services readily available in towns and cities throughout the region. This textual economy marked a new pattern of cultural production—characterized by delimited circulation of cheap, accessible journals—that facilitated diverse cultural projects.[2]

In stressing how lower–Yangzi region education circles' readers were also writers, I build on the insights of Michel de Certeau and others who have portrayed reading as an active process of making meaning.[3] But where de Certeau still preserves a fairly sharp distinction between the authoritative author and the "poaching" reader, I suggest here that the proliferation of print capitalism in modern China

[1] Material from this chapter was presented at AAS annual meetings in 2007 and 2009. My thanks to panel discussants Peter Bol, Shawn McHale, and Christopher A. Reed for challenging questions and stimulating comments. Discussion with copanelists Elisabeth Köll, Anne Reinhardt, Ted Mack, and Hoyt Long also shaped my thinking on these issues.

[2] By cultural production I mean both the production of cultural commodities and the various ways in which cultural resources and repertoires can be used to create a social identity for individuals and social groups and to construct power relations among them. My perspective is indebted to Pierre Bourdieu's analysis of how social identities and structures are constituted through creative work, cultural consumption, symbolic and linguistic performance, and participation in patterned forms of daily interaction. See Bourdieu, *The Logic of Practice; Distinction: A Social Critique; Language and Symbolic Power;* and *The Field of Cultural Production.* However, where Bourdieu often stresses the way social structures and power relations are reproduced through cultural action, this paper indicates some of the ways that cultural work provides a resource for producing new identities, communities, and forms of power.

[3] de Certeau, "Reading as Poaching," in *The Practice of Everyday Life.*

encouraged many readers also to be authors. In Republican-era Jiang-nan, school-based publications and local educational journals created many chances for students, teachers, and local educators to produce their own texts. For these groups, reading became a purposeful process of foraging for material to use in their own writings, or served as a stimulus that required a response. Active reading became the first step in writing as cultural production. The journals these students and edu-cators produced and consumed created a regional textual economy in which various writings circulated widely or narrowly and had different functions and value. The circulation of these writings created a loosely bounded community of readers and writers that was isomorphic with lower–Yangzi region education circles.[4]

Of course, many readers had been authors in late imperial China as well.[5] But this essay posits that, in the early twentieth century, new conditions transformed the dynamics of reading and writing in local communities. The establishment of modern schools, starting in the late Qing, probably did not immediately increase the overall number of readers who were fully literate and could aspire to be authors.[6] Yet

[4] In focusing on how the textual economy of educational journals worked to define a reading and writing community, I seek to follow Roger Chartier's call to discover how reading practices generate reading communities, rather than assuming that the boundaries of reading publics coincide with sociographic markers. See Chartier, "Communities of Readers," in *The Order of Books*, 4–8.

[5] Joseph P. McDermott, for instance, documents the emergence of what he calls a "*shengyuan* book culture," in which the lowest tier of the examination elite "wrote, edited, compiled, revised, and copied reading materials." See "The Ascendance of the Imprint in China," in Brokaw and Chow, *Printing and Book Culture in Late Imperial China*, 86. Similarly, Chow, *Publishing, Culture, and Power in Early Modern China*, describes the proliferation of a diverse array of "literary professionals" during the Ming. Brokaw, "Reading the Best-Sellers of the Nineteenth Century," in *Printing and Book Culture*, 197–199, 210, also demonstrates how local scholars revised, edited, pref-aced, and annotated even standard best-selling educational publications. Finally, Anne E. McLaren, "Constructing New Reading Publics in Late Ming China," in *Printing and Book Culture*, 163–167, identifies the "aficionado collector" (*haoshizhe*) as an arche-typal reader/writer during the Ming.

[6] For the distinction between functional and full literacy, see Rawski, *Education and Popular Literacy in Ch'ing China*. David Johnson has estimated that at any given time during the Qing dynasty, roughly five million adult men were classically trained. See Johnson, "Communication, Class, and Consciousness in Late Imperial China," in *Popular Culture in Late Imperial China*, 59. This calculation compares favorably with the roughly 5 million students that Christopher A. Reed in the introduction cites as attending modern primary schools by the early 1920s. Following Gu Yanwu, Benjamin Elman, *A Cultural History of Civil Examinations in Late Imperial China*, 140–141, suggests that there were five hundred thousand *shengyuan* in China during the eighteenth century. Republican China's numbers of secondary students, whose

the growing popular currency of the written vernacular after the 1910s significantly lowered the minimum threshold for public written expression. At the same time, the spread of mechanized printing facilitated local communities' growing production of periodicals, one of the few print genres that was not widespread in late imperial China. These new journals provided a forum for a wide cross-section of literate people, including secondary students and primary school graduates, to express their ideas by using new discursive forms and encounter a relatively broad readership.[7] The ability of a broad cross-section of literate people to publish short pieces, frequently, in a variety of journals, facilitated ongoing dialogue in print among many more people than in the late imperial period. Then, a relatively small subset of non-elite readers and the lower-ranking examination elite, such as first-degree holders (*shengyuan* 生員), could compete in writing with high-ranking literati for access to the print market. Moreover, new forms of writing in periodicals, such as editorials, short commentaries, and academic essays, provided a more flexible and accessible medium of expression for local authors than had the genres available to late imperial literati.[8] In short, twentieth-century interactions between readers and writers of local journals constituted a new kind of public sphere, one demarcated by both regional context and professional identification, as captured in the concept of "education circles."[9]

educational level roughly compared to that of the *shengyuan*, did not climb above five hundred thousand until the Nanjing Decade (1927–37). See Jiaoyubu tongji shi, *Quanguo jiaoyu tongji jianbian*, 36–37.

 [7] Local educational journals included many of the different hybrid prose forms of commentaries and critical essays (*pinglun, shelun, shiping, zaping*, or *qingtan*) that emerged in the Chinese press during the first decades of the twentieth century, allowing great freedom of expression and discursive register. On the development of these stylistic forms, see Andrea Janku's essay in this volume and Barbara Mittler, *A Newspaper for China?* chapter 1. However, prose forms in periodicals differed somewhat from those of newspapers, and the type of thorough stylistic analysis that Mittler and Janku have conducted for newspapers still remains to be done. One basic difference is that the academic essay (*lunwen*) was an important genre in periodicals, but uncommon in newspapers.

 [8] Because the late imperial print market was dominated by classics, educational texts, and fiction, it seems that authors from the marginal elite broke into print primarily through writing fiction, prefaces, and commentaries and through the choices they made in compiling. See, for instance, Brokaw, "Reading"; Chow, *Publishing, Culture, and Power*, chapter 3; and McLaren, "Constructing New Reading Publics," 163–166.

 [9] In stressing these two ways that the dialogue in local educational periodicals created a spatially bounded public, I contribute to recent work on modern Chinese

This regionally based textual economy was sustained by industri-
alization and market networks, which generated relatively cheap and
locally accessible mechanized printing services. Cynthia Brokaw's
groundbreaking work on the Sibao book trade has established that
cheap and adaptable woodblock technology facilitated the develop-
ment of regional book markets in peripheral areas, extending the reach
of the printed word in late imperial China.[10] Yet she also demonstrates
that, in part because of the characteristics of xylography, late imperial
regional markets depended on sales of canonized and uniform educa-
tional texts and popular culture bestsellers.[11] This market was eroded,
though not destroyed, in the early twentieth century by Shanghai-based
publishers' mass-produced textbooks for modern schools and cheap
fiction. In contrast to woodblock publishing, the spread of mechanized
print technology during the early twentieth century allowed for the
cheap proliferation of short runs of new titles and periodicals com-
missioned by people in local communities. In the present case, local
officials, educators, and students subsidized publication of journals to
create arenas for commentary on education, politics, and society—not
to make a profit.[12] Their printing fees allowed local mechanized print
shops to earn income while increasing the number of distinctive titles
that were produced and consumed at the local level. Thus, this paper
suggests that mechanized regional print markets of the twentieth cen-
tury may have superficially resembled late imperial woodblock-based
regional print markets, but their dynamics and print catalogues dif-
fered noticeably.

The resulting proliferation of local journals had various social and
cultural effects, two of which I explore here. First, as government offi-
cials, school administrators, and local teachers published articles and
opinion pieces on training, curricula, and pedagogy, they joined in an

publishing that has productively qualified how Habermas' well-known idea of the
public sphere might be applied in discussing twentieth-century China.

[10] Brokaw, *Commerce in Culture*, 8–19, 532, 553–56.

[11] Brokaw, "Reading," 190–191, and McDermott, "The Ascendance of the Imprint,"
80, both observe that xylographic print technology was more cost effective when used
to produce large numbers of standard texts, rather than relatively small numbers of
texts whose content changed regularly, like periodicals or newspapers. The need to cut
new woodblocks for each new text constrained the production of periodicals during
the late imperial period, even though the educated elite constituted a ready readership
for learned writing of various kinds.

[12] These local cultural producers' lack of concern for profit differentiates them from
Ling Shiao's Shanghai-based cultural entrepreneurs and from the post-1927 Commu-
nist publishers covered by Reed, discussed elsewhere in this volume.

increasingly specialized discussion about modern education, thereby casting themselves as modern professionals. Second, educational journals also facilitated the definition of and negotiation among various levels of community through their content and also through factors such as circulation, prescribed readership, internal organization, and paratexts of various kinds. Officials, students, and educators described communities ranging from schools themselves to villages and towns, counties and provinces, even as they related them to the nation. In these cases and many others, Jiangnan's educational journals provided a regionally delimited "platform" (see Guobin Yang's essay in this volume) for communication among educators and students.

Technology, Capitalism, and Printing Services

During the late Qing and Republican periods, rapid industrialization and commercial development in the lower Yangzi region led to the growth of publishing and printing enterprises throughout the region's cities and towns. Development was especially fast in the cities of the Yangzi River valley and along the rail lines connecting Shanghai to Nanjing and Hangzhou. In Jiangsu, for instance, by the Nanjing Decade (1927–37), Wuxi 無錫, Changzhou 常州, and Zhenjiang 鎮江 each had fourteen printing enterprises, Nantong 南通 had seventeen, Suzhou had five, and Changshu 常熟 had four.[13]

Many of these printing companies were small, and few of them were fully mechanized. But by the early years of the Republic, most of the printing companies in Jiangsu's core industrial cities and towns were reported to have made the transition from woodblock to letterpress and lithographic printing.[14] Local printing companies sometimes imported the most advanced foreign technology they could afford, but they also took advantage of the cheaper imitation presses, which, according to Christopher A. Reed, Shanghai's machine shops were producing in great numbers by the 1910s.[15] The ready availability of printing facilities at the local level led to an explosion of periodical

[13] Zhang Xueshu, "Lun minguo shiqi Jiangsu de chuban yu jingji," 128–129.
[14] Xu Su, "Minguo shiqi Jiangsu yinshua hangye gaishu," 242–243.
[15] Reed, *Gutenberg in Shanghai*, chapter 3. For the spread of these machines to print shops throughout the lower Yangzi region, see Zhang Xueshu, "Lun minguo shiqi Jiangsu de chuban," 118.

publishing. Between 1912 and 1949, areas in Jiangsu outside of Shanghai published 1,478 distinct periodicals.[16]

China's major publishing companies—all centered in Shanghai—concentrated on producing commodities that could generate and attract a mass market of readers. Large publishers compiled and printed marketable print commodities that they then distributed and sold in mass quantities throughout China, a practice that is clear, for instance, in the process of textbook production and sales during the Republican period.[17] In contrast to Shanghai's comprehensive publishing companies, I hypothesize that printing companies in the smaller cities and towns of the lower Yangzi region, and most likely smaller printers in Shanghai and other metropolitan areas, were much more service oriented. That is, rather than editing, printing, and distributing most of their products themselves, local printers offered a wide range of printing services to their communities.[18] Local printers' readiness to sell local communities a diverse array of printing services is captured in their advertisements. For instance, Wuxi's Xicheng Printing Company's (Wuxi Xicheng yinshua gongsi 無錫錫成印刷公司) advertisements announced proudly:

> [In the letterpress division,] we accept for printing books and journals, account books, forms, leaflets, instructions, posters, wrapping paper, receipts, invitations, securities, and name cards. In addition, in fine printing with copper and zinc plates we strive for elegance, and we sacrifice ourselves with the prices. In the lithography division, we have specially prepared a five-color large lithography machine to print colored maps, diplomas, stocks, labels, calendars, art prints, and scenic photographs.[19]

When schools and local government agencies wanted to publish journals, they most often turned to these local, service-oriented printing companies. For instance, during the 1920s Jiangsu Girls' Second Normal School (Jiangsu shengli di'er nüzi shifan xuexiao 江蘇省立第二

[16] Zhang Xueshu, "Lun minguo shiqi Jiangsu de chuban," 123.

[17] See, for instance, Culp, *Articulating Citizenship*, 43–47; and Reed, *Gutenberg in Shanghai*, chapter 5.

[18] This is not to say that printers in Jiangnan's smaller cities and towns did not also produce print commodities for the market. Many printers, for instance, also edited newspapers. Xu Su, "Minguo shiqi Jiangsu yinshua hangye," 239.

[19] Ibid., 247; on the same page, see also the advertisement for Zhenjiang's Dacheng Printing Factory (Dacheng yinshua gongsi), and for Songjiang's Chengzhang Printing Center, which printed the *Songjiang Girls' Middle School Journal*, which is discussed below. *Songjiang nüzhong xiaokan*, 12.

女子師範學校) in Suzhou used Wuxi's Xicheng Printing Company to print its periodic alumni association publication.[20] The *Songjiang Girls' Middle School Journal* (*Songjiang nüzhong xiaokan* 松江女中校刊) was printed by a local printer in Songjiang, and Zhenhua Girls' School's (Zhenhua nüzi xuexiao 振華女子學校) seasonal school journal was printed by the Suzhou Wenxin (文新) Press.[21] In Zhenjiang by the late 1930s, "more than half of the documentary materials of the provincial government and its agencies, the more than thirty locally published newspapers, and more than 120 magazines were printed by [Zhenjiang's] two [largest mechanized] factories."[22]

Local printers also produced Zhejiang's educational journals. The Zhejiang Provincial Education Association's (Zhejiang sheng jiaoyuhui 浙江省教育會) *Tides of Education* (*Jiaoyu chao* 教育潮) was printed by the Zhejiang Printing Company (Zhejiang yinshua gongsi 浙江印刷公司) in Hangzhou, while the provincial education department's *Zhejiang Youth* (*Zhejiang qingnian* 浙江青年) was printed in the 1930s by the provincial library's printing department.[23] School journals were often printed at an even more local level outside the regional publishing center of Hangzhou. *Zhejiang Provincial Seventh Middle School Alumni Association Semi-Monthly* (*Zhejiang shengli diqi zhongxue xiaoyouhui banyuekan* 浙江省立第七中學校友會半月刊) was printed by a local letterpress and lithographic printing company in Jinhua 金華, where the school was located.[24] The journal of the Normal Division (Shifanbu 師範部) of Zhejiang Tenth Middle School (Zhejiang shizhong xuexiao 浙江十中學校) in Yongjia 永嘉 was printed by the Tongwen Press (Tongwen yinshuguan 同文印書館) in Wenzhou 溫州.[25] And *Jizhong Middle Student* (*Jizhong xuesheng* 稽中學生)

[20] *Jiangsu shengli di'er nüzi shifan xuexiao xiaoyouhui huikan*, no. 14 (July 1922).

[21] For Songjiang Girls' Middle School, see *Songjiang nüzhong xiaokan*, no. 24. For Zhenhua Girls' School see *Zhenhua jikan*, Chuangkanhao (March 1934). The *Suzhou Girls' Middle Monthly* was also printed by Wenxin in Suzhou. *Suzhou nüzi zhongxue yuekan*.

[22] Xu Su, "Minguo shiqi Jiangsu yinshua hangye," 243.

[23] *Jiaoyu chao* 1, no. 1 (April 1919). The journal of Zhejiang Tenth Middle School in Yongjia was also printed there. See *Zhejiang shizhong qikan*, no. 1 (October 1921); *Zhejiang qingnian* 2, no. 5 (March 1936).

[24] *Zhejiang shengli diqi zhongxue xiaoyouhui banyuekan*, nos. 7–8 (January 20, 1932).

[25] *Zhejiang shizhong shifanbu qikan*, nos. 1–2 (June 1924).

seems to have been printed by the local Shaoxing 紹興 *Republican Daily* (*Minguo ribao* 民國日報) office.[26]

The proliferation of printing services in local cities and towns seems to have made printing cheap and accessible enough that local governments, schools, and even student groups could sustain a journal with limited financial strain. During the late 1920s, for instance, Songjiang Girls' Middle School, which published a weekly news bulletin in addition to its monthly journal, spent between 25.5 yuan and 79.4 yuan per month on printing, out of an overall monthly operating budget of 2,566 yuan.[27] Annually, printing expenses, which also would have covered the printing of forms, teaching materials, annual publications, and the like, generally drew only about 3 percent of the school's administrative and miscellaneous expenses in 1930.[28] Similarly, during the mid-1930s, the student self-government association of the lower middle division at Shanghai Middle School budgeted one hundred yuan a term for publishing expenses. In 1934 the group dedicated the funds from three sessions (or semesters) of the self-government association to producing an expanded special issue of the student self-government association journal, which ran to several hundred pages.[29] In general, printing costs in the lower Yangzi region seem to have been low enough to allow local schools and student groups to produce journals that varied widely in ambition and sophistication.

Education Circles and Publishing

Education circles were a key social sector in the corporate social and political orders of the Republican period.[30] The education sector was a composite arena that included teachers and students in local schools, alumni and supportive social elites, education theorists, and administrators, as well as government officials. All were linked by their common concern with education and learning. At the national level,

[26] *Jizhong xuesheng*, no. 7 (October 1937).

[27] *Songjiang nüzhong xiaokan*, no. 3: *zhuanzai*; no. 4 (April 10, 1929): *zhuanzai*; no. 6 (July 1, 1929): *zhuanzai*.

[28] "Bangongfei ji zafei gexiang zhipei baifen bijiao biao, shijiu niandu," *Songjiang nüzhong xiaokan*, nos. 19–20.

[29] Zhou Jianwen, "Fakan de hua," 1–3.

[30] For discussion of the division of the Republican citizenry into distinct "sections" or "circles" (*jie*), see Harrison, *The Making of the Republican Citizen*, 117–122.

education reform groups and major publishing companies produced journals such as *Educational Review* (*Jiaoyu zazhi* 教育雜志, 1909), *Youth Magazine* (*Shaonian zazhi* 少年雜志, 1911), *The Students' Magazine* (*Xuesheng zazhi* 學生雜志, July 1914), and *New Education* (*Xin jiaoyu* 新教育, 1919) that targeted education circles' officials, educators, and students.[31] At the local level in the lower Yangzi region, members of education circles also published journals that gave voice to their views on education and broader issues concerning society and politics. The circulation of these journals among groups of educators, students, and officials and the dialogue in their writings about common concerns were two of the primary ways that local, provincial, and regional education circles constituted themselves as a loosely bounded corporate entity. The textual economy of local journals helped these groups to see themselves as sharing particular concerns, experiences, and ideas.

Education associations composed of professional educators—teachers and administrators—and social elites concerned with educational matters provided a corporate core and a powerful leading voice for regional education circles, especially during the late Qing and the first fifteen years of the Republic. The Qing New Policies encouraged local elites to form local and provincial education associations, which they did in Jiangsu and Zhejiang, as well as in many other provinces, during the last decade of the Qing and the first years of the Republic.[32] In the fragmented political environment of the 1910s and 1920s, these associations became powerful agents of education reform and had significant influence in both local and national politics. Publication of education journals was one of the primary ways in which the associations expressed their views publicly and made their influence felt.

During the 1910s and 1920s, the Zhejiang and Jiangsu provincial education associations each published journals that became powerful tools to promote progressive educational and cultural reform.[33] For instance, the Zhejiang Provincial Education Association's *Tides of Education* continued the association's *Education Weekly* (*Jiaoyu*

[31] Keenan, *The Dewey Experiment in China*, 58–74; *Minguo sannian chun Zhonghua shuju gaikuang*; Ni and Mu, *Jiangsu baokan bianjishi*, 59–62, 111, 126–128, 155–157.

[32] Bastid, *Educational Reform in Early Twentieth-Century China*; Wen-hsin Yeh, *Provincial Passages*, 118–125.

[33] For a discussion of the Jiangsu Education Association's *Jiaoyu yanjiu*, which was also a forum for progressive education in China, see Ni and Mu, *Jiangsu baokan bianjishi*, 127–128.

zhoubao 教育週報), which had been published with association spon-
sorship since April 1913. The new journal, started in 1919, provided a
Zhejiang-based perspective on national and world education trends. It
declared it would concentrate on the following themes: "(1) introduce
the world's new educational thought and scholarship; (2) critique the
bad practices and shortcomings of Chinese education; (3) discuss the
construction of new education; and (4) record the current situation
of education in both China and abroad."[34] *Tides*'s main contributors
during its most influential first year came from a network of local edu-
cators and prominent supporters of local education circles, many of
whom were on the journal's editorial board.[35] Under the guidance of
association head Jing Hengyi 經亨頤 and anarchist educator and lead
editor Shen Zhongjiu 沈仲九, the journal called for education that
would foster individual moral character and scientific reasoning, as
well as spontaneity, freedom, self-regulation, and self-discipline.[36] But
contributors also did not hesitate to use this forum for professional
research and discussion to promote political reforms, such as local
self-government in Zhejiang.

With the formation of the Nationalist government in 1927, state
education administrative organs joined more intensively in educa-
tional research and promotion of education reform. At the provincial,
municipal, and local levels, they did so in part by publishing jour-
nals that provided forums for professional educators' research and
for the government to announce and promote its education policies.
The respective department and bureau of education launched *Jiangsu
Education* (*Jiangsu jiaoyu* 江蘇教育), started in 1932) and *Shanghai
Education* (*Shanghai jiaoyu* 上海教育, in 1928) to spread news about
educational administration in their respective jurisdictions and pro-
vide a forum for discussing the newest educational theories and meth-
ods. According to the Jiangsu Department of Education, the goals of
Jiangsu Education were twofold:

> One aspect is to introduce the world's newest educational trends and to
> research their fit with our national situation, so that we can take what is
> good and cast aside whatever falls short, promoting educational advance-
> ment. The other aspect is to mediate news about the whole province's
> educational administration and each school's and social education insti-

[34] *Zhejiang sheng jiaoyuhui yaolan*, 26–28. Quote on 27.
[35] *Jiaoyu chao* 1, nos. 1–6 (April–December 1919).
[36] Wen-hsin Yeh, *Provincial Passages*, 133–135.

tution's mutual learning and refining process, so that Jiangsu's education achieves full development.[37]

These journals' approach reflected simultaneous openness to a transnational exchange of educational ideas and methods and a local focus that took the province or municipality as a prime locus for educational reform activity. Local educational reform (perhaps based on foreign models) was to be a model for the nation as a whole and serve as the basis for national renewal. For instance, the editors of *Shanghai Education* posited that the newly expanded Shanghai Special Municipality (Shanghai tebie shi 上海特別市) could model new educational practices because it was a microcosm of the nation, including both rural and urban areas: a privileged cultural center.[38] *Jiangsu Education*'s editors, who introduced the journal soon after the Mukden Incident in the fall of 1931 and during the Japanese invasion of Shanghai in the winter and spring of 1932, were even more explicit about linking the local journal's immediate goal of educational reform in Jiangsu to the project of national revival.[39] The journals staked out a local—provincial or municipal—area of focus, but also promoted engagement with an international discussion about educational reform and viewed development of local education as contributing to national revival. In this way, local educational journals functioned in ways similar to newspapers like *Shanghai Journal* (*Shenbao* 申報), in which, Barbara Mittler argues, different groups debated the aspects of modernity exhibited in, or at least associated with, one locality (Shanghai) in an effort to craft a national model of Chinese modernity.[40]

Although also published by their respective provincial departments of education, *Jiangsu Student* (*Jiangsu xuesheng* 江蘇學生) and *Zhejiang Youth* differed from *Jiangsu Education* and *Shanghai Education* in being aimed directly at young readers, specifically secondary students and adolescent youths in the respective provinces. For instance, director of the Zhejiang Provincial Department of Education Ye Suzhong 葉溯中 (1902–1964),[41] in his essay introducing *Zhejiang Youth*, clearly

[37] Jiangsu sheng jiaoyuting bianshenshi, *Jiangsu jiaoyu gailan*, 83. Cf. "Fakanci," *Shanghai jiaoyu* 1, no. 1 (February 7, 1928), 1.

[38] "Fakanci," *Shanghai jiaoyu* 1, 2.

[39] Bianzhe, "Ben kan zhi ci," *Jiangsu jiaoyu* 1, no. 1 (February 1932).

[40] Mittler, *A Newspaper for China?* chapter 5.

[41] Ye Suzhong was a native of Yongjia, Zhejiang. In 1925 he graduated from National Beijing University, and in 1931 he served as principal of Zhejiang Provincial

demarcated a readership of the twenty-five thousand or so secondary-level students within Zhejiang province.[42] In defining their goals in initiating these journals, provincial educational administrators expressed that they were intended to "cultivate character education" and "practically guide students' lives and learning."[43] The ultimate goal of such training was to prepare educated youths to contribute to the nation, as was stated clearly in the opening editorial of *Zhejiang Youth*: "What we hope Zhejiang's youths will especially focus on is science, character (*renge* 人格), and physical strength (*tili* 體力) for national salvation!"[44] Despite this didactic approach, *Zhejiang Youth* seems to have built a readership quickly, with its circulation reportedly reaching several tens of thousands by the end of its first year.[45] In some places in Zhejiang, the journal began to compete favorably for readers with Kaiming Bookstore's popular youth journal *Middle School Student* (*Zhongxuesheng zazhi* 中學生雜志).[46]

Students contributed many writings to *Zhejiang Youth* and *Jiangsu Student*, and submissions by school administrators and teachers were a significant part of both provincial youth publications and journals like *Jiangsu Education* and *Shanghai Education*. Such pieces by local educators and students had the potential to diverge from the aims of the journals as articulated by the provincial officials who edited them. For instance, although provincial and municipal officials stressed the ways the journals would contribute to national development, local educators' writings, as we will see, worked at least in part to distinguish themselves as modern professionals and to raise the profile of their schools by presenting them as exemplars of new educational techniques. Moreover, although provincial educators aimed to make

Hangzhou Higher Middle School. In April 1934 he became a committee member of the Zhejiang provincial government and director of the Department of Education. Xu Youchun et al., 1260.

[42] Ye Suzhong, "Chuangkan xianci," 6.

[43] Jiangsu sheng jiaoyuting bianshenshi, *Jiangsu jiaoyu gailan*, 83–84.

[44] Ye Suzhong, "Chuangkan xianci," 6. Cf. Zhou Fohai, "Women zenyang qu zuoren," 5.

[45] Chen Gaoyong, "*Zhejiang qingnian yu Jiangsu yanjiu*," 125–126.

[46] A student-run survey at Shaoxing's Jishan Middle School found that twenty of 156 high school respondents reported favoring *Middle School Student* for their extracurricular reading, while fifteen students liked *Zhejiang Youth* better. Since students were reporting their *favorite* journals, it is likely that many more students at least read *Zhejiang Youth* regularly. Xu Keyu, "Benxiao gaozhong tongxue de xingqu he sixiang," 16.

student-oriented journals top-down instruments to influence student thought and behavior, students' contributions to the journals culti-vated a sense of provincial comradeship and portrayed their peer groups as model citizens.

Journals published by local schools similarly provided outlets for teachers, students, and alumni to express their views on diverse sub-jects, while also disseminating important news throughout the school community. Between the 1910s and the 1940s, many secondary and some primary schools throughout the lower Yangzi region published school journals that ranged from yearly to weekly publications. By the 1920s and 1930s, many schools organized publication committees (*chuban weiyuanhui* 出版委員會), composed of teachers and admin-istrators, that managed school publications, including journals, over-seeing their compiling, editing, and printing.[47] The most immediate aim of most of these journals was to spread school news and report on the activities of teachers, students, and alumni and create a shared ethos and sense of community. The hope that the school publication would serve as a medium for strengthening a corporate identity comes through clearly in the 1923 inaugural preface of *Zhejiang First Middle Weekly* (*Zhejiang yizhong zhoukan* 浙江一中週刊), the journal of one of the lower Yangzi region's most prominent secondary schools in Hangzhou:

> To blend harmoniously and understand all that is going on [within the school] is not an easy matter. Accordingly, we have established this weekly publication in the hope that everyone will be closely connected and there will be no barriers regarding [school] matters.... In general, we hope that [the weekly journal] can directly communicate the whole school's information and indirectly increase our fellow students' feelings [of interconnection].[48]

[47] E.g., *Shanghai Minli zhongxue sanshizhou jiniankan*, 40; Suzhou Zhenhua nü xuexiao, *Zhenhua nü xuexiao sanshinian jiniankan*, 24; *Songjiang nüzhong xiaokan*, no. 8 (December 1, 1929), 11–12; no. 33–34 (November 15, 1932), 105–106; no. 47 (November 1, 1933), 8–9; no. 53 (March 1, 1934), 14–15; Zhongyang daxue quli Yang-zhou zhongxue chuban weiyuanhui, *Yinian lai zhi Yangzhong*, 3.

[48] "Fakanci," *Zhejiang yizhong zhoukan* (The First Middle School Weekly [English title provided]), no. 1 (October 1, 1923). Similar hopes for creating more tightly knit school communities through a school publication were expressed at other schools as well. See, for instance, Jiezi, "Fakanci," 1; Zhao Shusheng, "Fakanci," *Minli xunkan*, 1–2.

Editors sometimes also portrayed school journals as arenas for publication of research by teachers and students that would contribute to academic learning within the school and perhaps in a broader community as well. Editors expressed the goal of joining a broader discussion of educational and academic research through calls for the public community of scholars to criticize and correct the pieces presented in the journal.[49] Editors also saw the potential for school journals to spread the word about their school's educational approach and contribute to research on education.[50]

Students, faculty, administrators, and alumni were the primary intended readership of school journals. But some schools, especially those where editors saw the journal contributing to a broader academic discussion, sold their journals to the general public. *Zhejiang First Middle Weekly*, for instance, sold openly for two copper cash an issue.[51] Jiangsu Second Normal School's journal sold subscriptions of thirty cents (*dayang sanjiao* 大洋三角) per year, and marketed a combined special issue separately for four cents.[52] Other school journals sold advertising that seems to have been aimed at a reading public beyond members of the immediate school community.[53] But most schools did not sell their publications, either through advertisement or subscription, indicating that their primary goal was not to make a profit but rather to provide an arena for academic exchange and a mechanism to generate school solidarity.[54]

[49] Jiangsu shengli diwu zhongxuexiao, "Ben zazhi qiqing zhizheng miuwu guang-gao." The editors' hope that the journal would serve as a forum for intellectual exchange was reflected as well in a notice calling for distinguished alumni to contribute their writings to the journal.

[50] "Fakanci," *Zhejiang yizhong zhoukan*, no. 1 (October 1, 1923); Wang Zhaoyang, "Xu."

[51] *Zhejiang yizhong zhoukan*.

[52] "Chubanke," in *Jiangsu shengli di'er shifan xuexiao xiaokan*, nos. 36–37 (May 5, 1925). *Zhejiang shizhong qikan* had an annual subscription cost of thirty-six cents (*sanjiao liufen*), with postal costs of three cents (*sanfen*) per issue. No. 1 (October 10, 1921).

[53] E.g., *Jiangsu shengli diwu zhongxuexiao zazhi*, no. 2.

[54] Some schools explicitly stated that the journal was *not* for sale. See, for instance, *Zhenhua jikan*, Chuangkanhao (inaugural issue) (March 1934). Of course, even not-for-sale journals often circulated beyond the school. Many of the school journals and student publications held in lower Yangzi region libraries are stamped as having previously been part of the holdings of other regional school libraries, suggesting that schools within the region might have circulated or exchanged them. For instance, one issue of the *Jingzhong xuesheng qikan* at Shanghai Municipal Library was originally

Corresponding to school publications, student groups throughout the Republican period published a wide array of journals. During the 1910s and early 1920s, student study groups and research associations, operating with varying degrees of school and government sanction, published journals that variously touted moderate cultural reform, anarchism, nationalism, and, by the early 1920s, Marxism. For instance, Wen-hsin Yeh has shown how students at Hangzhou's Zhejiang First Normal School and Zhejiang First Middle School formed a succession of journals that promoted various kinds of social and cultural reform.[55] During the mid-1920s student organizations at Zhejiang Fourth Middle School in Ningbo produced a number of journals exploring socialist and Marxist ideas.[56] In Zhejiang's Wenzhou during the mid-1920s, secondary-level student groups published a series of journals to promote their views.[57] In Jiangsu's Changshu in 1919, university and middle school students who returned home for summer vacation after the upheaval of the May Fourth Movement formed the Changshu Student Union (Changshu xuesheng lianhehui 常熟學生聯合會) and published the *Awakened Lion News* (*Xingshi bao* 醒獅報). In the fall of that year, when students attending school in other areas left Changshu, local youths continued their publishing activities.[58]

In the contentious political environment and rapid social change of the 1910s and 1920s, student groups in the lower Yangzi region published these journals with a great degree of independence. Early in the Republican period, the Yuan Shikai 袁世凱 regime instituted censorship laws that required publishers of newspapers and journals to register with the government. Such obligations restricted publication of material considered harmful to public order or threatening to the political system.[59] In practice, many publications evaded state controls. Even student journals presenting relatively radical social and political critiques could be published without interference from local authorities, especially if students had school administrators' support. Instances

from the Nanfang Middle School library. *Jingzhong xuesheng qikan*, Chuangkanhao (n.d.).

[55] Wen-hsin Yeh, *Provincial Passages*, 161–173.
[56] Dong, "Jing Hengyi yu Zhejiang shengli disi zhongxue," 74–96.
[57] Lin Mei, "1924–1927 nian Wenzhou xuesheng yundong," 168–171.
[58] Gui, "'Wu si yundong dui Changshu wenhua jie de ruogan yingxiang," 90–91.
[59] Ni and Mu, *Jiangsu baokan bianjishi*, 121–125.

where journals were banned by local authorities were often only the result of a backlash to a particularly provocative issue or article.[60]

During the Nanjing Decade, by contrast, students' publications were closely monitored and constrained. The Nationalist Party instituted a series of measures requiring registration and review of periodicals, including even small, popular publications that circulated locally.[61] Perhaps more important for student journals, such publications after 1930, like all student extracurricular activities, had to be organized by student self-government organizations, which were closely monitored by school administrators and local government and Nationalist Party authorities.[62] As a result, most student journals in lower Yangzi region schools during the Nanjing Decade were published by the academic or publishing committees of student self-government organizations, with teachers or administrators serving as supervisors or an advisory board.[63] These committees often also oversaw wall-poster newspapers, weekly bulletins, research group publications, and/or class association publications. Various combinations of student self-government dues, subsidies from the school administration, and occasional advertising funded student self-government association journals.[64]

Because of increased supervision by school administrators and local government and party authorities, student journals during the Nanjing Decade were not as overtly political as they had sometimes been during the 1910s and 1920s. However, they still served as a medium for students to express creativity and develop and circulate ideas among their peers and occasionally a broader audience.[65] As expressed by the editor of the student journal at Hangzhou Higher Middle School,

[60] For instances of the banning of student or youth journals because of radical content, see Chen Gongmao, "Xuan Zhonghua 'Sha Xuantong' yiwen," 82–83; Wen-hsin Yeh, *Provincial Passages*, 184–185.

[61] Liu Zhemin, *Jin xian dai chuban xinwen fagui huibian*, 104–109, 574–576; Ni and Mu, *Jiangsu baokan bianjishi*, 188–190.

[62] For a full account of school, government, and party supervision of student self-government groups, see Culp, *Articulating Citizenship*, chapter 3.

[63] "Ben jie xuesheng zizhihui huiwu baogao," *Hanggao xuesheng*, no. 11 (1935): 5, 14; "Huiwu baoga," *Wuben nüzhong xuesheng zizhihui banniankan*," no. 3 (January 1936): 127–128; "Xuesheng zizhihui benjie gaikuang, *Jingzhong xuesheng qikan*, Chuangkanhao (n.d.): 274–275.

[64] See, for instance, Zhou Jianwen, "Wode huigu," 48–49. Jingye Middle School's student self-government association helped to support its student journal by carrying advertising for a pasteurized milk company. See *Jingzhong xuesheng qikan*, Chuangkanhao (n.d.), facing 110.

[65] Zhou Jianwen, "Fakan de hua," 2–3.

Zhang Xueli 張學禮, student publications represented to society as a whole the ideas and group identity of a school's students: "This journal is a microcosm of our school's classmates. Thus, our classmates' thought, spirit, habits, and behaviors are all lodged here. Commending our school's spirit in society is only one mission of this publication."[66] By capturing in microcosm students' thought and action, student publications enabled students to recognize themselves as a group and work for self-transformation.[67] At the same time, though somewhat constrained by censorship, student publications still gave students a forum to discuss national issues. Students viewed such discussion as a way to assume their civic responsibility for national salvation in a time of crisis.[68]

With students at many regional secondary schools publishing their own journals through local printing facilities, the spread of mechanized printing in the lower Yangzi region at the start of the twentieth century facilitated growth in the number of readers who were also authors. Significantly, school journals were just as common at girls' schools, such as Jiangsu Girls' Second Normal, Zhenhua Girls' School, and Songjiang Girls' Middle, as they were at boys' schools. Moreover, female students consistently contributed to sections for student writings in provincial journals like *Jiangsu Student* and *Zhejiang Youth*. These thousands of youthful authors, of both sexes, outnumbered the *shengyuan* and literate women of elite families who had opportunities to write for the print market during the late imperial period. Moreover, through the medium of the journal, Republican-period educated youths could write in a range of new genres and access a diverse audience on a regular basis.

Thus, in the lower Yangzi region during the Republican period, disparate groups that were active in schools and writing about education produced four relatively distinct kinds of local journals: student publications; school journals; local government–managed education journals; and the journals of professional educational associations. The groups and organizations that edited and published these journals each articulated their own aims for them. Provincial education associations sought to participate in regional, national, and international

[66] Zhang Xueli, "Qianyan," *Hanggao xuesheng*, no. 11 (1935): 1–2.
[67] Ibid. See Zhou Jianwen, "Fakan de hua."
[68] E.g., Bianji tongren, "Fakanci," *Jingzhong xuesheng qikan*, Chuangkanhao (n.d.): 1–2.

debates on education reform. Provincial officials intended their journals to mold student thought and action and to orient local education toward national goals. School officials published journals to facilitate communication within the school and express their own perspectives on educational reform. And students published journals to effect social and/or political change and build fellowship within the student community. But the writings within these journals and the dialogue among them had cultural effects that often ranged beyond and diverged far from the stated intentions of the journals' publishers and editors.

Communication and Cultural Politics

One of the most notable effects of the regional textual economy of educational periodicals is that the dialogue among lower Yangzi region educators, officials, and students helped to constitute them as a single community. This dialogue was enacted through shared reading and writing, both within and across journals. For instance, during the Nanjing Decade, many students at Jishan Middle School in Shaoxing read the provincial education department's journal, *Zhejiang Youth*, and at the same time published their own student publication, *Jishan Middle Student*.[69] Through their journal, Jishan Middle's students engaged, from their own perspectives, issues that were central themes in *Zhejiang Youth*, such as student training and how students could help in the looming national crisis of the mid-1930s. At the same time, *Zhejiang Youth* itself provided a forum where officials, educators, and students could all express their ideas. Likewise, Shanghai Middle School student leader Zhou Jianwen 周鑑文 was a contributor to, and presumably a reader of, the Jiangsu Provincial Department of Education's *Jiangsu Student*.[70] And as head of the Shanghai Middle School Student Self-Government Association, he was instrumental in managing publication of and contributing to the association's many student publications, in addition to contributing to Shanghai Middle's school journal.[71]

[69] Xu Keyu, "Benxiao gaozhong tongxue de xingqu he sixiang," 16.
[70] See, for instance, Zhou Jianwen, "Feichang shiqi zhong qingnian xuesheng yingshou de xunlian," 49–55.
[71] Zhou Jianwen, "Fakan de hua"; Zhou Jianwen, "Wode huigu," 48–49.

In these and other cases, the readers of local educational journals were also writers who contributed to one kind of local journal or another. As teachers, officials, and students read and wrote for the same journals, or engaged in dialogue over common concerns using their own journals, they constituted themselves as a particular segment of society, a local education circle. But their circulation of texts also had other social and cultural effects, such as marking local educators' professionalization and defining their local communities in relation to the nation as a whole.

Pedagogy, Training, and Professionalization

Teacher training schools, professional associations, and introduction of formalized credentials all contributed to the professionalization of teaching and the constitution of educators as an occupational group with specialized skills.[72] In these dimensions, educators' professionalization during the early twentieth century roughly paralleled that of other occupational groups, such as lawyers, journalists, and physicians.[73] But as a highly diverse and much less exclusive occupational group, educators also used other means to establish a professional profile and differentiate among distinct levels of professional skill and achievement. Educational periodicals provided a vital cultural medium for demonstrating professional mastery through the publication of essays that discussed specialized topics and incorporated specialized language, concepts, and research methods.

At the national level, educators used journals like the *Educational Review* and *New Education* to formulate a discursive vocabulary for education research and to launch key topics of professional debate. Local educational journals, whether published by schools, professional organizations, or provincial or county governments, provided arenas in which teachers and administrators in local schools, as well as educational officials, could use this new idiom of educational professionalism to join debates over innovative methods, and exchange experience to improve local education. Through these writings, local educators demonstrated their specialized knowledge of Chinese and foreign pedagogy and training techniques and presented research regarding their

[72] For these processes, see Cong, *Teachers' Schools and the Making of the Modern Chinese Nation-State*; McElroy, "Transforming China through Education."
[73] Xiaoqun Xu, *Chinese Professionals and the Republican State*.

practical application at the local level, marking themselves as fully conversant, if not leading, participants in the emergent community of Chinese professional educators.

Official and educator dialogue over a new provincial government initiative for student character-development education (*xunyu* 訓育) in Jiangsu during the 1930s suggests how circulation of writings in the textual economy enabled educators both to raise the profile of their schools and define themselves as professionals. During the 1920s character-development education had been a central topic in nationally prominent educational journals like *Educational Review, New Education,* and *Secondary Education (Zhongdeng jiaoyu* 中等教育).[74] In the fall of 1932 the Jiangsu Department of Education implemented a new policy on character-development education that built on leading educators' debates of the previous decade.[75] The goal of the program was to make moral and civic training a more central part of school life by making all teachers within a given school responsible for overseeing and guiding students' conduct.[76]

Regional and local educational journals provided a sounding board for officials and educators to discuss the new program. In February 1933, the Jiangsu Department of Education explained the system and assessed it in its annual policy review in *Jiangsu Education.* The department discussed the advantages and challenges of implementation at boys' and girls' secondary schools.[77] At the same time, administrators at prominent regional schools, such as Principal Hu Huanyong 胡煥庸 at Suzhou Middle School, Principal Zhou Houshu 周厚樞 at Yangzhou Middle School, and Director of Instruction Shen Yizhen 沈亦珍 at Shanghai Middle School wrote articles on the program for their school journals or *Jiangsu Education.*[78]

By presenting their local approaches to the new policy, these educators effectively engaged in dialogue with the provincial government

[74] "*Jiaoyu zazhi* shang guanyu xunyu de cailiao" and "*Xin jiaoyu* shang guanyu xunyu wenti de cailiao"; Pan, "Jinhou zhongdeng xuexiao zhi xunyu"; Wang Yankang, "Zhongxuexiao jiji xunyu zhi sizhong shishi," 1–16.

[75] Jiangsu jiaoyuting, *Jiangsu sheng xianxing jiaoyu faling huibian,* 64–72.

[76] For discussion of implementation of the program in local schools and its impact on school life, see Culp, *Articulating Citizenship,* 173–174.

[77] Xiang Fu'an, "Yinianlai Jiangsu zhongdeng jiaoyu zhi huigu yu zhanwang," 74–76.

[78] Hu Huanyong, "Suzhou Zhongxue jiaoxun zhi heyi tan," 49–55; Shen Yizhen, "Jiaoxun heyi," 15–19; Zhou Houshu, "Yangzhou zhongxue jiaoxun heyi hou zhi chubu shishi," 56–66.

over the nature of character- development education and also established their schools as innovative model institutions. For instance, Hu Huanyong's article in *Jiangsu Education* suggested that experiments with training methods at Suzhou Middle had anticipated the spirit of the new policies of the Jiangsu provincial government. At the same time, he detailed distinctive elements of training at Suzhou Middle, such as grouping students by academic interest and using Boy Scouts as the framework for organization and moral education in the lower middle school.[79] By offering these creative strategies for character-development education, Hu actively engaged provincial officials over approaches to the new policy. Shen Yizhen, writing in Shanghai Middle's school journal, related the program to progressive educator John Dewey's exhortations to link education with social life, implicitly connecting the new government policies to the progressive educational experiments of the 1920s, from which more conservative Nanjing Decade educational officials often sought to distance themselves. Shen, too, claimed that Shanghai Middle had been taking this approach prior to the new government policies.[80]

Similarly, Zhou Houshu, writing in *Jiangsu Education*, listed the many innovative methods with which Yangzhou Middle was experimenting in its implementation of the new system.[81] These techniques, which extended beyond or gave practical expression to the Jiangsu Department of Education policies, established Yangzhou Middle School as a place for experimentation and innovation and as a model for other schools. Zhou also detailed the problems his school had encountered in implementing the program, especially the extra burdens it placed on teachers, raising local-level criticisms for officials to address. Through their writings in local journals, local educators entered into active dialogue with provincial government officials over a major policy initiative while representing their schools as prominent, innovative institutions.

Further, by recounting their schools' experiments and policies, administrators like Zhou Houshu, Hu Huanyong, and Shen Yizhen, who supervised these initiatives, hoped to establish themselves as educational authorities. In describing and assessing their schools' practices,

[79] Hu Huanyong, "Suzhou Zhongxue jiaoxun zhi heyi tan," 53.
[80] Shen Yizhen, "Jiaoxun heyi," 16–17.
[81] Zhou Houshu, "Yangzhou zhongxue jiaoxun heyi," 62.

270 ROBERT CULP

they claimed the capacity to provide models for other educators to
follow. By detailing his school's use of social science methods such
as surveys on students' character, environment, and expenses, Zhou
Houshu sought to generate additional authority for himself and his
teachers and staff as capable modern professionals.[82] Similarly, admin-
istrators reinforced their credentials as professional educators when
they invoked foreign experts, as Shen Yizhen did when he associated
the new system of uniting instruction and character-development edu-
cation with John Dewey's calls to create forms of education that would
prepare students for participation in social life.[83]

Producing Locality and Nation in Educational Journals

Provincial educational journals transmitted government policies and
directives and circulated writings on education, but they also contrib-
uted in various ways to constructing a sense of distinctive locality.
The sense of local place fostered by these journals was co-constructed
by the journals' editors and their diverse communities of readers and
writers through editorial choices, featured articles, and the different
kinds of writings submitted by readers. At the same time, in their writ-
ings on education and current events, provincial education journals
focused the attention of educators and students on the welfare of the
Chinese nation as a whole and situated their discussions of education,
politics, and culture in a comparative, transnational framework. These
journals simultaneously oriented their readers to locality and nation,
which they cast as dynamically interrelated, reinforcing Bryna Good-
man's assertion that the rise of nationalism in late Qing and Republi-
can China did not necessarily preclude the formation or continuation
of local identities.[84]

 Provincial and local educational journals produced a sense of local-
ity in a number of ways. We have already seen how school publica-
tions circulated school news and the writings of students, teachers, and
alumni to foster a sense of the school community. Journals focused
primarily on education policy like *Jiangsu Education* also cultivated
a sense of community by, for instance, publishing regular reports on

[82] Ibid., 62–64.
 [83] Shen Yizhen, "Jiaoxun heyi," 16–17.
 [84] Goodman, *Native Place, City, and Nation*; Goodman, "Networks of News,"
1–10.

schools within the province. This practice encouraged each school's teachers and administrators to see themselves as operating in the bounded universe of provincial education. Even more explicitly, provincial education journals like *Zhejiang Youth* systematically included material that portrayed Zhejiang, the students' home area, as a distinctive place.

Zhejiang Youth was recognized at the time as transmitting a strong sense of provincial identity. One reviewer noted that a significant portion of the journal's content was "particularly focused on Zhejiang's local products and economy, local customs and figures, as well as much important knowledge that cannot be obtained from common textbooks."[85] The editors encouraged this local focus in part through the columns they created and their selection of articles. For instance, one reader calculated that of the 454 pieces published during the journal's first year, fifty-one were features about distinctive areas in Zhejiang, sketches of special products, or accounts of locally notable people.[86] These locally focused articles included pieces like "Shaoxing's famous old wine," "Dongyang ham," "Historical accounts of three Zhejiang martyrs," and "An account of the Zhejiang school of Neo-Confucianism." At the beginning of each issue, the editors also included photographs that visually represented Zhejiang, often by capturing iconic scenes like West Lake, the seasonal tide of the Qiantang 錢塘 River, or "views of old Jinhua 金華." Such articles and images were congruent with efforts by Hangzhou's local government and elite to use urban planning, marketing, and publishing to invent traditions that cast Hangzhou as a distinctive place of literati culture and great antiquity.[87] But articles and images in *Zhejiang Youth* also portrayed the province's modern side. Photographs featured some of the province's new institutions, such as Zhejiang Library on West Lake, or activities of the province's many modern schools. Articles described provincewide public activities in which students played a central role, such as Scouting jamborees and reviews, New Life Movement rallies, youth service activities, and sports meets.[88] The journal also focused

[85] Chen Gaoyong, "*Zhejiang qingnian yu Jiangsu yanjiu*," 125.
[86] Silang, "Du 'Yinianlai *Zhejiang qingnian* yuekan de jiantao' hougan," 2–3 [page numbering discontinuous].
[87] Liping Wang, "Tourism and Spatial Change in Hangzhou, 1911–1927."
[88] For a list of both photographs and articles published in the journal's first volume, see "*Zhejiang qingnian* yuekan diyi juan zong mulu."

great attention on provincial educational initiatives like the Zhejiang Youth Corps (Zhejiang sheng qingniantuan 浙江省青年團).[89]

Further, the journal's editors explicitly invited its readers to self-identify as Zhejiang locals and contribute to the journal's construction of locality. For instance, the fifth issue had a simple map of Zhejiang on the cover, graphically representing the territorial spread of the journal. The journal's postscript asked readers to situate themselves physically within the province:

> If you are a native of Zhejiang, search on the map for whichever county or city is your hometown (*guxiang* 故鄉). If you have already found your hometown, further investigate the place where it is. Is it in eastern or western Zhejiang? In terms of the province's surrounding areas, in the northwest does it approach Jiangsu's or Anhui's borders? In the south-west is it adjacent to Fujian or Jiangxi?[90]

The map was an invitation to young readers to learn more about and identify with Zhejiang as a place. In a similar vein, the topic for the journal's second essay contest for readers (*zhengwen* 徵文) was "My Hometown" (Wode guxiang 我的故鄉).[91]

By writing pieces on their school experiences, youth activities, and home areas, *Zhejiang Youth*'s readers contributed to crafting local and Zhejiang provincial identities. For instance, Wenzhou Middle School student Xiang Jianzhong 項建中, in the column for young readers' writings (*qingnian yuandi* 青年園地), celebrated his native area of Yongqiang 永強 in glowing terms. He painted a vivid picture of his hometown of Qijia Township (七甲鄉), which rested on the plain between the mountains and the sea, and he promoted two of the area's most famous local products: peanuts and the swimming crab.[92] Xiang's piece related powerful feelings of local identification that served as a model for other young readers to think about the special qualities of their hometown and their connections to it. Young readers also wrote about their experiences in local or provincial youth gatherings, helping to build a sense of provincial youth identity. For instance, many students wrote about life during the three-month military training camp after the first year of high school. Whether a student's reflections on

[89] "Zhejiang sheng qingniantuan dagang," 202–211; Nianci, "Xu bensheng nan nü qingniantuan shaonian tuan ji shaonütuan tuanyuan," 8–10.

[90] "Bian hou yu yan," *Zhejiang qingnian* 1, no. 5 (March 1935): after 210.

[91] *Zhejiang qingnian* 2, no. 3 (January 1936).

[92] Xiang Jianzhong, "Yongqiang—shi wode jiaxiang," 138–140.

the rigors of camp life were enthusiastic or critical, these reminiscences conveyed an experience shared by young readers across the province. These published student reports of summer military training called on students to identify with the author of the piece and think of themselves again as part of the provincewide group, the "we," described in the columns.[93] In these ways, the writings of young readers combined with the choices of *Zhejiang Youth*'s editors and the contributions of educators and intellectuals to create a powerful sense of local identification. Dialogue in print served to create a sense of local and provincial community at the levels of both representation and interconnection.

Conclusion

Accessible printing services throughout the lower Yangzi region made possible an explosion of local-level periodical publishing during the Republican period. This essay has focused on the publications of education circles. However, journals and newspapers published by a range of other groups, including revolutionary parties, Shanghai entrepreneurs, and local social reformers, suggest that many other social sectors participated in this local publishing boom as well.[94] As educators, officials, and students wrote for journals and read each other's submissions, they generated a locally oriented mode of cultural production that ranged in scale from individual schools to the province or region.

The circulation of journals within this regional textual economy served in part to define Jiangsu's and Zhejiang's educational circles as the community that wrote for, published, and read these journals. But this textual economy also had various other social and cultural effects. In this essay I have highlighted two: local educators' self-representation as professionals with specialized knowledge and skills; and the construction of local identities that were nationally situated. Local educational journals' production of cultural value and meaning was

[93] See, for instance, Li Shaozhong, "Jizhong junxun qijian shenghuo de huiyi," 217–218; Tan Shaozeng, "Junxun qijian shenghuo huiyi," 145–147.

[94] Glosser, *Chinese Visions of Family and State, 1915–1953*, 140–143; Qin Shao, *Culturing Modernity*, chapter 3; Zhang Xueshu, "Lun minguo shiqi Jiangsu de chuban," 125; Ni and Mu, *Jiangsu baokan bianjishi*, 147–152, 178–185.

not limited to these two processes. Elsewhere I have shown how students writing in their own journals portrayed themselves as archetypal citizens of the Republic.[95] Equally important, one might argue, were the efforts by national and provincial governments to represent themselves as legitimate states by making pronouncements on educational policy, or all these journals' contributions to a discourse of the new (*xin* 新) or modern (*xiandai* 現代) in culture, society, and politics. Rather than attempting to be exhaustive, I have tried here to suggest several ways that the textual economy of local journals operated as a new mode of cultural production within local communities.

Open to question is how readily similar textual economies could develop and thrive in other parts of Republican China. At this juncture, generalizing about China as a whole is impossible. In recent new work, however, I have explored in a preliminary way the establishment of publishing enterprises and locally oriented publications, such as native-place textbooks and periodicals, in the Pearl River Delta.[96] As in the lower Yangzi region, Guangdong witnessed rapid growth of mechanized printing and publishing enterprises during the first half of the twentieth century and a concomitant proliferation of locally oriented publishing. Republican-Era Jiangnan and the Pearl River Delta shared some vital common characteristics that underpinned the development of local print markets in both regions. Most noteworthy were the sustained growth of a vibrant commercial economy across each region, long traditions of scholarship and community literacy, and access to Western printing technology through either Shanghai or Hong Kong. These factors generated regional print markets that roughly paralleled those of the late imperial period in size and location but differed from them in dynamic: Republican local publishers produced distinctive print commodities for a bounded regional market. As shown in this chapter, China's mechanized print revolution transformed printers and publishers in small cities and towns from transmitters of the national canon into producers of locality.

[95] Culp, *Articulating Citizenship*, 257–259.
[96] Culp, "Beyond Fuzhou Road."

ADVANCING THE (GUTENBERG) REVOLUTION: THE ORIGINS AND DEVELOPMENT OF CHINESE PRINT COMMUNISM, 1921–1947

Christopher A. Reed*

Introduction

In an article examining the propaganda culture of the Chinese Communist Party (CCP) between 1921 and 1927, Hans J. van de Ven observes that "[t]exts were, and are, fundamental to the...CCP...as an organization."[1] Later in the paragraph, van de Ven makes the somewhat stronger claim that the expansion of print media at the end of the Qing (1644–1911) and during the early Republic (1912–49) made possible the emergence of the party. Although van de Ven does not directly discuss print media or explain how print media occasioned the CCP, he does imply that a party-run printing and publishing system came into existence.

In fact, as the present essay argues, that printing and publishing apparatus was present from the birth of the party and was crucial to the party's formation and survival. For this reason, its development preoccupied the party leadership from July 1921 until the counter-revolution of 1927 and throughout the Yan'an Decade (1937–47).[2] The establishment of People's Press (Renmin chubanshe 人民出版社) in 1921 (within two months of the CCP's founding) and the foundation of the party-owned National Print Shop (Guomin yinshuasuo 國民印刷所) in 1925 provide evidence that the CCP quickly identified control

* I would like to acknowledge suggestions made by Nicolai Volland of the National University of Singapore on an earlier version of this article. I also benefited from reading his "Control of the Media in the People's Republic of China," which he shared with me. In addition, I thank Odoric Wou of Rutgers University and Eliza Ho of The Ohio State University for their comments and suggestions.
 [1] Van de Ven, "The Emergence of the Text-Centered Party," in Saich and van de Ven, *New Perspectives on the Chinese Communist Revolution*, 5.
 [2] Technically, the Yan'an Decade lasted from January 1937, when the Red Army made the city its capital, to March 1947, when the GMD's Hu Zongnan captured it. Due to space and source limitations, this article discusses the CCP's Jiangxi years only briefly; see also Volland, "Control of the Media," 40–41.

of publishing organs and print media as a vital means of advancing the cause of their revolution. Still, because of the organizational weaknesses of the early CCP, the publishing apparatus continued to be dominated by individual party leaders rather than by the party per se. Indeed, throughout the Shanghai period (1921–27), the party propaganda apparatus was buffeted between the tolerance or inefficiency of treaty port, warlord, or GMD authorities, Shanghai gangsters, and the CCP's own apparent inability or unwillingness to impose hands-on control of its publicity organs. All of these activities played out against a background of ruthlessly competitive pre-1927 Shanghai-based print capitalism symbolized by the publishing operations of Culture Streets (Wenhuajie 文化街).[3]

After the CCP left Shanghai, conditions improved drastically for the creation of what I call "print communism," used here in contrast to print capitalism.[4] By print communism, I mean party-dominated, centrally guided, noncommercially driven printing and publishing in pursuit of CCP goals.[5] In particular, from 1937, as the market dominance of Shanghai's GMD- and state-dependent print capitalists evaporated, a new generation of CCP propagandists claimed ever-increasing control of China's modern print media. In doing so, they created truly party-run, heavily subsidized print communism, in part by building on the party's Shanghai experiences.

By the late 1910s and early 1920s, critics of Shanghai's Big Three print capitalist firms (Commercial Press [Shangwu yinshuguan 商務印書館], established in 1897; Zhonghua Books [Zhonghua shuju 中華書局], 1912; and World Books [Shijie shuju 世界書局], 1921) were clear that the pursuit of privatized print-media wealth and opportunistically defined corporate advantage was no longer necessarily in the interest of "the people" or of China. Concurrently, just as early Chinese print capitalists had adapted Western technology and organizational

[3] On competition in Chinese print capitalism in the 1920s prior to 1928, see Reed, *Gutenberg in Shanghai*, chapter 5, especially on the "textbook wars."

[4] For more on Chinese print capitalism, see Reed, *Gutenberg in Shanghai*, 258, which defines print capitalism as "the social, economic, and political system that resulted from the reciprocal influences of the mental realm of literati print culture and the material world of industrialized mechanical duplication of printed commodities for privatized profit."

[5] Related concepts are the "socialist literary system" discussed by Link, *The Uses of Literature*, and "modern Chinese media concept" presented by Volland, "Control of the Media," 4ff.

models for Chinese circumstances, critics of Chinese print capitalism, including Chinese Communist printers, publishers, and distributors, now adapted Chinese print capitalist methods for their own purposes. This second adaptation included the subordination of printing, publishing, and distribution to party-designated objectives. Accordingly, the historical development of print communism is viewed in this essay as blending influences from Chinese print capitalism, including the advance of China's Gutenberg revolution, and the ideological ambitions and organizational goals of the CCP. At the same time, this study shows that an open, anonymous, competitive market is not a prerequisite for the promotion of the Gutenberg revolution.[6]

Itself a beneficiary of the rise of Shanghai-based Chinese print capitalism in the 1920s, the CCP's Department of Propaganda (Xuanchuanbu 宣傳部) publishing system nonetheless continued to evolve once it was forced to leave Shanghai. The Anti-Japanese War of Resistance (1937–45) proved crucial in this respect. Even as the CCP developed print communism beyond the reach of print capitalism, initially in Yan'an 延安 and then throughout the liberated and border areas of north and central China, the Anti-Japanese War destroyed Shanghai's supremacy in print-capitalist book publishing. Just as important as any military factor, the exhaustion, failure, and evacuation of the GMD state, which had proven critical to the success of Shanghai print capitalists in the late 1920s and 1930s, then bankrupted the Shanghai publishers as well, providing the CCP media network an opportunity for expansion.

Somewhat surprisingly, despite the large number of publications addressing the early history of the CCP, the Yan'an Decade, and the early years of the PRC, little scholarly attention has been paid to the impact of modern Western-style printing and publishing in the annals of the CCP or the degree to which the CCP promoted its own cause and, simultaneously, China's Gutenberg revolution. Leaving aside the mountains of early studies of CCP history and the Yan'an Decade that emerged before access to mainland archives and libraries improved in the late 1980s and 1990s, even recent works have not taken full advantage of eyewitness accounts (memoir literature) or mainland efforts to provide (admittedly still limited and biased) documentary access to early and middle-period CCP or early PRC propaganda media-related

[6] For China's Gutenberg revolution, see Reed, *Gutenberg in Shanghai*, 3, 12–16.

history.[7] Lacunae in the scholarly record become even more striking when discussing the impact of print capitalism on the Communists.

The result of this neglect is that the role of the Communists, who inherited the ideal of a technologically advanced China from Sun Yat-sen and the GMD, in advancing China's Gutenberg revolution has been neglected. Ironically, even official CCP history, although influenced ideologically by materialism, has tended to concentrate, much like Western scholarly commentary, on the intellectual infrastructure of China's Marxist revolution rather than on the material one. This essay aims, in part, to redress this imbalance.

Against the Grain: Communist Publishing in Print Capitalist Shanghai, 1921–27

This section seeks to establish three main points. First, the CCP was a text- and propaganda-oriented political party from its outset in 1921. Second, although the CCP's control of printed propaganda was nowhere near as regimented in the Shanghai period as it became in the Yan'an Decade, chiefly because the party conducted its Shanghai activities against an inescapable background of print capitalism, party control was nonetheless evolving in a print communist direction. Party control of publishing was evolving in tandem with the party itself, which developed in a more Leninist direction, especially after the Fourth Party Congress of January 1925. Third, I argue that in addition to being a text- and ideology-oriented party, the CCP was also

[7] Of the thirteen essays in Saich and van de Ven, *New Perspectives*, three address ideological issues on some level but only one (Timothy Cheek, "The Honorable Vocation: Intellectual Service in CCP Propaganda Institutions in Jin-Cha-Ji, 1937–1945") addresses the material processes involved in generating printed propaganda. Cheek's article and his closely related chapter 2 in *Propaganda and Culture in Mao's China, Deng Tuo and the Intellegentsia* are the most focused recent efforts to describe and assess the practical nature of base camp–area print communism, but naturally Cheek's main interest is Deng Tuo rather than China's Gutenberg revolution. Van de Ven, *From Friend to Comrade*, addresses propaganda operations on a largely bureaucratic level and not on an operational one (see 66–68, 70, 73, 83–84, 87, 127, 129, 137–139). Conversely, Dirlik, *The Origins of Chinese Communism*, 201–245, discusses the intellectual and organizational history of early propaganda struggles by focusing on journals and conflicts with anarchists and guild socialists. Volland, "Control of the Media," discusses the "modern Chinese media concept," including the propaganda sector and the place of printing and publishing within it, but without presenting its technological dimension.

acutely aware of the importance of Western printing technology for establishing control of the party's propaganda and textual matter. To this end, as the party became more Leninist, it also invested (probably aided by Comintern subsidies) in Western printing technology.

As is well known, the First Congress of the CCP was held clandestinely in July 1921 on rue Bourgeat (now Nanchanglu 南昌路) in Shanghai's French Concession. After the assembly was betrayed to the Sûreté, its participants were forced to flee and concluded their deliberations later that summer. Concealment and secrecy remained a primary concern of the party from the outset, leaving little in the way of records for the historian to consult. What few records remain from this period are not yet open to researchers.[8] Thus, in order to reconstruct the early history of CCP publishing, I rely, faute de mieux, on memoirs. Of course, memoirs, particularly those that have been vetted by collectivities such as CCP committees, pose their own challenges to historians,[9] but if scrutinized judiciously, memoir literature can also provide rewards not available from the publications lists, title pages, prefaces, and other documentation typically available to historians of publishing.

Among the thirteen Chinese and two Comintern representatives at that First Congress in July 1921 was Li Da 李達 (1890–1966). Li was selected as the party's first Department of Propaganda head (buzhang 部長),[10] probably on the strength of his reputation as a Marxist theoretician and educator; Li was already editor of the journal The Communist (Gongchandang 共產黨), started in November 1920 and circulating since then in secret.[11] One of the earliest CCP propaganda

[8] Van de Ven, From Friend to Comrade, 58, points out that the CCP kept no archives in the early period he discusses. Similarly, my own efforts (1993, 2004) to gain access to extant CCP archival materials have been only minimally successful.

[9] On memoir literature, see Fogel, "Mendacity and Veracity in the Recent Chinese Communist Memoir Literature," in Cheek and Saich, New Perspectives on State Socialism in China, 354–358. See also Dirlik, Origins of Chinese Communism, chapter 9, and van de Ven, Friend to Comrade, 56–59.

[10] Zheng Chaolin, "Ji Shanghai shudian," 45. In 1922, Cai Hesen was appointed head, followed in the summer of 1924 by Chen Duxiu's personal assistant Peng Shuzhi. At that time, Zhang Bojian was a member of the executive committee in charge of Shanghai Bookstore. In September 1924, Zheng Chaolin became propaganda department secretary (mishu) and, when Zhang changed jobs, Zheng assumed control of Shanghai Bookstore. For more on Li Da, see BDRC, 2, 328–329.

[11] Ji et al., Zhongguo chuban jianshi, 379, notes that The Communist was a monthly founded on the anniversary of the Bolshevik Revolution. It lasted for about a year (only seven issues were produced). Its purpose was to introduce the international

policy statements, "First Resolution on the CCP's Struggle Targets" (Zhongguo Gongchandang guanyu [douzheng] mubiao de diyi jueyi 中國共產黨關於[鬥爭]目標的第一決議), provides a sense of the new party's awareness of the importance of propaganda and public education to the realization of its goals. The resolution's statement that "publications, no matter whether they belong to the central or local organizations, must all be managed and edited by our comrades directly"[12] provided Li Da with the party's goals in creating its first formal publishing unit, People's Press, with offices in Shanghai and Guangzhou.[13] As significant as it is, however, this statement of principle says nothing about whether management and editing would be tightly or loosely controlled by the center.

In fact, as van de Ven has argued, after the First Party Congress, "the CCP's formal leadership...was a facilitating agency rather than a leadership body like the Politburo [of 1927 and later]."[14] After the Third Party Congress of June 1923, despite the creation of a permanent central leadership organization known as the Central Bureau (Zhongyangju 中央局), decentralization and regionalization of the CCP actually increased, he says. Arif Dirlik, similarly, observes that "while the first congress created a centralized organization, the center does not seem to have functioned as much of a center"[15] chiefly because "...real power throughout the twenties rested with Comintern advisers in Guangzhou."[16] Nicolai Volland adds to these observations, noting that, in the 1920s, the CCP's "various propaganda activities were...scattered over a number of institutions, with different individuals in charge, all of them strong characters,"[17] with the result that their personalities, rather than the party per se, guided operations.

communist movement. Each issue had about fifty pages and the largest printing was five thousand. Dirlik, *Origins of Chinese Communism*, 205, reports that *The Communist* published the first Chinese translation of Lenin's *State and Society*.

[12] Cited but not dated in Xiong Chongshan and Li Qiju, "Ji Renmin chubanshe," in *ZCSXB*, 1: 142. Much of my account of the activities of Li Da and Renmin chubanshe comes from this source.

[13] Ji, *Zhongguo chuban*, 367. Van de Ven, *Friend to Comrade*, 128–129, cites a 1921 Comintern document that he suspects guided early CCP views of party publishing; Volland, "Control of the Media," 36, notes that the CCP (and later the reformed GMD) were conforming to Comintern guidelines laid out in 1920.

[14] Van de Ven, *Friend to Comrade*, 56.

[15] Dirlik, *Origins of Chinese Communism*, 249.

[16] Ibid., 268.

[17] Volland, "Control of the Media," 37–38.

These characterizations accurately describe People's Press operations as well as its successor organizations in Shanghai.[18] Documentation detailing People's Press history offers only a sketchy outline of its activities. What is clear from existing documentation is that Li Da remained pivotal to its story until it folded in 1923. Little is known of the diurnal activities of the Guangzhou office, but Shanghai's People's Press actually started operations on September 1, 1921, in Li's home at 625 Chengdu South Road (Chengdu nanlu 成都南路), Fude Lane (Fude li 輔德里).

On the same day that the publishing outlet was founded, a public notice appeared in *New Youth* (*Xin qingnian* 新青年). Founded in 1915, this journal had, within five years, become, under the editorship of Chen Duxiu 陳獨秀 (1889–1943), the mouthpiece of what Dirlik calls the "first Communist nucleus in China."[19] Since September 1920, *New Youth* had been edited for New Youth Publishing (Xinqingnian-she 新青年社) in Shanghai. Like People's Press, both the journal and the publisher were considered "open" (*gongkai de* 公開的) publishing operations by the CCP.[20] In other words, unlike the short-lived *The Communist*, they depended on the print capitalist marketplace for customers and sales. Unlike both *The Communist* and *New Youth*, which predated the CCP but came under its direction in 1921, the party's propaganda directorship itself created People's Press. It was intended to issue fundamental Marxist and Leninist works in short supply in China in the years following the 1917 Bolshevik Revolution.[21]

[18] In *An Oppositionist for Life*, Zheng reports that even he, from 1924 the member of the CCP's propaganda department who was chiefly responsible for editing and contributing to the party journal *Guide Weekly* (*Xiangdao*), did not truly understand what propaganda work was all about until he worked with the wife of Comintern agent Pavel Mif (1901–1939) in Wuhan in late 1927.

[19] Dirlik, *Origins of Chinese Communism*, 203.

[20] New Youth Publishing was founded in September 1920 at what is now 279 Jinling donglu. Its chief editorial office was located at what is now 2 Nanchanglu, Mingde Lane. Chen Duxiu lived upstairs and his flat was frequented by Shen Yanbing (Mao Dun [1896–1981], then working a day job at the Commercial Press), Li Da, and Chen Wangdao, all of whom did editorial work for him. For more information, cf. Ji, *Zhongguo chuban*, 370. Closed by the Sûreté in January 1921 after four months of operation, New Youth Publishing moved to revolutionary Guangzhou and set up its operation at 26 New Changxing Street. To deter Shanghai opponents of the CCP, whether concession police, interfering warlords, or opposing political parties, Li Da was careful to print "26 New Changxing Street, Guangzhou" above "Renmin chubanshe" on the title page of each volume still produced in Shanghai. Chen Duxiu returned to Shanghai in late summer or fall 1921.

[21] Dirlik, *Origins of Chinese Communism*, 212.

The People's Press announcement in *New Youth* declared that the firm aimed to publish the complete works of Marx in fifteen volumes, Lenin in fourteen, a compendium of Marxism in eleven volumes, and another nine volumes on various related topics. People's first book publication turned out to be a reprint of the 1920 translation of the *Communist Manifesto* (*Gongchandang xuanyan* 共產黨宣言) with the name of translator Chen Wangdao 陳望道 (1891–1977) changed to Chen Fotu 陳佛突.[22] In all, in its first year, People's published between fourteen and twenty-one volumes (depending on the informant; Li Da himself reports fourteen). The total included four volumes by Lenin (e.g. *State and Revolution*[23] [*Guojia yu geming* 國家與革命]), three volumes by Marx, and four volumes of Communist theory.[24] Li Da continued editing *The Communist* for People's until the journal folded.

Apart from the printing responsibilities, which were delegated to various sympathetic printing houses in Zhabei 閘北 (then filling up with independent printing firms assembled around the massive Commercial Press plant on Baoshan Road [Baoshan lu 寶山路]), editing, publishing, and even distribution remained Li Da's responsibility, with apparently little guidance from the collective party itself until he left the CCP in 1923. More than thirty years later, on February 23, 1954, Li told a Shanghai audience:

> From July 1921 to June 1922, the Central Work Bureau (Zhongyang gongzuobu 中央工作部) had only three people [Chen Duxiu, Zhang Guotao 張國燾 (1897–1979), and Li himself] and afterwards it had only two [when Zhang left for Beijing]. Aside from these, there was no staff. The propaganda-work aspect only employed one worker to package

[22] Ji, *Zhongguo chuban*, 369, states that Chen Wangdao translated *The Communist Manifesto* in March and April 1920 from a Japanese translation supplemented by an English translation that Chen Duxiu borrowed from the Beijing University library. In August 1920, one thousand 56-page, lead-type copies were printed by the Shanghai Socialist Research Society. It quickly sold out. One of these copies eventually reached Mao Zedong. In 1923, Shanghai Bookstore published a new translation that eventually became a handbook for many on the Northern Expedition.

[23] Xiong Chongshan and Li Qiju, "Li Da yu chuban gongzuo," 76. For other titles in the Renmin series, see 76–77.

[24] Xiong Chongshan and Li Qiju, "Ji Renmin chubanshe," 1: 1, 143 state there were eighteen volumes, but list twenty-one; they also cite Li Da himself claiming fourteen. Ji, *Zhongguo chuban*, 368, lists fifteen volumes. Small print runs and official repression combined to complicate creation of a complete list today. Sixteen titles were issued by the Guangzhou office and are listed in [Zhang Jinglu], "Di yi ci guonei geming zhanzheng shiqi chubanwu jianmu," in Zhang Jinglu, *ZXCS*, 1: 68.

the books. Aside from publishing the *New Youth* and *The Communist* monthlies along with the People's Press books, all the Central Work Bureau did was read each local organization's documents, giving appropriate guidance.[25]

From this statement, delivered at a time when Li might have been tempted to exaggerate CCP involvement, one is struck by the fact that propaganda operations of his era hinged on the efforts of party individuals rather than the party bureaucracy per se. Reflecting the role of individual decision making, distribution beyond Shanghai, said Li Da, was done on an unplanned and sporadic basis. Sailors carried packages onto steamers and thence to outlying ports.

Eventually, People's Press itself was forced to leave Shanghai for Guangzhou. As Dirlik argues, the Third Party Congress, held at Guangzhou in June 1923, occurred in an environment much more favorable to the CCP than Shanghai had been in 1921. The congress[26] resolved to merge People's Press with New Youth Publishing House.[27] Decisions were also taken to establish several other party publishing operations. Among them was Shanghai Bookstore (Shanghai shudian 上海書店), about which we have significantly more information than we have about People's Press, thanks in part to surviving memoirs by Xu Baimin[28] 徐白民 and Zheng Chaolin[29] 鄭超麟 (1901–1998). Their

[25] "[Li Da] Gei Shanghai geming ji'nianguan," 1954, cited in Xiong Chongshan and Li Qiju, "Ji Renmin chubanshe," 1: 143.

[26] At the Third Party Congress, the Department of Propaganda was reorganized as a Department of Propaganda and Press (Xuanchuan baokanbu) with a separate Publishing Department (Chubanbu) headed by Luo Zhanglong and Zhang Bojian. For more details, see Volland, "Control of the Media," 37–38.

[27] Xiong Chongshan and Li Qiju, "Ji Renmin chubanshe," 1: 144. The merger resulted in the creation of Guangzhou's Common People's Books (Pingmin shushe) in 1924. Numerous sources hint at police surveillance to explain why People's left Shanghai. Van de Ven, *Friends to Comrades*, 264–265 n. 7 adds that Li left the CCP in 1923 after a dispute with Chen Duxiu, held a number of GMD appointments, and then reapplied for CCP membership in 1949. Van de Ven objects that this checkered history raises questions about the reliability of Li Da's multiple autobiographical writings, which is why I have not cited them in this article. After 1949, Li Da was appointed head of Hunan and then Wuhan universities.

[28] Xu Baimin, "Shanghai shudian huiyi lu [1953]," in Zhang Jinglu (1954–57), 1: 61–67. Wu Guifang, "Ji Dang de zaoqi yinshua gongzuo he di yi ge dixia yinshuachang," in Zhang Jinglu (2003) 6: 270–272, writes on early CCP printing.

[29] Zheng Chaolin was a Troskyist. His memoirs first appeared in 1986 and were followed in 1991 by Zheng's recollections of his work with Shanghai Bookstore. Posthumously, a memoir *Zheng Chaolin huiyilu, 1919–31* appeared, possibly published through the "second channel" system discussed in the introduction.

writings contain significant information about Shanghai Bookstore and how it operated, both commercially and bureaucratically.

Xu Baimin was a Shaoxing 紹興 native and graduate of Zhejiang Provincial First Normal School (Zhejiang shengli diyi shifan xuexiao 浙江省立第一師範學校),[30] a well-known cradle of the early Communist Party.[31] In the fall of 1923, however, Xu was still an obscure party member teaching in a Zhejiang girls normal school[32] when he received an express letter from a central party official, telling him to report to Shanghai within the next few days. Meeting with Qu Qiubai 瞿秋白 (1899–1935) and another CCP representative, Xu reports that he learned that the party wanted to set up a new publishing operation in Shanghai. Perhaps to avoid the kind of harassment that may have forced Li Da to migrate to Guangzhou, the party leadership this time favored selection of an individual unknown to the Shanghai police to manage the new bookstore.[33] After Qu and the other "comrade" briefed Xu on his assignment, Xu returned to Hangzhou, tendered his teaching resignation, then made his way back to Shanghai, where he spent the better part of a month searching for suitable premises for the party's new bookstore.

Finally, Xu located a single shopfront with a second floor near Shanghai's Lesser North Gate (Xiaobeimen 小北門) at what is now 1025 People's Road (Renmin lu 人民路). After Xu rented it, the party chose the shop's name—Shanghai shudian[34]—which, in the interest of promoting an air of legitimacy, was written on a blue enamel sign with white lettering of the sort that was common in Shanghai in those days.[35] Prior to opening, the new shop's largest expense was furniture, which was secured for 120 yuan[36] and included a couple of tailor-made

[30] Zheng Chaolin, "Ji Shanghai shudian," 45. Shaoxing natives were so prominent in Shanghai's publishing world in the 1920s that many Shanghainese automatically identified them with it, particularly the second-hand and antiquarian book business, which may have been part of Xu's appeal for the CCP.

[31] See Yeh, *Provincial Passages: Culture, Space, and the Origins of Chinese Communism.*

[32] Zheng Chaolin, "Ji Shanghai shudian," 45.

[33] Xu Baimin, "Shanghai shudian," 1: 61 n. 2.

[34] Ibid.," 1: 62.

[35] Ji, *Zhongguo chuban,* 373.

[36] Xu Baimin, "Shanghai shudian," 1: 62.

wood-and-glass bookshelves and a service counter.[37] The new firm opened on October 1, 1923,[38] just over two years after People's Press.

Zheng Chaolin, a native of Fujian 福建 province active in the CCP since 1922, became secretary (*mishu* 秘書) to the Propaganda Department in September 1924 and worked quite closely with Xu until early 1926, when Xu was replaced by Mao Zemin 毛澤民 (1895/6–1943). Unlike Xu himself, who remains mute about other store employees, Zheng reveals that there were always two or three bookstore employees helping Xu. All were young (about twenty *sui*) party members, including women.

Having praised Xu's savvy in bookstore operations, Zheng also makes clear that by the time Zheng joined the enterprise, any "constitutional" questions about ownership and responsibilities that might have complicated communication between Xu and the central party leadership had been sorted out. Given the fact that the bookstore was opened by party members such as Xu in their *private* capacity, Zheng asks, who in fact owned the firm's inventory, furniture, etc.? After some investigation, Zheng says, Zhang Bojian 張伯簡, a member of the propaganda department's executive committee and Zheng's own immediate superior, had determined that "this bookstore is the property of the central party,"[39] a view that likely reflected the growing assertiveness of the enlarged Central Executive Committee (Zhongyang zhixing weiyuanhui 中央執行委員會) and newly formed Central Bureau (Zhongyangju 中央局) over the CCP's propaganda work following the Third Party Congress.[40]

Although Shanghai Bookstore's stock could be classified as "progressive" within the terms of the post-May Fourth era, says Xu Baimin, the firm carried relatively few of the party's own publications openly. In fact, it seems to have operated much like any other retail

[37] Ji, *Zhongguo chuban*, 372.

[38] Xu Baimin, "Shanghai shudian," 1: 62.

[39] Zheng Chaolin, "Ji Shanghai shudian," 45. Perhaps these small-scale CCP-affiliated shops were run along the lines of the publishers and *tongren* writers discussed by Ling Shiao in this volume, but no such evidence has come to light. Although scholars have mentioned the possibility of Comintern subsidies to the CCP in this era, no one, including Zheng Chaolin, has yet pointed directly to the party print shops as recipients of such funds. In *Oppositionist for Life*, 76, Zheng does state that, around 1925, "The Party's entire expenses…amounted to a little over nine hundred dollars a month"; salaries for six persons, including himself and Chen Duxiu, cost only $210, suggesting that some of the rest might have been used for propaganda expenses.

[40] See van de Ven, *Friend to Comrade*, 102, 132.

bookstore of the pre-1927 print capitalist era, at least during daylight hours. For example, it contracted to distribute the publications of East Asian Library (Yadong tushuguan 亞東圖書館), New Culture Book Society (Xin wenhua shushe 新文化書社), and even those of People's Knowledge Bookstore (Minzhi shuju 民智書局), the pro-GMD publishing house founded in 1921 (by Hu Hanmin 胡漢民 [1879–1936]'s overseas relative, Lin Huanting 林煥廷). Minzhi was then considered quite "progressive,"[41] Xu insists. Xu also complains, however, that the Commercial Press and Zhonghua Books, China's two leading comprehensive publishers and both based in Shanghai, offered Xu what he considered unfairly harsh financial terms: although Shanghai Bookstore was welcome to sell books published by the Commercial Press and Zhonghua, Xu was not allowed to return any for credit. As a result, Shanghai Bookstore had to spend scarce cash to secure titles and could afford only three to five of the two large publishers' most worthwhile titles at any one time. Nonetheless, by these means the firm's shelves were soon filled and the shop open to walk-in customers, just like any other market-dependent bookstore of the era.

A year after it opened, Shanghai Bookstore commenced marketing the Central Committee's journal, *The Guide Weekly* (*Xiangdao* 嚮導), edited by Cai Hesen 蔡和森 (1890–1931), who was elected head of the CCP's Propaganda Department at the Second Congress in July 1922.[42] Xu, with a candor that recommends his memoirs as a source, acknowledges that the firm had trouble selling it. For example, 3,000 copies would be printed, but only about a thousand could be sold.[43] Other party publications, such as *The Vanguard* (*Qianfeng* 前鋒) and *New Youth*, did even more poorly, says Xu. He does, however, com-

[41] Xu Baimin, "Shanghai shudian," 1: 62, says that Minzhi shuju's first publication was CCP member Cai Hesen's *Shehui jinhua shi*, followed by Sun Lianggong's *Wenyi cidian* and Chen Shousun's *Shehui wenti cidian*. Not until after the Western Hills conference (*Xishan huiyi*) of 1925 did Minzhi become steadily reactionary, says [Zhang Jinglu], "Shanghai shudian," 1: 66, n. 3.

[42] Van de Ven, *Friend to Comrade*, 127. Ji, *Zhongguo chuban*, 380, indicates that *Xiangdao* commenced publication on September 13, 1922, and lasted until July 18, 1927. Unlike *New Youth*, whose purpose was to present Marxist-Leninist theory, *Guide Weekly* was developed to present the current revolutionary line. In *Oppositionist for Life*, 77, Zheng reports that he proofread *Xiangdao* and also wrote for it; this latter task included counterfeiting "letters to the editor" (a device undoubtedly influenced by Shanghai's market-driven journals and newspapers).

[43] Xu Baimin, "Shanghai shudian," 1: 62. As Ling Shiao notes, in the 1920s publications needed to sell 2,000 copies to break even.

plain that *The Vanguard*, a monthly, often failed to appear on time. It had a small market anyway and so, for these two reasons, Shanghai Bookstore simply stopped publishing it.[44]

By the fall of 1924, after the establishment of the First United Front (1924–27) with the GMD, when Zheng Chaolin got involved on behalf of the Department of Propaganda, Shanghai Bookstore was more heavily involved in book-editing work of its own devising. Significantly, in May of that year, the Central Executive Committee had met to reorganize propaganda and other party activities in anticipation of the critical Fourth Party Congress of January 1925. That congress, argues van de Ven, marked an important transition in the CCP's road to becoming a centralized Leninist party. According to Zheng, after the Department of Propaganda finished editing manuscripts, he passed them on to Xu, who then arranged for the printing.[45]

Despite the growing assertiveness of the central party apparatus in the activities of Shanghai Bookstore, there was clearly a disconnect between the editorial activities of the central party leadership and the marketing and distribution activities of Shanghai Bookstore. The latter clearly required the use of caution. Therefore, Shanghai Bookstore warehoused party publications in outside rented quarters and moved most of that stock at night. In 1926, an unnamed underworld gang discovered the printed party contraband being handled by the bookshop and shook the firm down for a significant amount of protection money.[46]

Although Shanghai Bookstore did not benefit financially from the official party publications it sold, it did manage to secure material consideration in an indirect way from *New Youth*. Within ten months of the opening of Shanghai Bookstore, Guangzhou's New Youth Publishing Company had closed down and its manager had returned to Shanghai. All of the publisher's inventory, including ten titles (mostly translations), was now transferred to Shanghai Bookstore. Among the stock passed to Shanghai Bookstore were some 10,000 copies of *Record of Workers' Blood on the Beijing/Hankou Rail Line* (*JingHanlu gongren*

[44] Ji, *Zhongguo chuban*, 380, notes that *The Vanguard* monthly lasted from July 1, 1923, to February 1924, but only three issues appeared.

[45] Wu Guifang, "Ji Dang de zaoqi yinshua gongzuo," 6: 270. Ji, *Zhongguo chuban*, 377, adds that Xu Baimin was helped by Xu Meikun, the sometime editor of *Guide Weekly* and *Chinese Youth* who is now known as "China's first Communist printer."

[46] Xu Baimin, "Shanghai shudian," 1: 65. According to van de Ven, *Friend to Comrade*, 63, the Green Gang in particular made life difficult for the early CCP.

liuxue ji 京漢路工人流血記), an account of the failed railway work-
ers' strike in early 1923. Possibly thanks to the transfer of New Youth
Publishing titles in 1924, in that year, says Xu, Shanghai Bookstore
needed only to reprint Chen Wangdao's translation of the *Communist
Manifesto* to keep party-related books on the shelves.

By the middle of 1924, Shanghai Bookstore's accounts began to sta-
bilize, thanks in part to its reprint publications and the New Youth
Publishing materials, but also to its development of a series of polit-
ical-lecture titles. This new series, nicely printed and bound, perhaps
for a more upscale market, was packaged as *Lectures on Social Science*
(*Shehui kexue jiangyi* 社會科學講義). The content came mostly from
Shanghai University lectures edited for publication.[47] For instance, Qu
Qiubai, a member of the Central Bureau after the Third Party Con-
gress, head of Shanghai University's social sciences division, and now
editor of *New Youth,* wrote the firm's philosophy books. *History of the
Worldwide Workers' Movement* (*Shijie laodong yundong shi* 世界勞動
運動史) was written by Shi Cuntong 施存統 (1889–1970), one-time
Socialist Youth League (Gongchanzhuyi qingniantuan 共產主義青
年團) director and now head of the sociology department. Zhejiang
Law and Politics School 浙江法政學校 CCP member An Ticheng
安體誠, later executed in the White Terror (*Baise kongbu* 白色恐怖),
wrote a history of economic thought.

Efforts were made to reach out to both literates and illiterates. For
example, *Chinese Youth* (*Zhongguo qingnian* 中國青年),[48] a journal
that Central Bureau member, labor activist, and Shanghai Univer-
sity dean Deng Zhongxia 鄧中夏 (1897–1933) started in 1923, began
to prosper; when Socialist Youth League activist Ren Bishi 任弼時
(1904–1950) returned from the Soviet Union, he lived in the journal's
office and contributed pieces to it. One landmark publication, accord-

[47] Shanghai University was founded in early 1923 after the failure of the Bei-
jing/Hankou railway workers' strike. It was headed by GMD journalist Yu Youren
(1878/9–1964); Shao Lizi (1882–1967) was vice director. *Communist Manifesto* trans-
lator Chen Wangdao headed the Chinese literature section. For more details, see
[Zhang], "Shanghai shudian," 1: 67 n. 5.

[48] Ji, *Zhongguo chuban*, 382, says *Chinese Youth* was founded on October 20, 1923,
and published by Shanghai Bookstore until it moved to Hankou, where Wang Jingwei
(1883–1944) forced it to close from July to November 1927. From 1927 to 1932, it
appeared secretly under a variety of names. In 1939, it reappeared in Yan'an and lasted
until 1941. In 1948, it came out again with Central Committee assistance and then
moved to Beijing in 1949, where it has been one of the Communist Youth League's
main publications ever since.

ing to Zhang Jinglu, was Jiang Guangci's 蔣光慈 collected poems, *New Dreams* (*Xinmeng* 新夢). In 1923, Jiang returned from a two-year sojourn in Russia and his poems, says Zhang, were China's earliest revolutionary verse.[49] A third publication was the primer *Common People's Thousand-Character Reading Course* (*Pingmin qianzi ke* 平民千字課) by Socialist Youth League propaganda director Yun Daiying 惲代英 (1895–1931), published in four volumes for party activists starting up night schools for illiterates.

In addition, Zheng Chaolin recalls having been involved with another category of propaganda manuscripts, consisting of a series of writings on the struggles of the CCP up to the mid-1920s. One title, edited by new Propaganda Department *buzhang* Peng Shuzhi 彭述之, was *The Last Five Years of CCP Political Positions* (*Zhongguo Gongchandang wunian lai de zhengzhi zhuzhang* 中國共產黨五年來的政治主張). Anthologizing reedited articles from *New Youth, Guide Weekly*, and *Vanguard*—that is, a mixture of "open" and "internal-only" publications—it was well received, claims Zheng. It also clearly symbolized Shanghai Bookstore's fence-sitting posture between commercial and party-driven publishing.

These and Shanghai Bookstore's other editorial efforts were also aided by increased requests for publications from southern provinces engulfed by the national revolution then reverberating outward from Guangzhou. In the build-up to the May Thirtieth Movement, Shanghai Bookstore's publications grew so significantly that Mingxing Print Shop (Mingxing yinshuasuo 明星印刷所), the left-wing private printing firm with which Xu contracted, could not keep up with the workload (partly, too, because the owner had been arrested).[50]

Consequently, the party leadership decided to open its own underground printing operation in Shanghai in June 1925, not surprising given the fact that in January 1925, the Fourth Party Congress had begun, but not yet completed, the party's transition to a centralized

[49] [Zhang], "Shanghai shudian," 1: 67 n. 7.

[50] According to Odoric Wou, who has researched Communist organizing in the remote Dabie Mountains districts of southeastern Henan, party organizing there began when the son of the local bookshop owner requisitioned his father's shop, which had formerly sold textbooks. In 1925, right after the May Thirtieth Movement began, the son and local CCP leaders organized both a local party leadership and a progressive book club in the shop, importing books from Shanghai (personal communication, September 9, 2009).

Marxist-Leninist party.[51] Xu Baimin recalls that the party's new print shop was called National Print Shop[52] and was run by Ni Youtian 倪憂天 from Hangzhou;[53] among nonparty customers it was known as Revere-Literature Hall Print Shop (Chongwentang yinwuju 崇文堂 印務局).[54] Thus, like Shanghai Bookstore itself, the party's print shop straddled the ideological and commercial realms. As an industrial operation, however, along with many other print shops in that period, it was located in Zhabei.[55]

Marking an important turning point in the CCP's publishing operation that revealed the party's growing awareness of the importance of owning the means of their production, the acquisition of the print shop also suggests that the party propaganda system was now benefiting from sizable Comintern subsidies. National Print Shop itself employed between twenty and thirty workers manipulating three folio-sized lithographic presses and one foot-powered press. When it first opened in 1925, it printed *Guide Weekly*, *Chinese Youth*, and *Shanghai General Labor Union* (*Shanghai zonggonghui* 上海總工會), as well as some one-off items. The party's goal was to avoid the shop's exposure (*bimian baolu* 避免暴露) as a unit of the CCP. For this reason, it advertised just like any other print shop in *The News* (*Xinwenbao* 新聞報) and other newspapers. Still, erring on the side of caution, it did post lookouts at both ends of a nearby bridge. Caught off-guard once by a municipal inspector checking household registrations, the shop was nearly shut down when he picked up a half-printed *Guide Weekly*, became suspicious, and had the bookkeeper arrested. Fortunately, says

[51] See van de Ven, *Friend to Comrade*, 131–146.

[52] Like many small businesses in Shanghai at that time, it had two names and two signs. As observed in note 39, resolving the mystery of how these shops—which required substantial investments that seem unlikely to have come solely from sales of left-wing books and periodicals, which did take off in this period—were financed must await further documentation.

[53] Wu Guifang, "Ji Dang de zaoqi yinshua gongzuo," 6: 271.

[54] Ibid.

[55] Xu Baimin, "Shanghai shudian," 1: 64; Wu Guifang, "Ji Dang de zaoqi yinshua gongzuo," 6: 271. Ji, *Zhongguo chuban*, 373, says that National was a commercial firm that printed nonparty works and Shanghai General Labor Union pamphlets as well as *Guide Weekly* and *Chinese Youth*. Between October 1925 and January 1927, Ni was often forced to relocate the print shop to stay ahead of the law and to complete the assignments he was given by the party. Ji, 377, says Ni Youtian and Chen Haoqian eventually moved the whole operation to Hankou in January 1927, where it became the print shop affiliated with Yangzi River Bookstore.

Wu, the men in the shop quickly collected the printing stereotypes and burned them. The bookkeeper was soon released on bail.

In October 1925, the printing operation changed its name to Cultural Printing (Wenming yinwuju 文明印務局) and was divided into two plants. At this point, drawing on financial resources that must have included substantial Comintern subsidies, the four-year-old Communist Party was able to set up a specialized casting plant in the Anglo-American International Concession. A full-service printing plant was opened in a second location. The latter shop had two floors and, doubling the original size of the National Print Shop workforce, now employed fifty to sixty workers running full-page letterpress and lithographic machines.[56]

This party-run print shop would prove invaluable in early 1926, when the revolutionary tide expanded out of Guangzhou and into surrounding provinces, stimulating a new demand for CCP materials. Many Communists now began to open left-leaning bookstores in their provinces' leading cities. Thus, Guangzhou Bookstore (Guangzhou shudian 廣州書店) was joined by others in Nanchang (Nanchang shudian 南昌書店), Ningbo (Ningbo shudian 寧波書店), etc. Relying on its distribution networks and industrial printing facilities, Shanghai Bookstore supplied them all and acted as their guarantor with other Shanghai publishers. The same was true of progressive bookstores abroad, in Hong Kong and even in Paris, for example. In effect, these stores were all Shanghai Bookstore's branch stores, even when they used their own names. At this point, the distribution system ran into trouble keeping up with rising demand. In response, the party leadership appointed Mao Zemin, brother of Mao Zedong, to take charge of distribution.

During the 1925–26 winter, Beiyang 北洋 warlord Sun Chuanfang's 孫傳芳 (1884–1935) troops occupied Shanghai. One of their targets was Shanghai Bookstore, which they closed down on February 3, 1926.[57] *Republican Daily* (*Minguo ribao* 民國日報) reported that "the reason given was that the store had published *Chinese Youth*, which

[56] The description of Wenming yinwuju and its two offspring comes from Wu Guifang, "Ji Dang de zaoqi yinshua gongzuo," 6: 271. Wu, 272, also says that apart from printing the party's periodicals and documents, Wenming printed a kind of a revolutionary calendar, with each page featuring a reminder of particular days in revolutionary history.

[57] Ji, *Zhongguo chuban*, 374.

incited workers groups and jeopardized public security."[58] This time, too, the police seized the shop's bookkeeper. Xu tried, unsuccessfully, to reopen the store with a well-placed bribe. Soon afterward, though, the bookkeeper was freed with a warning that the warlord soldiers had really been seeking Manager Xu.[59] Clearly, it was time for Xu Baimin to move on.

Thus, the party reassigned Xu Baimin to organize a new party publishing and distribution center in Hankou to be called Yangzi River Bookstore (Changjiang shudian 長江書店). Yangzi River was intended to continue with the mixed public/underground distribution system pioneered by Shanghai Bookstore. At the end of June 1926, party printer Ni Youtian, too, was transferred to Hankou to set up Yangzi River's print shop. He took enough equipment to outfit the entire new shop, no small undertaking.[60]

By the time Xu finally got back to Shanghai from Hankou, Shanghai Bookstore was shuttered and the Northern Expedition had reached Shanghai. The White Terror erupted there on April 12, 1927; the day before, Xu Baimin had been arrested for his activities with leftist bookstores. While in jail, Xu ran across a newspaper announcing the opening of Hankou's Yangzi River Bookstore. However, he would not be there to manage it; instead, he spent the next six years languishing in GMD prisons.[61]

In the meantime, CCP politics became extremely confused as its leadership disintegrated. Peng Shuzhi, the Department of Propaganda head since 1924, was cashiered after April 1927; the following month, the Fifth Party Congress held at Wuhan would structure the centralized Leninist apparatus of later days with a permanent Central Committee (Zhongyang weiyuanhui 中央委員會), Politburo (Zhengzhiju 政治局), and Standing Committee (Changwu weiyuanhui 常務委員會). By August, General-Secretary Chen Duxiu would be expelled from the party and the Standing Committee, under new General-Secretary Qu Qiubai, would take control of the party using "Marxism-Leninism as a legitimation device" for the first time in party history.[62]

[58] *Minguo ribao*, February 5, 1926, cited in Ji, *Zhongguo chuban*, 374.
[59] Zheng Chaolin, "Ji Shanghai shudian," 4: 46, says his connection with Shanghai Bookstore ended after the May Thirtieth Movement when Mao Zemin took over its distribution work.
[60] Wu Guifang, "Ji Dang de zaoqi yinshua gongzuo," 6: 272.
[61] Xu Baimin, "Shanghai shudian," 1: 65–66.
[62] Van de Ven, *Friend to Comrade*, 200–201.

Shanghai Bookstore, in the three years of its existence under Xu Baimin's management, had published, printed, and distributed three party journals, thirty titles (eighteen of them in 1925 alone) in multiple volumes, and at least one title in a sizeable print run of 2,000.[63] In addition, like many commercial bookstores of the era, Shanghai Bookstore opened branch stores (in the western and eastern districts of Shanghai, not to mention the "branches" claimed by Xu in other cities and abroad). The Shanghai University Bookstore (Shubao liu-tongchu 書報流通處) was also a front organization, actually serving as the firm's northern branch.[64]

While Xu Baimin was away in Hankou, the CCP had temporarily handed the Shanghai store's reins over to Mao Zemin, who had joined the CCP in 1922. After service in the Anyuan 安源, Jiangxi 江西 coal miners campaign, he was sent in 1925 to Shanghai, where he was assigned to manage the party leadership's publishing and distribution work. The CCP was becoming well aware of the value of having its own underground print shops, and so Mao began setting them up. Apart from National Print Shop, the first known underground print shop was off what is now Xizang North Road (Xizang beilu 西藏北路). Here, the CCP is said to have printed *The Bolshevik* (*Bu'ersaiweike* 布爾塞維克), *Chinese Youth*, and *Critiques of the "Three People's Principles"* (*Sanmin zhuyi pipan* 三民主義批判).

With Xu Baimin under lock and key, Hankou's Yangzi River Bookstore ended up under the direction of Qu Qiubai and the former manager of Guangzhou's New Youth Publishing House who were joined by Zheng Chaolin. After the Northern Expedition army, under the Left-Wing GMD leadership, arrived in Wuhan in October 1926, Yangzi River Bookstore opened on the corner of Jisheng Road (Jisheng malu 濟生馬路) and what is now Zhongshan Boulevard (Zhongshan dadao 中山大道). Stock was sent in from Shanghai and Guangzhou and sold out in the first three days.[65] Ni Youtian and Chen Haoqian 陳豪千, former party printers for Shanghai Bookstore, then opened the Yangzi River Print Shop (Changjiang yinshuasuo 長江印刷所) with the goal of printing only materials for the party bookstore. A total of fifty titles were issued. They included reprints from the former People's Press, Shanghai Bookstore, and New Youth Publishing such as *New Youth*,

[63] Ji, *Zhongguo chuban*, 374.
[64] Ibid.
[65] [Zhang Jinglu], "Shanghai shudian," 1: 67, n. 8.

Guide Weekly, and *Chinese Youth.* Added to these were Zheng Cha-
olin's translation of *The ABC of Communism* (*Gongchan zhuyi ABC*
共產主義 ABC) by Nikolai Bukharin and Yevgeni Preobrazhensky,[66]
The Complete Marx (*Makesi quanshu* 馬克思全書), *The Complete
Lenin* (*Liening quanshu* 列寧全書), and Mao Zedong's *Report on the
Hunan Peasant Movement* (*Hunan nongmin yundong kaocha baogao*
湖南農民運動考察報告). The large number of noncommercial titles
suggests a substantial Comintern subsidy.

After July 1927, when the Left-Wing GMD split with the CCP, a
Qu Qiubai publication and a translation of a work by Stalin (*Out-
line of Leninism* [*Liening zhuyi gailun* 列寧主義概論], his first work
published in Chinese) failed to appear because of police interference.
Furthermore, ten thousand revolutionary pamphlets printed by the
Changjiang shop never reached their destination in Shanghai; some-
one betrayed Changjiang to Hankou's British police, and the local
CCP had to sink the pamphlets in the Yangzi River. Later, several
thousand were reprinted along with a Qu Qiubai translation.[67] By
then, Qu, the CCP, and the Department of Propaganda had entered a
new phase in the evolving creation of Chinese print communism. The
party itself, rather than prominent individual operators such as Li Da,
Chen Duxiu, and Qu Qiubai, now became responsible for enforcing
party discipline via newly created central investigation committees.[68]

As seen from this survey of its print-media propaganda activities
from 1921 to 1927, the CCP clearly was, as van de Ven has argued,
"a text-centered party." Even more, however, the CCP and its Propa-
ganda Department throughout this period set an ever-higher priority
on establishing its own full range of editorial, publishing, and even
printing services. In doing so, the CCP created extensive distribution
networks—internal ones that demanded party membership and exter-
nal ones that depended on the commercial print market dominated by
Shanghai's print capitalists.

[66] Ji, *Zhongguo chuban,* 371. Zheng Chaolin's translation of *The ABC of Commu-
nism,* which sold for twenty cents, became the standard Chinese edition, and, with
the *Communist Manifesto,* was a widely used manual on the Northern Expedition. *An
Oppositionist for Life,* 95, reports that, in 1927, a Shanghai newspaper ranked Zheng's
ABC of Communism second among Shanghai best-sellers after Sun Yat-sen's *Three
People's Principles* (*Sanmin zhuyi,* which was distributed free) and ahead of Zhang
Jingsheng's *Stories of Sex Lives* (*Xingshi*).

[67] Ji, *Zhongguo chuban,* 377.

[68] Van de Ven, *Friend to Comrade,* 225.

Both ideological and technological concerns motivated the CCP's propaganda efforts from 1921 to 1927. We can divide this evolution into two periods. Between the First Party Congress of 1921 and the Third Party Congress of 1923, Li Da ran the People's Press largely on his own, albeit against a print capitalist background; Communist ideas were published via *New Youth* and *The Communist*, the former an "open," commercial commodity marketed through the channels of Republican China's print capitalist world, and the latter an internal, clandestine "organ." Between the Third and Fifth Party Congress (May 1927), however, the central party began to assert tighter organizational control over its publishing and propaganda system, even as it remained clearly influenced by the commercial marketplace. Its efforts now included establishing and supervising Shanghai Bookstore in particular along with its related National Print Shop. Dependence on sympathetic but independent editors, publishers, and printers had turned out to be inadequate for evolving party objectives.

Just as surely as earlier efforts to create propaganda publishing operations in Guangzhou, Shanghai, and elsewhere, Ni Youtian's transfer of printing equipment from Shanghai to Wuhan, some five hundred miles away, illustrates the party's determination to sustain its print-media self-sufficiency across China. Yet this transfer of men, texts, and equipment pales by comparison with the commitment shown by the CCP to sustain itself and its propaganda operation in Yan'an and the northern base camps during the Sino-Japanese War. There, as we will see in the next section, the party's propaganda work was neither the result of determined efforts by strong-willed party leaders nor merely a sideshow to Shanghai-based print capitalism. Instead, it brought forth party-guided print communism on its own terms, even as the CCP relocated China's Gutenberg revolution to the remote northwest.

Yan'an and the Birth of Print Communism, 1937–47

The discussion below focuses on activities in Yan'an, the political center of the Shaan-Gan-Ning Base Area (Shaan Gan Ning genjudi 陝甘寧根據地).[69] Like the previous section, it seeks to establish three main

[69] The leadership in Shaan-Gan-Ning and parts of northern China was appointed to the directorship of New China Bookstore (Xinhua shudian) once the PRC was established in 1949. By the late 1940s, the North China Military District in particular inherited much of the printing and publishing equipment available in China at that time, giving Xinhua a firmer material base on which to build the PRC's state-

points. First, it shows that, located far from Shanghai and market-based print capitalism, the CCP was able to realize its longstanding ambitions of integrating printing, publishing, and distribution in more concentrated ways than had been possible in the 1920s. Doing so, of course, was facilitated by the absence in Yan'an of competition from other publishers or organized sociopolitical groups.[70] Second, despite more primitive conditions in Yan'an than in Shanghai, and thanks to the absence of a full-fledged marketplace, the dedication of its cadres, and the CCP's willingness to subsidize its publications heavily, the CCP was actually more effective there at printing, publishing, and distribution. Third, as will become clear, the CCP brought both industrialization and the Gutenberg revolution to rural northwestern China.

Zhou Baochang 周保昌 and Song Yulin 宋玉麟, both of whom were present at the opening of New China Bookstore (Xinhua shudian 新華書店) in 1939, have written about the early operation of the CCP's printing and publishing operations in Yan'an.[71] Although rich in detail, Zhou's and Song's memoirs focus chiefly on the mid-Yan'an period (1939–42) that ended with the Rectification Movement (Zhengfeng yundong 整風運動, 1942–44/45). Therefore, their memoir literature is supplemented here by an earlier, anonymous Chinese secondary account, published in 1956, that extends coverage from 1937. These three Chinese accounts are augmented by another three penned

dominated printing and publishing system. See, for instance, the inventory of printing plants and printing presses in Pang Duoyi, "Xin Zhongguo shukan yinshua gongye de fazhan licheng," 4: 9. According to Pang's calculations, slightly less than a third of all Chinese printing plants in 1949 were in North China, which trailed only East China (Jiangnan and Shanghai) in its total inventory of plants and presses.

[70] The Sixth Party Congress was held in Moscow in 1928 and would not be followed by the seventh (held in Yan'an) until 1945. From 1938 until 1943, as Kampen, *Mao Zedong, Zhou Enlai, and the Evolution of the Chinese Communist Leadership*, 99, makes clear, the CCP had a collective leadership; Volland, "Control of the Media," 48–50, adds that, from 1938 to 1941, five persons, including CCP leader Zhang Wentian, controlled all important propaganda posts with the exception of New China News Agency (Xinhuashe) and the Party School (*dangxiao*). In spring 1943, Kampen argues, Mao Zedong took over the party and propaganda leadership. The Propaganda Department, which now included the party school, was staffed with Mao supporters; in July, the term "Mao Zedong Thought" (Mao Zedong sixiang) was first printed in *Liberation Daily*.

[71] Selden, "Yan'an Communism Reconsidered," 9–10, explains that Yan'an was by no means typical of the Communist-led base areas; it was the poorest and most backward technologically but the most advanced politically, thanks to the presence there of the Central Committee and, thus, the CCP's central government. Apter, "Discourse as Power: Yan'an and the Chinese Revolution," 206, counts a total of nineteen liberated and base areas.

by non-Chinese: one by American journalist Edgar Snow (1905–1972) that covers the early Yan'an years; a second by Yanjing University 燕京 大學 wartime refugees Claire Band and William Band (1906–1993), who resided in Yan'an from October 1943 to early January 1944; and a third by the German journalist Gunther Stein, who visited Yan'an from May until October 1944.[72]

Zhou Baochang observes that the CCP had long recognized the need for publishing work. Whether in Jiangxi 江西 (1927–34) or on the Long March 長征 (1934–35), he says, the party supported the idea of issuing newspapers and pamphlets; even in very straitened conditions, when the party's printers had only stencils and mimeography, for example, they kept at it.[73] With respect to Jiangxi, this view is supported by Edgar Snow, who wrote, "In the central Soviet printing plant at [Ji'an, occupied briefly by the Communists in October 1930] with its 800 workers, many books, magazines, and a big 'national' paper—the *Red China Daily News*—were published." Snow also notes that "[p]aper currency in the South, bearing the signature of the 'Chinese Workers' and Peasants' Soviet Government State Bank,' was excellently printed, on good bank paper."[74]

When the Red Army established itself in Shaanxi, it actually brought on an "industrial boom,"[75] comments Snow. Industrialization in turn promoted a local Gutenberg revolution. Over the entire 6,000-mile course of the Long March, the army had transported lathes, turning machines, stampers, dies, and other equipment. Dozens of Singer sewing machines were brought in from Jiangxi, as well as gold and silver. Also, "they brought lithographing blocks and light printing machines."[76] In 1936–37, just after the CCP arrived in Yan'an, Xu Teli 徐特立 (1877–1968), former teacher of the young Mao Zedong; an educational administrator in Yan'an; and a future deputy director of the Central Committee's Propaganda Department, told Edgar Snow: "Even our [modern] printing machinery has been destroyed,

[72] Band, *Two Years with the Chinese Communists* and Stein, *The Challenge of Red China*. Stein came from Chongqing with a group of Guomindang and foreign journalists.

[73] Zhou Baochang, "Xinhua shudian zai Yan'an chuchuang shiqi," 1.

[74] Snow, *Red Star over China*, 266, 246. Zhao Yuezhi, *Media, Market, and Democracy in China*, states that, by 1933, the Jiangxi Soviet supported thirty-four newspapers and journals.

[75] Snow, *Red Star*, 267.

[76] Ibid., 268.

and now we have to print everything by mimeograph and stone-block lithograph."[77]

Zhou confirms that he and his comrades first acquired crude lithographic equipment, which they used to print books, periodicals, propaganda materials, and even currency.[78] In order to get a lead-type shop going, the CCP sent someone to Shanghai to acquire letterpress equipment. When he returned, the party set up the Central Printing Factory (Zhongyang yinshuachang 中央印刷廠). It started issuing works such as a translation of Lenin's *State and Revolution* and *Selected Works* (*Liening xuanji* 列寧選集). Still, basic work conditions remained very bleak and the print shops remained undersupplied.

As early as January 13, 1937, following the resolution of the Xian Incident, Party Secretary Zhang Wentian 張聞天 (1900–1976) and two others organized the party's Newspaper Committee (Xinwen weiyuanhui 新聞委員會) with the goal of unifying news and propaganda work. New China News Agency (Xinhuashe 新華社) was founded in April[79] and on May 24, 1937, the party's Central Committee initiated their organ, *Liberation Weekly* (*Jiefang zhoukan* 解放週刊). Liberation Agency (Jiefangshe 解放社), an editorial and publishing unit, was started in 1938.[80] The following year, in early February 1939, *New China* newspaper (*Xin Zhonghua bao* 新中華報), the full-sized Central Committee newspaper, began to appear every three days.

Although the newspaper was typeset, overall conditions for printing in the cave dwellings of Yan'an's Mount Qingliang (Qingliang shan 清涼山) were quite poor, says Zhou Baochang. Some type characters had no matrices (needed for duplicating characters) and so they were carved by hand. Book covers, including the first sixteen issues of *Liberation Weekly*, were woodblocked (from number 17 on, Mao Zedong's calligraphy embellished the cover). Naturally, there was no electricity, and so only hand-operated machines could be used. The only paper then available was made from bamboo (*maobian zhi* 毛邊紙),

[77] Ibid., 254.

[78] Zhou Baochang, "Xinhua shudian," 1. Snow, *Red Star*, 246, after praising the paper and print qualities of the Jiangxi soviet currency, notes, "In the Northwest, technical deficiencies resulted in a much cruder issue on poorer paper, and sometimes on cloth…slogans appeared on all money."

[79] Ji, *Zhongguo chuban*, 464.

[80] Ibid., 465; on 466 he says that ninety-eight titles were published by August 1939.

on which industrial paper trimmers were useless, and so the journal always looked ragged.[81]

When *Liberation Weekly* began appearing, Yan'an's first bookstore was already in its planning stages. Known as Brilliance Bookstore (Guanghua shudian 光華書店), it was founded in the early summer of 1937. Located across from the clock tower in Yan'an city's government center, it had a two-pane window storefront, making it larger than the CCP's former Shanghai Bookstore. At the time, says Zhou Baochang, Yan'an residents regarded it as a modern store. In late 1938, when enemy planes attacked Yan'an, Brilliance had to move outside the city to Xishan 西山, where it occupied three caves, one for sales, one for stationery items, and one for a staff dormitory. The shelves were kept stocked by an endless supply of works shipped in by Xian's Life Bookstore (Shenghuo shudian 生活書店). At the time, the Liberation Agency's *Karl Marx* (*Ka'er Makesi* 卡爾·馬克思), a sixty-four-page pamphlet format printed on floppy bamboo paper, was a real best-seller. For many youths, says Zhou, Brilliance was a cultural center, especially on Sundays, when browsers and customers flocked to the store. The initial three male employees were eventually joined by three females, graduates of the Northern Shaanxi Public School (Shaanbei gongxue 陝北公學). "Wearing gray army suits," says Zhou, their job was to greet readers at the door enthusiastically.

In July 1938, book supplies were cut off by a GMD blockade levied in spite of the Second United Front (1937–45). For this reason, Brilliance Bookstore merged with another party-operated shop and moved to a new address outside the south gate of Yan'an city. Over the next year, the party called for a more unified leadership structure in the bookstores. On June 1, 1939, the Central Committee established a distribution center outside Yan'an city's north gate at the original location of the Lu Xun Art Academy (Lu Xun yishu xueyuan 魯迅藝術學院).[82] Brilliance Bookstore's stock was moved into the new compound.

The Central Committee's Publishing and Distribution Department (Zhonggong zhongyang chuban faxing bu 中共中央出版發行部) then set about planning a new, official, but "open" distribution unit to be called New China Bookstore. New China Bookstore was directed by the central organization department's (Zhongyang zuzhibu 中央組織部)

[81] Zhou Baochang, "Xinhua shudian," 1.
[82] Zhou Baochang, "Xinhua shudian," 2.

assistant head Li Fuchun 李富春 (1899/1900–1975). According to Zhou Baochang, everything was decided by the department, which consisted of five people, including Zhou himself. New China formally opened on September 1, 1939.[83] Mao Zedong wrote the first string of "Xinhua shudian 新華書店" characters and sent them over via his secretary.[84] Zhou took them to Chongqing to have a zinc plate made, and then the characters were printed on books.

During the Anti-Japanese War (1937–45), New China Bookstore expanded out of Yan'an into other base areas.[85] Before the war ended, it was flourishing most in three locations: Shaan-Gan-Ning, Jin-Cha-Ji (Shanxi 山西, Chahar 察哈爾, Hebei 河北,), and mid-Jiangsu 江蘇. All three were areas in which the Communist Party had both great authority and actual power from the mid- to late 1930s onward. Outside of these areas, there were only a few other New China branches, although branches increased rapidly everywhere from the mid-1940s.

The day New China Bookstore opened, Song Yulin, then a student at Yan'an's Anti-Japanese Military Politics University (Kangri junzheng daxue 抗日軍政大學), headed for the store (along with streams of others, including CCP head Zhang Wentian),[86] eager to find something to read. He comments that New China's operation was then divided among seven rough adobe buildings. The unpainted buildings were surrounded by an earthen wall. Inside the sales room, rough bookcases held some bamboo-paper books that turned out to be classic works of Marxism-Leninism, Mao Zedong's writings, and party documents "that you couldn't find in big city bookstores.... This was the kind of truth (zhenli 真理) that people had been yearning for,"[87] Song reports piously.

When New China started, it did not specialize the division of labor. The management changed three times within the first year and there were no designated wholesale, distribution, warehouse, or sales departments. Most of the staffers, as in People's Press in Shanghai in the

[83] Zhou's account of New China's lineage is disputed by some who find New China's predecessor not in Brilliance Bookstore but in *Liberation Weekly*. See *Chuban shiliao* 8 (1987), 96–106, for more on this debate.

[84] Zhou Baochang, "Xinhua shudian," 1. The second and more familiar calligraphy used by Xinhua shudian was written in December 1948.

[85] See "Xinhua shudian fazhan jianshi, 1937–1950," in *ZXCS*, 3: 256–265.

[86] Zhou Baochang, "Xinhua shudian," 1.

[87] Song Yulin, "Huiyi Yan'an Xinhua shudian," 5.

early 1920s, were about twenty *sui* 歲-old. Not surprisingly, life with New China was very stressful. It was collectivist in orientation and had a pronounced military flavor. A shop song, with music composed by a comrade from the Lu Xun Art Academy, emphasized that the workers were spreading seeds of knowledge among the people. When work ended each day, the staff studied or exercised together and, before bed, sang an Eighth Route Army marching song.[88]

Although conceived as a distribution outlet for the Liberation Agency and the party's newspapers, New China soon began publishing its own works as well. In fact, it managed to publish seven different periodicals within its first year of operation. *Chinese Women* (*Zhongguo funü* 中國婦女) actually started appearing three months prior to the establishment of New China (but had "Xinhua shudian" printed on its cover from the start). A month after New China opened, the bookstore began to issue *Communists* (*Gongchandang ren* 共產黨人), an intraparty organ. Six months later, *Chinese Culture* (*Zhongguo wenhua* 中國文化) and *Chinese Workers* (*Zhongguo gongren* 中國工人) started up. The Eighth Route Army's General Political Affairs Department published its own *Eighth Route Army Military Politics Magazine* (*Balujun junzheng zazhi* 八路軍軍政雜志) but distributed it through New China. New China also distributed the Youth Committee's *Chinese Youth* and the Shaanxi provincial committee's *The Northwest* (*Xibei* 西北).

In May 1941, the Central Committee's newspaper *Liberation Daily* (*Jiefang ribao* 解放日報), began to appear. It was the first standard-sized, lead-type-printed party newspaper in Shaan-Gan-Ning.[89] *Liberation Daily* was not cheap to buy, suggesting that books were even more expensive. A subscription ran three yuan for a month and thirty yuan for a year at a time when the newspaper's reporters were earning from one to three yuan per month. Even then, the paper alone cost four times the subscription rate, meaning that the newspaper had to be heavily subsidized by the party. Most subscribers were collectives.[90]

Meanwhile, the Liberation Agency was occupied with publishing a large number of classic Marxist-Leninist works, such as the

[88] Zhou Baochang, "Xinhua shudian," 4.
[89] Ibid., 2.
[90] Stranahan, *Molding the Medium, The Chinese Communist Party and the* Liberation Daily, 23.

Communist Manifesto, Selected Works of Lenin, Critique of the Gotha Program (*Geda gangling pipan* 哥達綱領批判), *Left-Wing Infantilism* (*Gongchan zhuyi yundongzhong de "zuopai" youzhibing* 共產主義運動中的"左派" 幼稚病), and Mao Zedong's *On New Democracy* (*Xin minzhu zhuyi lun* 新民主主義論).[91] New China was involved in distributing them all. It also issued some works useful for educating cadres, most edited by (or attributed to) Mao Zedong. As noted above, many books, including *Selected Works of Lenin* and *History of the Communist Party of the Soviet Union (Bolsheviks): Short Course* (*Liangong (bu) dang shi jianming jiaocheng* 聯共 (布) 黨史簡明教程) came from the Soviet Union in the late 1930s.[92] These books were printed on high-quality glazed printing paper (*daolinzhi* 道林紙) and were bound with vermilion-colored hard covers.[93] Since the Yan'an CCP had little choice but to honor Mao's call for members "to produce for themselves" (*ziji dongshou* 自己動手), and given the shortage of paper, New China staffers planted Malan grass near the Yan'an teahouses. This grass, named after the CCP-controlled town where the paper originated, was used to make what was called Malan paper (*malanzhi* 馬欄紙).[94]

Malanzhi was dark in color and of poor quality, and even so it was difficult to produce much, says Zhou. Under kerosene lamps, newspapers and even books were printed on it. Xu Teli told Edgar Snow that a blockade prevented Yan'an from importing enough paper. For that reason, "We have begun to make paper of our own, but the quality is terrible."[95] Eight years later, in the summer of 1944, Gunther Stein encountered what he called "a good-sized paper mill standing over a stream." Giant grindstones were driven, he reports, by large wooden water wheels, "milling grass from the near-by hillsides into pulp."[96] By the time Stein witnessed its work, this rude factory had given birth to more than a dozen other paper mills scattered around Shaan-

[91] Zhou Baochang, "Xinhua shudian," 2, provides a complete list.

[92] For a fascinating discussion of the *Short Course* and its influence on Mao and the CCP generally, see Volland, "Control of the Media," 121, 123–28, which says that Xinhua printed it in two volumes in 1939. Song Yulin, "Huiyi Yan'an," 6, reports the *Short Course* was the Chinese edition.

[93] Song Yulin, "Huiyi Yan'an," 6.

[94] Song, "Huiyi Yan'an," 5, says that Malan was liberated by the Eighth Route Army in 1941.

[95] Snow, *Red Star*, 254.

[96] Stein, *Red China*, 176.

Gan-Ning. The ex-peasants running these mills were part of the effort to supply paper to the Yan'an area's rudimentary but ever-broadening Gutenberg revolution.

Echoing Snow's view that the CCP had begun to industrialize Yan'an's impoverished countryside, Stein estimated that Shaan-Gan-Ning had boasted only 270 industrial workers before 1937, but by 1944 had about twelve thousand.[97] Of eight major groups of industrial workers recorded from 1941 to 1943, printers and paper-makers were the fourth most numerous, at 969 workers.[98] Capitalization of the paper and printing industries, as rudimentary as they were, ranked them third after textiles and chemicals in money value as well as in their millet equivalents.[99] Stein concluded that "considerable numbers of skilled workers from Shanghai and other Japanese-held industrial centers have constantly come over to the Communist forces and are helping them in the development of mobile as well as stationary plants."[100]

Once the Rectification Movement, initiated by Mao Zedong and the Central Committee, reached its "high tide" in the spring of 1942, New China published *Rectification Documents* (*Zhengfeng wenxian* 整風文獻). Reflecting the far closer ties between government media units in Yan'an than in Shanghai two decades earlier, graduates of the Anti-Japanese Military Politics University then in the Eighth Route Army edited the materials; the book cover was designed by a member of the *Liberation Daily News* Agency (*Jiefang ribao* she 解放日報社). Printed with a combination of white newsprint and Malan paper, the first hundred copies were given to the party leadership for study and the rest were sold retail in the New China shop for a fixed but presumably subsidized price.[101] In spite of the spartan living and production conditions in Yan'an, New China managed to distribute 113,000 copies of books (and just under 900,000 pages of newspapers) in its first

[97] Ibid., 177.

[98] Schran, *Guerilla Economy*, 110, Table 5.3. Printing and paper-making were well ahead of mining and machine tools. Supporting my contention that printing and paper making sparked industrialization in Yan'an, Schran, 109, writes, "Second [to textile production] in [overall economic] importance [in Yan'an from 1937–45] appeared paper-manufacturing plus printing...."

[99] Schran, *Guerilla Economy*, 147, Table 6.7.

[100] Stein, *Red China*, 177.

[101] Song Yulin, "Huiyi Yan'an," 7; Song does not disclose the price.

year.[102] These numbers go some distance toward explaining why each Lenin Club (Liening julebu 列寧俱樂部, also Liening tang 列寧堂) that Stein visited in the summer of 1944 had newspapers.

Delivery behind enemy lines often depended on the voluntary efforts of New China workers themselves.[103] The risks were very high. As a result, in December 1940, Mao Zedong directed, in *On Policy* (*Lun zhengce* 論政策), that "every base area must establish printing shops, publish books and newspapers and organize distribution and delivery agencies."[104] Afterwards, base areas reprinted Yan'an publications for themselves. In northern China, each base area established its own branch of New China Bookstore. In central China, Masses Bookstore (Dazhong shudian 大眾書店) was founded. Similarly, lists of publications and paper molds (used either for reprinting whole pages of text or for creating fonts) were sent to Xian, into GMD strongholds such as Chongqing, Guilin, and even into Hong Kong. New China publications were then reprinted in those areas. To counter the GMD's censorship, books had to have their covers changed frequently.[105]

Eventually, the party's propaganda and organization departments transferred Song Yulin, who by this time had graduated from both the Anti-Japanese Military Politics University and the Central Party School (Zhongyang dangxiao 中央黨校), back to Yan'an's southern gate area. Appointed by Li Zhuoran 李卓然, the Shaan-Gan-Ning Border Area's propaganda chief, Song was to set up the area's New China distributorship with two classmates from the university and the party school. With a letter of introduction, the three went to the director of the Border Area Bank (Bianqu yinhang 邊區銀行) and drew out 100,000 Border-area yuan for New China Bookstore expenses.[106] The revitalized New China branch operation opened on May 1, 1942, at the former site, purchased at a discount, of a cooperative society (*hezuo she* 合作社). The retail shop was on the ground floor, with the newspaper

[102] Ji, *Zhongguo chuban*, 467. For fascinating details on the distribution system, see Zhou Baochang, "Xinhua shudian," 3.

[103] Zhou Baochang, "Xinhua shudian," 3.

[104] Mao Zedong, "On Policy," 2: 448. The CCP's first major pictorial magazine—*Jin-Cha-Ji Pictorial*—was issued from July 1942 onwards by the Shanxi-Chahar-Hebei Military District's Political Department's propaganda unit. Produced by former employees of the National Palace Museum's print shop using copper-plate imaging, it featured photographs by the legendary photographer Sha Fei. See Ho, "Art, Documentary, and Propaganda in Wartime China."

[105] Zhou Baochang, "Xinhua shudian," 3.

[106] Song Yulin, "Huiyi Yan'an," 6.

distribution services and office on the second. Song, the manager, was assisted by a bookkeeper, someone responsible for distribution to the twenty-three Yan'an counties, and another in charge of intraparty distribution. Others handled sales, supplies, newspaper distribution, shipping, communications, and kitchen work. Ten more, all soldiers, dealt with distribution of revolutionary materials to the battlefront.[107] The various aides all hailed from different parts of China. No one was paid for their services.

By late 1943, when the Bands arrived in Yan'an, the printing and publishing operations of the CCP were concentrated in "a huge rock cavern overlooking the ruins of [Yan'an] city; its walls were one great mass of tiny carved Buddhas."[108] The cave had once formed the interior of a Ten Thousand Buddhas Temple (Wanfosi 萬佛寺). The Bands met the manager of the printing shop; he had once been an employee of Shanghai's Commercial Press but had escaped execution during the 1927–28 White Terror.[109] Seven months later, in May 1944, Stein arrived in Yan'an to witness many of the same phenomena; he reports that "press headquarters in the cave-punctured hill of Caves of the Ten Thousand Buddhas is one [with the CCP and Eighth Route Army] of [Yan'an's] three political commanding heights."[110]

Qin Bangxian 秦邦憲 (Bo Gu 博古, 1907–1946) was then visibly in charge of the CCP printing and publishing operations located in the cave complex. Still, according to Stein, "decisions on the [*Liberation Daily's*] policy [were] made in regular editorial conferences,"[111] possibly a Panglossian reading of the situation. Finding the editors to be "nondescript people in cotton pants and tunics of various shades and with the usual soldiers' caps," Stein was impressed by their awareness of Chinese and foreign affairs, including foreign languages. Much of their information now arrived via dozens of radio operators working around

[107] Ibid., 7. Song says nothing about the visit by Mao Zedong mentioned in Volland, "Control of the Media," 117, n. 139.

[108] Band, *Two Years*, 255.

[109] Ibid., 256.

[110] Stein, *Red China*, 226.

[111] Ibid. Volland, "Control of the Media," 42, 43, n. 100, citing Kampen, *Mao Zedong*, 104, reports that in March 1943, as part of the Rectification Movement, organizations were reconfigured and the new central Propaganda Committee (Xuanchuan weiyuanhui) was placed under Mao Zedong's leadership, with Bo Gu one of three others. Contrary to Stein, Volland concludes that Mao's subordinate Bo Gu was only "nominally in charge of the Xinhua news agency and *Jiefang ribao*."

the clock;[112] firing up their locally made radios with hand generators, they communicated constantly with New China's eight branches and eleven sub-branches. Along with the *Liberation Daily*, Stein found the CCP publishing another Yan'an daily, the *Masses Newspaper*,[113] which limited itself to two thousand or so Chinese characters to appeal to the newly literate.

The two newspapers and a broad range of books and pamphlets were printed using "an odd assortment of busy machinery—old-fashioned pedal-driven printing presses, some of which were made in [Yan'an] with remodeled Japanese 'dud' bombs as rollers, and all kinds of improvised equipment of which even men who once worked in Shanghai's modern printing plants are extremely proud."[114] Somewhat surprising, even *China's Destiny* (*Zhongguo zhi mingyun* 中國之命運), which the Christian missionary Bands dismiss as "an Oriental...*Mein Kampf*"[115] while denying that it was written by its putative author Chiang Kai-shek (Jiang Jieshi 蔣介石 [1887–1975]), was printed in a large-sized annotated edition using this plant. Taking the book's authorship at face value, Stein claims that foreign correspondents in Chongqing had earlier sought permission to quote from the book in reports home, only to have their reports rejected by GMD censors. "More than a dozen draft translations of a committee of high-ranking government officials were torn up: it was evidently impossible, in spite of further improvements and cuts of the revised Chinese edition, to make *China's Destiny* into a book which would give American or British readers the impression that its author really held democratic views."[116] Perhaps for just that reason, instructors at Yan'an University (Yan'an daxue 延安大學, formed in the early 1940s by merging three separate institutions) considered the book a useful digest of Chiang Kai-shek's views.

[112] Alongside the printed propaganda service of the CCP was, by this time, its radio service. Communist listening stations received international news from Reuters, Tass, and Domei broadcasts; at the same time, the CCP's own broadcasts, under the call letters CSR, and northern China interregional news systems, originated here. According to Band, *Two Years*, 243, in 1943–44, Western agencies concerned with Chinese affairs were able to receive Yan'an broadcasts despite GMD efforts to block them.

[113] Stein does not give the Chinese name of *Masses Newspaper*, but it was likely called *Bianqu qunzhongbao*. I thank Odoric Wou and Eliza Ho for this information.

[114] Stein, *Red China*, 228.

[115] Band, *Two Years*, 228.

[116] Stein, *Red China*, 235.

During Stein's 1944 visit, the print shop also turned out woodcuts, which he says took "modern Chinese art into the peasants' homes."[117] Educational posters and portraits of China's political leaders (including both Chiang Kai-shek and the Yan'an leadership as well as Roosevelt, Churchill, and Stalin) rolled off the presses. Confronted with 90 percent illiteracy in the Shaan-Gan-Ning area when they first arrived, the Communists had experimented with various approaches to overcome the problem. By the time Stein arrived, the CCP had prompted a literacy "craze" throughout its dominion via its "character-learning" (*shizi* 識字) movements. Thus, the Yan'an CCP now also published textbooks designed for educational needs from primary school to university levels and for many different age cohorts. By 1944, says Stein, "school attendance is now much greater than it was during the period of compulsory education [in the late 1930s]."[118]

After the Anti-Japanese War ended in 1945, the centrality of Shaan-Gan-Ning in the advance of print communism faded with the eventual departure of the party leadership. However, by maintaining its high level of commitment to print-media propaganda services, the CCP had clearly brought the internationalist Communist intellectual values of China's southern, eastern, and littoral regions to northwestern China. Although we cannot know precisely how deeply these values penetrated local minds, we can say that, along with the by-now standard texts of international communism, the CCP had also issued many of its own writings on its party presses, distributing the texts, whether in book, pamphlet, or newspaper form, widely. Initially finding it difficult to politicize the local people, the CCP had undertaken literacy campaigns, suggesting that the party had actually created a demand for its own heavily subsidized publications.

On the editorial, publishing, and distribution levels, the CCP created print communism via its own bureaucratic system outside the sphere of print capitalism. At the same time, the CCP brought a phase of industrialization to northwest China that included elements of China's Gutenberg revolution. Simple, ready-made printing equipment, along with imported machinery, laid the foundation not only for the CCP's triumph over the Japanese and the GMD but also for full-scale national print communism after 1949. After Yan'an, the CCP

[117] Ibid., 228.
[118] Ibid., 263.

knew better than anyone that the transformation required control of both the texts and the machinery that manufactured them.

Conclusion

This essay has argued that both ideological and technological concerns motivated the CCP's propaganda efforts from 1921 to 1947. Even before 1921 and the establishment of the CCP, Communist ideas were published in *New Youth* and *The Communist*, the former an "open," commercial printed commodity marketed via the channels of Republican China's print capitalist world until it died in 1928, and the latter an internal, clandestine party organ. Once the CCP was formally established, the editors of those journals (followed by others) built strategies for developing and controlling its printed propaganda. To this end, and following some of the same approaches as Shanghai's print capitalists, the party leadership placed priority on owning and managing the editing, publishing, and printing apparatus that made those media physically possible.

Over the twenty-six year period discussed here, the party's publishing and printing operations evolved from organizing impecunious, market-dependent bookstore operations run by committed activists with attenuated party involvement to operating sizable noncommercial publishing and printing enterprises strictly guided by the party's ideological program. The party and its printing and publishing operatives and cadres advanced China's Gutenberg revolution, taking it from its birthplace at the hands of Shanghai print capitalists to the impoverished back country of Shaanxi. Along the way, the CCP also created the foundation for national print communism after 1949.

In the 1920s, CCP bookstore managers and employees, along with the Department of Propaganda and its editorial workers, opposed, in varying degrees, the prevailing capitalist printing and publishing paradigm without being able fully to extricate themselves from that system. At the earliest organizational moment in the party's history, party leaders made decisions linking propaganda, popular education, and the Chinese revolution. The designation of Marxist intellectual Li Da as head of both the Department of Propaganda and People's Press, as well as the increasingly close relationship between the then-Shanghai-based Central Bureau and Shanghai Bookstore, illustrate that claim. At

the same time, however, the party recognized the need for its members to be involved in managing, editing, and distributing its own publications via "open," market-based bookstore operations that could provide a blind for clandestine activities. The arrival of Zheng Chaolin in 1924 to coordinate the interaction of the Propaganda Department and Shanghai Bookstore, as well as the June decision in the wake of the Fourth Party Congress of January 1925 to purchase and operate the party's own printing facilities, demonstrate strengthened organizational efforts by the Central Bureau to impose tighter party direction on the publicity organs. Establishment of party printing facilities might also reflect increased party resources, possibly coming from the Comintern, but on this the sources are still silent.

Both People's Press and Shanghai Bookstore issued works of Marxist-Leninist theory and trade publications related to popular industrial movements. They also sold a mixed stock of commercial and party works. Although noncommercial in orientation, both firms clearly needed to balance their accounts with mainstream and left-wing "best-sellers" whenever possible. Seeking to preserve an air of consumer legitimacy, the party designated bookstore managers who then hired young employees (both male and female). Like the print capitalists who defined Shanghai-centered printing and publishing, Shanghai Bookstore too opened print shops after it had secured its place in the retail market; again, like the print capitalists, Shanghai Bookstore even opened branch retail stores, both within Shanghai and abroad, to reach a broader clientele.

Unlike most "legitimate" Republican-era bookstores and publishers, however, Shanghai Bookstore quickly found itself confronted by gangsters, warlords, and pro-GMD constables who placed restrictions on the firm's distribution system. Different from the larger print capitalist firms, which sought a national readership, the CCP tended to focus on the south and Jiangnan from 1921 to 1927. The relatively narrow urban activities of these southern printers and publishers, working in an environment defined by print capitalism, contrasted sharply with the political and military hothouse environment of Yan'an and the northwest after 1937, a largely rural environment in which the CCP did not have to compete with other publishers.

From 1937 to 1945, the integration of CCP printing, publishing, and distribution all reached radically new levels while the CCP initiated first an "industrial boom" and then a Gutenberg revolution in northwest

China. In Yan'an, party-defined goals governed New China Bookstore to a far greater degree than they had People's Press or Shanghai Bookstore. Moreover, in Yan'an, the CCP leadership and its printing and publishing cadres were so isolated that they were able to—indeed, had to—create something radically new in Chinese printing and publishing. Their isolation in a poor area that did not enjoy much in the way of publishing before their arrival was crucial: they simply did not have to deal with the competition they had faced in Shanghai and the south. And they benefited from a sizable party constituency eager or compelled to buy, borrow, but above all, read their publications.

Where the chief publishing paradigm of 1920s Shanghai had been print capitalism, Yan'an and New China Bookstore epitomized print communism. Shaan-Gan-Ning and Huabei provided an extended ten-year apprenticeship in which patriotically and ideologically motivated publishing programs and noncommercial organizational distribution systems were tested and expanded under almost impossible conditions. Increasingly skilled and committed party-led personnel, both male and female, implemented them, both in the open and underground. Successful use of handmade paper on hand-operated woodblock and lithographic presses transported from Jiangxi during the Long March, and relief presses acquired from Shanghai or built locally, turned wartime austerity into a revolutionary virtue. New China's publications reached across the urban/rural divide, bringing to the Chinese countryside publications that were not available in wartime coastal cities. In fact, one could argue that a reversal of the normal urban/rural divide took hold, with the northwest countryside now better supplied than the coastal cities. All combined to prove invaluable achievements as the erstwhile oppositionists created a new, print-communist printing and publishing status quo.

October 1, 1949, changed everything for CCP printing and publishing cadres. Long accustomed to laboring in secret with inferior equipment, the most advanced printing and publishing facilities in China were now theirs, positioning them to assert an unprecedented level of hegemony over China's print culture. The northern orientation of the CCP from 1937, complemented by the party-dominated printing and publishing system, after 1949 facilitated the emergence of Beijing as China's national publishing center and positioned the CCP leadership to carry China's Gutenberg revolution to the next level. Modern printing technology, recognized as the sine qua non of modern

publishing, would now shift away from older coastal print capitalist centers in favor of newer inland print communist ones. And as shown here, further advancing China's Gutenberg revolution on a national scale would not require an open, competitive, and anonymous market as long as the party was willing to subsidize it heavily.

PRINT IN THE INTERNET ERA

CONSUMING SECRETS:
CHINA'S NEW PRINT CULTURE
AT THE TURN OF THE TWENTY-FIRST CENTURY

Daria Berg[1]

Introduction

The following study investigates relationships between the growth of consumer culture, the rise of a new kind of urban author, and the appearance of a new type of commercial publisher in the Deng Xiaoping–Jiang Zemin era. The essay uses fictional narratives as source material in order to gain insight into changing perceptions of print culture. Analysis traces the interplay of market forces, political pressures, and artistic expression, both in traditional print and online texts.

This analytical approach emphasizes how literary texts perceive and reflect on their changing world. I argue that the new works of fiction studied here turn secrets—aspects of social events usually considered too private to publicize—inside out and market them for public consumption, both in print and online. These secrets are consumed by the publishing and reading industries in both meanings of the word *consumed*: they become commodities exchanged in a network of negotiations to be consumed by the reading audience and, by this very act, they cease to be secrets, instead revealing fictional images of the private self, fashioned for public consumption.

Both Chinese society and print culture since the Deng era (1978–97) have been influenced by the digital revolution.[2] The Internet connected China to the world in 1994 and has been developing exponentially since the late 1990s.[3] By December 2008, China had become the world's largest Web population, with 298 million users and an Internet penetration rate of 22.6 percent, thus exceeding the world average

[1] I would like to thank Yongnian Zheng, National University of Singapore, for valuable comments.
[2] See Davis, *The Consumer Revolution in Urban China.*
[3] CNNIC, "The Internet Timeline of China 1997–2000."

of 21.9 percent.[4] Despite media commercialization and decentraliza-
tion, the party-state has managed to retain control of the print media
through licensing policies and censorship. The use of nonofficial chan-
nels of publishing and distribution implies a radical decentralization
of publishing in China.

The following study is divided into four main sections. The first sec-
tion discusses the emergence of a new literature at the turn of the mil-
lennium. The second section focuses on three case studies of works by
new authors—Wei Hui 卫慧 (b. 1973), Mian Mian 棉棉 (b. 1970), and
Muzi Mei 木子美 (b. 1978)—to analyze how the print culture of the
1990s has promoted a new style of writing. The third section examines
the structure of the new publishing industry. The final section identi-
fies the new reading audiences of different print media.

The New Literature

The late 1990s witnessed the rise of a new generation of young urban
writers who added their voices to the discourse on consumption. Chi-
nese critics refer to those writers born around or after 1970 as "Genera-
tion X" (literally, "brand-new human race" [*xinxin renlei* 新新人类]).[5]
The members of this generation were small children when Mao died
in 1976, have no memories of the Cultural Revolution, and came of
age when postsocialism, transnational capital, and consumerism trans-
formed the nation.[6] This *brand-new wave* of writers supersedes the *new-
wave* fiction of the 1980s, which included root-seeking "stray youth"
(*shiluodai xiaoshuo* 失落代小说 and avant-garde fiction, as well as the
new urban fiction of the 1980s and early 1990s.[7] Wei Hui, Mian Mian,
and Muzi Mei belong to the generation of brand-new wave writers and
offer a female perspective on post-Deng print culture.

The theme that links these three women writers is their associa-
tion with "body writing" (*shenti xiezuo* 身体写作).[8] Body writing has
been defined as a narrative genre that emphasizes sensuality, sensi-

[4] See CNNIC, "Di 23 ci Zhongguo hulian wangluo fazhan zhuangkuang tongji baogao."

[5] Cf. Jing Wang, "Bourgeois Bohemians in China?."

[6] Cf. Sheldon H. Lu, *Chinese Modernity and Global Biopolitics*, 53–67.

[7] Cf. Henry Y. H. Zhao, *The Lost Boat*, 9–18.

[8] Cf. Liu Dan, "Shenti yu nüxing wenxue," 100–103; Jiang and Wang, "Shenti xie-
zuo yu nüxing wenxue," 31–33.

tivity, and focus on private experience.[9] Fudan University professor Ge Hongbing 葛红兵 coined the term in a critique of Wei Hui and Mian Mian in 1999. Although the majority of body writers are female, the concept does not necessarily carry gender-specific overtones: Ge Hongbing, for example, published a semiautobiographical novel, *Love and Illusion* (*Shachuang* 沙床, literally "Sand bed"), earning fame as China's first "male body writer." The female authors, however, remain critical of the term "body writing" and insist their writings differ from autobiography.[10]

Critics have also labeled the works of these writers "privacy literature" (*yinsi wenxue* 隐私文学), a term coined in 1994 to refer to autobiographical fiction, by Chinese female authors, that focuses "on women's private lives, especially their sexual experiences."[11] Bonnie McDougall traces the origins of privacy literature to *At War with Oneself* (*Yige ren de zhanzheng* 一个人的战争, 1994), by Lin Bai 林白 (b. 1958) and *Private Life* (*Siren shenghuo* 私人生活, 1996), by Chen Ran 陈染 (b. 1962)—novels that opened the debate on sexuality and female homoeroticism in mainland China.[12] Wei Hui and Mian Mian have placed themselves in the category of privacy literature.[13]

By exposing female privacy in the literary discourse, these young writers fashion—and market—images of the female body and self. The tradition of female self-fashioning in literature dates back to imperial China.[14] *Miss Sophie's Diary* (*Shafei nüshi de riji*, 莎菲女士的日记, 1927), by May Fourth writer Ding Ling 丁玲 (1904–1986), gave readers the illusion of accessing a young, intellectual, revolutionary woman's private diary. The women writers of the 1990s also echo the literary construction of the "New Woman" in the 1920s and 1930s.[15]

In contrast to earlier privacy literature, works by the younger authors present themselves more consciously as consumer products. The authors' focus on privacy has become part of a best-selling strategy, in which private lives are exposed for public consumption, and works of fiction are marketed as commodities. The texts propagate

[9] Kun Zhang, "Bodies Melting into Words."

[10] Cf. Kong, *Consuming Literature*, 114ff.

[11] Ibid., 102.

[12] McDougall, "Discourse on Privacy by Women Writers in Late Twentieth-Century China," 97–119, especially 100.

[13] Cf. Kong, *Consuming Literature*, 102.

[14] See Berg, "Female Self-Fashioning in Late Imperial China," 238–289.

[15] Ferry, "Marketing Chinese Women Writers in the 1990s," 664.

the consumerism that surrounds their production.[16] Themes revolve around private life in China's cities, the new urban lifestyle, and the dreams and nightmares that China's economic transformation has produced.

The works of Wei Hui, Mian Mian, and Muzi Mei share similar publishing histories. They became best sellers and, although they incurred official bans, continued to be widely available by shifting between old and new media: Wei Hui and Mian Mian's banned books have survived as digital texts on the Web, while the contents of Muzi Mei's censored Web pages reappeared in print, when she published her blog as a book. Michel Hockx notes that Chinese "Web literature" (*wangluo wenxue* 网络文学) has become a "recognized genre within print culture" and distinguishes itself from conventionally published literature to a limited extent only.[17] Internet literature closely follows the narrative conventions, literary practices, and value judgments of print culture. Similar to print literature, Internet literature is also subject to state censorship.[18] The following sections of this study look at the publishing histories of three banned best sellers as case studies of the new print culture.

Wei Hui and Shanghai Baby

The author Zhou Weihui 周卫慧 uses her first name Wei Hui ("Protector of Wisdom") as a pen name.[19] The daughter of an army officer, Wei Hui was born in Yuyao 余姚, Zhejiang province, in 1973 and grew up in and around Shanghai. In 1995 she graduated from the Department of Chinese Literature at Fudan University and began working as a freelance writer—a new phenomenon in post-Mao China.[20] In 2003 she visited Columbia University to research her novel *Marrying Buddha* (*Wode chan* 我的禅, literally, "My Buddha," 2004).[21] She currently divides her time between Shanghai and New York.

[16] Cf. Davis, "Urban Consumer Culture," 692–709.
[17] Hockx, "Virtual Chinese Literature," 671.
[18] Cf. Barry, *Red—The New Black*.
[19] Cf. Wang Yu, "Wei Hui xiaoshuo xinlun," 83–97; Fu Jian'an, "Wei Hui xiaoshuo de hou xiandai xushi kuanghuan," 53–56.
[20] Cf. Berg, "Publishing Industry," 220–225.
[21] Cf. Zhu Chongke, "Xin dongfang zhuyi," 72–77.

Wei Hui's first major novel, *Shanghai Baby* (*Shanghai baobei* 上海宝贝), was published in China in September 1999 by Cloth Tiger Series (Bu laohu congshu 布老虎丛书) through the Beijing office of Harbin Spring Breeze Art and Literature Publishing House (Chunfeng wenyi chubanshe 春风文艺出版社).[22] The novel sold about half a million copies within six months.[23]

In April 2000 Wei Hui resorted to a provocative strategy to promote her novel, by wearing revealing clothing during a press conference in Chengdu, Sichuan province.[24] Her picture made the headlines of the local tabloid press.[25] The women's magazine *Life on Stage* (*Wutai yu rensheng* 舞台与人生) covered the story in detail.[26] Wei Hui's act sold body writing to the press and public by literally having the image of her body imprinted onto her story. Both in her fiction and book promotion, Wei Hui turns privacy inside out for profit and concludes that she "no longer wishes to conceal anything."[27]

The press conference apparently led the Chinese authorities to ban Wei Hui's novel later that month. The power over licensing policies and censorship of all print media lies with the General Administration of Press and Publication (GAPP, Xinwen chuban zongshu 新闻出版总署), a government body under the control of the State Council but overseen by the Party Central Committee's Propaganda Department. The censors pulped the remaining forty thousand copies of *Shanghai Baby* and ordered the publisher's Beijing office to shut down. Wei Hui's publisher, An Boshun 安波舜, the editor in chief of Spring Breeze Art and Literature Publishing House, explains that the book was banned because of "sex descriptions which had a negative influence on juveniles."[28] Others cite the book's references to Sylvia Plath's poem "Daddy" as the reason for triggering the official ban.[29]

Although the press reported the ban, no original official document has come to light thus far. In recent practice GAPP has been known to

[22] On *Shanghai Baby*, see Knight, *The Heart of Time*, 243–258.

[23] Not enough to reach a large percentage of China's literate population (estimated at 800 million), but still large compared to the print runs (as low as 1,700 copies) of some commercial authors in China.

[24] Cf. Kong, *Consuming Literature*, 110.

[25] Knight, "Shanghai Cosmopolitan," 639–653.

[26] *Wutai yu rensheng* 5 (2000), n.p.

[27] Cf. Kong, *Consuming Literature*, 112.

[28] Zhang Kun, "Bodies Melting into Words."

[29] Jeanne Hong Zhang, *The Invention of a Discourse*, 195.

ban certain publications by issuing no more than a phone call to the publisher, making the origins of, or reasons behind, book bans hard to trace.[30] However, one cannot exclude the possibility that the publisher, or even the author, promoted or provoked the ban, perhaps on a local level, as a publicity stunt. News of the official ban, as reported in the press, added both notoriety and publicity. The novel continued to circulate in Greater China, on the Internet and in translation in Europe and other countries, such as Japan and the United States. It became an international best seller, with rights in eighteen countries, selling two hundred thousand copies in Japan alone within a year. Wei Hui herself boasts about the ban on her Web site.[31] The Web site markets Wei Hui with pictures, interviews, and extracts from her writings, but it also functions as an act of defiance, featuring her writings online, with links to the banned novel and her other works.[32]

An Boshun was forced to resign as editor in chief of Spring Breeze in May 2000, and his publishing enterprise was suspended for eight months, but his Cloth Tiger Series resumed publication in 2001.[33] In 2005 and 2006, copies of Wei Hui's sequel, *Marrying Buddha*, were available in China. Wei Hui claims she had to self-censor her manuscript in order to publish it in the PRC.[34] Self-censorship now appears to be a common publishing strategy in China[35]—among many strategies for self-advertising a new novel—by adding an aura of notoriety and implicit scandal while building on the success of a previously banned best seller. In the absence of what Wei Hui alleges was the original complete and uncensored manuscript, there are few ways to assess the extent of literary self-censorship. Certain outside pressures such as literary convention and market-driven or publisher-driven directives causing self-censorship often play some part in this mode of cultural production.

[30] Private communication, Yongnian Zheng, National University of Singapore, June 12, 2008.

[31] Wei, homepage.

[32] The link to *Shanghai baobei* from Wei Hui's personal Web site does not appear to work as of June 20, 2008, but the novel is available on other sites. See, for example, http://www.tianyabook.com/shanghaibaobei/index.htm; http://www.oklinknet.00/0323/index.htm; http://www.shuku.net:8082/novels/dangdai/shanghaibaobei/shbb.html; http://www.xiaoshuo.com/readindex/index_0018576.html (all accessed September 6, 2009).

[33] Kong, *Consuming Literature*, 55.

[34] Prentice, "Bridget Jones with a Little More between the Ears."

[35] See McDougall, *Fictional Authors, Imaginary Audiences*, 205–220.

The plot of *Shanghai Baby* traces a traditional love triangle involving two men and one woman. The first-person narrator also acts as the main protagonist, CoCo (written in Roman letters). The narrative voice reveals itself as a female novelist who writes semiautobiographical fiction, blurring the boundaries between author and narrator. The narrator reveals herself, for voyeuristic consumption, in intimate detail. This act of consumption is not gratuitous; the narrator, as the implied novelist, says explicitly that her writings are profit driven. CoCo finds herself entangled in romantic liaisons with two lovers: Tian Tian 天天, a young Chinese avant-garde painter; and Mark, a married businessman from Berlin, who lives the expatriate "high life" in Shanghai. Both affairs end in tragedy; Tian Tian's addiction to heroin resolves only with his suicide, while Mark leaves CoCo, in the end, for his own country and family.

The narrative voice brands the discourse in several ways, combining consumerism with art and cliché. The narrator states that CoCo's name refers to the image of the fashion icon Chanel, although the use of two capital Cs marks it as a name with a difference. The name also puns on Coco, the French perfume—one of the exotic Western products that have fueled Chinese consumer dreams for the past two decades.[36] The references to exotic consumer goods are part of the discourse that identifies the text as a product of modernity and globalization. But the references also add a touch of absurdity to the tale; Mark, too, is identified with a luxury product—the perfume CK (Calvin Klein).[37] We witness not only a story of star-crossed lovers, but a comedy of consumption and commercialization.

Wei Hui's contemporary and rival, the best-selling author Mian Mian, also explicitly ponders the issue of branding herself and her writings. In the online piece "My Brand-Name Life" ("Wode mingpai shenghuo" 我的名牌生活) she plays with the idea of brand names as costumes or masks for herself and concludes: "Mian Mian is my brand name."[38] The new authors discussed in this study thus dramatize, in fictional and nonfictional discourse, how their texts participate in the commercialization of cultural production.

[36] On the consumer revolution, see Hooper, "Globalisation and Resistance in Post-Mao China," 440.

[37] See Wei, *Shanghai baobei*, 33.

[38] Mian Mian, "Wo de mingpai shenghuo"; cf. Ferry, "Marketing Chinese Women Writers in the 1990s," 670–671.

The new authors' works also illuminate the dark side of consumer culture, conveying a melancholy ambivalence about the modern age.[39] The portrayals of urban youth culture include drug abuse and teenage suicide; both are new topics in post-Mao Chinese literature and taboos breached by the new women writers. Although Wei Hui's novel includes such themes, they feature even more prominently in the works of Mian Mian.

Mian Mian and Candy

Mian Mian (b. 1970) is the pseudonym of Wang Shen 王莘, who works as a freelance writer in her native Shanghai.[40] She dropped out of school in 1987 and found herself drifting in Shenzhen from 1989 to 1994 before returning to Shanghai. She overcame heroin addiction, through rehabilitation, and started to work as a DJ, music promoter, and dance-party organizer. She is divorced from her British husband, with whom she has a child. Mian Mian began writing as a teenager, but in the late 1980s publishers rejected her stories about teenage suicide, a subject deemed unsuitable for publication in literary magazines. Her short stories were first published in 1997 by the magazine *Fiction World* (*Xiaoshuo jie* 小说界). That same year, her first book, *Lalala* (*Lalala* 啦啦啦), a collection of short stories, appeared in print in Hong Kong. Currently, she also writes columns for the Hong Kong independent newspaper *Apple Daily* and, since 2003, for several mainland Chinese lifestyle magazines.

In January 2000 the PRC publishing house Zhongguo xiju chubanshe 中国戏剧出版社 (Chinese drama publishing house) released Mian Mian's first novel *Candy* (*Tang* 糖), a semiautobiographical work dealing with heroin addiction, teenage suicide, and AIDS. Its plot is based on stories from the collection *Lalala*. *Candy* simultaneously appeared in the prestigious literary magazine *Harvest* (*Shouhuo* 收获) and sold forty thousand copies within the first two months.[41] The novel was banned in April of that year, along with *Shanghai Baby*. Shortly after-

[39] On melancholy ambivalence in Japanese literature and popular culture, see Treat, "Yoshimoto Banana Writes Home," 366, 375.

[40] For her biographical self-representation, see Mian Mian, homepage. On Mian Mian, see Ren, "Haipai nüzuojia de liubian guiji yu neizai chayi," 44–47.

[41] Cf. Mian Mian, *La la la*.

ward, Mian Mian's other works were also banned, but reappeared on the Internet.[42] Her fiction has been translated into Japanese and several European languages.

Mian Mian's novel *Candy* turns, as her preface claims, "garbage into candy."[43] The text recycles consumer waste into food for consumption, turning a story of urban tragedy into best-selling fiction. This sets her apart from Wei Hui, for in Wei Hui's narratives, characters themselves turn into consumer waste. Garbage becomes a metaphor for people; dysfunctional families appear as the symptoms of a malaise brought on by consumer society.[44]

The government removed the ban on Mian Mian's writings in 2002, allowing publication of a book based on her newspaper column. Her latest novel *Panda Sex* (*Xiongmao* 熊猫, literally "Panda") was printed by the small independent Beijing publisher Qun Yan 群言 in 2005.[45] *Panda Sex* reflects on the flawed love lives of Shanghai urbanites, a departure from *Candy* and its depictions of the underground world of drugs, addiction, and suicide.

Mian Mian recognized, early on, how the Internet could empower a writer. Enraged by the editors and publishers who censored her first traditional-print stories, she declared in an interview in 2000, "If they change what I want to say, I'll just put everything on the Net."[46]

The following section looks at an author who reversed Mian Mian's trajectory by starting to publish online and only later selling her writings in traditional book format.

Muzi Mei's Blog

Muzi Mei (b. 1978), born Li Li 李丽, a columnist from Guangzhou, has used the Internet to take the concept of privacy literature further than print literature has done.[47] A whole new discourse on body writing emerged on the Internet when Muzi Mei launched her Web site in the summer of 2003 with her blog (web log, online diary), a narrative

[42] For a Web site providing access to *Candy*, see Mian Mian, *Tang*. For a print version from Taiwan, see Mian Mian, *Tang* (Taipei: Shengzhi, 2000).

[43] Mian Mian, "Preface," xi.

[44] See Wei, *Shanghai baobei*, 15.

[45] Cf. "Mian Mian Reaches Maturity with *Panda Sex*."

[46] Jones, "The Vampire Chronicle."

[47] Yuan Jiansheng, "Xuni shijie zhong de 'tiaozhan,'" 40–43, 87.

posing as autobiography. The pen name Muzi Mei is a pun on the author's real name:[48] the characters for *mu* 木 and *zi* 子 together make up the character of her surname Li 李; *mei* 美 ("beautiful") is a synonym of *li* 丽, the character of her given name. The combination of characters in Muzi sounds foreign in Chinese and evokes an allusion to Japanese names. The postmodern best-selling Japanese novelist Yoshimoto Banana 吉本ばなな (b. 1964), who dramatizes youth culture and consumerism in Japan, also pens an online diary, but it lacks the aura of scandal that surrounds Muzi Mei's. By revealing her secrets online, Muzi Mei titillates her readers with the illusion of consuming the details of her private life almost in real time as she catalogues her erotic exploits in daily installments.

Muzi Mei's collected online writings appeared as a book, *Ashes of Love* (*Yiqingshu* 遗情书), in November 2003. The authorities banned her Web site and book within three days of publication, but she achieved record popularity on alternative Web sites, and pirate copies of the printed book circulated widely. Her publisher, Twenty-First Century Publishing House (Ershiyi shiji chubanshe 二十一世纪出版社) in Nanchang 南昌, Jiangxi province, admitted being aware of the ban but would not say why the book was forbidden.[49] In the wake of the ban, publishers, dot-com companies, and magazines have marketed the Muzi Mei phenomenon to maximum profit.[50]

Muzi Mei has created shock waves throughout the Internet audience by pushing the limits of freedom of expression in contemporary China.[51] Reactions on the Internet have made it clear that readers consider the contents of her online entries to be so private that they question whether such revelations merit publication. In particular, they condemn Muzi Mei's descriptions of erotic encounters in which she names celebrities from the art and music world as her partners. Public opinion, as reflected in chat rooms, appears to condone her revealing the private self, but disapproves of her infringing on the privacy of others.[52]

[48] On the transcription of her name, see Goldkorn, "A Short Interview with Muzi Mei."

[49] "Internet Sexual Diaries Are Banned."

[50] For example, *Marie Claire China* (November 2003) ran an article on Muzi Mei, titled "Sex, the City, and the Private Diary."

[51] Muzi, *Yiqing shu.*

[52] Yardley, "Internet Sex Column Thrills, and Inflames, China."

Internet readers do not seem to take into account that Muzi Mei peddles a literary product that provides merely the illusion of access to the pages of a young woman's intimate diary. Unadulterated by an editor's or a publisher's interventions, the blog *appears* to reproduce the author's raw materials and provide insight into her "real" experiences and "true self." The chain of transmission of the work—from the author as producer to the reader as consumer—may be significantly shorter than in traditional publishing, eliminating the roles of agent, editor, and publisher, but the product remains an artifact, even if it masquerades as a "private diary."

The willingness of the reading public in China to take Muzi Mei's blog at face value perhaps indicates current directions in print culture and in the values promoted by the new consumer culture. Lifestyle magazines and nonfictional works that expose the secret lives of pop stars, actresses, other celebrities, and prominent politicians enjoy popularity among the Chinese readership, generating record sales and vying with fiction for best seller status[53]—a topic that the following section addresses.

Commercial Publishing

China's consumer culture has produced a new phenomenon in the post-Mao era: best seller consciousness (*changxiao yishi* 畅销意识). The narrative voice of *Shanghai Baby* displays this phenomenon throughout its presentation. CoCo reveals herself as dreaming of writing a best seller, and she makes explicit that she does it for profit: "I have again started writing a novel. Hopefully it will become a best seller and make enough money for me to go on a trip to Europe."[54]

This statement shows how the commercial side of book publishing is now exploited in new writings, as authors state directly that they are interested in making money. This attitude clashes with Communist ideals that look to the common welfare and scorn individual profit, as well as with the traditional ideal of the Chinese scholar-gentleman's attitude toward money.[55]

[53] Cf. Schell, *Mandate of Heaven*, 301. For a literary dramatization of this trend, see Zhang Xin, "Ai you ru he?" 4–32.

[54] Wei, *Shanghai baobei*, 93.

[55] Cf. Berg, *Carnival in China*.

Nonetheless, the concept of the best seller has existed in China since at least medieval times: a Tang dynasty saying—"Luoyang zhi gui" 洛阳纸贵—has it that the price of paper rose as scholars were competing to copy a coveted poem.[56] In the late Ming dynasty, stories by famous scholars enjoyed such popularity that, according to Ming observers, they sold like hotcakes in the market.[57] In modern China, best-seller status is determined by numbers of copies sold, advances and royalties earned, and rank lists that are compiled by critics, publishers, and magazines.[58] In 1993, official sources named the *Selected Works of Deng Xiaoping* (*Deng Xiaoping wenxuan* 邓小平文选) as the official best seller[59]—an unsurprising designation since, as Geremie Barmé notes, it was "required reading in nationwide political study sessions."[60] Yet changes in the publishing industry have generated another type of best seller.

In Deng's China, the commercial publishing industry began to expand rapidly, catering to investors' interests and consumers' demands. Before the privatization of China's economy, the China National Publishing Administration (CNPA, Zhongguo guojia chubanju 中国国家出版局) controlled the Publishers Association of China (Zhongguo chuban xiehui 中国出版协会) and the distribution network of New China Publishing House (Xinhua shudian 新华书店), the party's major publication organ and official distribution service. In 1987, CNPA was replaced by GAPP.[61] All manuscripts had to undergo editorial review at official publishing houses before GAPP issues the official book registration numbers (*shuhao* 书号, similar to ISBN numbers) legally required for publication.[62] At the same time, as Nicolai Volland points out, a unique "responsible editor" (*fuze bianji* 负责编辑) system was created, making editors, rather than authors, ultimately responsible for dubious publications.[63]

[56] The best seller was *Rhapsody on the Three Capitals* (*San du fu*, ca. fourth century) by Zuo Si (ca. 253–ca. 307).
[57] *Wanli di chao*, 119.
[58] Cf. Barmé, *In the Red*, 186.
[59] Ibid., 185.
[60] Ibid., 186.
[61] Cf. Berg, "Publishing Industry"; Feldman, "The Organization of Publishing in China," 519–529.
[62] Schell, *Mandate of Heaven,* 301–306.
[63] Volland, "Control of the Media in the People's Republic of China," 234–236.

The privatization of China's economy ended the state monopoly on publishing, which had been held by the Central Committee's propaganda ministry since the Yanan period.[64] As noted in the introduction to this volume, during the late 1980s a nongovernmental publishing industry, or "second channel," emerged as an alternative to the "red channel," the state-run Xinhua publishing network.[65] This intermediate zone of semiofficial publishing also produced and promoted the works by the new authors under discussion here.

Second-channel publishing consists of the "white channel" (previously licensed, limited, local distribution networks that moved into unlicensed publishing but avoided controversial contents) and the "black channel" (illegal, profit-driven, underground operations without any license and willing to publish sensitive, censored, or restricted works). The second channel was established by wealthy private entrepreneurs known as "book kings" (shuwang 书王).[66] They run their operations through nationwide personal networks. Second-channel operations are officially prohibited; therefore, estimates about outputs vary widely. The annual number of book titles officially published in China has risen as follows: fifteen thousand in 1978; forty-five thousand six hundred in 1985; approximately eighty thousand in the early 1990s; one hundred twenty thousand in the late 1990s; and 222,473 in 2005.[67] According to estimates in the early 1990s, up to half of publications were printed using purchased book numbers, or in collaboration with second-channel book traders (shushang 书商).[68] In the early 2000s, estimates attributed around 25 percent of all titles (but most literary works and 80 percent of all best sellers) to second-channel publications.[69] In 2007, estimates of the number of second-channel publishers ranged from five thousand to thirty thousand.[70]

The second-channel book traders, in turn, began to exercise the imagination of the new urban writers. The story "What's Love?" ("Ai you ru he?" 爱又如何, 1994) by Zhang Xin 张欣 (b. 1954), for example,

[64] Schell, *Mandate of Heaven,* 296ff.

[65] Cf. Schell, *Mandate of Heaven,* 293–310; Kong, *Consuming Literature,* 65–94.

[66] Cf. Schell, *Mandate of Heaven,* 297–305.

[67] Cf. Feldman, "The Organization of Publishing in China," 521; Barry, *Red—The New Black,* 29.

[68] Schell, *Mandate of Heaven,* 297.

[69] Kong, *Consuming Literature,* 75; Barry, *Red—The New Black,* 87.

[70] Barry, *Red—The New Black,* 87; Soong, "The 'Malignant Tumor' in Chinese Book Publishing."

dramatizes the ways in which a book trader and literary agent help to create a best-selling novelist's career.[71] The book trader in Zhang Xin's story is a nanny, from the countryside, who lacks formal education but makes a fortune in publishing because she instinctively understands the market. Her characterization dramatizes the legendary semiliterate entrepreneurs of the 1980s who became China's first millionaire book kings.[72]

The development of the new publishers has aided the commercialization of literature. These publishers now work with, or even direct, authors to promote their texts. Shuyu Kong has shown how entrepreneurs have turned publishing houses into best seller machines; second channel publishing satisfies the demand for entertainment while maximizing profits.[73]

The commercialization of publishing features prominently in *Shanghai Baby*. In her quest to produce a best seller, CoCo turns to her editor, who becomes her literary agent.[74] In contrast to Zhang Xin's "nanny turned book agent," Wei Hui depicts CoCo's fictional agent as an elite university graduate and a sophisticated Shanghai professional. *Shanghai Baby* dramatizes the new generation of book traders who act as publishers, agents, and even editors, and have dominated commercial publishing since the 1990s. These new publishers are familiar with literary issues, as well as with the vagaries of the marketplace.[75]

The Writer's Income

Did *Shanghai Baby* make enough money for its author to travel to Europe? The three authors under discussion have not disclosed their earnings but, even if they did, it would be hard to verify any claims. The author's income remains confidential to each author, publisher, and the tax authorities. Occasionally a publisher may, as part of a marketing strategy, publicize an author's income figures, such as the one million yuan advance for *Abandoned Capital* (*Feidu* 废都), a 1993 novel by Jia Pingwa 贾平凹 (b. 1952). According to their publisher,

[71] Cf. Berg, *Portraying China's New Women Entrepreneurs*.
[72] Cf. Schell, *Mandate of Heaven*, 300.
[73] Kong, *Consuming Literature*, 37–94.
[74] Wei, *Shanghai baobei*, 76.
[75] Kong, *Consuming Literature*, 77.

twenty-first century best-selling authors Han Han 韩寒 (b. 1982), Anni Baobei 安妮宝贝 (b. 1975), and Guo Jingming 郭敬明 (b. 1983) earn three to four million yuan in advances and royalties, per book.[76] There are no official sales figures for *Shanghai Baby* in China, because the book is banned. Wei Hui's translator, Bruce Humes, notes: "How well the book sold in China is unknown."[77] If forty thousand copies of the book were burned, and the publisher was fined, the loss to the publisher must have had a negative influence on the author's share. A twenty-first century Chinese author might receive royalties of 8 to 10 percent, but lose out on pirate editions.[78]

Nonetheless, sales income must be significant from foreign translations and best sellers in countries outside China, such as Japan, Europe and the US. Only the writers' tax statements would disclose the evidence, but these are usually not published. The 2007 English-language film version of *Shanghai Baby* (cowritten by Wei Hui, Martin Hennig, and Margot Hennig; directed by Berengar Pfahl) must have added another source of income for Wei Hui. Mian Mian, as noted above, does other work. Muzi Mei traded on her Web notoriety in order to find employment promoting blogging at sina.com. The income from publishing appears sufficient for Wei Hui to continue her full-time writing career, finance an apartment in Manhattan, and support her lifestyle shuttling between Shanghai and New York.

The New Reading Audience

Gender expectations influence both the production and consumption of the new body writing literature. It is possible that the new authors are writing for a predominantly female readership that is looking for entertainment and pleasure. The declared target audience of the novelist narrator in *Shanghai Baby* is the new type of "smart urban girl"— "My dream is that of every trendy bright young woman with wild ambitions; I am writing my new novel for this kind of woman."[79] In this respect, the new authors continue the direction set by the new

[76] Martinsen, "Lu Jinbo."
[77] Fang Fang, interview with Bruce Humes.
[78] Soong, "The Underground Publishing Industry in China."
[79] Wei, *Shanghai baobei*, 79.

urban-fiction writers of the 1980s and early 1990s, who directed their work explicitly to women readers.[80]

But some evidence suggests that women may not necessarily be the primary readers of these texts, particularly as they appear on the Internet. Comments posted in the relevant chat rooms appear to stem from netizens of each gender. Men are generally more likely to surf the Internet and read online texts than are women. In 2003, the year Muzi Mei first published her blog, 60.4 percent of netizens were male, compared to 39.6 percent female netizens (in 2008 the ratio was 52.5 to 47.5 percent).[81] And male users spend more time online.[82] Gender issues aside, Internet users in China tend to be more affluent, better educated, and younger than nonusers.[83] Nearly three quarters of all netizens are teenagers or are in their twenties; more than half of the members of the World Wide Web population have a postsecondary diploma.[84] Students and staff of enterprises make up about two thirds of all Internet users.[85] Another factor that determines differences in readership—between print and online literature—may be the digital divide in China, a gap that runs along socioeconomic, regional, and gender lines and that points to inequalities between those who have access to the Internet and those who do not.[86]

Until further research is conducted, we can only speculate about the real readers of this new literature. Readers are most likely relatively young educated urban men and women whose enjoyment of such narratives derives from recognition of shared dreams and nightmares. As one fictional publisher remarks to CoCo, "Your writings should target the market of students in higher education and white-collar workers. Women readers in particular might prove rather susceptible to your

[80] Zhang Xin, "Wo shi shui?" 78; cf. Cheng Wenchao, "Yuhaili de shiqing shou-wang," 71–75.

[81] CNNIC, "Di 13 ci Zhongguo hulian wangluo fazhan zhuangkuang tongji baogao"; CNNIC, "Di 23 ci Zhongguo hulian wangluo fazhan zhuangkuang tongji baogao."

[82] CNNIC, "Di 19 ci Zhongguo hulian wangluo fazhan zhuangkuang tongji baogao."

[83] CNNIC, "Di 13 ci...baogao"; CNNIC, "Di 19 ci...baogao"; CNNIC, "Di 23 ci...baogao." On Muzi Mei's readership, see Yardley, "Internet Sex Column Thrills, and Inflames, China."

[84] CNNIC, "Di 19 ci...baogao."

[85] Ibid.

[86] Cf. Zheng and Wu, "Information Technologies, Public Sphere, and Collective Action in China," 507–536.

work."[87] In the absence of hard evidence (and on the basis of existing statistics), this quote might prove to be an accurate summary of the readership for the new literature, especially in traditional print versions, while the online versions may attract a higher percentage of male readers.

Conclusion

To sum up, this study has traced the publishing histories of three female urban authors—Wei Hui, Mian Mian, and Muzi Mei—whose works have bridged print media (in books and magazines) and the Internet at the turn of the twenty-first century. Individual participants in the body-writing genre, Wei Hui and Mian Mian, first published their novels as print books, which, after their official ban in China, acquired a presence as World Wide Web literature. Muzi Mei started her career as an Internet author but gained enough publicity to make a debut in print. Despite the government's stringent measures of Internet control, official bans have not succeeded in eliminating the targeted works. The new texts circumvent such bans by migrating between the media. New trends in publishing works via nonofficial channels testify to a radical decentralization of publishing in recent years, a reversal of the centralizing forces in twentieth-century Chinese print culture discussed in this volume's introduction.

What is perhaps most striking about body-writing literature is its frank reference and appeal to the new commercial economy and consumer culture of the past two decades. The new writers' declared acceptance of profit-driven cultural production goes against the very grain of both traditional Chinese Confucian thought and the Communist ideal of common benefit for the masses, rather than the individual. The body-writing works celebrate the border crossings between the sublime and the banal, popular culture, commercialism, and the avant-garde. In doing so, they create an innovative postmodern discourse.

What other impact has this new literature had? The new print media involve readers more directly, making entrance into debates with the literary works and other readers easier and faster. Works such as *Shanghai Baby*, *Candy*, *Panda Sex*, and *Ashes of Love* are not overtly

[87] Wei, *Shanghai baobei*, 205.

political, but they discuss, explicitly, the issues of state control and censorship, while pushing the boundaries of what is acceptable speech in public. They debate the issue of freedom of expression with reference to sexuality, not politics. Orville Schell has noted that Muzi Mei's literary "trading in sex" appears as "the ultimate form of self-expression" and is "deeply subversive to everything the [Chinese Communist] Party (not to mention the almost forgotten 'revolution') stands for. She is, in fact, 'digging up dirt right under the Buddha's nose,' to use an old Chinese *chengyu* [saying]."[88]

Following Schell's observations, future studies will have to explore the potential for dissident expression through displacement in body-writing literature.[89] The new writings have inspired intense debate among critics, scholars, publishers, and readers, and have created a niche market for literary discourse on the body and the books that consume its secrets on the printed page and online.

[88] Cf. Schell, comment on "*New York Times* article on Muzi Mei."
[89] Ibid.

CHINESE INTERNET LITERATURE AND THE CHANGING FIELD OF PRINT CULTURE

Guobin Yang

This essay explores the impact of the Internet on China's print culture through an analysis of Chinese Internet literature (*wangluo wenxue* 网络文学), defined as all Web-based writings that are viewed as literature by their authors or readers, regardless of genre. Chinese Internet literature thus includes works that are clearly "literary" and others that are not. A blog entry may or may not be literature, depending on how it is viewed by its author and readers. What counts as Internet literature is thus a matter of social construction. The "Chinese-ness" of this literature refers primarily, but not exclusively, to mainland China.

Internet literature in mainland China appeared in the late 1990s. The launching of the literary Web site Under the Banyan Tree (Rongshu xia 榕树下) in 1997 may be seen as its symbolic beginning. Since then, Chinese Internet literature has evolved into a complex of Internet businesses and online writing, publishing, reading, and gaming communities, thus significantly transforming the field of print culture. This essay focuses on the early history of Chinese Internet literature, from 1997 to roughly 2003,[1] a period that most starkly reveals the tensions between this new and emerging cultural field and the field of print culture. I argue that Chinese Internet literature developed in complex interaction with the existing literary field. In this process, aspiring writers with neither cultural nor economic capital turned to the new-found spaces of the Internet for self-publishing and community building, and made noninstrumental claims about literature in an attempt to achieve recognition. Literary Web sites, for their part, adopted

[1] The year 2003 was a turning point in the history of the Internet in China. Several major Internet incidents (*wangluo shijian*) significantly expanded the influence of online public opinion. Blogs became popular in that year as a result of the national influence of Muzi Mei's sex blogs. It this essay, I also allude to developments that have taken place through 2008. For a study of the Muzi case, see Farrer, "China's Women Sex Bloggers and Dialogic Sexual Politics on the Chinese Internet," 9–46. For a discussion of the periodization in the history of the Chinese Internet, see Guobin Yang, "Historical Imagination in the Study of Chinese Digital Civil Society," 17–33.

commercial strategies for self-promotion. Consequently, Internet literature not only successfully challenged the cultural hegemony of print literature but also expanded the field of literary production and consumption. More importantly, the commercialization of Internet literature and the appearance of business enterprises specializing in the form initiated a reorganization of the field of literary publishing. Much as new printing technologies transformed Chinese book printing and its social organization in late Qing and Republican China,[2] the Internet is playing a pivotal role in the transformation of print culture at the beginning of the twenty-first century.

The Development of Internet Literature in China

Chinese Internet literature is international in origin. Before China was linked to the Internet in 1994, Chinese-language works had appeared in the online newsletters, newsgroups, and magazines run and distributed by Chinese students and scholars overseas. First set up in the late 1980s and early 1990s, these were the earliest Chinese-language publications and forums on the Internet.[3] The forms and content of these publications reflected the influences of print literature as well as the new Internet technologies. The World Wide Web had not yet been invented,[4] and newsgroups were the main channel of online distribution. Another way of accessing online publications was via FTP (file transfer protocol), which required more computer know-how than the Web. Thus, the early Internet technologies limited the formats of publications. The size of the files had to be small, no graphics were possible, and artistic designs were held to a minimum. Most files were plaintext documents. In fact, *China News Digest—Chinese Magazine* (*Hua Xia Wen Zhai* 华夏文摘), one of the first Chinese-language magazines on the Internet, has continued to use the plain-text format to the present day. Table 1 lists the earliest Chinese-language Internet magazines and newsletters, set up Chinese students studying overseas.

[2] See Reed, *Gutenberg in Shanghai*. See also Ling Shiao's essay in this volume.
[3] Kozer, "Leaves Gleaned from the Ten-Thousand-Dimensional Web in Heaven," 129–153. See also Guobin Yang, "The Internet and the Rise of a Transnational Chinese Cultural Sphere," 469–490.
[4] According to the popular Hobbes' Internet Timeline, the World Wide Web was established in 1991; see http://www.zakon.org/robert/internet/timeline/.

Table 1. Selected Online Chinese-Language Magazines Established by Overseas Chinese Students, April 1991–December 1994

Magazine Name	Inaugural Issue	URL	Location
Hua Xia Wen Zhai 华夏文摘	April 5, 1991	http://www.cnd.org/HXWZ/	Canada–United States
Lian Yi Tong Xun 联谊通讯	January 30, 1992	http://uwalpha.uwinnipeg.ca:8001/lytxindex.html*	Canada
Wei Da Tong Xun 威大通讯	July 1993	http://www.cs.wisc.edu/~jiebing/wdtx/wdtx.html	United States
Feng Hua Yuan 枫华园	September 20, 1993	http://www.fhy.net/	Canada
Northern Lights 北极光	October 1993	http://www.acc.umu.se/~ncs/bjg/	Sweden
Little Mermaid 美人鱼	January 1, 1994	http://www.image.dk/~meirenyu	Denmark
Wei Ming 未名	January 1994	http://www.louisville.edu/~c0wang01/weiming/	United States
Buffalonians 布法罗人	February 10, 1994	http://www.acsu.buffalo.edu/~lhuang/buffalonians.html	United States
Red River Valley 红河谷	February 1994	ftp://ftp.cc.umanitoba.ca/cssa/	Canada
Dong Bei Feng 东北风	December 27, 1994	http://www.come.or.jp/	Japan

Source: http://www.xys.org/magazines.html (accessed April 1, 2002)
* Indicates the URL was no longer functioning as of April 1, 2002

Out of this first contingent of online publications there appeared in the United States, in 1994, a comprehensive Internet magazine called *New Threads* (*Xin yu si* 新语丝), which published literary works as well as news and other nonliterary writings. Two magazines of Chinese Internet literature, *Olive Tree* (*Ganlan shu* 橄榄树) and *Cute Tricks* (*Huazhao* 花招), were founded in 1995, also in the United States. Cute Tricks was devoted mainly to women's literature.

The contents of these online magazines ranged from news from the homeland to essays, poems, and stories about overseas life and memories of home. They reflected the authors' experiences as new immigrants and their yearnings for social connection. Yet the genres and writing styles differed little from those in Chinese print magazines. The principal genres were the personal essay, poetry, and the short story. The editors, authors, and readers of the earliest online Chinese magazines and personal Web sites had grown up in the culture of print magazines and newspapers in the 1980s. Thus, the magazines they produced online reflected the imprint of their socialization in print culture. In a sense, sociological generations are closely linked to generations of technologies such as television and computers—hence

terms such as the "TV Generation" and the "Net Generation." The first generation of Internet writers and editors among Chinese students overseas was undoubtedly more deeply influenced by print culture than by the Internet. The Web-based literature of this generation thus reflects the unique combination of print culture and elements of a new Internet culture still in the making.

In any event, by the time China was connected to the Internet in 1994 via the American National Science Foundation Network,[5] the earliest works of Chinese-language Internet literature had already appeared overseas. Like the overseas students who had pioneered online writing and publishing, Internet users in China embraced the new medium. Starting in 1998, with the rapid diffusion of the Internet in China,[6] personal Web sites and bulletin boards blossomed. Many of these sites published literary works. Under the Banyan Tree, launched in 1997 and incorporated in 1999, was the first major Web site devoted fully to Internet literature.[7] Its name reflects the influence of the U.S.-based Chinese-language Internet magazine *Olive Tree*.[8] Other influential literary Web sites that appeared at that time include Qingyun Academy (Qingyun shuyuan 清韵书院), founded in 1998, Fragrant Red Sleeves (Hongxiu tianxiang 红袖添香), founded in 1999, and Poem Life (Shi shenghuo 诗生活), founded in 2000. By June 2001 there were reportedly more than thirty-seven hundred Chinese-language Web sites devoted to literature worldwide. Of these, over twenty-five hundred,

[5] This step marked China's "official" connection to the Internet. Limited e-mail connections had been available since 1987. For a timeline of the development of the Internet in China, see the Web site of the China Internet Network Information Center (CNNIC), at http://www.cnnic.net.cn.

[6] The number of Internet users in China exceeded two million by December 1998. See CNNIC's third statistical survey report on Internet development in China, January 1999.

[7] For a case study of Under the Banyan Tree, see Hockx, "Links with the Past," 105–127.

[8] Overseas online magazines influenced Internet literature in mainland China in other ways as well; for example, by publishing works by mainland authors or providing sources of inspiration. Dissatisfied with the scarcity of information in Chinese cyberspace and curious about the outside world, early Internet users in China often visited Chinese-language Web sites overseas. The founder of Golden Book Cottage (Huangjin shuwu) recalled that he launched the site in 1998 after visiting New Threads and realizing that he could build a similar literary Web site in China. See Wu Guo, "Wangshang you jian 'Huangjin shuwu.'"

Table 2. Selected Chinese Literary Web Sites, 1994–2000

Web Site	Year Launched	URL	Location
New Threads (Xin yu si 新语丝)	1994	http://www.xys.org	United States
Cute Tricks (Huazhao 花招)	1995	http://www.huazhao.com	United States
Olive Tree (Ganlan shu 橄榄树)	1995	http://www.wenxue.com	United States
Under the Banyan Tree (Rongshu xia 榕树下)	1997	http://www.rongshu.com	China
Qingyun Academy (Qingyun shuyuan 清韵书院)	1998	http://www.qingyun.com	China
Golden Book Cottage (Huangjin shu wu 黄金书屋)	1998	http://www.goldnets.com	China
Fragrant Red Sleeves (Hongxiu tianxiang 红袖添香)	1999	http://www.hongxiu.com	China
White Deer Academy (Bailu shuyuan 白鹿书院)	Unknown	http://www.oklink.net	China
Poem Life (Shi shenghuo 诗生活)	2000	http://www.poemlife.com	China

or close to 70 percent, were in mainland China.[9] Table 2 lists the leading literary Web sites from 1994 to 2000.

With the proliferation of these sites, works of Internet literature flourished, new literary reputations were made, and a "canon" of Internet literature appeared. The best-known authors in the early history of the field were born in or after the 1970s. They include, among others, Pizi Cai 痞子蔡, Xing Yusen 邢育森, Ning Caishen 宁财神, Li Xunhuan 李寻欢, Hei Keke 黑可可, SIEG, Anni Baobei 安妮宝贝, and Murong Xuecun 慕容雪村.

In the early twenty-first century, Chinese Internet literature is a far cry from its humble origins in online magazines run by overseas students in the early 1990s. The influence of this literature is best reflected in the commercial success of Internet writers, literary Web sites, and online communities. Since the early 2000s, Web-based writers and their works have made their way into the field of print culture, gaining fame and fortune. Print publishers increasingly turn to Internet literature in search of new works. Famed authors in the print cultural field have embraced the market of Internet literature. In May 2009, for example, Shengda Literature Co., Ltd. (Shengda wenxue youxian gongsi 盛大文学有限公司), arguably the largest publisher of Internet literature in China, announced that Wang Meng 王蒙 (b. 1934),

[9] Ouyang, "Hulian wangshang de wenxue fengjing," 5.

Table 3. Major Chinese Literary Web Sites as of Year-End 2008

Web Site	Year Founded	Registered Users	Works Collected	Authors	Daily Page Views
qidian.com 起点中文网	2002	27 million	230,000	5,500 (contracted)	300 million
jjwxc.net 晋江原创网	2003	4.2 million	500,000	3,500 (contracted)	51 million
hongxiu.com 红袖添香	1999	Unknown	3 million (including short pieces)	1.5 million (registered)	30 million
xxsy.net 潇湘书院	2001	2 million	100,000	6,000 (contracted)	20 million
zhulang.com 逐浪网	2003	5 million	130,000 (novels)	60,000	10 million

Source: Jiang Xiaohu, "Shinian yijian," B11

China's preeminent novelist, had been contracted to serve as its literary adviser.[10] In the rapidly expanding Internet culture and economy, literary Web sites and online communities now rank among the most popular and influential sites. Table 3 shows the most influential of these sites as of year-end 2008.

What about the political control of the Internet? How has it influenced the development of Internet literature? As Gudrun Wacker shows in her contribution to this volume, in the past ten years an Internet regulatory regime has taken shape in China, with sophisticated methods of censorship and surveillance. Although most control efforts have targeted political discourse in BBS (bulletin board system) forums, literary Web sites are not immune. On August 29, 2005, I surveyed the six China-based literary sites listed in Table 2 and found that all posted their permit numbers on the opening page, as required by a regulation of the Ministry of Information Industry published in December 2001.[11] All but one of the six sites had active BBS forums and published government regulations about what information was *not* permitted in such forums. On July 9, 2009, in a quick survey of the Web sites listed in Table 3, I found that they all displayed not

[10] Han Haoyue, "Wang Meng to Be Shengda's Literary Adviser." This situation contrasts with an incident ten years ago, when Wang Meng withdrew from China's first Internet Literature Award committee in response to users' questioning the qualifications of print authors as judges of Internet literature. On that incident, see Guobin Yang, "The Internet as Cultural Form," 112.

[11] Ministry of Information Industry, "Dianxin yewu jingying xuke zheng guanli banfa."

only their permit numbers but also the "Internet Police 110" logo. A click on the logo opens a cyberpolice Web site, where users can file a report if they find illicit information on the site. Although guest visitors are free to browse these forums, posting a message requires an online registration procedure. These practices are clearly in response to government efforts to curb the publication and circulation of politically subversive material. Yet my own experience in visiting and studying these Web sites indicates that, overall, political censorship is not as much of a concern on literary sites as in BBS forums of more general interest. The literary character of these sites provides a protective shield. However, they do face a different set of challenges.

Internet Literature: A Product of Changing Times

Interrelated transformations in technology, the economy, and Chinese culture and society have all had a bearing on the development of Internet literature. Evidently, the diffusion of the Internet is essential, yet it is not the Internet per se but rather the development of a Chinese Internet culture that was more directly responsible for the rise of Internet literature in China. In the late 1990s, personal Web sites and bulletin board systems were the main channels of publishing in Chinese cyberspace. Many of these sites published literary works. As Internet portals and online communities came to prevail, they often incorporated literary communities. The major Web portals Sohu.com and Sina.com, for example, both maintain large literary communities. Tianya.cn, arguably the largest online community in China, with millions of registered users, has a famous literary community whose influential works were first published in the form of BBS postings.[12] Online communities are essential to Internet publishing because of their powers of circulation and dissemination.

Besides technological developments, the commercialization of Chinese media and the cultural industry have shaped Internet literature, which appeared at a time when print literature was in crisis and the

[12] The most notable example is the posting of the novel *Chengdu, Please Leave Me Alone Tonight* (*Chengdu, jinye qing jiang wo yiwang*), written by Murong Xuecong in 2002. The book was published in print form in early 2003 and made the short list for the Man Asian Literary Prize (awarded for Asian novels not published in English) in 2008.

field of cultural production was in flux. In the pre-reform decades, the state monopolized cultural production. With reform, cultural production became increasingly market oriented. Glossy lifestyle magazines blossomed in the 1990s, targeting young professional women working in private businesses.[13] Newspapers were also commercialized.[14] Sensationalist tabloids filled the newsstands in city streets,[15] and publishers competed for profits. No wonder that in the 1990s, the once flourishing field of literary print publishing was caught "between a rock and a hard place," according to Shuyu Kong. Focusing on literary journals, Kong argued in 2002 that "this once popular and prestigious industry has declined to such an extent that it has now reached a crisis point, and many journals cannot ignore the possibility that every issue could be their last."[16] The crisis of literary journals and print literature in the 1990s was an opportunity for both readers and aspiring authors, who found new possibilities (and markets) for expression and communication on the Internet. As I will show below, commercialization would soon turn the more successful literary Web sites into business enterprises.

Finally, social and cultural changes within China directly affected Internet literature. The rise of a middle class, along with the urban consumer revolution, provided the social basis for both producers and consumers of Internet literature.[17] New, young professionals with purchasing power and leisure time created demand for cultural products that offered entertainment rather than social or moral instruction. By 2003, entertainment had become the leading trend in online literary publishing. As one commentator put it then, "The vast majority of works of Internet literature belong to [the] literature of leisure" (*xiuxian wenxue* 休闲文学).[18] There also seems to be an elective affinity between Internet literature and middle-class consumers. Despite its rapid diffusion in China, the Internet has so far mainly reached the

[13] Andrews and Shen, "The New Chinese Woman and Lifestyle Magazines in the Late 1990s," 137–162.

[14] See Yuezhi Zhao, *Media, Market, and Democracy in China*.

[15] Yuezhi Zhao, "The Rich, the Laid-Off, and the Criminal in Tabloid Tales," 111–135. See also Zha, *China Pop*.

[16] Kong, "Between a Rock and a Hard Place," 94.

[17] On the class basis of reading habits in contemporary China, see Davis, Wang, and Bian, "The Uneven Distribution of Cultural Capital," 315–345.

[18] Jiang Xiaohu, "Shinian yijian," B11.

urban middle class, who have the time, money, taste, and technological know-how to be the natural consumers of online literature.

In considering the effect of sociocultural change on Internet literature, it is important to highlight the demographics of China's Internet users. As of December 2008, the number of people using the Internet in China had reached 298 million, or about 23 percent of the entire population. Thirty-five percent of those users were between ten and nineteen years old, and 32 percent were in the range of twenty to twenty-nine years old. Thus, over 60 percent of China's Internet population is under the age of thirty.[19] This is China's "Net Generation," a generation that was born after the beginning of economic reform and that came of age with the growth of the Internet. As I suggested earlier, sociological generations are also technological generations. Each generation has its own technologies of expression and communication. Thus, the life concerns and expressive styles of China's Net Generation will leave indelible impressions on Internet literature, just as Internet literature shapes the styles of this generation.

Internet Writers and Symbolic Struggles for Recognition

In addition to reflecting the structural changes in Chinese society, the ongoing development of Chinese Internet literature depends on the agency of Internet writers and Web sites. As new entrants in China's literary field, Web-based writers strive for recognition. They are engaged in a symbolic struggle in the Bourdieusian sense.[20] In the earlier period of Internet literature, this symbolic struggle focused on making claims about their writings, building reputations, and negotiating identities vis-à-vis print writers. Internet writers gain popularity and fame by attracting large numbers of "hits" (*dianji* 点击)—a mark of popularity and the online counterpart to the numbers of print copies sold. One volume of Internet essays published in print form even lists the number of hits each essay received to show its popularity. One essay lists 1,455 hits; another, 2,467; and so forth.[21] In 2002 a member

[19] See CNNIC's twenty-third statistical report on the development of the Internet in China, January 2009.
[20] Bourdieu, *The Rules of Art*, 47–112.
[21] Under the Banyan Tree, *Ai shi jueban.*

of the Lao She Literary Award committee noted that an important reason why *City with a Masked Face* (*Mengmian zhi cheng* 蒙面之城) by Ning Ken 宁肯 (b. 1959) won the award was that the novel attracted a huge number of hits—five hundred thousand in the month after it was first published at Sina.com. The award committee clearly took into account the book's online popularity.[22]

Early Internet authors stressed the noninstrumental aspects of literature published online, sometimes expressing an idealistic sense that Internet literature was a sign of the democratization of literary publishing. Li Xunhuan 李寻欢 (b. 1975), an early Internet writer who later became a successful publisher, once defined Internet literature as "literature published on the Internet, by Internet users, and for Internet users."[23] Here, his emphasis was on Internet users as authors and readers. He argued that the spirit of Internet literature was anti-elitist. "The real significance of Internet literature is that it gives literature back to the people," he wrote, claiming that print writers had distanced themselves more and more from the "ordinary people."[24]

Wu Guo 吴过, another well-known Internet writer, highlights the importance of the Internet as a new medium that enables writers to bypass the powerful "editorial committee" of print literature:

> In traditional media, it is common to see notices from editorial committees such as: "Due to limited human and financial resources, our journal does not return [rejected] manuscripts of less than 30,000 words. Please send postage for returning rejected manuscripts longer than 30,000 words." Strictly speaking, such notices are inhuman. Yet for many years, out of a near-superstitious worship of publications in white paper and black words and out of a blind trust in editors, people have actually accepted such unequal treaties and treated them as normal.[25]

Banly Zhang 笨狸 (sic), another popular Web writer, argues that Internet literature has its own unique features. It is free and flexible in technique and content, has a spirit of fun and humor, and is short and crisp, and its original purpose was simply to enable social communication among (often isolated) Chinese students overseas. He claims that

[22] Yao Wenxiang, "'Mengmian zhicheng' huojiang zhihou," 12.
[23] Li Xunhuan, "Wo de wenxue guan." After making his name as an Internet writer, Li became the business manager of the literary Web site Under the Banyan Tree in 2002, and has since become a well-known Internet publisher.
[24] Ibid.
[25] Wu Guo, "Wangluo xiezuo de ling yi zhong yiyi."

such disinterested, casual, and spontaneous communication is the true meaning of literature:

> Doing some writing after a meal, or a cup of tea, or after work and study—this is the real meaning of literature. On the Internet, there are no hypocritical and instrumental purposes, no cultivated intentions to compose.... People know they basically cannot persuade others on any specific issue. Yet, the urge to talk when you have something to talk about manifests the cool and authentic inner spirit of Internet literature. By returning to life and revealing the inner heart, Internet literature gives the fullest possible expression to the authentic part of humanity.[26]

The emphasis on the unique features of Internet literature implies that it has its own aesthetic criteria. This position is a challenge against print writers and editors. Yuan Chen 元辰, a proponent of Internet literature and host of Wen shi zhai (no English equivalent, 问石斋), a site devoted to the promotion of online criticism, spells out this position:

> I hope that commentators on Internet literature have at least three months of experience in reading Internet literature and discussing Internet writing. This is the most basic qualification.... Do not try to impose norms on Internet activities by using experiences from outside the Internet. You can discuss what norms to adopt only after you have become an insider.[27]

The popular novel *The First Intimate Contact* (*Diyi ci qinmi jiechu* 第一次亲密接触) illustrates some of the unique features of Internet literature.[28] First published in 1998 in a BBS forum in Taiwan, it quickly hit Web sites in mainland China and was disseminated widely online. Because the novel was serialized, the author received e-mail feedback and queries as soon as an installment was out. Toward the end of the installments, when it was clear that the female protagonist was facing death, some readers pleaded with the author not to let her die, while others argued that the author had to make up his own mind.[29]

The novel tells a love story about a young man and a young woman who have met in a chat room. After maintaining an online relationship

[26] Banly Zhang, "Zhi wen cheng wang."
[27] Yuan Chen, "Dui wangluo wenxue taolun hui de jinyan," cited in Guobin Yang, "The Internet as Cultural Form," 113.
[28] The novel is collected on many literary Web sites. My version is taken from Golden Book Cottage.
[29] Lu Qun, "Legendary Tales of Internet Worms in China," 29–35.

for a while, they agree to meet in person, and begin going to McDonald's and to the movies together. All this time, each is known to the other only by his or her online user ID. The girl's ID is FlyingDance (Qingwu feiyang 轻舞飞扬), the young man's, Slick Cai (Pizi Cai 痞子蔡). Every morning at three fifteen, they go online to chat until daybreak. One day Flying Dance disappears, leaving Slick Cai her e-mail password and telling him to read the unsent messages she has written to him. It turns out that FlyingDance has a terminal illness and has flown to a hospital in Taipei. The story ends with Slick Cai finding FlyingDance dying in her hospital bed.

This is a typical love story. Yet it is different from earlier love stories because it is about an Internet romance—a new phenomenon. There are linguistic and stylistic innovations as well, such as an Internet-derived vocabulary, dialogue, and tone typical of online chats. Examples of a unique Internet-derived vocabulary, just from this one novel, include "dinosaur" (*konglong* 恐龙), "frog" (*qingwa* 青蛙),[30] "message"(*tiezi* 贴子), "post" (*shangtie* 上贴), "go online" (*shangxian* 上线), "go offline" (*lixian* 离线, *xiaxian* 下线), "mail" (*youjian* 邮件), and "net friend" (*wangyou* 网友). The famous opening of *The First Intimate Contact* gives a sense of the overall tone:

> I got to know her online. How did it begin? I don't remember, perhaps because of a plan I had! That plan goes like this:
>
> If I had ten million, I would buy a house.
> Do I have ten million? No.
> So I still don't have a house.
>
> If I had wings, I would fly.
> Do I have wings? No.
> So I can't fly.
>
> If the entire Pacific Ocean were emptied of water, it wouldn't extinguish the fire of my love for you.
>
> Is it possible to empty the Pacific Ocean of water? No.
> So I don't love you.

As Internet writers began to challenge the authority of print literature, print writers remained ambivalent about the status of Internet

[30] "Dinosaur" is used to refer to an ugly female in chat rooms; "frog" refers to an ugly male.

literature. In heated debates about the meaning of Internet literature at the start of the new millennium, print authors like Chen Cun 陈村, an early supporter of online writers and a driving force behind Under the Banyan Tree, saw a promising future for Internet literature. Others took a condescending or outright dismissive attitude. Ge Fei 葛非 claimed Web-based writings were at best "apprentice works" (*xi zuo* 习作). Xu Kun 徐坤 was cited as saying that Internet literature had nothing whatsoever superior to print literature.[31] One critic wrote the following in *China Culture News* (*Zhongguo wenhua bao* 中国文化报), an official organ of the Ministry of Culture (Wenhuabu 文化部):

> The biggest appeal of the Internet is its openness. To publish "works" there is as easy as blowing off dust. People may do what they please. It is completely unrestrained. All the so-called "criteria" and "traditions" are overthrown. It only takes some typing and posting to "publish" works, to offer them to readers. How exciting this is for those who enjoy playing word games. And so it happens that an "Internet literature" has flourished.... In contrast to its quantity, its overall quality is disappointingly poor, [however]. In essence, the "Internet literature" as we know it is far more like play than like literature. I wonder whether we should not separate "Internet" from "literature" and call "Internet literature" "Internet writing" instead.[32]

Internet authors themselves were ambivalent. Some were disdainful of elite print writers; others aspired to their ranks. Few were beneath publishing their works in print form or cultivating a reputation as a *wangluo zuojia* (网络作家)—an Internet writer. As one person put it, "If Internet friends convene to elect Internet writers, who would admit that they are Internet writers? One wouldn't.... The fact is, up to now, I have not found a single individual who has declared him/herself an Internet writer."[33] The reason for such reluctance, according to the same author, is not that Internet writers are incapable of producing good literary works but that *zuojia*, or "writer," remains a sacred category.

[31] Wang Chong'er, "Wangluo wenxue zouhong, zuojia taidu lengdan," 37.

[32] Cited from http://www.xys.org/xys/neters/others/net/wangluowenxue7.txt. (accessed March 2, 2001).

[33] Yuan Chen, "Yue wang man ji."

The Promotional Strategies of Literary Web sites

Literary Web sites are hybrid creatures. They may be personal, commercial, and nonprofit. They are operated with mixed motives, some for fun, self-expression, and social interaction, others for profit or fame. Although some popular sites are noncommercial, the best-known ones in early Internet history, such as Under the Banyan Tree and Qingyun Academy, were joint ventures of business and art.

In their struggle for survival and recognition, literary Web sites apply strategies similar to those used by print literary journals. Shuyu Kong argues that the editors of literary journals adopt four survival strategies in crisis situations: 1) broadening the definition of literature; 2) becoming more "reader friendly;" 3) improving the journals' appearance and packaging; and, 4) developing synergistic alliances with business enterprises in related fields. Thus, for example, literary journals abandoned a conventional and narrow definition of literature in favor of a "literature broadly defined" (*da wenxue* 大文学) that includes nonfiction, marginal and mixed genres such as diaries, letters, and oral literature, cultural criticism, and essays on current affairs and social issues.[34]

Thanks to the technological features of Internet literature, literary Web sites are easily able to practice all these strategies. The definition of literature on the Internet has been from the beginning much broader than that in print literature, as Internet users publish a much broader range of works. In addition, partly due to its diversity and partly thanks to the relative openness of cyberspace, Internet literature is "reader friendly." The only limit to the size of its readership is the Internet itself.

If literary journals must improve their appearance as a strategy of reinventing themselves, literary Web sites again have the natural advantage of being "born" with a new look; they are also well suited for easy and routine packaging and repackaging. One challenge facing Web sites but not print journals is how to mobilize the technological capabilities of the Internet to attract writers and readers. Here, literary Web sites differ from print journals in notable ways. Typically, they do not limit themselves to publishing what are traditionally considered "literary works." Nor do they publish only "original works" (*yuan-*

[34] Kong, "Between a Rock and a Hard Place," 124.

chuang zuopin 原创作品), often posting archives of classical works of print literature, both Chinese and foreign.

To attract authors, literary Web sites set up functions enabling authors to submit their works online, promote column writers (*zhuan-lan zuojia* 专栏作家), and publish the collected works (*wenji* 文集) of their subscribers.[35] They use chat rooms and BBS forums to promote participation and virtual communities. Community building is, of course, an age-old literary tradition. As Michel Hockx shows, literary journals in the early twentieth century were similarly invested in community building.[36] The question is whether the Internet adds anything new to the forms of association and if so, how these new forms affect substance. The crucial difference here is interactivity and time-space compression. The Internet facilitates the rise of translocal and transnational online literary communities. The absence of physical locations also means that online communities can be much larger than literary communities in print culture.

In terms of success strategy, a main commonality between literary Web sites and print journals is what Shuyu Kong refers to as "synergistic alliances" with business enterprises. Like print journals, literary Web sites develop such alliances with businesses and utilize marketing strategies. There are, of course, enormous differences from one Web site to another. It is hard for small, personal sites to attract business interest. Those that do become famous have followed a path of institutionalization by transforming themselves into business enterprises or nonprofit organizations. In some cases (such as Qingyun Academy) a literary site starts out as a component of a business venture—it is a commercial investment in the first place.

Literary Web sites adopt self-promotional strategies similar to those used by print literary journals. One strategy is to hold literary competitions. These competitions are a means of promoting Internet authors and literary sites. Netease.com, Under the Banyan Tree, Qingyun Academy, and New Threads, among others, have all given awards to works of Internet literature on a more or less regular basis. Under the Banyan Tree instituted its awards in 1999 and had held three

[35] For example, Golden Book Cottage contained the collected works of more than one thousand "net friends" as of August 31, 2005. The majority of these "friends" have just one or two pieces of work, suggesting that the purpose is to encourage participation rather than to publicize the best authors.

[36] Hockx, "Links with the Past," 105.

Table 4. Chronology of Under the Banyan Tree, 1997–2000

December 25, 1997	Under the Banyan Tree launches as a personal Web site
June 1999	Produces literary programs jointly with Shanghai People's Radio
July 1999	Establishes an editorial board
August 6, 1999	Shanghai "Under the Banyan Tree" Computer Company, Ltd., registered
September 1999	"Banyan Tree Internet Literature Column" debuts in Shanghai's literary newspaper *Literature News* (*Wenxuebao* 文学报)
November 1999	Begins collaboration with Shanghai Eastern Radio Station
June 2000	Establishes its first branch office in Beijing
August 2000	Signs memorandum of friendly collaboration with more than three hundred traditional media companies

Source: http://www.rongshu.com (accessed May 8, 2005)

competitions by August 2004. New Threads launched literary competitions in 2000 and has done so annually ever since. Qingyun Academy began sponsoring competitions in 2001 and had held four as of 2004.

Another strategy is to have joint ventures with other media, especially book or journal publishers and television and radio programs. Qingyun Academy publishes a "Qingyun Book Series" (Qingyun shuxi 清韵书系) in collaboration with print publishers such as Shaanxi People's Press (Shaanxi renmin chubanshe 陕西人民出版社) and Shaanxi Tourism Press (陕西旅游出版社). Editors at Under the Banyan Tree not only turn works originally published online into books but also act as publishing agents and guest editors for print journals and publishers, TV programs, and radio stations. The site also collaborates with TV and radio stations to produce original programming. A brief chronicle of Under the Banyan Tree in its early years of operation (Table 4) shows how closely it collaborated with other media.

The connections between literary Web sites and other media again reflect the broader conditions of cultural production. If literary Web sites are eager to ally with print publishers, TV, and radio, print publishers and electronic media enterprises are no less eager to enter into mutually beneficial relations with their online counterparts. It has become increasingly common for literary journals to feature special columns featuring Internet literature. These include *Beijing Literature* (*Beijing wenxue* 北京文学), *The World of Fiction* (*Xiaoshuo jie*

小说界), *Fragrant Grass* (*Fangcao* 芳草), and *Chinese Literary Digest* (*Zhonghua wenxue xuankan* 中华文学选刊).

Book publishers have not neglected Internet literature. The classic example is the publication of *The First Intimate Contact* by the Sichuan Oriental Press (Sichuan dongfang chubanshe 四川东方出版社). As an editor of the press remarks, the publication of this Web novel was the result of careful strategic planning and marketing. Sichuan Oriental Press was small and little known before publishing the novel; at the time it lacked brand-name publications and had just undergone restructuring. Its owners felt a desire to introduce change and inject new energy into the business. At this point the idea of publishing *The First Intimate Contact* was proposed. Many at the press thought it was a risky venture, because Internet literature was a new phenomenon with no market record. Others thought it was worth a try precisely because of its newness. Sichuan then conducted an online market survey and found that although many Internet users had already read the novel, they would still like to own a print copy. Based on the survey, the press decided to publish the novel. It did careful work in book design and pricing, and chose what it deemed to be the best timing for release—not long before the Chinese New Year and the beginning of students' winter vacation—since young people were the book's targeted readers. As a result, the book was a huge success. Several months after its publication, it made the national best-seller list for literary works.[37]

Literary Web sites that adopt promotional strategies similar to those of print journals do so because they share more than a few challenges. Both are in a relatively weak position in the cultural market, print journals because they have undergone a crisis, Internet literature because it is new and evolving. The pressures they face pull them in the same direction: commercial success through consumer market expansion. Hence the need to be reader friendly, to broaden the definition of literature, to manufacture reputations, and to develop business alliances. It is more than likely that these conditions and dynamics are bringing Internet literature and print literature closer to each other, but the meeting point is not serious literature. Instead, they meet somewhere along the continuum of popular taste.

[37] This account is based on Xie, "Yu wangluo wenxue qinmi jiechu."

Conclusion: Internet Literature Transforms Print Culture

As a newcomer on the literary scene, Internet literature complicates
the social organization of print literature. The ease of online self-pub-
lishing shifts the balance of power among authors, editors, publishers,
and critics. Instead of seeking the approval of the gatekeepers of print
culture, Internet authors seek the highest number of "hits" on their
works, a key mark of popularity in cyberspace. As their works become
popular online, they attract contracts from print publishers. Print cul-
ture is less congenial to budding new authors than the Internet. Online
publishing eliminates many of the barriers of print culture. Thus, Muzi
Mei's sex blogs, discussed by Daria Berg in this volume, would surely
have had a hard time making it into print publication if they had not
first made a big splash online. The public controversy provoked by the
blogger's bold confessions of her pursuit of sexual pleasure indicates
the resistance she might have encountered if she had taken the blogs
directly to a print publisher. Nor would Pizi Cai have become such
a hot catch for print publishers if he had not first made a name for
himself online.

Internet literature is also changing the meaning of authorship and
the boundaries between authors and readers. The construction of this
boundary is an important strategy of symbolic distinction in print cul-
ture. In the conventional literary field, "writer" is a sacred title, hard
earned by enduring the rigors of print publishing. On the Internet it
becomes a much more democratic title, since common readers can
just as easily publish their own works. The diffusion of material on the
Internet has thus contributed to the kind of "downward extension" of
the written word described by Cynthia Brokaw in her essay. Brokaw
shows that the expansion of commercial woodblock printing brought
book culture to levels of the population previously excluded, for the
most part, from book culture. China's Internet population numbered
298 million at the end of 2008; as more people go online, the Internet-
based "downward extension" of writing and publishing will become
even more widespread.

One consequence of Internet publishing is the proliferation of
published works in cyberspace. Quantitative growth leads to diver-
sification and can gradually bring about qualitative change. Over the
years, Chinese Internet literature has taken on some distinct features
in content, genre, style, and language, thus expanding the range of

literary writing.[38] Romance, martial arts, fantasy, and science fiction have become dominant genres. In style, a kind of irreverence and free-spirited verve has almost become a new norm. In language, Internet literature exhibits such dazzling creativity that it has injected a new lexicon into everyday life, thus contributing to the transformation of Chinese society at the fundamental level of daily speech.

With the proliferation of works of Internet literature, print publishers are turning to literary Web sites in search of book manuscripts, while ambitious online publishers are expanding into print. The interpenetration of print and Web publishing shows the changes already taking place in the larger field of cultural production in China, changes due in no small part to the development of Internet literature. Since the field of cultural production is strategically linked to both state power and the society of consumers, as Christopher A. Reed points out in his introduction, in the long run these developments are bound to induce changes in citizens' relationship with the state. Furthermore, the commercialization of both Internet literature and print culture clearly shows that the market will play an increasingly important role in the field of cultural production. The development of new Internet technologies and Internet literature in China have upset the established cultural order.

[38] Note that Internet literature, at least works of fiction, comes closer to works of the "'new' new generation" (*xinxin renlei wenxue*) and "babe fiction" (*baobei wenxue*) than to fiction produced by the more established print writers. Both types have strong autobiographical and confessional elements. Both focus on the anxieties of young urban contemporaries. These similarities suggest that Internet literature and literary works of the new generation have a common social origin, athough, yet again, recognizable stylistic differences exist between the two. For studies of the so-called "'new' new generation," see Berg, "Consuming Secrets," in this volume; Ferry, "Marketing Chinese Women Writers in the 1990s"; and McDougall, "Discourse on Privacy by Women Writers in Late Twentieth-Century China."

RESISTANCE IS FUTILE:
CONTROL AND CENSORSHIP OF THE INTERNET IN CHINA[1]

Gudrun Wacker

Introduction

Compared to the means of publishing dealt with in other essays in this book, personal computers and the Internet are a very young technology. Their impact on political, cultural, and intellectual change in different societies is hotly debated. From the very beginnings of the Internet, it has been a widely held view in the West that, due to its global character, the worldwide computer network is by definition beyond the regulation and control of any single state. This assumption of uncontrollability was derived from the technology of the medium, the geographic distribution of its users, and the diverse character of its contents. While expensive means of production are required for traditional publishing, the Internet in theory empowers everybody not only to *receive* information in diverse forms, but also to *produce* information and make it accessible to everybody else with an Internet connection.

With respect to China, Western politicians such as former American president Bill Clinton famously announced that any effort to control the Internet was tantamount to nailing Jello to the wall.[2] George W. Bush also predicted that the spread of the Internet in China would release the genie of freedom from the bottle.[3] Despite the fact that the Internet and its underlying technology have undergone dramatic changes due to its commercialization from the mid-1990s onward, the vision of the Internet has been upheld as a means of communication that enforces the free flow of information of any kind, be it text, image or sound. The Internet is still believed to undermine state control of

[1] An earlier version of this paper was published as "The Internet and Censorship in China." In Hughes and Wacker, *China and the Internet*, 58–82.
[2] The statements of Clinton and Gore are cited in Drake, Kalathil, and Boas, "Dictatorships in the Digital Age."
[3] Cited in Kurlantzick, "The Web Won't Topple Tyranny."

the media and their contents, commonly a feature of authoritarian regimes such as the PRC. China's leadership, even as it stresses the importance of the Internet and new economy for China's future,[4] has with equal emphasis warned of the possible negative implications and side effects accompanying new communication technologies. Thus, party and government in China also seem to be convinced of the subversive potential of the Internet.

Simultaneous support and mistrust toward Western technologies, methods, and ideas are not new in the history of China. In imperial times, the Chinese approach to this dilemma was circumscribed with the formula "Chinese for essence, Western for usage" (*Zhong wei ti Xi wei yong* 中为体西为用), implying that the essence of China should not and would not be altered by introducing ideas and technologies from abroad. Those hoping to apply this formula faced the task of importing and adopting what is considered positive and useful from abroad, while at the same time filtering out apparently negative and harmful foreign influences. The challenges of this approach became evident in the late 1980s. As a result of the post-Mao reforms China, after a long period of isolation, was opened up to the outside world. But one of the products of this opening—the introduction of modern communication technology in the form of fax machines—allowed the student demonstrators of May and June 1989 to receive information from Chinese students abroad on the events unfolding in Tian'anmen Square. Modern communication technologies, introduced for economic and commercial reasons, cannot simply be shut off whenever it is deemed politically or ideologically desirable.

China's leaders know, however, that if they want to transform China into a modern country they have no real choice but to embrace Webbased technology. And they have not given up the idea of successfully keeping the negative (from their perspective) aspects of the Internet at bay. During the last two decades, substantial funds have been directed toward the expansion and modernization of China's telecommunications infrastructure. Internet usage has grown dramatically since a relatively late and modest start in the mid-1990s: from slightly more than one million users in mid-1998, the number of netizens (*wangmin*

[4] See Dai, "ICTs in China's Development Strategy," 8–29.

网民) had grown to almost three hundred million by the end of 2008.[5] Thus, China in 2008 surpassed the United States in terms of user numbers. Without active and massive support from party and government, this speed of development would have been impossible.

Despite the grand claims for the freedom-bringing powers of the Internet cited above, most studies on the Internet in China and in other authoritarian countries conclude that control and censorship are not only possible, but have been implemented quite successfully.[6] "Chinese authorities…exert their control over online users today as much by simple intimidation as by sophisticated electronic surveillance or by blocking direct access to politically suspect foreign websites [*wangzhan* 网站],"[7] wrote the *Los Angeles Times* in 2001. This position has over the last few years become dominant[8] as more empirical research has been done and also as cases of censorship have been taken up by human rights organizations and publicized widely in the Western press.

This essay addresses the capability of the Chinese party-state to contain those aspects of the Internet that are perceived as destabilizing and dangerous or "unhealthy." What instruments does the Chinese leadership have at its disposal to control and censor contents of the World Wide Web (WWW) (*wanweiwang* 万维网), electronic chat rooms (*wangluo liaotian shi* 网络聊天室) and discussion forums (*dianzi luntan* 电子论坛), bulletin board systems (BBS) (*dianzi bugaolan* 电子布告栏), e-mails (*dianzi youjian* 电子邮件), and blogs (*boke* 博客)? And

[5] Statistical data from Zhongguo hulianwang xinxi zhongxin, http://www.cnnic.net. cn (accessed February 16, 2009). (All subsequent World Wide Web citations were accessed on this date unless otherwise indicated.) CNNIC is an institution of the Chinese Academy of Sciences. From 1998 onward, CNNIC has conducted semiannual surveys for the Chinese government on the quantitative development of Web sites based in China as well as on Internet users. The results of these surveys are published regularly on the CNNIC Web site. Although the statistical data are unreliable and questionable in many respects, they are commonly used as rough estimates within China as well as outside. See, e.g., Karsten Giese, "Internet Growth and the Digital Divide: Implications for Spatial Development," Hughes and Wacker, *China and the Internet*, 30–57. The last survey was the twenty-third, and its results were published in January 2009 (English version: http://www.cnnic.cn/uploadfiles/pdf/2009/3/23/153540.pdf).

[6] E.g., Kalathil and Boas, *Open Networks, Closed Regimes*; Qiu, "Virtual Censorship in China"; Charles Li, "Internet Control in China"; Tsui, "The Panopticon as the Antithesis of a Space of Freedom"; Tsui, "Big Mama is Watching You"; MacKinnon, "China's Censorship 2.0." See also Wacker, "The Internet and Censorship in China."

[7] See Marshall and Kuhn, "China Goes One-on-One with the Net."

[8] See Hung, "Public Discourse and 'Virtual' Political Participation in the PRC." A more optimistic assessment is Chanse and Mulvenon, *You've Got Dissent!*

how successful can these efforts be if we assume that electronic communication via the Internet per se cannot be subjected to the control of an individual state? Are party and government fighting a battle that they have lost from the beginning, or do they have arsenals, voluntary or involuntary allies and collaborators, which make the final outcome of this battle less predictable? By applying the theoretical approaches of Lawrence Lessig and James Boyle to Web sites in China, I aim to show not only that controlling the Internet in China possible, but also that control, surveillance, and censorship have become inherent features of the technology on which it is based. An automatic "liberating" or "democratizing" effect cannot therefore be expected of Web sites in authoritarian societies. At the same time, however, modern communication technologies such as the Internet, mobile phones, etc. can facilitate, accelerate, and reinforce trends and movements within society, in other words, the offline world.[9]

First, with about 23 percent of China's population having access, the level of Internet penetration in China is not bad for an emerging country.[10] However, Internet penetration reflects general inequalities in China, on the regional as well as on the urban-rural level. Second, by focusing here on censorship, other aspects of Web sites in China will not be given the attention they deserve. Censorship, even when it works, does not mean that the Internet and electronic communication have no impact on society in China or do not support societal and political change. There can be no doubt that the Internet provides a quasi-public virtual space for debate and mobilization and that improved transparency and participation create positive effects.[11]

[9] On the correlation between online- and offline-worlds in the field of literary publications, see Guobin Yang's essay in this volume.

[10] For comparison, by mid-2008 Internet penetration in India was 12.3 percent, but Brazil's was 50 percent. See Internet World Statistics.

[11] By narrowly focusing on censorship, we get a rather incomplete and two-dimensional picture of China's Web policy. The Chinese leadership initiated the "government online" project, for example, in 1999 in order systematically to enhance the Web presence of ministries, administrative units, and local governments. By making more information accessible to citizens, the government created more transparency and accountability. At the same time, electronic networks are useful in the fight against official corruption, currency fraud, etc. See, for example, Dali L. Yang, "The Great Net of China"; and Zhang Junhua, "China's 'Government Online' and Attempts to Gain Technical Legitimacy."

Internet, Nation-State, and Control

The issue of controlling the Internet and electronic communication has not only arisen in authoritarian states such as China or Singapore, but has been widely discussed in Western democracies as well. Two factors determine and shape that control: on the one hand, the perception of the *necessity* for control and, on the other hand, the *technical possibility* of regulating the Web. While emphasis may differ from country to country, child pornography, racism, instigation of violence, rightist extremism, hate speech, and other issues are at the core of the debate over necessity in Western democracies. In contrast, radical proponents of a "digital libertarianism" advocate for unrestrained freedom of the Internet.[12] No government in the world, however, can ignore the necessity of regulating certain aspects of electronic communication. In addition to the issues already mentioned, problems of regulation include taxation of electronic commerce, data security, cyber-crime, and other difficulties. Drafts laws addressing these concerns have been passed in practically every country. And since laws also vary from state to state, the Internet in the age of commercialization has changed its nature. Its architecture has become more complex and the identification of users and their locations has become an urgent goal: "There is a growing demand for the ability to determine the geographical locations of individual Internet users, in order to enforce the laws of a particular jurisdiction, target advertising, or ensure that a website pops up in the right language."[13] Moreover, the terrorist attacks on September 11, 2001, in New York and Washington gave a new boost to discussions in all Western democracies on granting state organs more rights in conducting electronic surveillance and eavesdropping. At the core

[12] For a summary of the arguments of "digital libertarianism," see Boyle, "Foucault in Cyberspace." The proponents of this approach argue in favor of the state's noninterference in cyberspace, but they claim that the Internet is characterized by certain features that are beyond state control. Three main groups hold these contradictory views: computer enthusiasts (hackers and others who want to keep "their" Internet for themselves); traditional liberals who want to limit state interference; and economically oriented conservatives, who see the global reach of the Internet as desirable, because it weakens government control.

[13] See "Putting It in Its Place." See also "The Internet's New Borders," and Cha, "Bye-Bye Borderless Web." Through so-called geolocation programs that link IP addresses to countries, cities, and postcodes, it is possible to locate users.

of this renewed debate is the balance between civil liberties on the one hand and national security on the other.[14]

Some theorists cast fundamental doubts on the allegation that the Web is beyond control in general, and beyond control by the state in particular. To assess the prospects of successfully controlling the Web in China, some of these theoretical considerations are presented here.[15]

Lawrence Lessig identifies four elements by which behavior in cyberspace can be shaped and regulated: laws, social norms, the market and, last but not least, the architecture of the Internet itself, that is to say, its encoding or code. On this last and most important factor he states:

> The software and hardware that make cyberspace what it is constitute a set of constraints on how you can behave. The substance of these constraints may vary, but they are experienced as conditions on your access to cyberspace.... The code or software or architecture or protocols set these features; they are features selected by code writers; they constrain some behavior by making other behavior possible, or impossible. The code embeds certain values or makes certain values impossible. In this sense, it too is regulation, just as the architectures of real-space codes are regulations.[16]

According to Lessig, there are always methods to outmaneuver the "architecture" so that control can never be perfect. But just as the fact that a lock can be picked or broken does not prove the total uselessness of locks in general, we cannot conclude that *effective* control is impossible only because *perfect* control is not possible.[17] Governments are able *indirectly* to regulate the Web by *directly* regulating intermediary (commercial) institutions, especially Internet Service Providers (ISPs) (*hulianwang fuwu tigongshang* 互联网服务提供商) and Internet Content Providers (ICPs) (*hulianwang neirong tigongshang* 互联网内容提供商).[18] Lessig also cautioned about a possible development

[14] See, e.g., Robinson, "New Laws Seek to Balance Privacy and Surveillance," and Kaplan, "Concern Over Proposed Changes in Internet Surveillance." On the contradiction between freedom of expression and the fight against terrorism, see "United States," *Reporters without Borders*, and Stanley, *The Surveillance-Industrial Complex*, the American Civil Liberties Union report published in August 2004.

[15] For similar theoretical approaches see Charles Li, "Internet Control in China"; and especially Tsui, "Panopticon as the Anthithesis"; Tsui, "Big Mama is Watching."

[16] Lessig, *Code and Other Laws in Cyberspace*, 89.

[17] Lessig, *Code and Other Laws*, 57.

[18] Ibid., 97.

of cyberspace that enhances the options for its control: "If the change continues along the lines it has taken so far, it will become a highly regulable space—not the locus of liberty, not a space of no control, but a technology of government and commercial power wired into every aspect of our lives."[19]

In an essay published in 1997, James Boyle,[20] too, argued against the notion that nation-states cannot control the Internet. In Boyle's view, by proclaiming total freedom of information and by assuming that the Internet, due to its structure, can resist any effort of censorship, "digital libertarianism" proves to be blind not only to the effects of private power, but also to the power of the state within cyberspace. Its proponents tend to ignore how the state can utilize privatized methods of enforcement and state-sponsored technologies to undermine or cir-cumvent assumed practical or constitutional constraints in regulating the Internet. Boyle's observations are based on theories of the French sociologist Michel Foucault. According to Foucault, modern political or state power is determined by subtle, private, informal, and mate-rial forms of coercion, based on the concepts of "surveillance" and "discipline." These concepts can be illustrated by a prison built in the form of a wheel around a central tower. Every cell of this prison has a window facing the tower. From the central tower, the warden is able to see what any individual prisoner does any time he wants. Since the prisoner cannot be sure when he is watched and when not, his behavior is likely to comply with the rules; he tends to act as if under constant surveillance. Boyle applied this model of a "panopticon"[21] to the Internet and came to the conclusion that censorship can be made an integral feature of its underlying technology.

Boyle addresses different technological options discussed in the West, especially in the United States, and which are intended, for example, to protect children from access to pornographic websites. One such approach from the provider side consists of integrating specific information on the Web site itself, commonly invisible to the user. This system of self-description can contain such information as data on the age group for which this specific site is recommended. The

[19] Ibid., 211.
[20] For the following observations see Boyle, "Foucault in Cyberspace."
[21] The "panopticon," designed as an ideal prison, goes back to Jeremy Bentham. See Michel Foucault, *Discipline and Punish*, especially 195–228.

"neutrality" of such technological solutions is of central importance for Internet control in China.[22]

Another option that enables individual Internet users or ISPs to shield themselves or customers from access to undesired Web sites is filter software. Examples of such software programs include Surf-Watch, CyberPatrol, NetNanny, or CyberSitter. They can contain lists—invisible for the user, since encrypted—with Internet addresses of "forbidden" Web sites, but also filters that block access to Web sites containing specific words or phrases. These technical solutions can, of course, also be used in combination, and they enable the state to enlist private or commercial parties for tasks that the state itself is either not allowed to carry out—for constitutional reasons, for instance—or lacks the capacity to carry out. In contrast to individual Internet users, who can access cyberspace independently of a certain location and who can stay more or less anonymous while moving about in the virtual world, commercial ISPs and ICPs cannot operate quite as independently of geography and their real identity. In the United States, for example, ISPs are by law held liable for copyright infringements by their customers. In order to meet this responsibility, ISPs can erect "digital fences," that is, software programs that prevent unauthorized copying.

Another example Boyle cites is encryption technology. Encryption guarantees the safe transfer of data via the Internet, such as in online banking, and it can also protect electronic communication from surveillance. However, the "neutrality" of the technology has to be underlined in this case as well: encryption does not only enable human rights groups to communicate safely, but criminal organizations, terrorists, and other nefarious types can also use this method to shield their communication. Therefore, in many states, bills have been discussed to allow the state access to encrypted electronic communications under certain circumstances.[23] In the aftermath of the terrorist attacks in the United States in 2001, this issue has come up again in Western democracies.

[22] Boyle, "Foucault in Cyberspace."

[23] For initiatives in the United States—Clipper Chip and others—see Lessig, *Code*, 47ff., and Shapiro, "The Internet." On a controversial draft in England in 2000 see Grande, "Uunet and Nokia Attack E-mail Legislation." Providing the state with access to encryption has been compared to forcing all citizens to deposit a key to their house at the police station, so that security forces could enter it if they suspected burglary.

As for the assumed impossibility of controlling the Internet, Boyle concludes, "In fact, the state is working very hard to design its commands into the very technologies that, collectively, are supposed to spell its demise."[24] What makes such technological solutions attractive is not simply that they actually work. They are also hard to recognize as an exercise of state power and control. They ignite very little public protest or resistance, since they are perceived as a "natural" and integral part of the electronic communication media themselves.[25]

In sum, we should not prematurely write off the state if we are talking about bringing the Internet under control. "Virtual censorship" by the nation-state might not be perfect, but it can hardly be called nonexistent, either. Moreover, such control is not a phenomenon specific to authoritarian regimes like the PRC; efforts to regulate and control cyberspace have been ongoing in practically every country, and governments have found allies in commercial enterprises developing appropriate technologies. In the words of Jack Linchuan Qiu:

> Cross-media and cross-national comparisons depict virtual censorship as new measures imposed by the Chinese government upon China's cyberspace. However, on a more abstract level, when the totality of CMC [i.e., computer mediated communication] is considered in a global scope, virtual censorship can be seen as not so special. It reflects the emerging attempts of legislatures, governments, and various administrative organs worldwide to incorporate the cyberspace into their sphere of jurisdiction.[26]

In China, all four elements that, according to Lessig, can shape behavior in cyberspace—namely laws, social norms, market, and code—operate. As shown below, the four instruments come into play at different levels; they complement each other and are intertwined.

National Laws

The fast growth in Internet usage in China led to resolute efforts to regulate telecommunications, information technology, and Web sites based in China. Although jurisdiction with respect to the Internet could partially also be based on existing laws, a whole series of specific

[24] Boyle, "Foucault in Cyberspace."
[25] Ibid.
[26] Qiu, "Virtual Censorship in China," 22.

regulations covering different aspects of the Internet and computer-mediated communication was drafted and implemented.[27] China's accession to the World Trade Organization in 2001 most likely played an important role in accelerating the drafting of laws for this sector. Despite the ongoing streamlining of the state apparatus, a confusing number of ministries and administrative units were involved in formulating Internet regulations.[28] These institutions did not always pursue identical interests. Some of them did not much care about ideological issues, but had strictly economic or commercial interests. Institutional and regional competition and fragmentation of power could, in turn, result in differences in how regulations were implemented, thereby actually weakening efforts to control the World Wide Web in China.

Many of the regulations enacted in China so far have been intended to protect Internet users, especially their rights as consumers. Restrictions on online educational services and the online trading of medical drugs fall under this category. The protection of intellectual property rights and even the privacy of personal correspondence are addressed. In this respect, Internet regulation in China is not so different from

[27] The first laws were passed in 2000. [Ministry of Information Industry,] "Zhonghua renmin gongheguo dianxin tiaoli" (also under http://www.mii.gov.cn/news2000/1013_1.htm; [State Council,] "Hulianwang xinxi fuwu guanli banfa"; [State Council Information Office, Ministry for Information Industry,] "Hulianwangzhan congshi dengzai xinwen yewu guanli zhanxing guiding"; [Ministry for Information Industry,] "Hulianwang dianzi gonggao fuwu guanli guiding"; [Standing Committee of the National People's Congress,] "Guanyu weihu hulianwang anquan de jueding"). An excellent summary and evaluation of the main contents is in Giese, "Das gesetzliche Korsett für das Internet ist eng geschnürt." For a complete list in English of the relevant laws and regulations issued in 2004 and later, see the TransAsia Lawyers Web site, http://www.chinaeclaw.com/english/showCategory.asp?Code=022.

[28] In principle, regulation of the entire telecommunications sector falls under the jurisdiction of the Ministry of Information Industry (MII) which was later renamed "Ministry of Industry and Information Technology" (MIIT, website at http://www.miit.gov.cn). The growing importance of the telecommunications sector resulted in the establishment of a Leading Group for Informatization (Guojia xinxihua gongzuo lingdao xiaozu) at the highest government level in December 1999. For the members and responsibilities of this group, see [State Council Office,] "Guowuyuan Bangongting guanyu chengli guojia xinxihua gongzuo lingdao xiaozu de tongzhi." For supervising ICPs, an Internet Information Management Office (Guowuyuan xinwen bangongshi wangluo xinwen guanliju) was established under the Information Office of the State Council in April 2000. A broad range of ministries, government institutions, and administrative units—such as the Ministry of Public Security, ministries of culture and of health, State Administration for Industry and Commerce, and many more—also have a say in the drafting of Internet regulations relevant to their respective domains.

other countries, and the provisions cannot be interpreted exclusively as an effort to eradicate dissident views.

Around the turn of the century, the state issued a series of regulations governing telecommunications and the publication of news and electronic information on the Internet; these were to become effective in 2000. The following points highlight the portions of these regulations relevant to the issues of control and censorship:

1. *Forbidden content*: The regulations contain a list of contents that may not be distributed or published electronically. Since this list apparently represents the currently valid canon, thereby giving us an overview of the government's targets in controlling cyberspace, its full wording is cited here:

Forbidden is all information that

(1) contradicts the principles defined in the constitution [of the PRC];
(2) endangers national security, discloses state secrets, undermines/ subverts the government, destroys the unity of the country;
(3) damages the honor and the interests of the state;
(4) instigates ethnic hatred or ethnic discrimination, destroying the unity of [China's] nationalities;
(5) has negative effects on the state's policies on religion, propagates evil cults or feudal superstition;
(6) disseminates rumors, disturbs social order, undermines social stability;
(7) spreads lewdness, pornography, gambling, violence, murder, terror, or instigates crime;
(8) offends or defames other people, damages/infringes upon the rights and interests of other people;
(9) other contents which are forbidden by law or administrative regulations.[29]

This catalogue of prohibited contents is not at all new. In a slightly more general form, it can be found in the regulations for the publishing industry issued in 1997.[30] Since the banned contents of the Internet and those in other media are nearly identical, it can be concluded

[29] This list can be found as § 15 in "Hulianwang xinxi fuwu guanli banfa," § 9 in "Hulianwang dianzi gonggao fuwu guanli guiding," and § 13 in "Hulianwangzhan congshi dengzai xinwenyewu guanli zhanxing guiding."

[30] [State Council,] "Chuban guanli tiaoli." In these regulations, electronic publications were already explicitly mentioned as falling under their jurisdiction (§ 2). The banned contents, which also lists "superstition," can be found in § 25.

that the Internet and electronic services are basically treated like other means of publication.

2. *Restrictions on the distribution of news*: In principle, the regulations prohibit the distribution of news through the Internet, unless the news items are either published via the Internet by the official state-owned media or by the news departments of state institutions themselves; or unless they have been published previously by authorized media in other forms. If a pure[31] Web portal wants to publish news, it has to fulfill specific requirements (have a professional editorial board, sufficient financial means, adequate technical equipment, among other things), and it must enter into formal cooperation with one of the official media authorized by the state. Cooperation agreements must be filed with the authorities. The source and date of the published news must be cited in each case. As for the question of whether Web portals can publish news and articles by their own journalists, contradictory statements existed prior to these regulations.[32] With respect to links to foreign news Web sites or the publication of news taken from foreign media, (some portals had signed agreements with foreign information services like Dow Jones and others), regulation § 14 stipulates that prior approval of the Information Office (Xinwen bangongshi 新闻办公室) under the State Council is necessary.

These rules try to kill two birds with one stone. First, the unrestrained proliferation of (unauthorized) news is contained and directed to relatively stable channels. This aspect might be seen as the rules' *political* or *ideological* dimension. But the regulations also aim at securing the *economic* interests of the official media vis-à-vis pure Web portals such as Sina, Netease, or Sohu operating in Chinese. Due to their early Web presence and timely as well as attractively presented news services, these portals had become very popular, thus gaining a competitive advantage over latecomers to the Internet. As early as 1999 the "traditional" media—*People's Daily* (*Renmin ribao* 人民日报), Xinhua News Agency (Xinhuashe 新华社) and others—formed an interest group. In pointing out the risks created by granting too much freedom to the

[31] "Pure" means a portal exists solely in the online realm, not a Web site created by media in the offline world.

[32] For a statement by a representative from the Internet Information Office under the Information Office of the State Council, see Gary Chen and Dennis A. Britton, "China to Allow ICPs to Report Their Own News;" and *ChinaOnline*, "China: Eastsay.com may not write, collect news."

Web portals, they also appealed for official support from the state to improve their own Web presence. Fighting news piracy was one of their main issues.[33] In order to strengthen the competitive position of the official media against alternative sources of information, the party-state—by decision of the State Council—granted the most influential state media special funds (US $121 million) to launch and improve their own Web appearance.[34] The Management Office for Internet Information (Guowuyuan xinwen bangongshi wangluo xinwen guan-liju 国务院新闻办公室网络新闻管理局), established in April 2000 under the Information Office of the State Council, was, among other tasks, appointed to improve the online presence of the official media.[35] This economic dimension encompasses an ideological aspect as well, since by strengthening the Web presence of the state-owned media, the supply of content in line with party and government is expanded.

3. *Licenses*: Through the introduction of comprehensive and detailed rules, the providers of Web services—BBS's, news media, and the like—are forced to apply for different licenses and official permits. These have to be obtained from different authorities, and a separate license is necessary for each category of service. Expanding any licensed business activity without prior consent is prohibited. All Internet cafés must register with the local Office for Public Security (Gonganju 公安局). Paying for business licenses—the granting of which depends partly on fulfilling certain preconditions concerning personnel and financial and technical equipment—means that entry into the market costs more, so that smaller and independent Internet companies without official backing are maneuvered into a disadvantageous position vis-à-vis the bigger players. Thus the market (according to Lessig's categorization) is brought into play in a legal way as a restricting element.

[33] See *ChinaOnline*, "China's Print Media Concerned over New Internet Portals"; Gary Chen, "China's Booming Internet Sector." In Shanghai, the most important "traditional" media (*Jiefang ribao, Wenhui bao, Xinmin wanbao*, Shanghai TV Station, and others) united to form their own Web portal. See *ChinaOnline*, "China Web Site Has Got It Covered–Newswise."

[34] See Taylor Fravel, "The Bureaucrats' Battle over the Internet in China." This aid to the official media is especially noteworthy if seen in the context of two recent measures: the party's drastic reduction in subsidies for newspaper publishing companies and its strong recommendation that publishing companies finance themselves. See Doris Fischer, "Rückzug des Staates aus dem chinesischen Mediensektor?"

[35] A portrait of this institution can be found at *ChinaOnline*, "Internet Information Management Bureau (IIMB)."

4. *Storing of user data*: ISPs are required to store all user data. User data comprise not only the registration or customer number of the user, but also the telephone number used for logging in, which Web addresses or domains are visited during the session, and for how long. The data have to be stored for sixty days and handed over to the authorities if requested. Providers of electronic information services, that is, ICPs that offer BBS's, chat rooms, discussion forums, and other services, must store all contributions published on the Net, including time of publication and Web address or domain name, and keep those data for sixty days. Postings from users that violate one of the rules on banned contents must be deleted from the Net immediately. At the same time, however, their postings are required to be locally stored and reported back to the authorities.[36]

5. *Surveillance*: Passages explicitly addressing the surveillance of "telecommunications content" were included in appendices to the regulations published in January 2002.[37] The appendices state that no organization or individual is allowed to inspect the contents of electronic communication for any reason, with only one exception: surveillance for national security or investigating crimes can be conducted in accordance with laws and regulations by the organs of public security, the organs of national security, or the procurators' offices. Although "public" contents—such as contributions to BBS—must be controlled by the providers of telecommunication services (as noted above), different rules seem to apply to nonpublic contents such as e-mails. In contrast to some media reports,[38] which called the new regulations of January 2002 the most intrusive so far for requiring ISPs and ICPs to screen e-mails, the wording of the passages quoted above implies that providers are *not* allowed to screen the nonpublic communications of their customers.

[36] Regulations for electronic information services can be found in §§ 14 and 15 of "Hulianwang dianzi gonggao fuwu guanli guiding," 46.

[37] The MII published on its Web site "Management Methods for Licenses in the Telecommunication Business," with four appendices each for basic and value-added telecommunications services. The passages in question can be found in the relevant second appendix on "obligations and rights." See [Ministry of Information Industry,] "Dianxin yewu jingying xukezheng guanli banfa." The passages in question are found under part 3 ("telecommunication security"), §§ 4–6 in appendix 2 on "rights and obligations" for basic telecommunications services as well as part 3, §§ 4–7 in appendix 2 on value-added telecommunications services.

[38] See, e.g., Vivien Pik-Kwan Chan, "Beijing in Hard Drive to Patrol Net Users."

6. *Judicial liability*: Providers of electronic information services are required to notify their users or customers of the legal responsibilities that apply when posting and uploading information or contributions.[39] For published contents, however, final responsibility rests with the author.[40] The service providers can be held liable if they operate without the required business licenses, if they do not meet their obligations with respect to the storage of data and notification of the authorities,[41] and if they fail to protect personal data by passing them on without prior consent of the respective user/customer (with the exceptions, of course, stipulated by the law). In contrast to Singapore, where ICPs are held liable for all contents published within their business sphere, in China the author of an online publication, such as a contribution to a BBS, can be called to account.[42]

7. *Penalties*: With respect to ISPs and ICPs, the regulations provide for reprimanding, rectifying, imposing financial fines on, and, in serious cases, temporarily or even permanently closing down Web sites. If the provider does not delete content violating the regulations or fails to notify the authorities of the violation, the business license may be revoked.[43] As for the penal consequences of violations by ISPs, ICPs, and individual users, the regulations refer to the "relevant laws."[44]

In sum, we can see the regulations as an effort by the Chinese government to create a more proactive Internet policy and provide itself with better instruments than before to influence activities in cyberspace. This policy consists of content restrictions on an ideological level as well as administrative and economic requirements that strengthen the competitive position of official media, not to mention the bigger and financially better-equipped Internet.[45] Through these measures and by offering more content itself, for example, with projects like "government online," party and government have tried actively to set the agenda for the Internet in China.

[39] "Hulianwang dianzi gonggao fuwu guanli guiding," 46 (§ 10).

[40] Ibid.

[41] References to §§ 21 and 22 in "Hulianwang xinxi fuwu guanli banfa."

[42] This difference is stressed by Qiu, "Virtual Censorship." On Singapore's Internet policy, see Rodan, "The Internet and Political Control in Singapore."

[43] §§ 22 and 23 of "Hulianwang xinxi fuwu guanli banfa."

[44] According to the penal law of the PRC, sentences for several years are possible. See Giese, "Das gesetzliche Korsett," 1176.

[45] Ibid., 1176ff.

Direct State Intervention: Blocking URLs, Crackdowns, and Arrests

The blocking of websites is an obvious case of direct censorship. In China, blocking can be done on the national level, since all international data traffic has to pass through one of the state-owned backbones.[46] This method of blocking is applied mainly to Web sites operated by foreign news services such as CNN, BBC, or human rights organizations. Judging from the available reports on real experience in China, such blocking seems to be rather erratic and unsystematic. Tests conducted from May through November 2002 have given us a clearer idea of the scope and sophistication of Internet-blocking in China.[47] On special occasions, like summit meetings or the Olympic Games, this blocking can be temporarily lifted—but only on foreign media Web sites. If certain IP domains cannot be accessed, temporary bottlenecks in international data traffic might be the cause, but the user in China has no way of knowing.[48] Besides directly blocking Web sites and weblogs (or blogs),[49] reports also maintain that users trying to access a certain site are unknowingly redirected to another site.

In July 2004, the authorities initiated a campaign against pornography on the Internet and on mobile phones. Distributors of pornography were threatened with severe punishment, and, within weeks, hundreds of Web sites were closed down and about three hundred people arrested.[50] Moreover, a special committee under the Ministry of Culture was set up to inspect online games.[51] A special Web site

[46] See, e.g., Charles Li, "Internet Control in China," 24–25. "Backbones" refers to the main "trunk" connections of the Internet.

[47] The first systematic survey on the blocking of Web sites in China and other countries was conducted as part of a project at Harvard University. For the results, see Zittrain and Edelman, *Empirical Analysis of Internet Filtering in China.* A good overview of the variety of filtering measures is provided in "Internet Filtering in China in 2004–2005."

[48] In countries like Saudi Arabia, the user gets a message that a site cannot be accessed due to intentional blocking. In China, however, it is not clear why a certain site cannot be accessed. See Zittrain and Edelman, *Empirical Analysis of Internet Filtering in China.*

[49] Regulations issued in 2005 required all blogs in China to register by June 30 of that year. See "Chinese bloggers react to registration deadline." According to the CNNIC survey, there were 172 million bloggers in China as of December 2008.

[50] "China Threatens Internet Porn Merchants with Life."

[51] See "China to Pick 'Healthy' Internet Games for young people"; "Chinese Government Censors Online Games." This campaign aimed, among other things, at banning games that "threaten national unity, sovereignty, and territorial integrity."

invited people to report suspicious or provocative behavior of fellow Web users, aiming not only at pornography, but also at sites "attacking party and government" or "propagating evil cults."[52]

Internet cafés (wangba 网吧) have become widely popular, especially in China's cities. During the sessions of the National People's Congress and the Chinese People's Political Consultative Conference in spring 2001, some delegates advocated the closing of *all* Internet cafés, arguing that these institutions are harmful to children and youths. The discussion centered mainly on access to pornographic material and online gambling ("online poison" [wangdu 网毒]).[53] However, a complete ban of Internet cafés, which fulfill an important function by providing access in remote and poor areas, was never seriously considered. However, Internet cafés have been raided several times by security forces. These crackdowns aimed at identifying the places operating without a business license and stopping access to "unhealthy" websites, especially for children. Internet cafés must receive a business license and register with the local Office for Public Security, and also have to hire appropriate personnel to oversee the activities of their customers. Customers are supposed to show an ID and register.[54] According to regulations issued in May 2001, Internet cafés are required to be located at least two hundred meters from government offices, army units, and party organizations, as well as primary and middle schools.[55] "Cleansing" campaigns have been launched frequently since 2001. By closing down small (often illegal) Internet cafés and leaving chains of registered Internet cafés to dominate the scene, the authorities try to make sure that the remaining big players act in accordance with regulations.

The international watchdog organization Reporters Without Borders has called China "the world's biggest prison for cyber-dissidents."[56] Until mid-2001, between ten and twenty people had been arrested and

[52] In September 2005, this website (http://net.china.com.cn) was still operative. Apparently the site drew more than sixteen thousand reports within the first weeks. See "Despite an Act of Leniency, China Has Its Eye on the Web."

[53] See "Should Internet Cafes Be Closed?"

[54] See "China Issues New Regulations for Internet Cafes"; "China's Beijing Cracks Down on Internet Cafes."

[55] See Michael Ma, "Beijing Gets Tough on Internet Bar and BBS Operators."

[56] See "China," *Reporters Without Borders*, June 26, 2004, http://www.rsf.org/print.php3?id_article=10749 (accessed June 23, 2004).

sued for more or less "political" offences committed in cyberspace.[57] By early May 2004, the number of Internet users in detention had gone up to sixty-one. In 2007, fifty-one cyber-dissidents were presumed to be in jail.

The first actual conviction known involved a businessman in Shanghai who had sold thirty thousand e-mail addresses in China to an organization in New York in early 1998. The New York–based organization distributed the prodemocratic newsletter *VIP Reference* (*Dacankao* 大参考) via e-mail in China, and among the involuntary recipients of this service were some high party officials. Lin Hai (林海), who explained his deed as strictly profit driven, was sentenced to two years, but was released before serving his full term.[58] The following examples show that most cases fall under the category of publishing or posting banned contents on the Internet:

- Huang Qi (黄琦) established a website (www.6–4tianwang.com) (*tianwang* 天网) for relatives of missing persons, and he even received official praise for successfully clearing up some cases of abduction. However, when contributions commemorating the events of June 3–4, 1989, in Tiananmen Square—a topic still taboo for public discussion—appeared under his Web address, the authorities closed down the Web site and arrested its operator. Huang was accused of trying "to subvert the government and to destroy national unity."[59]
- A case widely reported by Western media was the detention of student Liu Di (刘荻, pen name or *biming* 笔名 "Stainless Steel Mouse" [*buxiugang laoshu* 不锈钢老鼠]), who was held without trial for one

[57] "Political" is meant here in contrast to cases that violate financial regulations—illegal appropriation by breaking into banking networks, for example. The number of cases varies depending on the source used. Qiu, "Internet Censorship in China (1999–2000)," states that, because of the increase in specialized police units and deployment of new technologies, thirteen people were arrested between summer 1999 and the end of 2000, while only one person was arrested in the years prior to that date. According to A. Lin Neumann, "The Great Firewall," altogether seven people were arrested for Internet "crimes" between 1998 and 2000. A *Human Rights Watch Backgrounder*, published in July 2001, lists fifteen individuals detained for posting material on the Internet; see "Freedom of Expression and the Internet in China."

[58] See "The Cracker War on China"; Farrall, "Whither the China Net?"; "Chinese Engineer Who Helped Dissident Newsletter Is Freed." The complete archive of *Dacankao* can be found at http://www.bignews.org/.

[59] See "Trial of Internet Entrepreneur Starts in Chengdu." On this case, see also "Chinese Webmaster to Be Tried February 13"; "'6–4' Web Site Creator Put to Subversion Trial in Sichuan."

year for posting controversial contributions on the Internet. She was finally released in November 2003.[60] In mid-2004, Du Daobin (杜导斌), who had also posted critical articles on the Internet and come out in support of "Stainless Steel Mouse," was sentenced to four years on probation for "subverting state power."[61] In April 2005, a Chinese journalist was sentenced to a ten-year prison term for e-mailing an internal document of the Communist Party to foreign Web sites. This case caused a stir outside China because the Hong Kong branch of the American Internet company Yahoo! was suspected of having helped the Chinese authorities to identify the person in question by handing over user data.[62]

From the perspective of the Chinese government, the spiritual movement Falun Dafa (法轮大法, also known as Falungong 法轮功) has become the most prominent example of the subversive potential of the Internet. The group, whose spiritual leader lives in the United States, propagates its ideas on a number of Web sites outside China. Electronic means of communication like e-mail reportedly played a central role in secretly planning and organizing a mass demonstration by Falungong members. Held in April 1999 right in front of Zhongnanhai 中南海, the center of power in Beijing, this demonstration apparently caught the Chinese leadership by total surprise. After the demonstration in Beijing, Falun Dafa was declared illegal in China. A campaign was launched to criticize the movement. In addition to this traditional campaign, cyberspace became one of the battlefields on which the Chinese authorities fought against Falun Dafa.[63]

To meet the new challenges of the digital age in terms of personnel, special police units were organized, first in Anhui province in August 2000, then in other Chinese regions and cities as well. The central tasks of these forces are the fight against cyber-crime, information

[60] On Liu Di's case, see Yardley, "A Chinese Bookworm Raises Her Voice in Cyberspace."

[61] "Public Opinion in China."

[62] See "Yahoo 'Helped Jail China Writer.'" The verdict in the case cites the data received from Yahoo! as evidence; see Reporters Without Borders for the English translation. For the full text of the verdict in Chinese, see Independent Chinese PEN Center.

[63] See Craig S. Smith, "Falun Dafa Defies Authority by Preaching in Cyberspace," 1, 6; Buruma, "China in Cyberspace," 9–12; "Falun Dafa and the Internet"; "Government, Falun Gong Followers in Internet Battle."

technology (IT) security–such as information and consulting on computer viruses—and "keeping order" on the Internet.[64] According to estimates, the ranks of this cyber-police force might have reached about thirty- to forty thousand personnel by 2004.[65] Although Western media tend to interpret all these moves as efforts to control and censor electronic communication and access to information for political and ideological reasons, we should not totally dismiss the official Chinese argument that fighting crime in cyberspace, protecting children from developing harmful habits, and preventing addictions to gambling might actually also play a role.[66]

Deterrence and Self-Censorship: State vs. "Privatized" or Commercialized Control

"Security" in the realm of IT is, as Olaf Winkel has pointed out, foremost a matter of perception. The perception of security does not depend on hard- and software ("objective security") alone; it is also influenced by factors like trust and knowledge ("subjective security"). Combined, these make up the two dimensions of security that also play an important role in how well security technology is accepted.[67] Winkel discerns four features of IT security—accessibility/availability, integrity, binding force, and the confidentiality of information and communication—all of which have to be considered reliable and trustworthy by the users.[68]

Boyle's argument cited above—that technological solutions, if entities other than states are co-opted to deploy them, are less likely to

[64] See A. Lin Neumann, "The Great Firewall"; "Internet Police Ranks Swell to 300,000."

[65] See "Despite Acts of Leniency, China Has Its Eye on the Web." For comparison: As a consequence of the terrorist attacks of September 11, 2001, the United States established a special division of several thousand personnel for preventing cyber-attacks under the Department of Homeland Security, based on the *National Strategy to Secure Cyberspace* issued by President George W. Bush in February 2003. For a description of its priorities, see the U.S. Department of Homeland Security Web site: "Fact Sheet: Protecting America's Critical Infrastructure—Cyber Security"; also "Ridge Creates New Division to Combat Cyber Threats."

[66] A service for parents offered by ChinaTelecom that allows screening the online behavior of children has quickly gained popularity. See "Internet Screening Technology Popular among Chinese Parents."

[67] See Winkel, "Sicherheit in der digitalen Informationsgesellschaft," 19–30 (21).

[68] Ibid., 22.

be perceived as state intervention or coercive measures, and therefore ignite hardly any protest—may well be valid in Western democracies. The majority of Internet users in the United States and Europe likely have never seriously considered whether the technological capabilities for storing user data and surveillance exist, and how they are implemented. And neither do they care too much, since a certain amount of "trust capital" comes into play with respect to modern information technologies. Even if the individual user thinks about the electronic traces he or she might leave in cyberspace, one would normally not assume that these traces could have any legal, not to mention penal consequences.

In an authoritarian state, where citizens have lived with censorship for decades, the issue might present itself in a different light. Doubts with respect to availability, not to mention confidentiality of information on the Internet, would suggest a lack of trust capital and a large amount of insecurity concerning the capacities of the state (and its helpers) in surveying the Internet. This perception would then lead, at least with the majority of users, to behavior conforming to the rules— just as in the "panopticon" described above, in which the inmates do not know exactly *when* they are watched, but nevertheless assume *that* they are watched.

The majority of censorship measures in Chinese cyberspace are rather unspectacular and operate on a level far below arrests and prison sentences. However, even if police forces and courts only become active sporadically, their measures can constitute an effective deterrent by demonstrating that unruly behavior is, after all, fraught with risk. Thus, an attitude of "voluntary" self-control and self-censorship, a "firewall within one's head,"[69] is encouraged and nurtured. Laws and regulations in China are not necessarily implemented and enforced in a strict sense, and this applies to the Internet as well. Due to the vagueness of the terms used, the list of forbidden contents leaves a lot of room for interpretation. Depending on the political situation and the ideological climate, they can be implemented in a looser or a stricter sense. Practically every piece of information can, for example, be declared a "state secret" in China, even seemingly

[69] This "inner firewall" was explicitly advocated in an article on the Web site of *People's Daily*. See "Party Daily Calls for Action against Internet Pollution."

harmless statistical data on the last grain harvest.[70] In this way, laws supplement more subtle means of control.

Internet companies that do not want to risk their market position are well advised to play by the rules set by the state. The majority of comments by managers of Web portals after the publication of the regulations in 2000 expressed clearly that the new directives held no surprises. Practically all ICPs had been well prepared: "The bottom line: the new regulations don't make anyone happy, but they're completely expected and in line with other Chinese government policies. Anyone who was not already in de facto adherence with the policies was being very naive."[71] Drafts of the provisions had been circulated, and the Internet providers had hurried to obey even before they came into force. The Internet Society of China (Zhongguo hulianwang xiehui 中国互联网协会) initiated a "Public Pledge on Self-Discipline for the Chinese Internet Industry" (Zhongguo hulianwang hangye zilü gongyue 中国互联网行业自律公约) in early 2002; this was immediately signed by more than one hundred ISPs and ICPs.[72] In 2007, Internet companies, including Yahoo and MSN, signed the "China Internet Industry Self-Discipline Pact" (Boke fuwu zilü gongyue 博客服务自律公约), which strongly encouraged an end to anonymity for bloggers.[73]

However, Internet companies in China may still find themselves on a tightrope between their customers and the government. As an American representative of the Chinese-language portal Sina.com put it: "We are playing that role, to let people talk about sensitive issues,

[70] See "Bureau for the Protection of State Secrets (State Secrets Bureau)." The State Secrets Law was enacted in 1988. "Provisions Governing the Implementation of the State Secrets Law of the People's Republic of China" was issued in 1990; for the Chinese text, see [State Secrets Bureau,] "Zhonghua renmin gongheguo baoshou guojia mimi fa shishi banfa." The regulations define under what circumstances information is considered a state secret. One of the points listed here refers to information that "undermines consolidation and defense of the State's political power and which influences the unity of the State, ethnic unity and social stability" (538).

[71] For commentary of a representative of a Web portal, see A. Lin Neumann, "The Great Firewall." See also Cowhig, "New net rules not a nuisance?"

[72] The Internet Society of China was founded in May 2001 with one hundred thirty members. For the full text of the "Public Pledge on Self-Discipline for the Chinese Internet Industry," see "Zhongguo hulianwang hangye zilü gongyue"; for an English translation see http://www.bobsonwong.com/index2.php?option=content&task=view&id=63&pop=1&page=0.

[73] Melissa Wang, "CHINA: Internet Society of China Releases a Code of Conduct for Web Bloggers."

but also to help the government manage the flow of ideas."[74] Due to the vague wording of the regulations and their incoherent or arbitrary enforcement, Internet companies have to deal with the problem of where to draw the line between what is tolerable and what is illegal.

The methods of self-censorship used in China by ICPs offering BBS or chat rooms cover practically the whole array described by Boyle. Filter software that can block access to a certain Web site or set off an alarm if a site contains the word "nipple" or a synonym can, of course, be programmed to do the same when the name of a Taiwanese politician or "Falungong" appears in the posting for a BBS. This is exactly what characterizes technology as "neutral."

Western companies are eager to supply the Chinese market with the appropriate software and technology. Their firewall software and other technical solutions are suited to protect police networks from hacker attacks, as well as to screen millions of electronic messages for keywords. Ironically, the Western media frequently criticize China for crippling the Internet and obstructing its development, while Western companies supply the technological means that enable China to do exactly this.[75]

Search engines are powerful tools that strongly influence the kinds of information one can get. The Chinese version of the search engine Yahoo! apparently complied from the beginning with the demands of the Chinese authorities by filtering search results in order to get a foot into the Chinese market. By contrast, the Chinese establishment blocked access to Google in 2002. In fall 2004, however, reports stated that Google News had signed up with the Chinese authorities and agreed to block certain search results from being displayed if accessed from within China, while listing these very same results when accessed from other countries. Apparently, the search engine identifies IP addresses of the accessing personal computer (PC) and relates them to the country of origin, so that it displays different results depending on whether a Google search in Chinese originates from France, the United States, Taiwan, or somewhere within China.[76]

[74] Cited in McGill, "Sina.com's Delicate Balancing Act."

[75] E.g., Cisco Systems supplies China with routers that allow Chinese authorities to locate dissident users. See "United States." Jill R. Newbold recommended that Congress should end this involvement of U.S. companies in China's Internet censorship in "Aiding the Enemy."

[76] See Liedtke, "Google's Chinese News Service Omits Government-Banned Sites." The Google Team issued a statement on this practice on September 27, 2004: "[...]

Chinese companies have also developed special surveillance and
filter software.[77] In 2004 a list was published containing words and
terms that are blocked in China by the instant messaging software QQ.
The list came with the installation package of QQ for individual PCs.
About 15 percent of the words were related to sex, the rest to politics.
The latter included terms concerning Falungong, names of high offi-
cials, and issues of nationalism (Taiwanese and Tibetan independence)
and political discourse (concerning democracy).[78]

In addition to technological solutions, ISPs and ICPs employ spe-
cial personnel ("Big Mamas" [Dama 大妈]). They take a close look
at the postings and contributions that the filter software identifies as
suspicious, simply deleting them if necessary. Which postings go into
the Net (and stay there) and which do not thus depends on a series
of factors, not the least of which is the personal decisions of the web-
masters.[79] One important form of "punishment" is that information
violating the rules is simply eliminated from the Net—with no expla-
nation. Webmasters and system administrators can, moreover, criticize
or reprimand authors for posting controversial contributions. If the
offense is repeated, the IP address or registered name of the person in
question can be permanently blocked, so their virtual existence is ter-
minated.[80] On the level of ISPs and ICPs, punishments are virtual and
are meted out in cyberspace; real-world punishment (fines or arrests)
of the person posting information does not take place. However, this
virtual punishment also draws its credibility and deterrent effect from
the possibility of more serious sanctions in cases that are considered
grave violations. "Real-world punishments thus function mostly as
potential deterrence rather than direct penalty like message eradica-

links to stories published by blocked news would not work for users inside the PRC—if
they clicked on a headline from a blocked source, they would get an error page. It
is possible that there would be some small user value just in seeing the headlines.
However, simply showing these headlines would likely result in Google News being
blocked altogether in China." See "China, Google News, and source inclusion."

[77] On the implications of Chinese dependency on foreign soft- and hardware for
national security, see Christopher R. Hughes's article on cyber-warfare, "Fighting the
Smokeless War: ICTs and International Security."

[78] See Xiao Qiang, "The Words You Never See in Chinese Cyberspace."

[79] A representative of Sohu.com described the approach as follows: "We go with
our intuition [...] If something makes us uncomfortable, we nix it." See Marshall and
Kuhn, "China Goes One-on-One with the Net."

[80] For a detailed description of this method see Wenzhao Tao, "Censorship and
Protest: The Regulation of BBS in China's *People's Daily*"; Qiu, "Virtual Censorship
in China."

tion, which hurts only the virtual existence of the netizens rather than their tangible life."[81]

Topics that are banned from public discussion are Falungong, explicit criticism of China's leaders and—despite some moves to reverse this verdict—the events in Tiananmen Square in 1989. As for current events such as scandals concerning official corruption, which trigger debate in cyberspace, a decision is made on a case-by-case basis.[82] Censors seem to be more tolerant of online comments criticizing international incidents than those taking on domestic affairs. The Internet provides a welcome and officially tolerated outlet for nationalistic sentiments,[83] as long as the postings are not directed against the Chinese government or conflict with official state policies. The proliferation and popularity of nationalistic Web sites in China should dampen Western expectations that one "liberalizing" effect of the Internet will be increased criticism of the state by Chinese netizens.

Counterstrategies

As has been noted above, legal provisions in China are often not strictly enforced, and Internet cafés commonly operate without a business license, making them less likely to insist on proper identification and registration of their customers. And of course Chinese Internet users, too, have found means and methods to outsmart government-prescribed blockades and restrictions. They can, for example, go through proxy servers abroad in order to get access to blocked Web addresses. (The user accesses the proxy server, which then connects to the site in question while the user remains anonymous and the blocking device still "believes" him to be connected to the proxy server.) Lists of IP addresses of such proxy servers are reportedly distributed among Internet users in China, often via e-mail. However, these IP addresses can be blocked as well. Moreover, there have been rumors that the security offices circulate false IP addresses, so that efforts to

[81] Qiu, "Virtual Censorship in China."

[82] See Wenzhao Tao, "Censorship and Protest." See also the study on censorship of blogs by MacKinnon, "China's Censorship 2.0."

[83] On the question of Chinese nationalism on the Internet see Hughes, "Nationalism in Chinese Cyberspace"; Kluver, "New Media and the End of Nationalism."

outsmart the blockades could end up directly at one of the Offices for Public Security.[84]

Employing the methods of government circumvention described above requires a certain level of technical knowledge and sophistication. Even users who possess this kind of expertise have to ask themselves whether they are willing to live with the residual risk involved in using these methods. Several points should be taken into consideration within this context. According to official statistics in China, the main reasons people there access the Internet are information, education, and entertainment. Although the lack of Chinese-language information on the Net was one of the most frequent complaints in the first surveys on Internet usage in China, beginning in 1997, this issue has faded in importance over time. Solutions to this problem have come, not least, from initiatives launched by the state and party themselves: the "government online" project as well as the state-sponsored Web presence of "traditional" media. With the expansion and improvement of information and entertainment in the Chinese language placed online by providers with strong links to the state and party, users' need to look for alternative sources and activities in cyberspace is clearly reduced.

Therefore, a more general question might also be: How large is the interest of the average Chinese Internet user in gaining access to information and activities that could be deemed politically subversive? A German research project, "Chinese Identities in the Internet," analyzed contributions to four popular Chinese bulletin boards on lifestyle, partnership, and society over several months. It came to the conclusion that Internet users have a good sense of how far they can go. Like statements on matters of personal life, political postings in cyberspace serve the goals of identity building, albeit in an individualized and fragmented way.[85] More such studies and in-depth analyses are necessary for a clearer picture of online behavior in China, how the different forms of electronic communication are used, and how this activity relates back to the off-line world. Statements of youths

[84] Mentioned in Qiu, "Internet Censorship in China"; Judy M. Chen, "Willing Partners to Repression?"

[85] "Chinese Identities in the Internet" is found at http://www.chinabbsresearch.de/. A brief summary of the results was published in German; see Giese, "Freier Diskurs oder perfekter Überwachungsstaat?"

and students suggest that they see gaining access to blocked sites as a kind of game.[86] The political content of the sites is not the core interest in this game, and these users do not exhibit overwhelming interest in politics in general.[87] Only for groups like Falun Dafa can we assume a motivation that is strong enough to put at risk not only one's virtual, but also one's actual, existence by being discovered and punished, and such groups operate outside the law in China anyway.

Reports and comments in Western media communicate the impression of cyberspace in China as a battleground in a war between a repressive party-state and Internet users constantly posting, or hunting for, politically subversive information. This view, however, narrows our perspective to a very small, and so far most likely not very significant, group of China's netizens.

Is Resistance Futile? A Preliminary Conclusion

The Internet in China might not be protected from each and every form of subversive usage by insurmountable "digital fences," but efforts at control and censorship are by no means ineffective. In China, effective control and censorship is accomplished by the interplay between state institutions and commercial entities such as ISPs, ICPs, and official media. By practicing self-censorship and executing duties of surveillance and supervision assigned to them by the state, Internet providers at least in part relieve the state of the tasks of control and censorship. The state supports and complements these efforts by developing suitable laws and, if necessary, making an example of an offender, thereby increasing the authority of the measures taken by Internet providers and creating deterrence. All these efforts become possible through the technological embedding of control into the architecture of the Internet itself, an act not specific to China, but mainly the result of the commercialization of the Web worldwide.

However, freedom for the expression of personal opinions in China has undoubtably expanded since the late 1970s, when the post-Mao

[86] See Daria Berg's essay, "Consuming Secrets Online," in this volume for the observation that official bans of literature contribute to authors' reputations and the circulation of their work.

[87] See Neumann, "The Great Firewall."

reform policy started, even if there have been intermittent phases of contraction. This expansion applies to the social as well as the economic and political spheres.[88] What can be said of other media in China is true for the Internet as well: the borders between critical remarks that are tolerated or even welcomed, and those considered subversive, are not fixed. Rather, those boundaries are always being tested and negotiated. Since discussions in cyberspace are mostly anonymous (under an alias or *biming*) and the sanctions mostly virtual, the Internet, in contrast to other media, opens a window for relatively free expression of opinions in a quasi-public space.

The Internet by itself will hardly trigger a democratic or other mass movement in China. "Technological determinism"—in the sense that a specific technological development predetermines specific social changes—cannot be equated with the Internet. The Internet might ignore territorial boundaries or surmount them without much effort (although even this capacity has changed), but this technological feat does not mean that the Internet exists in a social and political vacuum, detached from and independent of its environment.[89]

If, however, a social or political movement emerges in the nonvirtual world, electronic communication media—mobile phones, SMS (Short Message Service) (*duanxin* 短信), blogs, e-mail—will, thanks to their speed in distributing news, support, facilitate, and accelerate the process of organizing and connecting people. Thanks to the new communications technologies, information on events, such as accidents, cannot be kept local and suppressed easily. Outside of criminal cyber-activities, the Internet offers people in China a quasi-public space with improved access to information and greater chances for participation. The Internet has strengthened the force of public opinion in China, as is evident from the number of recent cases in which popular reaction expressed online helped to exert pressure on the authorities to act or to revise

[88] A public discussion on issues like homosexuality or AIDS, as can be found today on electronic forums, would have been unthinkable some years ago.

[89] See Shapiro, "The Internet," 15: "We must also consider the way a technology is used and the social environment in which it is deployed. Taking all three of these factors into account—design, use, and environment—it should be clear that the Internet may suppress as well as promote democracy." The Internet, based on the sheer amount and multitude of information and opinions it transmits, might not even lead to more openness or tolerance vis-à-vis dissident views, or to more pluralism. Quite the contrary, as Shapiro points out (25), the multitude of Internet users, with widely diverging interests and opinions, could make possible the creation of one's own "global village," populated only by like-minded people.

decisions. The Internet and other means of electronic communication might not directly undermine the authoritarian regime—indeed, they might at times even strengthen it—but they can nevertheless be carriers for social change. The question of *whose* resistance is futile—the party-state's or the Internet users'—has not yet been decided.

COMPREHENSIVE BIBLIOGRAPHY

AFP. "China to Pick 'Healthy' Internet Games for Young People." September 2004. http://www.findarticles.com/p/articles/mi_kmafp/is_200409/ai_n6863201/ (accessed October 27, 2009).

Anderson, Benedict. *Imagined Communities, Reflections on the Origin and Spread of Nationalism.* New York: Verso, 1991.

Andrews, Julia F., and Kuiyi Shen. "The New Chinese Woman and Lifestyle Magazines in the Late 1990s." In Link, Madsen, and Pickowicz, *Popular China,* 137–162.

Apter, David E. "Discourse as Power: Yan'an and the Chinese Revolution." In Saich and van de Ven, *New Perspectives on the Chinese Communist Revolution,* 193–234.

Archives Françaises de la Compagnie de Jesus (AFCJ), Vanves.

Arens, Bernard. *Das katholische Zeitungswesen in Ostasien und Ozeanien.* Aachen: Xaverius, 1918.

Bailey, Paul J. *Gender and Education in China, Gender Discourses and Women's Schooling in the Early Twentieth Century.* New York: Routledge, 2007.

Band, Claire, and William Band. *Two Years with the Chinese Communists.* New Haven: Yale University Press, 1948.

Banly Zhang 笨狸. "Zhi wen cheng wang" [Weaving literature into a web]. http://www.xys.org/xys/netters/zwcw.txt (accessed July 7, 2004).

Bao Tianxiao 包天笑. "Shiping er" 時評二 [Second short comment]. *Shibao,* September 1, 1911.

Bao Ziyan 包子衍. "1928 nianjian Shanghai de shudian" 1928 年间上海的书店 [Publishers in 1928 Shanghai]. In Song Yuanfang, *ZCSXB,* vol. 1, pt. 2: 444–447.

Barmé, Geremie R. *Shades of Mao: The Posthumous Cult of the Great Leader.* Armonk, NY: M. E. Sharpe, 1996.

——. *In the Red: On Contemporary Chinese Culture.* New York: Columbia University Press, 1999.

——. *An Artistic Exile: A Life of Feng Zikai.* Berkeley: University of California Press, 2002.

Barry, Virginia. *Red—The New Black: China–UK Publishing.* London: Arts Council England, 2007.

Bastid, Marianne. *Educational Reform in Early Twentieth-Century China.* Translated by Paul Bailey. Ann Arbor: Center for Chinese Studies, University of Michigan, 1988.

Bays, Daniel. "Christian Tracts: The Two Friends." In *Christianity in China: Early Protestant Missionary Writings,* edited by Suzanne Wilson Barnett and John King Fairbanks, 19–34. Cambridge, MA: Harvard University Press, 1985.

Beckmann, Johannes. *Die katholische Missionsmethode in China in neuester Zeit (1842–1912): Geschichtliche Untersuchung über Arbeitsweisen, ihre Hindernisse und Erfolge.* Immensee: Calendaria, 1931.

"Benbao gaige yaoyan" 本報改革要言 [Important words on the reform of our paper]. *Shenbao,* August 25, 1911.

"Benguan tebie gaobai" [Special announcements from our office]. *Shibao,* February 21, 1907.

Bennett, Adrian A. *Missionary Journalist in China: Young J. Allen and His Magazines, 1860–1883.* Athens: University of Georgia Press, 1983.

Benton, Gregor, ed. and trans. *An Oppositionist for Life, Memoirs of the Chinese Revolutionary Zheng Chaolin.* Atlantic Highlands, NY: Humanities Press, 1997.

Berg, Daria. *Portraying China's New Women Entrepreneurs: A Reading of Zhang Xin's Fiction*. Durham: Department of East Asian Studies, 2000.
——. *Carnival in China: A Reading of the* Xingshi yinyuan zhuan. Leiden: Brill, 2002.
——. "Female Self-Fashioning in Late Imperial China: How the Gentlewoman and the Courtesan Edited Her Story and Rewrote Hi/story." In *Reading China: Fiction, History and the Dynamics of Discourse. Essays in Honour of Professor Glen Dudbridge*, edited by Daria Berg, 238–289. Leiden: Brill, 2007.
——. "Publishing Industry." In *Encyclopedia of Modern China*, edited by David Pong et al., 220–225. Detroit, MI: Charles Scribner's Sons, 2009.
"Bian hou yu yan" 編後餘言 [Afterword]. *Zhejiang qingnian* 浙江青年 [Zhejiang youth] 1, no. 5 (March 1935).
Bianji tongren 編輯同人 [Fellow editors]. "Fakanci" 發刊詞 [Inaugural preface]. *Jingzhong xuesheng qikan* 敬中學生期刊 [Periodical of Jingye Middle School's students]. Chuangkanhao 創刊號 [Inaugural issue] (n.d.).
Birnbaum, Raoul. "Master Hongyi Looks Back: A Modern Man Becomes a Monk in Twentieth-Century China." In *Buddhism in the Modern World: Adaptations of an Ancient Tradition*, edited by Steve Heine and Charles S. Prebish, 75–124. Oxford: Oxford University Press, 2003.
Blader, Susan. "Introduction." In *Tales of Magistrate Bao and His Valiant Lieutenants*, i–xlvi. Boorman, Howard L., ed. *Biographical Dictionary of Republican China*. 5 vols. New York: Columbia University Press, 1967–79. (Abbreviated as *BDRC*.)
Borthwick, Sally. *Education and Social Change in China: The Beginnings of the Modern Era*. Stanford, CA: Hoover Institution Press, Stanford University, 1983.
Bourdieu, Pierre. *Distinction: A Social Critique of the Judgement of Taste*. Translated by Richard Nice. Cambridge, MA: Harvard University Press, 1984.
——. *The Logic of Practice*. Translated by Richard Nice. Stanford, CA: Stanford University Press, 1990.
——. *Language and Symbolic Power*. Edited by John Thompson. Cambridge, MA: Harvard University Press, 1991.
——. *The Field of Cultural Production: Essays on Art and Literature*. Edited and translated by Randal Johnson. New York: Columbia University Press, 1993.
——. *The Rules of Art: Genesis and Structure of the Literary Field*. Translated by Susan Emanuel. Stanford, CA: Stanford University Press, 1996.
Boyle, James. "Foucault in Cyberspace: Surveillance, Sovereignty, and Hard-Wired Censors." 1997. Duke Law Faculty Scholarship. Paper 619. http://scholarship.law.duke.edu/faculty_scholarship/619 (accessed November 6, 2000).
Bristow, Michael. "Who Owns Mao's Millions?" BBC News, December 29, 2007. http://news.bbc.co.uk/2/hi/asia-pacific/7163445.stm (last accessed June 19, 2009).
Britton, Roswell S. *The Chinese Periodical Press 1800–1912*. Shanghai: Kelly & Walsh, 1933. Reprint, Taipei: Ch'eng-Wen, 1976.
Brokaw, Cynthia J. *The Ledgers of Merit and Demerit: Social Change and Moral Order in Late Imperial China*. Princeton, NJ: Princeton University Press, 1991.
——. "Commercial Publishing in Late Imperial China: The Zou and Ma Family Businesses of Sibao, Fujian." *Late Imperial China* 17, no. 1 (June 1996): 49–92.
——. "On the History of the Book in China." In Brokaw and Chow, *Printing and Book Culture in Late Imperial China*, 3–54.
——. "Reading the Best-Sellers of the Nineteenth Century." In Brokaw and Chow, *Printing and Book Culture in Late Imperial China*, 184–234.
——. "Book History in Premodern China: The State of the Discipline I," *Book History* (Fall 2007): 253–290.
——. *Commerce in Culture: The Sibao Book Trade in the Qing and Republican Periods*. Cambridge, MA: Harvard University Asia Center, 2007.

——. "Regional Publishing and Late Imperial Scholarship: The Zunjing shuyuan of Chengdu and Scholarly Publication in Late-Qing Sichuan." Paper presented at the conference "Imprimer sans profit? Le livre non commercial dans la Chine imperial," Paris, France, June 12, 2009.

Brokaw, Cynthia J., and Kai-wing Chow, eds. *Printing and Book Culture in Late Imperial China*. Berkeley: University of California Press, 2005.

Brook, Timothy. "Censorship in Eighteenth-Century China: A View from the Book Trade." *Canadian Journal of History* 22 (August 1988): 177–196.

——. *The Confusions of Pleasure: Commerce and Culture in Ming China*. Berkeley: University of California Press, 1998.

Brossollet, Guy. *Les Français de Shanghai, 1849–1949*. Paris: Bellin, 1999.

Brunhes, J. "Les travaux des Jésuites à l'observatoire de Zi-ka-wei." *Revue d'histoire des missions* 1 (1924): 26–38.

Buruma, Ian. "China in Cyberspace." *The New York Review of Books* 46, no. 17 (November 4, 1999): 9–12.

Cadafaz de Matos, Manuel. *História da imprensa e da circulação das ideias religiosas na China entre os anos de 1892 e 1938: a imprensa do Orfanato de T'ou-sè-wè, em Zi-Ka-Wei, Xangai e a colecção Variétés Sinologiques na sua 1a fase*...Lisbon: Centro de estudos de historia do livro e da edição, 2004.

Cai Huiming 蔡惠明 and Yu Wangmei 郁望梅. "Jueyuan yu Zhongguo fojiao" 觉园与中国佛教 [The Bodhi garden and Chinese Buddhism]. In *Ershi shiji Shanghai wenshi ziliao wenku*.

Cai Shuliu 蔡漱六. "Beixin shuju jianshi" 北新书局简史 [A brief account of the Beixin Press]. *Chuban shiliao* 出版史料 [Historical publishing materials] 2 (1991): 91–92.

Cai Youmei 蔡友梅. "Xiao E" 小额. In *Zhongguo jindai wenxue yanjiu* 中國近代文學研究 [Research in modern Chinese literature]. 2 vols. Guangzhou: Guangdong renmin chubanshe, 1983–85.

——. "Kuduanyan" 庫緞眼 [The Snob]. In Yu Runqi, *Qing mo Min chu xiaoshuo shuxi*, 510–546.

——. "Cao Erjing [Ergeng]" 曹二更 [Midnight Cao]. In Yu Runqi, *Qing mo Min chu xiaoshuo shuxi*, 626–672.

Cao Sibin 曹思彬, Lin Weixiong 林维熊, Zhang Zhi 张至, eds. *Guangzhou jinbainian jiaoyu shiliao* 广州近白年教育史料 [Historical materials on the last century of education in Guangzhou]. 广州文史资料专辑 [Special issue, Materials on Guangzhou culture and history]. 1983.

Cao Xueqin 曹雪芹. *Honglou meng* 红楼梦 [Dream of the red chamber]. Beijing: Renmin wenxue chubanshe, 1972.

"Catalogue of Publications by Protestant Missionaries in China," [being] An Appendix to Inspector General of Chinese Maritime Customs, *Catalogue of the Chinese Imperial Maritime Customs Collection at the United States International Exhibition* [Philadelphia]. Shanghai: Inspectorate General of Customs, 1876.

Catalogus librorum lingua sinica scriptorum (qui prostant in Orphanotrophio T'ou-sè-wè). Zi-ka-wei prope Changhai: Ex Typographia Missionis catholicae, 1904.

Catalogus librorum lingua sinica scriptorum: Shanghai Cimu Tang yinshuguan jingshu jiamubiao 上海慈母堂印書館經書價目表. Zi-ka-wei prope Changhai: Ex Typographia Missionis catholicae, 1909, 1917, 1927.

Catalogus librorum lingua sinica scriptorum. Zi-ka-wei prope Changhai: Ex Typographia Missionis catholicae, 1934.

Catalogus librorum venalium in Orphanotrophio Tou-sai-vai prope Chang-hai ex typographia missionis Catholicae. Jingshu zongmu 經書總目. Ex Typographia Missionis catholicae, 1876.

de Certeau, Michel. *The Practice of Everyday Life*. Translated by Steven Randall. Berkeley: University of California Press, 1988.

Cha, Ariana Eunjung. "Bye-Bye Borderless Web: Countries Are Raising Electronic Fences." *International Herald Tribune*, January 5, 2002. [http://www.iht.com].

Chan, Sin-wai. *Buddhism in Late Ch'ing Political Thought*. Hong Kong: Chinese University of Hong Kong Press, 1985.

Chan, Vivien Pik-Kwan. "Beijing in Hard Drive to Patrol Net Users." *SCMP*, January 18, 2002. [http://www.scmp.com].

Chan, Wing-tsit. *Religious Trends in Modern China*. New York: Columbia University Press, 1953.

Chang Kangpin 常康平. "Jinling kejingchu de bianqian" 金陵刻经处的变迁 [The evolution of the Jinling scripture engraving house]. In *Jiangsu wenshi ziliao jicui*.

Chanse, Michael S., and James C. Mulvenon. *You've Got Dissent! Chinese Dissident Use of the Internet and Beijing's Counter-Strategies*. Santa Monica, CA: Rand, 2002.

Charbonnier, Jean. *Histoire des Chrétiens de Chine*. Paris: Les Indes savantes, 2002.

Chartier, Roger, ed. *The Culture of Print, Power, and the Uses of Print in Early Modern Europe*. Princeton, NJ: Princeton University Press, 1987.

——. "Communities of Readers." In *The Order of Books: Readers, Authors, and Libraries in Europe between the Fourteenth and Eighteenth Centuries*, translated by Lydia G. Cochrane, 1–24. Stanford: Stanford University Press, 1994.

——. "Gutenberg Revisited from the East." *Late Imperial China* 17:1 (June 1996): 1–9.

Chen Baixi 陳百希. *Tamen yingxiang le shijie* 他們影響了世界 [They influenced the world]. Taipei: Guangqi she, 1961.

Chen Binhe 陳彬龢, ed. "Zixu" 自序 (Preface). *Shenbao pinglun xuan* 申報評論選 [Selections from *Shenbao* editorials]. Shanghai: Shenbao guan, 1932.

Chen Bing 陈兵 and Deng Zimei 邓子美. *Ershi shiji Zhongguo fojiao* 二十世纪中国佛教 [Twentieth-century Chinese Buddhism]. Beijing: Minzu chubanshe, 2000.

Chen Fukang 陈福康. *Zheng Zhenduo zhuan* 郑振铎传 [Biography of Zheng Zhenduo]. Beijing: Shiyue wenyi chubanshe, 1994.

Chen Gaoyong 陳高傭. "Zhejiang qingnian yu Jiangsu yanjiu" 浙江青年與江蘇研究 [Zhejiang youth and Jiangsu research]. *Zhejiang qingnian* 浙江青年 [Zhejiang youth] 1, no. 12 (October 1935): 125–126.

Chen, Gary. "China's Booming Internet Sector: Open or Closed to Foreign Investment?" ChinaOnline, October 8, 1999. [http://www.chinaonline.com] (accessed April 19, 2001).

Chen, Gary, and Dennis A. Britton. "China to Allow ICPs to Report Their Own News." ChinaOnline, April 24, 2000. [http://www.chinaonline.com] (accessed April 25, 2000).

Chen Gongmao 陈公懋. "Xuan Zhonghua 'Sha Xuantong' yiwen 宣中华 '杀宣统' 一文" [Xuan Zhonghua's piece "Kill the Xuantong Emperor"]. In *Zhejiang geming shiliao teji (Wu): Zhejiang geming qingnian yundong zhuanji. Zhejiang wenshi ziliao xuanji* 浙江革命史料特辑 (五): 浙江革命青年运动专辑; 浙江文史资料选辑 [Special edition of Zhejiang revolutionary cultural and historical materials, 5: Specialized edition of Zhejiang revolutionary youth movement. Selections from "Zhejiang Cultural and Historical Materials] 19 (1981).

Chen-Hua. *In Search of the Dharma: Memoirs of a Modern Chinese Buddhist Pilgrim*. Edited by Chun-fang Yu. Translated by Denis C. Mair. Albany: State University of New York Press, 1992.

Chen Jiang 陳江. "Lu Xun yu Shangwu yinshuguan" 鲁迅與商務印書館 [Lu Xun and the Commercial Press]. In *Shangwu yinshuguan jiushi nian*, 544–551.

Chen Jilong 陈吉龙. "Ye Kai qingrong chanshi shilüe" 冶开清镕禅师史略 [Summary of Chan master Ye Kai]. In *Jiangsu wenshi ziliao jicui*.

Chen, Judy M. "Willing Partners to Repression?" Digital Freedom Network, November 27, 2000. http://bobsonwong.com/dfn/focus/china/multinationals.htm (accessed September 5, 2009).

Chen, Kenneth. *Buddhism in China*. Princeton, NJ: Princeton University Press, 1964.

Chen Leng 陳冷. "Shishi piping" 時事批評 [Short critique of current affairs]. *Shibao*. December 29, 1906.

——. "Shiping yi" 時評一 [First short comment]. *Shibao*, August 28, 1911.

Chen Shengshi 陳聖士. "Jindai Zhongguo baozhi shelun zhi yanbian" 近代中國報紙社論之演變 [The evolution of the newspaper editorial in modern China]. *Baoxue* 報學 [Journalism] (Taipei) 2, no. 3 (August 1958): 8–15.

Chen Shiwen 陳詩雯. [Preface]. In *Honglou fumeng* 紅樓復夢 [Return to dream of the red chamber], by Chen Shaohai 陳少海, 1. Beijing: Beijing daxue chubanshe, 1988 [1799].

Chen Yushen 陳玉申. *Wan-Qing baoye shi* 晚清報業史 [History of the late Qing press]. Ji'nan: Shandong huabao chubanshe, 2003.

Cheng Wenchao 程文超. "Yuhaili de shiqing shouwang—Wo du Zhang Xin de dushi gushi" 欲海里的诗情守望—我读张欣的都市故事 [A poetic watchtower in the sea of desire—My reading of Zhang Xin's urban fiction]. *Wenxue pinglun* 文学评论 [Literary criticism] 3 (1996): 71–75.

Chia, Lucille. "Mapping the Book Trade: The Expansion of Print Culture in Late Imperial China" Unpublished research. Field reports, 1998–99: 6; 1999–2000: 1–4.

——. "The Development of the Jianyang Book Trade, Song-Yuan." *Late Imperial China* 17, no. 1 (June 1996): 10–48.

"China, Google News, and Source Inclusion." Official Google Blog, September 27, 2004. http://googleblog.blogspot.com/2004/09/china-google-news-and-source-inclusion. html (accessed October 2, 2004).

China Internet Network Information Center (CNNIC). "Di 13 ci Zhongguo hulian wangluo fazhan zhuangkuang tongji baogao" 第13次中国互联网络发展状况统计报告 [13th statistical survey report on Internet development in China]. January 2004. http://www.cnnic.cn/index/0E/00/11/index.htm (accessed August 1, 2009).

——. "Di 19 ci Zhongguo hulian wangluo fazhan zhuangkuang tongji baogao" [19th statistical survey report on Internet development in China]. January 2007. http:// www.cnnic.cn/index/0E/00/11/index.htm (accessed August 1, 2009).

——. "Di 23 ci Zhongguo hulian wangluo fazhan zhuangkuang tongji baogao." [23rd statistical survey report on Internet development in China]. January 2009. http:// www.cnnic.cn/index/0E/00/11/index.htm (accessed May 22, 2009, and August 1, 2009).

——. "The Internet Timeline of China 1997–2000." http://www.cnnic.net.cn/html/ Dir/2003/12/12/2001.htm (accessed June 1, 2007).

——. [Third statistical survey report on Internet development in China]. January 1999. http://research.cnnic.cn/html/1242871496d456.html (accessed November 17, 2009).

——. "Zhongguo hulianwang xinxi zhongxin" 中国互联网信息中心 [The Information Centre of the Internet in China]. [http://www.cnnic.net.cn] (accessed February 16, 2009).

ChinaOnline. "Bureau for the Protection of State Secrets (State Secrets Bureau)." January 28, 2000. [http://www.chinaonline.com].

——. "China: Eastsay.com May Not Write, Collect News." June 5, 2000. [http://www. chinaonline.com] (accessed June 6, 2000).

——. "China Issues New Regulations for Internet Cafes." January 21, 1999. [http:// www.chinaonline.com] (accessed January 27, 2000).

——. "China's Beijing Cracks Down on Internet Cafes." March 24, 2000. [http://www. chinaonline.com] (accessed March 29, 2000).

——. "China's Print Media Concerned over New Internet Portals." September 22, 1999. [http://www.chinaonline.com] (accessed October 24, 1999).

——. "China Web Site Has Got It Covered—Newswise." May 24, 2000. [http://www. chinaonline.com] (accessed April 19, 2001).

——. "Internet Information Management Bureau (IIMB)." May 30, 2000. [http:/www. chinaonline.com] (accessed November 2, 2000).

Chuban tongye diaocha fanban Beiping banshi chu 出版同業調查翻版北平辦事處. "Chahuo gechu fanban weishu anjian yilan biao" 查獲各處翻版偽書案件一覽表 [A chart of pirate publications discovered in the area]. Shanghai Archives, file no. 313:156, 1935.

Colombel, Auguste. *Histoire de la Mission du Kiang-nan.* Lithograph, T'ou-sè-wè, 1900.

Cong, Xiaoping. *Teachers' Schools and the Making of the Modern Chinese Nation-State, 1897–1937.* Vancouver: UBC Press, 2007.

Couturier, Joseph. *Histoire de la Mission de Kiangnan.* Manuscript, n.d., AFCJ (FCh 209).

Cowhig, David. "New Net Rules Not a Nuisance?" ChinaOnline, December 5, 2000. [http://www.chinaonline.com] (accessed December 6, 2000).

"The Cracker War on China." Virtual China, January 15, 1999. http://www.virtualchina.com/infotech/perspectives/perspective-011599.html (accessed January 2, 2000).

Cui Gu 崔谷. "Zhou Dasan" 周达三. In *Sichuan jinxiandai renwu zhuan* 四川近现代人物传 [Biographies of figures in modern and contemporary Sichuan]. Vol. 6, edited by Ren Yimin 任一民, 499–503. Chengdu: Sichuan daxue chubanshe, 1990.

Culp, Robert. *Articulating Citizenship: Civic Education and Student Politics in Southeastern China, 1912–1940.* Cambridge, MA: Harvard University Asia Center, 2007.

——. "Beyond Fuzhou Road: Local Publishing Centers and Reading Communities in Late Qing and Republican China." Paper presented at the 2009 AAS Annual Meeting, Chicago, IL, March 30, 2009.

Dai Fanyu 戴藩豫. *Zhongguo fodian kanke yuanliu* 中国佛殿刊刻源流 [The source of Chinese Buddhist canon publishing]. Beijing: Shumu wenxian chubanshe, 1995.

Dai, Xiudian. "ICTs in China's Development Strategy." In Hughes and Wacker, *China and the Internet*, 8–29.

Darnton, Robert. "What Is the History of the Book?" *Daedalus* 111 (Summer 1982): 69–84.

Davis, Deborah S. *The Consumer Revolution in Urban China.* Berkeley: University of California Press, 2000.

——. "Urban Consumer Culture." *China Quarterly* 183 (2005): 692–709.

Davis, Deborah S., Shaoguang Wang, and Yanjie Bian. "The Uneven Distribution of Cultural Capital: Book Reading in Urban China." *Modern China* 32, no. 3 (2006): 315–345.

Dehergne, Joseph. "La presse catholique en chine." *Rythmes du monde* 3 (1951): 71–80.

D'Elia, Pascal M. *Les missions catholiques en Chine.* Shanghai: Commercial Press, 1935.

Deng Hongmei 邓红梅. Nüxing cishi 女性词史 [History of Ci poetry by women]. Ji'nan: Shandong jiaoyu chubanshe, 2000.

Deng Zimei 邓子美. *Chuantong fojiao yu Zhongguo jindaihua* 传统佛教与中国近代化 [Traditional Buddhism and Chinese modernization]. Shanghai: Huadong shifan daxue chubanshe, 1996.

Denton, Kirk A. *The Problematic of Self in Modern Chinese Literature: Hu Feng and Lu Ling.* Stanford: Stanford University Press, 1998.

Des Forges, Alexander. *Mediasphere Shanghai: The Aesthetics of Cultural Production.* Honolulu: University of Hawai'i Press, 2007.

Digital Freedom Network. "Chinese Engineer Who Helped Dissident Newsletter Is Freed." March 6, 2000. [http://www.dfn.org] (accessed February 28, 2001).

——. "Chinese Webmaster to Be Tried February 13." February 9, 2001. [http://www.dfn.org] (accessed February 28, 2001).

Ding Fubao 丁福保. *Foxue chujie* 佛學初階 [Elementary Buddhism]. Shanghai: Yixue shuju, 1921.

——. *Foxue dacidian* 佛學大辭典 [Dictionary of Buddhism]. 1920. Reprint, Shanghai: Foxue shuju, 1996.

——. *Foxue qixin bian* 佛學起信編 [Buddhist inspiration of faith]. Shanghai: Yixue shuju, 1919.

——. *Foxue zhinan* 佛學指南 [Guide to Buddhism]. Shanghai: Yixue shuju, 1919.

Dirlik, Arif. *The Origins of Chinese Communism*. New York: Oxford University Press, 1989.

Doleželová-Velingerová, Milena, Oldrich Král, and Graham Sanders, eds. *The Appropriation of Cultural Capital: China's May Fourth Project*. Cambridge, MA: Harvard University Asia Center, 2001.

Dong Qijun 董启俊. "Jing Hengyi yu Zhejiang shengli disi zhongxue" 经亨颐与浙江省立第四中学 [Jing Ziyuan and Zhejiang provincial fourth middle school). *Ningbo wenshi ziliao* 宁波文史资料 [Cultural and historical materials on Ningbo], no. 1 (1983): 74–96.

Drake, William J., Shanthi Kalathil, and Taylor C. Boas. "Dictatorships in the Digital Age: Some Considerations on the Internet in China and Cuba." *iMP*, October 2000. http://www.cisp.org/imp/october_2000/10_00drake.htm (accessed November 11, 2000).

Drège, Jean-Pierre. "Les aventures de la typographie et les missionnaires protestants en Chine au xixe siècle." *Journal Asiatique* 280, nos. 3–4 (1992): 279–305.

Dudink, Adrian. "Xu Guangqi's Career: An Annotated Chronology." In *Statecraft and Intellectual Renewal in Late Ming China: The Cross-Cultural Synthesis of Xu Guangqi (1562–1633)*, edited by Catherine Jami, Peter Engelfriet, and Gregory Blue, 399–410. Leiden: Brill, 2001.

Duff, David, ed. *Modern Genre Theory*. New York: Longman, 2000.

Eastern Times. See *Shibao*.

Eastman, Lloyd. "Ch'ing-i and Chinese Policy Formation during the Nineteenth Century." *Journal of Asian Studies* 24, no. 4 (1965): 595–611.

——. *Throne and Mandarins: China's Search for a Policy during the Sino-French Controversy, 1880–1885*. Cambridge, MA: Harvard University Press, 1967.

Edgren, Soren, ed. *Chinese Rare Books in American Collections*. New York: China Institute of America, 1984.

Edwards, E. D. "A Classified Guide to the Thirteen Classes of Chinese Prose." *BSOAS* 12 (1948): 770–788.

Elman, Benjamin. *From Philosophy to Philology: Intellectual and Social Aspects of Change in Late Imperial China*. Cambridge, MA: Harvard University Press, 1990.

——. *A Cultural History of Civil Examinations in Late Imperial China*. Berkeley: University of California Press, 2000.

——. *On Their Own Terms: Science in China 1550–1900*. Cambridge, MA: Harvard University Press, 2005.

Ephémérides du Collège St. Ignace, 1910–12. AFCJ (FCh 311).

Ershi shiji Shanghai wenshi ziliao wenku 二十世纪上海文史资料文库 [Collected cultural and historical documents of twentieth-century Shanghai]. Vol. 9. Shanghai: Shanghai shudian chubanshe, 1999.

"Fakanci" 發刊詞 [Inaugural preface]. *Zhejiang yizhong zhoukan* 浙江一中週刊 [The first middle school weekly]. No. 1 (October 1, 1923).

"Falun Dafa and the Internet: A Marriage Made in Web Heaven." Virtual China, July 30, 1999. http://www.virtualchina.com/infotech/perspectives/perspective-073099.html (accessed January 2, 2000).

Fan Muhan 范慕韩. *Zhongguo yinshua jindai shi* 中国印刷近代史 [The modern history of Chinese printing]. Beijing: Yinshua gongye chubanshe, 1995.

Fang Fang. Interview with Bruce Humes. August 7, 2007. http://web.mac.com/katchoolik/katchoolik/Interviews/Entries/2007/8/7_Interview_31:_Bruce_Humes.htm (accessed July 13, 2008).

Fang Hanqi 方汉奇. *Zhongguo xinwen shiye tongshi* 中国新闻事业通史 [General history of Chinese journalism]. Beijing: Zhongguo renmin daxue chubanshe, 1992.

Fang Hao 方豪. *Zhongguo tianzhujiao shi renwu zhuan* 中國天主教史人物傳 [Biographies related to the history of Catholicism in China]. 3 vols. Beijing: Zhonghua shuju, 1988.

Farrall, Kenneth. "Whither the China Net?" Virtual China, February 5, 1999. http://www.virtualchina.com/ (accessed January 2, 2000).

Farrer, James. "China's Women Sex Bloggers and Dialogic Sexual Politics on the Chinese Internet." *China aktuell* 3 (2007): 9–46.

Feldman, Gayle. "The Organization of Publishing in China." *China Quarterly* 107 (1986): 519–529.

Feng Zikai 丰子恺. *Feng Zikai sanwen manhua jingxuan* 丰子恺散文漫画精选 [Selected essays and cartoons of Feng Zikai]. Edited by Feng Yiyin 丰一吟. Beijing: Zhongguo wenlian chubanshe, 2003.

"Fengliu cike" 風流詞客 [A cosmopolitan teller of tales]. In *Qing Che wangfu chaocang quben: zidishu ji* 清車王府鈔藏曲本: 子弟書集 [The handwritten libretti of the Qing dynasty Che prince household collection: the collected *zidishu*], edited by Liu Liemao 劉烈茂 and Guo Jingrui 郭精銳, vol. 2, 346–350. Nanjing: Jiangsu guji chubanshe, 1993.

Ferry, Megan. "Marketing Chinese Women Writers in the 1990s, or the Politics of Self-Fashioning." *Journal of Contemporary China* 12, no. 37 (2003): 655–675.

Finnane, Antonia. *Speaking of Yangzhou: A Chinese City, 1550–1850*. Cambridge, MA: Harvard University Asia Center, 2004.

Fischer, Doris. "Rückzug des Staates aus dem chinesischen Mediensektor? Neue institutionelle Arrangements am Beispiel des Zeitungsmarktes." Paper presented at meeting of ASC (Arbeitskreis sozialwissenschaftliche Chinaforschung), Witten, Germany, November 17–18, 2000.

Fogel, Joshua A. "Mendacity and Veracity in the Recent Chinese Communist Memoir Literature." In *New Perspectives on State Socialism in China*, edited by Timothy Cheek and Tony Saich, 354–358. Armonk, NY: M. E. Sharpe, 1997.

Foucault, Michel. *Discipline and Punish: The Birth of the Prison*. London: Penguin, 1991.

Fravel, Taylor. "The Bureaucrats' Battle over the Internet in China." Virtual China, February 18 2000. http://www.virtualchina.com/news/feb00/021800–ministries-tf.html (accessed February 19, 2000).

French, Howard W. "Despite an Act of Leniency, China Has Its Eye on the Web." *New York Times*, June 27, 2004. http://www.nytimes.com/2004/06/27/international/asia/27chin.html (accessed June 28, 2004).

Fu Jian'an 傅建安. "Wei Hui xiaoshuo de hou xiandai xushi kuanghuan" 卫慧小说的后现代叙事狂欢 [Postmodern narrative carnival in Wei Hui's fiction]. *Zhongguo wenxue yanjiu* 中国文学研究 [Research into Chinese literature] 1 (2009): 53–6.

Fu Yiling 傅衣凌. "Qianyan" 前言 [Preface]. In *Mindu bieji* 閩都別記 [An unofficial record of the capital of Fujian]. Vol. 1, 1–4. Fuzhou: Fujian renmin chubanshe, 1987.

Gallagher, Louis J. *China in the Sixteenth Century: The Journals of Matthew Ricci, 1595–1610*. New York: Random House, 1953.

Gao Zhennong 高振农. "Shanghai fojiao gaikuang" 上海佛教概况 [A brief account of Shanghai Buddhism]. In *Ershi shiji Shanghai wenshi ziliao wenku*.

Ge Gongzhen 戈公振. *Zhongguo baoxue shi* 中國報學史 [*History of the Chinese press*]. 1927. Reprints, Taipei: Xuesheng shuju, 1982; Shanghai: Shanghai guji chubanshe, 2003.

Ge Zhaoguang 葛兆光. "Xihu que zi dong liu lai" 西湖却自东流来 [The west lake is fed from a flow from the east]. In *Ge Zhaoguang zixuanji* 葛兆光自选集 [Self-selected writings of Ge Zhaoguang], by Ge Zhaoguang. Guilin: Guangxi shifan daxue, 1997.

Ge Zhuang 葛壮. *Zongjiao he jindai shanghai shehui de bianqian* 宗教和近代上海社会的变迁 [Religion and the changes in modern Shanghai society]. Shanghai: Shanghai shudian chubanshe, 1999.

Genette, Gérard. "The Architext." In Duff, *Modern Genre Theory*, 210–218.

——. *Palimpseste. Die Literatur auf zweiter Stufe*. Paris: Seuil, 1982. Reprint, Frankfurt: Suhrkamp, 1993.

——. *Paratexte. Das Buch vom Beiwerk des Buches*. Paris: Seuil, 1987. Reprint, Frankfurt: Suhrkamp, 2001.

Gezhi xinbao 格致新報 [*Revue scientifique*]. Nos. 1–16 (March 13–August 13, 1898). Reprinted in *Jindai Zhongguo shiliao congkan sanbian* 近代中國史料叢刊三編 [Anthology of materials for the history of modern China], edited by Shen Yunlong 沈雲龍. 3d series, vols. 231–233. Taipei: Wenhai chubanshe, n.d.

Gezhi yiwen huibao 格致益聞匯報 [*I-wen-lou et Revue scientifique*]. Nos. 1–99 (August 17, 1898–August 5, 1899).

Giese, Karsten. "Das gesetzliche Korsett für das Internet ist eng geschnürt." *China aktuell* (October 2000): 1173–1181.

——. "Freier Diskurs oder perfekter Überwachungsstaat? *Identity Work* im chinesischen Internet." *China aktuell* (January 2005): 35–51.

Gimpel, Denise. *Lost Voices of Modernity: A Chinese Popular Fiction Magazine in Context*. Honolulu: University of Hawai'i Press, 2001.

Glosser, Susan L. *Chinese Visions of Family and State, 1915–1953*. Berkeley: University of California Press, 2003.

Golden Book Cottage. See Huangjin shu wu.

Goldkorn, Jeremy. "A Short Interview with Muzi Mei." Danwei, February 26, 2004. http://www.danwei.org/archives/000599.html (accessed February 5, 2006).

Goldman, Merle. "The Party and the Intellectuals: Phase Two." In *An Intellectual History of Modern China*, edited by Merle Goldman and Leo Ou-fan Lee, 349–394. New York: Cambridge University Press, 2002.

Gong 共 [pseudonym]. "Huaibei zhenwu shanhou shiyi yi" 淮北賑務善後事宜議 [Discussion of measures for relief of the crisis in Huaibei]. *Shenbao*, January 29, 1907.

Gong Jimin 龔济民 and Fang Rennian 方仁念. *Guo Moruo nianpu* 郭沫若年譜 [Biographical chronology of Guo Moruo]. 3 vols. Tianjin: Tianjin renmin chubanshe, 1992.

Goodman, Bryna. *Native Place, City, and Nation: Regional Networks and Identities in Shanghai, 1853–1937*. Berkeley: University of California Press, 1995.

——. "Networks of News: Power, Language and Transnational Dimensions of the Chinese Press, 1850–1949." *China Review* 4, no. 1 (Spring 2004): 1–10.

"Government, Falun Gong Followers in Internet Battle." *Sing Tao Jih Pao* 星島日報 [*Sing Tao Daily*]. July 28, 1999, A4. Cf. *SWB FE/3599*, July 29, 1999: G/5–6.

Grande, Carlos. "Uunet and Nokia Attack E-mail Legislation." *Financial Times*, July 12, 2000.

Gu Weimin 顾卫民. *Zhongguo tianzhujiao biannianshi* 中国天主教编年史 [Annalistic history of Catholicism in China]. Shanghai: Shanghai shiji chubanshe, 2003.

Gu Xin 顧昕. *Zhongguo qimeng de lishi tujing: Wusi fansi yu dangdai Zhongguo de yishixingtai zhi zheng* 中國啓蒙的歷史圖景：五四反思與當代中國的意識形態之爭 [Historiography of the Chinese enlightenment: The May Fourth and ideological debates in contemporary China]. Hong Kong: Oxford University Press, 1992.

Gu Yulu 顾裕禄. "Shanghai tianzhujiao chuban gaikuang" 上海天主教出版概況 [Outline of Catholic publishing in Shanghai]. *Chuban shiliao* 出版史料 [Historical publishing materials] 10 (April 1987): 30–34.

Guan Xihua 管錫華. *Zhongguo gudai biaodian fuhao fazhanshi* 中國古代標點符號發展史 [History of the development of punctuation marks in ancient China]. Chengdu: Bashu shushe, 2002.

Guang Li 广隶. "Yijiu eryi nian de Taidong Tushuju" 一九二一年的泰东图书局 [Taidong Press of 1921]. *Chuban shiliao* 出版史料 [Historical publishing materials] 2 (1990): 95–101.

Guangdong shengzhi: Chuban zhi 广东省志: 出版志 [Guangdong provincial gazetteer: Publishing gazetteer]. Guangzhou: Guangdong renmin chubanshe, 1997.

Guangxi shengzhi: Chuban zhi 广西省志: 出版志 [Guangxi provincial gazetteer: Publishing gazetteer]. Nanning: Guangxi renmin chubanshe, 1999.

Gui Zimai 归子迈. "'Wu si' yundong dui Changshu wenhua jie de ruogan yingxiang" 五四运动对常熟文化界的若干影响 [Some influences of the May Fourth Movement on Changshu's cultural circles]. *[Changshu] Wenshi ziliao jicun* [常熟] 文史资料积存 [Collected materials on culture and history (of Changshu)], no. 7 (1980).

Guo Guangrui 郭广瑞. *Yongqing shengping qianzhuan* 永庆升平前传 [Tale of everlasting blessings and peace, part I]. Annotated and edited by Ergong 尔弓. Wuhan: Jing Chu shushe, 1988.

Guo Moruo 郭沫若. *Xuesheng shidai* 學生時代 [My student years]. Beijing: Renmin wenxue chubanshe, 1979.

Gutzlaff, Charles. *China Opened: A Display of the Topography, History, Customs, Manners, Arts, Manufactures, Commerce, Literature, Religion, Jurisprudence, etc., of the Chinese Empire*. Revised by the Reverend Andrew Reed. London: Smith, Elder, and Co., 1838.

——. "Remarks Concerning the Conversion of the Chinese." *Chinese Repository* 2, no. 2 (April 1834): 565.

Han Haoyue 韩浩月. "Wang Meng to Be Shengda's Literary Adviser; Power of Traditional Writing to Lean toward Internet Literature?" 王蒙出任盛大文学顾问, 传统写作势力向网络文学倾斜? May 20, 2009. http://www.china.com.cn/economic/txt/2009–05/20/content_17806601.htm (accessed May 21, 2009).

Han, Oliver Lei. "Sources and Early Printing History of Chairman Mao's *Quotations*." N.d. Bibliographical Society of America. http://www.bibsocamer.org/bibsite/han/index.html (accessed March 11, 2008).

Hanan, Patrick. *The Chinese Vernacular Story*. Cambridge, MA: Harvard University Press, 1981.

——. "The Missionary Novels of Nineteenth-Century China." *Harvard Journal of Asiatic Studies* 60, no. 2 (December 2000): 413–443.

——. "Chinese Christian Literature: The Writing Process." *Treasures of the Yenching: 75th Anniversary of the Harvard-Yenching Library: Exhibition Catalogue*, 261–83. Cambridge, MA: Harvard-Yenching Library, 2003.

Hanchuan xianzhi 汉川县志 [Hanchuan county gazetteer]. Beijing: Zhongguo chengshi chubanshe, 1992.

Handlin, Joanna F. *Action in Late Ming Thought: The Reorientation of Lu K'un and Other Scholar-Officials*. Berkeley: University of California Press, 1983.

Harrison, Henrietta. *The Making of the Republican Citizen: Political Ceremonies and Symbols in China, 1911–1929*. Oxford: Oxford University Press, 2000.

——. "Newspapers and Nationalism in Rural China, 1890–1929." In *Twentieth-Century China: New Approaches*, edited by Jeffrey N. Wasserstrom, 83–102. London: Routledge, 2003.

——. *The Man Awakened from Dreams*. Stanford, CA: Stanford University Press, 2005.

Hayhoe, Ruth. "Towards the Forging of a Chinese University Ethos: Zhendan and Fudan, 1903–1919." *China Quarterly* 94 (June 1983): 323–341.

Hayhoe, Ruth, and Lu Yongling, eds. *Ma Xiangbo and the Mind of Modern China, 1840–1939*. Armonk, NY: M. E. Sharpe, 1996.

He Changling 賀昌齡, comp. *Huangchao jingshi wenbian* 皇朝經世文編 [Collected writings on statecraft from our great dynasty]. Reprinted as *Qing jingshi wenbian* 清經世文編. Beijing: Zhonghua shuju, 1992.

He Gengyong 何耿鏞. *Hanyu fangyan yanjiu xiaoshi* 汉语方言研究小史 [Short history of research on Chinese dialects]. Taiyuan: Xi'an renmin chubanshe, 1984.

He Shengnai 賀聖鼐. "Sanshiwu nian lai Zhongguo zhi yinshuashu" 三十五年來中國之印刷術 [Chinese printing in the past 35 years]. In *Zhongguo jinxiandai chuban shiliao* 中國近現代出版史料 [Historical publishing materials in modern China], edited by Zhang Jinglu 張靜廬, vol. 1, 257–285. 8 vols. 1931. Reprint, Shanghai: Shanghai shudian, 2003.

Heijdra, Martin J. "The Development of Modern Typography in East Asia, 1850–2000." *East Asian Library Journal* 11, no. 2 (Autumn 2004). 100–168.

Hermand, Louis. *Les Étapes de la Mission du Kiang-nan, 1842–1922, et de la Mission de Nanking, 1922–1932*. Shanghai: Imprimerie de la Mission Zi-ka-wei, 1933.

Hightower, James R. "The *Wen Hsüan* and Genre Theory." *HJAS* 20 (1957): 512–534.

Ho, Eliza. "Art, Documentary, and Propaganda in Wartime China: The Photography of Sha Fei (1912–1950)." PhD diss., Ohio State University, forthcoming.

Hockx, Michel, ed. *The Literary Field of Twentieth-Century China*. London: Curzon, 1999.

——. "Links with the Past: Mainland China's Online Literary Communities and Their Antecedents." *Journal of Contemporary China* 13 (2004): 105–127.

——. "Virtual Chinese Literature: A Comparative Case Study of Online Poetry Communities." *China Quarterly* 183 (2005): 670–691.

Holtzberg-Call, Maggie. *The Lost World of the Craft Printer*. Urbana: University of Illinois Press, 1992.

Hong Zicheng 洪子誠. *Zhongguo dangdai wenxueshi* 中国当代文学史 [A history of contemporary Chinese literature]. Translated by Michael M. Day. 1999. Reprint, Leiden: Brill, 2007.

Hongyi 弘一. *Hongyi dashi gequ quanji* 弘一大師歌曲全集 [The complete songs of Master Hongyi]. Introduction, liner notes, and lyrics on cassette tapes sung by the Beijing Aizhong Women's Chorus. Taipei: Yinyue Zhongguo chubanshe, 1992.

——. "Nanmin shinian de mengying" 南閩十年的梦紫 [Shadow dreams of ten years in south Fujian]. In Tan Guilin, *Puti xinyu.*

Hooper, Beverley. "Globalisation and Resistance in Post-Mao China: The Case of Foreign Consumer Products." *Asian Studies Review* 24, no. 4 (2000): 439–470.

Hou Zhi 候芝. *Jin guijie* 金閨傑 [Heroines of gold]. 1824. In Qinghua University Library.

——. *Zai zaotian* 再造天 [Constructing another heaven]. 1828. Reprint, Shanghai: Dada tushu gongyong she, 1936.

Huangjin shu wu 黃金书屋 [Golden book cottage]. http://www.goldnets.com. Established 1998.

Hu Anshun 胡安顺. *Yinyunxue tonglun* 音韵学通论 [Phonology: a general survey]. Beijing: Zhonghua shuju, 2003.

Hu Daojing 胡道靜. *Shanghai xinwen shiye shiliao jiyao* 上海新聞事業史料輯要 [Summary of materials on the journalist profession in Shanghai]. 2 vols. 1937. Reprint, Taipei: Tianyi chubanshe, 1977.

——. "1933 nian de Shanghai zazhi jie" 1933 年的上海杂志界 [Periodical press of Shanghai in 1933]. 1933. Reprinted in Song Yuanfang, *ZCSXB*, 350–360.

Hu Huanyong 胡焕庸. "Suzhou Zhongxue jiaoxun zhi heyi tan" 蘇州中學教訓之合一談 [A discussion of uniting instruction and character-development education at Suzhou Middle School]. *Jiangsu jiaoyu* 江蘇教育 [Jiangsu education] 1, no. 10 (November 1932): 49–55.

Hu Shi 胡适. *Zhongguo zhanghui xiaoshuo kaozheng* 中国章回小说考证 [A study of the Chinese vernacular novel], 293–323. Hefei: Anhui jiaoyu chubanshe, 1999.

——. "*Er nü yingxiong zhuan* xu" 儿女英雄传序 [Preface, The tale of romance and heroism]. In Hu Shi, *Zhongguo zhanghui xiaoshuo kaozheng*, 345–362.

——. "*Haishang hua liezhuan* xu" 海上花列传序 [Preface, The flowers of Shanghai]. In Hu Shi, *Zhongguo zhanghui xiaoshuo kaozheng*, 365–388.

——. "*Jinghua yuan* de yinlun" 镜花缘的引论 [Introduction, Flowers in the mirror]. In Hu Shi, *Zhongguo zhanghui xiaoshuo kaozheng*, 391–423.

——. "*San xia wu yi* xu" 三侠五义序 [Preface, The three knights and the five gallants]. In Hu Shi, *Zhongguo zhanghui xiaoshuo kaozheng*, 293–323.

Hu, Siao-chen. "Literary *Tanci*: A Women's Tradition of Narrative in Verse." PhD diss., Harvard University, 1994.

Hu Wenkai 胡文楷. *Lidai funü zhuzuo kao* 歷代婦女著作考 [A study of female writers through the ages]. Shanghai: Guji chubanshe, 1985.

Hu Yuanjie 胡远杰, ed. *Fuzhou lu wenhua jie* 福州路文化街 [Fuzhou Road: The Cultural Street]. Shanghai: Wenhui chubanshe, 2001.

Huang Xiexun 黃協塤. "Zhengdun baowu yuyan" 整頓報務餘言 [More words on the readjustment of the press]. *Shenbao*, August 24, 1898.

Huang, Zhiwei. "Xujiahui cangshulou—The Xujiahui Library." *Tripod* 70 (July–August 1992): 23–32.

Hughes, Christopher R. "Fighting the Smokeless War: ICTs and International Security." In Hughes and Wacker, *China and the Internet*, 139–161.

——. "Nationalism in Chinese Cyberspace." *Cambridge Review of International Affairs* 13, no. 2 (Spring/Summer 2000): 195–209.

Hughes, Christopher R., and Gudrun Wacker, eds. *China and the Internet: Politics of the Digital Leap Forward*. London and New York: RoutledgeCurzon, 2003.

Huibao 匯報 [Revue pour tous]. Nos. 100–3106 (August 9, 1899—August 22, 1911).

Huibao kexue huibian 匯報科學彙編 [Revue scientifique] (September 24, 1908—late 1909).

Huibao shishi huibian 匯報時事彙編 [Huibao news digest] (September 24, 1908—late 1909).

"Huiwu baoga" 會務報告 [Report on association affairs]. *Wuben nüzhong xuesheng zizhihui banniankan* 務本女中學生自治會半年刊 [Semi-monthly publication of Wuben Girls' Middle School Student Self-government Association], no. 3 (January 1936): 127–128.

Human Rights Watch. "Freedom of Expression and the Internet in China." N.d. Human Rights Watch Backgrounder. http://www.hrw.org/backgrounder/asia/china-bck-0701.pdf (accessed August 24, 2001).

Hummel, Arthur W. *Eminent Chinese of the Ch'ing Period*. 2 vols. Taipei: SMC Publishing, 1991.

Hung, Chin-fu. "Public Discourse and 'Virtual' Political Participation in the PRC: The Impact of the Internet." *Issues and Studies* 39, no. 4 (December 2003): 1–38.

Hyatt, Irwin T. Jr. *Our Ordered Lives Confess*. Cambridge, MA: Harvard University Press, 1976.

Idema, Wilt L. Review of Evelyn S. Rawski, *Education and Popular Literacy in Ch'ing China* [untitled]. *T'oung Pao* 66, nos. 4–5 (1980): 314–324.

——. "Proud Girls." *Nan Nü* 3, no. 1 (2001): 232–248.

Idema, Wilt L., and Beata Grant, eds. *The Red Brush: Writing Women of Imperial China*. Cambridge, MA: Harvard University Asia Center, 2004.

Independent Chinese PEN Center. September 10, 2005. http://www.penchinese.com/wipc/08news-may/st-pjs.htm (accessed September 12, 2005).

Inoue Susumu 井上進. *Chūgoku shuppan bunkashi-—shomotsu sekai to chi no fūkei* 中国出版文化史—書物世界と知の風景 [A cultural history of Chinese publishing—the world of texts and the landscape of knowledge]. Nagoya: Nagoya daigaku shuppansha, 2002.

"Internet Filtering in China in 2004–2005: A Country Study." OpenNet Initiative, April 14, 2005. http://www.opennetinitiative.net/studies/china/ONI_China_Country_Study.pdf (accessed July 26, 2005).

"Internet Screening Technology Popular among Chinese Parents." July 8, 2004. http://english.people.com.cn/200407/08/eng20040708_148883.html (accessed September 10, 2005).

"Internet Sexual Diaries Are Banned." *China Daily*, November 28, 2003. http://www.chinadaily.com.cn/en/doc/2003-11/28/content_285466.htm (accessed January 18, 2004).

Internet World Statistics. http://www.internetworldstats.com/stats.htm (accessed May 22, 2009).

"The Internet's New Borders." *Economist* 360, no. 8234 (August 11, 2001): 9–10.

Janku, Andrea. *Nur leere Reden: Politischer Diskurs und die Shanghaier Presse im China des späten 19. Jahrhunderts.* Wiesbaden: Harrassowitz, 2003.

——. "Preparing the Ground for Revolutionary Discourse: From the *Jingshiwen* Compilations to Journalistic Writings in Nineteenth Century China." *T'oung Pao* 90, nos. 1–3 (2004): 65–121.

——. "Ironie, Spott und Kritik: Zeitgenössische Ansichten über den Rebellen Kang Youwei." In *Kritik im alten und modernen China*, edited by Heiner Roetz. Jahrbuch der Deutschen Vereinigung für Chinastudien 2, 207–223.Wiesbaden: Harrassowitz, 2006.

——. "'New Methods to Nourish the People': Political Economy in Late Qing Encyclopaedic Writing (1888–1903)." In *Early Modern Chinese Encyclopaedias (1870s–1920s): Changing Chinese Ways of Thought*, edited by Milena Doleželová-Velingerová. Cambridge, MA: Harvard University Press (forthcoming).

Ji Shaofu 吉少甫 et al., eds. *Zhongguo chuban jianshi* 中国出版简史 [Concise history of Chinese publishing]. Shanghai: Xuelin chubanshe, 1991.

Jia Shumei 贾树枚, ed. *Shanghai xinwen zhi* 上海新闻志 [Annals of journalism in Shanghai]. Shanghai: Shanghai shehui kexue yuan chubanshe, 2000.

Jiang Min 姜敏 and Wang Yupeng 王玉鹏. "Shenti xiezuo yu nüxing wenxue" 身体写作与女性文学 [Body writing and women's literature]. *Xinyu gaozhuan xuebao* 新余高专学报 [Journal of Xinyu College] 10, no. 4 (2005): 31–3.

Jiang Xiaohu 江筱湖. "Shinian yijian: wangluo wenxue zhongcheng zhengguo" 十年一剑: 网络文学终成正果 [A sword forged in ten years: Internet literature finally bears fruit]. *Zhongguo tushu shangbao* [China Book Business Report]. (November 21, 2003): B11.

Jiangsu sheng chubanshizhi bianjibu 江苏省出版史志编辑部. *Jiangsu chubanshi (minguo shiqi) xueshu taolunhui wenji* 江苏出版史 (民国时期) 学术讨论会文集 [Collection of papers from the academic conference on Jiangsu publishing history (Republican period)]. Nanjing: Jiangsu sheng xinhua shudian, 1991.

Jiangsu sheng jiaoyuting 江蘇省教育廳, comp. *Jiangsu sheng xianxing jiaoyu faling huibian* 江蘇省現行教育法令彙編 [Compendium of current educational laws for Jiangsu province]. N.p.: Jiangsu sheng jiaoyuting, 1932.

Jiangsu sheng jiaoyuting bianshenshi 江蘇省教育廳編審室. *Jiangsu jiaoyu gailan* 江蘇教育概覽 [An overview of Jiangsu education]. Vol. 1. [Zhenjiang:] Jiangsu sheng jiaoyuting bianshenshi, 1932. Reprinted in *Minguo shiliao congkan* 民國史料叢刊 [Collection of Republican historical materials]. Vol. 7, edited by Wu Xiangxiang and Liu Shaotang. Taipei: Zhuanji wenxue chubanshe, 1971.

Jiangsu shengli di'er nüzi shifan xuexiao xiaoyouhui huikan 江蘇省立第二女子師範學校校友會彙刊 [Publication of the friends of Jiangsu Provincial Second Girls' Normal School], no. 14 (July 1922).

Jiangsu shengli di'er shifan xuexiao xiaokan 江蘇省立第二師範學校校刊 [School publication of Jiangsu Provincial Second Normal School], nos. 36–37 (May 5, 1925).

Jiangsu shengli diwu zhongxuexiao 江蘇省立第五中學校. "Ben zazhi qiqing zhizheng miuwu guanggao" [This magazine's request for rectification of any errors]. *Jiangsu*

shengli diwu zhongxuexiao zazhi 江蘇省立第五中學校雜誌 [Jiangsu provincial fifth middle school magazine], no. 2 (September 1915).

Jiangsu wenshi ziliao jicui: shehui juan 江苏文史资料集萃: 社会卷 [Selected Jiangsu cultural and historical materials: volume on society]. Nanjing: Jiangsu sheng zhengxie wenshi ziliao weiyuan hui, 1995.

Jiaoyu chao 教育潮 [*Tides of education*] 1, no. 1 (April 1919).

"*Jiaoyu zazhi* shang guanyu xunyu de cailiao" 教育雜志上關於訓育的材料 [Material on character development education in *Educational Review*] and "*Xin jiaoyu* shang guanyu xunyu wenti de cailiao" 新教育上關於訓育問題的材料 [Material on character development education issues in *New Education*]. *Zhongdeng jiaoyu* 中等教育 [Secondary education] 3, no. 2 (August 1, 1921).

Jiaoyubu tongji shi 教育部統計室. *Quanguo jiaoyu tongji jianbian, Zhonghua Minguo ershisi niandu* 全國教育統計簡編中華民國二十四年度 [Concise edition of the national education statistics for 1935]. Changsha: Shangwu yinshuguan, 1938.

Jie 潔 [pseudonym, full name unknown]. "Shiping san" 時評三 [Third short comment]. *Shibao*, September 4, 1911.

Jiezi. "Fakanci" 發刊詞 [Inaugural preface]. *Suzhou Zhenhua nüxue xiaokan* 蘇州振華女學校刊 [Suzhou Zhenhua girls school periodical], no. 1 (May 1927): 1.

Jin Wuxiang 金武祥. *Suxiang sanbi* 粟香三筆 [Third record of Suxiang]. Suzhou: Saoye shanfang, 1884 (preface date).

Jingzhong xuesheng qikan 敬中學生期刊 [Periodical of Jingye Middle School's students]. Chuangkanhao 創刊號 [Inaugural issue] (n.d.).

"Jiu han shuo" 救旱說 [On how to find relief from drought]. *Shenbao*, July 29, 1873.

Jizhong xuesheng 稽中學生 [Jishan middle student], no. 7 (October 1937).

Johnson, David, Andrew J. Nathan, and Evelyn S. Rawski, eds. *Popular Culture in Late Imperial China*. Berkeley: University of California Press, 1985.

Jones, Gary. "The Vampire Chronicle." *Tofu*, no. 2 (2000). http://www.tofu-magazine.net/newVersion/pages/mianmian.html (accessed May 31, 2007).

Judge, Joan. *Print and Politics:* Shibao *and the Culture of Reform in Late Qing China*. Stanford, CA: Stanford University Press, 1996.

Kai-wing Chow. *Publishing, Culture, and Power in Early Modern China*. Stanford, CA: Stanford University Press, 2004.

Kalathil, Shanthi, and Taylor C. Boas. *Open Networks, Closed Regimes: The Impact of the Internet on Authoritarian Rule*. Washington, DC: Carnegie Endowment for International Peace, 2003.

Kampen, Thomas. *Mao Zedong, Zhou Enlai, and the Evolution of the Chinese Communist Leadership*. Copenhagen: NIAS, 2000.

Kaplan, Carl S. "Concern over Proposed Changes in Internet Surveillance." *New York Times*, September 21, 2001. http://www.nytimes.com/2001/09/21/technology/21CYBERLAW.html.

Kaske, Elisabeth. *The Politics of Language in Chinese Education, 1895–1919*. Leiden: Brill, 2008.

Kavanagh, D. J. *The Zi-Ka-Wei Orphanage*. San Francisco: James H. Bowey, n.d.

Keenan, Barry. *The Dewey Experiment in China: Educational Reform and Political Power in the Early Republic*. Cambridge, MA: Harvard University Press, 1977.

Kelsall, Anne Nottingham. *Zi-ka-wei and the Modern Jesuit Mission to the Chinese, 1842–1952*. Master's thesis, University of Maryland, 1978.

Kern, Martin. "Yao Nais pragmatischer Umbau der literarischen Genretheorie." In *Tradition und Moderne—Religion, Philosophie und Literatur in China. Referate der 7. Jahrestagung 1996 der Deutschen Vereinigung für Chinastudien (DVCS)*, edited by Christiane Hammer and Bernhard Führer, 143–163. Bochum: Projekt Verlag, 1997.

Keulemans, Paize. "Recreating the Storyteller Image: Publishing Martial Arts Fiction to Renew the Public in the Late Qing." *Twentieth Century China* 29, no. 2 (April 2004): 7–37.

Kieschnick, John. *The Impact of Buddhism on Chinese Material Culture*. Princeton, NJ: Princeton University Press, 2003.

King, Gail. "The Xujiahui (Zikawei) Library of Shanghai." *Libraries & Culture* 32, no. 4 (Fall 1997): 456–469.

Kinkley, Jeffrey C. *Corruption and Realism in Late Socialist China: The Return of the Political Novel*. Stanford, CA: Stanford University Press, 2007.

Kluver, Alan R. "New Media and the End of Nationalism: China and the US in a War of Words." *Mots Pluriels*, no. 18 (August 2001). http://motspluriels.arts.uwa.edu.au/MP1801ak.html (accessed September 5, 2009).

Knight, Sabina. "Shanghai Cosmopolitan: Class, Gender and Cultural Citizenship in Wei-hui's *Shanghai Babe*." *Journal of Contemporary China* 12, no. 37 (2003): 639–653.

——. *The Heart of Time: Moral Agency in Twentieth-Century Chinese Fiction*. Cambridge, MA: Harvard University Press, 2006.

Kong, Shuyu. "Between a Rock and a Hard Place: Chinese Literary Journals in the Cultural Market." *Modern Chinese Literature and Culture* 14, no. 1 (2002): 94.

——. *Consuming Literature: Best Sellers and the Commercialization of Literary Production in Contemporary China*. Stanford, CA: Stanford University Press, 2004.

Kozer, Seana. "Leaves Gleaned from the Ten-Thousand-Dimensional Web in Heaven: Chinese On-Line Publications in Canada." *Journal of American Folklore* 115, no. 456 (2002): 129–153.

Kropp, Michael. "Ma Xiangbo (1840–1939) und die Modernisierung des chinesischen Bildungswesens." *Monumenta Serica* 42 (1994): 397–443.

Kuang Xinnian 旷新年. *1928: Geming wenxue* 1928: 革命文学 [1928: Revolution literature]. Ji'nan: Shandong jiaoyu chubanshe, 1998.

Kurlantzick, Joshua. "The Web Won't Topple Tyranny." *New Republic*, March 25, 2004. [http://www.tnr.com].

Kurtz, Joachim. "The Works of Li Wenyu (1840–1911): Bibliography of a Chinese-Jesuit Publicist." *Wakumon* 11 (2006): 149–158.

Lao Xiang 老向. "Guanyu kangri *Sanzi jing*" 关于抗日三字经 [On the anti-Japanese *Sanzi jing*). In *Lao Xiang* 老向 [Lao Xiang selections], 292–293. Beijing: Huaxia chubanshe, 2000.

La Servière, Joseph de, S. J. *Histoire de la Mission du Kiang-nan*. 2 vols. Shanghai: Imprimerie de T'ou-sè-wè, 1914.

——. *L'orphelinat de T'ou-sè-wè: son histoire, son état présent*. Shanghai: Imprimerie de T'ou-sè-wè, 1914.

——. *La nouvelle Mission du Kiang-nan, 1840–1922*. Shanghai: Imprimerie de T'ou-sè-wè, 1925.

Latourette, Kenneth Scott. *A History of Christian Missions in China*. London: Society for Promoting Christian Knowledge, 1929.

Lazzarotto, P. I. "Xujiahui: Contribution to Science and Society." *Tripod* 70 (July/August 1992): 39–73.

"Le Collège Saint Ignace." AFCJ (FCh 309).

"Le Père Laurent Li, S. J." Manuscript, AFCJ (n.d.).

"Le Père Laurent Li." *Lettres de Jersey* 30 (1911): 256–259.

"Le Père Laurent Li (1840–1911)." *Lettres de Jersey* 33 (1914): 135–141.

"Le Père Laurent Li." *Relations de Chine* 6 (1918/1921): 191–192.

Lee, Leo Ou-fan. *Shanghai Modern: The Flowering of a New Urban Culture in China, 1930–1945*, Cambridge, MA: Harvard University Press, 1999.

——. "Incomplete Modernity: Rethinking the May Fourth Intellectual Project." In Doleželová-Velingerová, Král, and Sanders, *The Appropriation of Cultural Capital*, 31–65.

Lee, Leo Ou-fan, and Andrew J. Nathan. "The Beginnings of Mass Culture: Journalism and Fiction in the Late Ch'ing and Beyond." In Johnson, Nathan, and Rawski, *Popular Culture in Late Imperial China*, 360–398.

Lei Xiaotong 雷晓彤. "Jindai Beijing de Manzu xiaoshuojia Cai Youmei" 近代北京的满族小说家蔡友梅 [Cai Youmei, a modern Manchu novelist from Beijing]. *Manzu yanjiu* 满族研究 [Manchu research] 4 (2005): 108–116.

Lessig, Lawrence. *Code and Other Laws in Cyberspace*. New York: Basic Books, 1999.

Leung, Angela. "Elementary Education in the Lower Yangtze Region in the Seventeenth and Eighteenth Centuries." In *Education and Society in Late Imperial China, 1600–1900*, edited by Benjamin A. Elman and Alexander Woodside, 381–416. Berkeley: University of California Press, 1994.

"L'Imprimerie de T'ou-sè-wè." AFCJ (FCh 352).

Li, Charles. "Internet Control in China." *International Journal of Communications Law and Policy* 8 (Winter 2003/2004): 2–8.

Li Liangrong 李良荣. *Zhongguo baozhi wenti fazhan gaiyao* 中国报纸文体发展概要 [An overview of the development of Chinese newspaper genres]. Fuzhou: Fujian renmin chubanshe, 1985.

Li Mingshan 李明山. *Zhongguo jindai banquan shi* 中国近代版权史 [A history of copyright laws in China]. Kaifeng: Henan daxue chubanshe, 2003.

Li Ruzhen 李汝珍. *Jinghua yuan* 镜花缘 [Flowers in the mirror]. 2 vols. 1828. Reprint, Beijing: Renmin wenxue chubanshe, 1996.

Li Shaozhong 李紹忠. "Jizhong junxun qijian shenghuo de huiyi" 集中軍訓期間生活的回憶 [Memories of life during collective military training]. *Zhejiang qingnian* 浙江青年 [Zhejiang youth] 2, no. 1 (November 1935): 217–218.

Li Songsheng 李嵩生. "Benbao zhi yange" 本報之沿革 [The evolution of our newspaper]. In *Zuijin zhi wushi nian: 1872 nian—1922 nian, Shenbao wushi zhounian jinian* 最近之五十年: 1872 年—1922 年申報五十周年紀念 [The last fifty years: 1872–1922, in commemoration of Shenbao's 50th anniversary]. Vol. 2, 29–34. 1922. Reprint, Shanghai shudian: 1987.

Li Wenyu 李問漁. *Lianyu lüeshuo* 煉獄略說 [Short treatise on purgatory]. Xujiahui: Tushanwan yinshuguan, 1871. Reprinted Hejian: Hejian shengshi tang, 1877.

——. *Li ku* 理窟. *Puteus rationum* [The well of reason]. 7th ed. 4 vols. Xujiahui: Tushanwan yinshuguan, 1930.

——. *Xu li ku* 續理窟. *Puteus rationum, continuatur* [The well of reason, continued]. 2nd ed. 2 vols. Xujiahui: Tushanwan yinshuguan, 1926.

Li Xiaofeng 李小峰. "Xinchao she de shimo" 新潮社的始末 [History of the New Tide Society]. *Wenshi ziliao xuanji* 文史资料选集 [Collected materials on culture and history] 61 (1979): 82–128.

Li Xiaofeng 李小峰. "Lu Xun xiansheng yu Beixin shuju" 鲁迅先生与北新书局 [Lu Xun and the Beixin Press]. In Song Yuanfang, *ZCSXB*, 336–341.

——. "Wo de wenxue guan" 我的文学观 [My view of Internet literature]. N.d. http://suzhj.edu.chinaren.com/netwen.htm (accessed May 6, 2001).

Li Yonghu 李永祜. "Jiaodian houji" 校點後記 [Some remarks after punctuating]. In Tanmeng daoren, *Peng gong'an quan zhuan*, 330–334.

Li Zongfen 李宗奋. "Li Xiaofeng yu xin wenxue yundong" 李小峰与新文化运动 [Li Xiaofeng and the New Culture Movement]. *Jiangyin wenshi ziliao* 江阴文史资料 [Materials of culture and history of Jiangyin] 4 (1983): 48–73.

——. "Beixin shuju de shengshuai" 北新书局的盛衰 [The rise and decline of the Beixin Press]. *Jiangyin wenshi ziliao* 江阴文史资料 [Jiangyin cultural and historical materials] 6 (1985): 71–85.

Liedtke, Michael. "Google's Chinese News Service Omits Government-Banned Sites." Associated Press, September 24, 2004. http://www.detnews.com/2004/technology/0409/27/technology-284189.htm (accessed September 10, 2005).

Lin Mei 林枚. "1924–1927 nian Wenzhou xuesheng yundong" 温州学生运动 [Wenzhou's student movement in the years 1924–1927]. *Wenzhou wenshi ziliao* 温州文史资料 [Wenzhou cultural and historical materials], no. 4 (1988): 168–171.

Lin Ziqing 林子青. *Hongyi fashi nianpu* 弘一法师年谱 [Chronological biography of Dharma Master Hongyi]. Beijing: Zongjiao wenhua chubanshe, 1995.

Link, Perry. *Mandarin Ducks and Butterflies: Popular Fiction in Early Twentieth-Century Chinese Cities*. Berkeley: University of California Press, 1981.

——. *The Uses of Literature: Life in the Socialist Chinese Literary System*. Princeton, NJ: Princeton University Press, 2000.

Link, Perry, Richard P. Madsen, and Paul G. Pickowicz, eds. *Popular China: Unofficial Culture in a Globalizing Society*. Lanham, MD: Rowman & Littlefield, 2002.

Liu Chen 刘辰. "Congshu, leishu, baike quanshu jiqi bijiao" 丛书、类书、百科全书及其比较 [A comparative view of book series, compendia, and encyclopedias]. http://www.cbkx.com/2001–3/109.shtml (accessed July 13, 2005).

Liu Dan 刘丹. "Shenti yu nüxing wenxue" 身体与女性文学 [The body and women's literature]. *Changjiang shifan xueyuan xuebao* 长江师范学院学报 [Journal of Yangzi Normal University] 24, no. 1 (2008): 100–103.

Liu Guangsheng 刘广生. *Zhongguo gudai youyi shi* 中国古代邮驿史 [The History of China's traditional postal service]. Beijing: Zhongguo youdian chubanshe, 1999.

Liu Na 刘纳. *Chuangzao she yu Taidong tushuju* 创造社与泰东图书局 [The Creation Society and the Taidong Press]. Nanning: Guangxi jiaoyu chubanshe, 1999.

Liu Ts'un-yan. *Chinese Popular Fiction in Two London Libraries*. Hong Kong: Lungmen, 1967.

Liu Zhemin 刘哲民. *Jinxiandai chuban xinwen fagui huibian* 近现代出版新闻法规汇编 [A collection of laws for modern and contemporary publishing and the press]. Shanghai: Xuelin chubanshe, 1992.

Liuru yisun 六如裔孙. [Preface]. *Honglou yuan meng* 紅樓圓夢 [Complete dream of the red chamber], by Meng meng xiansheng 夢夢先生. Beijing: Beijing daxue chubanshe, 1988.

Liste des livres chinois de la Province de Champagne, conservés aux archives de la Province Jésuite de France. Typescript, AFCJ (n.d.).

Lou Shiyi 娄适宜. "Nanwang de guli he bangzhu" 难忘的鼓励和帮助 [Unforgettable encouragement and assistance]. In Zhongguo chuban gongzuozhe xiehui, *Wo yu Kaiming*, 51–55.

Löwenthal, Rudolf. *The Religious Periodical Press in China*. Peking: Synodal Commission in China, 1940.

Lu Qun 陆群. *Zhongguo wang chong chuangqi* 中国网虫传奇. [Legendary tales of Internet worms in China]. Beijing: Zhongguo qingnian chubanshe, 2003.

Lu, Sheldon H. *Chinese Modernity and Global Biopolitics*. Honolulu: University of Hawai'i Press, 2007.

Lu Yingyong 路英勇. *Rentong yu hudong: Wusi xinwenxue chuban yanjiu* 认同与互动: 五四新文学出版研究 [A study of May Fourth new literature and publishing]. Hefei: Anhui wenyi chubanshe, 2004.

Lu 傻 [pseudonym]. "Yangzhou jimin canzhuang ji" 揚州飢民慘狀記 [A record on the miserable condition of the famine victims in Yangzhou]. *Shenbao*, January 4, 1907.

Lufei Kui 陆费逵. "Liushinian lai Zhongguo zhi chubanye yu yinshuaye" 六十年来中国之出版业与印刷业 [Chinese publishing and printing in the last sixty years]. In Song Yuanfang, *ZCSXB*, vol. 1, pt. 2; 415–424.

"Lun jinri yanju zhuzhen shi" 論今日演劇助賑事 [On the present charity theatricals]. *Shenbao*, January 19, 1907.

Lynch, Daniel C. *After the Propaganda State: Media, Politics, and "Thought Work" in Reformed China*. Stanford, CA: Stanford University Press, 1999.

Ma Guangren 马光仁. *Shanghai xinwen shi 1850–1949* 上海新闻史 [History of the Shanghai Press, 1850–1949]. Shanghai: Fudan daxue chubanshe, 1996.

Ma, Michael. "Beijing Gets Tough on Internet Bar and BBS Operators." *SCMP*, May 10, 2001. [http://www.scmp.com].

MacKinnon, Rebecca. "China's Censorship 2.0: How Companies Censor Bloggers." *First Monday* 14, no. 2 (February 2, 2009). http://firstmonday.org/htbin/cgiwrap/bin/ojs/index.php/fm/article/view/2378/2089.

——. "Chinese Bloggers React to Registration Deadline." Global Voices, July 2, 2005. http://globalvoicesonline.org/2005/07/02/chinese-bloggers-react-to-registration-deadline/ (accessed September 12, 2005).

Mao Dun 茅盾. *Mao Dun zizhuan* 茅盾自传 [Autobiographical essays of Mao Dun]. Nanjing: Jiangsu wenyi chubanshe: 1996.

Mao Zedong. "On Policy." In *Selected Works of Mao Tse-tung*. Vol. 2, 441–49. Peking: Foreign Languages Press, 1977.

Marshall, Tyler, and Anthony Kuhn. "China Goes One-on-One with the Net." *Los Angeles Times*, January 27, 2001. http://www.latimes.com/business/cutting/lat_chi-tek010127.htm.

Martinsen, Joel. "Lu Jinbo: Marketing the Wang Shuo Brand." Danwei, June 21, 2007. http://www.danwei.org/books/lu_jinbo_marking_the_wang_shuo.php (accessed September 3, 2008).

McDermott, Joseph P. *A Social History of the Chinese Book: Books and Literati Culture in Late Imperial China*. Hong Kong: Hong Kong University Press, 2006.

——. "The Ascendance of the Imprint in China." In Brokaw and Chow, *Printing and Book Culture in Late Imperial China*, 55–104.

McDougall, Bonnie. "Discourse on Privacy by Women Writers in Late Twentieth-Century China." *China Information 19, no.1* (2005): 97–119.

——. *Fictional Authors, Imaginary Audiences*. Hong Kong: Chinese University Press, 2003.

McElroy, Sarah Coles. "Transforming China through Education: Yan Xiu, Zhang Boling, and the Effort to Build a New School System, 1901–1927." PhD diss., Yale University, 1996.

McGill, Douglas C. "Sina.com's Delicate Balancing Act" Virtual China, May 23, 2000. [http://www.virtualchina.com/] (accessed May 25, 2000).

McLaren, Anne E. "Constructing New Reading Publics in Late Ming China." In Brokaw and Chow, *Printing and Book Culture in Late Imperial China*, 152–183.

——. *Performing Grief: Bridal Laments in Rural China*. Honolulu: University of Hawai'i Press, 2008.

McLuhan, Marshall. *The Gutenberg Galaxy: The Making of Typographic Man*. Toronto: University of Toronto Press, 1965.

McMahon, Keith. *Misers, Shrews, and Polygamists: Sexuality and Male-Female Relations in Eighteenth-Century Chinese Fiction*. Durham, NC: Duke University Press, 2005.

Medhurst, W. H. *China: Its State and Prospects*. London: John Snow, 1838.

"Meiguo jinshi" 美國近事 [Recent news from America]. *Zhongxi wenjian lu* 6 (January 1873). Reprinted Nanjing: Nanjing guji shudian, 1992: 377–378.

Meisner, Maurice. *Mao's China and After*. New York: Free Press, 1977.

Meng Qing 孟庆. "Xiaoshi de Tushanwan" 消逝的土山湾 [Vanished Tushanwan]. *Zhongguo zongjiao* 中国宗教 [Chinese religions], no. 6 (2003): 40–41.

Menghuan 夢幻. "Xianping yi" 閒評一 [Idle critique one]. *Dagongbao*, September 10, 1911.

Meyer-Fong, Toby. *Building Culture in Early Qing Yangzhou*. Stanford, CA: Stanford University Press, 2003.

Mian Mian 棉棉. *Tang* 糖 [Candy]. Taipei: Shengzhi, 2000.

——. "Wo de mingpai shenghuo." 我的名牌生活 [My brand-name life]. http://www.shuwu.com/ar/fanti/111251.shtml (accessed June 12, 2001).

——. *La la la* 啦啦啦. Translated by Karin Hasselblatt. Cologne: Kiepenheuer and Witsch, 2002.

——. "Preface." In *Tang*, translated by Andrea Lingenfelter, xi. Boston: Little, Brown, 2003.

——. Homepage. http://www.mianmian.com/ (accessed December 16, 2005).

——. *Tang*. http://www.21gbook.com/shu/a2/s3/ (accessed January 25, 2006).

"Mian Mian Reaches Maturity with *Panda Sex.*" *China Daily*, March 1, 2005. http://www.chinadaily.com.cn/english/doc/2005–03/01/content_420714.htm (accessed January 25, 2006).

Miao Quansun 繆荃孙, Wu Changshou 吳昌綬, and Dong Kang 董康. *Jiaye tang cangshu zhi* 嘉業堂藏書志 [Chronicle of the Jiayetang book collection]. Shanghai: Fudan daxue chubanshe, 1997.

Miller, Carolyn R. "Genre as Social Action." *Quarterly Journal of Speech* 70 (1984): 151–167. Reprinted in *Genre and the New Rhetoric*, edited by Aviva Freedman and Peter Medway, 23–42. London: Taylor & Francis, 1994.

Milne, William. *Zhang Yuan liangyou xianglun* 張袁兩友相論 [Dialogue between Two Friends Zhang and Yuan]. Shanghai: Meihua shuguan baiyin, 1906.

Minford, John. "Introduction." In *A Chinese Winter's Tale*, by Yu Luojin, vii–xix. Translated by Rachel May and Zhu Zhiyu. Hong Kong: Renditions, 1986.

Minguo sannian chun Zhonghua shuju gaikuang 民國三年春中華書局概況) [Zhonghua Book Company's general situation in spring 1914]. [Beijing: Zhonghua shuju], 1914.

[Ministry of Information Industry.] "Zhonghua renmin gongheguo dianxin tiaoli" 中华人民共和国电信条例 [Regulations on telecommunications of the People's Republic of China]. *Zhonghua renmin gongheguo guowuyuan gongbao* 中华人民共和国国务院公报 [State Council Bulletin of the People's Republic of China] (*GWYGB*), September 25, 2000. 33: 11–21.

——. "Hulianwang dianzi gonggao fuwu guanli guiding" 互联网电子公告服务管理规定 [Administrative regulations on BBS service over the Internet] (October 8, 2000). *GWYGB* 2 (2001): 45–46.

——. "Dianxin yewu jingying xukezheng guanli banfa" 电信业务经营许可证管理办法 [Administrative measures for telecommunications business permits]. December 26, 2001. http://www.cnnic.net.cn/html/Dir/2003/12/12/1987.htm (accessed November 17, 2009).

——. "Dianxin yewu jingying xukezheng guanli banfa." January 1, 2002. [http://www.miit.gov.cn/] (accessed February 28, 2002).

Mitchell, B. R. *European Historical Statistics, 1750–1970*. New York: Columbia University Press, 1978.

Mittler, Barbara. *A Newspaper for China? Power, Identity, and Change in Shanghai's News Media, 1872–1912.* Cambridge, MA: Harvard University Asia Center, 2004.

Mohr, Wolfgang. *Die chinesische Tagespresse. Ihre Entwicklung in Tafeln und Dokumenten*. 3 vols. Wiesbaden: Steiner, 1976.

Mungello, David E. *Curious Land: Jesuit Accommodation and the Origins of Sinology.* Honolulu: University of Hawai'i Press, 1989.

——. "The Return of the Jesuits to China in 1841 and the Chinese Christian Backlash." *Sino-Western Cultural Relations Journal* 27 (2005): 9–46.

Muzi Mei 木子美. *Yiqing shu* 遺情書 [Ashes of love]. Hong Kong: Cosmos Books, 2004.

Nagasawa Kikuya 長澤規矩也. *Wa Kan sho no insatsu to sono rekishi* 和漢書の印刷とその歴史 [Japanese and Chinese printing and their histories]. In *Nagasawa Kikuya chosakushū* 長澤規矩也著作集 [Collected works of Nagasawa Kikuya]. Tokyo: Kyūko Shoin, 1982.

Nanning shizhi: wenhua juan 南宁市志: 文化卷 [Nanning municipality gazetteer: Culture section]. Nanning: Guangxi renmin chubanshe, 1998.

Nathan, Andrew J. "The Late Ch'ing Press: Role, Audience and Impact." In *Proceedings of the International Conference on Sinology: Section on History and Archeology*. Vol. 2, 1281–1308. Taipei: Academia Sinica, 1981.

Navarra, B. R. A. "The Institution of the Jesuit Fathers at Sikawei." Shanghai: n.p., 1884. AFCJ (FCh 309).

Neumann, A. Lin. "The Great Firewall." *Ming Pao*, December 8, 2000. http://www.mingpao.com/. Cf. *SWB FE*/4020, December 11, 2000: G/5–7.

——. "Internet Police Ranks Swell to 300,000." *Ming Pao*, December 8, 2000. [http://www.mingpao.com/]. Cf. *SWB FE*/4020, December 11, 2000: G/5–7.

Newbold, Jill R. "Aiding the Enemy." *Journal of Law, Technology and Policy*. Quoted in "U.S. Corporations Should Stop Being Complicit in China's Cyber Censorship, Journal Editor Says," August 10, 2004. [http://www.eurekalert.org/] (accessed October 4, 2004).

Ni Bo 倪波, and Mu Weiming 穆纬铭. *Jiangsu baokan bianjishi* 江苏报刊编辑史 [A history of the publication of newspapers and periodicals in Jiangsu]. Nanjing: Jiangsu renmin chubanshe, 1993.

Nianci 念慈. "Xu bensheng nannü qingniantuan shaoniantuan ji shaonütuan tuanyuan" 勖本省男女青年團少年團及少女團團員 [Encouraging the members of this province's boys' and girls' youth corps, youth troops, and girls' youth troops]. *Zhejiang qingnian* 浙江青年 [Zhejiang youth] 3, no. 1 (November 1936): 8–10.

Nottingham, Anne Kelsall. *Zi-ka-wei and the Modern Jesuit Mission to the Chinese, 1842–1952*. Master's thesis, University of Maryland, 1978.

Oates, John. "Chinese Government Censors Online Games." *The Register*, June 1, 2004. http://www.theregister.co.uk/2004/06/01/china_bans_games/ (accessed September 10, 2005).

Okamoto Sae 岡本さえ. *Shindai kinsho no kenkyû* 清代禁書の研究 [Research on censored books of the Qing Dynasty]. Tokyo: Tokyo daigaku, Tôyô bunka kenkyûjo, 1996.

Ôtsuka Hidetaka 大塚秀高. *Zôho Chûgoku shôsetsu shomoku* 增補中國通俗小說書目 [Supplemental catalogue of Chinese fiction]. Tokyo: Kyuko shoin, 1987.

Ouyang Youquan 欧阳友全. "Hulian wang shang de wenxue fengjing—woguo wangluo wenxue xianzhuang diaocha yu zoushi fenxi" 互联网上的文学风景—我国网络文学现状调查与走势分析 [Literary horizons on the Internet: a survey and analysis of the current condition and future of Internet literature in our country]. *Sanxia daxue xuebao* 三峡大学学报 [Journal of (Hubei) Three Gorges University], no. 6 (2001): 5–9.

Pan Wenan 潘文安. "Jinhou zhongdeng xuexiao zhi xunyu" 今後中等學校之訓育 [Future character-development education for secondary schools]. *Zhongdeng jiaoyu* 中等教育 [Secondary education] 3, no. 2 (August 1, 1924): 1–7.

Pang Duoyi 庞多益. "Xin Zhongguo shukan yinshua gongye de fazhan licheng" 新中国书刊印刷工业的发展历程 [The development of industrial printing of New China's books and periodicals). In *Zhongguo dangdai chuban shiliao* 中国当代出版史料 [Current Chinese publishing materials], edited by Song Yingli 宋应离 et al., vol. 4, 8–33. Zhengzhou: Daxiang chubanshe, 1999.

"Party Daily Calls for Action against Internet Pollution." *People's Daily*, March 21, 2001. [http://english.people.com.cn/]. Cf. *SWB FE*/4106 (March 28, 2001): G/7.

Pepper, Suzanne. *Radicalism and Education Reform in 20th Century China: The Search for an Ideal Development Model*. New York: Cambridge University Press, 1996.

Peterson, Glen. *The Power of Words: Literacy and Revolution in South China, 1949–95*. Vancouver: UBC Press, 1997.

Piel, O. "Le 70ème anniversaire du Musée Heude." *Bulletin de l'Université Aurore* 1938/39: 8–46.

Pittman, Don A. *Toward a Modern Chinese Buddhism: Taixu's Reforms*. Honolulu: University of Hawai'i Press, 2001.

Pratt, J. B. *The Pilgrimage of Buddhism*. New York: MacMillan., 1928.

Prentice, Claire. "Bridget Jones with a Little More between the Ears." *Times Online*, August 14, 2005. http://www.timesonline.co.uk/article/0,,2090-1731964,00.html (accessed January 24, 2006).

"Public Opinion in China." *Asian Wall Street Journal*, June 15, 2004, A11.

"Putting It in Its Place." *Economist* 360, no. 8234 (August 11, 2001): 18–20.

Qiang, Xiao. "The Words You Never See in Chinese Cyberspace." China Digital Times, August 30, 2004. http://chinadigitaltimes.net/2004/08/the_words_you_n. php (accessed September 2, 2004).

Qin Yanhua 秦艳华. "Taidong tushuju ruhe chengwei chuangzao she de yaolan" 泰东图书局如何成为创造社的摇篮 [How did the Taidong Press become the cradle of the Creation Society?]. http://news.xinhuanet.com/book/2004-02/26/ content_1332613.htm (accessed July 13, 2005).

Qiu, Jack Linchuan. "Internet Censorship in China (1999–2000)." *Communications Law in Transition Newsletter* 2, no. 3 (February 18, 2001). http://pcmlp.socleg.ox.ac. uk/archive/transition/ (accessed February 25, 2002).

——. "Virtual Censorship in China: Keeping the Gate between the Cyberspaces." *International Journal of Communications Law and Policy* 4 (Winter 1999): 1–25.

Rankin, Mary B. "'Public Opinion' and Political Power: Qingyi in Late Nineteenth-Century China." *Journal of Asian Studies* 51, no. 3 (1982): 453–484.

Rao Hongjing 饶鸿竟, et al. "Chuangzao she dashiji" 创造社大事记 [A chronicle of the Creation Society]. In Rao et al., *Chuangzao she ziliao*.

——, et al., eds. *Chuangzao she ziliao* 创造社资料 [Materials on the Creation Society]. Fuzhou: Fujian renmin chubanshe, 1985.

Ratio studiorum pro utroque Seminario Missionis Sinensis in Provincia Nankinensi. Manuscript, AFCJ (n.d.)

Rawski, Evelyn S. *Education and Popular Literacy in Ch'ing China*. Ann Arbor: University of Michigan Press, 1979.

——. "Economic and Social Foundations." In Johnson, Nathan, and Rawski, *Popular Culture in Late Imperial China*, 3–33.

Rea, Christopher Gordon. *A History of Laughter: Comic Culture in Early Twentieth-Century China*. PhD diss., Columbia University, 2008.

Record of Things Heard and Seen from the East and the West. See *Zhongxi wenjian lu*.

Reed, Christopher A. *Gutenberg in Shanghai: Chinese Print Capitalism, 1876–1937*. Vancouver, BC: UBC Press, 2004.

——. "Gutenberg in Shanghai: Mechanized Printing, Modern Publishing, and Their Effects on the City, 1876–1937." Ann Arbor: University Microfilms International, 1996.

——. "Re/Collecting the Sources: Shanghai's *Dianshizhai Pictorial* and Its Place in Historical Memories, 1884–1949." *Modern Chinese Literature and Culture* 12, no. 2 (Fall 2000): 44–72.

Reporters Without Borders. "Information Supplied by Yahoo! Helped Journalist Shi Tao Get 10 Years in Prison." September 6, 2005. http://www.rsf.org/Information-supplied-by-Yahoo.html (accessed September 12, 2005).

Ren Jing 任静. "Haipai nüzuojia de liubian guiji yu neizai chayi" 海派女作家的流变轨迹与内在差异 [Development paths and internal differences in the works of Shanghai woman writers]. *Nanjing gongye zhiye jishu xueyuan xuebao* 南京工业职业技术学院学报 [Journal of Nanjing Institute of Industry Technology] 6, no. 1 (2006): 44–47.

Reuters. "China Overtakes US as Top Internet Market: Researcher." *China Post* (Taipei), March 14, 2008.

——. "China Threatens Internet Porn Merchants with Life." September 6, 2004. http:// cnn.netscape.cnn.com/ns/news/story.jsp?id=20040905212200002433150&dt=200409 05212200&w=RTR&coview= (accessed September 6, 2004).

Robinson, Neil. "New Laws Seek to Balance Privacy and Surveillance." *Jane's Intelligence Review* 14, no.1 (January 2002): 52–53.

Rodan, Garry. "The Internet and Political Control in Singapore." *Political Science Quarterly* 113, no. 1 (1998): 63–89.

Roddy, Stephen J. *Literati Identity and Its Fictional Representations in Late Imperial China*, Stanford, CA: Stanford University Press, 1998.

Rogaski, Ruth. *Hygienic Modernity: Meanings of Health and Disease in Treaty-Port China.* Berkeley: University of California Press, 2004.

Ruan Renze 阮仁泽 and Gao Zhennong 高振农, eds. *Shanghai zongjiao shi* 上海宗教史 [History of religion in Shanghai]. Shanghai: Shanghai renmin chubanshe, 1992.

Saich, Tony, and Hans van de Ven, eds. *New Perspectives on the Chinese Communist Revolution.* Armonk, NY: M. E. Sharpe, 1995.

Sakai Tadao 酒井忠夫. *Chūgoku zensho no kenkyū* 中国善書の研究 [Research on Chinese morality books]. Tokyo: Kobundo, 1960.

——. "Confucianism and Popular Educational Works." In *Self and Society in Ming Thought,* edited by William Theodore deBary, 331–366. New York: Columbia University Press, 1970.

Saoye shanfang shuji fadui 掃葉山房書籍發兌 [Published books by Saoye shanfang]. In *Zhongguo jindai guji chuban faxing shiliao congkan* 中國近代古籍出版發行史料叢刊 [Compendium of historical materials on publication of traditional books in recent history], edited by Xu Shu 徐蜀 and Song Anli 宋安莉, vol. 23. Beijing: Beijing tushuguan chubanshe, 2003.

Schell, Orville. *Mandate of Heaven: A New Generation of Entrepreneurs, Dissidents, Bohemians and Technocrats Lays Claim to China's Future.* London: Little, Brown, 1995.

——. Comment on *New York Times* article on Muzi Mei. China Digital Times Blog, comment posted November 30, 2003. http://chinadigitaltimes.net/2003/11/new_york_times.php (accessed June 4, 2007).

Schran, Peter. *Guerilla Economy: The Development of the Shensi-Kansu-Ninghsia Border Region, 1937–1945.* Albany, NY: State University of New York Press, 1976.

Schwarcz, Vera. *The Chinese Enlightenment: Intellectuals and the Legacy of the May Fourth Movement of 1919.* Berkeley: University of California Press, 1986.

Seeberg, Vilma. *Literacy in China: The Effect of the National Development Context and Policy on Literacy Levels, 1949–1979.* Bochum: N. Brockmeyer, 1990.

——. *The Rhetoric and Reality of Mass Education in Mao's China.* Lewiston, NY: Edwin Mellen Press, 2000.

Selden, Mark. "Yan'an Communism Reconsidered." *Modern China* 21, no. 1 (January 1995): 8–44.

Shaanxi shengzhi: Chuban zhi 陕西省志: 出版志 [Shaanxi provincial gazetteer: publishing gazetteer]. Xi'an: Santai chubanshe, 1998.

Shandong shengzhi: Chuban zhi 山东省志: 出版志 [Shandong provincial gazetteer: publishing gazetteer]. Ji'nan: Shandong renmin chubanshe, 1993.

Shang, Wei. "The Reception of the *Story of the Stone* and Popular Culture from 1791 to 1919." Unpublished essay.

Shanghai jiaoyu 上海教育 [*Shanghai education*] 1, no. 1 (February 7, 1928): 1.

Shanghai Journal. See Shenbao.

Shanghai Minli zhongxue sanshizhou jiniankan 上海民立中學三十週紀念刊 [Memorial volume for the thirtieth anniversary of Shanghai's Minli Middle School]. Shanghai: n.p., 1933.

Shanghai tushuguan. *Zhongguo congshu zonglu* 中國叢書總錄 [Master record of Chinese compendia]. Shanghai: Shanghai guji chubanshe, 1986.

Shanghai zongjiao zhi bianzuan weiyuanhui 上海宗教志編纂委圓會, ed. *Shanghai zongjiao zhi* 上海宗教志 [Annals of religion in Shanghai]. Shanghai: Shanghai shehui kexue yuan chubanshe, 2001.

Shangwu yinshuguan jiushi nian 商务印书馆九十年 [Ninety years of the Commercial Press], 544–551. Beijing: Shangwu yinshuguan, 1987.

Shao, Qin. *Culturing Modernity: The Nantong Model, 1890–1930.* Stanford, CA: Stanford University Press, 2004.

Shao Zhenji 邵振紀. *Jiaohui qianshuo* 教誨淺説 [Introductory moral instruction]. Vol. 2. 1925. Reprint, Shanghai: Foxue shuju, 1936.

Shapiro, Andrew L. "The Internet." *Foreign Policy* 115 (Summer 1999): 18–19.

Shen Quji 沈去疾. *Yinguang fashi nianpu* 印光法师年谱 [Chronological biography of Dharma Master Yinguang]. Chengdu: Tiandi chubanshe, 1998.

Shen Songquan 沈松泉. "Guanyu Guanghua shuju de huiyi" 关于光华书局的回忆 [My recollections of the Guanghua Press]. *Chuban shiliao* 出版史料 [Historical publishing materials] 2 (1991): 31–47.

———. "Huainian Zhang Jinglu xiansheng" 怀念张静庐先生 [Commemorating Mr. Zhang Jinglu], *Chuban shiliao* 出版史料 3 (1990): 26–32, 66.

Shen Yizhen 沈亦珍. "Jiaoxun heyi" 教訓合一 [Uniting instruction and character-development education]. *Jiangsu shengli Shanghai zhongxuexiao banyuekan* 江蘇省立上海中學校半月刊 [Jiangsu provincial Shanghai middle school biweekly], no. 76 (October 22, 1933): 15–19.

Shenbao 申報 [*Shanghai Journal*]. Shanghai. Established 1872.

Shenbao guan 申報館. "Zixu" 自序 [Editor's preface]. *Shenbao pinglun xuan* 申報評論選 [Selection of *Shenbao* editorials]. Shanghai: Shenbaoguan, 1932.

Shengxin bao 聖心報 [Messenger of the Sacred Heart]. *Messager du Sacré-Coeur*. (July 21, 1889–May 1949).

Shi Yukun 石玉昆. *Zhonglie xiayi zhuan* 忠烈俠義傳 [The tale of loyalty and righteousness]. Beijing: Juzhen tang, 1879.

———. *Bao gong'an* 包公案 [The cases of Judge Bao]. In *Zhongyang yanjiuyuan Lishi yuyan yanjiusuo suocang suqu* 中央研究院歷史語言研究所所藏俗曲 [Popular songs collected in the Institute of Historical Linguistics of the Academia Sinica]. Microfilm reprint, reel 304. Ithaca, NY: Cornell University, 1970–1979?

———. *Longtu er lu* 龙图耳录 [Aural record of the Dragon Diadem]. Annotated by Fu Xihua 傅惜华. 2 vols. Shanghai: Shanghai guji chubanshe, 1981.

———. *Xiao wu yi* 小五义 [The latter five gallants]. Punctuated by Lu Shulun 陆树仑 and Zhu Shaohua 竺少华. Shanghai: Shanghai guji chubanshe, 1993.

———. *San xia wu yi* 三俠五义 [The three knights and the five gallants]. Annotated and punctuated by Wang Jun 王军. 2 vols. Beijing: Zhonghua shuju, 1996.

———. *Tales of Magistrate Bao and His Valiant Lieutenants*. Translated by Susan Blader. Hong Kong: Chinese University of Hong Kong Press, 1998.

Shiao, Ling. "Printing, Reading, and Revolution: Kaiming Press and the Cultural Transformation of Republican China." PhD diss., Brown University, 2008.

Shibao 時報 [*Eastern Times*]. Shanghai. Established 1904.

"Should Internet Cafes Be Closed?" *Beijing Review* (April 26, 2001): 30–31.

Shunde xianzhi 順德縣志 [Shunde county gazetteer]. Shunde: n.p., 1853.

Sichuan shengzhi: Chuban zhi 四川省志: 出版志 [Sichuan provincial gazetteer: publishing gazetteer]. 2 vols. Chengdu: Sichuan renmin chubanshe, 2001.

Silang 四郎. "Du 'Yinianlai Zhejiang qingnian yuekan de jiantao' hougan" 讀 '一年來浙江青年月刊的檢討' 後感 [Feelings after reading 'A review of *Zhejiang Youth*' monthly after one year]. *Zhejiang qingnian* 浙江青年 [Zhejiang youth] 2, no. 3 (January 1936): 2–3 [page numbering discontinuous].

"6'-4" Website Creator Put to Subversion Trial in Sichuan." *China News Digest*, February 11, 2001. [http://www.cnd.org/] (accessed February 12, 2001).

Smith, Craig S. "Falun Dafa Defies Authority by Preaching in Cyberspace." *Asian Wall Street Journal*, September 10–11, 1999.

Snow, Edgar. *Red Star over China*. New York: Random House, 1938.

Song Lihua 宋莉华. "Fangyan yu Ming Qing xiaoshuo ji qi chuanbo" 方言与明清小说及其传播 [Dialect, the Ming-Qing novel and its dissemination]. In *Ming Qing xiaoshuo yanjiu* 明清小说研究 [Research on Ming and Qing fiction] 4 (1999): 36–50.

Song Yuanfang 宋原放, ed. *Zhongguo chuban shilao: xiandai bufen* 中国出版史料: 现代部分 [Source materials on Chinese publishing history: 1911–1949]. Vols. 1, 5; Parts 1, 2. Ji'nan: Shandong jiaoyu chubanshe, 2000. (Abbreviated as *ZCSXB*.)

Song Yulin 宋玉麟. "Huiyi Yan'an Xinhua shudian" 回忆延安新华书店 [Recalling Yan'an's New China Bookstore]. *Chuban shiliao* 出版史料 [Historical publishing materials] 2 (December 1983): 5–7.

Song Yunbin 宋云彬. "Kaiming jiushi" 开明旧事 [Reminiscences of Kaiming]. *Wenshi ziliao xuanji* 文史资料选集 [Collected materials on culture and history], *zong* 31 (1962): 1–29.

Songjiang nüzhong xiaokan 松江女中校刊 [Songjiang Girls' Middle School Journal], no. 3 (February 5, 1929): *zhuanzai*; no. 4 (April 10, 1929): *zhuanzai*; no. 6 (July 1, 1929): *zhuanzai*; nos. 19–20 (June 15, 1931); no. 24 (November 25, 1931); no. 42 (May 1, 1933).

Soong, Roland. "The Underground Publishing Industry in China." EastSouthWestNorth, June 14, 2005. http://zonaeuropa.com/20050614_1.htm (accessed October 16, 2007).

——. "The 'Malignant Tumor' in Chinese Book Publishing." EastSouthWestNorth, January 27, 2005. http://zonaeuropa.com/20050130_1.htm (accessed October 16, 2007).

Soothill, William Edward, and Lewis Hodous. *A Dictionary of Chinese Buddhist Terms.* London: RoutledgeCurzon, 2004.

Standaert, Nicolas, ed. *Handbook of Christianity in China. Volume One: 635–1800.* Leiden: Brill, 2001.

[Standing Committee of the National People's Congress.] "Guanyu weihu hulianwang anquan de jueding" 关于维护互联网安全的决定 [Decisions on defending the safety of the Internet]. *GWYGB* 5 (2001): 21–23.

Stanley, Jay. *The Surveillance-Industrial Complex: How the American Government Is Conscripting Businesses and Individuals in the Construction of a Surveillance Society.* August 2004. American Civil Liberties Union. http://www.aclu.org/SafeandFree/SafeandFree.cfm?ID=16226&c=282 (accessed October 4, 2004).

[State Council.] "Chuban guanli tiaoli" 出版管理条例 [Administrative regulations on publication] (January 1, 1997). *GWYGB* 2 (1997): 38–46.

——. "Hulianwang xinxi fuwu guanli banfa" 互联网信息服务管理办法 [Administrative measures on the Information Service of the Internet] (September 20, 2000). *GWYGB* 34 (2000): 7–9.

[State Council Information Office, Ministry for Information Industry.] "Hulianwangzhan congshi dengzai xinwen yewu guanli zanxing guiding" 互联网站从事登载新闻业务管理暂行规定 [Temporary administrative provisions on the business of publishing news on websites] (November 6, 2000). *GWYGB* 2 (2001): 46–48.

[State Council Office.] "Guowuyuan Bangongting guanyu chengli guojia xinxihua gongzuo lingdao xiaozu de tongzhi" 国务院办公厅关于成立国家信息化工作领导小组的通知 [The State Council's notice establishing the leading group of national informational works] (December 23, 1999). *GWYGB* 6 (2000): 8–9.

[State Secrets Bureau.] "Zhonghua renmin gongheguo baoshou guojia mimi fa shishi banfa" 中华人民共和国保守国家秘密法实施办法 [Enforcement of the state secrets law of the People's Republic of China]. *GWYGB* 14 (1990): 538–543.

Stein, Gunther. *The Challenge of Red China.* New York: McGraw-Hill, 1945.

Stranahan, Patricia. *Molding the Dream: The Chinese Communist Party and the Liberation Daily.* Armonk, NY: M. E. Sharpe, 1990.

Streit, Robert, and Johannes Dindinger, eds. *Bibliotheca Missionum. Zwölfter Band: Chinesische Missionsliteratur, 1800–1884.* Freiburg: Herder, 1958.

Struve, Lynn. "Ancestor *Édite* in Republican China: The Shuffled Journal of Xue Cai (1595–1665)." *East Asian Library Journal* 13, no. 1 (Spring 2008): 33–65.

Su, Jing. *The Printing Presses of the London Missionary Society among the Chinese.* PhD diss., University College London, 1996.

Sun Jiaxun 孫佳迅. *Jinghua yuan gong'an bianyi* 鏡花緣公案辨疑 [An investigation into public records concerning Flowers in the mirror]. Ji'nan: Jilu shushe, 1984.

Sun Kaidi 孫楷第. *Zhongguo tongsu xiaoshuo shumu* 中國通俗小說書目 [Index of Chinese popular novels]. 1956. Reprint, Taipei: Fenghuang chubanshe, 1974.

Suzhou nüzi zhongxue yuekan 蘇州女子中學月刊 [Suzhou girls' middle school monthly] 1, no. 8 (November 15, 1929).

Suzhou Zhenhua nü xuexiao 蘇州振華女學校, ed. *Zhenhua nü xuexiao sanshinian jiniankan* 振華女學校三十年紀念刊 [The commemorative volume for the thirtieth anniversary of Zhenhua Girls' School]. *Zhenhua jikan* 振華季刊 [Zhenhua quarterly] 2, nos. 3–4 (August 1936).

"Symposium on 'Public Sphere'/'Civil Society' in China." *Modern China* 19, no. 2 (April 1993).

Tan Guilin 谭桂林. *Puti xinyu: ershi shiji Zhongguo fojiao sanwen* 菩提心语: 二十世纪中国佛教散文 [Words of the enlightened mind: short essays of twentieth-century Chinese Buddhism]. Huai'an: Tiandi chubanshe, 1996.

Tan Shaozeng 譚紹曾. "Junxun qijian shenghuo huiyi" 軍訓期間生活回憶 [Memories of life during military training]. *Zhejiang qingnian* 浙江青年 [Zhejiang youth] 1, no. 12 (October 1935): 145–147.

Tan Sitong 譚嗣同. "Baozhang wenti shuo" 報章文體說 [On newspaper genres]. *Shiwubao*, nos. 29 and 30 (June 10 and June 21, 1897).

——. "Baozhang zong yuzhou zhi wen shuo" 報章總宇宙之文說 [On the Newspaper, Which Brings All the Writings of the World Together]. *Tan Sitong quanji* 譚嗣同全集 [Collected writings of Tan Sitong]. Beijing: Zhonghua shuju, 1981.

Tang Xiguang 唐錫光. "Kaiming de licheng" 開明的历程 [The historical journey of Kaiming]. In Zhongguo chuban gongzuozhe xiehui, *Wo yu Kaiming*, 289–314.

Tanmeng daoren 貪夢道人. *Peng gong'an quanzhuan* 彭公案全傳 [Complete tales of the cases of Judge Peng]. Tainan: Shiyi shuju, 1992. 2 vols.

——. *(Zhengxu) Peng gong'an* (正续) 彭公案 [Orthodox continuation of the cases of Judge Peng]. Annotated by Li Yonghu 李永祜, Li Wenling 李文苓, and Wei Shuidong 魏水东. 4 vols. Beijing: Qunzhong chubanshe, 2001.

Tanxu 倓虛. *Yingchen huiyi lu: Zhanshan Tanxu dashi shu menren daguang ji* 影尘回忆录: 湛山倓虚大师述门人大光记 [Memoir of shadows and dust: Master Tanxu of Zhanshan expounds to his followers great glory]. 1969. Reprint, Chengdu: Sichuan sheng zongjiao wenhua jingji jiaoliu fuxu zhongxin, n.d.

Tao Jingsun 陶晶孙. "Ji Chuangzao she" 记创造社 [My recollection of the Creation Society]. In Rao et al., *Chuangzao she ziliao*, 775–782.

Tao, Wenzhao. "Censorship and Protest: The Regulation of BBS in China's *People's Daily*." *First Monday* 6, no. 1 (2001). http://firstmonday.org/htbin/cgiwrap/bin/ojs/index.php/fm/article/view/826/735 (accessed October 22, 2009).

Tao Xisheng 陶希圣. "Shangwu yinshuguan bianyisuo jianwen ji" 商务印书馆编译所见闻记 [An account of my experience at the Shangwu editorial department]. In *Shangwu yinshuguan jiushiwu nian*, 484–496.

Teiser, Stephen F. *The Scripture of the Ten Kings and the Making of Purgatory in Medieval Chinese Buddhism*. Honolulu: University of Hawai'i Press, 1994.

Ting, Lee-hsia Hsu. *Government Control of the Press in Modern China, 1900–1949*. Cambridge, MA: Harvard East Asian Research Center, 1974.

Todorov, Tzvetan. "The Origin of Genres." In Duff, *Modern Genre Theory*, 193–209.

Treat, John Whittier. "Yoshimoto Banana Writes Home: *Shojo* Culture and the Nostalgic Subject." *Journal of Japanese Studies* 19, no. 2 (1993): 353–387.

"Trial of Internet Entrepreneur Starts in Chengdu." RTHK Radio 3 (Hong Kong), February 13, 2001. http://www.rthk.org.hk/channel/radio3/. Cf. *SWB FE*/4070, February 14, 2001: G/4.

Tschopp, Martin, et al. "Accessibility, Spatial Organization, and Demography in Switzerland, 1920 to 2000." Paper presented at the Swiss Transport Research Conference, Monte Verità, Ascona, Italy, March 19–21, 2003: 1, Figure 1. http://www.strc.ch/Paper/tschopp.pdf (accessed July 12, 2008).

Tsien, Tsuen-hsuin. *Paper and Printing*. Vol. 5, pt. 1, of *Science and Civilisation in China*. Edited by Joseph Needham. New York: Cambridge University Press, 1985–86.

Tsin, Michael. *Nation, Governance, and Modernity in China: Canton, 1900–1927*. Stanford, CA: Stanford University Press, 1999.

Tsu, Yu Yue. "Present Tendencies in Chinese Buddhism." In *China Today*, edited by T.T. Lew et al. London: Student Christian Movement, 1922.

Tsui, Lokman. "Big Mama Is Watching You: Internet Control and the Chinese Government." Master's thesis, University of Leiden, 2001. http://www.lokman.nu/thesis/010717–thesis.pdf.

——. "The Panopticon as the Antithesis of a Space of Freedom: Control and Regulation of the Internet in China." *China Information* 17, no. 2 (2003): 65–82.

Under the Banyan Tree (Rongshu xia 榕树下), ed. *Ai shi jueban* 爱是绝版 [Love is a last edition]. Shanghai: Shanghai wenhua chubanshe, 2002.

United Nations Development Programme (UNDP), ed. *Human Development Report 2007/2008. Fighting Climate Change: Human Solidarity in a Divided World*, 226. New York: UNDP, 2007. http://hdr.undp.org/en/media/HDR_20072008_EN_Complete.pdf (accessed March 14, 2008).

"United States." Reporters Without Borders, June 22, 2004. [http://www.rsf.org].

U.S. Department of Homeland Security. "Fact Sheet: Protecting America's Critical Infrastructure—Cyber Security." http://www.dhs.gov/dhspublic/display?content=4359 (accessed September 6, 2005).

——. "Ridge Creates New Division to Combat Cyber Threats." June 6, 2003. http://www.dhs.gov/xnews/releases/press_release_0173.shtm (accessed September 6, 2005).

Van den Brandt, Joseph. *Catalogue des principaux ouvrages sortis des presses des Lazaristes à Pékin de 1864 à 1930*. Beijing: Henri Vetch, 1933.

Van de Ven, Hans J. *From Friend to Comrade: The Founding of the Chinese Communist Party, 1920–1927*. Berkeley: University of California Press, 1991.

——. "The Emergence of the Text-Centered Party." In Saich and van de Ven, *New Perspectives on the Chinese Communist Revolution*, 5–32.

Vita functi in Provincia, 1897–1926. 5 vols. Manuscript, AFCJ (n.d.).

Vittinghoff, Natascha. *Die Anfänge des Journalismus in China (1860–1911)*. Wiesbaden: Harrassowitz, 2002.

Volland, Nicolai. "The Control of the Media in the People's Republic of China." PhD diss., Heidelberg University, 2003.

Wacker, Gudrun. "The Internet and Censorship in China." In Hughes and Wacker, *China and the Internet*. 58–82.

Wagner, Rudolf G. "The Canonization of May Fourth." In Doleželová-Velingerová, Král and Sanders, *The Appropriation of Cultural Capital*, 66–122.

——. "Joining the Global Imaginaire: The Shanghai Illustrated Newspaper *Dianshizhai huabao*." In Wagner, *Joining the Global Public*, 105–173.

——, ed. *Joining the Global Public: Word, Image, and City in the Early Chinese Newspapers, 1870–1910*. Albany: State University of New York Press, 2007.

Wan, Margaret Baptist. *"Green Peony" and the Rise of the Martial Arts Novel*. Albany: State University of New York Press, 2009.

Wan Jun 萬鈞. *Guanyin lingyi ji* 觀音靈異紀 [The mysteries of Guanyin]. 1915. Reprint, Shanghai: Shanghai foxue shuju, 1998.

Wang Zhaoyang 王朝陽. "Xu" 序 [Introduction]. *Jiangsu shengli diyi shifan xuexiao niankan* 江蘇省立第一師範學校年刊 [Jiangsu provincial first normal school annual]. N.p.: 1923.

Wang Chong'er 网虫儿. "Wangluo wenxue zouhong, zuojia taidu lengdan" 网络文学走红, 作家态度冷淡 [While Internet literature is in fashion, writers show cold attitudes]. *Zhishi jingji* 知识经济 [Knowledge economy], no. 6 (2000): 37.

Wang, David. *Fin-de-Siècle Splendor: Repressed Modernities of Late Qing fiction, 1849–1911*. Stanford, CA: Stanford University Press, 1997.

Wang Gai 王概. "Yu shuo" 雩說 (On the Yu sacrifice). In He Changling 賀昌齡, comp. *Huangchao jingshi wenbian* 皇朝經世文編 [Collected writings on statecraft from our great dynasty]. Reprinted as *Qing jingshi wenbian* 清經世文編, j. 45, 33a–35b. Beijing: Zhonghua shuju, 1992: 1083–1084.

Wang Gang 王纲. "Qingdai Sichuan de yinshuye" 清代四川的印书业 [Sichuan book printing in the Qing]. *Zhongguo shehui jingjishi yanjiu* 中国社会经济史研究 [Research on Chinese social and economic history], no. 4 (1991): 62–70.

Wang, Jing. "Bourgeois Bohemians in China? Neo-Tribes and the Urban Imaginary." *China Quarterly* 183 (2005): 532–48.

Wang, L. Sophia. "The Independent Press and Authoritarian Regimes: The Case of the *Dagong bao* in Republican China." *Pacific Affairs* 67, no. 2 (Summer 1994): 216–241.

Wang Lanping 王兰萍. *Jindai Zhongguo zhuzuo quan fa de chengzhang* 近代中国著作权法的成长 [The development of copyright laws in Chinese modern history]. Beijing: Beijing daxue chubanshe, 2006.

Wang, Liping. "Tourism and Spatial Change in Hangzhou, 1911–1927." In *Remaking the Chinese City: Modernity and National Identity, 1900–1950*, edited by Joseph W. Esherick, 107–120. Honolulu: University of Hawai'i Press, 2000.

Wang, Melissa. "CHINA: Internet Society of China Releases a Code of Conduct for Web Bloggers." AsiaMedia, May 22, 2007. http://www.asiamedia.ucla.edu/article.asp?parentid=70356 (accessed May 22, 2009).

Wang Qingyuan 王清原, Mou Renlong 牟仁隆, and Han Xiduo 韩锡铎, eds. *Xiaoshuo shufang lu* 小说书坊录 [Record of booksellers of novels]. Beijing: Beijing tushu guan chubanshe, 2002.

Wang Xiaoming 王晓明. "Yifen zazhi he yige 'shetuan'" 一份杂志和一个社团 [A magazine and a society]. In *Cicong li de qiusuo* 刺丛里的求索 [Quests in an inhospitable world], edited by Wang Xiaoming. Shanghai: Yuandong chubanshe, 1995.

Wang Xiaoyuan 王孝源. "Qingdai Sichuan muke shufang shulüe" 清代四川木刻书坊述略 [Brief narrative of Qing-era woodblock bookshops in Sichuan]. *Sichuan xinwen chuban shiliao* 四川新闻出版史料 [Historical materials on Sichuan news and publishing] 1 (1992): 43–65.

Wang Xirong 王锡荣. "*Nahan* geban guoyan lu"《呐喊》各版过眼录 [An account of all editions of "Call to Arms"]. In *Lu Xun zhuzuo banben chongtan* 鲁迅著作版本丛谈 [Essays on editions of Lu Xun's works], edited by Tang Tao 唐弢, 49–60. Beijing: Shumu wenxian chubanshe, 1983.

Wang Yankang 王衍康. "Zhongxuexiao jiji xunyu zhi sizhong shishi" 中學校積極訓育之四種實施 [Four kinds of implementation of active character-development education for middle schools]. *Zhongdeng jiaoyu* 中等教育 [Secondary education] 3, no. 2 (August 1, 1924): 1–16.

Wang, Ying. "Imitation as Dialogue: The Mongolian Writer Yinzhan naxi (1837–1892)." *Tamkang Review* 34, no. 1 (2003): 2–39.

Wang Yintong 汪陰桐. "Xiao shudian de fazhan yu houqi wenhua yundong" 小书店的發展與後期文化運動 [The development of small press and cultural movements in the post–May Fourth era]. *Changye* 長夜 [Long Night] 3 (May 1928).

Wang Yu 王瑜. "Wei Hui xiaoshuo xinlun" 卫慧小说新论 [Rethinking Wei Hui's fiction]. *Hunan wenli xueyuan xuebao* 湖南文理学院学报 [Journal of Hunan University of Arts and Science] 35, no. 5 (2008): 83–97.

Wang Yuanfang 汪原放. *Huiyi Yadong tushuguan* 回忆亚东图书馆 [Recollections of the Yadong Press]. Shanghai: Xuelin chubanshe, 1983.

——. "Yadong tushuguan jianshi" 亚东图书馆简史 [A short history of the Yadong Press]. In Song Yuanfang, *ZCSXB*, vol. 1, pt. 1: 287–296.

Wang Zhiyi 王知伊. "Kaiming shudian jishi" 开明书店纪事 [History of the Kaiming Press]. *Chuban shiliao* 出版史料 (Historical publishing materials] 4 (1985): 3–24.

Wanli di chao 萬曆邸鈔 [Newsletters from the Wanli era]. Taipei: Guting, 1968.

Wei Hui 卫慧. *Shanghai baobei* 上海宝贝 [Shanghai baby]. Xianggang: Tiandi tushu youxian gongsi, 2000.

——. Homepage. http://goldnets.myrice.com/wh/ (accessed January 24, 2006).

Welch, Holmes. *The Practice of Chinese Buddhism, 1900–1950*. Cambridge, MA: Harvard University Press, 1967.

——. *The Buddhist Revival in China*. Cambridge, MA: Harvard University Press, 1968.

Wen Kang 文康. *Ernü yingxiong zhuan* 儿女英雄传 [The tale of romance and heroism]. Edited and annotated by Ergong 尔弓. 2 vols. Ji'nan: Qi Lu shushe, 1995.

Widmer, Ellen. *The Beauty and the Book: Women and Fiction in Nineteenth-Century China*, Cambridge, MA: Harvard University Press, 2006.

——. "The Saoye Shanfang of Suzhou and Shanghai: An Evolution in Five Stages." Unpublished essay.

Wiest, Jean-Paul. "Bringing Christ to the Nations: Shifting Models of Mission among Jesuits in China." *Catholic Historical Review* 83, no. 4 (October 1997): 654–82.

Will, Pierre-Etienne. *Bureaucracy and Famine in Eighteenth-Century China*. Stanford, CA: Stanford University Press, 1990.

Willaeys, Hélène. *L'aurore: 1903–1951. Une rencontre entre l'orient et l'occident*. Maîtrise de chinois, Université de Provence, Marseille, 1996.

Williamson, Alexander. *Journeys in North China, Manchuria, and Eastern Mongolia, with Some Account of Corea*. 2 vols. London: Smith, Elder, 1870.

Winkel, Olaf. "Sicherheit in der digitalen Informationsgesellschaft." *Aus Politik und Zeitgeschichte*, B 41–42/2000 (October 6, 2000): 19–30 (21).

Wolverstan, Bertram. *The Catholic Church in China: From 1860–1907*. London: Herder, 1909.

Wong, Lawrence Wang-chi. "A Literary Organization with a Clear Political Agenda: The Chinese League of Left-Wing Writers, 1930–1936." In *Literary Societies of Republican China*, edited by Kirk A. Denton and Michel Hockx, 316–320. Lanham, MD: Lexington Books, 2008.

Wu Guifang 吳貴芳. "Ji dang de zaoqi yinshua gongzuo he diyige dixia yinshuachang" 記黨的早期印刷工作和第一個地下印刷廠 [Remembering the CCP's early printing work and the first underground print shop]. In *Zhongguo jin xian dai chuban shiliao, xiandai, bubian* 中國近現代出版史料, 現代, 補編 [Modern and contemporary Chinese historical publishing materials, contemporary supplement], edited by Zhang Jinglu 張靜盧, vol. 6, 270–272. Shanghai: Shanghai shudian, 2003 [1954–57].

Wu Guo 吳过. "Wangluo xiezuo de lingyizhong yiyi" 网络写作的另一种意义 [An alternative meaning of Internet writing]. [http://www.xys.org/xys/] (accessed March 2, 2001).

——. "Wang shang you jian 'Huangjin shu wu': Wanglu fang youth" 网上有问 '黄金书屋': 网路访 youth [There is a "Golden Book Cottage" on the Internet: An online interview with 'youth'"]. [http://www.oklink.net/] (accessed August 29, 2005).

Wutai yu rensheng 舞台与人生 [Life on stage] 5 (2000): n.p.

Wu, Xiaozhou. "Genre Theories from the Chinese-Western Perspective." *Tamkang Review* 24, no. 1 (Autumn 1993): 39–74.

Wu Yankang. "The Revered Master Deep Willows and the Hall of Deep Willows." Translated by Frederick W. Mote. *East Asian Library Journal* 12, no. 2 (2006), 14–48.

——. "Yang Renshan and the Jinling Buddhist Press." Translated by Nancy Norton Tomasko. *East Asian Library Journal* 12, no. 2 (2006), 49–98.

Wu Yuzhang 吴玉章. *Wu Yuzhang huiyi lu* 吴玉章回忆录 [Reminiscences of Wu Yuzhang]. Beijing: Zhongguo qingnian chubanshe, 1978.

Wylie, Alexander. *Notes on Chinese Literature*. New York: Paragon Book Reprint Corporation, 1964.

——. *Memorials of Protestant Missionaries to the Chinese: Giving a List of Their Publications, and Obituary Notices of the Deceased, with Copious Indexes*. Taipei: Chengwen, 1976.

Xia Mianzun 夏丏尊. "Hongyi fashi zhi chujia" 弘一法师之出家 [Dharma Master Hongyi's becoming a monk] In *Xia Mianzun sanwen yiwen jingxuan* 夏丏尊散文译文精选 [Selected essays and translations by Xia Mianzun], edited by Xia Hongning. 1939. Reprint, Beijing: Zhongguo wenlian chubanshe, 2003.

Xia Renhu 夏仁虎. *Jiujing suoji* 舊京鎖記 [Scattered notes on the old capital]. Beijing: Guji chubanshe, 1986.

Xiang Fu'an 向復菴, ed. "Yinianlai Jiangsu zhongdeng jiaoyu zhi huigu yu zhanwang" 一年來江蘇中等教育之回顧與展望 [A look at Jiangsu's middle school education during the past year, and a look forward]. *Jiangsu jiaoyu* 江蘇教育 [Jiangsu education] 2, nos. 1–2 (February 1933).

Xiang Jianzhong 項建中. "Yongqiang—shi wode jiaxiang" 永強一是我的家鄉 [Yongqiang is my hometown]. *Zhejiang qingnian* 浙江青年 [Zhejiang youth] 2, no. 4 (February 1936): 138–140.

Xiao Dongfa 肖东发. *Zhongguo tushu chuban yinshua shilun* 中国图书出版印刷史论 [A history of Chinese book publishing and printing]. Beijing: Beijing daxue chubanshe, 2001.

Xiao Feng 萧枫. *Hongyi dashi wenji shuxin juan* 弘一大师文集书信卷 [The collected correspondence of Master Hongyi]. Vols. 1–2. Huhehaote/Hohhot: Neimenggu renmin chubanshe, 1996.

Xiao Ping 肖平. *Jindai Zhongguo fojiao de fuxing yu riben fojiaojie de jiaowang lu* 近代中国佛教的复兴与日本佛教界的交往录 [The modern Chinese Buddhist revival and its association with Japanese Buddhist circles]. Guangzhou: Guangdong renmin chubanshe, 2003.

Xie Gang 谢钢. "Yu wangluo wenxue qinmi jiechu—Cai Zhiheng xilie zuopin yingxiao celüe" 与网络文学亲密接触—蔡志恒系列作品营销策略 [Intimate encounters with Internet literature—strategies for marketing Cai Zhiheng's novels]. http://www.cass.net/cn/chinese/s15_wxs/qianyan/wlwx/05.htm (accessed June 29, 2004).

Xiong Chongshan 熊崇善, and Li Qiju 李其驹. "Li Da yu chuban gongzuo" 李达与出版工作 [Li Da and publishing work]. *Chuban shiliao* 出版史料 [Historical publishing materials] 6 (1986): 74–80.

——. "Ji Renmin chubanshe" 记人民出版社 [Recalling People's Publishing House]. In Song Yuanfang, *ZCSXB*, 142–145.

Xiong Yuezhi 熊月之. *Xixue dongjian yu wan-Qing shehui* 西学东渐与晚清社会 [The dissemination of Western knowledge and late Qing society]. Shanghai: Shanghai renmin chubanshe, 1994.

Xu Baimin 徐白民. "Shanghai shudian huiyi lu [1953]" 上海書店回憶錄 [Recollections of Shanghai Bookstore]. In Zhang Jinglu, *Zhongguo jin xiandai chuban shiliao, xiandai, jiabian*, vol. 3, 61–67.

Xu Baohua 许宝华 and Miyata Ichirô 宫田一郎, eds. *Hanyu fangyan dacidian* 汉语方言大辞典 [Great dictionary of Chinese dialects]. 5 vols. Beijing: Zhonghua shuju, 1999.

Xu Keyu 徐克譽. "Benxiao gaozhong tongxue de xingqu he sixiang: Yige diaocha baogao" 本校高中同學的興趣和思想: 一個調查報告 [The interests and ideas of this school's high school students: a survey report]. *Jizhong xuesheng* 稽中學生 [Jishan middle school students], no. 7 (October 1937): 13–22.

Xu Su 徐蘇. "Minguo shiqi Jiangsu yinshua hangye gaishu" 民國時期江蘇印刷行業概術 [A general account of Jiangsu's printing industry during the Republican period]. In *Jiangsu chubanshi (minguo shiqi) xueshu taolunhui wenji*.

Xu, Xiaoman. "'Preserving the Bonds of Kin': Genealogy Masters and Genealogy Production in the Jiangsu-Zhejiang Area in the Qing and Republican Periods." In Brokaw and Chow, *Printing and Book Culture in Late Imperial China*, 332–367.

Xu, Xiaoqun. *Chinese Professionals and the Republican State: The Rise of Professional Associations in Shanghai, 1912–1937*. New York: Cambridge University Press, 2001.

Xu Xinfu 徐信符. "Guangzhou banpian jilüe" 广州版片记略 [Brief record of Guangzhou woodblock publishing]. *Guangdong chuban shiliao* 广东出版史料 [Historical materials on Guangdong publishing] 2 (1991): 13–19.

Xu Youchun 徐友春 et al., eds. *Minguo renwu dacidian* 民國人物大辭典 [Biographical dictionary of Republican China]. Shijiazhuang: Hebei renmin chubanshe, 1991.

"Xuesheng zizhihui benjie gaikuang" 學生自治會本屆概況 [General situation of the student self-government asociation during this session]. *Jingzhong xuesheng qikan* 敬中學生期刊 [Periodical of Jingye Middle School's students]. Chuangkanhao 創刊號 [Inaugural issue] (n.d.): 274–275.

"Xuesheng zizhihui huiwu shikuang" 學生自治會會務實況 [Actual situation of the affairs of the student self-government association]. *Hanggao xuesheng* 杭高學生 [Hangzhou High Students], no. 11 (1935): 5, 14.

Xujiahui da xiuyuan 徐家匯大修院, ed. *Jiangnan xiuyuan bai zhou jinian* 江南修院百周紀念, *1843–1943* [Memorabilia de Seminario Kiang-nan, 1843–1943]. Xujiahui: Xuhui da xiuyuan, 1943.

Xuyun. "Master Xu-yun's Discourse on the Twelfth Anniversary of the Death of Dharma Master Yin-guang, a Saint of the Pure Land, on 21 December 1952." www.hsuyun.com (accessed August 5, 2006).

"Yahoo 'Helped Jail China Writer.'" *BBC News*, September 7, 2005. http://news.bbc.co.uk/default.stm. The Chinese text of the verdict, which cited the data received from Yahoo! as evidence, was published at http://www.penchinese.com/wipc/08newsmay/st-pjs.htm (accessed September 12, 2005). Partial English translation at http://www.zonaeuropa.com/20050501_1.htm (accessed September 12, 2005).

Yan Jingchang 颜景常. *Gudai xiaoshuo yu fangyan* 古代小说与方言 [Fiction and dialect in ancient China]. Shenyang: Liaoning jiaoyu chubanshe, 1992.

Yang, Dali L. "The Great Net of China." Homepage. http://www.daliyang.com/files/Yang_the_great_net_of_China.pdf (accessed October 22, 2009).

Yang Daxin 杨大辛 and Zhang Shouqian 张守谦. "Tianjin chuban shi gailüe" 天津出版史概略 [An outline of publishing history in Tianjin]. In *Tianjin wenshi ziliao xuanji* 天津文史资料选集 [Selected Tianjin cultural and historical materials]. Vol. 42. Tianjin: Tianjin renmin chubanshe, 1988.

Yang, Guobin. "Historical Imagination in the Study of Chinese Digital Civil Society." In *China's Information and Communications Technology Revolution: Social Changes and State Responses*, edited by Xiaoling Zhang and Yongnian Zheng, 17–33. London: Routledge, 2009.

——. "The Internet and the Rise of a Transnational Chinese Cultural Sphere." *Media, Culture & Society* 25, no. 4 (2003): 469–490.

——. "The Internet as Cultural Form: Technology and the Human Condition in China." *Knowledge, Technology & Policy* 22, no. 2 (2009): 109–115.

——. "Virtual Transgressions into Print Culture: a Sociological Analysis of the Rise and Impact of Internet Literature in China." Unpublished conference paper.

Yang, Lan. *Chinese Fiction of the Cultural Revolution*. Hong Kong: Hong Kong University Press, 1998.

Yang Liying 杨丽莹. "*Saoye shanfang shi yanjiu*" 扫叶山房史研究 [Research on the history of Saoye shanfang]. PhD diss., Fudan University, 2005.

Yang Shouqing 楊壽清. *Zhongguo chuban jianshi* 中國出版簡史 [A concise history of Chinese publishing]. Shanghai: Yongxiang yinshuguan, 1946.

Yang Wenhui 楊文會. *Fojiao chuxue keben* 佛教初學課本 [Introductory Buddhist textbook]. 1906. Reprint, Nanjing: Jinling kejing chu, 2003.

Yang Yi 杨义. *Zhongguo xiandai xiaoshuo shi* 中国现代小说史 [A history of contemporary Chinese fiction]. 3 vols. Beijing: Renmin wenxue chubanshe, 1986.

Yao Nai 姚鼐. *Guwenci leizuan* 古文辭類纂. [Anthology of writings in the ancient style arranged in categories]. Shanghai: Shanghai guji chubanshe, 1998.

Yao Wenxiang 姚文祥. "Mengmian zhicheng huojiang zhihou" 蒙面之城获奖之后 [After Mengmian zhicheng wins the prize]. *Dianzi yu diannao* [Electronics and computers], no. 12 (2002): 12.

Yardley, Jim. "Internet Sex Column Thrills, and Inflames, China." *New York Times*, November 30, 2003. http://www.nytimes.com/2003/11/30/international/asia/30CHIN.html (accessed February 4, 2004).

——. "A Chinese Bookworm Raises Her Voice in Cyberspace." *New York Times*, July 24, 2004. http://www.nytimes.com/ 2004/07/24/international/asia/24prof.html.

Ye Dehui 葉德輝. *Shulin qinghua* 書林清話 [Brief talks on books]. Beijing: Zhonghua shuju, 1957.

Ye Shengtao 叶圣陶. "Liang fashi" 兩法師 [Two dharma masters]. In Tan Guilin, *Puti xinyu*.

Ye Suzhong 葉溯中. "Chuangkan xianci" 創刊獻詞 [Words offered at the founding of the journal]. *Zhejiang qingnian* 浙江青年 [Zhejiang youth] 1, no. 1 (November 1934).

Ye, Xiaoqing. *The Dianshizhai Pictorial: Shanghai Urban Life 1884–1898*. Ann Arbor: Center for Chinese Studies, University of Michigan Press, 2003.

Ye Zaisheng 叶再生. *Zhongguo jindai xiandai chuban tongshi* 中国近代现代出版通史 [Comprehensive history of publishing in modern China]. 4 vols. Beijing: Huawen chubanshe, 2002.

Yeh, Catherine Vance. "Shanghai Leisure, Print Entertainment, and the Tabloids, *xiaobao* 小報." In Wagner, *Joining the Global Public*, 201–233.

Yeh, Wen-hsin. *Provincial Passages: Culture, Space, and the Origins of Chinese Communism*. Berkeley: University of California Press, 1996.

Yinguang 印光. *Yinguang fashi wenchao* 印光法師文钞 [Collected writings of Dharma Master Yinguang]. Edited by Xu Weiru. 4 vols. 1918. Reprint, Suzhou: Honghuashe, 1935.

——. *Yinguang fashi wenchao* 印光法師文钞 [Collected writings of Dharma Master Yinguang]. Edited by Zhang Yuying. 1918. Reprint, Beijing: Zongjiao wenhua chubanshe, 2000.

——. *Xinyuan nianfo* 信愿念佛 [Belief in reciting the Buddha's name]. Edited by Wang Jingrong. Guangzhou: Huacheng chubanshe, 1995.

——. *Yinguang dashi kaishi lu* 印光大师开示录 [A record of the preaching of Master Yinguang]. No publishing information; found at Qixiashan Monastery near Nanjing, 2003.

Yisu 一粟. *Honglou meng shulu* 紅樓夢書録 [Records of books on *Dream of the Red Chamber*]. Shanghai: Guji chubanshe, 1963.

Yiwenlu 益聞錄. Nos. 1–1800 (March 16, 1879—August 13, 1898).

Youhuan sheng 忧患生. "Jinghua bai'er zhuzhici" 京华百二竹枝词 [One hundred twenty bamboo-branch songs of the capital]. In *Zhonghua zhuzhi ci* 中华竹枝词 [Bamboo-branch songs of China], edited by Lei Mengshui 雷梦水, Pan Chao 潘超, Sun Zhongquan 孙忠铨, and Zhong Shan 锺山, vol. 1, 273–297. 6 vols. Beijing: Beijing guji chubanshe, 1996.

Yü, Chün-fang. "P'u-t'o Shan: Pilgrimage and the Creation of the Chinese Potalaka." In *Pilgrims and Sacred Sites in China*, edited by Susan Naquin and Chun-fang Yu, 190–245 Berkeley: University of California Press, 1992.

Yu Runqi 于润琦. *Qingmo Minchu xiaoshuo shuxi: jingshi juan* 清末民初小说书系: 警世卷 [Novels from the late Qing and early Republic: awakening the world]. Beijing: Zhongguo wenlian chubanshe, 1997.

Yu Zhi 余志. *Deyi lu* 得一錄 [A record of keeping all the virtues]. Suzhou: Dejian zhai, 1869.

Yuan Chen 元辰. "Yue wang manji: shui shi wangluo zuojia" 阅网漫记: 谁是网络作家 [Random notes on online reading: Who is an Internet writer?]. May 1, 2000. http://wsz.hg.net.cn/cgi-bin/BBS.exe?id=wsz&msg=691 (accessed June 29, 2004).

Yuan Jiansheng 袁建胜. "Xuni shijie zhong de 'tiaozhan'—xi Muzi Mei xianxiang" 虚拟世界中的"挑战"—析木子美现象 [The challenge to battle in the fictional world—analyzing the Muzi Mei phenomenon]. *Zhida xuebao* 职大学报 [Journal of the Staff and Workers University] 1 (2008): 40–3, 87.

"Yuechixian mukeye qingkuang diaocha baogao" 岳池縣木刻業情況調查報告 [Report on the investigation into block-cutting industry in Yuechi county]. In *Jianchuan* 建川 054: Sichuansheng xinwen chubanchu 四川省新聞出版處, *juan* 34. 1954. Sichuan Provincial Archives.

Zakon, Robert, comp. Hobbes' Internet Timeline. http://www.zakon.org/robert/internet/timeline/ (accessed September 8, 2005).

Zha, Jianying. *China Pop: How Soap Opera, Tabloids, and Bestsellers Are Transforming Culture*. New York: New Press, 1995.

Zhang Chao 張潮, ed. *Zhaodai congshu* 昭代叢書 [Compendium of works of our time]. Suzhou: Saoye shanfang, 1697.

Zhang Cixi 張次溪. *Renmin shoudu de Tianqiao* 人民首都的天桥 [Tianqiao, capital of the people]. Beijing: Zhongguo quyi chubanshe, 1988.

Zhang Hua 張化. *Shanghai zongjiao tonglan* 上海宗教通览 [A general overview of religion in Shanghai]. Shanghai: Shanghai guji chubanshe, 2004.

Zhang Huaijiu 張怀久 and Liu Chongyi 刘崇义, eds. *Wu di fangyan xiaoshuo* 吴地方言小说 [Wu dialect novels]. Nanjing: Nanjing daxue chubanshe, 1997.

Zhang Jinglu 張靜盧. *Zai chubanjie ershinian* 在出版界二十年 [Twenty years in the publishing world]. 1938. Reprint, Taipei: Longwen chubanshe, 1994.

——, ed. *Zhongguo xiandai chuban shiliao* 中國現代出版史料 [Contemporary Chinese publishing materials]. 4 vols. Beijing: Zhonghua shuju, 1954–57. Reprinted 2003. (Abbreviated as *ZXCS*.)

[——.] "Diyici guonei geming zhanzheng shiqi chubanwu jianmu" 第一次國內革命戰爭時期出版物簡目 [A short list of published materials from the First Revolutionary War period]. In Zhang Jinglu, *ZXCS*, vol. 1, 68–78.

[——.] "Xinhua shudian fazhan jianshi, 1937–1950" 新華書店發展簡史 [A brief history of the development of New China Bookstore, 1937–1950]. In Zhang Jinglu, *ZXCS*, vol. 3, 256–265.

——, ed. *Zhongguo jin xiandai chuban shiliao, xiandai, jiabian* 中國近現代出版史料, 現代, 甲編 [Modern and contemporary Chinese historical publishing materials; contemporary, vol. 1]. 1954–57. Reprint, Shanghai: Shanghai shudian, 2003.

Zhang, Junhua. "China's 'Government Online' and Attempts to Gain Technical Legitimacy." *Asien* 80 (July 2001): 93–115.

Zhang, Kun. "Bodies Melting into Words." *China Daily*, December 4, 2003. http://app1.chinadaily.com.cn/star/2003/1204/fo5–1.html (accessed July 1, 2008).

Zhang Mo 張默. "Liushi nian lai zhi *Shenbao*" 六十年來之申報 [Sixty years of Shenbao]. In *Shenbao gaikuang* 申報概況. Shanghai: [Shenbao guan], 1935.

Zhang Nanzhuang 張南庄. *He Dian* 何典? (What classic?) Annotated by Cheng Jiang 成江. Shanghai: Xuelin chubanshe, 2000.

Zhang Xueshu 張學恕. "Lun minguo shiqi Jiangsu de chuban yu jingji" 論民國時期江蘇的出版與經濟 [A discussion of publishing and the economy in Republican period Jiangsu]. In *Jiangsu chubanshi (minguo shiqi) xueshu taolunhui wenji*.

Zhang Xin 張欣. "Wo shi shei?" 我是谁 [Portrait of myself.] Translated by Li Ziliang. *Chinese Literature* 3 (1993): 78.

——. "Ai you ru he?" 爱又如何? [What's love?] *Shanghai wenxue* [Shanghai literature] 10 (1994): 4–32.

Zhang, Jeanne Hong. *The Invention of a Discourse: Women's Poetry from Contemporary China*. Leiden: CNWS Publications, 2004.

Zhang Xiumin 张秀民. *Zhongguo yinshua shi* 中国印刷史 [History of Chinese printing]. Shanghai: Shanghai renmin chubanshe, 1989.

Zhang Yuanji 张元济. *Zhang Yuanji riji* 张元济日记 [Diary of Zhang Yuanji]. 2 vols. Beijing: Shangwu yinshuguan, 1981.

Zhang, Zhen. *An Amorous History of the Silver Screen: Shanghai Cinema, 1896–1937*. Chicago: University of Chicago Press, 2005.

Zhang Ziping 张资平. "Shuxinqi de Chuangzao she" 曙新期的创造社 [Early years of the Creation Society]. In Rao et al., *Chuangzao she ziliao*, 707–716.

Zhao, Henry Y. H., ed. *The Lost Boat: Avant-Garde Fiction from China*. London: Wellsweep, 1993.

Zhao Jianzhong 趙建忠. *Honglou meng xushu yanjiu* 紅樓夢續書研究 [Research into sequels to dream of the red chamber]. Tianjin: Guji chubanshe, 1997.

Zhao Shusheng 趙樹聲. "Fakanci" 發刊詞 [Inaugural preface]. *Minli xunkan* 民立旬刊 [Minli ten-day periodical]. Chuangkanhao 創刊號 [Inaugural issue] (March 20, 1936): 1–2.

Zhao, Yuezhi. *Media, Market, and Democracy in China: Between the Party Line and the Bottom Line*. Urbana: University of Illinois Press, 1998.

——. "The Rich, the Laid-off, and the Criminal in Tabloid Tales: Read All about It!" In Link, Madsen, and Pickowicz, *Popular China*, 111–135.

"*Zhejiang qingnian* yuekan diyijuan zong mulu" 浙江青年月刊第一卷總目錄 [Comprehensive index of the first volume of *Zhejiang Youth* monthly]. *Zhejiang qingnian* 浙江青年 [Zhejiang youth] 1, no. 12 (October 1935).

Zhejiang sheng jiaoyuhui yaolan 浙江省教育會要覽 [*Essentials of the Zhejiang Provincial Education Association*]. N.p.: 1919.

"*Zhejiang sheng qingniantuan dagang*" 浙江省青年團大綱 [Outline of the Zhejiang Province Youth Group]. *Zhejiang qingnian* 浙江青年 [Zhejiang youth] 2, no. 7 (May 1936): 202–211.

Zheng Boqi 郑伯奇. "Yi Chuangzao she" 忆创造社 [My recollection of the Creation Society]. In Rao et al., *Chuangzao she ziliao*, 836–868.

Zheng Chaolin 郑超麟. "Ji Shanghai shudian" 记上海书店 [Remembering Shanghai Bookstore]. Edited by Zheng Xiaofang 郑晓方. *Chuban shiliao* 出版史料 [Historical publishing materials]. Vol. 4 (1991): 45–46.

——. *Zheng Chaolin huiyilu, 1919–31* 郑超麟回忆录 [Mcmoirs of Zheng Chaolin]. 2 vols. Beijing: Dongfang chubanshe, 2004.

Zheng, Yongnian, and Guoguang Wu. "Information Technologies, Public Sphere, and Collective Action in China." *Comparative Political Studies* 38 (2005): 507–536.

Zheng Zhiming 鄭志明. *Zhongguo shanshu yu zongjiao* 中國善書與宗教 [China's morality books and religion]. Taipei: Taiwan xuesheng shuju, 1988.

Zhenhua jikan 振華季刊 [Zhenhua quarterly]. Chuangkanhao 創刊號 [Inaugural issue] (March 1934).

Zhejiang qingnian 浙江青年 [Zhejiang youth] 2, no. 5 (March 1936).

Zhejiang shizhong qikan 浙江十中期刊 [Periodical of Zhejiang Tenth Middle School], no. 1 (October 1921).

Zhejiang shengli diqi zhongxue xiaoyouhui banyuekan 浙江省立第七中學校友會半月刊 [Zhejiang Provincial Seventh Middle School Friend Association semi-monthly], nos. 7–8 (January 20, 1932).

Zhejiang shizhong qikan 浙江十中期刊 [Periodical of Zhejiang Tenth Middle School] (n.d.): 20, fn.

Zhejiang shizhong shifanbu qikan 浙江十中師範部期刊 [Periodical of the Normal Division of Zhejiang Tenth Middle School], nos. 1–2 (June 1924).

Zhongguo chuban gongzuozhe xiehui 中国出版工作者协会, eds. *Wo yu Kaiming* 我与開明 [Kaiming and me]. Beijing: Zhongguo qingnian chubanshe, 1985.

Zhonggong Shanghai shiwei dangshi ziliao zhengji weiyuanhui 中共上海市委党史资料征集委员会, ed., *Shanghai geming wenhua dashi ji* 上海革命文化大事記 [The

chronicle of Shanghai revolutionary culture]. Shanghai: Shanghai shudian chuban-she, 1995.

"Zhongguo hulianwang hangye zilü gongyue" 中国互联网行业自律公约 ["The self-discipline convention of the Internet trade in China"], March 27, 2002. http://www.people.com.cn/GB/it/49/149/20020327/695927.html (accessed September 12, 2005). For an English translation see http://www.bobsonwong.com/index2.php?option=content&task=view&id=63&pop=1&page=0 (accessed September 12, 2005).

Zhongxi wenjian lu 中西聞見錄 [Record of things heard and seen from the East and the West]. Beijing. Established 1872. Reprinted Nanjing: Nanjing guji shudian, 1992.

Zhongyang daxue quli Yangzhou zhongxue chuban weiyuanhui 中央大學區立揚州中學出版委員會, ed. *Yinian lai zhi Yangzhong* 一年來之揚州 [Yangzhou Middle School during the last year]. [Yangzhou]: Zhongyang daxue quli Yangzhou zhong-xuexiao, 1928.

Zhou Baochang 周保昌. "Xinhua shudian zai Yan'an chuchuang shiqi" 新华书店在延安初创时期 [The initial stages of New China Bookstore in Yan'an]. *Chuban shi-liao* 出版史料 Historical publishing materials) 2 (December 1983): 1–4.

Zhou Fohai 周佛海. "Women zenyang qu zuoren" 我們怎樣去作人 [How can we conduct ourselves?]. *Jizhong xuesheng* 稽中學生 [Jishan middle school students] 1, no. 1 (October 1, 1932): 1–5.

Zhou Houshu 周厚樞. "Yangzhou zhongxue jiaoxun heyi hou zhi chubu shishi" 揚州中學教訓合一後之初步實施 [Yangzhou Middle School's initial joining of the instruction and character-development education system). *Jiangsu jiaoyu* 江蘇教育 [Jiangsu education] 1, no. 10 (November 1932): 56–66.

Zhou Jianwen 周鑑文. "Wode huigu 我的回顧" [My recollections]. *Jiangsu shengli Shanghai zhongxue banyuekan* 江蘇省立上海中學半月刊 [Jiangsu provincial Shanghai middle school biweekly], nos. 83–84 (May 12, 1934): 33–60.

——. "Fakan de hua" 發刊的話 [Words upon launching the journal]. *Shangzhong shi-kan* 上中市刊 [Shanghai middle school municipality's publication]. Shimin zuopin teji 市民作品特輯 [A special collection of citizens' works] (June 5, 1934): 1–3.

——. "Feichang shiqizhong qingnian xuesheng yingshou de xunlian" 非常時期中青年學生應受的訓練 [The training young students should receive during the cri-sis period]. *Jizhong xuesheng* 稽中學生 [Jishan middle school students] 8, no. 1 (December 1936): 49–55.

Zhou Lianggong 周亮工, ed. *Chidu xinchao* 尺牘新鈔 [Newly recorded letters]. Shanghai: Shangwu yinshuguan, 1936.

Zhuang Suoyuan 庄索原. "Tushanwan yinshuguan suoji" 土山湾印书馆琐记 [Brief account of the Imprimerie de T'ou-sè-wè)]. *Chuban shiliao* [Historical publishing materials] 10 (April 1987): 35–36.

Zhu Chongke 朱崇科. "Xin dongfang zhuyi: libiduo shixian zhong de rentong zheng-zhi: cong 'Shanghai baobei' dao 'Wode Chan'" 新东方主义: 力比多实践中的认同政治—从《上海宝贝》到《我的禅》 [Neo-orientalism: the politics of identifica-tion in libidinal practice—from "Shanghai baby" to "Marrying Buddha"]. *Hainan shifan daxue xuebao* 海南师范大学学报 [Journal of Hainan Normal University] 21, no. 6 (2008): 72–77.

Zhu Lianbao 朱联保. *Jin xian dai Shanghai chubanye yinxiangji* 近现代上海出版业印象记 [Impressions of Shanghai publishing in the modern era]. Shanghai: Xuelin chubanshe, 1993.

Zhu Ziqing 朱自清. "Mai shu" 买书 [Buying books]. First published in *Shuixing* 水星 [Water star] 1, no. 4 (January 10, 1935). Reprinted in *Zhu Ziqing sanwen quanji* 朱自清散文全集 [Collected short essays of Zhu Ziqing]. Nanning: Guangxi renmin chubanshe, 2003.

——. "Wenwu, jiushu, maobi" 文物, 旧书, 毛笔 [Cultural artifacts, old books, writing brushes]. First published in *Dagongbao* 大公報, (March 31, 1948). Reprinted in *Zhu Ziqing sanwen quanji*.

Zhuo Nansheng [Toh Lam-seng] 卓南生. "Chûgoku kindai shimbun seiritsushi 1815–1874" 中国近代新聞成立史 1815–1874 [The beginnings of modern Chinese newspapers and their development in the nineteenth century]. Tokyo: Bunkansha, 1990.

"Zi-ka-wei, Séminaires." AFCJ (FCh 303).

Zittrain, Jonathan, and Benjamin Edelman. *Empirical Analysis of Internet Filtering in China*. April 2003. Research Publication no. 2003–02. The Berkman Center for Internet & Society. http://cyber.law.harvard.edu/home/uploads/203/2003–02.pdf (accessed September 12, 2005).

INDEX

NB: In this index page numbers followed by an *i* indicate illustrations and those followed by a *t* indicate information found in tables.